MONUMENT MAN

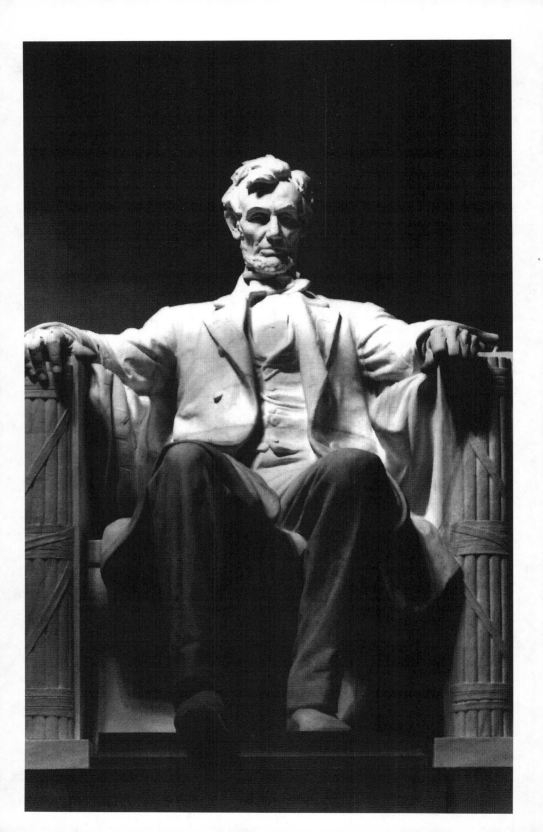

MONUMENT MAN

The Life and Art of
Daniel Chester French

HAROLD HOLZER

ROWMAN & LITTLEFIELD
Lanham • Boulder • New York • London

THE PAPERBACK EDITION OF
*MONUMENT MAN: THE LIFE AND ART OF
DANIEL CHESTER FRENCH* WAS MADE
POSSIBLE BY THE GENEROUS CONTRIBUTION
OF MICHAEL F. AND SUSAN MOYLE LYNCH

Let's go see old Abe

Sitting in the marble and the moonlight,

Sitting lonely in the marble and the moonlight,

Quiet for ten thousand centuries, old Abe.

Quiet for a million, million years.

Quiet—

And yet a voice forever

Against the

Timeless walls

Of time—

Old Abe.

"Lincoln Monument: Washington"
Langston Hughes, 1926

"I'd like to see what this is going to look like
a thousand years from now."

Daniel Chester French to his daughter, on seeing
the Lincoln Memorial for the last time, 1929

FRONTISPIECE:
**Abraham Lincoln at the Lincoln Memorial, 1911–22,
Washington, DC**

Published by Rowman & Littlefield
An imprint of The Rowman & Littlefield Publishing Group, Inc.
4501 Forbes Boulevard, Suite 200, Lanham, Maryland 20706
www.rowman.com

86-90 Paul Street, London EC2A 4NE

British Library Cataloguing in Publication Information Available

Library of Congress Cataloging-in-Publication Data
Names: Holzer, Harold, author.
Title: Monument man : the life and art of Daniel Chester French / Harold
 Holzer.
Description: First edition. | New York : Princeton Architectural Press, 2019.
Identifiers: LCCN 2018007925 | ISBN 9781616897536 (hardcover : alk. paper) |
 ISBN: 9781538190623 (pbk : alk. paper)
Subjects: LCSH: French, Daniel Chester, 1850-1931. | Sculptors—United
 States—Biography.
Classification: LCC NB237.F7 H65 2019 | DDC 730.92 [B] —dc23
LC record available at https://lccn.loc.gov/2018007925

∞™ The paper used in this publication meets the minimum requirements of
American National Standard for Information Sciences—Permanence of Paper for
Printed Library Materials, ANSI/NISO Z39.48-1992.

Acknowledgments

In the long, happy process of investigating and writing this life of Daniel Chester French, I relied on the advice and encouragement of many scholars, librarians, colleagues, friends, and family, and I am delighted to acknowledge and thank them here.

Above all, for commissioning me to undertake this biography, I am indebted to Donna Hassler, executive director of Chesterwood, Daniel Chester French's former home, studio, and gardens at Stockbridge, Massachusetts, now owned and operated by the National Trust for Historic Preservation. Donna was a steadfast and inspiring partner throughout the effort to research and produce the book, and without her hospitality and encouragement, it would not have been possible. Her irresistible invitations—not only to dwell as an unofficial scholar-in-residence at the Meadowlark (formerly the Lower Studio, built by French and converted into a cottage by his daughter), but also to perform Lincoln-themed programs each summer at the main Chesterwood studio—have kept me in a sustained, hypnotic "D. C. F. mood" for years. Special thanks to Chesterwood Emeritus Council member and patron Jeannene T. Booher for her financial support for the entire project.

Heartfelt thanks go also to Chesterwood curatorial researcher Dana Pilson, a knowledgeable, patient, and tireless French scholar and onetime Metropolitan Museum curatorial department staffer who tirelessly guided me through the essential D. C. F. venues and resources. At the Chapin Library at Williams College, to which the Chesterwood Archives were transferred in 2010, Dana introduced me to Chapin librarian Wayne Hammond, whose help is gratefully acknowledged as well.

As far as I am concerned, the most knowledgeable expert on American sculpture anywhere is Thayer Tolles, Marica F. Vilcek Curator of American Paintings and Sculpture, and my longtime colleague, at the Metropolitan Museum of Art, where I served as head of external affairs for twenty-three years. Thayer gave the original manuscript a careful and most useful reading, and offered sage advice whenever I peppered her with subsequent questions.

From Cornish to the Met to the Knickerbocker Club, she has been a great friend and guiding star, and I thank her sincerely. Additional thanks go to Donald LaRocca, curator in the Met's Arms and Armor Department, for his guidance on French's memorial plaque honoring the department's founding chairman, Bashford Dean; to archivist James Moske for his help in culling materials and photographs from French's years as a Met trustee; and to curator Susan Stein and curator emerita H. Barbara Weinberg, for answering some perplexing questions about Impressionists—French as well as American.

Gratitude goes, too, to Valerie Paley, chief historian of the New-York Historical Society, with whom I have enjoyed previous collaborations on books and exhibitions, as well as her historical society colleagues Margi Hofer and Nick Juravich. I had the honor of serving a few years ago as its Roger Hertog Fellow. Thus, thanks go as well to Mr. Hertog for that opportunity; to another former board chairman, Richard Gilder, for his longtime generosity and support; and to CEO Louise Mirrer for her long-standing encouragement.

I am also grateful to Margaret "Peggy" Burke, former executive director of the Concord Museum at Daniel Chester French's boyhood hometown, as well as to the museum's wonderful curator, David Wood; Dennis Fiori, former director of the Massachusetts Historical Society, along with his colleagues Peter Drummey and Elaine Heavey; Leslie Wilson of the Concord Free Public Library; Barbara Allen, curator of the Procter Museum & Archives of Stockbridge History at the Stockbridge Library; and Deborah Smith and Julie Swan of the Bowdoin College Museum of Art in Maine, all of whom supplied expert guidance and warm welcomes.

At the Library of Congress, where much of the French Family Papers are housed, I received guidance—along with vital instructions on the elusive mechanics regarding flash drives and microfilm readers—from Jeffrey M. Flannery, head of Reference and Reader Services at the Manuscript Division. Thanks go as well to Dr. Alice L. Birney, library historian, who provided access to some original French material usually off-limits to researchers; and Library of Congress Civil War specialist Michele Krowl for her unfailing help and friendship.

At Princeton Architectural Press, I have benefitted from terrific support and a most professional expediting of this project, especially by designer Paula Baver, acquisitions editor Abby Bussel, content editor Jan Hartman, copy editor Christopher Church, and production editor Nina Pick.

I want also to thank my longtime research assistant, Avi Mowshowitz, for his resourcefulness in locating and securing copies of key documents online, as well as at both Columbia University and the New-York Historical Society. Karen Needles, whose "Documents on Wheels" project has unearthed and recorded troves of Lincoln-related material at the National Archives, located the complete file of government records relating to the Lincoln Memorial Commission. At the Nebraska Capitol Commission in Lincoln, important assistance was provided by Matthew G. Hansen, preservation architect. And my longtime friend and occasional coeditor, Sara Vaughn Gabbard, sent me a bulging file of newspaper clips on French's Lincoln statues from the Lincoln Financial Foundation collection in Fort Wayne, Indiana. Her colleague Jane Gastineau at the Indiana Historical Society guided me to still more resources. I also enjoyed corresponding with children's book author Linda Booth Sweeney, who shared and commented on her favorite D. C. F. letters.

There are always lingering tidbits of information requiring fact checks, and many friends and colleagues endured repeated questions and responded with useful answers. They include John F. Marszalek and David Nolen of the Ulysses S. Grant Presidential Library and Museum at Mississippi State University Starkville, regarding Ulysses S. Grant's opinion of General Joseph Hooker; Craig L. Symonds, the country's leading naval historian, on both Admiral Samuel F. du Pont and the USS *Concord*; James Cornelius of the Abraham Lincoln Presidential Library and Museum in Springfield, Illinois, on Lincoln sculptures in its collections; and Lincoln assassination expert Richard Sloan of Long Island, about the "chiseler" of the Lincoln Memorial's ornamental lettering, Ernest C. Bairstow.

I also acknowledge three other figures who influenced me indirectly, yet crucially. One, the late Hungarian-born historian and photojournalist Stefan Lorant (1901–1997), was a childhood hero of mine who strongly influenced my own interest in Lincoln iconography. In 1972 he invited my wife and me to his home in Lenox, Massachusetts, and from there took us to neighboring Stockbridge for our first visit to Daniel Chester French's Chesterwood estate. There, in the sculptor's studio, he proudly showed us a bust of himself created by French's daughter, Margaret, whom he knew personally. We will forever be grateful to Lorant for introducing us to Chesterwood, indeed to the Berkshires. I feel a strong debt as well to Michael Richman, a pioneering and prolific D. C. F. scholar whose catalogs, articles, and exhaustive research notes have provided much guidance to me. And to Daniel Preston, editor of the James Monroe papers at the University of Mary Washington, who

completed Richman's work in transcribing French's letters. And I would like to express admiration to an enthusiast I have never met: Douglas Yeo, an accomplished musician and music scholar whose engaging website (http:// yeodoug.com) boasts an extraordinary collection of information and photographs recording his visits to what appear to be every D. C. F. sculpture on display nationwide. Thank you, Mr. Yeo, for sharing such a thorough and captivating archive.

Finally, a word of sincere thanks, for their help in copying, shipping, fielding email and phone messages, and general indispensable organizing, to my executive assistant at the Roosevelt House Public Policy Institute at Hunter College in New York, AmyRose Aleonar Yee, as well as Jacki Mariani Summerfield; and to my onetime staff Met Museum aide Kraig Smith, who happily (for me) remains a key part of my professional life. I owe my new career as Johnathan F. Fanton Director of Roosevelt House to the support of a brilliant and engaged Board of Advisors, whose members embrace and encourage scholarship; and above all to Hunter's indefatigable president Jennifer J. Raab, who has been both a blessing and a booster to the field of historic study.

Last but not least—for I might easily have begun with this most important acknowledgment of all—I have no words adequate to express my gratitude and love for my wife, Edith Holzer, not only for emotional support for more than fifty years (counting from our high school days) but for working so closely, and so crucially, with me on this project from beginning to end. Edith joined me for all of the research trips, read, transcribed, and photocopied documents, and later reviewed and edited repeated drafts of the manuscript. During the course of the project, she also nursed me through two serious illnesses. It is more than a cliché to say that I could not have undertaken, much less completed, this book without her. While any and all errors of fact and judgment in this book are mine alone, any credit it receives I gratefully share with her.

HAROLD HOLZER
Rye, New York
February 12, 2018

Foreword

On May 30, 1922, Robert Russa Moton, the sole invited Black speaker at the dedication of the Lincoln Memorial, beseeched the segregated audience to "strive on to finish the work Lincoln so nobly began—to make America the symbol for equal justice in the world." Now, more than a century after this iconic monument's unveiling, the United States is still striving to become a nation of equal justice. Between the 2019 publication of the first edition of Harold Holzer's definitive biography *Monument Man: The Life & Art of Daniel Chester French* and the release of this paperback version five years later, Americans have experienced a global pandemic, harrowing incidents of racial and social inequity, and stark political division. As never before, public monuments and memorials have become rallying points for public protests and catalysts for national conversations about societal reform, the shaping of America's past, and individuals' sometimes problematic legacies. Sculptures in bronze and stone, whether installed in parks, squares, or cemeteries, serve as tangible manifestations of political and cultural trends, both historical and contemporary, that are scrutinized through diverse—and often divergent—lenses. They also offer context for considering overlooked and missing histories—what stories heretofore have not been publicly commemorated in three dimensions.

It is for this reason—and many others—that Daniel Chester French (1850–1931) and his work remain boundlessly relevant to audiences today. Over the course of his six-decade career, French created more than one-hundred public statues for eighteen U.S. states, the District of Columbia, and France. These monuments, undeniably *all* monuments, while often changing little physically, are necessarily, as Holzer observes in *Monument Man*, "cultural works in progress" (p. 18). They are civic actors on a large stage performing shifting roles around notions of American identity and power structures. Indeed, French's monuments will undoubtedly remain at the forefront of national consciousness in coming decades as dynamic visual barometers of political, social, and artistic conditions, past and present.

No work by French embodies transitory, elastic status of monuments more than his over lifesize seated *Abraham Lincoln* (1911–22) for the Lincoln Memorial. Created by an artist of privileged White New England

stock, its stone was quarried by African American laborers and carved by the Piccirilli Brothers, Italian immigrants based in the Bronx. Ubiquitous in American cultural consciousness and visited in person by hundreds of millions, the statue is variously a beacon of hope and healing as well as a symbol of the celebrated and/or contested legacy of the sixteenth President of the United States. It is a "hard worker," reflecting multivalent voices, as it has been since its unveiling, and will continue to be, itself a "voice forever," as poet Langston Hughes described it in 1926.

In the following pages, Holzer contextualizes Daniel Chester French within the artistic, historical, and cultural landscape of the sculptor's times. This holistic and balanced narrative draws on abundant archival material as well as the author's expertise on Lincoln and the Civil War era, collective memory, and the robust ensuing visual culture response. The hope of most biographers, Holzer among them, is that their work will spawn additional research and scholarship on their chosen subjects while challenging specialists and non-specialists alike to reach their own conclusions. *Monument Man* is authoritative, and it has already served as the springboard for further inquiry about French as a monument maker—delving into why he chose to pursue specific commissions, who he collaborated and associated with, and how his creative visions became sculptural reality.

For example, new protagonists in the complex process of sculpture-making continue to be foregrounded: in 2020, as a result of encountering Augustus Saint-Gaudens's *Victory*, a sculpture acquired by French as a trustee for the Metropolitan Museum of Art, independent scholar Eve Kahn undertook exhaustive work on Hettie Anderson, a model of African American ancestry employed by French, Saint-Gaudens, and other leading turn-of-the-twentieth century artists. Her research resulted in articles in *The New York Times* and *The Magazine Antiques*. Chesterwood's Curatorial Researcher and Collections Coordinator Dana Pilson has in lectures and writings freshly considered the lasting impact of Margaret French Cresson, French's daughter, as a sculptor and preservationist. In 2022 documentary filmmaker Eduardo Montes-Bradley premiered *Daniel Chester French: American Sculptor*, with the goal of introducing the artist and his summer home, studio, and gardens, Chesterwood, a site of the National Trust for Historic Preservation in Stockbridge, Massachusetts, to wider audiences by relying on archival resources, recent digital footage, and scholarly voices, including Holzer's.

Chesterwood, under the leadership of Donna Hassler, now Director Emerita, has in recent years been a thought leader in presenting French as an artist of and for the nineteenth, twentieth, and twenty-first centuries, an

individual of his time, enjoying lasting fame and recognition while generating mixed legacies. After commissioning Holzer to write *Monument Man*, the historic site responded to the escalating controversy over public statuary by conducting a thoughtful review of the entirety of French's body of work, resulting in two digital conversations: "Casting Identities: Race and American Sculpture," a project funded by the National Endowment for the Humanities and led by Emily Burns, professor of art history at the University of Oklahoma. French's figurative works require broader, more nuanced consideration—for instance, the Francis Parkman Memorial (1897–1907) in Jamaica Plain, Massachusetts, which represents the sculptor's idealized vision of Indigeneity, or the Lafayette Memorial (1914–16) in Brooklyn, New York, which depicts the French military officer with an unidentified Black attendant. For twenty-first century audiences, other civic sculptures by French demand urgent reckoning; while historical context serves as a vital armature, it may be overlaid and overshadowed by present realities. Notably, French's Four Continents (Asia, America, Europe, and Africa; 1903–07) for the U.S, Custom House in New York City perpetuate racial typing and hierarchal assumptions once normative and reassuring to White audiences that are harmful and offensive.

Chesterwood has also modeled new ways to contextualize French and his sculpture through exhibitions. In 2022, with the Norman Rockwell Museum, it organized the *Lincoln Memorial Centennial Exhibition: The Lincoln Memorial Illustrated,* highlighting the monument's resonance for illustrators and cartoonists as an icon of freedom and democracy. Likewise, the work of considering French among other leading cultural figures of his day is ongoing. Chesterwood, with the American Federation of Arts and the Saint-Gaudens National Historical Park, has co-organized the multi-venue exhibition, *Monuments and Myths: The America of Sculptors Augustus Saint-Gaudens and Daniel Chester French* (traveling 2023–25). This project un-siloes these artists, positioning them as collaborative and complementary partners in shaping turn-of-the-twentieth-century America, while reassessing and reframing their creative accomplishments through historical and present-day perspectives.

Holzer's *Monument Man: The Life & Art of Daniel Chester French*, now issued as a paperback third edition, and these ensuing scholarly inquiries—with more to come, offer readers the opportunity to examine our textured and complicated past—and the sculptor's place in it—with greater critical insight.

THAYER TOLLES
Marica F. Vilcek Curator of American Paintings and Sculpture
The Metropolitan Museum of Art

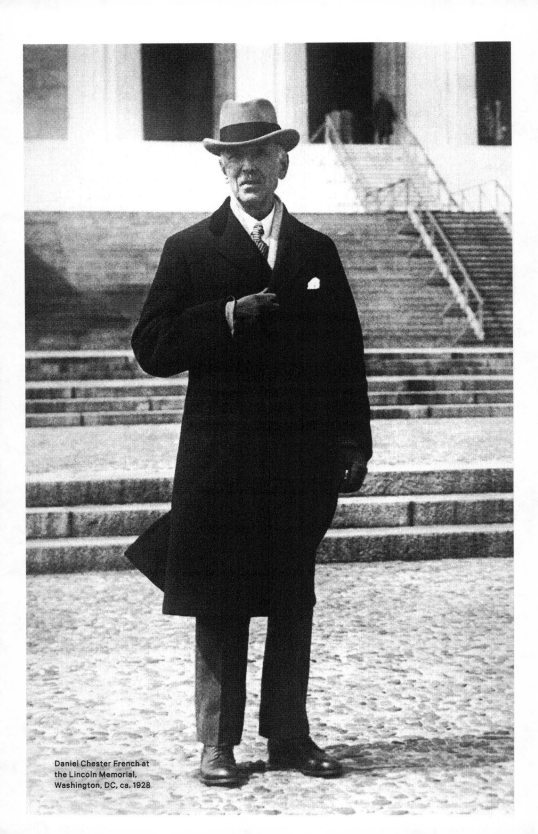

Daniel Chester French at
the Lincoln Memorial,
Washington, DC, ca. 1928

IN THIS TEMPLE

IN THIS TEMPLE

AS IN THE HEARTS OF THE PEOPLE

FOR WHOM HE SAVED THE UNION

THE MEMORY OF ABRAHAM LINCOLN

IS ENSHRINED FOREVER

Words inscribed on a tablet behind Daniel Chester French's seated
Lincoln inside the Lincoln Memorial, Washington, DC

With the Gettysburg Address carved into its interior walls, the new Lincoln Memorial should have inspired a dedication ceremony of, by, and for the people—all the people, black as well as white. Like Abraham Lincoln's transcendent speech, the inscription behind the massive statue dominating the memorial's atrium made no exceptions based on race. In the hearts of African Americans, too—at this moment, perhaps especially—Abraham Lincoln's memory remained firmly enshrined. And on this hot and sunny Memorial Day afternoon in 1922, sculptor Daniel Chester French's marble colossus, a godlike Lincoln, enthroned in marble, seemed to be watching over the entire crowd of fifty thousand and the millions of admirers they represented.

Such a "for the people" event, however, the ceremony was not to be—not for all the people, anyway. The *Washington Times* had predicted otherwise. For "the mother," the paper predicted, it would inspire "gratitude that the war is over," and for the veteran of the Great War, it would rekindle the "memory of battlefields." The historian would find here "the immortalizing

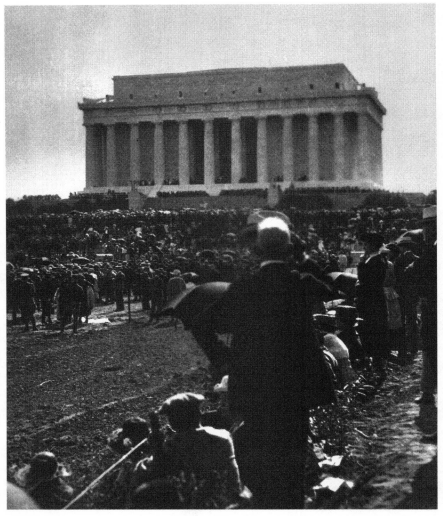

Dedication of the Lincoln Memorial, May 30, 1922

of the hero dead"; the businessman, "a respite from office cares"; the elderly, a "look behind into memory's mirror"; and the young, "a day of pleasure." Females, the newspaper promised, could even expect to discover a symbol "of woman's new emancipation."[1] Tellingly, the *Times* made no mention at all of the significance the Memorial might hold for people of color.

Welcome or not, African Americans arrived at Washington's Potomac Park early that dedication day hoping for places at the front of the expected throng. But before the pageant got underway, on instructions from the North Carolina–born superintendent of public buildings and grounds,

soldiers armed with guns and bayonets ordered these early arrivals from their chairs and herded them into a "colored section" situated at the far edge of the grounds and "roped in from the rest of the audience."[2] Aggressive bullying, one white Marine corpsman boasted openly at the scene, was "the only way you can handle these 'damned niggers.'"

Black dignitaries who had come bearing tickets marked "Platform Section V" learned that their section was located "a block away from the memorial itself, back in the grass and weeds."[3] While the "seats arranged for white people were chairs...those for colored people were benches without backs."[4] A day of jubilation turned into a "scene of unpleasantness," a source of "consternation and chagrin."[5] America's racial gulf would not be bridged even at a ceremony dedicated to a man the black press still called the "Great Emancipator."[6]

Rather than submit to an overt "act of segregation," some twenty-one prominent African Americans, including several federal officials, a Howard University administrator, and Alain LeRoy Locke, the first African American Rhodes Scholar, walked out in protest. When one well-known black realtor, ordered to take a seat on a particularly "rough bench," replied, "I'll think about it," a white guard threatened: "Well, think damned quick." The remark triggered a "near riot."[7]

From their remote "Bloc d'Afrique," as the *Chicago Defender* characterized their ersatz ghetto, even the most eminent of the remaining community leaders were compelled to peer at the ceremonies from a distance that emphasized their isolation and separateness.[8] To add gross insult to grievous injury, a group of "gray-clad survivors of the Confederate army"—elderly white men who had waged the rebellion to defy Lincoln and defend slavery—received seats of honor alongside equally ancient veterans from the Union side.[9] The *Washington Post* applauded the fact that "two groups of bowed men in blue and gray had seats to right and left of a flag for and against the existence of which they once did battle."[10] But an African American eyewitness saw cruel irony in the fact that such insensitivity, not to mention "Jim-Crowism of the grossest sort,"[11] had been shown by "the hypocrites of the great nation" on a day devoted to Abraham Lincoln. The seating anomalies made it clear, he said, that "the spoils have gone to the conquered, not the conquerors."[12] The theme of this day was to be reconciliation of the country's geographic sections, not of the races still dwelling separately in a house divided. In a scathing analysis published in the *Crisis*, the official newspaper of the NAACP, W. E. B. Du Bois decried the event under the headline: "Lincoln, Harding, James Crow, and Taft."[13]

Yet another indignity awaited Lincoln's "stepchildren," as Frederick Douglass had described African Americans at the dedication of a Lincoln statue erected in Washington forty-five years earlier.[14] This additional slight, however, would at first be known only to some of the public officials and special guests who now ascended to the speakers' platform atop the Lincoln Memorial steps.

As silent-film cameras recorded the arrivals, President Warren G. Harding and Vice President Calvin Coolidge took places of honor alongside Chief Justice (and ex-President) William Howard Taft and the ancient, bewhiskered former Speaker of the House, "Uncle Joe" Cannon, who as a youth had glimpsed Lincoln back in Illinois, and as Speaker counted himself a twentieth-century Lincoln Republican. Joining them was Lincoln's only surviving son, Robert, now a reclusive octogenarian, sporting a white beard that made him look more like Speaker Cannon than his martyred father. Here too were Edwin Markham, the seventy-year-old Oregon poet, set to recite his ode "Lincoln, the Man of the People," chosen over two hundred rival entries for the program, and Henry Bacon, the architect who had designed this magnificent building. Finally, unrecognized by most, was the thin, aging, but still spry sculptor who had created the miraculous statue before whose gaze they all now assembled: Daniel Chester French.

Only one person of color stood out among the sea of white skin, white hair, and white beards arrayed before the temple's white marble columns: Robert Russa Moton, Booker T. Washington's successor as principal of the all-black Tuskegee Industrial School. In something of a token gesture, organizers had invited Moton to represent "the colored race" that day with a separate, and presumably equal, dedication speech.[15] Moton, a moderate Republican himself and no favorite of black progressives, had drafted a surprisingly provocative address, insisting: "So long as any group within our nation is denied the full protection of the law," then what Lincoln had called his "unfinished work" remained "still unfinished." The memorial itself would be "but a hollow mockery, a symbol of hypocrisy," he wrote, "unless we together can make real in our national life, in every state and in every section, the things for which he died."

The heirs of the "party of Lincoln," however, planning to use the event in part to launch their campaign to increase Republican Congressional majorities in the upcoming fall elections, had no intention of permitting any African American to tell potential voters that Roaring Twenties society needed profound change. After reviewing Moton's manuscript in advance, Chief Justice Taft, in his capacity as Chairman of the Lincoln Memorial Commission,

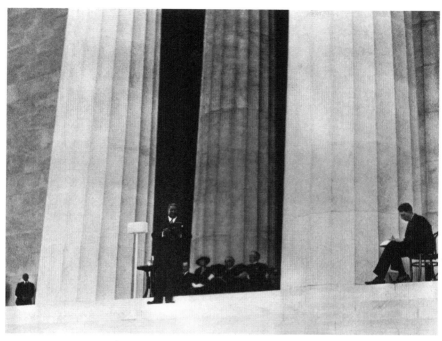

Dr. Robert Russa Moton, Tuskegee Industrial School, Tuskegee, AL,
at the Lincoln Memorial dedication, May 30, 1922

insisted a week before the ceremony that Moton cut five hundred words from his text, urging him to emphasize "unity" and "tribute" and avoid "propaganda." The implication seemed clear: without the recommended modifications, the entire appearance might be jeopardized. Moton yielded. His unedited original manuscript would remain unpublished for decades.[16]

Calling the memorial a fitting "symbol of our gratitude" when he rose to deliver the first speech of the day, Moton did manage to urge "black and white, North and South" to "strive on to finish the work Lincoln so nobly began—to make America the symbol for equal justice in the world."[17] Perhaps because these words paraphrased the Gettysburg Address, they had survived scrutiny by the White House. Yet after delivering the truncated speech, Moton was ushered not to a seat on the steps alongside fellow speakers and dignitaries, but to a spot in the crowd below.

Following Moton's speech and Markham's recitation—"The grip that swung the ax in Illinois / Was on the pen that set a people free," among its memorable lines—the emphasis abruptly changed. Rising to present the Lincoln Memorial to the nation, ex-President Taft, who had chaired the commission that built it, contradicted Moton's argument. Taft insisted that

the new shrine represented the "restoration of brotherly love of the two sections," not the two races. Lincoln, he maintained in a breathtaking repudiation of historical fact, "is as dear to the hearts of the South as to those of the North."[18]

Taking center stage next to accept the memorial on behalf of the American people, President Harding, echoing Taft and as if speaking mainly to the Confederate veterans enjoying privileged status in the audience, declared of Lincoln: "How it would soften his anguish to know that the South long since came to realize that a vain assassin robbed it of its most sincere and potent friend...when Lincoln's sympathy and understanding would have helped heal the wounds and hide the scars and speed the restoration."[19] To the *Chicago Defender*, Harding's speech was "a supine and abject attempt to justify in palavering words of apology the greatest act of the greatest American—the freeing of the poor, helpless bondmen." The paper went so far as to advise its readers that no genuine Lincoln Memorial dedication had occurred at all that day. "With song, prayer, bold and truthful speech, with faith in God and country," it urged African Americans, "later on let us dedicate the temple thus far only opened."[20]

The Lincoln Memorial has remained a contested space ever since.

◆　◆　◆

Yet art eventually transcended politics. Perhaps the most remarkable thing about the Lincoln Memorial is that for all the unease that permeated its holiday dedication—despite the partisanship it evoked, the hypocrisy it lay bare, and the class and race distinctions its organizers had perpetuated— the Lincoln Memorial soon emerged as the most revered of America's secular shrines.

Nearly a century after its dedication, it is now the first and most important stop on any individual American's list of patriotic destinations, as well as a magnet for groups numbering in the tens of thousands. On a purely visceral level, whether serving as a shrine for contemplation or a rallying spot for protest, it seldom disappoints. In whatever season, whether by day or night, the giant Lincoln continues to beckon and inspire, just as it dazzled a onetime resident of Lincoln, Illinois—Langston Hughes—when he visited the memorial for the first time just a few years after it was dedicated, while enrolled at the all-black Lincoln University in Pennsylvania.

However it has been interpreted since, the Lincoln Memorial retains its status as a preeminent national symbol, not to mention the crowning achievement of the so-called "American Renaissance." And much of the

credit for its enduring impact belongs to French, the gifted but elusive man who created the statue that looms within its walls.

The statue masterfully evokes the combination of majesty and humility that Americans believe their country and their leaders should personify. As historian Christopher A. Thomas has put it, French's seated Lincoln successfully—and simultaneously—portrayed the Union martyr as both "man and god." The moody behemoth manages to present America's sixteenth president, in the words of French himself, in all "his simplicity, his grandeur, and his power"[21]—a trinity of virtues not easily conveyed in a single work of art. The textured portrayal underscores Americans' concurrent, seemingly incompatible, belief in both their collective modesty and their preeminent standing in the world. And yet it leaves open the possibility of further growth.

For the tens of millions who have visited the Lincoln Memorial, French's statue has stirred a combination of affection, awe, pride, and expectation. Its admirers have come to regard it as the quintessential representation of what Lincoln once called America's "political religion"—democracy—and of the "almost chosen people" who worship at its symbolic altar.[22] The work has not only achieved and retained iconic status, but in each succeeding decade has grown more crucial to America's evolving notion of its collective self. Designed to suggest American perfection, it has instead become an adaptable symbol of necessary change. Lincoln's own reputation has come under reappraisal, not all of it sympathetic, particularly from within the black community, but the memorial in Washington has maintained its elastic appeal to those advocating social justice and progressive reform.[23]

Unavoidably fixed in both material and moment as representations of both an artist's style and a subject's reputation, heroic statues seldom strike a chord across generations. A rarity among American statues, the seated Lincoln remains a triumphant artistic achievement as well as a cultural work in progress. Its impact continues to evolve.

◆ ◆ ◆

Whether it will endure for ten thousand centuries more, as Langston Hughes predicted, it would be no exaggeration to state that French's statue of Lincoln is now regarded as the most famous sculpture ever created of or by an American—not to mention, at nineteen feet in height and some two hundred tons in weight, the largest. It is the most frequently visited and reproduced of national icons. In an age in which controversy rages over public statuary honoring Confederate generals, slave-holding founding fathers, and

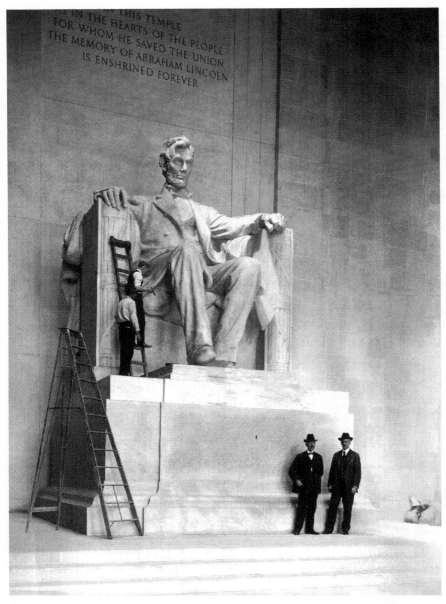

Daniel Chester French (left) and architect Henry Bacon at the Lincoln Memorial, May 30, 1922

other blemished figures from the American past, French's Lincoln remains enthroned without objection.

Artists have painted the statue, commercial sculptors have reproduced it, and professional and amateur photographers alike, armed over the years with everything from Leicas to Kodaks, Polaroids to iPhones, have recorded it. Cartoonists have used the statue to express the gamut of national moods: from Bill Mauldin's iconic sketch of the Lincoln statue contorted in grief at the death of John F. Kennedy; to images showing "Lincoln" joyfully fist-bumping Barack Obama on the occasion of his inaugural; or toppling over in disbelief at the 2016 election of Donald Trump.[24] The statue not only adorns paper currency and coins, it has morphed into the nation's most recognizable backdrop for aspiration and transformation.

That this inspiring statue was the work of a reserved, sometimes impenetrable professional artist who lived most of his life in the formal Gilded Age and left few written clues about his ideas or instincts makes its ever-expanding relevance all the more astonishing. Yet while the Lincoln Memorial is today known to almost everyone, the name of its creator is known by very few. A professional sculptor for nearly half a century when his most famous statue took its place among Washington's great public monuments, French was a crusty New Englander, a man of many accomplishments but few words. His shut-mouthed exterior, however, masked the energy of his creative spirit.

French never illuminated his art through explanation. Rather, he expressed himself passionately through an uncommon skill and a common touch. "If I'm articulate at all," he once remarked with typically modest understatement, "it is in my images."[25] Judged on visual terms alone, French became America's most articulate public artist. His taciturnity may help explain why, except for worshipful memoirs by his wife and daughter, he has never before inspired a full-scale biography.

Although he presented an aura of gentlemanly imperturbability to the public, when he appeared in public at all, French was a passionate, somewhat repressed, deeply sensitive, and for a time rootless man. For decades, he remained embarrassed about his relative lack of formal training. Privately, he confided anxieties about his reputation, his competition, and his place in art history. These aspects of his life and personality he kept as voluminously draped as those of his statues awaiting unveiling. Nor did he ever fully admit to the struggles that had preceded his fame and fortune.

In truth, French's seemingly ideal life was far more fragile than the durable granite, marble, and bronze he employed for his finished art. It was much

more like the soft clay he used to craft the tentative sculptural models that the public rarely saw: ever-malleable, constantly modulating in shape and emphasis, and reflecting the moods and motivations of an artist capable of dominating civic space but prone to fretting about bad reviews, unpaid royalties, high taxes, and unauthorized piracies. His is a complex American story of creative expression in perennial conflict with the demands of status, wealth, and propriety—a career spent successfully negotiating the chasms dividing craft and compromise, private doubts and public confidence, and the missionary and mercenary aspects of his profession. Along the way, he made a last stand for classicism in the fast-approaching age of modernism. That his Lincoln Memorial has so defiantly transcended changing artistic tastes and shifting public moods is a testament to French's almost defiant belief in the enduring relevance of the heroic image even—especially—in an antiheroic age.

French may have reached the apogee of his career on May 30, 1922, but he had long since struck his claim as America's premier visual interpreter of shared history and common yearning, its greatest monument man. While French would surely have remained a financial and critical success—winning prestigious commissions and creating well-received statues—he might eventually have faded into obscurity had it not been for the titanic Lincoln assignment he earned in 1915: the once-in-a-lifetime opportunity to create the giant statue for the federal government's long-planned, long-delayed official Lincoln Memorial.

Ironically, his greatest work has unfairly kept his other major achievements in the shadows. During the first phase of his long and prolific artistic career, the young French did nothing less than create the definitive symbol of American military preparedness plus the official representation of the new American century. Along with these came powerful sculpted assertions of his country's growing world dominance, beloved symbols of American educational opportunity, and poignant memorials to Civil War and World War I heroes that consistently stressed sacrifice over triumph, to the occasional chagrin of his patrons.

With the Lincoln Memorial, French accomplished not only a magisterial crowd-pleasing portrait for posterity, but also a platform for its infinite aspirations. French's story is a saga of professional ambition, hard work, deep passion, unquenchable patriotism, and, most of all, artistic genius. His life, and his art, as explored on the following pages, hold the keys to comprehending the "mystic chords of memory"[26] about which Abraham Lincoln once so hypnotically wrote, and French so masterfully illustrated.

◆ ◆ ◆

The Lincoln Memorial dedication closed with a benediction—sculptor French, as was his long-standing custom at such events, had said nothing—after which most of the dignitaries along the top step clustered around Robert Lincoln to offer the old man their greetings and congratulations. As the huge, segregated crowd below began to disperse, French, a mustachioed, impeccably dressed man of seventy-two years, strolled into the memorial building and spent a few moments there alone, silently communing with the huge marble figure he had created. After a few minutes in solitude, he glanced to his side and noticed Robert Russa Moton standing next to him, gazing at the Lincoln as well.

To French's delight, Dr. Moton "praised the statue." French in turn confided to him that he remained worried about the way it was lit; despite last-minute modifications, the sculpture still did not look as he had intended. Moton asked where the beautiful marble had come from. It was domestic, replied French: from Georgia. Perhaps he added proudly that it had come from more than two dozen individually carved blocks, assembled on-site a few years earlier. "Dr. Moton was a sympathetic listener, and Dan found himself being drawn out to give him some of the details of the building," remembered the sculptor's daughter, Margaret French Cresson, who had accompanied him to the ceremony. [27]

The two men talked a while longer. Did French tell Moton he had created a dozen Civil War memorials during his long career—including statues of Generals Grant, Butler, Hooker, Meade, and others—or that he had produced a standing statue of Lincoln for the Nebraska State Capitol eleven years earlier? Did he confide that he had intended that the new statue "convey the mental and physical strength of the great president"? [28] Did Moton confide his disappointment at the prejudice manifested at the dedication ceremony? We do not know. No one made a further record of their conversation.

After they spoke, however, "together, the powerfully built college president and the frail-looking sculptor walked out into the sunshine and the May wind as they went down the steps and stood on one of the terraces looking up at the memorial." [29]

Daniel Chester French
at three years old, 1853

THE MAKING
OF A
SCULPTOR

N ext week I am going to begin a bust of father."[1] With these words, dashed off in the early spring of 1878, Daniel Chester French casually informed his older brother, William, that he was returning to a familiar theme: a portrait of the most important person in his life, Judge Henry Flagg French. Behind the sculptor's nonchalant update, however, lay considerable anxiety. Already professionally accomplished, but lacking for important new work, the twenty-eight-year-old artist had been yearning for major commissions that paid real money and promised wide public exposure. His first—and, so far, his only—major statue had been unveiled three years earlier. It must have seemed like an eternity had passed since.

French had not been entirely without assignments. He was laboring at the time on plaster models of two figures meant to be enlarged and placed as architectural decorations atop a new St. Louis post office. Prestigious as that commission seemed at first glance, it paid only per diem wages: eight dollars a day. Worse, the project had come his way through outright nepotism— arranged by his influential and well-intentioned father.[2] Unwittingly, the elder French may have further sapped his son's ebbing self-confidence by warning him, "business will not come to you without the help of your friends." Defending his less-than-subtle effort to provide assistance, Henry Flagg French could not help adding: "I thought I was suggesting an order that any sculptor in the country would have been glad to have."[3] Now, as Dan began fashioning the bust of this kind-eyed patriarch, he grew increasingly frustrated. No big projects loomed on the horizon. The likeness of his father— whose thick beard and piercing gaze made him a fascinating and challenging

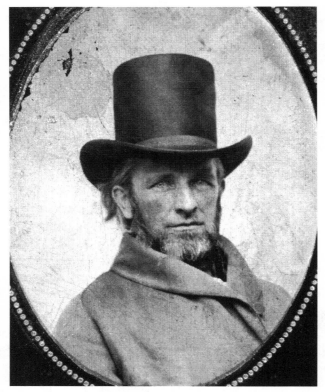

Photograph of Henry Flagg French, ca. 1855

subject ("it promises well," he reported a few weeks into the project)—would be a labor of love, and also a way to mark time and keep busy.[4]

The bust, actually the second that French produced of his distinguished father during the first six years of his career as a sculptor, should also be seen as a heartfelt tribute to the loving parent who had long served as his strongest and most resourceful booster. A respected federal official who ardently championed formal education, the elder French had encouraged his son's nonconformist interests from the start, especially once the boy's artistic talent and corresponding scholarly ineptitude could no longer be ignored. Dan French owed this man much. Yet, undertaking another unpaid portrait of his parent was surely something of a letdown. In his earliest experiments in clay, he had been glad for the opportunity to sculpt members of his family—readily available models like his brother, Will, his sisters, Harriette and Sallie, and their father as well—but these were necessary experiments in a demanding art form he was still trying to master.

Daniel Chester French, *Henry Flagg French*, 1878
(Chesterwood, Stockbridge, MA)

French was no beginner. By 1878, the year his father began posing for him for the second time, he had produced thirty-six recorded works in plaster, marble, Parian ware, and even ebony. Just three years earlier, to universal acclaim, his hometown of Concord, Massachusetts, had unveiled his heroic bronze statue of the *Minute Man*. Its success had vaulted French from obscurity as a modeler of mass-produced decorative pieces to public fame for his maiden effort as a monument maker. Yet praise for the *Minute Man* and advanced art study abroad had failed to generate major new public statuary commissions at home. Now, with his father serving as President Rutherford B. Hayes's assistant secretary of the treasury, French had agreed to join him briefly in the nation's capital. He stayed two years.

The decision to reenter the family household reflected the sculptor's continued reliance on his relatives. Just before heading to Washington, Will, already a successful landscape architect in Chicago—and destined to

become the founding director of the Art Institute—had lured Dan French to visit him first. In Chicago, Will arranged a few portrait jobs for him, enough to bring him some much-needed income, but not enough to keep him in the Windy City very long. It was then that the sculptor, lacking further prospects, accepted his father's invitation to his new home near Capitol Hill and headed back east, where he was always more comfortable. But the portrait bust of Henry Flagg French that he commenced sculpting there would offer him neither inspiration nor further moneymaking commissions, even in a city rife with people worthy and wealthy enough to commission sculpture. In fact, French complained, his Washington sojourn became "ruinous to my business"—such as it was.[5] Although the finished bust of the elder French demonstrated his growing fluency and skill, it was also the work of an artist at a crossroads between family loyalty and professional independence.

As it turned out, this period of drift not only proved brief, but represented the very last time French would ever need to harbor serious concerns about his future. Neither the anxious sculptor nor his indulgent family could have imagined how successful he was soon to become, and remain. That Dan was at least beginning to realize that his father could no longer serve as his refuge and protector became evident in the finished 1878 bust. In his previous effort to portray his father, French had sculpted the judge in the manner of an all-powerful Roman emperor, his shoulders draped in a classical toga. The new bust revealed the bewhiskered statesman in a buttoned frock coat, a bow tie at his neck, still an imposing and dependable elder but a mortal man in a modern world Daniel Chester French clearly hoped to conquer on his own.

◆　◆　◆

The baby's birth came earlier than expected. The parents—thirty-seven-year-old, Harvard-educated attorney Henry Flagg French and his wife, Anne Richardson French, daughter of another New England lawyer—had previously welcomed two girls and an older boy into the world. The new arrival made his appearance shortly after sunrise. The baby was born in a rented house in Exeter, New Hampshire, which the French family had already begun packing up in preparation for a summertime move to a nearby home of their own.

"No lady was ever less disturbed by the gathering of her fruit," gushed the proud father, "than is the Lady Anne." Little wonder that Henry made such a boast. Anne had wakened to her first labor pains at 4 a.m., waited another full hour to rouse Henry, and then, marveled her husband,

"introduced the child to 'the breathing world,' at the most appropriate hour in the day, while the sun was rising, and all the wild birds were singing." Anne soon joined Henry to take breakfast "at the usual hour," and mother and dark-haired infant went on to enjoy an idyllic day. "The child was perfectly satisfied with his first impressions," Judge French proudly noted, "and has quietly dreamed over them ever since....[He] has not been awake more than ten minutes since he was born."[6]

The arrival of the placid infant coincided with a rare moment of tranquility in the nation at large. The roiling debate over slavery had recently calmed on the wings of an 1850 Congressional compromise that succeeded in bottling up the toxic genie for another half decade. Many New Englanders bristled at the new law's requirement that they capture and return fugitive slaves who sought refuge in their midst. To the blissful new parents in New Hampshire, however, the controversy doubtless seemed blessedly remote. For the rest of his long life, Henry and Anne French's son would embrace a sense of distant observation, somehow managing to evoke the history through which he lived without ever involving himself in the maelstrom of the politics that defined it.

As for a name for his baby son, after welcoming two successive daughters in recent years, Judge French now playfully asked one of his older brothers to remind him of the proper order of family monikers for newborn Flagg males. "They come along so slowly," he teased, "that I have most forgotten." In the case of the latest addition, the senior French declared, "I *believe* the name of *Daniel* is due to him," since it was his own father's given name. But even "Daniel" was not sufficient for such a boy. "I have a notion to alter little Dan's name," his father prattled on, "and call him *Chester*," after his New Hampshire birthplace: Chester Street in Chester, New Hampshire. The child would grow up, he predicted, as if in an ambition-fueled reverie, to be "Chester French—Chester French, Esquire!—Reverend Chester French—Doctor Chester French—Hon. Chester French.—Now, I rather like that." The father set to work carving "a head and tail...for Dan's [future] wooden horse." As the figure took shape, Henry French jested that it "bore a striking resemblance to the Elgin Marbles."[7] So perhaps he should not have been surprised that its future rider might turn out to be "Chester French—sculptor."

The child grew up as contentedly as he had entered the world: happy, well-behaved, and by age three boasting luxuriant blond ringlets that were shorn only after his parents dragged him to a neighborhood photographic gallery and had him pose for his first likeness. The enchanting 1853 daguerreotype reveals a cherubic toddler attired in skirtlike pantalets,

looking for all the world like a little girl, true to the feminizing style imposed on midcentury male children by affluent parents. What sets the picture apart is the young subject's toothy smile, a rare example of recorded spontaneity in the age of the formal daguerreotype. The primitive process required subjects to freeze their expressions for as long as fifteen seconds, and most sitters assumed a vacant stare or locked their lips into a rigid frown. According to family legend, the camera operator secured little Dan's sustained grin by holding aloft a bird cage occupied by a fluttering, chirping canary. The warbler all but hypnotized the child. A few years later, at age six, the little boy produced his first known drawing—a rudimentary outline profile of a spotted, beaked creature facing a leafless tree. His doting mother inscribed this masterpiece: "Dannie French wrote this bird."[8] The little boy's fascination with the subject of birds would endure a lifetime.

Four years later, in 1860, when Dan was ten, the French family relocated to a farm in Cambridge, Massachusetts. Henry Flagg French opened a legal practice across the Charles River in Boston and prospered. At one point he served as a justice of the court of common pleas, earning and forever after retaining the title "Judge." Simultaneously, he maintained a more than amateur interest in agricultural science, later writing a book called *Farm Drainage*. Dan remembered his father as a "great horticulturist" who, "wherever he lived, made the place as beautiful as a landscape gardener would."[9]

Here in their small college town, the French family lived through the clamorous early days of the Civil War. Though safely removed from the bloody action of the early 1860s, they were surely aware that a growing number of the town's local residents and elite Harvard students were rushing off to fight—and, in many cases, to die. President Lincoln's own son, Robert, attended Harvard, though the boy itched to leave school to join the army as well, and would finally do so in the waning months of the war.[10] At age forty-eight, Judge French was too old to enlist, and his sons Will and Dan far too young. Death had invaded their home a few years earlier, when Anne Richardson French faded away from consumption in 1856. Three years after that wrenching loss, Judge French had married Pamela Prentiss, the plump, amiable daughter of a Keene, New Hampshire, newspaper editor. Fifteen years her husband's junior, Pamela instantly endeared herself to her lonely stepchildren.

Dan inched toward adolescence "determined" yet "serene." As his father put it, "Dan wakes up and goes to bed smiling."[11] His future wife would later cannily summarize his upbringing: "Dan French seems never to have encountered the struggles of poverty and misunderstanding which have

been considered—which he theoretically considered—as necessary to the development of genius."[12] Seldom given to sentimental reminiscence, the boy would later summarize his entire youth by recalling only: "I got up washed and dressed and nothing particular happened until I went to bed again."[13] He offered no early inkling that he might become an artist, barely taking notice of the plaster casts that hung from brackets in his "little primary school house" on Brattle Street. Although Dan's own art-minded father had installed these adornments in the school, the boy's "chief interest" was using one of them for chalk "after it was broken."[14] The first sign of artistic talent came after a winter storm, when Dan and his brother carved a pair of lions out of the snow. The creations were apparently skillful enough to impress their neighbor, Henry Wadsworth Longfellow. Dan later denied that he'd had any hand in their creation.[15]

The most prominent among the boy's early passions was bird-watching, a hobby emphasizing comparative anatomy that the budding sculptor began to pursue avidly once a shy schoolmate named William Brewster approached him during a game of marbles on a Cambridge sidewalk, and demanded to know: "Playin' in earnest, Frenchy?" Before long, they became "inseparable" companions, launching a friendship that was to last half a century. When they first met, Cambridge was "hardly more than a country town," as French remembered it, and all its "territory" became their "playground."[16] Will and "Frenchy" shared an aversion for team sports, eschewing baseball, football, tennis, and the newest rage, croquet, but enjoyed swimming, skating, and hunting together. Above all, these two "reticent and diffident" boys loved tracking, bagging, and stuffing the birds they discovered in the woods. Brewster soon headquartered a "Nuttall Club" at his home, named for the famous ornithologist, Thomas Nuttall, to display the nests and eggs they collected.[17] Together, the boys studied bird manuals, Dan claimed, "with a thoroughness which would have put us at the head of our classes if applied to our school."[18] The friends went on to create a bird sanctuary in Will's family garden, cleverly fencing it off to keep local cats at bay. Judge French collected stuffed birds, too, but Will Brewster stimulated Dan's once-passing interest into a near obsession. Eventually, Will's "devotion" to birds "left me far behind," Dan conceded. It came as no surprise to neighbors when Brewster went on to become a world-famous ornithologist, or that French later fashioned a plaster bust of Will's father, John, who had so often welcomed him into the paradise of taxidermy the Brewsters called home.[19] The French family soon relocated, separating the two young birders. But Dan and Will Brewster would later reunite and remain friends for life.

So intent was young French on recording the reappearance of every bird species that alit near his family's subsequent home at Amherst that his journal entries from mid-April 1865 make absolutely no mention of the earth-shattering news that transfixed the rest of the nation that month: the end of the Civil War and the death of Abraham Lincoln, the leader he would later portray so canonically. French was fifteen when John Wilkes Booth assassinated President Lincoln, certainly old enough to remember the event as vividly as did most of his contemporaries, including his first cousin Mary Adams French, known as Mamie, who would decades later become French's wife.

Though Mamie was nine years younger than her future husband, she never forgot the "flash of the light breaking in through the stillness" on the fateful morning of April 15, 1865, followed by "the creeping terror of those whispered words" she overheard from inside her curtained bed: "President Lincoln assassinated. Dead!" Of course Mamie lived in Washington, where her Uncle Benjamin, another future portrait subject for French, served as Lincoln's commissioner of public buildings. Word of Lincoln's murder would have reached her home quickly and no doubt dramatically. French's family might not have heard the tragic news until the morning paper arrived.[20]

Still, it seems astonishing that never once, in 1865 or, for that matter, thereafter, did French mention the national cataclysm or his reaction to it when it occurred. His bird-watching journal for the day Lincoln died, April 15, records only the sighting of the first ruby-crowned kinglet of the spring—no other news.[21] Meanwhile, little Mamie's family took her to join the mourners lined up to view Lincoln's embalmed remains as they lay in state at the White House. The "large and white face, as if carved out of marble," never left her memory—"the face of a giant lying there asleep."[22] Soon thereafter, before the coffin was shut at the US Capitol, Uncle Benjamin gently wrested from Lincoln's petrified hands a rose and evergreen "which had lain directly over the bosom of the martyred president" and presented them to his wife. Later the carefully preserved sprig passed to Mamie, who kept the relic with her for the rest of her days.[23] If her future husband ever noticed it, however, he kept as silent about the memento as he had about the calamity it represented. The "treasured heirloom" was rediscovered at Chesterwood, their summer home, after Mamie's death decades later. Similarly, if Daniel Chester French subsequently read the eulogy that his future neighbor and sculptural subject Ralph Waldo Emerson delivered in Lincoln's honor at Concord a few days later, he offered no recollection of that signal tribute either. It was as if he took to heart one of Emerson's most famous essays: "Self-Reliance." But unlike Emerson, whom he did not yet know, or his

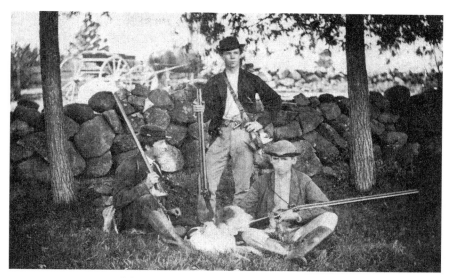

(left to right) Daniel Chester French, Ruthven Deane, and William Brewster, with a hunting dog, ca. 1867

father, whom he adored, Dan French would seldom be comfortable expressing himself in words. "Writing does not come easily to me," he later conceded. "My ideas do not crystallize themselves in the form of speech."[24]

At the time of Lincoln's murder, Judge French was in the midst of a new professional challenge. On November 29, 1864, just a few weeks after Lincoln had won a second term as president of the United States, Henry Flagg French had shifted careers to pursue his lifelong love of farming technology, and became the first president of the new Massachusetts Agricultural College in Amherst, a school chartered under the wartime Morrill Land Grant College Act, which Lincoln had signed into law in 1862. Judge French's own presidential term lasted only two years. The school's governing board, Dan French admitted with some bitterness, found his father's agricultural theories too "radical."[25] Not until the summer after the judge's 1866 exit did the very first class of seniors graduate from "Mass Aggie," a grand total of just thirty-four students who matriculated under a faculty numbering but four. Only in the following century would the tiny school reemerge as the crowded and well-branded University of Massachusetts at Amherst.

Henry Flagg French then resumed his Boston legal practice and moved the family once again, this time to a Revolutionary War–era cottage on a working farm along the Sudbury Road in the nearby village of Concord. Here his youngest son, now sixteen, was expected to tend to his own strawberry patch and help with the asparagus crop and the cows. Claiming after

a June 1869 visit that he had "seen no place so large, in such perfect order," Uncle Benjamin seemed particularly impressed that the farm was "carried on by the Judge and Dan, with the help of a single man," adding: "I do not see why, in a very few years, that farm will not produce an income of four or five thousand dollars a year."[26]

As always, the senior French made the labor-intensive experience great fun. The popular judge boasted a winning personality—a rare combination of scientific curiosity, a passion for beauty and culture, and a mordant wit—all of which his son seems to have inherited. Dan French loved how his father "killed his enemy...with a rapier, not with a bludgeon." Henry's humor came from "the dextrous [sic] side-stroke," not "the ponderous joke." Once, when a guest sighed, "riches are relative," the judge shot back, "No relative of mine." On another occasion, when the elder French sent his son scampering up a creaky ladder to repair a second-story window at their Concord house, the boy peered down and said he was frightened he might fall. "Oh go ahead!" came the playful reply. "I'd risk you where I wouldn't myself."[27]

One thing Judge French did not want to risk was letting his sons grow up without proper schooling. His "lifelong convictions" told him that education was "worth more to a boy than many riches."[28] Like his older brother Will, Dan would be expected to learn "algebra and geometry." Ideally, both boys would eventually enter the law and, hopefully, public service. Not only had Henry French succeeded at the bar; his own father had served as attorney general of New Hampshire, and his late wife's father as chief justice of the New Hampshire Supreme Court. The legal profession was in their blood.

The family's new hometown, however, offered formidable distractions. For one thing, its untamed forests and waterways were irresistibly thick with game. Sixteen-year-old Dan enjoyed shooting as much as any other teenage boy. He and his father went duck hunting one morning at nearby Fairhaven Bay, although his only shot of the day left a male wood duck "unhurt." Later he did bag a marsh hawk, which he stuffed in the style he had learned from his Cambridge pal Will Brewster. It was clear that French missed Brewster. To no other friend would the reticent young man confide that he had gone to a party at one of his new neighbors, "and had a very pleasant time though they played kissing games a little too much," adding, "You know 'too much of a good thing spoils it.'"[29]

Postwar Concord was also a dazzling intellectual community percolating with creativity, home to some of America's eminent writers, philosophers, and painters. Its talented residents were prominent and numerous enough to turn the head of a teenager beginning to sense his own artistic inclinations.

After all, Thoreau and Hawthorne had once lived here. Emerson still did, along with the celebrated Alcott family.[30] History had happened here, too. At the old bridge north of the French home, past the town square, colonial militia had opened fire on British troops in 1775, effectively launching American resistance to the crown. Few towns cherished their local heritage more devotedly. As one of its residents, Henry David Thoreau, had put it, Concord was "my Rome."[31] Although French would later turn for further inspiration to Italy itself, Concord would always hold him in its thrall.

Ambitious as he was for his children, the judge did nothing to discourage his son's earliest artistic attempts: "sculptures" that the boy unexpectedly began carving from turnips he took to rescuing from boiling stewpots. These productions included a "grotesque" frog likeness that Dan mischievously set on his father's dinner plate one evening as a surprise. Playing his part to the fullest, the judge recoiled from the apparition with feigned horror.[32] Outright encouragement followed. When French was sixteen, he and his siblings received, courtesy of their father, the gift of "a large package of clay" that he purchased for them in Boston. Dan, Will, and their sister Sallie immediately plunked themselves down at the family table and worked to pummel and knead the stubbornly resistant material into sculpted shapes. Not surprisingly, Dan French labored longest and most patiently, and his finished work, crafted into a dog's head, revealed the greatest talent. But none of the children knew how to keep their clay wet and soft enough to sculpt properly. So "nothing came of it," French recalled, dismissing the effort—though it did ignite something inextinguishable in him.

Before long he had successfully fashioned the much more complex image of a wounded deer. He kept secret from his astonished family the fact that he had shot such an animal himself not long before in the thick Concord woods, leaving the haunting impression of its suffering indelibly etched in his mind.[33] That he was able to visualize and recreate such observations set French apart. "I was first interested in the modeling of animals," he recalled with typical understatement, "but, in a very short time, developed an interested [sic] in the human figure, which has been my chief one since."[34] Whatever his subject, he demonstrated that he possessed more than skill; he had a gift. He could take clay and somehow mold the soft earthy-smelling material into recognizable shapes and forms—into likenesses uncanny in their resemblance to living things. He could make inert matter come alive. His talent was undeniable.

Unquestionably imaginative, but still short on raw materials, French resorted to "whittling and carving things from wood and gypsum," he

recalled, and "as usual the family thought the product was remarkable." In fact, such encouragement was anything but "usual" at the dawn of the Gilded Age, when professional men expected their sons to become professionals, too. Apparently, the elder French saw something in these early experiments that transcended childish whittling. In response, the judge modified his expectations for the son he once had hoped would grow up to become the "Hon. Chester French."[35]

"There were no stumbling blocks placed in my way," French testified, adding, "My father helped me, gladly." Henry French had "always wanted one of his sons to be an artist, as he was a lover of art and all things beautiful." He had long thought, however, that Will would emerge "the artist of the family."[36] Now the judge wisely sought advice about his younger boy from one of Concord's leading creative forces—"the artist of the community," as the budding sculptor admiringly called her—accomplished watercolor painter May Alcott. "[W]ith her ever-ready enthusiasm," Dan French remembered, she examined his earliest work, and "immediately offered to give me her modeling clay and tools. I lost no time in harnessing the horse and driving over for them, and, in experimenting with the seductive material, although I didn't know even how to moisten it."[37] Assistance from such a celebrity—one who had been immortalized by her sister Louisa as "Amy" in Little Women, no less—imbued French with confidence.

In all likelihood, Judge French had sought from May Alcott nothing more than a frank professional assessment of his son's precocity. In response to Alcott's outright encouragement, he ended up enrolling the boy for thrice-weekly lessons at Alcott's neighborhood art school. "That was the beginning of evil!" young French joked. "I then decided to go ahead and to be a sculptor."[38] Under Alcott, he rapidly progressed from solitary vegetable-carving with a jackknife to formal training under a genuine artist, armed now with newly acquired professional carving implements, one of which Dan kept for the rest of his career.[39]

Crucially, May also taught French to use calipers—compass-like tools designed to measure the distance between opposite sides of a three-dimensional object—to calculate facial features before attempting to model them. Reminding her new student that a sculptor must be "a plumber...as well as a carpenter," she taught him how to craft lead-pipe irrigators to keep clay moist and malleable, and wooden braces to support cumbersome sculpted heads.[40] But finding himself the one and only boy in a class of twenty-five girls may well have left the teenager too discombobulated to focus on his art. Hormones no doubt raging, he soon abandoned the program. However

brief, Alcott's sympathetic instruction proved more than enough to advance his knowledge and fuel his determination.

Nonetheless, Henry Flagg French made good on his vow—or threat—to educate his son formally, sending him to Boston to the Massachusetts Institute of Technology in 1867. Perhaps worried that, without his supervision, the seventeen-year-old would shirk his studies, the judge compelled young French to board at home and commute by rail to the Copley Square school, twenty minutes each way. The plan backfired calamitously. Either unprepared, unengaged, or both, French not only flunked the courses his father had once deemed most crucial—algebra and geometry, with grades of 42 in each—he also failed physics (47) and trigonometry (19), managing scores barely higher than 60 only in English and German. From his chemistry course, he withdrew altogether.

Mercifully, his father spared him the humiliation of a sophomore year. Instead of reenrolling him at MIT, Judge French allowed his son to take special courses with a succession of respected artists. Dan French apparently did so in a sequence that he recalled with such inconsistency over the ensuing years that it is impossible now to assemble a definitive chronology of his art education. In whatever order they occurred, these experiences gave the boy a more than decent education in the fundamentals of draftsmanship and technique.

Even before he commenced these formal but limited studies, French had begun producing actual sculptures of family members. One such endeavor commenced when a gaggle of French relatives descended on Concord from Washington in 1869, and he attempted to reproduce the head of the little girl who had been so moved by Lincoln's death a few years earlier: his comely but fidgety ten-year-old first cousin, Mamie. But the "unappreciative" little girl found it so hard to sit still that French aborted the portrait "in despair"—both frustrated artist and squirming subject completely unaware, of course, that one day they would become husband and wife.[41]

Over the Christmas holidays that year, the nineteen-year-old set to work executing sculpted likenesses of far more cooperative sitters: his older siblings. His very first surviving work is his eighteen-inch-wide plaster relief portrait of sister Sallie, completed on December 16, 1869. A few days later, he commenced a relief sculpture of his oldest sister, Harriette, obviously meant as a companion piece. French began the second likeness when Harriette and her husband visited the family home at Christmastime. It was finished on January 4 of the new year, 1870. Not long after, on a visit to Chicago, he added to the series a relief portrait of his brother, Will.[42]

French's real training began that March. Still a month shy of his twenti-
eth birthday, he left his brother's Chicago home to journey alone all the way
to Brooklyn by train. With the country's rail system still a fractured network
of independent lines, he probably changed trains several times at every hour
of day and night, all to visit a favorite aunt and no doubt to explore the New
York art scene for himself. He ended up staying there a month to study under
the formidable John Quincy Adams Ward, across the river in Manhattan.
Already one of America's best-known sculptors at age thirty-nine, Ward,
a colorful fellow later known for his walrus mustache and pleated artist's
smock, had produced the first sculpture, the *Ether Monument*, installed in
the Boston Public Garden. Dan had likely seen it. Ward had also executed
four large statues for the new Central Park, ten blocks from which stood his
overcrowded Forty-Ninth Street studio in New York.[43] French's aunt, whose
husband knew the sculptor, accompanied the aspiring artist there on his first
visit, and made the introductions. Initially, Ward seemed reluctant to take
the young man under his wing. It would be "very inconvenient," he bluntly
told them, being so "pressed for room" in his workplace.[44] Neither inter-
loper would take no for an answer. Worn down, Ward relented. Sculptors
of the day routinely took in apprentices who were expected to tote mounds
of clay and shift studio equipment as required in return for instruction and
advice. French had less experience than most, but chatted so little that Ward
may have concluded he would not prove a distraction. A contemporary
called the "reserved and diffident" Ward "one of the least talkative of men
when the conversation touches the subject of his own ways and means in
modeling a figure."[45]

Ward nonetheless proved an inspiration. A master of heroic realism,
he also harbored ambitions to see his statues dominate public parks and
squares, and a yearning to organize his peers into professional associations,
goals French would later adopt for himself. "He gave me a cast of a foot to
copy, to see how true my eye was, and showed me how to work nicely in
finishing," French soon reported to his father. "This may seem like a waste
of time but the finishing, which is what takes time, is just what I want to
know about." Finishing—adding texture—was tedious work, he admitted,
but "excellent practice." Ward also provided crucial instruction in the craft of
plaster casting and shared "more tricks of the trade" with his aspiring pupil.[46]
No doubt he taught French to avoid "difficulty" by keeping all parts of a
sculpted figure at the same stage of completion in order to maintain proper
proportions. Like Alcott, Ward advocated setting up an armature—a "skel-
eton" of iron rods and lead pipes—to support and moisten large statues as

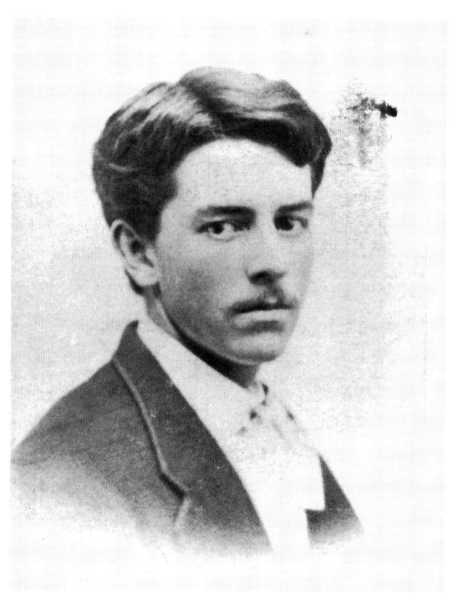

Daniel Chester French as a young man, ca. 1871

they took shape.[47] Motivated as never before, French wrote home that he also planned to attend classes at New York's National Academy of Design "three evenings in the week," adding, perhaps in acknowledgment of the tuition payments his father had wasted on him at MIT: "Instruction *free!!!*"[48]

The young sculptor earned his first professional commissions during or shortly after his brief apprenticeship with Ward, both of them silhouette portraits of female subjects. He asked all of forty dollars for the first, but the subject's husband would offer no more than twenty-five, and the fledgling sculptor had little choice but to accept. He needed both the experience and the money. For the second effort, he earned only ten dollars. Returning to Concord after his month in Manhattan with Ward, French produced two more portrait reliefs, one depicting his stepmother's niece, the other Ralph Waldo Emerson's future daughter-in-law. His career was truly underway.[49]

About 1871, French also began studying "art anatomy in connection with sculpture and painting,"[50] the florid description that the celebrated English-born, Boston-based artist William Rimmer used to advertise his new course in anatomical drawing. The fifty-four-year-old Rimmer was no doubt the personification of Judge French's idealized notion of the professional artist: a prominent sculptor who successfully practiced medicine as well. When he wasn't working at his many jobs, Rimmer dabbled as a poet and inventor. Probably Judge French still harbored the dream that, like Rimmer, his son too would develop a professional career to augment his art pursuits. Of far more importance to the ambitious sculptor, Rimmer was well into a career that would ultimately yield more than six hundred sculptures, including a work said to be the first nude statue carved in America.[51] The newspaper *Art World* later dubbed him "a Yankee Michelangelo,"[52] hyperbole that nonetheless accurately reflected his exalted reputation at the time. In truth, Rimmer was then more widely admired for his spirited lectures than for his sculpture, which some critics dismissed as too hastily produced to qualify as "great and noble."[53] He had also authored a seminal art textbook, *Elements of Design*, first published in 1864. *Art Anatomy* would follow in 1877. These volumes became French's first reference manuals, although as late as 1879 he confided that he was as yet unable to afford to buy copies for himself.[54]

Under Rimmer's tutelage, French began copying human and animal figures in pencil, duplicating the sketches that his teacher chalked into lifelike form on his classroom blackboard. The students pursued this regimen two hours a day, three times a week. In a class again dominated by women, this time forty of them, French proved as inhibited as he had been at the Alcott

school. "Very few men wanted to go in for art at that time," he recalled, "at least in Boston. They evidently did not consider it a man's job." That clichéd understatement masked the real problem: he found the young women too distracting. Facing the female students' flirtatious hazing ("I didn't know *men* were included in this class," teased one), he found it difficult to concentrate. "Embarrassed," he came to think of himself as an "intruder." Yet tenaciously imagining himself Rimmer's "special pupil," French managed to endure the classes for "two winters," working with Rimmer on a bust of a Concord neighbor named Mary Fay, until he quit because, as he reversed reality, "I saw that my presence was embarrassing to the girls."[55]

In all, under Rimmer's watchful eye French produced a total of ninety-nine pencil drawings in two sketchbooks that he had begun keeping in 1869 at age nineteen.[56] The sketchbooks boast tentative but able scrawls of male and female forms, along with contorted anatomical drawings of muscular and skeletal details. The eager student often identified the muscles by name on the page. The occasional likenesses of animals—not then, or ever, French's strong suit—proved less accomplished.[57] Several sketchbook leaves bear notations in red, perhaps provided as commentary by his famous teacher. Around this time he managed a stilted but appealing parlor scene, complete with a brick hearth, depicting family members in various attitudes, a roomful of primitive furniture, and a dozing dog and cat. The sketch revealed a growing knack for perspective and naturalism.[58]

French took additional instruction around this time from yet another successful artist—forty-six-year-old Boston-based painter William Morris Hunt, who also presided over a class of females, most of them wealthy women from Beacon Hill. Although it has escaped the notice of French scholars since, Hunt had only recently completed an oil portrait of a brooding full-figure Lincoln, portrayed with head bowed and long arms clasped before him. It is reasonable to assume that French saw it. Its marked but hitherto unrecognized influence would become apparent decades later when in 1911 French unveiled a standing Lincoln of his own—a bronze statue that he fashioned in an uncannily similar pose. Like Hunt's full-figure Lincoln, French's statue would portray the president's contemplative side—an orator pausing before sharing his thoughts. Hunt's agonized Lincoln exuded both melancholy and restrained power; so would French's.

For now, the sculptor probably focused principally on Hunt's well-known painting, *Drummer Boy*, a tribute to the youngsters forced to come of age too quickly in the crucible of the recent rebellion. The romanticized picture had achieved widespread popularity despite the fact that its tattered

subject looked more like a waif from the French Revolution than a child musician of the Civil War. This canvas surely had its impact on French as well. Hunt had crafted the figure to resemble a statue atop a pedestal—a classical conceit that may well have appealed to the budding sculptor.

Rimmer and Hunt evinced individualistic styles that sharply contrasted with each other's. Combined, their powerful, if somewhat incompatible, visions helped forge the young sculptor's own approach: a fresh combination of classicism and romanticism. "Dr. Rimmer one day remarked to me 'The trouble with Mr. Hunt is that he can't draw,'" French liked to point out. "Afterwards when I spoke to Mr. Hunt about Dr. Rimmer's work, he exclaimed, 'O, that stuff Rimmer does isn't drawing.'" French offered this explanation: "Dr. Rimmer saw only, or chiefly, line. Mr. Hunt saw masses of light and shade and color. Let us be thankful if an artist is able to see nature in either way in a manner to give pleasure to his kind."[59] The styles of the two masters combined to inform French's personal approach. His best work would capture form and line with unwavering reality while reflecting light and shade with uncanny vividness.

French, too, came to see "nature" from both perspectives. Yet by the time he completed his training under these unharmonious masters, he began to eschew drawing altogether. Eventually, his idea of a preparatory "sketch" would seldom call for a flat pencil approximation, but instead a fully formed three-dimensional clay model. Learning more about drawing evidently convinced French that he could not draw well enough himself—at least to consider himself an accomplished professional draftsman—an assessment that, judging from his lovely surviving pastels, may have been too harsh. After relying on pencils to sketch out his first major statue, he would seldom do so again. Not for decades would he turn back to drawing and painting—and then, purely for enjoyment.

◆　◆　◆

Unwilling to settle for a career as a sculptor of relief portraits of affluent private clients, French soon hit upon a new arena for his talent: figurines and small statuary groups that could be reproduced in quantity and sold as home decorations. Displaying such pieces was the rage among the growing middle class, and there was good money, though little critical acclaim, to be earned in making them. Another Yankee sculptor of the day, John Rogers of Connecticut, had emerged as the undisputed master of this genre, specializing in homespun narrative scenes like *The Village Schoolmaster* and *Coming to the Parson*.[60] Bulky as they were, these immensely popular

Matchmaking, also known as *Honeymoon*, Parian, 1870–71
(Chesterwood, Stockbridge, MA)

"Rogers Groups" adorned parlors throughout the nation, and while most art connoisseurs of the period dismissed them, French considered himself a Rogers admirer, as had been the late President Lincoln.[61] Now he decided to enter the market with smaller-size groups of his own. After making miniature plaster figures of a hound and a wounded deer (the latter inspired by his youthful clay original), French summoned his childhood knowledge of birds to fashion his first Rogers-like "group," titled *Matchmaking*. The little novelty portrayed a pair of snuggling owls "love making," he joked, "in the style of humans!" For this amusing work, he obtained his first copyright on February 6, 1871.

Shortly thereafter, French ill-advisedly accepted a pittance to transfer ownership of the *Matchmaking* piece to the Boston crockery makers Clark, Plympton & Company. He earned nothing further than a straight $50 fee

from the $1,000 that the company subsequently obtained from a London firm under a contract to reproduce the owls overseas. The English concern went on to manufacture a thousand copies in Parian ware—bisque porcelain, glazed to look like marble—retailing for three dollars apiece. At age twenty-two, the young sculptor could boast of his first commercial success, but one that generated absolutely no royalties. French never got over missing out on the financial windfall that benefitted his patrons alone. "Thousands of dollars were made out of this small thing of which the sculptor received fifty dollars," he was still complaining more than fifty years later. "This piece took [off] like wild-fire and had a vogue that nothing I ever did afterward approached. I even found them scattered over Europe when I was there in 1875."[62] The experience transformed him into a wary businessman unashamed to insist on generous compensation for, and full reproduction rights to, his future work. Years later, he produced plaster replicas of the owls and used them as centerpieces for a dinner party at one of his clubs—unwilling to concede, even in old age, that he no longer held the copyright to his first popular work.[63]

More, equally mawkish "French Groups" followed between 1871 and 1872, all mass-produced by Nathaniel Plympton: *Imposing on Good Nature* (showing a small dog pestering a larger one); a timely piece inspired by the recent Great Fire, *The Chicago Incendiary* (Mrs. O'Leary's clumsy cow); and several groups illustrating characters from Charles Dickens novels: *Sairey Gamp* (the tipsy old nurse from *Martin Chuzzlewit*); *Dick Swiveller and the Marchioness* from *The Old Curiosity Shop*; and Dan's most popular literary group, *Joe's Farewell*, inspired by the more obscure Dickens novel, *Barnaby Rudge*. The last piece, manufactured in Parian for the English market, and in creamily painted plaster for domestic audiences, in clear imitation of John Rogers's signature statuary, at least earned the enthusiastic approval of teacher William Rimmer, who examined it as a work in progress.[64] Meanwhile French turned to his early love for birds to produce a dove, reproduced en masse for home decoration. Each figurine featured small eyelets on top from which to suspend the ornament from a window. And in another attempt to illustrate recent literature, he began a relief portrait of Elsie Venner, the title character of Oliver Wendell Holmes's turgid novel about a woman condemned at birth by genetic misfortune: her mother had been bitten by a snake during her pregnancy, and Elsie unavoidably became reptilian. French pictured her in profile with snake-like locks and a dagger-shaped hair barrette above her ear.[65] So few casts of this effort have survived that it is safe to assume it appealed to few customers in its time.

In 1873 the sculptor earned his highest fee yet—three hundred dollars from his Washington, DC, cousin, Francis French, to create a bust of Francis's late father (Dan's uncle), Benjamin Brown French. The onetime Lincoln administration official was no stranger to Washington society, nor to the young sculptor. Dan had traveled to the capital to visit the former US commissioner of public buildings during the final year of the old man's life in 1870. There, Uncle Benjamin had made possible his nephew's very first encounter with a living American president—surely never dreaming that Ulysses S. Grant, too, would become a future subject of his art. The encounter took place on a cold February evening, when Benjamin took his nephew to an overcrowded White House reception. There, they endured "much tribulation and tremendous squeezing" in order to reach the Blue Room and greet President Grant and his wife, Julia.[66]

The former commissioner, who had once handled receiving-line introductions for the Lincolns, declared himself unimpressed by their successors, hardly a surprise considering that Grant's allies had recently ousted the onetime Democrat from his cherished government sinecure. Now Benjamin petulantly confided to his diary—and doubtless directly to his nephew as well—that the "stiff" and "military" former army general sorely lacked Lincoln's gentle manner. As for the cross-eyed Julia, French rather cruelly reported that she looked like "a lady 'with one eye on the pot and another up [the] chimny' [sic]." Dan must have reveled in the head-turning experience, for a week later he reciprocated by presenting Uncle Benjamin with a paper cutter whose ornamental handle he had carved in walnut. "I shall prize it much," the commissioner promised. Hailing his nephew as "a natural born sculptor" with "superior skill in the art," Benjamin added: "I prophecy that the name of Daniel French will hereafter stand by the side of the best sculptors in America & aye, in the world!"[67]

Still feeling far more modest about his future, three years after Benjamin Brown French had offered that prediction, the sculptor completed the bust of his late uncle and turned back to his career in decorative work, producing a new bas-relief of birds along with a plaster called *Reveries of a Bachelor*. He earned fifty dollars from his Boston manufacturer, Plympton, for a relief sculpture titled *Scholar*. At last, he could take pride in being promised seventy-five dollars, plus a share of the profits, for an unrealized project called *Tinting the Leaves*. But French was no John Rogers; he aspired to much more. He was rapidly exhausting his interest in the decorative arts while advancing too slowly in the world of serious sculpture. He needed a change of pace—and a change of scenery.

The Chicago Incendiary, Parian, 1870 (Chesterwood, Stockbridge, MA)

Rather than churn out more parlor pieces for equally modest fees, French decided to take an enormous risk and resume his art education abroad. As he surely knew, no American sculptor could hope to make a great career without studying in Europe. So he resolved to journey to Italy in 1874, to work in Florence under Thomas Ball, the Massachusetts-born sculptor whose equestrian bronze of George Washington held pride of place in Boston Public Garden. At the time he welcomed French as a student, Ball had recently completed a statue depicting Lincoln lifting a kneeling slave from bondage, the first sculpture of the martyred president funded exclusively by free African Americans. The plaster model remained on view at Ball's studio. Though previous French biographers have overlooked this fortuitous coincidence, it would undoubtedly offer him a valuable opportunity for daily proximity to yet another example of heroic Lincoln portraiture, exposure that would later expand his own artistic vision.

As routine as it was for a young American artist to venture to the Old World for training, there was something decidedly unusual about the timing of French's departure for Europe. In terms of step-by-step career-building, it came decidedly out of sequence. Following a more traditional trajectory, Thomas Ball, well past age fifty, had won his recent Lincoln assignment at the apex of his career as a crowning achievement. Ball might have been

startled indeed when he learned that his new protégé arrived in Florence fresh from earning a major sculptural commission of his own—but at half that age—and, moreover, accomplishing it even before commencing his European studies. With his usual diffidence, French seemed as surprised as anyone else. "How I ever managed to do it at that time, having so little knowledge," he admitted, "remains a mystery to me."[68] It would remain so for a while longer.

Daniel Chester French, 1874

THE
MINUTE
MAN

Months before departing Concord for two years in Italy, the untested French miraculously scored his first major art commission: an assignment to create a centennial monument in his hometown honoring the legendary minutemen of the Revolutionary War.

Those self-trained, armed civilian colonists had courageously responded to the British military threat to New England by organizing themselves into militia units that could be deployed "at a minute's notice"—hence earning their evocative name. Tradesmen and farmers rather than professional soldiers, the patriotic minutemen parlayed remarkable agility and superior knowledge of the local terrain to outfox and often outfight better-trained, better-equipped, numerically superior British forces. They emerged from the war for American independence with near-mythical status. Now, a hundred years later, the minutemen were at last to inspire a monument, slated to stand on the Concord side of the North Bridge, where they had returned fire against the British on April 19, 1775, sending them scurrying toward Boston in retreat. The salvo the patriots unleashed that day became known as the "shot heard round the world." Many Massachusetts residents believed this sacred date—rather than July 4 of the following year, 1776—represented the true birthday of American freedom.

Yet since 1836, as the "Sage of Concord," Ralph Waldo Emerson, often complained, the hallowed site had been marked only by an obelisk situated "on the ground on which the enemy stood, instead of on that which the Americans occupied during the Concord fight." Fortuitously, a farmer named Ebenezer Hubbard, who owned the historic land, left a thousand

dollars in his will to erect a proper statue "on the identical ground occu-
pied by our minutemen and militia," bequeathing an additional six hun-
dred dollars to reconstruct a new wooden footbridge over the narrow river.
"The town accepted the legacy," Emerson reported, "built the bridge, and
employed Daniel French to prepare a statue to be erected on the specified
spot."[1]

But why risk assigning such a major project to a novice? After winning
the commission, even French sheepishly admitted to his brother, "Of course,
I have never made a statue. I wonder if I can do it?"[2] Later he concluded,
perhaps half in jest, "My admiring friends ignorantly thought I could attack
a job of any magnitude, and I was engaged to go ahead."[3] In fact, French
was not being overmodest.

The young artist with not a single larger-than-life sculpture to his credit
won this daunting job the old-fashioned way: through family connections
and geographic propinquity. While he had produced nothing grander than
busts, relief medallions, and quaint groupings, he enjoyed widespread pop-
ularity and confidence in his hometown. He understood its history and
culture. Emerson, who served on the organizing committee along with
ex-Congressman George M. Brooks, abolitionist hero John B. Moore, and
chairman John S. Keyes, a local legislator and sheriff, all unabashedly cham-
pioned him.[4] Judge French still exerted considerable influence among his
neighbors, and counted many friends among the committeemen. Defying
custom, the city fathers instituted no formal competition. By the time the
official selection committee organized itself in March 1872, the local sculp-
tor was already the one and only candidate for the commission. Chairman
Keyes had actually extended the offer to Judge French's son the year before.

In fact, the judge reported as early as August 1871: "Dan is just finishing
a cast of a soldier twenty-seven inches high made at the suggestion of Keyes
as a model for a large figure for a monument on the hill where the minute-
men assembled for the Concord fight. They think they can get funds for a
granite or bronze figure."[5] Judge French's confession suggests that the com-
mittee had urged his son to commence work on a statue idea nearly a year
before officially commissioning—or for that matter, funding—the project.

Later that same year, 1871, Dan French's sketchbook began filling up
with daubs of details he hoped to sculpt for the monument: a flintlock rifle
on one page, a plow and firing mechanism on another. Accompanying these
preparatory drawings was a scrawled reminder to himself about how accu-
rately to render the human arm: "The shorter the humerus, the longer the
hands / The longer the humerus, the shorter the hands."[6] Moving from pencil

sketches to clay figures, French imagined a solitary minuteman clutching a rifle, and then tried endless variations on this basic pose. Within months, his bedroom at home—along with those of his siblings—descended into "a welter of small clay sketches, some draped, some undraped, in every considerable attitude and position." The army of miniature clay models soon covered the mantels, washstands, bookcases, and windowsills throughout the house. Eventually, to his stepmother's relief, French moved his workshop to the nearby barn.[7] Inside both makeshift studios, his vision took shape: a solitary minuteman, sensing an alarm, roused to the defense of his town.

For all his zealous preparation, the first official *Minute Man* model French submitted to the committee in late 1871 (and now lost, perhaps destroyed by the artist) failed to earn official approval. Based on a drawing of it, sketched around this time by his older brother, Will, it showed a fierce-looking figure using a muzzle to load his outsized rifle. Chairman Keyes bluntly dismissed it as "pretty bad," and French himself agreed that it was "not good for anything."[8] But the sympathetic organizing committee kept faith with its favorite son. Seeking fresh inspiration, the sculptor made a pilgrimage to the nearby Boston Athenaeum to consult its plaster cast of the *Apollo Belvedere*, a statue from classical antiquity long admired by both critics and the public. Its naturalistic pose and graceful torsion at the hip had once influenced the great sculptor Antonio Canova. Here was the catalyst French needed. Adapting the antique statue's innovative stance, with one foot advancing slightly forward, he excitedly dashed off a fresh new drawing for his sketchbook.[9] Essentially a mirror image of the Hellenistic-style original, he further modified the pose by dressing the legs in colonial-era breeches and boots. A new idea—or more accurately an inspired updating of a very old one—was coming into sharper focus, brimming with a vitality absent from his first clay model.

Determined to recreate details with precision, French began studying time-appropriate props, among them antique buttons and colonial-era tricorn hats, many of them hauled out of storage from local attics and toted to the French home by pretty women dressed in their finest clothes, some of them no doubt eager to meet the slight but handsome young artist with the haunting dark eyes.[10] Keen on accuracy, twenty-one-year-old French purchased a genuine antique musket and borrowed an authentic eighteenth-century powder horn, copying both props faithfully—even if he mistakenly located the elegantly curved cow-horn behind his figure's back, where its gunpowder supply would have been far from the easy reach of a minuteman in combat. When French encountered difficulty in reproducing his

Photograph of Daniel Chester French's stepmother,
Pamela Prentiss French, ca. 1865

figure's left hand, he cast his own hand in clay and then faithfully copied it. Neighbor Jacob Green lent the young sculptor an ancestor's green broadcloth coat adorned with coin-size pewter buttons and uniquely capped sleeves. Although it dated to 1785, ten years after the events at the North Bridge, it was a remarkably preserved relic of the period, and French happily adapted it.[11]

Correlating all these sources, he fashioned a revised clay model in 1873, modestly describing the result only as "a Continental."[12] Here, emerging at last, was the now-iconic figure of a brawny yeoman soldier in his shirtsleeves, clutching his upturned musket in his right hand, his discarded coat thrown casually over the nearby plow whose handle he grips with his left. As his alert expression vividly suggests, he suddenly but calmly senses

danger in the distance, and prepares to drop everything and defend kith and kin. The larger-than-life, seven-foot-tall figure would be well balanced and alive, a breathtaking achievement for the young artist. How the unschooled, untested tyro accomplished such a masterful statue remains an unfathomable mystery.

When French submitted his new model in the fall of 1873, the Concord committee quickly approved it and enthusiastically ordered their sculptor to proceed. But two years into the project, they left open the matter of remuneration. Put on the spot and compelled to name his own price, the untested young sculptor asked only "that I should receive...the actual cost of materials, rent and casting in plaster, not exceeding three hundred and fifty dollars," along with "any compensation for my skill and labor...left entirely to your committee or the town. If in the future it is found convenient to pay me therefore I shall be thankful and if not I will try to be content."[13] It was the last time that French would leave the matter of his fee to the whim of clients, even friends. Sparing no expense, the town would later spend $51.30, a considerable sum at the time, just to cart the statue back to Concord from the foundry that cast it.[14] But years would elapse before Concord awarded French a belated, and rather paltry, expression of gratitude for his efforts. Meanwhile, he could at least be satisfied with the fifteen dollars that his little maquette soon earned him—by winning first prize at a local cattle fair.[15]

It was hardly enough to compensate him. After nearly exhausting his expense allotment, the sculptor fretted that he would not have sufficient money left over to pay for a full-size final casting in the costly medium that most connoisseurs preferred for public statuary: bronze. For a time he speculated that cheaper zinc would suffice. "I would not do it," his old teacher, J. Q. A. Ward, cautioned him from New York. "There is no way of keeping the zinc in a presentable condition except by painting or electroplating with copper, neither permanent—go for the bronze! Make your model so fine and soul stirring that all the ladies in the land will bring their jewelry and copper pans to have them melted up to cast the 'Minute Man.'" With his early mentor, French shared both his financial worries and his artistic concept. "Your design is very good," Ward responded with more gravitas after studying a photograph of the model; he would make no attempt "to criticize it." He merely advised: "Make what you feel in the subject and work at it until your hair drops off—or words to that effect."[16]

The young man set about his next step—the task of creating a full-size model—precisely as Ward urged, laboring tirelessly in a small dimly lit third-floor room he rented on Tremont Street in Boston and converted

French family home, Sudbury Road, Concord, MA, August 28, 1878

into a studio. French equipped the space, really his first professional head-
quarters, with a modeling stand, ordered in a thousand pounds of clay, and
built his own armature: the wooden framework grid designed to stabilize
the bigger-than-life statue as it took shape. At first uncertain as to how to
set about modeling in so large a format, he installed a full-length mirror
and began studying, and sculpting, himself. By one account he posed and
worked at first in the nude. At least that was the later contention of his
daughter, Margaret French Cresson, who maintained that her father's orig-
inal clay was nude as well, and that Dan later added clothes and accoutre-
ments to it layer by layer.[17]

"Clothes," she explained of this long-accepted academic sculpting tra-
dition, "even clay ones—have to be placed upon something, and, naturally
enough, they don't fit very well unless they are draped upon the form of
a human body." Hence French "surveyed his own not unattractive form,"
she contended, and as a source for the minuteman's sinewy arms turned to

a family farmhand named Patrick, who looked as if he "could handle that plow with ease."[18] This had been the practice advocated by J. Q. A. Ward, who advised: "No matter how the figure is to be draped, always model it in the nude first, so as to feel the masses and the movement of the figure."[19] Although the reticent French never confirmed that he employed this method to create the *Minute Man*, a photograph taken years later, showing him at work on another unclad figure to which he later added a costume, suggests that this is the process he pursued.

For months in early 1874, French worked on his full-size *Minute Man*, using additional live models to pose for specific details of the figure. His father hovered constantly, an ever-present adviser. When his son had difficulty getting the hair to look natural in clay, Judge French exclaimed, "Oh, take a brush and comb, and treat it the way you would treat hair, and I guess it will look like hair."[20] At one point, informed by both his sketch of the *Apollo Belvedere* along with his own innate sense of proportion, French "moved the forward leg of the *Minute Man* an inch further forward," a demanding and "unpleasant" adjustment, he confided. However tiny the correction, it suddenly seemed to infuse the creation with a sense of coiled action.[21] French, apparently eager to share his excitement, invited friends and advisers—including Emerson, Bronson Alcott, and his old teachers May Alcott and William Rimmer—to examine the work as it further progressed. Finally, on July 30, 1874, he placed the completed clay model on display for a public reception at his Boston studio. With his customary economy of language, he reported his visitors merely "pleased" by the display, sufficient praise to inspire him to advance to the final stage of preparation.

The following day, together with a trio of studio assistants, French launched into sawing the clay statue into sections and began making thick plaster molds of the separated pieces. Judge French came over to help with the grueling job, joining the inexperienced group that did not quite know how to accomplish the task. At one point, wet plaster erupted so uncontrollably from a gash that opened in the upside-down torso that its head nearly fell off. To his credit, the young French kept his nerve. Laughing off the near-decapitation, he repaired the hole, and proceeded unfazed.[22] From the reassembled mold, the sculptor and his staff created a full-size plaster model, six weeks in the making. On September 11, French at last shipped the finished seven-foot model to the foundry. Dedication day was six months away.[23]

Judge French remained deeply involved in the production, both as his son's most trusted counselor and as something of a project manager once the

Drawing of plaster cast of *Apollo Belvedere*, graphite,
from French's sketchbook, 1871–74 (Chapin Library, Williams College)

Drawing of musket, graphite, from French's sketchbook, 1871–74
(Chapin Library, Williams College)

young French left for Italy. For one thing, the judge helped his son achieve his quest for a proper granite pedestal after the town proposed planting the statue on a boulder to evoke the colonial-era terrain. The sculptor also insisted that the base be placed precisely where he envisioned it—urging his father to go to the site and use a plumb, along with his own "true eye," to make sure the *Minute Man* rested within no more than an inch of his specifications. Judge French obliged, and in a drizzle, though he left the plumb at home.[24]

Will French, too, ultimately joined several architects to design the pedestal in accordance with his brother's original concept, with two of its sides smoothed and incised with descriptive words, and two sides rough-hewn to synchronize with the rocky landscape. Dan admitted the result was "not a great work of art," but seemed gratified that it came to be regarded as "a sort of landmark."[25] Installed over a time capsule—a copper box stuffed with maps and relics from previous battle commemorations, along with photographs of the statue and its sculptor—its base bore the carved formal inscription "D. C. French Sculpt." It was the first time his name appeared on a public monument—a true career milestone. As a finishing touch, artisans "chiseled and lettered" the pedestal's front panel with the stirring first stanza of Emerson's beloved July 4, 1837, poem, "Concord Hymn":

> By the rude bridge that arched the flood,
> Their flag to April's breeze unfurled,
> Here once the embattled farmers stood
> And fired the shot heard round the world.[26]

Before leaving for Europe, still unsure how he could pay for the bronze casting, French had sent his large plaster model to the Ames Manufacturing Works, a onetime sword-making foundry located some eighty-five miles from Concord in Chicopee, Massachusetts. In another reminder of the regenerative continuity of the sculpting profession, this was the same foundry at which Dan's teacher J. Q. A. Ward had worked in his youth, earning extra money designing ornamental sword handles for the firm's founder, James Ames.[27]

Ames Manufacturing Works was the first American foundry to cast a full-size statue in bronze. By 1874, it was the best in the nation. In French's absence, the US House and Senate overcame the last remaining budgetary hurdle: how to pay for the costly metal needed for the casting. Under the sponsorship of Congressman George Frisbie Hoar, whose family had lived

Sketch of the *Minute Man*, from French's letter to
Henry Flagg French, March 18, 1875

in Concord for generations, the House and Senate voted to send ten "condemned" Civil War–era bronze cannons to the foundry to be melted down to provide the raw material for the *Minute Man*.[28] Dan later claimed it was his idea, hinting that he expected the savings to result in a higher fee for himself.[29] However it transpired, the legislation transformed the local project into a national one by adding a measure of historic continuity. The statue would now be made of bronze repurposed from weapons that had been used in the fight to preserve the Union—a union that the minutemen had helped create.

Glimpsing the seven-foot-tall bronze behemoth after it emerged at last from the Ames furnace, a newspaperman on the scene reported it to be "the best piece of work ever done at the Chicopee foundry," adding that the result "is quite satisfactory to the town committee which went to see it this week."[30] As these final arbiters opined in their official records, "There is

nothing hot or theatrical in the movement, which is considered, and the face serious, as of one who sees all the doubt and danger from the first and yet goes quietly on. The figure is of heroic proportions...yet has the lightness of a man skilled in wood-craft as well as farm labor. The anatomy and poise are conscientiously studied from nature; and even the long waistcoat, hanging heavy with the bullets in its pockets, the worn gaiters and rude accoutrements show faithful work and historical accuracy."[31] These initial observers had glimpsed an essential feature of an emerging artistic style: a naturalism that eschewed drapery and instead suggested the musculature beneath the costume. The judge proudly alerted his son: "Well Mr. French, the committee are loud in praise of the minuteman. The people at Chicopee say they have never made a better casting and they pronounce the statue itself the best single figure they ever cast."[32]

Another journalist who secured a sneak preview raved: "It is no ideal face, no countenance or form that would be at home in other countries, but a thorough Yankee, that Mr. French has given to immortality. The features... bear the energy, the self-command, the ready shrewdness, the immediate decision, and, above all, the air of freedom that belongs to the New-England face. The frame is stalwart, the shoulders squarely held, the muscles of the bared forearms...tense and unencumbered by flabby flesh; the great veins stand knotted on the strenuous hands. The man is alive from head to foot, and indeed we know not where there is better represented the momentary pause of vigorous action than in this noble statue."[33]

◆　◆　◆

By then French was ensconced in Florence. And for reasons that remain unconfirmed, he declined to return home for the dedicatory event planned for April 19, 1875, the hundredth anniversary of the battle. To be sure, Italy lay thousands of miles away from Massachusetts, and travel between the continents was exhausting and costly. Perhaps he was simply afraid to hazard being present at what might turn out to be a career-ending debacle. And, perhaps feeling imperiled by the competition,* Dan decided not to travel home to witness the humiliation he imagined for himself.

* His dread may have grown exponentially once he learned that the nearby town of Lexington had intensified its longtime rivalry for Revolutionary War–era glory by commissioning statues of its own for the battle centennial. Four-ton marble portrait sculptures of both John Hancock and John Adams were to be executed by the experienced artists Martin Milmore and Thomas Ridgeway Gould, respectively, and worse, unveiled to the public on the very same day as Concord's *Minute Man*.

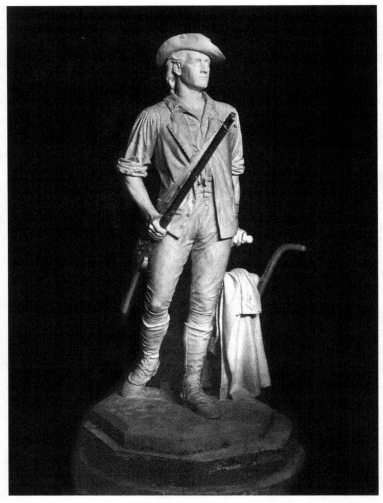

Minute Man, working clay model, 1874

Even if he was simply unwilling to interrupt his Italian sojourn, the sculptor declined the official invitation (which bore an enticing image of his statue under the headline " 1775—Concord Fight—1875 "). All he explained was that "my studies in Florence will render it impossible for me to be present at the celebration." With painstaking formality, he added—perhaps hoping his greeting might be read aloud in April (it was not): "To the town which I am proud to call my home, I must ever feel most deeply indebted, and I would express my grateful sense of the honor conferred on so inexperienced a man, by the confidence implied in the commission for a statue,

which is to commemorate so important an event. If by prospering in my profession, I am ever enabled to accomplish any-thing worthy of my citizenship, I shall owe my gratitude to my friends at home, for the encouragement they have so early and generously extended to me."[34] By an "odd coincidence," French privately noted from Italy, he had "completed my twenty-fifth year" on the same day the *Minute Man* statue was dedicated in Concord. Not even what he perceived to be the confluence of momentous personal and professional milestones could lure French home in April 1875.[35]

While the little-known sculptor stayed away from the unveiling, the most famous man in America—the president of the United States—did not. Ulysses S. Grant had immortalized a number of battlefields during his own career in uniform as he fought to save the country he now led. A prelude to the upcoming centennial of American independence, Grant agreed to pay homage at the battlefield where Americans had first fought to achieve it.[36] In accepting the invitation to Concord, the president was moved to recall (albeit awkwardly): "Though the numbers were small, the principals [*sic*] they fought for were of the greatest possible value to struggling, advancing mankind. The battle of Lexington though but the commencement of the struggle, yet it decided that on which all rested viz—that the people of the colonies knew their rights, and as brave people dared to maintain them."[37]

True to both custom of the day and his own legendary taciturnity, Grant chose not to speak publicly at what he impassively called the "interesting ceremony" at Concord. (He would remain silent a year later at the Washington dedication of the Lincoln statue by French's latest mentor, Thomas Ball.) For his part, the president bore no regrets over this lost opportunity. If he regretted the sculptor's absence, he never said so. As he appreciatively told one of the celebration's local organizers: "Nothing was left undone to make our short stay in the state most pleasant."[38]

Memorable as the occasion proved to those who did attend, few others would describe the experience as "pleasant," not after winter-like weather returned to Concord with a cruel vengeance. On that frigid April day, the temperature in town struggled to reach twenty degrees, "much to the discomfort" of the earliest arrivals.[39] Summoned to the event by a booming, hundred-gun salute at 5:18 a.m., shivering celebrants streamed into Concord by rail, carriage, wagon, and on foot, braving overcrowded trains and slippery, frozen roads on this "cold and windy" but "glorious" New England morning. By midday, as many as thirty thousand onlookers would mass at the historic riverbank, the vapors from human breath puffing from the one-time battlefield like gun smoke from the original minuteman muskets.

At precisely 10 a.m., five separate divisions set off for the site in a noisy parade up Concord's Main Street, the thoroughfare "enlivened" for the occasion by patriotic "banners and martial music." The procession boasted thousands of policemen, soldiers, college students, and politicians, all striding rapidly to ward off the brutal chill. Judge French occupied the lead carriage "as your representative," he proudly informed his son, with Emerson and the day's other featured speakers following right behind.[40] Among the marchers were a former Mexican War drummer boy and an even hoarier survivor of the War of 1812. To "cheer upon cheer," President Grant and former Speaker of the House James G. Blaine rode in a gleaming barouche drawn by four bay horses, and flanked by a twelve-member uniformed guard from the "Concord Artillery." One of New England's most famous Civil War generals, Ambrose E. Burnside of Rhode Island—sporting the trademark luxuriant side-whiskers long known in his honor as "sideburns"—led a group of infantry veterans on foot. "Prolonged and renewed applause" greeted the old commander all along the route, his gruesome 1862 military failure at Fredericksburg forgotten in the mists of patriotic nostalgia.[41]

At the exact moment the lead marchers reached the monument site, the *Minute Man* statue, draped until then under American flags, was dramatically unveiled, the military "saluting it" as they passed.[42] After two full hours on parade, the last of the marchers finally ascended the Concord high ground, where an oversize wind-buffeted tent set up for the main event somehow accommodated an audience of thousands of standing spectators ringing a shaky, two-foot-high wooden platform groaning with dignitaries. When the tent filled to bursting, the unlucky late-arriving "multitudes" huddled outside against the canvas to shelter themselves from the bone-biting north gale, sacrificing their ability to hear the speakers in a vain effort to keep warm.[43]

The crush of celebrities did not inhibit the famous Concord resident Louisa May Alcott from striding onto the scene at the last minute, and confidently leading a group of women friends onto the rostrum. Discovering all the special chairs occupied, she demanded of committee member John Hoar: "Where can we sit?" The "harassed" Hoar stirred up "a mild hornet's nest" with his reply: "Anywhere in the town of Concord, Miss Alcott, except upon this platform."[44] Alcott would soon count herself fortunate. As soon as the minister began his opening prayer, a loud creaking noise erupted like an other-worldly "amen," and the overburdened platform directly "under President Grant and the [Cabinet] Secretaries broke down and they settled about two feet." Moments later, "another section broke down, and a third."[45]

When the dust cleared, Ralph Waldo Emerson, his beak-like nose as oversized as in his portraits, launched into a brief dedicatory address. Before beginning his pithy tribute to America's divinely ordained quest for liberty, Emerson took pains to extol local success story Daniel Chester French. Describing the monument as "the severe work of our young townsman, who is now in Italy to pursue his profession," he told the vast crowd, "His statue is before you. It was approved by the town, and to-day it speaks for itself. The sculptor has rightly conceived the proper emblems of the patriot farmer, who, at the morn alarm, left his plough to grasp his gun. He has built no dome to cover his work, believing that the blue sky will make his best background."[46]

When Emerson finished, the bearded Cambridge poet James Russell Lowell followed him to the lectern, intoning a ten-stanza-long dedicatory ode to freedom which no one then or thereafter would remember as among his notable works. Finally, onetime Concord resident George William Curtis, a Republican newspaper publisher recently named by President Grant to oversee civil service reform, offered the principal oration. Such speeches, in the tradition of Edward Everett's interminable and promptly forgotten oration at Gettysburg in 1863, were expected to drone on endlessly. Curtis did not allow cold weather to inhibit tradition. His garrulous sermon lasted two full hours. Wags joked that more people died of exposure during the benumbing speech than "had died in the battle they were celebrating."[47]

For all his bombast, the principal speaker managed only a tepid acknowledgment of the statue itself, calling it "yon manly figure wrought in the metal which but feebly typifies his inexorable will." In some measure of consolation, when Curtis's popular "journal of civilization," *Harper's Weekly*, reprinted his stem-winder across three bonus pages of its May 1, 1875, edition, it at least honored the sculptor with a prominent illustration of the new *Minute Man* statue. The caption, however, misidentified its creator as "*David C.* French."[48] Such were the perils of too much expatriation and too little reputation.

In the end, President Grant, although (or because) he stayed silent, and Emerson, who spoke so concisely, emerged as the major objects of admiration among the "brilliant assemblage of the distinguished men of the nation" gathered that day for the centennial of "the shot heard round the world." After what one journalist unconvincingly called the "appropriate but brief ceremonies," the audience crowded into another mammoth tent "worthy of Barnum himself," erected nearby for dining, dancing, and yet more speeches. Organizers had decorated its thirteen wooden poles with patriotic "flags

and streamers," and assigned "various companies of minute-men" reenac-
tors to stand guard.[49]

The celebration did not end there. That night, Concord staged a "grand
centennial military and civic ball" at an agricultural hall on the banks of the
Sudbury River. The US Marine Band and other well-known orchestras took
turns entertaining the large crowd. Like most of their neighbors, a proud
Henry and Pamela French paid seven dollars to attend the festivities that
their son had missed, and kept the printed program for the remainder of
their days. "The ball," Judge French exclaimed, "was splendid beyond any-
thing I ever saw." The ballroom itself was covered "top and sides with flags,"
the judge reported, along with an arrangement of "guns, bayonets, swords,
and pistols and decorations of all kinds sent by order of the Secretary of the
Navy. The floor was covered with white cloth, the room warmed with fur-
naces, and brilliantly lighted with gas." The celebrants danced until sunrise,
but Judge French spent most of the night proudly "receiving congratulations
about my artist son."[50]

Absent or not, Dan French earned rhapsodic reviews for his debut mon-
ument. More than one critic declared it an instant masterpiece. A Kansas
newspaper hailed the *Minute Man* as a "great statue." Echoing that pre-
vailing sentiment, a Chicago daily called it "one of the finest statues in the
country."[51] A critic for the *Aldine* saluted its historical accuracy and artis-
tic "spirit." A Boston paper marveled that the figure exuded both "determi-
nation and fire." And the famous old abolitionist Wendell Phillips put into
words what so many visitors felt as they cast eyes on the statue for the first
time: uncannily, it seemed "so full of life and movement that one fears he
shall not see it again if he passes that way the next week."[52] Concord's offi-
cial report on the project, published a year later, emphasized without exag-
geration that the statue had earned "praise alike from the scholar and the
laborer, the cultivated and the untrained taste," adding in gratitude: "Mr.
French is only twenty-five years old, and this is his first work of importance.
The town cannot fail to be long grateful to him for the good work he has
done, and the charm he has added to its meadows."[53]

Accolades in hand and urged on by a father who remained ambitious,
even impatient, for his son's success, the sculptor soon—though at first reluc-
tantly—decided that he was not yet done with his first major project. The
profit motive proved decisive. The Concord committee continued to with-
hold the honorarium it had dangled, and Dan took the news hard, express-
ing "more loss of faith in the righteousness of the Concord people than the
actual loss of the money expected."[54] Apparently, the town fathers told the

sculptor, "I 'ought to be satisfied with the reputation I have made out of it.' Very good," French bristled. "If the statue had been so poor as to ruin my reputation I suppose they would have paid me handsomely."[55] In an altogether different mood, he plaintively told his father, "My chief regret at not getting paid for the statue is that I am so expensive a luxury to you. I hope to make it up sometime."[56] So when the judge proposed putting reproductions "into the market," his son demurred only briefly, admitting that "beggars can't be choosers." The "Concord people might be upset," he conjectured, but "they can hardly expect me to live on air."[57]

Accordingly, in November 1875, Judge French dispatched to the Library of Congress a photograph of the small plaster model and secured a copyright. Then he brought the plaster to the Boston art-manufacturing firm Doll & Richards and set in motion a plan to produce replicas and sell the statuettes for twenty-five dollars, assuring his son, "money can be made of it."[58] The firm promoted the statuettes with a flyer featuring a review of the original from the *Springfield Republican*. As many as nine casts of this initial reproduction sold quickly. The perennially upbeat judge wittily dubbed the small-size pieces "the *minuettes*."[59]

Dan French did put his foot down when his father suggested circulating portraits of the artist. "O come now!" he barked to his father from Italy with uncharacteristic vehemence. "Don't let them sell my photographs. Sell my statuettes, sell my 'Minute Man' sell anything but spare, oh spare my head....Seriously, is that the proper thing to do? I don't like it anyway. Grand premium, a photo of the artist given to every purchaser of a statuette of the 'Minute Man.' How does it sound?" He added a half-hearted ultimatum he suspected would redirect his father's well-intentioned energies: "I shan't come home if this is the way I am treated."[60]

◆ ◆ ◆

For decades to come, Daniel Chester French would deservedly profit from reproductions of his iconic *Minute Man*, more than making up for the meager thousand dollars in remuneration he eventually earned from the original.

In 1889, a group of patrons, including Edward Emerson and Samuel Hoar, sons of two of the men who had been instrumental in getting the original statue created, invited French to create a bronze "reduction" of the *Minute Man* for a new US Navy gunboat to be named the *Concord*. Rather than slavishly copy his original, French, by then a far more accomplished artist, produced a mature revision, adding more coiled tension to the figure's back foot. He retitled the new composition *The Concord Minute Man*

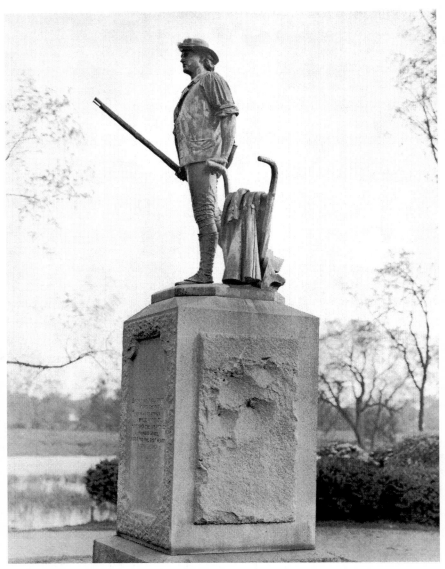

Minute Man, bronze, 1871–75, Minute Man National Historical Park, Concord, MA

of 1775 and used it as the model for all his subsequent replicas. The original USS *Concord* later saw action at Manila Bay in the Philippines, at the outset of the Spanish-American War. Decades later, a modern light cruiser bearing the same name, and like all previously commissioned *Concords* proudly carrying the same *Minute Man* statue on board, would participate in the final naval battle of World War II, the bombardment of the Kuril Islands in the North Pacific on August 25, 1945. According to legend, sailors on all the vessels called USS *Concord* always made sure, just before firing their loud guns, to respectfully stuff the statue's ears with wads of cotton.

Minute Man statuettes had long reigned as marketplace favorites when, in 1898, Lexington reentered the eternally competitive battle for preeminence in Revolutionary War nostalgia—not to mention the lucrative visitation it generated. That year, Concord's neighboring town paid sculptor Henry Hudson Kitson ten thousand dollars to create a twenty-foot-high fountain to be topped by a statue of real-life minuteman John Parker. Its unveiling attracted some forty thousand spectators, but did little to eclipse French's version dedicated down the road in Concord twenty-five years before, and at a tenth of the cost.

In the early years of the twentieth century, French earned additional royalties by marketing yet more *Minute Man* reproductions. In one such effort, he commissioned dealer Thomas B. Starr to sell bronze statuettes for $400 dollars apiece (at a 25 percent commission for the dealer), and according to French's surviving account books, dispatched one early copy to financier and art collector Solomon R. Guggenheim (at a discount). French later offered up smaller, twelve-inch-high reproductions priced at $160, along with three-foot statuettes for $1,500.[61] He did reject several 1917 requests to authorize further copies in both "plastic" and bronze—complaining to one aspirant that "my experience with reproductions in small size of my statues have given me so much trouble and have been so little remunerative that I hesitate about embarking on an enterprise of this kind."[62] Yet later that same year, French allowed the Gorham Company to produce bronze replicas for $250. Seven years afterward, Gorham officials reported to French, who liked to keep apprised of fluctuating prices, that they had recently sold one of the miniatures for $700.[63] For years to come, despite his initial reticence, the *Minute Man* remained for French a lucrative cottage industry. Today, casts may be found at Chesterwood, the Mead Art Museum at Amherst College, the Ball State University Gallery of Art, and, fittingly, the National Board for the Promotion of Rifle Practice in Washington.[64]

As for the original full-size plaster model, the summer after the ceremony at Concord, Judge French convinced his son to accept a two-hundred-dollar fee to exhibit it, now painted the color of bronze in less than subtle imitation of the statue, at the 1876 centennial in Philadelphia. There, one dazzled critic called it "the best work of American sculpture" on view.[65] A gallery of Rogers Groups nearby went ignored.

The sculptor later ordered the plaster returned to him in Concord and for a time kept it on display at his studio there. Finally he shipped it to Chicago, where it entered the collection of the Art Institute. More than a decade after his brother Will's long tenure as its director, and several years after the sculptor's own death, the museum inexplicably deaccessioned, and in all probability destroyed, the relic. At least it has never resurfaced since.

Despite that inexcusable loss, it is probably fair to assert that no other American sculpture—with the possible exception of French's own Lincoln Memorial, created almost half a century later—ever inspired as many adaptations, authorized and unauthorized alike. For a time, French even contemplated granting the city of Minneapolis permission to produce a full-size bronze copy for a local park, cautioning that the project would be expensive.[66] Meanwhile, *Minute Man* replicas remained available to buyers as decorative statuary for years, and for generations appeared and reappeared as an advertising icon, the symbol of, to name but a few of the enterprises that appropriated the image: Nissin Foods ("Ready in Minutes"), Minute Man Lime ("instantly plastic"), Minute Tapioca ("Always Ready"), and the Citizens Trust Bank ("an ideal of unselfish service"). Later, it also became the emblem of the Citizens Committee for the Right to Keep and Bear Arms. Less controversially, the statue graced US savings bonds as well as World War II victory bonds, and appeared as the symbol of the National Guard ("Always Ready, Always There!") and the US Army itself ("Reserve today for tomorrow"). Used and abused over time, the image unveiled in 1875 stayed in fashion for nearly a century.[67]

In 1975, as his hometown prepared to celebrate the bicentennial of the Battles of Lexington and Concord, several newspapers alerted readers that the date would coincide with the 125th anniversary of sculptor Daniel Chester French's birth.[68] This flurry of publicity notwithstanding, the serendipitous confluence of milestones, which French himself had first noted back in 1875, again went unacknowledged.

French had since become the best-known American sculptor of his day, but by 1975 had been dead more than forty years. By then, the fame of the sculpture had again eclipsed that of the sculptor—just as it did on its dedication

day a hundred years earlier. For convincing modern verification of this double-somersault in reputation, one need look no further than the modern signage that welcomes visitors to the monument site today. The 970-acre grounds surrounding the statue and its sacred environs are now named not for the battlefields or townships they embrace, but for the defining likeness at their core. The site is fittingly called the Minute Man National Historical Park.

Daniel Chester French in Italy, ca. 1875

AT HOME ABROAD

A mbitious as he was for fame and fortune, Daniel Chester French spent surprisingly little time studying abroad—a rite of passage, not to mention a form of advanced education, that American artists of the day were expected to pursue if they were to be taken seriously back home. By comparison, sculptor Augustus Saint-Gaudens, French's slightly older contemporary, sometime rival, and future friend, devoted nearly seven years to studying and working both in Paris and Rome. That was more than triple the time French would spend just in Italy during his first European visit from 1874 to 1876.[1]

It is hard to know whether French headed overseas to learn from masters and masterpieces in Europe, or to flee from scrutiny over the unveiling of his maiden statue in Concord—or both. Although a well-connected friend had invited him to visit his family's home in Florence whenever he desired, the *Minute Man* still had not been cast in bronze when French abruptly decided to accept the offer, making his timing seem, at best, odd. Leaving no clues about his deepest motivations, he booked his ocean voyage from Boston to Liverpool for October 19, 1874. Right up to departure day, the question of how long he would spend in Europe remained a matter of grave concern within his close-knit family. Other young American artists had extended their European stays indefinitely once exposed to vibrant European culture. As his father forewarned him, "If I thought this foreign journey would lead to your loss of your home in this country, I should regard it as a misfortune inexpressible."[2]

Although the sculptor booked a solo passage, he found himself sharing a small cabin on his oceangoing steamer with a young doctor who vowed

to minister to him when he succumbed to the inevitable mal de mer that plagued most first-time travelers. While the crossing proved nightmarishly rough, more typical than rare for this time of year, it was the smug physician who took sick. Dan, whose aquatic experience had been limited to occasional canoe trips on the placid Concord River, "never missed a meal." The pitching sea actually served to lull him to sleep, he boasted, unless a particularly turbulent squall made his bed stand on end.[3]

Liverpool, the teeming English city where the ship's passengers disembarked a week later, might have reminded him of Boston, with its bracing salt air and thick concentration of Irish immigrants. Its politics, however, differed markedly from Boston's progressivism. An active port since the beginning of recorded time, Liverpool had long connected England to North America, continental Europe, and Africa. Before the United States outlawed the slave trade in 1807 and the British banned slavery in 1833, Liverpool had notched a long and cruel history as a transfer point for kidnapped Africans bound for bondage in the Western Hemisphere. More recently, Southern sympathizers in England had used the city as a base to build, shelter, and launch Confederate ships. Some of these had gone on to menace Union vessels on the high seas during the Civil War—continuing their piratical rampage even after the war ended, since news of Northern victory took months to reach distant ports. As historian Sven Beckert has put it, Liverpool was "the most pro-Confederate place in the world outside the Confederacy itself."[4]

Probably unaware of its refractory past, the visiting Yankee sculptor likely took far more notice—if he noticed anything at all there before catching his next boat—of the city's current exhibition of "modern pictures" at the Free Public Library and Museum.[5] On the chance he at least spied a newspaper notice, he would have realized with interest that even this emphatically commercial town had begun to showcase sculptural works.

Before leaving for the Continent, Dan detoured to London. Although repelled by its congestion, vastness, utter confusion, and acrid air, he devoted "awestruck hours" to both the National Gallery of Art and the British Museum. The highlight of his brief stopover, he proudly admitted, came when he caught glimpse of a Parian ware copy of his own 1873 Dickens-inspired sculptural group *Joe's Farewell*, on display in a shop window on the Strand. Whether he paused to rue the lack of remuneration he had earned from it went unrecorded, though it was a source of personal fury for decades.[6]

Within a few days French made his way across the English Channel to northern France, and on to Paris by rail. Here could be found precisely

The Duomo, Florence, from Daniel Chester French's *Scrapbook of Art and Painting and Sculpture / Italy 1875*

what the sculptor had journeyed to Europe to see. Everywhere he looked stood breathtaking works of art he had long dreamed of viewing for himself: statues and architecture, older than anything in America, adorning streets, parks, and museums. While his time in Paris lasted only a week, Dan managed to visit all "the great sights" he felt he was required to examine, including, of course, the Louvre.[7] Yet these did not include the art schools and studios where some of his more daring American contemporaries were then taking instruction. Itching to reach Italy, he departed far too soon, as he would only later admit. In weighing the "relative merits" of the art scene in each hub, he confided from Paris: "They all think I ought to stay here to study. I do not. I shall try Florence any way, and if I am ever rich enough, I may think it is worth while to study here."[8] Half a century later, French was still expressing regret over rushing off from France so quickly: "I am sorry that I did not get to study in Paris with that brilliant crowd that came from there when I was young."[9]

His decision to hasten to Italy provides insight into his traditional aesthetic sensibility. At the time, Paris was a magnet for a new generation of painters and sculptors committed to modernism, contemporary subjects, and the mutually supportive community of young artists attracted there by these experimental concepts. Aside from Saint-Gaudens, the American John

Singer Sargent now lived in the city, studying under painter Carolus-Duran at a bohemian atelier on the Boulevard Montparnasse. Calling Paris "the Mecca of all art students," French's first teacher, May Alcott, opined that the city was "apt to strike a new-comer as being but one vast studio"[10]—but with a palpable tension dividing the old and new. Just a few months before the sculptor's arrival, a group of artists calling themselves the "Société Anonyme"—among them Claude Monet, Edgar Degas, Camille Pissarro, and Pierre-Auguste Renoir, strikingly original painters whose works had been rejected by the Paris Salon—had organized a renegade show of their own. There, a disparaging critic unknowingly coined an indelible new name for their movement from the title of Monet's groundbreaking 1872 harbor scene: "Impressionism." Creating shock waves destined to redefine painting itself, the Impressionists made a convert of American-born artist Mary Cassatt, who in turn enticed the future art patron Louisine Elder—later the wife of the fabulously wealthy H. O. Havemeyer—to their circle.[11]

The avant-garde did not suit everyone, French included. Those drawn to idealized subjects and neoclassical style of art continued to drift to Rome and Florence, as had the famous expatriate sculptor Hiram Powers, celebrated for his chained nude, *The Greek Slave*. At the time French arrived in Europe, he identified not only intellectually with the latter group but personally as well. He had earlier befriended Powers's sculptor son, Preston, in Boston. After only a brief acquaintance, it was Preston who had invited him to accept the family's hospitality in Florence.[12] Whether in Italy or America, the tension between classical idealism and modern naturalism would continue to tug at French for many years to come.

When French finally reached the birthplace of the Renaissance by rail on November 20, 1874, Preston Powers was there at the Florence depot to meet and transport him home in a fiacre, what French would have known as a public carriage. The young New Englander who alit from the train that day was wiry in build, his arms well-toned from the years he had already spent molding resistant clay. French's pale, oblong face featured inquiring dark eyes and a thicket of unruly black hair. A large fashionable mustache sprouted from his upper lip. The younger Powers, a second-generation artist, wore a more worried look, and for good reasons. For one thing, his own sculpting career seemed stalled. Worse, after serving as secretary to his father until the famous sculptor's death a year earlier at age sixty-seven, Preston had grown short of funds. Desperate, he had challenged his father's will and was now in the midst of an unseemly public battle with his mother

over control of Hiram Powers's estate. For the cosseted French, such a family contretemps seemed unimaginable. If the two friends ever discussed the feud, neither made mention of it to others. Preston Powers was destined to lose this legal challenge—indeed he would end up dying a pauper in Florence the very same year French died wealthy in America—but at least for now the courts had granted the thirty-one-year-old control over his father's spacious compound.

The Villa Powers—actually a series of villas on the Via Farinata degli Uberti—stood on a hillside across the river Arno, just outside the Porta Romana, the southern gate of the thirteenth-century walled city. Here French unpacked his suitcase and enjoyed his blissful first days in the ancient city of timeless art and architecture, gazing from his bedroom window at a panoramic view dominated by the "Lily of Florence," the wondrous fifteenth-century cathedral campanile that jutted nearly three hundred feet into the azure sky. The spectacular scenery more than compensated for the surprisingly cold fall weather, and the seasoned New Englander endured without complaint the brisk "zephyrs" that wafted through his high-ceilinged chamber. "They all do everything they can to make me happy," he reported home of his reception by the Powers clan. "They not only treat me like one of the family, they take me about to see everything and everybody."[13]

A few days later, Preston's sister led French in search of studio space, locating a suitable little spot near the city gates not far from the Powers villas. Using cash he had brought from home, he rented the room for six dollars a week, then learned it would not be ready for his occupancy for another seven days. Luxuriating in his free time, he set about to explore. On long walks, he visited the ancient churches in the center of the walled city and inhaled the intoxicating aroma of lemons and oranges from nearby citrus groves. Recently modernized, but still teeming with dark warrens that terminated in broad sun-suffused plazas, the city proper housed 163,000 inhabitants, most of them proud to live in a special universe devoted to art and "religious thought."[14] With tourism lately on the rise, grand new hotels had recently opened along the widest boulevards, although side streets remained thick with unassuming pensiones offering cheap but often insect-plagued rooms. Nearby squatted countless smoke-filled trattorias set with outdoor tables groaning with carafes of wine, bottles of olive oil, and platters of meat. To French's unending delight, dominating the cityscape were marble statues hypnotically competing for his gaze—sculptures that decorated noble cathedrals and bestrode vast squares.

Braving the late-autumn cold snap, the eager American investigated the city's exotic palaces and imposing piazzas, "more grand than anything I had ever seen."[15] He tiptoed along the icy, mud-encrusted riverbank so he could reach the merchant stalls inside the storied Ponte Vecchio, the arched stone bridge that had spanned the Arno since 1345. Near the Pitti Palace he haunted art galleries chockablock with "lovely pictures," none of which he could afford.[16] Like many first-time visitors, French may well have carried the latest Baedeker handbook that touted Florence as "one of the most interesting and attractive places in the world," filled with "art, such as exists in no other locality within so narrow limits."[17] Perhaps he also toted John Ruskin's recently published guide to the city's greatest paintings and heeded its emphatic recommendation that first-time visitors devote hours just to works by Giotto and Cimabue. At the Uffizi, its galleries crowded shoulder-to-shoulder with copyists, French indulged in studying paintings he had seen only in engraved reproductions. Later, when Italian authorities imposed the first-ever admission fee for museums, he was delighted to obtain "a permit to visit the gallery free of charge," for which "artists and some of the *other* lower classes" had become eligible.[18] At the Accademia, he stared in awe at Michelangelo's expressionistic wax model for his sculpture of a young slave, confiding reverently that it "struck me as the best thing I ever saw."[19] He also took time to visit Michelangelo's house, which he thought inauthentic, and trekked to a hilltop outside the city to experience Galileo's Tower.

The frigid weather did nothing to curtail the social season in the city, either. Preston Powers immediately drew Dan into the hard-partying circle inhabited by wealthy residents and the young expatriate artists who added a bohemian flair to their spectacular galas. There was music and dancing to be enjoyed, bracing conversation to exchange, and pretty and well-connected young women to meet. To the newcomer's delight, Preston's own sisters were beautiful. Nellie Powers impressed French as particularly "lively and handsome," but their relationship foundered almost as soon as it began. A year later, he would admit that "she fails to stir my soul, perhaps because she doesn't try."[20] Stung by rejection, Dan conceded, "I don't think she likes me very well, and I am not drawn toward her enough to make unrewarded attention its own reward."[21] Despite the friction between them, Nellie and Dan remained close, if wary, friends, while he continued to reside in the Powers family compound.

Within days of his arrival in Florence, already rejected by Nellie Powers, French found a way to more than compensate for this unrequited affection.

In the company of the charismatic Thomas Ball and his family, he promptly developed a special crush on Ball's sophisticated blond-haired daughter Eliza, known to her parents as "Kitty" and to her friends as "Lizzie."[22] The attraction became serious enough to motivate the twenty-four-year-old to purchase an expensive Florentine dress coat and "the best" lavender kid gloves "on the market," so he could shine at the nightly soirees frequented by Lizzie and her coterie.[23] Though he joked that the attire made him feel "Dan-di-fied," he gravely assured himself that his extravagant new clothes would last a decade. Yet within the year he ordered a tailor to turn the coat inside out to extend its life.

In something of an understatement, he wrote his family, "Mr. and Mrs. Powers are doing everything to make life pleasant for me, and are successful in their efforts."[24] Nights in Florence were filled with parties at sumptuous venues, capped by a masked ball that did not end until dawn, hosted by the king's mistress at the opulent Borghese Palace.[25] When they were not frequenting such revels, French and his circle of friends stayed home and entertained each other. Lizzie played the piano and taught Dan to sing, and he instructed the Ball and Powers girls in the latest dance crazes from America—including the voguish, slow-tempoed waltz "The Boston," surely a reminder of home. Preston's wife began giving Italian lessons to the young sculptor, although even after two years in the country, French would sadly admit that "his knowledge of Italian" remained "limited."[26]

His leisurely week of solitary strolls and blissful social engagements at an end, French acknowledged that it was time to attend to business: "I have to get settled down into a regular routine which I have not been able to do yet."[27] His studio finally became available, and although the space was freezing, it was bathed in an ideal northern light, dear to all sculptors, and the likes of which the sculptor had never enjoyed at home. Dan bought some cheap secondhand furniture, got two men to help him install his new modeling stand, hauled in a supply of clay, unpacked his tools—among them the implement given to him as a gift years earlier by May Alcott—and as a solitary decoration, hung a photograph of his sentinel-like *Minute Man*. The place still felt "forlorn," he confided in his diary.[28] Turning dutifully to work, he hired a local model to pose for him inexpensively, and enrolled in anatomy classes at the Accademia di Belle Arti, where, to refresh his draftsmanship skills, he sketched both plaster casts and live sitters.

As a sign of his gratitude to the Powers family, he had proposed to begin his work in Florence with a bust of Preston's brother, Ned, though nothing seems to have come of it. On one occasion, Dan and Ned did arrange to sit

side-by-side for a flagrantly precious photograph—by Ned's older brother, Longworth Powers, a professional photographer—with French sporting a black mustache so thick it resembles the bottom end of a push broom. Both young men appear to be wearing fake wings fastened to their slim frames, so that they might pose as Raphaelite cherubs. Perhaps they concocted the elaborate *tableau vivant* for the benefit of the local girls, to create a calling card that testified visually to their angelic natures.

When he could spare time from his sculpting, art classes, and fruit-less Italian lessons, French recorded in his diary that he also began to enjoy—perhaps "experience" would be a better word—the glorious sculpture that adorned Florence everywhere his eyes could turn. Among these, Michelangelo's works remained, just as they had for more than three centuries, the principal attractions for tourists and students alike. Surprisingly, French found some of these masterworks disappointing. After visiting the Medici Tomb to study the reclining marble figures representing the four times of day, he confided, "I am not very enthusiastic, but I do enjoy them greatly." The statue of *Evening* he counted as his "favorite of the four—the most graceful and beautiful," though he hastened to explain that this sculpture was "not perhaps so fearfully Michelangelesque as the others." The most enthusiastic comment French offered about the Medici Tomb statues was that they "*do* wear well."[29]

Becoming increasingly "free in my opinions," as he confided in the pages of his private journal—perhaps sensing the need to account for his suddenly acquired candor—he offered particular misgivings about the cherished statue of David that dominated the city's Piazza della Signoria. While "Michelangelo's works strike me always," Dan allowed, the famous *David* impressed him "less so than any of the others." Nearly seventeen feet high, the 370-year-old statue was more than twice the size of French's *Minute Man*. Michelangelo had miraculously carved it from a single block of marble. Yet neither its scale nor its artistry seemed to impress the young American. French was simply "not very enthusiastic" about it, justifying his aversion in prose he may have been reluctant to commit to paper: "The David is big, but I cannot think it is good as a figure merely, but the power that is in it makes up to me what is wanting in beauty and form." French seemed particularly disenchanted by "the right hand that holds the sling," complaining, "That hand looks as if it could throw a stone a mile."[30]

If the young sculptor was feeling particularly judgmental of the masters, possibly it was because he had just turned to a truly daunting project of his own. Not long after airing his startling assessments of Michelangelo, French

Daniel Chester French and Ned Powers posing as cherubs after
Raphael's *Sistine Madonna*, 1875

decided to attempt a neoclassical-style statue of Endymion, the handsome
Aeolian shepherd-king of Greek myth who rests in an eternal sleep imposed
on him by his father, Zeus, according to but one version of the legend, for
trying to seduce his wife, Hera. Another iteration of the legend held that
Endymion's beloved, Selene, kept him in perpetual slumber to preserve his
exquisite looks. Elaborating on the story, Dan proposed to depict the beau-
tiful youth awakening from his trance to meet his true love. It was a daring,
demanding choice of subject, a far cry from his quaint interpretations from
Dickens. The sculptor had tackled nothing so ambitious before.

◆　◆　◆

Before he could make much progress, Preston Powers lured French to
accompany him on an irresistible three-hour journey to Seravezza, near the
university village of Lucca, in pursuit of a supply of marble. Here was a rare
chance to learn about the raw materials that great sculptors always needed
for their work. The two began their Tuscan adventure with a breakneck visit
to the storied nearby town of Pisa. "As for the tower," he wrote home as
many a tourist before and after him, "it does not seem as if it could stand
at all." The friends experienced the usual disorientation after descending
the Leaning Tower's dizzyingly spiral staircase. Reaching the street, French
likened his swirling brain to "a maze of crooked rows of columns, uneven
arches, and utter disregard for the perpendicular," adding, "It is a wonder
to me that the Pisans do not all appear in an intoxicated condition." Shortly
after noon, Dan and Preston rode toward the Seravezza marble quarries
past "plantations of olive trees," surrounded by "mountains and brooks and

queer old houses on either side." At a small hotel, they dined together on "macaroni to spare."[31]

Returning to Florence, Dan found waiting for him a life-altering letter from the great Thomas Ball. Having learned of French's plan to sculpt Ned Powers, Ball flattered the young American by unexpectedly inviting him to fashion the work under his guidance. "How would you like to do it in my studio so that I can look over you?" Ball proposed, "I can offer you a corner in my big room, just eight ft. by 6½ ft., with a window to yourself to model in and the use of the entire studio to 'swing cats in'"—deploying a thoroughly American expression that alluded to the large spaces once required to administer punishment with a wide-swinging cat-o'-nine-tails. "Sleep on it tonight," Ball urged, "and come into the studio tomorrow and let me know the result."[32] As French understood it, he would be "the only pupil except for Milmore that Mr. Ball ever had"—a reference to the gifted Irish-born Martin Milmore, sculptor of the Lexington statue that was about to vie for public attention with French's Concord Minute Man.[33]

French wasted no time in accepting Ball's generous offer, thrilled to trade his modest atelier for even a corner space in the much grander setting. In short order he hired a donkey cart to transfer his meager furnishings to the Ball studio. Like the Powers compound, Ball's Florentine villa stood on a hillside near the Poggia Imperiale outside the city walls, along a "grand old" boulevard guarded by double rows of "sentinel-like cypresses" planted centuries earlier by the Medicis. To French, the surroundings seemed so manicured that "one might almost think one's self in the suburb of one of our New England cities, so new and green and prosperous does everything appear, and so modern." French entered the walled-off grounds through an iron gate in the style of "enchanted castles of childhood," passing a gurgling marble fountain fronting the sprawling house.[34]

Ball's sprawling studio was a maze of six rooms occupying the villa's entire ground floor, boasting interiors so high and voluminous that snowflakes occasionally danced along the ceiling. The warren of workspaces brimmed with models of the sculptor's recent works: a statue of Massachusetts's curly-haired, bespectacled Civil War governor John A. Andrew; another of Saint John the Evangelist; a likeness of tragedian Edwin Forrest; and a marble bust of George Washington. Here, too, French encountered the maquette of Ball's recently completed statue of Abraham Lincoln for Washington, DC, portrayed clutching his Emancipation Proclamation in one hand and lifting a half-naked black man from his knees with the other. The original had been funded entirely by African American freedmen. Ball

(from left) Daniel Chester French, Susan Jewell, Ellen Ball, Thomas Ball,
Eliza Ball, at the Villa Ball, Florence, June 1875

may well have told the new arrival that he had just been invited to create a replica for Boston.[35]

In another section of Ball's capacious studio stood a large unfinished statue of Daniel Webster, the sculptor's latest work in progress, and, like Lincoln, a subject that would in later years engage Daniel Chester French. A gaggle of gallery employees, among them "a great corps of marble cutters" and plaster casters, scurried about, hauling materials or waiting for instructions from the great man while visitors strolled through the place as if it was a public museum.[36] Indeed, one large chamber functioned solely as a showroom, its decorative crimson curtains swathing the works on display. This, French learned, was how famous sculptors worked and lived.

Then there was Ball himself: bigger than life, his large face crowned by flapping ears, a drooping handlebar mustache, and an extravagant chest-long beard that seemed to part in the middle to resemble an upside-down set of cattle horns. Possessed of a booming baritone that he frequently raised in song, Ball had worked as a professional vocalist in America, performing in operas by Mendelssohn and Handel. When he wasn't sculpting, greeting customers, or launching into his favorite arias, the prodigiously eclectic impresario also "wrote poetry and played the violin."[37] The artist's generous hospitality seemed to Dan an act of "pure goodness." He exulted when Ball "showed me my corner in the room in which he is modeling his fourteen foot Webster and said that he thought he could assist me more by having me in his studio than by visiting me now and then at my room. I should think... it is just the thing for me."[38]

Apparently Judge French initially worried otherwise, for Ball soon felt it necessary to assure his new protégé's father that his residency would be of benefit to both artists. "You would like to know why I have done this thing?" Ball seemed almost to roar. "I would ask you why the hearts and homes of the entire neighborhood were thrown open to your son before he had even been here a week?" Though an admirer of the *Minute Man*, Ball now found himself "thinking much more about the artist than the statue.... And when he came here and took a studio not far from me, but too far for me to see him as often as was good for him, I thought how, twenty years ago, I came here to make my first struggle, and how welcome was the face of dear old [Hiram] Powers whenever it brightened my door." More selfishly, Ball admitted, he welcomed the idea of having someone to "call upon to receive my visitors" when the great sculptor himself was "up to my elbows in clay" or "on a ladder 15 feet in the air." The plan was already working well, Ball laughed, save for the times he had descended his ladder at the

sound of "*female* voices" below, only to find "a bevy of pretty girls" indifferent "to the head of the establishment, when that son of yours is beaming round."[39]

Then there was the alluring Lizzie Ball, floating in and out of the bustling scene at the villa with almost disruptive charm. French grew more smitten than ever. "Miss Ball's hair is beautiful," he confided to his diary, provocatively adding, "as I have discovered by private observation."[40] When the weather improved, he and "Miss Lizzie B." headed into central Florence for gelato and ended up strolling "about the city by moon and gas light." Besotted by the experience, French rhapsodized: "Night is one of the best times to see Florence—the dreamy, poetical, romantic time when the old palaces and churches and statues and fountains are felt as well as seen, and the glory of the old time comes back again; the poverty and the general air of neglect, that in the daytime are too closely connected with the present day, being put gently into the background."[41]

No wonder that, within the year, rumors reached home that the two would be married. Young French admonished, "don't you believe it," but to his brother confided: "Miss Lizzie, I need confess, is very lovely, with the golden hair that my heroine always has had, and I must confess that she now and then gets a little dangerous, but who was ever in the presence of a pretty girl for any length of time without feeling his weakness?"[42] To friend Will Brewster, French offered a franker, although equally perplexing, account. "If any body ever behaved in a more cold-blooded manner toward a young lady than I have toward Miss Lizzie," he wrote, "I should like to know it; and it isn't easy for me...to be in the company of a pretty girl without having strong inclination to flirt."[43]

Despite these powerful distractions, French in fact focused his attention on work. Ensconced in a fairytale setting whose uplifting atmosphere he likened to a Renaissance workplace of old, he began shaping his concept for *Endymion*.[44] The actual sculpting progressed slowly. To make ends meet, French took on several undemanding but fairly lucrative commissions he had brought with him from home. From a strictly professional perspective, having each piece carved and signed in Florence would undoubtedly increase their cachet. The first was a sculpture called *May Queen*, for which he would earn $500; the second, a cupid riding a swallow through the clouds, earned him $250.[45] After considering the idea of making a copy of the latter as a gift for Thomas Ball's daughter, the frustrated suitor scotched his original concept altogether. "It was a Cupid when it was a present for Lizzie Ball," he grumbled, "but he has exchanged his arrow for a

Elsie Venner, marble, 1876
(Museum of Fine Arts, Boston, MA)

torch and is now a 'Day-break.'"[46] French may have tried to adapt either
or both works in marble, but ultimately handed the task over to the expe-
rienced carvers who worked for Thomas Ball at the villa. Although he had
carefully observed Ball chipping away skillfully at polished stone, French
had not quite mastered the technique himself. If nothing else, he learned in
Florence to concentrate on his clay and plaster models, and delegate to spe-
cialists the task of enlarging, casting, and carving his "sketches" into final
form. It was a routine he would follow for the rest of his long career. As
French learned, great sculptors conceived their works, but did not necessar-
ily carve them, too. Michelangelo may once have done so in this city, but the

masters of the modern age were no longer expected to be expert marble cutters. French vowed never to take chisel to marble again. Except for polishing and finishing, which he would always insist on performing himself before any of his marbles were unveiled, after *Endymion* he never again worked in the medium.

More journeyman work trickled French's way, including a bust of a Maine clergyman named Nathaniel William Taylor Root. The portrait was commissioned by one of the minister's neighbors who happened to visit Ball's compound, and French was grateful to begin work "under Ball's directions."[47] French also returned to the literary genre, completing his relief portrait of *Elsie Venner,* a piece he had begun in Concord in 1872, yet which he signed and dated from Italy—"D. C. French. / Florence, 1876"—indicating that he completed it while working under Ball.[48] Although French's output was rising as swiftly as the perennially rain-swollen Arno River, French scholar Michael Richman later dismissed these works as "decorative conceits," a harsh but fair judgment of a sculptor who seemed inexplicably to be regressing.[49]

French's Concord patrons had not abandoned him when his *Minute Man* project foundered, and now, similarly, Thomas Ball refused to express alarm over the young man's seeming descent into humdrum work. After all, Dan had to eat as well as sculpt, and his commissions, however mundane, at least paid real money. In January 1876, Ball even helped him secure an order to produce a portrait, now lost, of a visiting American child named Mary Hayden, for which the young sculptor received another decent $250 fee from the subject's father. Once again, French focused on the clay sketch and plaster model, leaving the actual marble carving to Ball's employees. Yet the uninspired final result bore marks of his own seeming indifference—or temporary loss of courage to tackle more demanding subjects.

French may have been collecting a steady income, but it amounted to a trickle compared to what, he learned, some of his contemporaries were then earning. Surely he would have known that five years before, a totally untrained young sculptress named Vinnie Ream had won the lucrative and prestigious ten-thousand-dollar commission from Congress to produce a marble statue of Lincoln for the US Capitol Rotunda.[50] Critics veered between assailing the result as clumsily amateurish, or expressing doubts that so young a woman could have produced anything so graceful and professional. The swirling controversy, complicated by the unpopular Mary Lincoln's vocal opposition to the commission, elevated Ream into a genuine celebrity. And yet, French, approaching his twenty-fifth birthday, had

been unable to join her rarefied league. Perhaps he was at least beginning to sense—with Ball's newly dedicated Lincoln statue and Ream's widely reported triumph in the news—that the American president, whose murder he had once ignored, remained "the" seminal artistic subject of his age. Certainly the demand for Lincoln portraiture seemed boundless—and highly remunerative. For French, another year would pass before, at age twenty-six, he would at long last receive word from his father that the town of Concord had awarded him a mere thousand-dollar honorarium for the *Minute Man*.[51]

Thomas Ball believed emphatically that his protégé should not feel discouraged. As he assured Judge French, "I recognize in his simple ingenious artist nature...a talent...indispensable to a true Artist."[52] In technique and enthusiasm, however, French seemed to be flagging. Worse, the combination of hard work, late nights, and the extreme Florentine climate—"always too hot or too cold, or something"[53]—eventually exacted a physical toll, and he fell sick. Taking to his bed, he found himself longing for home. "I admit there is more to be seen in the way of art here, and that the marble work is better," he confided to his sister Sallie, "but I have seen enough to convince me that these by no means make up for the loss that one must experience in being away from his native land....Don't fear my ever wishing to make Florence my permanent residence."[54]

Far from home, French's winter illness lingered into the spring of 1875, increasingly sapping his strength. (French would likely have been unable to return home for the *Minute Man* dedication even had he wanted to.) The women in the neighborhood began taking turns nursing him, much to the young bachelor's mortification. Worse, none of their ministrations seemed to help. He continued to lose energy and found it difficult to concentrate on his work, such as it was. He tried exercise, resuming his walks through the city, but they tended to exhaust rather than revive him. It took Preston Powers finally to come up with the perfect remedy: a restorative April cruise along the Italian coast. On a two-week-long vacation with Powers, French finally rebounded and began to gain strength. Feeling rejuvenated, he devoted hours to haunting the region's sculpture-rich palaces, museums, and churches.

In Rome, he fell under the particular spell of the ancient Pantheon. "Neither St. Peter's nor the Colosseum produced the same effect," he gushed in a letter home after visiting the exquisite two-thousand-year-old Roman temple built by the Emperor Hadrian. The flawless structure, now a church,

had inspired architects from Brunelleschi to Thomas Jefferson. French's fondness for it reflected more than his attraction to classical forms. Like many of the Pantheon's earlier enthusiasts, he especially admired the distinctive oculus dramatically cut into the center of its domed rotunda. "There is something about that open hole with the blue sky above it that is unaccountably impressive," he exulted to his sister Sallie, "not to be obtained by any of the ingenious complications of modern architecture."[55]

Living landmarks beckoned as well. Learning that the aging Italian nationalist hero Giuseppe Garibaldi was scheduled to address a rally from his apartment balcony in the Roman suburbs, the travelers hastened to his residence. There they somehow talked their way into a private interview with the legendary general. Heading upstairs, they found an old man seated on a sofa in a plain dining room, dressed in "the proverbial red shirt, blue trousers and purple and gold cap" that had become his trademark, his face still handsome under a crop of "almost white hair." As French may have known, Garibaldi, his martial reputation already well established across the Atlantic, had once been touted as a leader for the Union army. The supposed invitation turned out to be the brainchild of Garibaldi's American admirers, not of government authorities, so he wisely decided to remain home. Now, just fifteen years later, the once imposing military man was so plagued with rheumatism that he walked with crutches, one hand "bent doubled."[56]

For French, one thrilling excursion followed another, including a side trip to Naples highlighted by a climb up Mount Vesuvius and a tour of the entombed ruins of Pompeii below. More than ever, French now felt like a genuine member of the Powers and Ball families. Indicating that the Ball tribe in particular had for now replaced his own as a much-needed safe haven, he kept Thomas Ball posted about his movements whenever he ventured away from Florence without him, ending one typical letter, "with much love," and urging Ball to "give my love to Mrs. Ball and Lizzie."[57] Although Judge French had stood in for him three thousand miles away at the *Minute Man* ceremonies, Dan, age twenty-five, still needed a father figure close at hand.

By the same token, he kept his real family continuously updated with richly descriptive accounts of his adventures on tour. Now, at his father's ingenious suggestion, he agreed that some of these letters home could be submitted to the newspapers as travel pieces, "as if from a foreign correspondent." One such anonymous "private letter," ably describing the excavated

houses and cobblestoned streets of Pompeii, soon appeared in the *Chicago Tribune*. Dan's brother, Will French, then serving as an art columnist for the paper, no doubt arranged publication. Additional freelance pieces soon appeared on Florence and the Villa Ball. Offering his typical brand of succor, sincere but overdone, Judge French flattered him, "tho' I have nothing ag[ains]t Will, I think your style is fully equal to his....You are a poet."[58] Exaggeration or not, the contributions signaled a major change in French's ability to communicate his acute observations of the ancient Roman world, gradually deepening as his experiences widened and his exposure to great art and iconic artists expanded. Just a few years earlier, he had found it almost impossible to reflect on his sensory experiences in words. Now he was a published, if uncredited, travel writer. French proudly kept the first *Tribune* clipping for the rest of his days.[59]

By the time he and his companions ended their vacation and returned to Florence, the April chill had finally given way to a warm, sunny May. Feeling "restored in body and mind," French resumed work at the Ball studio "as if I belonged there," now rewarded with a workroom of his own so he could enjoy a modicum of privacy while working with live models.[60] As it happened, he returned to health—and Florence—just in time to rejoice in the news of his unqualified success at home. "The Minute Man," reported his proud father, "is triumphant. Everybody admires [it] and nobody finds any fault....[former Speaker James G.] Blaine says that it will alone give you a high reputation, and he said it seemed as if the whole centennial was got up to glorify you! Your success is my great happiness. We are all proud of you."[61]

With almost clichéd New England restraint, Judge French could not help admonishing his son to "remember how fickle public sentiment is, and how a man is one day a prophet and the next is crucified by acclamation." But by June, caution and superstition thrown to the winds, the judge's letters began pouring forth thrilling updates about the growing popularity of the *Minute Man*. The minister who had offered the prayer at its dedication judged the statue "without doubt one of the very best works in the country if not *the* best." Louisa May Alcott, seemingly recovered from the humiliating slight she had endured at the ceremony, not only "praised" the *Minute Man* but inquired into French's price for sculpting a bust of herself. Suggesting that the statue could only look better with a copse of trees planted behind it (eventually a number of trees were instead cut down to afford a clearer vantage point), Judge French reported: "Crowds of people go there to see it, especially Sundays. It is a grand work, Dan, and you are getting a great

reputation for it and it will turn to gold by and by."[62] The artist might have felt himself flattered even when he learned that a group of hometown vandals had been sentenced to jail time and stiff fines for pelting the statue with stones. "The sin ag[ains]t the Holy Ghost," crowed his father, "is nothing at Concord compared with stoning the Minuteman."[63]

◆ ◆ ◆

Invigorated, Dan French resumed work on the sculpture he still believed would justify his entire Italian idyll: *The Awakening of Endymion,* the long-slumbering Aeolian shepherd of Greek myth. It did not seem to matter that other, better-known expatriate American sculptors had tackled the subject before him. In fact, during his recent visit to Rome, he had glimpsed and dismissed Harriet Hosmer's similar *Sleeping Faun,* declaring that it "would seem better if one did not immediately compare it with the old Greek one." Then he had toured William Henry Rinehart's nearby studio, where Rinehart's model for his own *Endymion* was still on view, the finished marble already en route to the Corcoran Gallery in Washington.

French remained undaunted. During his final months in Florence, he added the finishing touches to his own version, for which he still held high hopes. He had labored on the sculpture for more than a year. Once, after sending a photograph of a conceptual clay sketch home to his father, he had been gratified to learn that his family and friends thought it "the loveliest thing that ever was." Acting in his son's behalf, as usual, the judge had summoned Boston ceramic manufacturers and gallery owners Doll & Richards to examine it, and they responded by exclaiming, "That fellow has genius." But then the visitors added what must have been received in Florence as a devastating critique: "Can a sleeping man's arm stay up from his body as the left one is? Would it not fall down?" Responding that the faulty arm "troubles me as it troubles you," young French set to work trying to "subdue" it.[64]

By Christmas 1875, father began trying to lure son home. While conceding that Boston would surely seem "a dull & cold place" compared to "the art culture" in Italy, Judge French tried to inject an optimistic note with a clumsy promise that if his son "sh[oul]d win the golden haired, we should have to all have season tickets between Concord and Florence."[65] In fact, while Dan French admitted to Will Brewster a few weeks later that the "blondes are much as ever," he reported, "I am in no condition to make love and find it hard even to talk with a girl. Think of that!!"[66] His romantic attachments, loose as they already were, now seemed irreparably frayed.

Despite his father's hopes, not to mention his own, the "golden haired" Lizzie Ball seemed an increasingly unlikely part of his future.

Months more passed before, in February 1876, French at last alerted his family that he planned to be home before summer. By March he was "disturbing Endymion's repose" to make final adjustments on its stubbornly off-kilter left arm and, for good measure, giving the "pose of the head...a little poke" to make it right, too.[67] Not until late June did he satisfy himself that the sculpture could not be improved upon further. Electing to leave the plaster model behind to be cut in marble by Ball's studio experts, French vowed to have photos of the piece made "and come home as a kind of 'drummer' with samples."[68]

Although he worried that it would be "hard to break the golden chains that bound me to Florence"—yet another not-so-veiled reference to the blond Lizzie—he now learned that the trauma of separation would be softened, or at least postponed: the Ball family was heading to Boston, too.[69] The notion of enjoying their company on the 3,300-mile trip across the Atlantic convinced French to join them on their passage. While he acknowledged that the ten-day journey with "one of the loveliest girls I know" might be "dangerous," he audaciously bet Will Brewster a dinner "that I don't do anything desperate."[70] After bidding goodbye to the sprawling Powers family, French departed Florence on July 10, 1876—just six days after millions of his countrymen had celebrated another signal event he had failed to attend: the centennial of American independence.

French probably regretted leaving his friends behind in Italy more than he reproached himself for missing the patriotic, and distant, festivities in America. Then there was Lizzie Ball, from whom he would part without a formal goodbye once the travelers reached Boston, much to his eventual sorrow. Only later did he try explaining to Lizzie's mother, Ellen Ball, "you may rest assured that my reason was not because I didn't want to." Perhaps they quarreled on the voyage, or with less drama, simply failed to come to an agreement about their future. Young French may have come close to proposing to—or at least propositioning—Lizzie. Alluding to the voyage, he confessed to Mrs. Ball with remarkable, sexually charged candor: "Do you remember when she lay on the sofa in the stateroom of the steamer, asleep with her face in her folded hands? I have great faith in my withstanding almost any temptation after that."[71]

Putting personal contrition aside, French headed home determined to attract a high-paying customer for *Endymion*. He was destined to be

Interior of French's studio in Concord, MA, 1880–86, with *The Awakening of Endymion*,
marble, 1875–79 (Chesterwood, Stockbridge, MA)

disappointed. Although a succession of patrons would express interest in the statue over the next few years, no offer surfaced. Just before terminating his long Italian odyssey, he had designated Preston Powers as his agent for the marble adaptation, a sentimental decision that proved not only unwise but costly. Once French left Florence, Preston ordered the plaster model carved in marble. The sculptor had estimated that the carving would cost "six or seven hundred dollars."[72] Two years later, faced with mounting medical bills and "delays" in his own sculptural projects, Powers asked French to dispatch $1,200, to cover costs "for the marble and work," offering small solace as he assured his friend that Thomas Ball himself had been "consulted" about the unexpectedly huge bill.[73]

Eventually shipped back to Concord at still further expense, the finished *Endymion* earned decent enough reviews when placed briefly on exhibit at Boston's St. Botolph Club, but still ended up a white elephant. "I am glad somebody liked my Endymion," French grumbled in late 1878 after learning that one visitor to Ball's Florence studio had expressed his approval. "I wish somebody would like it about three thousand dollars worth."[74] But no one did. While calling it "a better than average product of American skill and enthusiasm in combination with Florentine methods," sculptor Lorado Taft

spoke for many contemporaries in dismissing *Endymion* as "a woeful fall-
ing off in inspiration from the virile, original power of the 'Minute-Man.'"[75]
Some time afterward, philanthropist and collector William Corcoran did
express admiration for the work, but since his Washington museum already
owned Rinehart's version, he declined to purchase French's. Years later, per-
haps eager to forget the entire experience, a disappointed Daniel Chester
French would leave the statue behind when he moved out of his Concord
home. A century later still, a subsequent owner would relegate the weath-
er-beaten marble to the backyard. Not until 1983 would it be rescued and
installed at Chesterwood.

◆ ◆ ◆

Having concluded wistfully, following his nearly two years in Florence, that
"the world we live in here is far too small,"[76] French had joined the Balls
for the one extended side trip that remained on his itinerary. En route to
Liverpool for the return crossing to Boston, he paid a second visit to Paris,
this time making sure to inspect the École des Beaux-Arts, where the already
famous Augusta Saint-Gaudens had studied a few years earlier. After a
thirty-five-hour train trip, French and the Balls divided their time in Paris
"between shopping and art—Mr. Ball and I doing more of the latter, and
Mrs. and Miss Ball the former."[77] More impressed by Paris than ever, the
sculptor may have wondered anew whether he had chosen the right city
in which to pursue his own training. Although he returned to Paris years
later, French never stopped regretting his decision to shun it for his early
European education.

Still, he no doubt thoroughly enjoyed his requisite apprenticeship in
Florence, and would return to the Continent on several future visits as a
tourist, spending much additional time throughout Italy. On his initial
eye-opening foray, he had seen countless great works of art. He had labored
and learned in a Florentine villa under the revered Thomas Ball. He had
lived on his own and socialized with attractive women. The only thing that
rankled was that the masterpiece he hoped to create there, his *Endymion*,
proved a failure.

"It lacked the vitality, the inner fire," French later admitted. If it reflected
the Italian obsession with the classical form, and its adherents' ongoing
devotion to the style of earlier sculptors like Canova, perhaps its failure
meant that he "had been leaning on somebody else and had lost the inde-
pendence of his own point of view." Once, he had felt privileged just to be in
Italy. Now he began thinking that the trip might have "sidetracked" him.[78] It

was time to pick up the pieces, settle on his true individual artistic style, and resume his career in the United States.

What he had sighed to Thomas Ball during their days together in Florence now seemed more apt than ever: "Ah, me! for the times that are past, and, hurrah! for the days to come."[79]

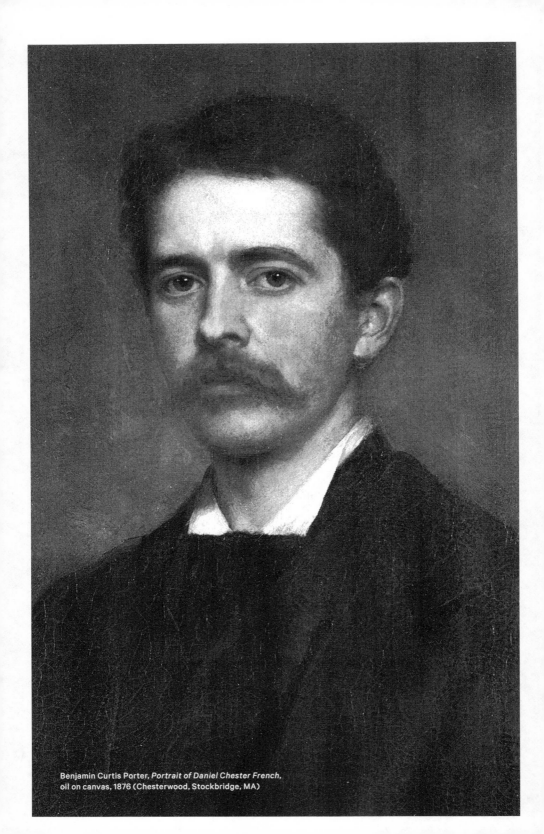

Benjamin Curtis Porter, *Portrait of Daniel Chester French*,
oil on canvas, 1876 (Chesterwood, Stockbridge, MA)

THE RAGE
OF CONCORD

As the SS *Parthia*, the iron-hulled Cunard ocean liner transporting twenty-six-year-old Daniel Chester French home from Europe, approached Boston harbor on a steamy August afternoon in 1876, its hundreds of passengers crowded the decks to catch the first glimpse of the golden-domed State House as it materialized on the horizon. Attention to this traditional activity was diverted, however, when a "jaunty little revenue cutter" sidled up to the steamer before it could dock, ostensibly to collect the mail.[1] To his astonishment, French soon heard himself being paged by a uniformed officer, who explained that his father was waiting for him aboard the smaller vessel to take him ashore. Mortified but elated, he rushed below to greet him.

Inquiring about this extraordinary surprise as the cutter made for port, he learned that Judge French had just been named assistant secretary of the treasury by the outgoing Grant administration, entitling him to the use of the government-owned boat. The judge had commandeered it specifically to welcome his son home and spirit him to town ahead of the *Parthia*. More consequently, as Dan must have immediately realized, this meant that the French family would now be relocating to Washington. If the long-absent traveler had returned to America in the hope of reestablishing himself in Concord, he was to be disappointed. The most he could hope as he absorbed this dizzying news was that his father's posting might prove brief. Still, the sculptor realized that he would be compelled to choose now between his allegiances to Concord and to his family, at least temporarily. His ultimate decision—to follow his father to Washington—would in fact keep him away

from New England for two long, minimally productive years. Eager as he was to take advantage of his strong local reputation by picking up where he had left off in Concord, he could bear no further separation from his beloved family.

As Dan soon learned, the country was at the time embroiled in one of the most contentious presidential election campaigns in its history. The tight race pitted Ohio's Republican governor, Rutherford B. Hayes, against New York governor Samuel J. Tilden, the first Democrat since the Civil War given a real chance of capturing the White House. Corruption had tainted the final years of Ulysses S. Grant's second term, and a systematic erosion of newly won black voting rights in the South had reestablished a Democratic stronghold in the former Confederacy. No matter who prevailed in November 1876, Grant's term would expire on March 4 of the following year, meaning that his father's federal appointment was guaranteed for no more than four months. Chances were that even if the Republicans held the White House, the new president would opt to cleanse the bureaucracy of holdovers from his predecessor's scandal-tarred administration.

Before he made a final decision about his immediate future, Dan yearned to bear witness at long last to his triumphant recent past. His strongest desire was to visit the bronze statue that had been erected in his absence on the Concord battlefield. He had never set eyes on the finished *Minute Man*, and his old neighbors intended to remedy the situation promptly, and in lavish style. On the very night of his return, he reigned as guest of honor at an elaborate welcome-home celebration at the "Old Manse," a historic home built a century earlier by Ralph Waldo Emerson's grandfather. One of its walls still boasted the remnants of a bullet fired inside by the British during the 1775 battle. Now, 101 years later, its rooms and yards overflowed with musicians, refreshments, and special guests, among them Emersons, Alcotts, Hoars, and even Dan French's old bird-watching Cambridge chum, Will Brewster. As the carefully planned highlight of the reception, attendees formed a procession and led Daniel Chester French to Monument Avenue and over the Old North Bridge to the site of his now two-year-old statue. If family lore is to be believed, the ever undemonstrative creator beheld his creation for the very first time "in a detached sort of manner."[2]

Only the relentless summer temperatures marred the brilliant homecoming. Dan had arrived back in town into the teeth of a scorching heat wave, but was so delighted by the reunion with his family, by the chance to view not only his statue but the new barn his father had built at the Concord farm in his absence, that he seemed unfazed by this latest blast of the

extreme weather that seemed almost to follow him. It took something else to rouse his indignation: the Boston art scene had changed—and not, the sculptor complained, for the better. A return visit to the Boston Athenaeum left him "greatly disgusted with the board that governs it even though they did let me in free for being an artist." He had good reason. "Those fools," he ranted, "have gone and painted with house paint those beautiful plaster casts that I sketched with so much pleasure at the Athenaeum before I went away." Among them was the *Apollo Belvedere*, his inspiration for the *Minute Man*. "Can you imagine an enlightened set of Bostonians doing such a stupid thing?" he asked. "Yes I am wrathy."[3] His anger may have made his impending relocation to Washington easier to bear.

As it happened, the results of the equally heated November presidential election remained in doubt even after the ballots were counted. Tilden earned a decided edge in the popular vote, winning an outright national majority of more than 260,000, but with the tally in four states still in dispute, the New York governor lacked enough electoral votes to clinch outright victory. Branding the contest rigged, Tilden supporters threatened to march on Washington to forcibly install their candidate in the White House. Further unsettling news came from the country's heartland, this time regarding one of America's greatest heroes—and French's greatest future subject.

On Election Day, a band of grave robbers took advantage of the intense spotlight on Hayes and Tilden to attempt stealing from its freshly built tomb in Springfield, Illinois, the venerated remains of Abraham Lincoln. Entering the structure in the shadow of Larkin Goldsmith Mead's new bronze statue of the late president, the inept gang managed to move the heavy coffin only a few inches before a loud gunshot from approaching law officers frightened them off. Lincoln's vandalized sarcophagus was reentombed, but not before appalled Americans digested yet another jolting reminder, eleven years after his assassination, that the martyred Lincoln still held precious symbolic value to society, even among ransom-seeking ghouls.[4]

Meanwhile, Dan and his parents took up residence in politically fractured Washington and, along with the rest of the country, awaited resolution of the presidential contest. Judge French began his Treasury Department duties burdened by the uncertainties of lame duck status that was further muddled by the disputed election. "Of course, the position is not a very certain one," Dan advised his brother, Will, about their father's new status, "especially if the democrats come into power." As far as his own career was concerned, "I shall be all right till next spring," he believed, "& then if I am not wanted longer, I shall be no worse off for my winters [*sic*] work."[5]

◆ ◆ ◆

In theory, the city of Washington promised not only access to leading art-
ists but excellent prospects for new commissions—or so Daniel Chester
French initially believed. For the time being, however, the only work on his
plate was the new bust of his father, along with the poorly paid government
order for the *War and Peace* group for the St. Louis Post Office and Custom
House. Although the meager terms for the St. Louis commission made him
feel like a mere "modeler at eight dollars a day," he at least found consola-
tion in the fact that his "expenses are paid by the government."[6]

With rent and housekeeping provided free of charge, young French
moved by February 1877 into a three-room, third-floor studio on G Street,
between Thirteenth and Fourteenth—just a few blocks from the Treasury
Department and its neighbor, the White House. He carted in some sec-
ondhand furniture, made a few attempts at decor, and set up his sculpting
stand opposite a window that provided bright southern exposure all after-
noon long. It was no Florentine villa, but his spacious work space alone was
twenty by eighteen feet, easily accommodating a blackboard for sketches
(in the William Rimmer tradition), along with easels, tables, screens, a mir-
ror, and his "modeling arrangements." The sixteen-by-eleven reception
room soon featured Dan's reliefs of *Elsie Venner* and *Daybreak*, which he
imported from Boston to serve as showpieces to attract clients. Treasury
Department workers helped him with all the "rough work," including the
hauling and unpacking of clay. "I am monarch of all I survey," he reported
of his new space, "for about one month longer and then—well who knows
what may happen in a month?"[7]

"My life here is tranquility itself," he soon remarked of his daily routine.
"I go to my studio in the morning...getting there about 9 (walking), work till
12:45 when I come home to lunch, by horse-car, and get back at 2 and work
till past 4. Then I walk slowly home by way of Penn. Ave. look at the pretty
girls, who parade at about that time, and do what errands I have, and have
dinner at 5½."[8] With the presidential race still unresolved, the city and most
of its less complacent inhabitants remained on edge.

Not until February 1877, just a few weeks before Inauguration Day,
was the official outcome of the Hayes-Tilden race certified. In an eerie pre-
cursor of disputed elections to come, the entire canvass came down to a con-
tested vote tally in Florida. The victor was ultimately chosen along strict
party lines by an electoral commission anchored by five justices of the US
Supreme Court. To procure Democratic acceptance of the stacked decision,

War or *Vigilance*, United States Custom House and Post Office,
St. Louis, MO, 1877

Republicans agreed to abandon Reconstruction of the former Confederate states—an enormously steep price to pay, since the deal ended for generations the painfully slow advance of civil rights for African American citizens. By this time, Judge French probably expected that either result would end his brief career with the federal government, but as it turned out, he survived what amounted to a bloodless coup untouched. While Treasury Secretary Morrill resigned a few days after the Hayes inaugural, his successor, John Sherman, US senator from Ohio and brother of the Civil War hero William T. Sherman, decided to keep French on his executive staff. The judge survived the transition, and as a result, his son's exile from Concord continued. Whether the family attended the Hayes inaugural we do not know.

Trying to stay focused on work amid the political turmoil, young French labored away on the St. Louis project, though he struggled with the modeling. In April 1877, seeking advice, he sent a photograph of the clay maquette to Thomas Ball. It showed two reclining figures surrounding an eagle. "I like the general design and effect very much," Ball encouragingly replied from Florence, tempering his praise by echoing Dan's own concern that the figure of *War* seemed "too peaceful. Why not call it 'Vigilance,'" Ball suggested, as "it expresses that virtue capitally and I think it a more appropriate pendant for 'Peace' than even 'War.'"[9] Dan French obligingly renamed his sculptural group per Ball's recommendation, but continued to encounter

Peace, United States Custom House and Post Office,
St. Louis, MO, 1877

difficulty working out his design for *Peace*. Still he managed to convert both figures into half-size plaster models within the year, completing the work by April 1878.

The sculpture of *Peace* "pleases me," French finally allowed in a letter to Ellen Ball that month, "whether she does any one else or not."[10] It would take another six years for both works to be enlarged, carved in marble, and placed atop the St. Louis Custom House, which finally opened its doors in 1884. French declared himself "a little sentimental" upon completing the models for his statues, not only feeling "regret at leaving" them, but still disappointed that "the figures are so far from what I wish they were."[11]

Of far deeper concern was the fact that the *Minute Man* sculptor's relocation to Washington had so far failed to generate any of the private clients that he and his father had expected from among the city's political elite. With but one exception, it became apparent that whatever French's connections to his still-influential father, the new Republican vanguard in the capital would not be commissioning the son of a Grant appointee to sculpt their portraits—not after several members of the old general's administration had enmeshed the White House in scandal. Fortunately, the sculptor did receive one order for a relief sculpture when another old Civil War general, the controversial Benjamin F. Butler, commissioned a memorial portrait of his recently deceased wife—perhaps because he, like French, was

New Hampshire–born. That the job came from a commander who had once been dismissed by Grant himself for gross ineptitude on the battlefield was an irony lost to both artist and patron. French was by this time so demoralized that he predicted midway through the project that the likeness of Mrs. Butler would "probably fail."[12]

Few prominent nineteenth-century Americans were as widely loathed as the bald, droopy-eyed former Union general known far and wide as "Beast" Butler. Although he represented Massachusetts in Congress after the war, and was in the midst of yet another political comeback as a candidate for governor, most Southerners still remembered him primarily for his ungallant treatment of distaff residents of New Orleans during the 1862 Union occupation of that city: Butler had declared that any female who taunted federal troops would be "regarded and held liable to be treated as a woman of the town plying her avocation"—in other words, as prostitutes.[13] Butler's detractors often exhumed additional allegations that he had pillaged personal property from residents, a reputation that earned him the additional derisive nickname of "Spoons."

Yet Butler had also admirably provided shelter to enslaved people escaping to Fortress Monroe, Virginia, early in the rebellion, labeling them worthy of protection as "contrabands of war." That ingenious phrase had entered the national vocabulary and provided a new legal status that helped advance black freedom. Butler had also commanded "colored" troops in battle, and later generously honored his veterans with unauthorized, and expensive, bronze medals.[14] Hard as it was to believe from his monstrous appearance and gruff manner, Butler evidently had a sentimental side, too. Married for more than thirty years to Sarah Hildreth Butler, he and his wife had been parents to four children, and the widowed general apparently missed his late wife deeply. To young French's regret, the Sarah Butler commission paid him little and led nowhere.

For a time, he tried to make the best of Washington's social opportunities—meeting new friends, enjoying parties, going to church, and attending the opera (one of its new stars, who "sang like a nightingale," was the daughter of sculptor Clark Mills, who had taken a life mask of Lincoln shortly before the late president's death).[15] On one occasion, the entire French clan took to sea on an excursion to Hampton Roads, Virginia.[16] Their steamer got underway from the Washington Navy Yard, heading down the Potomac River and into the Chesapeake Bay to reach Hampton Roads, the very same route President Lincoln also plied to inspect the Union fleet at the Virginia naval port. Their steamer roamed the very waters on which the

first ironclads, the *Monitor* and *Merrimac*, had fought their fabled Civil War naval duel back in 1862.

◆ ◆ ◆

Returning to Washington, French dutifully studied the city's magnificent new outdoor Civil War monuments, including Louis Rebisso's recently unveiled equestrian statue of General James B. McPherson. He pronounced it "particularly fine." Henry Kirke Brown's two-year-old statue of General Winfield Scott he regarded with less enthusiasm. In French's opinion, the Brown sculpture made "Old Fuss and Feathers" look too big for his "beautifully modeled" steed, so much so, he joked, "that you can't help pitying the horse."[17] Actually, the six-foot-four, three-hundred-pound Scott had looked too big for nearly all the overburdened horses he ever sat, and Brown deserved credit for refusing to sacrifice accuracy for flattery, even in a city filled with romanticized statuary and vain sitters. In fact, the aged and infirm Scott rarely, if ever, mounted his horse as commander of the Union army in the early days of the Civil War.

Around Christmas 1877, Dan French attended the dedication of Brown's latest statue, an equestrian of Revolutionary War general Nathanael Greene. "It does not please me entirely," he admitted, this time criticizing both horse ("not graceful") and rider ("not satisfactory"). Notwithstanding his reproaches, perhaps tinged with envy, French was witnessing a golden age of public sculpture in the national capital, even if he was still an observer, not a participant. "Works of art are increasing in the city," he acknowledged on New Year's Day 1878, hastening to add in a paean to his home region: "Boston continues to lead the world, it seems to me, & aint [*sic*] we proud?"[18]

His residence in Washington brought French into proximity with sculptors, as well as sculptures. After hearing the eminent William Wetmore Story deliver an art lecture a few weeks earlier, French gathered the nerve to introduce himself to Story "as 'a very small sculptor.'" The sixty-eight-year-old Story—whose rejected design for the Washington Monument many citizens still preferred to the half-finished obelisk chosen in its stead (and whose construction had only recently resumed after a long and unsightly hiatus)—proved "very civil & quite exerted himself to be agreeable." The old sculptor vowed to visit the younger man's studio "if he had time (!)" but never appeared, "as expected."[19]

French had more success befriending Larkin Mead, sculptor of the Lincoln statue at the martyr's recently violated Springfield tomb. Also New Hampshire–born, but fifteen years French's senior, Mead did pay a call,

"and likes my War," the sculptor proudly reported to Ellen Ball, thinking it "better than the Peace," a judgment he did not dispute.[20] Sculptor Franklin Simmons, who had recently produced a statue of Maine's first governor, William King, for display in the Capitol, joined the procession of callers to the French studio. His professional circle widening, French may have attended the 1878 wedding of Lincoln sculptress Vinnie Ream to military man Richard Hoxie; at the very least, he met the handsome couple.

It seemed more fortunate than ever that, before his departure from office, former treasury secretary Morrill—his father's boss, fellow New Englander, and friend—had arranged not only the modest order for the statuary group for St. Louis, but also authorized commissions for similar decorative groups to adorn government buildings planned for Philadelphia and Boston. (The US Treasury Department, then as today, oversees the construction and management of most owned and leased federal government space.) By this time, however, French had lost whatever enthusiasm he held for Washington, and not only because he had failed to attract lucrative work there. The city, blessedly temperate in the colder months, seemed to wilt under unbearable heat and humidity by summer.

Nor did its racial diversity hold much appeal, for Dan French had grown up in antislavery communities where few people of color actually lived. His young cousin Mamie French remembered post–Civil War Washington as a city of grateful formerly enslaved people eager to resume their service for onetime owners.[21] In a ghastly description committed to paper years later by her daughter—but which could only have reflected her parents' frank opinions of the city and its residents in the 1870s—she echoed the sentiment by describing the capital in her father's day as "a sleepy southern city…of slow-moving people, darkies, and heat." In a particularly insensitive passage, she commented with painful specificity on the African American population: "The darkies, who were not so much in evidence in the winter, poured out of their houses and shacks and the alleys in the summertime and seemed ever underfoot, sitting on the low walls, lying on the pavements asleep in the sun, and spinning their heels in the sticky asphalt of the newly paved streets."[22]

Except for the theater, French took little solace from his social life in town, which stagnated as dispiritingly as his professional career. Still blissfully unaware that his attractive young cousin Mamie, a teenager then studying in a nearby convent, was growing up quickly, and quite nearby, he met other attractive single girls in Washington, but made no commitments, shying away from one prospect because she was too wealthy, and another for the apparent sin of being a brunette.

Daniel Chester French, *Mary Adams French*, charcoal and white chalk
on paper, 1875 (Chapin Library, Williams College)

It had been months since he had learned with mixed emotions that
Lizzie Ball had announced her engagement back in Florence—worst of all, to
another, younger American sculptor in her father's circle, William Couper.[23]
Ironically, French had introduced the pair back in Italy; yet on departing, he
had described the Virginia-born Couper as "rather a dangerous person to leave
behind." Perhaps now part of him regretted his foray into matchmaking.[24] He
and Lizzie had not seen each other for nearly a year, and by the time of their
parting had come to regard each other more as siblings than potential lovers.
Yet her betrothal unnerved him. "To think that our sweet little sister should
have gone and fallen in love with a great horrid *man*," he teased her in a con-
gratulatory letter he must have found so difficult to compose that he deployed
humor to mask his conflicted feelings: "Won't I give it to him, though, when I
catch him—and tell him all kinds of disagreeable things about you?"

French seemed consoled only when he learned that Couper now felt jealous of *him*. "And you think it is very *ridiculous* that he should think you could be in love with me!" the onetime suitor all but taunted Lizzie. "Well, on my word; if that isn't the severest cut of all." Turning serious, he congratulated Lizzie, bade her a melodramatic goodbye, and promised to "rejoice when you rejoice, & weep when you weep," closing with a plaintive: "How I wish I could see you!"[25] Lizzie believed "I was in love with her," he lamented, admitting, "and so I was, and am." At least, as French wistfully told Lizzie Ball's mother, her engagement gave him "a freedom of action that I could not assume before."[26]

Yet "freedom" failed to inspire much action, and certainly did not bring him happiness. "The number of girls I know astonishes even me," he admitted in March 1878, on the eve of his twenty-eighth birthday, adding with almost mournful sadness, "and yet—there is not one who can rouse my hardened heart from the sleep to which it has been hushed by the beauty & the smiles that have so long, and in so many different forms, made life endurable." Oblique his lament may have seemed, but its object was unmistakable: Lizzie Ball. "Let us hope," he added dramatically, "that sleep is not death. I know it is *not*, for...I am capable of an overwhelmingly [*sic*] love for somebody, if only 'my Queen' would appear."

Whether he realized it or not, such an appearance was already in view, sitting right before his tear-filled eyes. At this very time, he was finishing a crayon portrait of young Mamie.[27] Try as he might, it was "by no means as pretty as she is," he soon reported to the correspondent to whom he most often confessed, Ellen Ball. Nineteen years old now, his subject suddenly seemed to French "about the prettiest creature I ever saw." As he confessed, "I can't make anything one quarter so lovely, but it is a good study, & she sits well. I should like to keep her in my studio as an inspiration all the time."[28] Instead of recognizing a potential gain, however, he began lamenting the painful loss of his own crowning glory: "My hair is getting beautifully less," he confided to Lizzie Ball's mother, Ellen, near Christmas 1877. "You may be expected to see me with my forehead extending to the nape of the neck next fall. Shan't I be a beauty?" More bitterly, he later told Ellen Ball: "Another year, I should think would make me shine. It is all probably on Lizzie's account."[29]

◆ ◆ ◆

In July 1878, determined to escape the crippling heat during the family's second Washington summer, French headed north to Concord for a vacation.

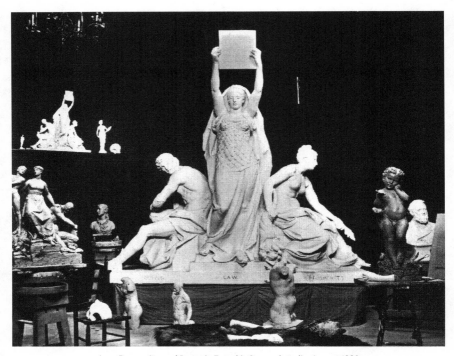

Law, Prosperity, and Power in French's Concord studio, August 1880

There he spent leisurely time "in the old house" with his sister Sallie Bartlett and her new husband, Ned.[30] Their stepmother had decided against spending that summer in Massachusetts, and Ned and Sallie had fortuitously taken over the family home for the season. Now, on impulse, French elected to take up residence with them. After this latest lurch toward independence, he decided by fall that he would remain behind in the village he loved, rather than return to the capital. When his next government commission came through—for the statues to decorate the Philadelphia Custom House—he rented a studio in nearby Boston, in the very same professional building he had occupied a few years earlier to finish the *Minute Man*. Whatever its imperfections, he would again be working close to home, and in a space that promised to bring him in daily contact with fellow artists.

Although it paid as meagerly as the St. Louis commission, the Philadelphia project would be far more daunting. The new statuary group, *Law, Prosperity, and Power*, was slated to occupy a pedestal 120 feet above "a street sixty ft. wide from wall to wall. You can imagine," he groused, "how much it will show." He had studied similar statuary at buildings in New York City, Hartford, and Washington, and judged them all harshly.

Even those crafted by leading sculptors, he observed, were so subtly carved that they failed to show to proper advantage when viewed from the ground below. Bearing this challenge in mind, French determined to carve his details more deeply, so folds of drapery would be clearly visible from the street. Still, the work was not inspiring him. "I don't think I like flying goddesses," he admitted, "as well as the more earthly ones."[31]

French commenced his latest government project with the now-customary Rimmer-inspired blackboard sketches. "This promises better than anything I have done yet," he confidently predicted by late August.[32] Within months, however, he grew disenchanted, having learned that the new group would face not a grand plaza, after all, but rather a "narrow street so my work will not show to advantage"[33] no matter how deeply he carved it. Nonetheless the sculptor labored for the better part of twenty-four months to fulfill the commission, completing the three separate plaster models, two seated and one standing, by April 1880, his thirtieth birthday. Not for four more years, and still disappointed at how the project had evolved, would French learn that his statues had been enlarged and carved not in marble, but in granite, and at last hoisted onto their ledge atop the custom house. There they would stand until 1938, when, after the building was marked for demolition, art-lovers rescued his works and transported them to nearby Fairmount Park.

It was during the course of creating the *Law, Prosperity, and Power* models that French at last concluded in 1879 that Concord should become his permanent headquarters. He budgeted the considerable sum of five hundred dollars to build a studio of his own there, just a few yards down Sudbury Road from the family manse.[34] Undertaking some of the carpentry himself—his years on a working farm had trained him well—French oversaw construction of a two-story shingled building, outfitting it with furnishings and bric-a-brac he bought in Boston. A reception room soon housed the full-size *Minute Man* model, recently returned to Concord after its display in Philadelphia, along with the marble *Endymion*, which arrived in Concord from Italy "without a scratch to mar it." He had declared himself "more than satisfied with Mr. Ball's and Preston [Powers]'s careful supervision of the cutting."[35] He painted the new studio walls in rich colors, covered the wooden floors with carpets, installed a carved fireplace frieze, hung curtains, and contemplated an official opening party worthy of this milestone.

The sculptor's actual work area, two stories high and suffused with light, gravitated around an enormous turntable, now supporting its first project, the models for *Law, Prosperity, and Power*, for Philadelphia. French was

proud of the new arrangement. "My working room is tinted with Pompeiian red with woodwork of olive green," he described the space. "There is a handsome southern pine floor & there are shelves about for casts, a closet [toilet] in the corner for water from Sandy Pond, my turntable with the beginning of Force [his Philadelphia figure] on one end, the cast of the 'Minute Man' in full size in one corner," and busts of his father and brother in another. "The reception room connects with the working room by a large doorway with yellow curtains (called 'oldgold'); the walls are greenish gray; there are heavy draperies at the windows, lots of old furniture, a Franklyn [sic] stove," even a window seat "fitted up...luxuriously with different colored cushions." Dan hosted an opening fête champêtre at the family home, replicating the 1876 procession to the *Minute Man* by inviting his seventy-five guests to stroll along a walkway strung with Chinese lanterns, leading to the new studio where the sculptor and his sister Sallie French Bartlett officially received them.[36]

◆ ◆ ◆

The return to his idyllic family home invigorated the sculptor. Still a "beautiful village," in the words of his future wife, the "low-lying town" of Concord, "with its sloping fields and winding river," was "full of peace and loveliness. Back of the houses upon Main Street were lawns and gardens, down to the very edge of the stream, and when we wanted to go anywhere, we took a boat and paddled along from one home to the other." Though it abounded with famous men and women, Concord remained solid and unpretentious as well, a home to churches and lyceums, "theatricals, picnics, and shows." As Will had put it, it was "a place where you felt that the people themselves were finer than the clothes they wore and the houses they lived in."[37]

Here the artist at long last hit upon the perfect new subject. As with the *Minute Man*, the idea again came from within his extraordinary hometown, exactly as he hoped that inspiration would strike once he returned there. In late spring 1879, even before setting up shop at his new Concord studio, as he was arranging to move his completed Philadelphia Courthouse models from their temporary display at the Corcoran Gallery in Washington to the annual show at the National Academy of Design in New York, he decided to sculpt no less than the most famous citizen in Concord: Ralph Waldo Emerson. French could remember the philosopher when he was still in his prime ten years earlier, the "tall figure, walking the village streets enveloped in a long black cloak or shawl, and looking as I imagined Dante must have looked as he walked the streets of Florence." Uncertain as he remained

Exterior of Concord studio, ca. 1885

about his ability to describe his feelings in words, he left a vivid description of these early encounters: "Young as I was, I was impressed, as everyone was, with his dignified, serene presence. We have all had the common experience of disappointment in meeting some celebrity whose works we have long known and esteemed, because the man himself did not realize our ideal of him, but Emerson seemed as great as he really was."[38]

Executing a good likeness, however, would be no simple task. Emerson's unique features had confounded portrait artists for decades. When French convinced Emerson to sit for him, the eminent philosopher was seventy-six years old and familiar to hundreds of thousands of admirers through his lecture tours and ubiquitous photographs. "His hair was long, white, thin, and combed closely to his head, as in early colonial days," observed one journalist.[39] Another contemporary declared that "Emerson in aspect reminds one of a plain country parson of advancing years."[40] And yet another concluded, "He is not what the ladies would call a handsome man, but at the same time he would anywhere attract attention as a superior person, by the character manifested in his face."[41]

Concord studio reception room, 1886

Emerson's tight-lipped half-smile and small, kindly but piercing eyes were difficult enough to capture, but above all, acknowledged the *Chicago Times* during one of Emerson's appearances in the West, there was his impossibly long hooked nose. "More than half the people who go to see Mr. Emerson, go to see that nose," the paper declared. "When Mr. Emerson's Greek paragraphs are rolled off in that peculiar mumble which renders their incomprehensibility more incomprehensible than ever, it is no wonder that the audience falls back on the nose as something tangible, something which comes within the province of the senses, something that compensates for the investment at the door."[42] Any portraitist was obligated to capture that trademark feature perfectly, along with Emerson's other unique features.

An 1821 graduate of Harvard, Emerson had notched a long surpassingly influential career as a public intellectual, minister, essayist, philosopher, champion of American literary achievement, and globe-trotting, highly paid lecturer. Filled with the inspiration of learning, the newly minted college graduate had sailed to England to meet leading poets William Wordsworth and Samuel Taylor Coleridge, then returned to America to

define a bracing new philosophy. With his 1836 essay, *Nature*, he helped launch the Transcendentalist movement, which stressed the responsibilities of the individual in God's world and the sacred value of American ideas and ideals. Growing into an ardent abolitionist, Emerson cast his ballot for Abraham Lincoln in 1860, but once the Civil War broke out, began criticizing the new president's seeming reluctance to emancipate the slaves. His opinion of Lincoln changed in early 1862, when the "Sage of Concord" visited Washington to lecture at the Smithsonian. On February 2, 1862, Senator Charles Sumner—who liked both men—took Emerson to the White House to meet Lincoln. The two had actually encountered each other casually nine years earlier, when Emerson lectured in Illinois, but this time Lincoln sought the philosopher's advice on a roiling controversy: the ongoing case of convicted slave trader Nathaniel Gordon, whose pending execution the president was currently reviewing.[43] A few days later, perhaps with Emerson's counsel in mind, Lincoln allowed Gordon to be hanged.[44]

For his part, French harbored his own fond personal memories of the great Concord writer, who had once invited the twenty-two-year-old to his home on the Cambridge Turnpike to study souvenir photographs of statues he had seen abroad. "Had I been of his age and importance he could not have treated me with more deference or taken more pains for my entertainment and enlightenment." The sculptor recalled a "very tall, spare, loosely hung figure with small head and rather large hands and feet, with clothes worn for use and without thought of them. It was none of these things that made all who approached him aware that they were in the presence of a demigod. Perhaps it was the soul that shone out upon you from his face."[45] Whether or not he could capture that character would determine if Daniel Chester French would be regarded as a one-shot success—even if it had been a sculptural shot heard round the world—or an artist with a true future in the profession.

As early as August 1878, French had confided to his friend Ellen Ball his hope "of modelling a statuette of Mr. Emerson."[46] Yet it took him nearly four months after his return to Concord to summon the nerve to ask for sittings, and surviving evidence suggests that his stepmother, Pamela Prentiss French, played a decisive role in prodding him to pursue the project. When rival sculptor Martin Milmore exhibited his own new Emerson bust in Boston, Mrs. French wrote from Washington to remind her stepson that the elderly Emerson would not live forever, and that Milmore's portrait should not stand as the final portrait. "Those lights often go out so suddenly," she warned, "and don't let Mr. Milmore's honor be the latest memory of him."[47]

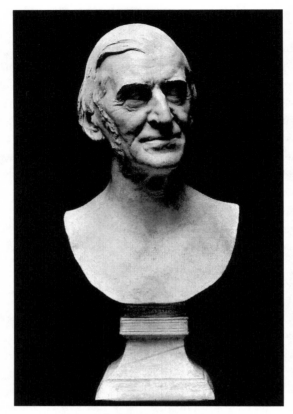

Portrait of Ralph Waldo Emerson, plaster, 1879

French, who graciously referred to the Milmore portrait as "spirited" while privately noting that Emerson's own son failed to "recognize it as his father," agreed. It probably served as further encouragement that Milmore had shunned French's attempts to strike up a friendship. Within weeks of receiving the uplifting message from his stepmother, French procured Emerson's permission to sculpt him.

"I am modelling the philosopher at his own house," he reported in March 1879. "I begin [the bust] with many misgivings knowing how difficult is the task & how often it has been tried before. I have an advantage over others of having known him long & well, & if I fail it will have done no harm to try."[48] Over the next few weeks, he regularly reported to his father on the headway he was making, and periodically shared photographs of his work in progress with mentor J. Q. A. Ward. Evidently Ward liked what he saw, for when French in turn reported Ward's reaction to his

father, Judge French wrote: "An artist's reputation depends ultimately upon artists' opinions and Mr. Ward's praise will help you in every way."[49] So, of course, would an endorsement by the subject himself. Though his stamina and memory were fading, Emerson immediately put the sculptor at ease by commenting on a recent portrait by another artist—probably the bust by Martin Milmore: "It looks as harmless as a parsnip."[50]

"My improvised studio was, for his convenience," French remembered, "a room on the lower floor of his house, and here, almost daily for a month, patiently and uncomplainingly, this good man sat to me, more from the wish to do me a favor than from any great interest in the work itself." Emerson was cooperation personified. When the artist apologized for taking so much of his time for the initial session, the old man replied, "This is as easy as sleeping." In truth, the sittings proved more arduous than the subject admitted. Determined to use the "system of triangulation," which he had learned from Thomas Ball in Florence, French took "countless measurements" of Emerson's face and head, striving to achieve "as close a record of his features as my conscientious endeavors could attain." In the process, he almost magically supplemented the "cold facts" by laboring "to catch somewhat of the glorified expression—that 'lighting up' that people noted in Emerson's face."[51]

The illustrious subject not only endured the repeated sittings patiently, he mesmerized French with endless yarns and recollections. Emerson expounded on the eternal value of poetry and spun anecdotes about his famous contemporaries. He spoke "affectionately," though critically, of his onetime neighbor, the late Henry David Thoreau ("his own worst enemy"), recalled his persistent efforts to carve out a friendship with Nathaniel Hawthorne when he lived at Concord's "Old Manse," and remembered his horror at hearing John Ruskin drone on once about the inherent evil of mankind (Emerson "could not bear it"). "He talked of all the great men of the century," French marveled, yet voiced particular admiration for Daniel Webster "above all other Americans or English of the time." Pausing from these spirited recollections to inspect the bust as it took shape, Emerson adopted "an inimitably droll expression" to tease Dan: "The trouble is that the more it resembles me the worse it looks."[52]

French, too, strove to remain modest even as he began planning how to market his newest effort. He described the finished piece only as a "valuable... record of Emerson's head," adding that it "was the result of not only the closest study, but of countless measurements."[53] Only much later did he share the secret of its success: he had labored specifically to "fix the illuminated expression" for which Emerson was known, "the delicacy of which evinced the

refinement of the soul that evolved it." Apparently, his elusive subject agreed
that French succeeded. As Emerson remarked in his deep voice when he beheld
the almost completed clay model, "That is the face that I shave!"[54]

By summer 1879, after some twenty sittings, French reported the
Emerson bust "nearly done" and informed his family that it is "pronounced
a success by those who have seen it." The finished work was, he confided
to his brother, "far better than any bust I have ever made."[55] French imme-
diately cast the clay in plaster, then presented the first copy to the Emerson
family. When it was given a "ceremonious unveiling" at the philosopher's
home on July 26, 1879, Mrs. Emerson reiterated that "the likeness is per-
fect."[56] The artist enterprisingly secured a copyright and arranged with his
old Boston manufacturers, Doll & Richards, to display the original in its
window and produce plaster reproductions to sell for thirty dollars each.

By August 1879, French finally allowed himself to tell his friends back
in Florence that the piece "seems to meet the approval of the multitudes,"
claiming the Emerson was "more popular than anything I have done since
the *Minute Man*."[57] The critics concurred, one of them praising the Emerson
bust as "a very graphic and characteristic work which entitles the artist to a
high position among our portrait sculptors."[58] Another contemporary remem-
bered soon thereafter seeing a plaster copy at Henry Flagg French's office in
the Treasury Department, recalling, "I was so struck by it as a portrait that I
inquired instantly the sculptor's name....It was the first work of Daniel Chester
French's I ever saw."[59] Emerson's longtime Concord neighbor, Bronson Alcott,
added his own testimonial, declaring: "His 'Head of Emerson' represents the
man as he now is, touched with age yet youthful in his manly features and
expression. It is the form in which we wish to perpetuate our friend."[60] The
Alcott paterfamilias would eventually pose for French, too.

The most meaningful praise came from the influential *New York
Times*. "It has been a notably difficult thing to get a characteristic picture
of Mr. Emerson," the paper reported. "The photographers have given the
outer man, but not the man himself. The same is true of the sculptors. They
have idealized Mr. Emerson until his friends could not distinguish his bust
from that of Socrates or Plato....It has been reserved for one of his own fel-
low-townsmen to catch the Emerson of to-day and imprison him forever in
the plastic clay. Daniel Chester French has made the only bust of him that
is natural or desirable, the only one that has just his look, the only one that
is true to life and yet not the literal but slightly ideal expression of the man.
Everybody looks at the bust in the art store of Doll & Richards, or in the
bookstore of A. Williams & Co., and says, 'That is Emerson.'"[61]

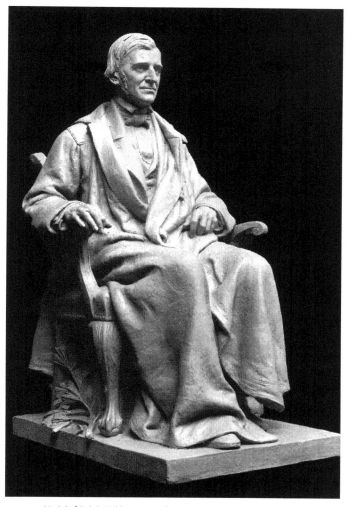

Model of *Ralph Waldo Emerson* for the Concord Free Public Library,
Concord, MA, 1911–14

Famous as the bust portrait eventually became, French encountered con-
siderable difficulty obtaining an order for a marble version. Asking a fee of
six hundred dollars, he may have come to regret encouraging the prolifera-
tion of inexpensive plaster copies too soon. A preliminary plan to ship the
original model to Florence to be carved at the Ball studio he aborted, prob-
ably when the potential patron backed out. To encourage a prestigious and
lucrative commission in marble, the money-starved sculptor had the plas-
ter bust placed back on public display, this time at the Boston Arts Club in
the spring of 1880, and again at the annual 1881 exhibition of the Society of

American Artists in New York City, where an observer noted, "Mr. French's portrait of Mr. Ralph Waldo Emerson is a very graphic and characteristic work which entitles the artist to a high position among our portrait sculptors."[62] Yet not until Emerson's death in 1882 did Harvard University order the first six-hundred-dollar marble.[63] A few years later still, French reproduced the piece in bronze and exhibited it at the 1889 Exposition Universelle in Paris.[64] The Boston Public Library's 1892 proposal to commission a full-length Emerson statue left Dan "a little weak in the knees," but nothing came of it.[65] Then, in 1907, during his service as a trustee of the Metropolitan Museum of Art, French ordered a new replica cast in bronze and donated it to that institution.[66] As late as 1912 he was again showing the piece to a new "Emerson Committee" in Boston, eager to generate further sales.[67]

Only in 1914 would French at last get to create a life-size, seated Emerson marble for the Concord Free Public Library. By then, thirty-five years had elapsed since French had enjoyed life sittings with the long-dead Sage of Concord. To produce a posthumous likeness, he turned to "photographs and daguerreotypes as could be collected, together with my study of his head as a foundation." Emerson's daughter lent the sculptor the "heavy, wadded and quilted, dark blue" gown that French had often seen the philosopher wearing in his book-lined study to warm himself on cold winter mornings. Emerson had nicknamed the garment his "Gaberlunzie," the medieval word for "beggar" employed by Sir Walter Scott in such novels as *The Antiquary*. The elaborate folds of fabric visible at the rear of the statue revealed not only French's unwavering commitment to meticulous accuracy, but a new mastery of the human form. The addition of a cluster of pine boughs at the base, testifying to Emerson's love of nature, demonstrated the sculptor's whimsical self-assurance. The appealing statue soon "occupied the most prominent position in the main room" of the library, where it has remained ever since.[68]

The resulting statue proved another triumph. Yet as much praise as the new Ralph Waldo Emerson portrait earned, the sculptor remained self-effacing about his achievement. "No statue or picture, however true it might be to a passing phase," French said of his latest Emerson portrait in 1916, "could be an adequate representation of his face, the expressions of which changed with his thoughts and mirrored them." French had only "endeavored to fix the elusive, illuminated expression" he had used for his bust from life, he said, and "to perpetuate the peculiar sidewise thrust of the head on the neck that was characteristic of him, conveying an impression of mental soul searching."[69]

Like the *Minute Man*, Daniel Chester French's Emerson portrait lived on in different formats for decades to come. In 1923, yet another version joined busts of Lincoln, Grant, Robert E. Lee, Henry Ward Beecher, and Alexander Hamilton by other sculptors at New York University's Hall of Fame for Great Americans.[70] Additional replicas today grace Memorial Hall at Harvard, the Metropolitan Museum in New York, a high school in Williamsport, Pennsylvania—and of course, Chesterwood, which owns both plaster and bronze versions.[71]

Although French liked to joke that a newspaper critic of the day had once dismissed his original bust as no more than "a topographical survey of Emerson's head,"[72] he likely knew that it eventually came to be ranked as one of the greatest portraits not only of his career, but in the entire history of nineteenth-century American sculpture. Realistic, dignified, fluid, and luminously soulful, the portrait stands as one of his great achievements. Succeeding generations of art historians have acknowledged as much, praising the Emerson over the years as both "singularly delicate and appreciative" and notably "physical and spiritual."[73] Seldom again would French—or the public—doubt his ability or determination.

◆ ◆ ◆

With the Emerson triumph behind him, the major question facing the increasingly successful Dan French as he contemplated the new decade of the 1880s was what he might tackle as his next subject. A clue was awaiting him, but as yet remained well-masked. Earlier, when writing to the Ball family from Washington in the midst of his two-year residence there, he had faithfully reported his activities, especially his experiences "dipping into society."[74] Among his oddest updates was the flippant report of one "funny party at the house of the Pres[ident] of a Deaf & Dumb College." It was a "beautiful party," French conceded, "but funny in that wherever one was introduced to anybody else, they were both in doubt whether to speak or sign, there being, as everybody knew, a number of the 'dummys' present. Lots of pretty girls though."[75] The host that fateful evening was Edward Miner Gallaudet, principal of Washington's Columbia Institution for Deaf Children. The school would later be renamed for its founder, Edward Gallaudet's late father, Thomas Gallaudet. And when it came time to honor that pioneering educator with a statue on campus, Gallaudet College turned to the young man who had so callously reported on that 1877 reception: none other than Daniel Chester French.

That he would bring such exquisite sensitivity to the task would mark the sculptor's growth as both an artist and a human being.

Daniel Chester French revisiting the Villa Ball, Florence, Italy, 1887

LABOR
SUSTAINING
ART

For all its distinctive charms and warm memories, Concord—even nearby Boston, with its nurturing circle of professional colleagues— could not hold Daniel Chester French much longer. Once he saw to the reproduction of his acclaimed Emerson bust, he began yearning for a larger field. By early 1883, he firmly decided he must relocate to the epicenter of the American art scene—and the site of some of his sculpture lessons years earlier—New York City.

Although French's permanent move would be delayed for five long years characterized by growing professional fame and seismic changes in his personal life, the mere decision to make New York his future headquarters marked a career watershed for the thirty-three-year-old sculptor. It also carried special irony, since his next two major assignments—one, a decorative work for a government building, the other, a statue for an elite university— both required his continued involvement with Boston. For a time, understandably, French held off establishing a permanent studio in Manhattan, choosing instead to share space there with fellow artists whenever he needed it, wherever he could find it.

He began the new decade of the 1880s fulfilling a succession of lofty, if routine, commissions for portrait busts of prominent New Englanders. They included Unitarian minister John H. Morrison, the late Civil War general William Francis Bartlett, and Emerson biographer James Elliot Cabot. After French's oldest sibling, Sarah ("Sallie") French Bartlett, died following a long and painful illness, he channeled his grief into a memorial bust of his beloved sister. In a similar vein, he produced a posthumous bust of the one-time US representative from New Hampshire, Amos Tuck, whose daughter

was married to one of Dan French's many cousins.[1] The sculptor traveled up to the late congressman's hometown of Exeter to meet his patrons. For him it was also something of a homecoming. During his visit, he walked the same ground where Abraham Lincoln's son Robert trod in the village while attending Phillips Exeter Academy back in the 1860s, as had Tuck, who had served with Lincoln in the House in the late 1840s and looked after the president's son there during Robert's student days. In a remarkable coincidence, Judge French and his family, too, had resided in Exeter in that same period, and it is possible that young Dan may have known about Robert's presence in town firsthand. In such unanticipated ways, the Lincoln story continued to supply context for French's projects, even though the late president had yet to emerge as one of his sculptural subjects.

For each of his most recent commissioned bust portraits, French likely earned several hundred dollars. He commanded a more princely sum—at least a thousand dollars—for the next, and far more prestigious, order. It was to be French's first presidential portrait: a bust of the recently assassinated James A. Garfield. The onetime Civil War general had unexpectedly won the White House in 1880 after the Republican National Convention thwarted Ulysses S. Grant's hopes for a third-term comeback. Following thirty-five deadlocked ballots, the party had turned in exhausted desperation to the inexperienced dark horse from Ohio. Eking out a slender victory in November, Garfield's time in office proved one of the briefest on record. Shot by a rejected office-seeker on July 2, 1881, less than four months after his inauguration, Garfield lingered in acute pain for more than ten weeks before finally succumbing to blood poisoning and pneumonia, dying on September 19. Dan's young cousin Mamie French remembered the amiable president as "a quiet, dignified gentleman who had probably done as little in his life to deserve such an end as any man who ever lived."[2]

The impetus for French's Garfield commission, however, owed little to the late president's tragically abbreviated term in the White House. Rather, it took shape because, like the previously martyred Lincoln, Garfield had served in the House of Representatives. There, he had championed government support to educate deaf children. Garfield's death now inspired the nation's preeminent specialty school, the Columbia Institution for the Instruction of the Deaf and Dumb and Blind, located in Washington, DC, to order a marble bust in tribute to its onetime congressional advocate.

Still ensconced in the capital, now serving in his fourth presidential administration, and alert as ever to such opportunities, Henry Flagg French sought out the wife of the school's innovative director, Dr. Edward

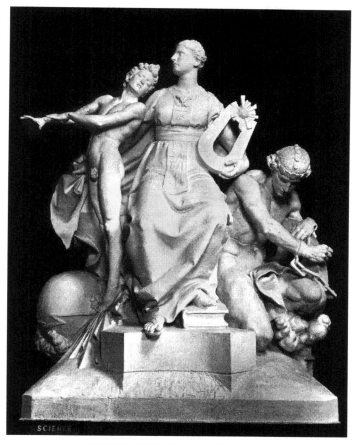

Science Controlling the Forces of Electricity,
for the Boston Post Office Building, 1880–85

Gallaudet, and urged that Dan be granted the assignment. Now, the judge needed only to encourage the busy sculptor. "It will be a great thing to have Dr. Gallaudet for a friend," the judge coaxed Dan just four weeks after Garfield's death, assuring his son that there were "a thousand photos" of the late president, "and you can get the size of his hat."[3] French took the job.

Yet, distracted by other deadlines, he continued to require occasional prodding from his father, who at one point lectured him not "to sham" about his "progress" on the commission. The sculptor did not commence the actual work on his Garfield until months later, in July 1882. The completed marble bust was installed at Gallaudet late the following year, intended as a constant inspiration to deaf students whom Dan by this time presumably had come to encounter more regularly, and regard less callously as "dummys."

Daniel Chester French with *Labor Sustaining Art and the Family,*
for the Boston Post Office Building, 1882–85

During the 1881–82 season, French struggled to balance these fortu-
itous commissions with his unfulfilled obligation to complete the remain-
ing groups in the trio of large-scale projects in Philadelphia, which he had
been awarded earlier by the US government. His latest assignment called for
two colossal ornamental sculptures for a new Post Office and Sub-Treasury
building under construction in downtown Boston. The designated themes
were as ponderously specific as they were invitingly symbolic: *Science
Controlling the Forces of Electricity and Steam* and, as a companion piece,
Labor Sustaining Art and the Family. Judge French admonished his son that
no "decent artist would do one for less than $6,000." But the senior French
proved powerless to rescue Dan from the compensation agreement still in
force: he was required to labor on these gigantic pieces for a paltry eight
dollars a day.[4] The sculptor had reluctantly accepted the meager rate after
returning from Italy under much different circumstances, when he was still

struggling to find a major project worthy of the sculptor of the *Minute Man*. After earning renewed plaudits for his recent bust of Emerson, the per diem arrangement seemed more insulting than ever.

Unable to amend his contract, French proceeded without further complaint to sketch out an ambitious model for the first Boston group. His concept called for a central figure of "science" situated between representations of "electricity" and "steam" on either side. Before this trio of allegorical figures, French ambitiously proposed placing a sculpted locomotive wheel meant not only to suggest the practical result of the combination of education and energy, but to demonstrate the artist's own technical virtuosity. Contrary to prevailing custom, and to Judge French's mock horror, Dan decided to portray *Electricity* as a male. "Electricity a boy!" joshed the father. "Well I declare. There is more electricity in one girl than in forty boys." Wasn't the unsuccessful, half-naked *Endymion*, the judge wondered, "enough boys" for one sculptor's résumé?[5] French ignored him. In search of models, he spent hours during a summertime vacation in Concord sketching the impoverished Boston boys invited to swim at Walden Pond charity outings.[6] Working for the first time with an assistant to help him produce a succession of plaster enlargements, each bigger than the last, he completed what he nicknamed "Electricity and Co." by Christmas 1881—just a few months after the Garfield assassination. By then he was yearning to "drop all my other work" and return to study in Europe. Eventually he admitted that the final clay looked "better than I expected," and kept working.[7]

Labor Sustaining Art and the Family was next on the docket, and for this pendant to his *Science* group, Dan joined his father in once again lobbying for more generous remuneration. Judge French, overheard one day deploying a then all-too-common slur to urge his son "not to let people Jew him down; not to work for less than his price," now petitioned the supervising architect of the post office building to treat this second sculptural group as a commission, not another per diem assignment.[8] Again the appeal failed. Dan consoled himself with a rejuvenating visit to painter Frederic Crowninshield's artists' retreat in Richmond, Massachusetts, where he did "nothing in the way of work" but "got what I came for, a rest and change."[9] Rejuvenated, he went back to work on his *Labor* model at the studio of his good friend, the painter and teacher Abbott Handerson Thayer, on West Fifty-Fifth Street in Manhattan. For the first eight months of 1883, Dan worked there, together with an assistant, Frank Elwell, to produce a series of successively grander enlargements, and finally to sculpt a half-size model that would serve as a guide for marble cutters.

How much Daniel Chester French earned in total for the two Boston statuary groups is lost to history—his financial records for this period do not survive—but existing archives show that the two sculptures were ultimately carved in marble at a cost of $11,300 each in November 1883. In that bounty the sculptor certainly did not share.[10] "They are, I fear, pretty bad architecturally," a dispirited French complained to his brother the day before the statuary groups were to be hoisted atop the new building, "and I sometimes get pretty blue thinking of them." At least, as he confessed on the eve of their installation, "I shall know at once whether to seek or avoid the P.O. square in the future."[11] Whether he ever again viewed the works is unknown, but his imposing statuary groups did remain in place atop the post office for more than four decades. Only when the building itself faced demolition in 1928 were they carefully taken down and relocated to Boston's Franklin Park, where they have remained ever since, relics of the era when major new buildings were ornately adorned with public art as a matter of routine.

◆　◆　◆

It was at Abbott Thayer's New York studio, during his work on *Labor Sustaining Art,* that elderly Boston businessman Samuel J. Bridge paid French an unexpected but career-changing visit in June 1883. Bridge was a proud alumnus of and major donor to Harvard University—described as "a pious worshipper at Harvard's Shrine"[12]—who now proposed to donate to the campus a bronze statue depicting the school's first financial angel and namesake, Rev. John Harvard. His only stipulation was that the university's overseers agree to install the gift on the grassy triangular delta outside Memorial Hall, the hulking neo-Gothic pile erected the previous decade in tribute to the Harvard students who died in the Civil War. Bridge's proposal had generated the expected enthusiasm at Harvard, spurring the donor now to journey to New York to offer the project to Dan French.

At first glance, the invitation seemed irresistible. There would be no competition for the Harvard statue; onetime Cambridge resident French, once again regarded as a favorite son, could have the prestigious assignment outright and would be paid a healthy part of the budgeted twenty-thousand-dollar cost (the balance for casting in bronze). The sole prerequisite, aside from the site west of Memorial Hall, was that the completed work be installed within a year.

Daunting as this timetable seemed, it was more than offset by the appealing challenge of reimagining an all-but-forgotten figure from the distant past. No living person had ever set eyes on the original John Harvard—

or even an authentic representation of his features—for the seventeenth-century clergyman was long dead, and no likeness of him survived. In short, Daniel Chester French could create the image entirely out of his imagination. And he would be doing so for generous compensation, without the need to compete against rival designs, and for a highly influential clientele. "The statue of John Harvard...will afford me an opportunity to do a really good thing," French wrote in accepting the assignment in July 1883, "and I pray that I may prove equal to the requirements of the subject."[13] Turning to prayer was unusual for Dan. Perhaps the thought of creating his first statue of a clergyman had inspired not only a high fee, but also divine guidance.

As to "the requirements of the subject," French soon discovered that almost nothing was known about the English-born prelate, except that he had settled near what later became Cambridge, Massachusetts, around 1637. Soon after arriving, Rev. Harvard had learned of a recent decision by the Bay Colony legislature to appropriate four hundred pounds to establish a "schoale or colledge" in the neighborhood.[14] Married but childless, Rev. Harvard pledged to bequeath half of his own estate—nearly 780 pounds plus the four hundred books in his large library—to endow the new academy.[15] No doubt the minister intended his contributions to come due in the distant future. But only a year later, after a particularly severe New England winter, Rev. Harvard died of tuberculosis at the young age of thirty, and the college received his generous bequest in time to cement its survival.[16] In gratitude, its founders named the school in his memory.

Based on his preliminary research, French determined to portray John Harvard with long hair and wearing Pilgrim-style attire, but for a time could not decide whether to create a seated statue or a standing one. A few years earlier, he had submitted a small standing figure to a sculptural competition for a memorial to New England abolitionist William Lloyd Garrison. Every rival entry had been a seated figure. French was disappointed, but not surprised, when the committee awarded the assignment to Connecticut-born and Paris-trained Olin Levi Warner, one of the artists who had produced a "dignified" seated maquette.[17]

Not long afterward, French, still preoccupied by his government work, had entered yet another spirited competition, this one for a Paul Revere monument in Boston, a job the sculptor coveted. On this occasion, the patrons specified an equestrian statue. French, for all his observations and criticisms of the sculpted horses he had seen while living in Washington, experienced considerable difficulty in modeling a steed of his own. Nonetheless the committee selected him as one of three finalists for the Revere commission,

along with New Yorker James Kelly and Utah-born Cyrus Edwin Dallin, both French's junior.

Finalist status at least earned Dan a much-needed three-hundred-dollar prize, plus a brief display of the model, alongside his competitors' submissions, at the Boston Arts Club in April 1883. In the end, however, the committee awarded the commission to Dallin, the youngest and least experienced of the triumvirate. (They would pay dearly for their risky decision: after rejecting four of Dallin's subsequent models, his statue would not be installed until 1940—some sixty years later.) Losing the Paul Revere job stung Judge French even more than it did his son: "Where are the fools to give the money for a great work to a man who never made a statue?" he railed, proposing to protest the choice to his still-influential Massachusetts friends. Dan shared his father's dismay, but forced himself to worry only that by accepting the three-hundred-dollar finalist's fee, he might have forfeited the rights to his rejected design.[18]

In the end, Dan recovered his Paul Revere model, though he subsequently, perhaps petulantly, destroyed it. From the entire humbling experience, Dan at least learned two valuable lessons. First, having chosen years earlier to study sculpture only in Italy, he now became painfully aware that he sorely lacked the Paris art education that seemed increasingly to beguile art patrons. (Dallin, too, had already studied there.) Second, Dan concluded that art competitions of any kind were frustrating, time-consuming, and ultimately heartbreaking affairs, and should be avoided if possible, just as his contemporary, Augustus Saint-Gaudens, had vowed to do.[19] Around that same time, in fact, Saint-Gaudens had been invited by a committee in Chicago—*after* a major sculptural competition there failed to attract a satisfactory entry—to take on a major project that Dan would have dearly loved: a larger-than-life standing figure of Abraham Lincoln for Lincoln Park.[20] It would be more than twenty-five years before an opportunity to portray Lincoln finally came Dan's way.

◆　◆　◆

In the absence of a disconcerting rivalry with other artists, French proceeded deliberately with the Harvard project. He began by fashioning two small preparatory models, one of a standing figure, the other seated, and only then returned to Boston, where he could be close to the local archives he might need to scour for information about his elusive subject. He leased a downtown studio on Channing Street and, sparing no expense, installed a large window to add extra light.

Shedding light on John Harvard would prove more challenging. "I could only go to the Harvard Library to read what few data there are recorded about his personality," French remembered, as he delved deeper into the life and character of his subject. "That he was 'reverend, god-like, and a lover of learning'...was about all that could help an artist," he recalled years later to writer Charles Knowles Bolton, who served as librarian at the Boston Athenaeum, "but it is recorded that he died at the age of about thirty from consumption and that gave a clue to the sort of physique that he had. It is fair to assume that his face would be delicate in modeling and sensitive in expression, and in looking about for a type of the early comers to our shores I chose a lineal descendant of them for my model in the general structure of the face."[21] This was an apt description of the "handsome young" friend he invited to pose for him: Harvard Law student Sherman Hoar, who happened not only to be appropriately gaunt, but could trace his family tree to John Sherman, signer of the Declaration of Independence.[22] Dan opaquely explained to his brother, Will, that Hoar had "more of what I want than anybody I know," hastening to add, "Of course I shall not make it a portrait of *him*."[23] (It was probably no coincidence that Hoar had only recently commissioned the sculptor to execute a bust portrait of his fiancée.)[24]

The idea to base his John Harvard likeness on a slim, pale-skinned Boston blueblood provoked an artistic breakthrough—for a time, anyway. At first French made rapid progress on the final model, which he decided should be seated after all. In February 1884, Harvard president Charles William Eliot visited Judge French at the Treasury Department in Washington and told the sculptor's father that the model, which he had apparently inspected back in Boston, seemed "very interesting." Not given to hyperbole, Eliot almost reluctantly admitted that French's work "moves one, which is...an indication of merit."[25] The Harvard president's muted enthusiasm had at least grown with time. Earlier, he had warned the Massachusetts Historical Society that any "attempts to make portrait statues of those of whom there are not only no portraits, but no records or recollections, are of very doubtful desirability."[26] In fact, Eliot had originally suggested that donor Samuel Bridge would be better advised to spend his money on a generic statue of the Muse of History grasping a book inscribed with John Harvard's name.

Ironically, Charles W. Eliot's confidence in the John Harvard project grew just as French's waned. A month after learning of the college president's minimally encouraging comments, the sculptor grew as anxious as he was ever known to be when in the throes of creating a new work.

Dispatching a photograph of the still-unfinished model to his brother, he admitted to Will that there remained "problems to be worked out," particularly with the figure's stubbornly awkward hands, which he was struggling to model more naturally. Dan pointed out, "of course, I have done a good deal since the photos were taken and it is much better now."[27]

Soon battling fresh doubts about costume and hair, French asked his onetime New York mentor, J. Q. A. Ward, to provide guidance on these details. (Ward had just completed a statue of George Washington.) Emphasizing the scarcity of "portraits of men of the early days in Boston," French consulted the few sketches and engravings he could find at the Massachusetts Historical Society and the Museum of Fine Arts.[28] Then, "to settle the point definitely," he borrowed from the historical society a work called *The Customs of New England* by Salem antiquarian Joseph B. Felt. Though the book was "not very specific" about the "dress and habits of the Puritans," it finally satisfied him about the sartorial styles familiar in 1630s New England.[29] He determined to portray his subject wearing a skullcap above shoulder-length tresses, and dressed, according to a journalist who got to glimpse the work before its completion, in a minister's robe "drooping from the shoulders; a buttoned tunic with broad collar, broad belt and buckle; knee breeches, and low shoes with rosettes."[30]

"I wish I could offer you some sufficient inducement to come to Boston," Dan wrote with more confidence to Ward, "but I have been unable to find any unless you wish to see the greatest statue of the country at my studio."[31] This uncharacteristic burst of bravado masked the renewed surge of insecurity that began to plague French as his deadline neared. To Will he confided more frankly, at the end of April 1884, that "my Harvard statue has hung fire." Translation: he was now simply unable to work on it further. Fretting that each revision or new touch would be irrevocably magnified in bronze, he worried himself into creative paralysis. It "comes to be pretty serious when every mark of the tool is to be reproduced," he agonized. "I find it very difficult finishing a statue for bronze."[32]

As much progress as he had made on the statue, the project was beginning to overwhelm him just as the time for its delivery grew close. "I am sometimes scared by the importance of this work," the tortured sculptor confided to Will. "It is a subject that one might not have in a life-time and a failure would be inexcusable. As a general thing my model looks pretty well to me, but there are dark days when I fear I have wrought in vain. Any way, I have done my best; and I think it has at least individuality."[33] As it turned out, French's painful self-doubt concealed a masterpiece in the making.

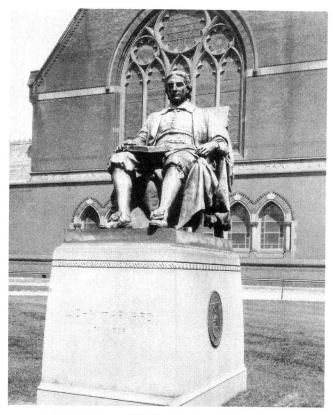

John Harvard, bronze, 1883–84, in its original location in front of
Memorial Hall, Harvard University, Cambridge, MA

Fortunately, in the midst of his own crippling uncertainty, newspapers far and wide began heralding the novelty of a sculptor creating a portrait of a historical figure for whom no previous likenesses existed. "The face is altogether ideal," went one typical report, "as no portrait of Harvard has been found and only the merest outline of a description."[34] The very hurdle that had most tormented him—the absence of a reliable prototype—now, even before it was unveiled, became his work's strongest virtue, and triggered a media sensation in the bargain.

"You must be lonesome without John Harvard," his father wrote French in June 1884, indicating that the final plaster model had by then left the studio for casting in bronze. That assignment went to the Henry-Bonnard Bronze Company in New York, a twelve-year-old foundry run by Edouard Henri and Pierre Bonnard and now favored by the preeminent J. Q. A. Ward. A tradition had fallen by the wayside: the cost estimate quoted by the Ames

Foundry in Chicopee, Massachusetts, the regional favorite that years earlier had cast the *Minute Man,* now proved too "exorbitant."[35] The Harvard casting process took more than three months, but when the bronze finally emerged from the furnace, the president of the foundry exulted that if "he never does another work, this immortalizes him."[36]

Harvard University formally dedicated the new statue on October 15, 1884. The afternoon ceremony took place inside Memorial Hall's packed Sanders Theatre. Few people in the "throng of professors, students and civilians" would have been aware that the man who opened the proceedings, Chairman of the Harvard Board of Overseers, Ebenezer Rockwood Hoar, was the father of the young man who had posed for the statue. Also seated on the platform were President Eliot, sculptor French, and donor Samuel Bridge, among other dignitaries.[37] The event got underway with the glee club singing in Latin from the balcony gallery above the stage. The audience then joined in reciting the Lord's Prayer, led by the minister who had won fame as the author of *The Man Without a Country,* Edward Everett Hale. So far it was a typical New England dedication, not unlike the *Minute Man* program that Dan French had missed in Concord ten years earlier.[38]

The sculptor, who, true to the custom of the day, remained silent throughout the ceremony, content to let his work speak for itself, must have been pleased when principal orator George Edward Ellis, a revered emeritus professor of divinity, rose to hail his *"simulacrum* of John Harvard." As Ellis put it: "This exquisite moulding in bronze serves a purpose for the eye, the thought, and sentiment, through the ideal, in lack of the real."[39] What was the speaker getting at? Was it perhaps another grateful acknowledgment that French had crafted a believable image of one for whom no images previously existed? As it turned out, not exactly.

Yet he must have winced when Ellis added a dash of Puritan fire and brimstone—literally—by vowing: "And if the contingency which has been imagined should present itself, or the coming to the light of some authentic portraiture of John Harvard, the pledge may here and now be ventured, that some generous friend, such as, to the end of time, should never fail our alma mater, notwithstanding her chronic poverty, will provide that this bronze shall be liquefied again, and made to tell the whole truth so as by fire." In a mellower vein, Ellis did praise Daniel Chester French as a "gifted artist" and his Harvard portrait a success at replicating "in body and lineament... what we know that he was in mind and soul."[40] After the glee club offered a closing song, President Eliot at last led the audience outside for the formal unveiling. At a signal, "the cloth which covered the statue was undraped" to

the sound of three cheers apiece for John Harvard, Samuel Bridge, and "Mr. French, the sculptor."[41]

Critics cheered as well, impressed by the lifelike bronze that showed John Harvard leaning back contemplatively in his chair, as if pondering a religious question. His right hand gracefully held an open book perched on his knee; his brow was furrowed in thought. A pile of tomes sat beneath his oversize, elaborately carved seat, perhaps meant to suggest a heavenly throne, its design as ornate as Rev. Harvard's astutely conceived clerical garb was plain. The faintest hint of a mustache alluded to a young life destined to end too soon. Few American sculptures had ever so successfully melded the real and the ideal.

The *New York Times* imagined that John Harvard himself "would have certainly smiled with pleasure if he had foreseen the luck that was to befall his memory...in finding his statue in the hands of so able a sculptor as Mr. French. For while the latter did a good thing in his Minute Man, and a respectable piece of work in his bust of Emerson, he has surpassed himself in his Harvard....The casting is a triumph of foundry work, [and] the ideal or inner beauty of the face and figure makes it a very remarkable and imposing piece of art." The *Times* critic seemed especially taken with the expressive face that appeared to be glancing upward from a book—"and looks forward with an abstracted air so natural and pleasing that we may fancy he is weaving a dream of the thousands to come in the future of the new colony who shall read the books of that library he has given to the struggling school, and perhaps remember the giver."[42]

Other newspapers heaped on praise of their own, the *Boston Traveller* predicting: "This statue will rank among the few great works of American sculpture."[43] With equal enthusiasm, the *New Orleans Times-Picayune* saluted the Harvard bronze as a work of "strength and merit...very impressive in its effect." The *Washington Evening Star* praised it as "an unusually satisfactory and creditable piece of sculpture," and the popular *Frank Leslie's Weekly* honored the statue by featuring a prominent engraved illustration.[44] None of these accolades could possibly have gratified French more than the extraordinary and unexpected letter he received shortly after the unveiling—part of the note composed in verse—from his family's onetime Amherst neighbor, the reclusive Emily Dickinson:

> We learn with delight of the recent acquisition to your fame,
> and hasten to congratulate you on an honor so reverently won.
> Success is dust, but an aim forever touched with dew.

God keep you fundamental.
Circumference, thou bride of awe,—possessing, though shalt
be possessed by every hallowed knight that dares to covet thee.[45]

A decade later, in 1893, President Eliot would confirm French's importance
to the college—and to American art—by inviting him to "deliver a course of
lectures on Sculpture at Harvard." Although flattered by the idea, which he
conceded "would serve to increase the general interest in an art for which
there has been a want of sympathy due largely I think to ignorance or at
least to familiarity," French turned down the offer. For one thing, he was too
busy with new commissions. For another, as he modestly replied: "I am not
fitted by natural gifts or by training...and I am sure that I should do little
credit either to you or to myself if I should undertake it. Congratulate your-
self therefore that I am wise enough to decline."[46] The sculptor's refusal did
little to reduce the reputation of his Harvard statue. The following year, its
fame undimmed, French's *John Harvard* elicited renewed accolades from the
influential art writer Lilian Whiting, a sure indication that his achievement
would stand the test of time. "There is not in America a more impressive and
beautiful work than Mr. French's statue," Whiting wrote in 1896. Exuding
spirituality, dignity, and grace, Whiting declared, "the statue is a living les-
son to every one who contemplates it."[47]

For the better part of the next thirty years, *John Harvard* held pride
of place on the lawn that donor Samuel Bridge intended it to occupy per-
manently. But in 1920, French, by then America's foremost sculptor, asked
the university's reform-minded president, Abbott Lawrence Lowell, Eliot's
successor, to relocate it "somewhere in the College Yard. As it is placed at
present," French argued, "the statue has no particular relation to anything,
practically or from the point of view of sentiment, and I have always felt that
the site was unfortunate in every way." If resituated in front of University
Hall, French now proposed, "the statue would have excellent effect deco-
ratively, facing the long walk to the gate."[48] Such was French's influence by
this time that the college overseers consented.[49] In 1924, the school rein-
stalled the *John Harvard* statue in its new location, where it has remained
ever since—achieving, in art historian Michael Richman's description, iconic
status as a "geographical landmark, a college symbol, [and] a prankster's
delight."[50]

The pranks would begin almost immediately. Only a few weeks after
Harvard University unveiled the statue, students from the freshman class
of 1888 ignited "holy horror" by smearing it with black paint, trigger-
ing another burst of nationwide publicity that only served to enhance the

defaced statue's fame.[51] "Does culture cultivate?" wondered the *Detroit Free Press*. "The Indian savages who once lived on the site of Harvard College would have had more respect for their own antiquities and memorials than these 'young barbarians at play.'"[52] The *Boston Transcript* thundered that "The injury done to that fair bronze by its coating of tar...exceeds what would naturally have followed from climate and weather for half a century. The community will have an anxious and jealous watch over the consequences of this outrage."[53] The incident proved the first, but hardly the last, act of vandalism to befall Daniel Chester French's *John Harvard*. In fact, the act of splashing the minister's face and torso with paint soon became something of a Harvard rite of passage.

By the twenty-first century, the statue had become a must-see attraction for campus visitors and an object of mildly repulsive desecration by irreverent students.[54] "From the moment the sun rises, tourists come by the busload to stand before him like pilgrims gazing upon a relic. From the moment the sun sets, people pee on him," observed the *Harvard Crimson* in 2006, noting the "peculiar fate" of the *John Harvard* statue. "This combination of veneration by day and urination by night is one of Harvard College's most pregnant idiosyncrasies."[55] Attempting a more scholarly image reinvention, the college tried offering a 2013 course in "Tangible Things: Harvard Collections in World History." Among other "things," the syllabus called for a closer look at French's *John Harvard*. In a head-on revisionist reappraisal, university professor Laurel Ulrich maintained that the statue had become outdated as soon as it was unveiled. Ulrich posited that the sculpture showed "an idealized Harvard student through a defiant Mayflower lens, while the wider nineteenth-century world was becoming more explicitly diverse," adding: "It's such an Anglo-Saxon specimen, at a time of mixing."[56]

More recently, Krzysztof Wodiczko, a professor at Harvard's Graduate School of Design, oversaw a public art project for which twenty students projected their faces onto the statue's head and added accompanying audio tracks of their voices. "This sculpture is already a kind of projection-animation in itself because the sculptor Chester French was clever enough that rather than depicting John Harvard, he chose one of the students, or some kind of idealized type of student to impersonate Harvard," explained Professor Wodiczko. "Since it already happened I thought maybe I should continue this and create conditions for students to animate this 'student,' one student who stands for Harvard."[57]

Long before his statue morphed into a shiny-toed curiosity—not only a work of art but a stage from which to test the meaning and boundaries of

the student experience as well as the very nature of public art itself—the initial success of his *John Harvard* had inspired French and his admirers to consider commercial reproductions. At first he warmed reluctantly to the idea, believing he could neither accomplish a reduction for less than a four-hundred- to five-hundred-dollar honorarium, nor price copies for under fifty to seventy-five dollars each, which might limit their appeal.[58] By 1915, however, authorized bronze replicas did go on sale, indicating that the sculptor had relented. That fall, a visitor even noticed a pirated copy on display at the Harvard Club in New York City, advising French that it was "high time that the sculptors of America got together to protect themselves from things of this character."[59] Perhaps aware that imitation could be as flattering as good reviews and high fees, the sculptor replied only that it "naturally interests me to know that somebody has been plagiarizing my work."[60] How he would have reacted had he known that people would soon begin ritualizing both *John Harvard's* veneration and desecration can only be left to the imagination.

◆ ◆ ◆

Back in 1883, the same year that the Columbia Institution for the Deaf installed French's memorial bust of James A. Garfield—and even as he worked to conquer his Harvard project demons—the National Association of the Deaf met in convention to consider a statue of its own. That was when the organization passed a resolution urging the institute to erect a sculpted memorial to the school's inspiration, Rev. Thomas Hopkins Gallaudet, who had died in the early 1850s. By 1885, the institute raised the funds to commission such a statue.

In the meantime, French had won a number of prestigious commissions while gamely entering, and losing, several more competitions. All in all, his reputation had grown handsomely, as had his business. The Gallaudet would wait as he pursued the contest for a Revolutionary War battle monument at Bennington, Vermont, in 1883. Though his well-known *Minute Man* suggested he would become a likely candidate for the Bennington project, once again he failed to secure the job, notwithstanding a time-consuming excursion to view the site, and his father's now-familiar behind-the-scenes efforts to promote him. Judge French proved equally powerless to prevent his son from losing the enviable assignment to sculpt a statue of the Marquis de Lafayette for the park named for the hero directly across from the White House and surrounded by the tony residences of leading Washington, DC, families. Even though the judge was able to convince his

onetime boss, former treasury secretary Lot Morrill, now a US senator from Maine, to put pressure on the architect of the Capitol on Dan's behalf, the prize commission went instead to the foreign-born sculptors Jean Alexandre Falguière and Antonin Mercié.[61]

In October 1884, the month Harvard University dedicated his *John Harvard,* French did succeed in winning a thousand-dollar commission from the veterans of the Civil War 2nd Massachusetts Cavalry to produce a marble bust of its late colonel, Charles Russell Lowell. The brother of poet James Lowell, the colonel had been mortally wounded at the 1864 Battle of Cedar Creek.[62] The finished likeness earned a place inside Harvard's Memorial Hall, not far from the *John Harvard* statue still sitting outside the building.

New England commissions continued to come French's way. The following January 1885, Congress hired him to execute a marble bust of former vice president Henry Wilson, the onetime US senator from Massachusetts elected to the nation's second-highest office as President Grant's second-term running mate in 1872. Wilson had barely served in that office, however, his ability to fulfill his duties curtailed after he suffered a stroke in early 1873. Two years later, he collapsed again during a visit to the Capitol barber shop. Borne to the vice president's sitting room, Wilson died there two days later. Now, after a decade, the Senate wanted a memorial sculpture installed on the site of his demise and paid French one thousand dollars for the work, which he completed in record time. "I am in the last days of the bust of Wilson which pleases me more than any bust I have done lately," he happily reported in April 1885.[63] Sent to Florence to be carved in marble, the piece arrived within the year at the Capitol, where it was installed in the vice presidential room, just off the Senate floor.[64]

Whether Judge French got to witness the dedication of this, his son's first Washington success, is not known. Sometime in 1885, after nearly a decade at his post, Henry Flagg French learned to his acute disappointment that his services at the US Treasury Department would no longer be needed. The elder French, though at age seventy-two well beyond retirement age, evidently took the news hard. While the onetime Grant appointee had resiliently held onto his job through several Republican administrations, Grover Cleveland's election the previous November—as the first Democrat to win the White House since before the Civil War—predictably purged entrenched Republicans from all Cabinet departments.

Besides, Judge French's tenure had not been without its share of controversy. His relentless pressure in support of his son had not gone unnoticed.

Worse, at one point the judge had been accused of misappropriating federal funds by assigning Treasury Department artisans to construct eighteen replicas of the historic little wooden lap desk that Thomas Jefferson had used to draft the Declaration of Independence. Critics charged that the assistant secretary intended to present these reproductions as gifts aimed at generating further political influence. Indeed, President Rutherford B. Hayes himself received one of the desks from Judge French, as did former treasury secretary John Sherman, Civil War general Winfield Scott Hancock, and one or two of the judge's children and Concord friends. Dan was not among them. The resulting scandal triggered two separate Congressional investigations, both of which heard testimony that Judge French had improperly used government workers and materials for private benefit. No formal charges were ever brought against him, and while a concerted effort to curry favor still sounds entirely out of character, the dustup surely tainted his remaining years at the Treasury Department.[65]

Dan French never commented on the Jefferson desk imbroglio. Even his unpublished manuscript titled "Notes on the Life of Henry Flagg French," which he wrote years later, acknowledged only that his father had filled his post "with great efficiency." This period, his son further acknowledged, "was one of the happiest of his life."[66]

Judge French returned to Concord to take up farming again in a modest way, enjoying leisurely time with his family, and optimistically pondering new writing projects. All seemed set in place for a long and rewarding retirement. But fatigue and an element of depression began taking their toll on the old man. As his granddaughter heard tell: "He missed Washington, the Department, his handsome office, the responsibility, and the hard work more than he cared to admit. The walks were shorter and slower. The breath became less free."[67] On November 20, 1885, the judge walked through his front door after a nighttime stroll, only to seize up in crushing pain. Stumbling inside, he collapsed on a sofa, his face ashen. Terrified, his wife, Pamela, cried out to Dan, who rushed downstairs to find his father struggling for breath. Gripping his chest with one hand and squeezing his son's hand tightly with the other, Henry Flagg French died within seconds. The end, though agonizing, was mercifully swift.

Consistent with his customary silence on personal matters, Dan French left no clue about his emotional response to his father's sudden demise. And he likely shared few of his feelings even at the time. "When anything struck very deeply at his soul," his daughter later tried explaining, "Dan could only look at you with his warm brown eyes and a distressed little expression

at the corners of his mouth and say nothing."[68] To be sure, he missed his father's "clean-cut, incisive sort of wit"—his ability to kill his target "with a rapier, not with a bludgeon." French was surely consoled by the rudiments of the judge's philosophy of life, which the son recalled with accuracy for decades. "It is the mark of a friend," the judge had once advised him, "to stand by you when you are wrong; anyone will stand by you when you are right." To those who demurred at planting trees "because it takes so long for them to grow," the sculptor would remember his father's wise answer: "It's not as if you had got to wait for the trees to grow, alone. You would have to wait anyway and the trees might as well be growing....The way to have big trees, is to plant them a long time ago." For the rest of his life, Daniel Chester French would cultivate both loyal friends and big trees.[69]

At first, however, much as he strove to take his father's loss in stride as the natural end to a long life well-lived, the prospect of facing his own future without his father's encouragement and influence—and even his well-meant meddling—must have terrified the thirty-five-year-old. For two decades, the judge had not only supported his efforts to succeed as a professional sculptor, he had relentlessly sought patrons for him, offered counsel, lobbied committees, influenced patrons, bemoaned his son's setbacks, and exulted in his triumphs. When necessary, he had provided money and even helped pour plaster, and when appropriate—or not—had lobbied potential clients, including his own government bureau. Now, with no time to prepare for independence, French was cast adrift from his chief adviser and advocate. Had he lacked work to sustain and divert him, Dan might well have lost the momentum he had finally begun building. Instead, Henry Flagg French's youngest child proved ready at last to stand on his own.

Working now in a new studio inside a "fine new large building"[70] on Boston's Hamilton Place, French commenced a bust of prominent Bostonian Martin Brimmer. Quickly thereafter came a commission to sculpt his father's onetime boss at the Treasury, now a US senator from Ohio, John Sherman. After posing the veteran politician for life sittings at a temporary studio inside the US Capitol, he completed the clay likeness in 1886.[71] The Gallaudet project would have to wait a bit longer, though by this point in his career, French had become adept at balancing assignments, and his clients had grown increasingly willing to wait as long as it took to secure his services.

Further bolstering his confidence was a visit from his late father's old Concord friend, US Senator George F. Hoar, who shared his plan to introduce a bill in Congress creating the first national fine arts commission.

Model of *Lewis Cass* for Statuary Hall,
United States Capitol, Washington, DC, 1889

"Empowered to award all government commissions for works of art," its
ranks would be filled, Hoar assured French, "from among the best paint-
ers, sculptors and architects in the country"[72] Hoar not only implied by his
very visit that he wanted French to serve on the panel, but asked him to help
define its role and seek out ideas from fellow professionals. Noting "the mis-
takes that have been too frequent here-to-fore in the award of government
work"—no doubt an allusion to his own painful experience with such com-
missions—French promptly sought advice from J. Q. A. Ward. How many
commissioners should be appointed? By whom? From what professions?
And, crucially, "Should not artists in this jury be barred from receiving com-
missions?"[73]

As it turned out, Congress, long responsible for awarding art projects for the nation's capital, was not yet ready to cede its authority. Hoar's bill died in 1897. When the idea for the US Commission of Fine Arts was revived and enacted in 1910, the issue of whether or not its members could compete for projects remained unresolved. And it would come to haunt none other than Daniel Chester French at precisely the moment he was pursuing the most important federal commission of his career. In 1886, French had no way of anticipating such momentous future challenges.

What came his way instead that year was one of the most prestigious assignments he would earn that entire decade: a commission to execute a life-size marble statue of onetime presidential candidate Lewis Cass. The marble would grace newly established Statuary Hall inside the Capitol Building. With each state granted the right to select two honorees for this cherished display space, Michigan's choice of its onetime US senator surprised few. A staunch supporter of the Union before and during the Civil War, Democrat Cass had served as secretary of state in the administration of Democratic president James Buchanan, resigning in protest when the hapless Buchanan, afraid to confront secession, refused to resupply federal forts in the South.

Conveniently forgotten was Cass's earlier claim to ignominy as the one and only Democrat to lose the White House between 1840 and 1860.[74] It is unlikely that French would have known that when Cass ran unsuccessfully for president in 1848, he had been denounced right inside Statuary Hall—where his statue would soon sit—during its earlier incarnation as the chamber of the House of Representatives; or that the attack had come from none other than Congressman Abraham Lincoln. Rising from his back-row freshman's desk to mock Cass's supposed record as a War of 1812 military hero, Lincoln had claimed Cass had merely "invaded Canada without resistance, and...*out*vaded it without pursuit." To howls of laughter, the Illinois Whig likened the Democrats' campaign-season effort to attach a "military tail" to Cass's résumé to "mischievous boys tying a dog to a bladder of beans."[75] Cass went on to lose the 1848 race by 140,000 votes.

Gamely determined to "become as intimate with the character of his subject as possible," French headed to Detroit to meet his Cass patrons, and began teasing out a small clay model by March 1886. A visitor to his studio that month spied the "severe-" looking work in progress and exclaimed, "Ah, the king of America."[76] By October 1886, the State of Michigan liked the plaster sketch well enough to officially engage French to sculpt a full-size clay model. It was then, busy as he was, that French felt emboldened to

act on the unfulfilled dream he had harbored since returning from Italy ten years earlier: to spend an extended period studying and working in Paris. He would take the Cass project along with him, and stay nearly a year.

◆　◆　◆

Heading abroad for the second time, now accompanied by his widowed stepmother, Pamela French, the American sculptor found himself far more welcome in European salons than he had been during his first visit a decade earlier. During his London stopover he met the famed literary expat Henry James and socialized with leading British artists, then crossed the Channel and rapidly settled into the Parisian art scene. In Paris he became a frequent visitor at the city's great museums, especially the Louvre. By one account, he also took sketching classes under history painter Leon Glaize; according to another, he studied with sculptor Antonin Mercié, who would soon win the coveted commission to create an equestrian statue of Robert E. Lee in Richmond, Virginia.[77] In either or both settings, it seems clear that in Paris, French honed his approach to the human figure and considered anew the shifting balance between the formally classical and fluidly romantic styles then vying for predominance in contemporary sculpture.

Just before Independence Day 1887, French wrote home to Will to describe his progress during the "last six months...whittling away at the Cass statue." By this time, save for "a fingernail or button," he pronounced the portrait as an "accomplished fact as far as the clay image is concerned." In a refreshingly positive appraisal of his own work, he told a friend: "I wish you could see the statue in clay. In some respects it is more interesting than it will ever be again." American artist G. P. A. Healy boosted French's confidence further. On a visit to the sculptor's Paris studio, Healy congratulated him on so accurately portraying Cass, whom he had known personally and painted professionally, predicting that "the statue would please artists as well as the people generally."[78]

In that prophesy, it turned out, Healy proved too optimistic. With no reason to suspect that criticism awaited him back in the States, French proceeded to create a plaster cast from his clay model, which he then forwarded to a marble cutter in Paris for carving. As soon as he arrived back in America in the late summer of 1888, French confidently sent photographs of the model to the Detroit selection committee, and awaited its reaction. He was stunned when one of its most influential members, Michigan law professor James V. Campbell, objected strenuously to the likeness. While no record survives of Campbell's specific complaints, French relayed the criticisms to

friend and redoubtable Washington art historian Charles Moore: "I seem to have failed where I am the strongest." The finished marble presents an unblemished depiction of the obese, grotesque-looking Cass, so it can only be surmised that Campbell hoped that French would have softened his old friend's repulsive features for posterity. This sole response by the perplexed French acknowledged that his Cass portrait might easily have morphed into "a disaster for me and the statue."[79] Fortunately for the sculptor, other members of the committee rose up to defend the unapologetically realistic statue, and carried the day. One of the ugliest men in American political history would be depicted just as he looked. "Catch me taking another statue subject to the verdict of a committee," French concluded to Moore with a combination of sarcasm and relief.[80]

The heightened naturalism that began to imbue French's evolving style during his second round of study abroad added a greater fluency to his maturing technique. French's Lewis Cass sculpture was a triumph of sculptural realism. It also taught French to rely more than ever on studio assistants who could help him enlarge his models, cast them in plaster, or carve them in marble. And it provided another priceless lesson in the vagaries of art patrons. French still had much to learn about catering to those who hired him.

The finished Cass marble arrived back in the United States in January 1889, after which it was shipped to Washington, DC, polished off by French himself, and dedicated as planned at Statuary Hall. There, the orator of the day, Michigan's freshman senator Thomas W. Palmer, tactfully welcomed the Cass likeness as "a felicitous contribution to our American Pantheon,"[81] leaving observations about the old hero's homeliness unexpressed. A newspaper critic hailed French's first full-length marble statue with only slightly more specificity, judging it not only "an excellent model of the great statesman," but "a statue full of character and expression as well."[82] Most crucially, as far as French was concerned, the Cass statue's installation prompted his largest honorarium to date. But not until March 1889, following what French described with irritation as a "vexatious and inconvenient" delay, did the State of Michigan pay him the final installment in a commission that totaled an impressive $9,848.13.[83]

He needed the money to finance a lifestyle he planned to alter dramatically. By then, his professional life had ascended to new peaks. Yet his personal life had grievously suffered. The beautiful blondes of his youthful fantasies had long before hitched their stars to other men. Daniel Chester French was about to make up for lost time.

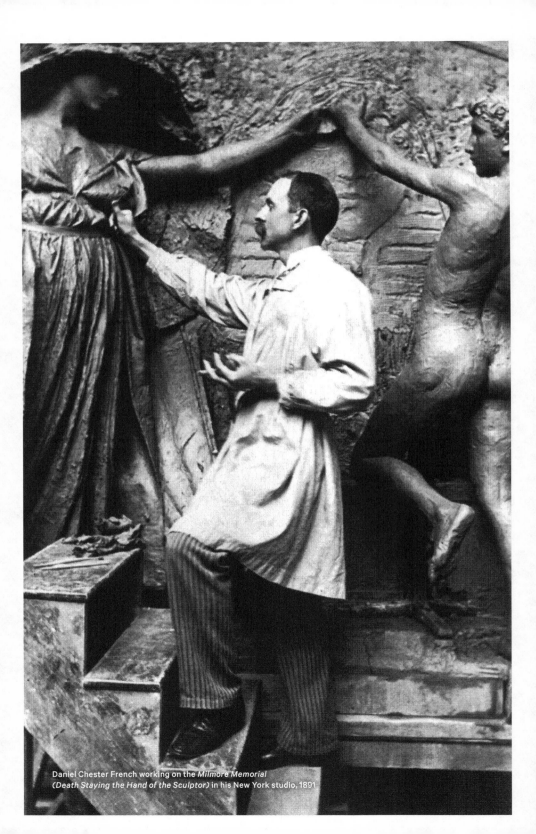

Daniel Chester French working on the *Milmore Memorial*
(*Death Staying the Hand of the Sculptor*) in his New York studio, 1891

THE HAND
OF THE
SCULPTOR

Throughout the early 1880s, while French worked away in different parts of the country on his portrait busts of Charles Lowell, Henry Wilson, and John Sherman, the Columbia Institution for the Deaf was campaigning in earnest in Washington to raise the full ten thousand dollars needed to finance its proposed memorial to Thomas Gallaudet. After years of fund-raising, the institution finally amassed three thousand dollars to pay French, and another seven thousand to cast in bronze the statue he designed. With the contract to portray Gallaudet, French all but cornered the market on statues of long-gone ministers who had turned their attention to education.

Like John Harvard before him, Gallaudet had encouraged the establishment of a school he did not live to see reach full flower. Born in 1787, the year of the Constitutional Convention, Rev. Gallaudet had been raised in Connecticut and educated at the divinity school at Yale. He had abandoned the ministry early in the nineteenth century after a life-changing encounter with a nine-year-old deaf girl named Alice Cogswell, the daughter of a neighbor, to whom he tried to teach reading and writing. Inspired by the experience, Gallaudet determined to devote the rest of his life to educating deaf people. Alice's grateful parents paid to send him to Europe to study the experimental teaching methods recently introduced there. In 1817, Gallaudet returned home to help found the pioneering Connecticut Asylum for the Education and Instruction of Deaf and Dumb Persons. Later he passed on his calling to his son, Edward Miner Gallaudet, born in 1837.

Next to enter the story was a colorful old newspaperman, politician, and entrepreneur, the Jacksonian-era postmaster general Amos Kendall, who

had earned a fortune in the 1840s and 1850s from investing in the Morse telegraph. In the latter decade, notwithstanding the distractions of the growing national discord over slavery, Kendall had unexpectedly developed an interest of his own in educating deaf children. It began when twenty homeless deaf orphans from New York found themselves stranded in Washington. The old gentleman came to their rescue, took some of them into his own District of Columbia home, and soon founded the Kendall School for the Deaf, naming Edward Miner Gallaudet as its first superintendent.

Again, the saga ultimately involved Abraham Lincoln, who in 1864 signed federal legislation to incorporate the growing institution as the National Deaf-Mute College. In 1865, Congress appropriated funds to purchase land on Kendall's Washington estate and convert it into a fourteen-acre campus renamed the Columbia Institution for the Deaf. Recruited to run it, Edward Gallaudet, a leading proponent of sign language, went on to serve for more than half a century as its chief administrator, and in that role made the acquaintance of Judge French and his family.[1] When French secured the Garfield commission for the college, their professional association may well have blossomed into friendship; the younger French had by then become nearly as adept as his father at collecting and cultivating influential friends. Both Dan French and Edward Gallaudet had enjoyed rural bird-watching in their youth, and may have forged a bond over these nature-bound experiences.

French, who by then had sworn off art competitions, initially believed he had won the Gallaudet assignment outright, and even celebrated the agreement together with school officials at the Gallaudet Club in Manhattan in December 1885, just before he left for Paris. A month earlier, according to one report, French visited the Columbia School campus to study surviving portraits of Thomas Gallaudet and enjoy dinner with the Gallaudet family, certain the job was already his. Security bred overconfidence, for just before Christmas, French told his brother: "I would not have done this if I had plenty of work, but, even if nothing more should come of it, I would rather be earning $3,000 than to be idle." Apparently, French had already submitted a preliminary idea, reporting that "Dr. Gallaudet...and the others were very much pleased with the sketch I sent them."[2] All these calculations and festivities turned out to be premature. By 1887 the school announced a competition for the commission, after all, and only "after thorough consideration" received a "contract...by a unanimous vote awarded to Mr. Daniel C. French"—again.[3]

Then, a deaf sculptor began vying for the commission anyway, and, riding a wave of support from among the school's activist students, demanded

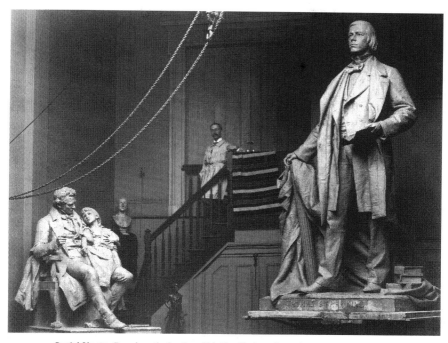

Daniel Chester French on the landing of his New York studio at 125 West Eleventh Street,
with models of the Thomas Gallaudet Memorial (left) and statue of Thomas Starr King (right), 1890

that the agreement be voided.[4] In the wake of this unexpected challenge, French's casual indifference quickly melted away. To his dismay, he learned that not only had the deaf sculptor, Albert Victor Ballin, asked the committee to reconsider him for the assignment, but that a group of "deaf-mutes" at the school had demanded "that the statue should not be made by a 'hearing' sculptor," French again confided to Charles Moore.[5] To add insult to injury, French now discovered that none other than Augustus Saint-Gaudens had recommended Ballin for the commission. Writing from Paris in July 1887, French indignantly told his distinguished colleague, "I should be less than sincere...if I did not confess to being somewhat surprised at your listening to the request of the deaf-mute sculptor, for a recommendation of his plan, particularly as I know your views regarding competitions." In the end, Gallaudet held fast to the school's original commitment to French, who, striking an uncharacteristically competitive pose of his own, half-jokingly warned Saint-Gaudens, "I have been enjoying immeasurably my sojourn in Paris....I shall however return home next month—I hope a little wiser than I came, so look to your laurels!"[6]

Vague threats aside, French had arrived back in America bursting not with resentment but with new ideas about sculptural technique, and quickly withdrew his winning Gallaudet design and substituted a new one showing a thirty-year-old minister together with the little girl who had first inspired him. Explained a journalist who visited French that summer in his comfortable old Concord studio, where he began work on a small model: "Parisian sculptors never let an occasion of this kind pass; they tell the story of the man's life as well as depict his features."[7] Indeed, French had likely been inspired by two statues he surely saw in Paris: Ludovic Durand's 1879 *Philippe Pinel*, showing a doctor with a patient kneeling by his side; and Badiou de Latronchère's 1859 statue of the teacher of the blind, *Valentin Haüy*, depicting the educator gently placing his hand on a young student's head.[8] By fall 1887, French was describing his own reconceived *esquisse* as specifically representing "Gallaudet teaching his first pupil, Alice Cogswell." As he added with his usual combination of self-confidence and self-deprecation: "It gives a chance to make a very charming thing full of tenderness and pathos and I find myself better pleased by my rendering of it than I am usually with my productions, but it isn't done yet and there is time enough to spoil it."[9]

For guidance, French consulted the requisite late-in-life portraits of Rev. Gallaudet, but, just as with John Harvard, found no reliable likeness or model of Alice Cogswell on which to fashion her portrait. Once again, he turned for inspiration to a local model, in this instance a Concord child named Mary Sherman. French spent most of the autumn on his small clay model, completing and inscribing the maquette in Concord on November 8. But lacking adequate space to make an enlargement at the modest hometown work room he had once helped build with his own hands, he rented a new studio on West Eighteenth Street in Manhattan and finally headed to work and live in New York. In early 1888 he collected half his fee for the Gallaudet, $1,500, and by June, describing himself after several bouts with bad colds as "in perfect health, but working harder and with more on my mind than ever before,"[10] raced to complete the statue on time. With less success, he worked to satisfy another pressing deadline, this a decidedly personal one: making and keeping a date for his own wedding.

◆　◆　◆

Even during the years he undertook income-generating projects for government and private patrons, French had devoted a remarkable amount of time as well to crafting likenesses of one particular subject for which he received no payment at all. From 1880 through 1883 he had produced several works

depicting his first cousin, Mary Adams French. "Mamie" was the pretty young relative who had first sparked his attention during his initial days in Washington in the autumn of 1876. That year, Mamie emerged from her convent school so utterly transformed that French barely recognized the child he had once known. Busy as he was, he used her as a model, ostensibly to refine his professional technique, though for the better part of the decade his personal technique with her remained hopelessly inept. As model, muse—and ultimately more—Mamie began casting a spell on him of which both of them long remained surprisingly unaware, or at least unwilling to acknowledge.

Mamie—who was often referred to as such even though she came to despise the nickname—had felt little more than awe for her congenial cousin, nearly ten years her senior, during her childhood visits to Concord. And when French came home from Italy years later to take up residence in his family's compound on Capitol Hill, Mamie was away at the Convent of the Visitation in nearby Georgetown, too far to be part of his life, but too close to be ignored. For her part, aside from a brief girlish crush on Admiral Robert Peary and a thrilling glimpse of "the March King," John Philip Sousa, bedecked in a braided uniform, Mamie increasingly came to regard French as "very handsome...soft and peachy,"[11] despite his rapidly retreating hairline. Of course, flirtations with cousins, merely the thought of such relationships, carried a formidable stigma, and for a time neither one made their growing affection known, even to each other. Convent education notwithstanding, Mamie, the more inexperienced of the two (for years she had slept in her parents' bedroom), also became the more uninhibited, and in a way, the more worldly. Late in her teens she dove enthusiastically into the vibrant Washington social scene, attending "the Inaugural Balls, the Presidential reception[s], the official gatherings" populated by both American celebrities and "foreigners in gorgeous regalia—at least gorgeous for America." She and her chums never minded being "flattened out into pancakes" if it meant getting another chance to greet a president on a White House receiving line.[12]

Back in the summer of 1876, even before Mamie first began posing for him in earnest, the then twenty-six-year-old sculptor had taken his young cousin on a Concord vacation by ship. Mamie later playfully referred to the voyage as "our first wedding journey," wondering provocatively why her "conventional family let me go in so bohemian a matter." (In fact, French's stepmother, Pamela, had accompanied the pair, possibly as a chaperone.)[13] When they arrived at the quiet New England village, the city girl found herself surprisingly enchanted by the town's attractions and atmosphere, offering

her observation that "philosophers" were as abundant there as "flies." She met Dan French's congenial neighbors, enjoyed picnics and outdoor theatricals in which the sculptor often starred, took moonlit boat rides on the river, and even paid a visit to one of Ralph Waldo Emerson's private salons. Very likely, French ushered Mamie to view his *Minute Man* statue. Idyllic Concord, even to a young woman who admitted to "a great leaning toward pretty clothes and the amenities of life," enthralled Mamie precisely because it frowned on such trappings. It was, as she approvingly quoted Will French, "a place where you felt that the people themselves were finer than the clothes they wore and the houses they lived in."[14] Dan French was feeling something quite different—finding himself increasingly "self-conscious" around Mamie, "a new sensation, for he had always felt so much at home with girls."[15]

Maintaining the charade a while longer, French asked his cousin to sit for him that summer of 1876 at his Concord studio. Once they returned to Washington, he resumed posing her there. It was as if he were conducting a moveable courtship through art. Toward the end of 1880, he produced a plaster bas-relief of twenty-one-year-old Mamie. Then, three years later, their relationship still unresolved, indeed unmentioned, French undertook a more ambitious and unusual bust portrait, this one bursting with vivid color that seemed totally at odds with his own pallidly repressed emotions. Utilizing a new technique to add zest to the plaster, and perhaps by extension to their own alliance, he added paint to portray Mamie "with the hair slightly tinted in auburn, the face and neck faintly colored, the gown in green, and a rose in the corsage in pink." The vibrant result, one critic of the day gushed, was "beautiful."[16] An unsuspecting Judge French had predicted that the "bust of Mamie will be good to exhibit," convinced that "a tolerable work of a pretty woman will receive more approbation than an excellent one of a horn'd old man."[17] French briefly put the work on view at the Society of American Artists in New York City.[18]

Reluctant to abandon his pursuit of a sculpted likeness of Mamie, French also worked that same year, 1883, to fashion a plaster cast of her right hand, ostensibly to guide him in sculpting details for his Post Office group, *Labor Sustaining Art and the Family*. Yet he never adapted it into his final work. Perpetuating the intrigue of pursuing Mamie through his work, the cast might have been no more than a symbolic request for her own hand—in marriage—a request the roguish yet reluctant sculptor failed to put into words for five more years. By this time, even though the oblivious Judge French continued "humorously urging him to marry and settle down, often picking out girls for him,"[19] as Mamie recalled without a trace

of resentment, his son, despite his painful torpor, seems to have set his hopes exclusively on his attractive cousin.

During this entire frustrating period, neither of French's parents seem to have harbored a clue about their son's repressed desires, and he made no effort to confide in them. Still acting the typical shut-mouthed New Englander, French remained as silent as "an iceberg, nine-tenths submerged." To "exteriorize his position with any member of the family," his daughter asserted later in his defense, was "completely improbable." To seek the advice of outsiders was "impossible."[20] And to unburden himself even to Mamie seemed unthinkable. French had no "doubt about its being wrong to think of marrying one's cousin, and so he had been careful never to let her know by look or word or deed that she was anything more than a pet relation....They were cousins, and one simply couldn't fall in love with one's cousin....So firmly had the lesson implanted itself that it didn't even occur to him to look into the matter."[21]

No one knew Dan French better than his father, who surely must have eventually noticed that his son was no longer prattling on about his amours. Sometime in the last years of his life, perhaps finally coming to terms with what he had long overlooked, or chosen to ignore, the judge had assured his son that "no objection of his must ever stand in the way" of his future happiness. Did Henry Flagg French suspect his son's torment? He never said so. And even after the judge's death, French continued to hesitate, not only stymied by the forbidden nature of his desires, but unsure that Mamie reciprocated them, and afraid to ask her. Mamie returned for yet another Concord summer in 1887, but still, neither of them yet brought themselves to put their feelings into words.

As fate would have it, the rocky Concord terrain that French had once worked into his *Minute Man* pedestal at last presented the perfect opportunity to force the issue when the two were together one August evening for a Concord excursion. Alighting from a river craft and heading up a jagged hill toward the French family farm, Mamie stumbled in her high-heeled boots, and French instinctively threw his arm around her waist "to steady her." The impact of his grasp proved electric. Finally "it all came pouring out....She had loved him, she said, ever since she first saw him at the convent, after he came back from Italy."[22] Welcome as it was, Mamie's impassioned outburst did little to quell their panic over the "cousin" issue. She quickly urged that they "both try to forget" each other. French insisted he could not.

Mamie returned to her Washington home unpersuaded, but their separation soon triggered some sort of nervous collapse. His own anxiety rising,

for her well-being as well as his, French finally resolved to cross the biggest hurdle of his life in the same methodical way he had overcome the absence of data on John Harvard. He undertook exhaustive research on the delicate matter that was keeping them apart. Consulting books at the library, he convinced himself that the ban on cousins marrying was based only on "superstition...unless there was insanity in the family...in which case the peculiarity would be likely to be emphasized in the children." Scientific data in hand, he rushed down to Washington and proposed to Mamie on the spot, insisting they be married as soon as possible "before either of them had time to reconsider," and even if either of their families opposed the match. Inevitably, some relations did raise eyebrows, if not objections, but the one potentially disapproving voice that might have stopped them in their tracks, French's father, had now been gone for nearly three years. So, once French's widowed stepmother proved "angelic about the whole thing"—apparently her only concern was whether Mamie was up to the task of efficient housekeeping—the couple resolved to go ahead with their plans, and quickly.[23] They had waited long enough. A decision that may have appeared to the outside world as impulsive had in fact taken many vexing years to reach.

The unconventional couple scheduled a conventional June wedding, but as the date approached, French—to whom the bride-to-be was still referring almost perversely as "my cousin"—wrote to beg for a month's postponement. Work had come between them, for the first, but not the last, time. "What should you think," he dared asking her, "if I told you that even now at the last minute I must change my statue and I am afraid it will put off our wedding for a month?"[24]

Although "apologetic and contrite," the fact was that the sculptor had just endured a critique of his Thomas Gallaudet statue that he felt he must address immediately while it remained fresh in his mind. "Saint-Gaudens has been in," he described the painful but revelatory moment, "and says that the legs are too short. Perhaps I should have known this without any one telling me, had I not been diverted by the prospects of approaching matrimony. However, when you can pin Saint-Gaudens down and get a real criticism from him, it is better than anybody's, and so what can I do except give the Doctor an inch or two more of leg, and meanwhile, what kind of a lover will you think me anyhow?"[25]

"Of course," Mamie remembered, "I knew well enough that, in sculpture, legs and arms and heads were always being cut off and jostled about, and there was nothing to do but accept it, so we picked out a nice hot day in the hottest city in the world...and were married."[26] Why it had taken nearly

Mary Adams French in the New York studio, March 1891

a decade for this perfectly suited couple to plunge into matrimony, neither bride nor groom ever ventured to explain. All Mamie ever said was that the Gallaudet statue's legs "had pretty nearly wrecked our marriage."[27]

Dan and Mamie French wed on the steamy afternoon of July 7, 1888, in the bride's Washington home—"a terrible time and place, to be sure, to do anything," Mamie admitted, adding pointedly, "but if one will marry an artist..."—implying that ordinary conventions were of little concern. The groom was thirty-eight, his bride a few months short of twenty-nine.[28]

◆　◆　◆

When the newlyweds returned from their honeymoon at Lake Placid, New York, Mr. and Mrs. Daniel Chester French settled into a new four-story

town house that the husband had purchased at 125 West Eleventh Street
in Manhattan a few months before the wedding and commenced refurbish-
ing before they moved in.[29] He apparently did not consult his nearly thir-
ty-year-old bride about a single detail of its renovation or decor. In fact,
Mamie vividly remembered entering the fully furnished house for the first
time after their honeymoon trip and, like a visitor to a historic site, gliding
from room to room under her new husband's guidance—apparently with-
out surprise or complaint. "The house was most interesting and I loved it,"
she later recalled. The only aspect of her carefully arranged new life she
found "appalling" was its potential for isolation: "all the hustle and hub-
bub of a great city...the hurried, slap-dash methods of a metropolis...with no
intimate friends and no neighbors."[30]

As Mamie now beheld, the couple's newly installed parlor mantel fea-
tured a copy of the Grecian-style frieze French had first modeled for his
studio in Concord. A built-in divan covered by a yellow Chinese parasol
fronted a stained-glass corner window. Everywhere one looked was evidence
of the artist's singular and eclectic taste: an Italian primitive of three saints, a
teakwood Japanese lantern, a gilt chandelier fitted for gas, and in the corner,
the tinted 1883 bust portrait of Mary on a pedestal, where it would remain
for four decades. Upstairs he had installed a library fitted with shelves and
a gilt-molded ceiling adorned with painted green wreaths. A large canopied
brass bed dominated the third-floor master suite. In the room next door,
French was building a dressing area for his wife, to be screened off by a cur-
tain made of glass beads from Paris and furnished with yellow sateen-cov-
ered walls and a dressing table surrounded by a flouncy valance, before
which would sit a small gilt chair. Mamie, who had played no part at all in
decorating her new home yet who cherished his industry, could only remark:
"Dannie, you've certainly come a long way from Chester!"[31]

French intended that their new residence reflect the graceful combina-
tion of domesticity and work, which he had so admired at the Thomas Ball
compound in Florence. His new town house was roomy enough to provide
two upper floors that might eventually be rented as work space to young
artists. The backyard was so spacious that he had built an adjoining stu-
dio—one enormous room with green walls, still undecorated, but lined
with shelves already groaning with plaster casts, and a cupboard filled with
sculpting tools, along with an ample clay bin and a long workbench—all of
it brightly illuminated by a generous sloping skylight. There was no direct
door to the street, but French designed the studio to open into the kitchen—
providing a direct pathway for sculptures and supplies to move in and out of

Mary Adams French holding Margaret French in the
New York studio, March 1891

the compound without disturbing anyone in residence except perhaps "the cook."[32] A year later, even as his environment expanded, Dan French's family expanded as well. In August 1889, he and Mamie welcomed their first and, as it would turn out, only child, a daughter they named Margaret, born, appropriately enough, at the old French farmhouse during a summer vacation in Concord.

◆ ◆ ◆

Seven months earlier, French placed his full-size, recently modified plaster Gallaudet model on view at the new Manhattan studio to show it off to the city's influential art connoisseurs, and then sent it to Henry-Bonnard for casting in bronze. Six months later, on June 16, the college unveiled the finished statue, with Dan and Mamie French in attendance for the ceremony. Yet, as usual, the artist was silent. The gleaming bronze sat in precisely the spot on the campus's Kendall Green, fronting the college, that French had chosen for it. Originally, the Gallaudet family had opposed the site, reluctant to take down the big apple tree that had long stood there. Then not one,

but two violent storms struck the tree, leaving nothing more than a stump, and Dr. Gallaudet's "unreasonable offspring" relented. "I find myself better pleased with the effect of the group in bronze than I expected to be," he confided to his friend Charles Moore.[33] Critics felt much the same way. Once again, art writers lauded the latest Daniel Chester French work, with the *Washington Evening Star* commending its "handsome and effective design" and praising the sculptor for imagining such a convincing likeness of a long-gone subject. "A more graceful, sympathetic piece of work it is rare to see," added the *New York Times*. "[I]t tells its story plainly and with simple poetry of motive and execution."[34]

Commenting a few years after its dedication, the art critic known as V. Robard made the case that the *Gallaudet Memorial* signaled for Daniel Chester French "the perfection of his technique," the moment he mastered the ability to transform the realistic into the sublime. Describing the piece with unrestrained enthusiasm, Robard noted that "Gallaudet, whose homely face is not too much idealized, beams encouragement upon the little deaf-mute at his side, who tries to imitate the language of his hand. There is an ineffable charm to the graceful little body swaying against Gallaudet's knee, and the wild beauty of the eerie face is fairly haunting....Out of this awkward subject, Mr. French has evolved a very poem."[35]

No less acute an observer than Henry James concurred, so moved by a mere photograph of the statue that he could not restrain himself from dispatching a letter of praise to the sculptor, whom he had met only briefly when French stopped in London en route to his Paris sojourn a few years earlier: "I am delighted that work of such high distinction & refinement should come from the country which you appear, deludedly, to suspect me of not being in a hurry to return to," wrote the expatriate novelist. "I feel in a tremendous hurry, when I think of the beautiful things you are doing—and when I *do* get back, the desire to see them will not leave me without a part in the adventure."[36]

In the coming decades, like most of Daniel Chester French's best-known works, the *Gallaudet Memorial* would inspire further exhibitions and reproductions. For a time, French kept the full-size model at his Manhattan studio. A photograph made around 1890 shows it sitting below a stairway, with the balding sculptor, elaborately mustachioed and clad in an artist's smock, posing above it on the upper landing. He would go on to display it at the 1893 World's Columbian Exposition in Chicago, after which the original plaster sadly vanished. When the National Association of the Deaf proposed in 1924 to commission a replica for Thomas Gallaudet's first academy

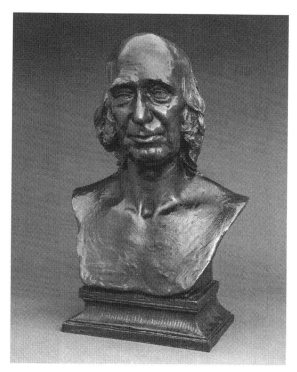

Portrait of Amos Bronson Alcott, bronze, ca. 1889-91 (Chesterwood, Stockbridge, MA)

for the hearing-impaired in Hartford, Connecticut, French was compelled to order a fresh mold taken from the statue in Washington. The resulting bronze was cast and dedicated in fall 1925, and the now esteemed French received an extra five-thousand-dollar fee for his participation, nearly double what he had earned for the original.

Additional models ended up at various institutions, including the replica now at the University of Illinois Library, which French had "unloaded," as he put it, on the younger sculptor Lorado Taft in 1926.[37] None of the replicas could ever convey the unique power that great art achieves in a perfect setting. By the time the Columbia Institution for the Deaf officially changed its name to Gallaudet College in 1954, the school had long served as the home of the original statue, and the statue had become the symbol of the school.

Whether influenced by his ten months of advanced study in Paris, or reflective of his maturing style and increasingly assured technique, the *Gallaudet Memorial* took Daniel Chester French to a new plateau of virtuosity. In depicting his subjects staring at each other, rather than at the viewer, the sculptor commanded attention with assurance, flair, and daring. In

focusing on the figures' hands—floating naturalistically in the air, attempt-
ing to communicate the letter "A" in sign language—French invited a multi-
dimensional appreciation of his work; it can, and should, be viewed from all
angles. His portrait of Rev. Gallaudet was imbued with sympathy and antic-
ipation. And in idealizing, but not exaggerating, the hopeful young deaf girl,
leaning expectantly toward her teacher, the sculptor demonstrated inventive
command of his craft without descending into sentimental exaggeration.

◆ ◆ ◆

French spent the rest of the decade, the waning years of the century, attract-
ing prestigious portrait and monument work, respectable fees, and grow-
ing acclaim. Among the most successful of his efforts was a bronze bust
of another Concord living legend, the Transcendentalist patriarch Amos
Bronson Alcott, which he sculpted in 1889. For French, it proved another
milestone work because he refused to leave the casting process entirely
to others. After years of assigning the final modeling to foundry artisans,
French made this the first bronze he completed under his own supple touch.

The subject, an acclaimed philosopher and onetime superintendent of
Concord schools, was perhaps best known to the nation as the father of
a brood of accomplished Alcott daughters that included French's first art
instructor, May Alcott. Following a protracted illness, the ancient author
of *Concord Days* and other books had slipped away in March 1888 at the
impressive age of eighty-nine, followed in death just two days later by his
most famous offspring, *Little Women* author Louisa May Alcott. French had
actually posed Bronson for "a head" from life back in 1880 for his home-
town's Fortnightly Club. Although the philosopher had happily sat for "our
young artist, Mr. French," and at first commented that the work in prog-
ress "flatters my pride," he disapproved of the final result, which nonetheless
was installed on a wall bracket facing the club's speaker's platform oppo-
site a bust of Emerson. To his fussy subject's chagrin, French had depicted
Bronson Alcott in "modern coat and cravat," and the old man believed he
had earned the right to be portrayed in the classical garb befitting a fig-
ure for the ages. "My friends think this is a good likeness," Alcott sniffed of
French's effort. "I do not. At least, I hope it is not."[38]

Nonetheless, when French's *Ralph Waldo Emerson* bust inspired adap-
tation into marble, a number of Concord residents proposed that his Alcott
plaster be carved as well. But Alcott's unanswered complaints put an end
to that aspiration. After he died, and although French had by then shunned
neoclassicism for naturalism, the sculptor graciously agreed to refashion the

portrait in accordance with Alcott's vision of himself. The beautifully modeled result, nude and in the "herm" style (an artistic compromise, since it featured neither modern nor classical garb) remained on display at the Concord Free Public Library only until 1897. Today it is preserved at Chesterwood. The plaster model French sent as a gift to the Art Institute of Chicago, then headed by Will French. But it would vanish along with other French casts in the museum's lamentable deaccessioning purge of the 1940s.[39]

Around the same time as he worked on his posthumous Alcott in the early 1890s, French contributed a second sculpted portrait to the US Capitol collection, this time a thirty-one-inch-high marble bust depicting the nation's first vice president, John Adams (and thus, in a way, French's second presidential portrait, his earlier Garfield bust being the first). As flattered as he was to be invited to depict Adams, French was none too pleased about the modest eight-hundred-dollar fee that the Senate authorized for each of five vice presidential likenesses it commissioned. Protesting that his customary fee for such work was now one thousand dollars, French only reluctantly accepted the lower pay after advising architect of the Capitol Edward Clark: "I consider it an honor and worth a good deal to have a bust of mine in so important a position," but cautioning: "I do not know how many sculptors you will find who will look at it in the same way."[40] Clark, who was the longest serving chief architect of the Capitol, sought to ease the burden by recommending that the sculptor merely copy an existing Adams statue.

Mindless replicas were not French's style, even for discounted honoraria. Besides, as French pointed out: "There is an absurd bust in Faneuil Hall, Boston, that was taken late in life and looks like a silly old woman, and there is another in the church at Quincy that was probably made after his death and is not necessarily authentic. I should not want to copy either of them."[41] Instead, French consulted life paintings of the founding father, particularly a Gilbert Stuart canvas commenced during Adams's presidency and completed, after both artist and subject had died, by the portraitist's accomplished daughter, Jane Stuart.[42]

"I think you have been successful," the architect of the Capitol congratulated French when he first saw a photograph of the finished Adams model. "You have put some character in it." Today, the naturalistic bust and Moses Ezekiel's marble of Thomas Jefferson occupy the central niches directly above the vice president's chair in the Senate chamber, where they are surrounded by the sculpted portraits of their successors that now encircle the visitors' gallery.[43]

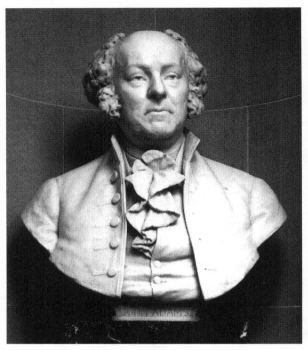

John Adams, marble, 1886–90, Senate chamber,
United States Capitol, Washington, DC

Although he had sworn off art competitions and committees, French could not resist the temptation next to prepare a clay model for a proposed Henry Wadsworth Longfellow monument at Minnehaha Falls near Minneapolis, the pristine site celebrated in Longfellow's "Song of Hiawatha." The memorial site was to be designed by the venerable landscape architect H. W. S. Cleveland. French visited Minnesota in June 1890 and returned home to prepare an inspired clay maquette that portrayed Longfellow enthroned in a niche carved out of a cliff, seated before a frieze adorned with relief portraits depicting Native Americans. "I am running wild over the photo of Dan French's Longfellow Memorial," Cleveland soon exulted. "He wrote me that he thought it the best thing he had ever done." Cleveland agreed. "I tremble to think that it may prove only a vision," the patron wrote some months later, perhaps in response to local opposition to such an incursion at an otherwise wild and natural setting. This may explain why nothing came of the project. No record survives of the unrealized effort save for a lone photograph of the clay model. (The sculptor would turn again to his conception only after winning another Longfellow commission, twenty years later.)[44]

French had better luck securing a contract to produce a larger-than-life bronze of the clergyman-turned-orator Thomas Starr King, his third major statue of a celebrated minister (following Harvard and Gallaudet). Though King's fame was by then dimming, the Unionist patriot had earned considerable acclaim during the Civil War by helping to keep his sprawling adopted state of California from either splitting in two (with the southern section joining the Confederacy), or establishing itself as a Texas-style independent republic. When King died at age thirty-nine in San Francisco, a year before the war ended, he was said to have uttered as his final words, "Keep my memory green."[45] Yet it took nearly a quarter of a century for his admirers to form the King Monument Committee dedicated to installing a statue in his honor at a cost of some fifteen thousand dollars—a healthy eleven thousand of which was earmarked for French.

"I am going to make it ten or eleven feet high—the biggest I have done," the sculptor determined when he started the commission in January 1889. Preoccupied with other work, he did not complete his initial model for another six months. "It represents the great divine as delivering an address," reported an observer who saw the piece in September of that year. "[A] roll of manuscripts is held in the left hand, and the right rests upon a set of Roman fasces"—the classical symbol of political authority.[46] French ordered the final model cast in bronze in Massachusetts and then shipped the statue to San Francisco, where it was dedicated in October 1892. Not considered one of the sculptor's most inspired creations, though it at least showcased French's growing fluency with drapery, it sits now within Golden Gate Park, as neglected today as its once-famous subject. It was not always so. King was once so admired that a mountain peak in Yosemite was named in his honor. In 1931, California would send a Thomas Starr King bronze by another sculptor, Haig Patigian, to represent the state in the US Capitol's Statuary Hall. But by 2009, with King's achievements long forgotten, California ordered the statue removed from the Capitol and replaced it with one of a more recent favorite son: Ronald Reagan.

◆ ◆ ◆

Without question, the most acclaimed of French's works in the 1890s was the ambitious composition in extreme high relief formally titled *Death Staying the Hand of the Sculptor*. This memorial to French's deceased contemporary and onetime artistic rival, Martin Milmore, was commissioned for the Forest Hills Cemetery in the Roxbury section of Boston, a municipal burial spot that combined new trends in rural cemeteries: providing solace

through the "surroundings of nature" and offering affordability to the poor for plots at a discounted rate.[47]

This time, French knew precisely what his subject looked like. He had known Milmore in both Florence and Boston, though never intimately enough to consider him a close friend, even though at one time they both worked at the same professional building on Boston's Tremont Street. Milmore had died of cirrhosis of the liver at the age of thirty-eight in 1883, without ever approaching French's success.

Still, subject and artist had much in common. Like French, Milmore had been a disciple of Thomas Ball and a onetime student at his Florence studio. Both men had rented space at Boston's Studio Building at the same time. The Irish-born Milmore had achieved success at a very young age—again much like French—creating giant decorative statues for Boston's Horticultural Hall by the time he was twenty, a commission that Ball had secured for himself but turned over to his promising student. Milmore's other works included busts of Longfellow, Webster, and Sumner, along with the Ralph Waldo Emerson that both Emerson and French's stepmother had once pronounced inadequate—inspiring French to attempt his own portrait of the philosopher. With more success, Milmore had sculpted the "vibrant and stoic" enlisted men for the Soldier's and Sailor's Monument on the Boston Common, and, with his brother, created the curious *American Sphinx* for the Bigelow Chapel at Mount Auburn Cemetery in Cambridge, a figure the Milmores "Americanized" by replacing the asp on the creature's headdress with a carved eagle.[48] Chicago sculptor Lorado Taft judged Milmore's output merely workmanlike, declaring of his sculptures that few seemed "inspired; they never thrill."[49] Yet when the sculptor died he was widely mourned, not so much for his accomplishments but for his unfulfilled promise. More importantly, before his death, Milmore had unknowingly arranged to perpetuate his own memory.

The sculptor's will earmarked funding for a sculpted monument not to himself but to his late older brother, James, a stonecutter with whom he had occasionally collaborated. The will of a third stonecutter brother, Joseph, who survived Martin by only three years, in turn called for a different monument featuring bronze busts of all three Milmores, along with their mother. To complicate matters even further, Martin's onetime fiancée and coexecutor—who had gone on to marry brother Joseph but was now widowed—also envisioned the monument as a tribute to all the Milmore boys, but not her mother-in-law, for reasons that can only be imagined. French, who was accustomed to navigating large and complex families,

evidently saw the project from the first as a chance to craft a symbolic tribute to all sculptors taken from their work too soon. He well remembered Martin Milmore as "a picturesque figure, somewhat of the Edwin Booth type, with long dark hair and large dark eyes," but he resolved to attempt no traditional likeness.[50]

No one knows for certain how French won the commission, but by February 1889 he had shared the news that "I am working on the design for the Milmore memorial, which will test my abilities to do an ideal thing."[51] Indeed, his extraordinarily ambitious concept would have tested the skills of any sculptor of the time. It would be a literal depiction of death striking down an artist in his prime, an otherworldly figure confronting an earthly one, daringly combining classical and naturalistic styles, and allegory and realism, in a single composition. French's original clay maquette showed an elaborately winged angel calling home a vigorous young sculptor midwork, his chisel and mallet in hand, and his knee resting on a ledge for support as he labors on a sculpture of his own. The rough clay sketch is rigidly posed, but one can sense the frenzy of inspiration that animated it. While the concept seems to have sprung principally from French's imagination, he may well have seen reproductions of Jules Joseph Lefebvre's 1865 *Young Painter of Greek Masks*, for that character, also seen from behind, bears an uncanny resemblance to French's "young sculptor."[52]

Although his final composition would stray little from this audacious original conceit, French worked diligently to improve—and, in a sense, to simplify and humanize—its design. For one thing, French rearranged the figure of the sculptor, positioning his left knee, rather than his right, on the ledge, an alteration that made the pose infinitely more balanced. In addition, his final design would show the angel of death hooded, her face in somber and perpetual shadow, yet somehow unthreatening, even comforting. She would appear clutching a garland of poppies, signifying both death and the bestowal of fame, leaning toward and gently touching the chisel held by the visibly startled, quintessentially modern young artist. The young sculptor, who would appear younger than Milmore to better represent youthful talent cut short, is shown carving a sphinxlike figure in relief, the very project that the Milmore brothers had executed together for Mount Auburn Cemetery, though as French hastened to point out, sphinxes were "usually interpreted as mystery. In this case the mystery of life and of death." That the Milmores had "sculptured" such a beast for Mount Auburn French unconvincingly insisted was "a coincidence."[53] Although recent scholarship has suggested that Milmore had less to do with the Mount Auburn sphinx than

did its patron and designer, Jacob Bigelow, French clearly counted himself among those who credited the figure to Milmore.[54]

As always, French conducted methodical research to get his details exactly right. In 1890, he even wrote to his childhood bird-watching companion, William Brewster, now a leading naturalist, to seek his advice about a key element of his design. "Our pursuits join hands," he enthusiastically announced to his old friend. "I have this winter to model an angel and it occurred to me...that you might help me in the study of wings. Can't you without much trouble...get me a lot of them? I should like half a dozen pairs or so of different kinds and sizes, not with a view of copying any one particular specimen, but for the purpose of studying up on the subject. They would serve my purpose best, dried just as they naturally close."[55] Before long, French's studio boasted a collection of birds' wings in different shapes and colors, provided by Will Brewster with the same thoroughness he had shown in filling his little home museum as a boy.[56]

French produced his life-size clay model at his New York studio. The eight by eight-foot clay block soon filled a large corner of the room. Here, a remarkable photograph was taken depicting the sculptor at work, dressed in striped pants and smock, holding a lump of clay in his left hand and theatrically using his right thumb to refine the angel's breast. The staged but compelling image reveals the angel elaborately draped, but the figure of Milmore still nude, his buttocks fully delineated, indicating that French had not altered his working methods since sculpting his *Minute Man* twenty years earlier. Now, as then, he began such projects by creating his figures nude, working only later to add clothing—in the case of the "young sculptor," a laborer's tight trousers and a form-fitting sleeveless shirt that gave French the opportunity to highlight his subject's taut, muscular arms, possibly modeled after his own. He would add an apron and slippers, and give the angel a symbolic trumpet to announce her sad mission on earth.

French took a plaster version with him on yet another extended European trip that began in November 1891. Returning to Paris, he established a "dear little studio" on the Rue du Faubourg Saint-Honoré, not far from the Arc de Triomphe. His neighbors included sculptor Emanuel Frémiet and American-born painter Julius Rolshoven.[57] Here, French received compliments from guests who inspected the Milmore as it progressed further, and then basked in additional praise from a hundred "artists and otherwise" who visited when French exhibited the finished plaster at a studio salon in January 1892. As he reported to his brother once the "big reception" ended, "really, William, it looks as if I had done something tolerable well this time."[58]

If he embarked on any visits to local cemeteries during this trip, he remained uninspired by their many memorial sculptures featuring winged angels floating through space. Though ethereally gowned and formidably winged, French's angel of death remained firmly grounded and touchingly humanized. French was now confident enough to reject affectation; the result of his previous studies in Paris had already been subtly absorbed into his own technique. Returning briefly to America in February 1892, French left the Milmore plaster behind to be cast in bronze by a local foundry. In May, the completed work went on exhibit at the Salon de Champs-Élysées, where it won a third-class medal from the jury, a rare honor for an American. "To those who understand the undercurrents of the Parisian art world," marveled art critic William A. Coffin, "the significance of such an award under the circumstances is very great, for it shows that the work was thus recognized purely because of its transcendent merit."[59] In the one surviving review by a Parisian critic, French was mistakenly identified as "an English sculptor," but earned praise for both the "conviction" and "strength" of his *Death and the Sculptor*.[60]

French had meanwhile shipped his plaster model to New York, and when he followed it home it soon stimulated an extraordinary publicity wave of its own, fueled by two separate and widely praised local exhibitions, the first at the Society of American Artists, the second at the New York Architectural League. Photographs of the model were soon "seen in every picture store," with sculptor Lorado Taft reporting that "they hang in thousands of homes" and could be found "in offices and upon the desks of men of business." Applauded Taft: "It is a wonderful thing, a very great privilege, to be able to talk thus to one's countrymen. And to do it in a language so exalted, with an eloquence so sustained."[61]

Though gratified by the adulation, French permitted himself to admit of the statuary group only that "the newspapers have puffed it up," joking that "I am likely to be impoverished giving away photographs."[62] On a more serious note, the craze for these photos made him aware for the first time of a potentially lucrative confluence of media: sculpture and photography. One-dimensional images of his three-dimensional works might not convey the full depth of the originals, but they could successfully "puff" his creations and, in the bargain, earn extra money as authorized reproductions. For years, French had used photography merely to record progress on his statues or share images with his brother and other distant advisers. Now, he began adapting photography as a promotional tool. Within months, the sculptor would copyright an official photograph of *Death and the Sculptor*,

presumably to begin marketing copies on his own. For the rest of his career, French kept a close watch on photographs of his statues, trying when he could to control the images and profit by them. Of course he sent pictures of the Milmore to his old pal Will Brewster, hoping the noted ornithologist would "see what use I made of the wings that you were kind enough to send me." French hoped the results would meet with Brewster's approval, "even if you cannot decide at a glance what genus or species of angel in particular they belong to."[63]

Meanwhile, in August 1893, without the fanfare of an official public dedication, the Milmore family quietly installed the original bronze over the brothers' gravesite at Forest Hills Cemetery, mounting it on an unadorned, independently designed pedestal that, according to one disparaging critic, crossed the border of "simplicity...and grazed on the edge of inanity."[64]

Three months earlier, in May 1893, French had placed his already famous Milmore plaster on display at the World's Columbian Exposition in Chicago. When the fair closed the following October, Will French made the Milmore the centerpiece of an exhibition at the city's Art Institute. It was then that Will French came up with the inspired idea that his brother make a fresh mold of the plaster before it began inevitably deteriorating. With the approval of the Milmore heirs, Dan French authorized four new plaster copies—one each for museums in Boston, St. Louis, Philadelphia, and, of course, Chicago, where it became a mainstay and an inspiration to both writers and musicians. One poet composed an ode and sent a copy of his handwritten manuscript to the sculptor: "How the marble throbs beneath my touch." A minister wrote and published a long sermon lauding French for "shaping death as a friend" and urging that replicas be produced and distributed so the image could be appreciated outside of the cemetery for which it had been created. And in 1919, a visit to the Chicago display, accompanied by French himself, stirred New England composer George Whitefield Chadwick to create "a Symphonic poem," which he debuted at the New York Philharmonic that February. Assuring French that he had not altered his belief that "music exists for itself alone," Chadwick admitted that the *Milmore Memorial* had inspired him, generously telling French he hoped he "had given expression, however inadequate, to the principal motive of your work," and had expressed "what I saw and heard in your beautiful sculpture."[65]

Sadly, the plaster replicas that had so deeply moved Chadwick, along with all the other second-generation plaster casts of *Death and the Sculptor*, proved no less perishable than the original. All of them, save for the sole copy now preserved at Chesterwood (originally on view at the Museum of

Fine Arts, Boston, and later at the Corcoran in Washington), were destroyed in the 1940s.[66] Long before that, almost mercifully, the cement base at Forest Hills Cemetery began to give way, igniting an angry exchange between French and Joseph Milmore's son, Oscar, who held the sculptor responsible for eroding conditions at the gravesite. French would have none of it. At one point, he snapped at Oscar Milmore: "If you had appreciated how it would sound to the recipient, I doubt if you would have written exactly what you did. When you say that the masonry in the monument was not what the contract specified, you are coming pretty near accusing me of dishonesty. This, of course, you did not intend and I pass over it without further comment. It is my wish not to discuss ancient history, but to see what can be done to mount the bronze in such a way as to display it to best advantage."[67] In a later effort to patch things up, French would generously offer in 1921 to pay up to $2,500 out of his own pocket to relocate and stabilize the monument, and even asked his by-then closest architectural collaborator, Henry Bacon, to design a replacement base. Ultimately, the Milmore clan acted on its own to move the sculpture to a new location, atop a new pedestal, which the sculptor praised when it would have made no difference had he objected. Unable to dictate location and accompaniment, as he had done with such authority at Harvard, French could only express his presumably sincere compliments to the Milmore heirs for at least successfully preserving the statue and the site.

Wherever it was installed, on whatever base it was mounted, *Death and the Sculptor* took its place as French's best work to date and one of the greatest funerary monuments created by any American artist—"justly celebrated," in the words of one critic of the day, as "a production of singular beauty and surpassing impressiveness."[68] While acknowledging a "suggestion of the theatrical in the composition," the *Chicago Tribune* nonetheless saw "something distinctly fine about the conception and the execution of this work" after its critic observed the plaster at the Columbian Exposition.[69] Commenting a few years later, art critic Henry Charles Payne dubbed *Death and the Sculptor* "Mr. French's Masterpiece," adding: "It seems to me that art could no better suggest the mystery, the awe, the inevitableness of death than Mr. French has done here." Remarkably, Payne appreciated not only the beauty of the composition, but the power of what French had left unexpressed: "There is something potential and beyond this action, free and large, something held in reserve....It is this feeling of unspent energy, this that is the very spirit of life when all its best years are before it, that makes the group so adequate a symbol, and that is its great distinction as art."[70] Nearly

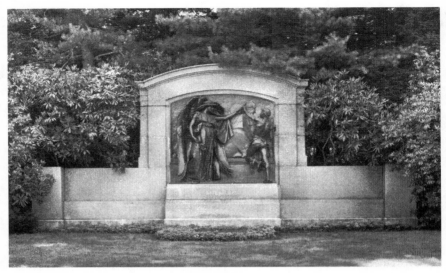

The *Milmore Memorial*, bronze, 1889–93,
Forest Hills Cemetery, Jamaica Plain, MA

two decades later still, the work's reputation remained high. "It would be difficult to find a piece of modern sculpture in any country," pronounced *The Art World* in 1917, "that surpasses 'Death and the Young Sculptor' in beauty, majesty, and tenderness—all qualities, in truth, that we have a right to demand in the monument of a youth of genius."[71]

"The idea is simplicity itself," marveled the highly regarded traditionalist Royal Cortissoz, who served as art critic of the *New York Tribune* for more than fifty years. "The allegory needs no elucidation. The group has no complexities. Its meaning is pithily conveyed. Yet no work has left an impression more deep, more lovely, more richly laden with the solace of lofty sentiment beautifully enshrined." As Cortissoz concluded, in what amounted to the most rhapsodic review the sculptor had inspired to date, "Mr. French is more than a craftsman...and his example, therefore, is beyond price in this period. His star has risen very recently, but it flings a steadfast beam of pure and welcome light into the ranks of the American school." To Cortissoz, the "most remarkable monument...turns criticism into something not unlike eulogy."[72]

Inevitably, at least one contemporary came to believe that art, music, and literature by professionals all failed to convey what French intended to communicate in his sculpture. In a heartfelt but clumsy attempt at narrative accompaniment, the Milmore brothers' surviving sister, Josephine "Pepita" Milmore, composed a poem and had it inscribed in all-capital letters on

a bronze tablet mounted at the memorial, now often partly obscured by unpruned leaves.[73] In this effort she clearly aimed for the same effect provided years earlier by the Ralph Waldo Emerson verse gracing the pedestal supporting the *Minute Man*. The striking difference—aside from the quality of the writing—was that back in 1874 an acclaimed poet had inspired an untested sculptor; now, an acclaimed sculptor had inspired a young, untested poet:

> "Come, stay your hand," Death to the Sculptor cried
> Those who are sleeping have not really died.
> I am the answer to the stone your fingers
> Have carved, the baffling riddle that still lingers
> Sphinx unto curious men. So do not fear
> This gentle touch. I hold dark poppies here
> Whose languid leaves of lethargy will bring
> Deep sleep to you, and an incredible spring.
> Come with your soul, from earth's still blinded hour
> Mount by my hand the high—the timeless tower
> Through me the night and morning are made one.
> Your questions are answered, your long vigil done,
> Who am I? On far paths, no foot has trod.
> Some call me Death, but others call me God.

Around the same time the *Milmore Memorial* was reset at Forest Hills Cemetery—as America entered World War I, destined to bring more death to the nation than any conflict since the Civil War—French would undertake to produce a marble replica of his Milmore bronze. By then a trustee of the Metropolitan Museum of Art, French was invited by the museum's president, Robert W. de Forest, to produce the marble for the permanent collection. First, the museum exhibited one of the still-surviving plaster models at a 1918 "Exhibition of American Sculpture."

Not until the war ended did French's representatives secure a satisfactory block of marble in Italy. His Bronx-based carvers commenced their demanding work in 1921, with French personally refining the piece beginning in 1925. The following year, he offered to donate the result to the Met, but his fellow trustees overruled him and raised funds to purchase it.[74] A near-exact replica except for structural changes to accommodate the medium of marble, the Met version lacks some of the depth that French had so miraculously accomplished in the bronze—particularly in the angel's

wings. Otherwise, the eight-by-eight-foot marble retains all the power and mystery of the original bronze.

Other than his fleeting mentions of Milmore's physical appearance and Mount Auburn sphinx, French left few written descriptions of his signature nineteenth-century work either during or after its creation. It was 1917, the year the Met authorized the marble reproduction, when the sculptor finally provided his own revealing narrative accompaniment—privately, of course—in a letter to museum president de Forest. As his comment reveals, French had not modeled his group geometrically, or even artistically, but primarily out of a conviction that previous sculptors, starting in medieval times, had far too fearfully imagined the grim reaper. "My message, if I had any to give," he now confided, "was to protest against the usual representations of Death as the horrible gruesome presence that it has been represented to be ever since the Christian era. It has always seemed to me that this was in direct opposition to the teachings of Christ which represented the next world as a vast improvement over this one."[75]

The very next month, the *Art World* made a similar observation about the serene statue, but came to a rather different conclusion: "One may say of the *Milmore Memorial* that it is not Christian in any specific sense, nor is it heathen...if any parallel holds, it would be better to call it in spirit Greek." After all, reasoned the writer, French had likely digested more "spiritual nutrition" from Emerson and the classics "than he did in the Bible."[76]

In *Death and the Sculptor*, Daniel Chester French imagined a painless voyage from life to immortality. In conceiving and crafting it, he came close to achieving it for himself. French demonstrated that he was now capable of incisive portraiture, emotional staging, and soaring allegory—all at once, when necessary. As art historian Thayer Tolles has put it: "In the *Milmore Memorial*, French joined high and low relief with in-the-round sculpture and assimilated realistic and ideal elements into a concordant whole." The exuberant result proved nothing less than a "landmark...in the history of American funerary sculpture."[77] Moreover, by depicting an artist confronting the tenuousness of life against a backdrop of eternal mystery, French also managed to suggest that great art—his own included—would outlast great artists.

French's new, hard-won status had become more evident than ever. On February 14, 1891, one of the greatest Union heroes of the Civil War, William T. Sherman, died in New York City at age seventy-one. The next day, his son Philemon Tecumseh Sherman summoned Augustus Saint-Gaudens to the family's West Seventy-First Street home to make a death

mask of the late general, presumably as he lay in his coffin. As the nation's most prominent sculptor, Saint-Gaudens seemed the obvious choice for such a prestigious assignment. Yet according to one version of what ensued, the Sherman family lawyer (a friend of Saint-Gaudens) proposed that French "be present also," pointing to the somewhat irrelevant fact that French had already sculpted the general's brother, Senator John Sherman. (An alternative bit of family lore holds that it was Saint-Gaudens who invited French to accompany him to the grisly session.) In any event, the two sculptors arrived together at the Sherman home at 10:30 on Sunday night, February 15. Sherman's granddaughter believed that once there, Saint-Gaudens was simply "unable to make the death mask, so French did it." She did not remember why. For whatever reason it occurred, the collaboration served as a powerful reminder that French had now joined his older friend in the pantheon of elite American sculptors. No Civil War–related project, it seemed, could be undertaken without him.[78]

He was beginning to leave a major legacy. And it was not just a reflection of his growing influence on Civil War memory. It might even be argued that at least in America, at least for a time, French's recent depiction of an angel touching the hand of an artist to signal death generated almost the same cultural impact as had Michelangelo's depiction of God touching the hand of Adam to transmit life.

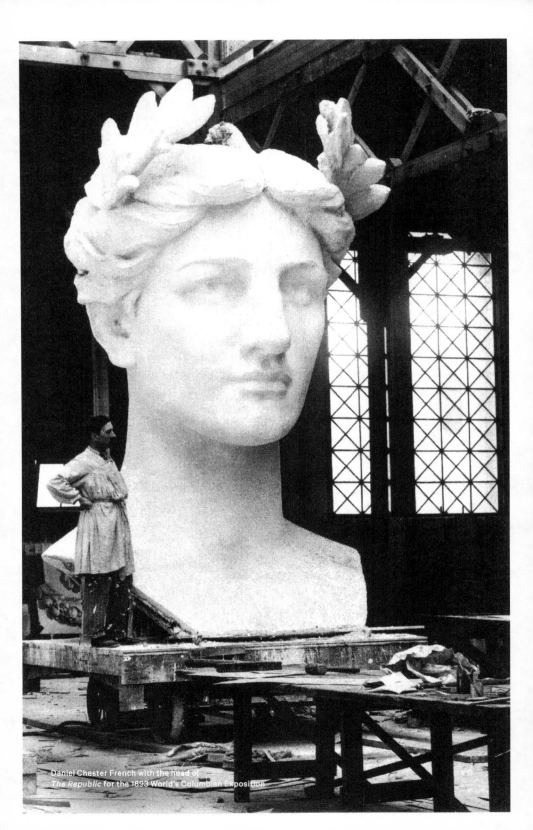

Daniel Chester French with the head of
The Republic for the 1893 World's Columbian Exposition

THE
WHITE
CITY

A n insignificant-looking, two-inch-high plaster cast of a turtle shell is the only surviving relic of Dan and Mary French's idyllic 1891 summer vacation at a farmhouse near "Aspet," Augustus and Augusta Saint-Gaudens's country estate at Cornish, New Hampshire.[1] Charming as it is, the tiny sculpture offers no hint of the enormous impact the visit exerted on French. On the most obvious level, it provided him a welcome escape from the brutal Manhattan heat and a chance to fraternize with fellow artists. And it offered both Frenches a novel, perhaps welcome, break from the inhibiting family tradition of annual summer reunions at the crowded family house at Concord.

As it transpired, the trip provided—and the sculpted turtle shell symbolized—significantly more. In a way, it helped change the very arc of French's personal and professional life, just as his youthful attempt to sculpt a clay frog, the result left on his bemused father's dinner plate, had altered his life thirty-five years earlier. French's visit to Cornish—really more of an artists' colony than a cohesive village—brought him the opportunity to socialize, brainstorm, and even work alongside a revered contemporary in the glorious setting Saint-Gaudens had chosen as a conspicuous summer retreat. Saint-Gaudens had converted a onetime federal-style country inn into a unique mansion with a flourish of eclectic additions and details. Thus the sojourn showed French how an artist of real stature might aspire to live—in a word: grandly. The setting reflected confidence in success while providing further inspiration. At Aspet, French not only executed one of his smallest sculptures but, with Saint-Gaudens's encouragement, began planning his very largest.

Saint-Gaudens's bucolic estate, near the picturesque Connecticut River dividing New Hampshire from Vermont, included near the main house a capacious studio, oriented to bring in the soft northern light. The setting was pastoral without being rustic, baronial yet utilitarian, and above all a showcase testifying to Saint-Gaudens's taste and success. Here was a luxurious summertime arrangement that French could never hope to replicate at the now inadequate little studio he had once built alongside his Concord family home. Aspet offered the awed visitors plenty of space for family activities, too. Never physically strong, Mary French soaked up sunshine while happily watching young Margaret frolicking on the sloping grounds and occasionally playing children's word games with Saint-Gaudens himself. That summer, Dan French observed what might be called an ideal domestic "pedestal"—created by the most renowned sculptor of the day to display himself—a retreat that not only facilitated work, but stimulated it. Someday, French may have promised himself on this trip, he would create such a retreat for himself.

French inscribed his cherished sculpted turtle shell on its underside, "Cornish / Sept. 6 / 1891," taking it back to New York at the end of his vacation. He would keep it on display at his own various studios for the rest of his life, signifying that it represented something much bigger than its modest size, and far more complex than its rudimentary design. It may have reminded him that while he had arrived at Aspet as Saint-Gaudens's guest, he proudly departed as his peer. The two sculptors spent at least part of their vacation discussing upcoming joint projects, for they were soon to begin work on the biggest stage either of them had yet attempted to conquer. But following up immediately on their shared plans would have to wait. Within weeks of his return to Manhattan, Dan and Mary French departed for "cold and gray and muddy" Paris so the sculptor could personally oversee the bronze casting of his Milmore memorial.

It was Mamie French's first trip abroad, and while she came to hate the bone-chilling weather—her husband had grown accustomed to cold European autumns back in Florence years earlier—she reveled in the Parisian social whirl. She and French regularly called on fellow artists, paying frequent visits to the nearby studio of painter William-Adolphe Bouguereau. There they met the New Hampshire–born mistress of the Bouguereau house, "whom he either married or didn't marry," Mamie reported, so excited she could barely keep the gossip straight. Advancing up the ranks of expatriate society, the Frenches attended the wedding of the American ambassador to France, Whitelaw Reid, the newspaper publisher who under the pen name

"Agate" had once filed Civil War battlefront stories. Mary met Oscar Wilde several times, and sat next to a Danish prince at a dinner.[2] But she also came down with a nasty cold that lingered for months.

For French, the trip was all about the work: above all, another chance to absorb and apply the Beaux-Arts sculptural techniques to which he had been first exposed during his previous Paris sojourn in 1886. In addition to completing and exhibiting his Milmore, he also began to refine his design for the challenging commission he had begun brainstorming with Saint-Gaudens at Aspet. It was to be a colossal-size statue for the prime location in an enormous man-made pool at the upcoming World's Columbian Exposition in Chicago, marking the four-hundredth anniversary of Christopher Columbus's first voyage to the Americas. *The Republic*, as the behemoth would be called, was meant not only to be the centerpiece of the fair, but the emblem of the entire country—a highly ambitious, perhaps unattainable, goal, considering that Auguste Bartholdi's Statue of Liberty had already achieved iconic status after less than a decade overseeing the entrance to New York Harbor.

The fair's director of works, Chicago architect and urban planner Daniel Burnham, chose French for the commission on the recommendation of his official sculptural adviser, none other than Augustus Saint-Gaudens.[3] Whether or not French knew it, Burnham also promised Saint-Gaudens, who began jocularly referring to French's proposed statue as "Liberty in the lagoon," a six-thousand-dollar fee so that the "important" figure would have the senior sculptor's "supervision and care."[4] Burnham contracted to pay French eight thousand dollars of his own once he produced his model, and another fifteen thousand to create the enlargement on-site.[5] In creating the signature image for Chicago, French would be expected to trump Bartholdi and, more importantly, New York City, while exalting American virtues to the world. In scale, the massive statue, roughly the height of a five-story building, would be monumental beyond anything French (or any other American sculptor) had ever attempted. If he nursed any reservations about the daunting assignment, French had little choice but to bow to the confidence expressed by Saint-Gaudens, who thought "no one else could do it so well."[6]

For his part, French readily admitted that "St. Gaudens was very helpful to me...instrumental in getting the statue of 'The Republic' for me to do."[7] Afterward, French relied on his senior colleague for ongoing advice. "St. G. thinks it is a buster," French proudly informed his brother after returning from Aspet. The preliminary "design by French," he freely admitted, had

been "improved by St. G" and other professionals residing at Cornish. "I think the *ultra* artists may like it, but I have my doubts about the *populi*....It is almost archaic."[8]

The fair promised French his first opportunity to engage officially with Saint-Gaudens in a professional, yet mostly collegial and administrative, collaboration.[9] Both men agreed to serve on juries empowered to choose among their fellow sculptors' submissions to the exposition. There would ultimately be thousands. Saint-Gaudens became one of five jurors representing New York City, while French, with claims to professional status in two different cities, joined the Juries of Selection from New York and Boston alike. Together with Lorado Taft of Chicago and Robert Bringhurst of St. Louis, French obligated himself to additional work by agreeing to serve as well on the prestigious International Committee of Judges for the Department of Fine Arts. The eminence of the jurors, declared the *New York Times*, guaranteed "the faithfulness and intelligence of their work."[10] "Gentlemen," Saint-Gaudens was said to have jokingly boasted to Burnham at one of their earliest meetings, "Look here, old fellow, do you realize that this is the greatest meeting of artists since the fifteenth century?"[11] But participants remembered that French never let the proceedings become too ponderous, throwing up his hands "in feigned despair" whenever "baffled" by a new proposal, then exclaiming that he "didn't know anything about sculpture anyway."[12]

Eventually the juries would choose 148 American sculptures for exhibition at the World's Fair—more than from any other nation—including three by "Daniel C. French" himself.[13] The emphasis would be on contemporary themes and native-born heroes. Saint-Gaudens's son later lauded French as one of the handful of artists who, through sheer talent and "the force of his mind...joined with my father in discovering the path that led out from the forest of petrified heroes and galvanized athletes of the early days."[14] It was high praise indeed, undoubtedly gleaned directly from Saint-Gaudens, who, though only two years French's senior, had already earned a national reputation.

Except for his notorious arrow-shooting nude, *Diana*, removed from New York's Madison Square Garden and installed on the roof of the fair's Agricultural Building, Saint-Gaudens himself remained underrepresented at the exposition. While he later lent (or did not lend) one of his other pieces for display (the contribution was acknowledged in some accounts of the fair, but ignored in the official catalog, suggesting it may have been an afterthought installed by popular demand), an array of old and new works by

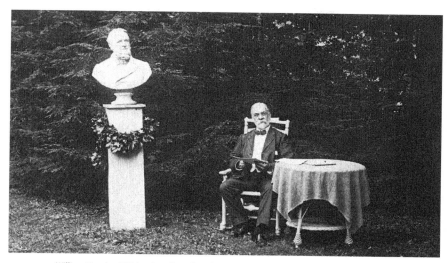

William Merchant Richardson French in the garden at Chesterwood, his brother's estate,
alongside Daniel Chester French's portrait of their father, August 1913

French would go on view both outdoors and indoors. In fact, by the time the exposition closed in October 1893, following a triumphant six-month run that lured some twenty-six million visitors, it is reasonable to say that more people saw Daniel Chester French sculptures there than had ever gazed on his works before—anywhere. Yet for a surprisingly long time, not even the extraordinary opportunity to reach such a massive audience could compel the preoccupied French to turn his exclusive attention to his obligations for the fair.

French did make one preliminary trip, in June 1891, to inspect the fairgrounds when it was little more than a barren landscape of construction pits. This was just a few months before joining Saint-Gaudens at Cornish. But then he had headed off to Paris. As Daniel Burnham fretted, then seethed, French showed little inclination to return to the States to work on his statue, unapologetically admitting to Will French, as fall turned to winter, that he and Mary had gotten into the lazy habit of doing "a little sight-seeing when we get time," and then "going to an occasional dinner or something" before sleeping "about nine or ten hours" a night.[15] Meanwhile, the deadline for submitting his design for *The Republic* grew nearer with nothing to show for it. Shortly after Christmas 1891, Burnham anxiously cabled French to stress that it was "of the utmost importance that you should come at once to Chicago with your models." He vowed to provide French "studios with abundant space for yourself and assistants, and the most perfect

light possible," adding a week later a promise that the work space would sit within "the grounds," and come "free of cost to yourself."[16] Receiving no immediate reply, Burnham felt compelled just days later to remind French more pointedly that, "as per your contract," the sculptor was obligated "to be here with the completed model on or before April 1st," adding ominously: "This must be done. We cannot go on with your statue except as agreed." The deadline, he warned, was a "dead certainty."[17]

Burnham's dogged reminders succeeded only in irking French. "Agitated by telegrams," he implored his Chicago-based brother, Will, to calm Burnham down, terming the fair manager's wires "so emphatic that I thought nothing less than an artistic earth-quake had happened in the affairs of the Exposition." Refusing to be pressured, French argued that rushing his work to satisfy what he regarded as an arbitrary deadline "would have necessitated hurry and slurring and a generally unsatisfactory result." He pledged only to work "as hard as I know how" in Paris, eventually to have the finished model photographed there, and only then to ship pictures to Burnham.[18] It did not seem to concern him that the fair was scheduled to open in May 1893, then only sixteen months away. In truth, he was, as usual, anxious about his concept. "Is it too archaic for you?" he asked Burnham after sending a photograph of a rather conventional model. His original design showed a female figure with her arms extended, "as if welcoming the nations," but he had now decided on something "more conventional" and "symmetrical." Even then, he confided to Will, "I fear it will be a good deal criticized."[19] Ultimately he settled on a figure with arms upraised—not just in greeting, but in a gesture of celebration. French's steely self-confidence, buttressed by the raves he was receiving for his Milmore memorial, would have been unimaginable just a few years earlier.

Not until early February 1892 did he finally board the *Normandie* for his return to America. The pursers safely stored below deck his long-delayed and newly completed three-foot-high model of "the colossus." A classically robed, crowned female figure, destined to rise in giant form in Chicago, now crossed the Atlantic in miniature, swaddled in packing cloth and lying on its back in a steamer trunk. It proved to be the only "woman" accompanying French home: fearing the winter crossing "would be too hard on Mamie," he left his sickly wife behind with their daughter "to become familiar with Paris," he jested, especially "the gowns." In a graver vein, he fretted that "I shall be blue and homesick till I find her again by my side," hoping that "the worry and rush over this big statue will divert my mind so that I shan't commit suicide."[20]

Ready at last to begin personally supervising his fairground project, French collected his "studio properties" from New York, and at last got himself, his model, and his tools to Chicago on Lincoln's Birthday, February 12, 1892—well ahead, after all, of the April 1 deadline Burnham had imposed.[21] There, French took up temporary residence with Will French and his second wife, Alice, and their baby son, Henry, who had been named for the late judge. Boarding with his beloved older brother eased French's loneliness. And viewing the transformation at the fairgrounds stoked his creative fires. "I find myself already an enthusiast on the subject of the World's Fair," he reported to his stepmother on the twenty-first. "What they have done since I was here last June is amazing. The buildings some of which are nearly done exteriorly are beautiful and of magnitude beyond imagining. I really think they will be done on time. There is great system and unbounded energy brought to bear and much local pride to keep the enthusiasm up."[22]

"I find myself of considerable consequence here and expect to have a good time once I get underway," he added. As promised, Burnham assigned French prime studio space inside the fair's brand-new Forestry Building, and since it stood so far from the entrance to the grounds, arranged for a carriage and horses to "transport me to and from the station daily."[23] Here, under Burnham's watchful eye, French would begin bringing his giantess to life.

In Burnham's defense, it was this ambitious planner who first envisioned a colossal statue representing the republic to dominate one end of the fair's majestic "Court of Honor." There it would reign as "one of the most conspicuous locations in the park"—facing a mammoth domed administration building rising from a "Grand Basin" filled with water from adjacent Lake Michigan—a spot that would make it "visible from many different directions and constitute one of the great centers of attraction."[24] Originally, Burnham had served only as the exposition's comanager of design and construction, sharing duties with his business partner, fellow architect John Welborn Root. But Root had died suddenly in 1891, and Burnham had taken solo helm, supported by an advisory committee that grew to include Frederick Law Olmsted, the brilliant landscape architect responsible for designing New York's Central Park; forty-four-year-old "American Renaissance" architect Charles McKim; McKim's partner, Stanford White; and their young protégé, Henry Bacon, known as "Harry," sixteen years French's junior. In Chicago, these men would forge strong friendships with French, particularly Bacon, destined in future years to emerge as the sculptor's most frequent collaborator.[25]

Burnham's taste came to dominate all. After Root's death, he discarded some of the fair's more avant-garde design proposals and imposed a monumental scale and harmonious rigor to the architecture. Not everyone in Chicago endorsed his grand but staid vision for a neoclassical ersatz metropolis. Chicago's "father of modernism," for one, rival architect Louis Sullivan, warned that "the damage wrought by the World's Fair will last for half a century from its date, if not longer." Sullivan, who conceded that Burnham at least showed a "remarkable executive capacity" in hastening construction, nevertheless mocked the vision he imposed. Sullivan had hoped for a "Garden City." In its place, he carped, would rise "an appalling calamity" of "stark immensity," an "incredible vulgarity," and "a lewd exhibit of drooling imbecility and political debauchery."[26] It did not seem to matter that Burnham's plan constituted a kind of elaborate stage set, built to last no longer than the fair itself. As the influential *Century Magazine* pointed out, it was "not architecture at all, but rather a scenic display of architecture...models executed on a colossal stage, and with a degree of apparent pomp and splendor." "It was here," Sullivan countered, "that one man's...unconscious stupor in bigness, and in the droll phantasy of hero-worship, did his best and his worst, according to his lights, which were dim."[27]

It was in just this sort of "phantasy" world, however, that French convinced himself he could shine—in this case, literally. His *Republic* would synchronize with the fair's "archaic" surroundings, yet contrast vividly with the stark whiteness of buildings meant to simulate a Greek metropolis. The statue would not only be gilded in bright gold leaf (except for its face and daringly bare arms, to be painted ivory); it would be crowned by a halo-like diadem (meant to suggest American might) illuminated each night by the latest Westinghouse electric bulbs. Thus art would embrace technology, and sex appeal would merge with patriotism, all within an artificial body of water facing a faux-antique city. The prospect of such a cacophony alarmed many. Critics began to refer to French's statue as the "Golden Lady" or "Big Mary," not always admiringly.[28] To little avail, boosters reminded the dubious that the great plazas of Athens had featured large gilded sculpture, too. Sensing that the advance publicity would invariably generate attention and mass visitation, French embraced the loopy discordance. Once shy and uncertain, he now believed himself more than big enough to make the biggest statue at the biggest exposition in the history of the world, even if some would later judge the result cold and unfinished, and others complain it was pretentious and lifeless. At least it would not endure forever.

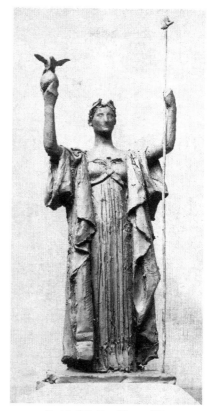

Edith Minturn posing for *The Republic*, 1892 Model of *The Republic*, ca. 1892

Designed to stand 65 feet high atop a 35-foot-high base—110 feet from lagoon to crown—French's *Republic* was conceived to reaffirm American confidence and pride. In keeping with that ambition, French designed his draped goddess to hold above her head emblems of republican virtues: in her right hand, a globe surmounted by a winged eagle to suggest strength and immortality; in her left, a beribboned liberty pole hooded by a Phrygian cap, the symbol of freedom popularized during the French Revolution and reintroduced more recently in American artworks inspired by the eradication of slavery. Unfortunately, what one writer has called "the mix-and-match iconography" would render *The Republic* incomprehensible and pretentious to some observers.[29] At worst, the pose made her look a bit like an overdressed bank customer caught in a holdup, reaching for the skies. What was remarkable about the colossus was not that it proved controversial, but that it got built at all, massive chunk by massive chunk.

French had begun his creative process back in Paris by securing as a model the American beauty Edith Minturn, destined years later to be portrayed alongside her wealthy husband in a beloved painting by John Singer Sargent.[30] Dressing her in a Roman-style *stola* augmented by metal breastplates (a feature wisely de-emphasized for the final statue), handing her a long wooden staff to grasp, and encircling her head with a halo-like metal ring, French had the elaborately costumed Edith photographed arms raised—an unnatural but unquestionably alluring pose—and used the result to fashion his first clay sketch. From this maquette he sculpted the three-foot-high model he took across the ocean to New York, progressing to a twelve-foot-high model four times larger once he returned to the United States.[31] In Chicago, French directed at least four further enlargements. To create the massive final statue, twenty times the size of the original model, he and his assistants draped swaths of mortar-dipped jute (a burlap-textured cloth) over a wood-and-iron skeleton, binding the joints to the frame with thick rope, and slathering the finish with a thick liquid called staff (made by mixing plaster of Paris, cement, and glycerin). It was the same fugitive material that would also cover most of the buildings at the exposition: an oyster-white veneer, substantial-looking to the naked eye, and though capable of drying hard, basically impermanent, and likely to disintegrate after only a few years of exposure to Chicago's extreme climate.[32]

Delighted to find several other sculptors at work on their own architectural ornaments and statues inside the unheated Forestry Building—so cold it froze up the plaster one winter day—French set up his twelve-foot scale model in one corner and soon reported that it "seems to meet with general favor" from his fellow artists, adding: "A cut of it is to appear in *Harper's Weekly* soon and in the *Century Magazine* in May. It looks as if I might be well advertised by it before we get through." While Dan deeply missed his family, he had arrived in Chicago fit, fat (by his standards), and ready to toil. "Paris seems to have agreed with me," he remarked. His weight had ballooned from 135 pounds to all of 147, still leaving his five-foot, nine-inch frame painfully spare. Anticipating "a good deal of worry and labor in the execution of the colossus," he predicted of the welcome extra weight: "I rather expect to work a good deal of it off here."[33] By May he reported, "I am devoting body and soul to the World's Fair."[34]

In late spring, Mamie and Margaret finally joined French in Chicago. Mamie had become so enfeebled in Paris that "a man had to carry her" aboard her ship. French was alarmed by "her condition of nervousness and lack of vitality," though he was "awful glad to have her with me, even if

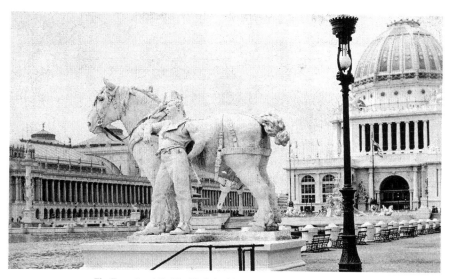

The Teamster at the World's Columbian Exposition, Chicago, IL, 1893

there isn't much of her left!"[35] For her part, the reunion with her husband seemed to rejuvenate Mamie, and she soon felt well enough to visit her husband's studio, where she found him contentedly working alongside artists like Kenyon Cox and Edwin Blashfield. Two young assistants labored with French on *The Republic*: eighteen-year-old Andrew O'Connor (later to become a sculptor of Lincoln), and a twenty-year-old student named Augustus Lukeman (destined to struggle years later to complete Gutzon Borglum's enormous Confederate memorial at Stone Mountain, Georgia).[36] Lukeman took "charge of Mr. French's particular gang" as superintendent of the *Republic* project and eventually became foreman of the entire "studio force" that grew to a hundred men.[37] "It was a good deal, it seemed to me, like building the Tower of Babel," Mamie French remembered after one visit to the studio, leaving a priceless record of how her husband actually constructed his large pieces:

> They made a big square platform a few feet from the ground, and upon this, near the edge, a kind of stockade or fence ten feet high in broad convolutions, covered it with a mixture of jute and plaster which gradually developed into the great ripples of a not very conventional woman's skirt.
>
> They built another section and still another until there were these mushroom growths all about the floor of the Forestry Building where the work was being done.

Of course it was a good deal of a job for a mere artist to plan this great structure, but I have always said that, if Mr. French had not been a sculptor, he would have been an inventor; and the work went steadily on until finally the first section and then the other sections, one at a time, were carried out, planted in the Lagoon, and the head and shoulders of the statue settled into place.[38]

The process Mamie described could be highly dangerous. Laborers and apprentices scampered over scaffolding that ascended to the ceiling, gingerly hoisting cumbersome sections that might each be "as large as a small house."[39] Mamie fretted for her beloved husband's safety: "I used to go down and watch the work going on and shiver to see my only husband climbing around at such a height. The men were always tumbling off things, the work was rushed, and the workmen were perfectly reckless. Ambulances were dashing around the town at all hours of the day and night, and we wives, sitting at home, used to wonder at each noise clanging by the house which particular husband was being brought home, and what particular accident had happened to *him*!"[40] Constructed in five huge sections, the first, the bottom chunk, was placed on its pedestal in July 1892. The final piece—the head—included a small interior stairway so technicians could electrify its crown. French had the entire statue installed and conjoined by November 1892.[41] Gilding commenced the following spring, with French reporting in late April 1893: "The Republic is being covered with fine gold—real gold leaf—and will burst from her chrysalis the last of the week....She will be splendid."[42]

Although working nine hours a day to complete this signature piece on time, French could not resist the temptation to accept other prestigious assignments for what he now called "this blessed Fair."[43] To some visitors, the World's Fair would seem a large gallery designed particularly for the display of sculptures by Daniel Chester French. Fortunately, he quickly enlisted another colleague to help him undertake the additional projects. In this case it was his onetime pupil, Edward Clark Potter, now a specialist in sculpting animal figures. Potter's expertise dovetailed perfectly with French's reluctance to dabble further in that elusive field of modeling, never his forte. Potter made the animals while French worked exclusively on the humans. Launching a long and productive collaboration, the two partnered seamlessly on a suite of figural groups that would stand at the entrances to Charles McKim's Agricultural Building. The sculptures would represent the *Teamster*, the *Farmer*, *Indian Corn*, and *Wheat*. ("Classic beauty... effectively combined with...noble horses and oxen," declared one observer.

French himself was no less pleased. "You should see a negro teamster I have made," he told his stepmother, a sculpture that a critic went so far as to call nothing less than "Michelangelesque.")[44] As another writer pointed out: "It is rare indeed to see groups by two sculptors so perfectly harmonious in their central motive and in the treatment of it."[45]

French and Potter split the work as well on yet another dominant sculpture entitled the *Columbus Quadriga*, designed to represent Christopher Columbus arriving "at the triumphal fete given in his honour on returning from his first voyage."[46] Meant to represent "the spirit of discovery" rather than depict the explorer himself, it featured a heroic figure riding in a Roman-style chariot drawn by four horses and led along by draped female figures in seemingly fluid motion.[47] The big statuary group (the plinth was forty feet square, while each horse would rise fifteen feet high) was to be hoisted onto the roof of the so-called Peristyle building designed by architect C. B. Atwood, directly behind the *Republic*, a structure whose arched entryway led dramatically from the interior lagoon into Lake Michigan. Working an exhausting schedule by day and seldom leaving his "tiny' house to "seek entertainment in the evening," French managed to balance all these assignments.[48] As for the result of his final contribution to the fair, one critic hailed the *Quadriga* "an achievement worthy of its situation as the dominating embellishment of the great court with its wealth of sculpture and ornament."[49] That one sculptor undertook, much less completed, so many pieces for the exposition must be ranked as nothing short of extraordinary.

To execute these additional World's Fair commissions with Potter once *The Republic* was complete, French moved his studio out of the Forestry Building and into a walled-off corner of the even more spacious Agricultural Building. There, he and Potter "made their horses with the attendant figures of girls and pages," Mary French reported, "and here the models came and posed for them, some in Greek draperies and sometimes, I imagine, without draperies." One day a bemused French "discovered that workmen outside were making holes in the plaster walls of the studio...to accommodate a human eye, and allow the curious to gaze upon the mysteries of studio life!"[50]

If Mamie ever grew jealous of her husband's daily proximity to nude female models, she never permitted herself to say. Instead, though still struggling to regain her strength, she tried to create a more permanent home for her family in Chicago. The Daniel Frenches soon moved from Will's house and joined Potter's brood in a cottage of their own, where fellow artists congregated to take meals together—that is, until an infestation of bedbugs

The Columbus Quadriga (seen at eye level),
for the World's Columbian Exposition, Chicago, IL, 1893

drove them all out and into a nearby hotel. Mamie blamed the pests on the
most recent supply of lumber imported onto the grounds, but while others
were too embarrassed to mention the plague of insects, she felt no such con-
straints. After all, she unapologetically pointed out in a cringeworthy expla-
nation she would later share widely: "I had lived in Washington, where on
account of the darkies and the warm climate, they were of necessity a sub-
ject of discussion."[51]

◆ ◆ ◆

On October 21, 1892, just a few days after the actual four-hundredth anni-
versary of Columbus's "discovery" of the New World, a procession led by
fifteen thousand uniformed soldiers, thirty-one state governors, ex-Presi-
dent Rutherford B. Hayes, and the justices of the Supreme Court marched
into Chicago's Jackson Park for the official dedication of the fair. French no
doubt witnessed the imposing scene, though the historical record is silent.
More than a hundred thousand spectators filled bleachers and thronged the
unfinished sidewalks, "a wall of humanity so deep that many who stood on
the outer edge" could do no more than "get an occasional glimpse of the
baton of a drum major as it whirled through the air glistening under the
rays of a noonday sun."[52] Shortly thereafter, Daniel Burnham invited French
and his fellow World's Fair artists to one of its newly built attractions for a
small private event of their own. After assembling "at the Log-cabin on the

island near the Electricity Building (in silk hats)," they were "decorated with medals" in appreciation of their contributions to the exposition. "I would much rather be with you," French had assured his brother that week. But to Burnham he revealed himself to be deeply moved by the honor. Expressing his "keen appreciation of the value of this public recognition," he told his boss: "I am sure that not only I but all the artists will bless you for this happy thought, which may (who knows?) mark the beginning of a time when people will remember not only that somebody paid for the edifice or statue or decoration but that somebody conceived and did it."[53]

Daniel Chester French's magnificent contributions to the White City completed, the French family at last packed up and headed back east, pausing to visit relatives in Washington before proceeding to Concord for a reunion with French's stepmother and "a series of fetes and dinners and suppers that left us little time to ourselves." He even spent a day with his childhood soul mate, Will Brewster, "at his log cabin down the river," where Dan "got the latest intelligence from the bird world."[54]

If he believed that returning to New York would provide a welcome escape from all things Chicago, he soon learned otherwise. Although he had already begun turning his attention to other commissions, he learned by early March 1893 that Charles McKim and his fellow architects were planning a springtime tribute dinner to Daniel Burnham in New York City. McKim not only invited French but asked that his "model for the figure of the *Republic* should be there," too, promising that if the sculptor was "willing to let her stand on that occasion for Art at the Fair...she will, I am sure, make a greater impression upon the hearts of the men than any other girl in the room."[55] Three hundred guests crowded the concert hall of Madison Square Garden for the feast, with *The Republic* indeed dominating "the center of one end of the hall." As French proudly reported, "It received more and higher compliments than I could repeat. I am a good deal surprised by its popularity."[56] He did not get home until past 3 a.m.

The fair was scheduled to open in less than two months, and the gigantic original at last to go on view to the public. French was determined to be on hand for the May 1, 1893, grand opening, even if it meant leaving Mamie behind in New York. Arriving in Chicago in late April, French was shocked to find shrubbery and flowers only now being planted on the grounds, although "the way things move over there," he predicted, "I suppose it will be as verdant and flowery by May 1 as the Garden of Eden."[57] He was pleased to discover that his *Republic* at least stood in place in the lagoon, albeit still shrouded by a wooden box. The most prolific sculptor at

the fair maintained his exuberant confidence. After all, Chicago had moved heaven and earth to reach this climactic moment.

◆ ◆ ◆

The World's Columbian Exposition had been authorized by Congress to serve as an "International Exhibition of arts, industries, manufactures, and products of the soil, mine, and sea."[58] Chicago was more than ready to play host. After winning an 1890 competition against rivals New York, Washington, and St. Louis, the Windy City threw its vast resources and renowned bootstrap energy behind the project as if conducting a do-or-die campaign to overcome the acrid memory of the great 1871 fire that had consumed the town only twenty years earlier.[59] To qualify as host, the city pledged ten million dollars (including one hundred thousand allocated just for statuary on buildings). Ultimately, through both subscriptions and stock offerings, it raised and spent nearly double: some nineteen million. And it set aside a thousand acres, enough land to accommodate displays from thirty-nine states, three territories, and twenty foreign countries. Burnham's plan cleared derelict space south of town, and the World's Fair constructed massive buildings with lighting speed while publicizing the exposition with breathless enthusiasm.

The "White City," as it came to be known for its sepulchral uniformity, rose along the shores of Lake Michigan, and inland through a vast swath of undeveloped parkland, until its grounds encompassed more than a thousand acres and transformed "a flat, dreary" landscape long blighted by treeless sand dunes and "swampy flat swales."[60] The "Phoenix City of the Great Lakes," its promoters vowed, would be five times the size of the 1876 Centennial International Exposition in Philadelphia, and would boast five million enclosed square feet of exhibition space, "nearly twice as much as the greatest exposition of the past."[61]

Opening day, May 1, 1893, found America's newly inaugurated president on hand to "press the magic button" that would dramatically set the fair's big new power plant humming. Just two months into his second, nonconsecutive term, Grover Cleveland was not only the first Democrat elected to the White House since the Civil War, but the chief executive whose initial administration had dismissed, and quite possibly broken the heart of, Daniel Chester French's father. If he bore any resentment against the president, the sculptor, who attended the festivities, never said so.[62] Shortly after noon, as 250,000 onlookers cheered, trumpets blared, cannon boomed, whistles blew, and flags representing dozens of nations unfurled on countless white

facades, the bulky chief executive pressed the "golden key" that ignited the electric lights throughout the fairgrounds and set its fountains awash with water. "At the instant the drapery fell from the golden figure of the 'Republic,' reported an observer, "she stood forth in radiant beauty welcoming the world."[63]

In his official address, President Cleveland left no doubt that, like its signature statue, the World's Columbian Exposition was meant to remind the Old World of the strength of the New. "Surrounded by the stupendous results of American enterprise and activity, and in view of magnificent evidences of American skill and intelligence," he proclaimed, "we need not fear that these congratulations will be exaggerated. We stand today in the presence of the oldest nations of the world and point to the great achievements we here exhibit, asking no allowance on the score of youth."[64] That the fair also aspired to heal the wounds that still divided America's long-embittered North and South became clear when the honor of delivering the official dedicatory address fell to Kentuckian Henry Watterson. During the Civil War, the onetime secessionist newspaper editor had served in the Confederate Army, under the infamously racist Nathan Bedford Forrest. Thirty years had passed since the Emancipation Proclamation, but reunion did not yet embrace racial reconciliation. In fact, the only evidence of African Americans on display at the World's Fair (aside from French's sculpted "Teamster") would come in a retrograde Barnum-like display of so-called "savages" from Africa itself.

At this highly theatrical moment, Chicago was more than ready to claim the spotlight. By opening day, the rejuvenated city boasted seven railroad terminals (one of them within the fairground itself) that combined to offer a staggering total of 1,360 daily trains in and out of town. Visitors could reach the fair, seven miles from City Hall, either by riding the elevated rapid transit system or the cable cars, taking a scenic water route aboard a lake steamer, or choosing a leisurely horse-drawn cab ride down Michigan Avenue. For tourists, overnight accommodations could be booked for as little as one dollar daily at low-end Gore's Hotel, or for as much as fifteen dollars for the most expensive suite at the elegant Palmer House. It was considered a modern miracle that hostelries of all classes could now provide baths and showers for a mere twenty-five cents extra, soap and towels included. The hungry could choose from more than a thousand local restaurants, running the gamut from "the grandeur" of the Richelieu to "the 5-cent 'beaneries' of savory South Clark Street." While the city had earned particular culinary fame for its oyster saloons and chop houses, women were urged

to avoid these boisterous all-male preserves and opt for the "magnificent" but demure cafés at retail emporiums like Marshall Field's.[65]

The fair itself would become the city's greatest attraction ever. A fifty-cent general admission—children under six free, and ages six to twelve at half price—gave visitors entrance to every state and foreign pavilion, along with access to the eighty-acre "Midway Plaisance" at the epicenter of the grounds, plus another forty acres in livestock sheds, seventy-seven acres of "interior waterways," and an entire wooded island devoted to "floriculture and horticulture." Extra added attractions for which supplemental fees were required included an array of theaters, a natatorium (fifty cents extra), a panorama of the Bernese Alps (fifty cents), a model of St. Peter's Church in Rome (twenty-five cents), a twenty-foot-high replica of the Eiffel Tower (twenty-five cents), and a Nippon Tea House (for a dime).[66]

No extra fee was required for access to such exotic destinations as the cold storage building, where visitors could watch artificial ice being made; or an "exact reproduction of the Convent of La Rabida, in Spain, where Columbus found shelter"; not to mention replicas of the explorer's original ships, the *Niña*, *Pinta*, and *Santa Maria*. Nearby could be found sawmills and windmills; a Krupp Gun Exhibit dominated by a weapon so large it cost $1,250 merely to discharge it; and a panoramic painting that depicted a fiery Hawaiian volcano. Among all the "comforts, conveniences, and luxuries," fair organizers took particular pride in offering "1,500 comfortable and convenient toilet-rooms and closets" free to the public. Organizers barred liquor from the grounds, except, of course, at the on-site drinking spots that catered to thirsty visitors.[67]

Visitors might avail themselves of a babysitting facility for toddlers, a wire-netted rooftop playground featuring uncaged butterflies and birds, book-lined libraries, craft booths, and manufacturing displays. Authentic national relics on view included the sword that the US Congress had presented to the Marquis de Lafayette in 1799, jewelry containing locks of George and Martha Washington's hair, and the original Liberty Bell, reverently shipped from Philadelphia to ovations even louder than those that greeted President Cleveland. The fair boasted its own concert hall, hospital, fire department, telegraph and telephone services, an "intramural railroad" to transport visitors around the grounds, a serpentine series of canals, and a giant electrified fountain spewing water from a large and ornate ship of state.[68] The gaudily lit amusement park boasted a 136-foot-high Ferris wheel (the first ever) capable of accommodating hundreds of passengers on each twenty-minute ride, plus a moving sidewalk, a snow slope, and a

roller coaster (all visited by Mamie French—usually with a security escort). Here in fact is where the terms *Ferris wheel* and *midway* were first coined. The more ribald offerings on the midway included forty scantily dressed "hootchy-kootchy girls."[69]

It is little wonder that visitors of all backgrounds and means found themselves entranced. Arriving at the "Dream City" by gondola on the main lagoon, blueblood Florence Adele Sloane gushed, "I actually stood up in the boat and almost screamed with wonder and surprise at the marvelous beauty of the scene." Yale freshman Clarence Day, years later to write *Life with Father*, similarly recalled "a vision of grandeur, at least for innocent eyes." A few costly visits to watch the "dancing girls with bare stomachs, who wriggled in what clergymen said was a most abandoned way" forced Day's further attention to the fair's free "educational" offerings. "I saw that if I had good times on the Midway, I'd have a bad time with creditors," he explained. "My creditors won and I didn't go to the Midway again."[70]

Among these "educational" offerings were the vast displays of paintings and sculpture. As a member of the selection jury, Daniel Chester French believed from the start that, even amid all the competing attractions, the Palace of Fine Arts would be hugely popular in its own right. In that assumption, he proved correct. Its grand scale alone made it a visitor magnet. Designed in the Beaux-Arts tradition by Chicago architect C. B. Atwood, it would rank as one of the largest showplaces for the visual arts ever created in America, offering within its five-acre site more than 145,000 square feet of wall and floor space to display paintings and sculpture.[71]

Situated near the lake, fronted by a large pond, and surrounded by state and foreign pavilions, the 500-by-320-foot behemoth aimed to rival the Louvre in size and grandeur. Inspired by the Ionic style, but festooned with a host of overripe, sometimes discordant, design elements, the structure boasted four grandly ornamented entrances, not to mention a roof-top dome surmounted by a replica of the famous statue *Winged Victory* perched atop a globe. Niches and ledges abounded with caryatids, angels, busts of famous artists, and eight figures representing the arts and sciences. "The grace and beauty of the building," the official guidebook enthused, "can not be described by mere words."[72] Indeed, with colonnades running along the entire facade, towers rising on each corner, plus a dizzying array of gables, friezes, and pillared promenades, the building defied category even as it somehow cohered. Unlike most other buildings at the fair, moreover, this fireproof, brick-and-iron structure was built to last, since major collectors would not lend valuable artworks to a jute-covered tinderbox. After the

exposition closed, the building would become the new permanent home of Chicago's Museum of Science and Industry, which still occupies the original structure. (The Art Institute of Chicago, still run by Will French, by prearrangement took over the fair's equally sturdy World Congress Auxiliary Building.)

Built at a reported cost of $670,000, the Palace of Fine Arts boasted seventy-four galleries in all, spilling over into twin annexes to the east and west.[73] Oil paintings from around the world went on show, including, appropriately, a Sebastiano del Piombo *Portrait of Columbus* from the Talleyrand collection in France, and, in something of a challenge to the theory of Columbus's "discovery," Norwegian artist Christian Krohg's large canvas of *Leif Eriksson Sights Land in America*. Yet spacious as they were, the rooms could not possibly accommodate all the entries submitted by the art capitals of America. New York City alone nominated 1,350 paintings, of which only 325 could be displayed; Boston proposed 600, of which but 139 gained entry—including works by notables like Winslow Homer, John Singer Sargent, Elihu Vedder ("known for his choice of weird subjects"), and Eastman Johnson. From overseas, at American ambassador Robert T. Lincoln's official invitation, Queen Victoria lent 22 oils from the Royal Collection, while a descendant of Pocahontas dispatched a portrait of the Native American princess purportedly made in 1612. The French exports included Édouard Manet's *Dead Toreador*, which struck several astute observers as stylistically inspired by Velázquez. Galleries displayed not only oil paintings, but watercolors, pastels, porcelains, engravings, and antique carvings.[74]

French and his colleagues worked dutifully to winnow down the equally plentiful roster of sculptural submissions. North of the central rotunda, the generous space set aside for American works ultimately featured a dense array of statuary "bewildering in its riches and the immense number of subjects shown." Here, not far from Hiram Powers's popular *Figure of a Buffalo*, Saint-Gaudens's bust of Civil War general John A. Logan, and French's own recently executed bronze of Bronson Alcott, sat *Death and the Sculptor*.[75] Although sculpture from France elicited frequent praise as "the best at the Fair," sculptures by Daniel Chester French attracted their share of commendation. Eventually the artist was persuaded to add a model of his *Thomas Gallaudet* statue as well.[76]

A surviving period photograph of the fully installed, two-story-high sculpture court shows his big Milmore relief holding pride of place near an entranceway, but situated behind a large architectural model of the Palace

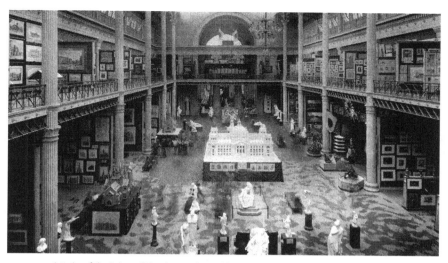

Interior of the Palace of Fine Arts at the World's Columbian Exposition, Chicago, IL, 1893.
French's *Milmore Memorial* is in the background on the main floor.

of Fine Arts itself, an indulgence that sadly obscured much of the Milmore from view. A forest of floor-to-roof iron pillars divides the side rooms into galleries abundant with framed pictures, while dormer windows can be glimpsed thrown open to admit the fresh lake air—this was the age before climate control became a prerequisite for the safe display of artwork.[77]

Among all the stellar works on view, it was the Milmore memorial that attracted principal attention, perhaps the most lavish praise it and its creator had yet earned anywhere. "[S]urrounded by the extravagances of the Italian carvers and the clever plastic jokes of the Spanish modellers," sculptor Lorado Taft enthused, French's masterpiece "rose superb—the expression of a self-respecting master of a noble art."[78] According to the official historians of the exposition, Trumbull White and William Igleheart—two journalists who spent a full year observing the preparations and installation—it was "the opinion of some able critics that Mr. Daniel French's group, *The Angel of Death and the Sculptor*, has never been surpassed in this country." Noting the dramatic contrast between "the still figure of this angel" and the "strong form of the young sculptor, apparently in the very prime of youth and health," the writers marveled at how deftly French had portrayed the sculptor's work so suddenly arrested by "one icy touch from that resistless outstretched hand." In the well-expressed judgment of White and Igleheart:

It is certainly one of the most original, beautiful, striking and impressive works of sculpture in the entire [World's Fair] collection. There is a classic dignity in the figure of the angel of death which must be seen to be understood and appreciated. There is an absolute repose about it, an influence of resistless power, without the slightest violence of action; only the slow, dignified movement hardly to be described in words....The subject has been used so many times by different sculptors all over the world that it has seemed difficult and even impossible to make of it something entirely original and yet Mr. French has succeeded in doing this. The more his work is studied the better it will be appreciated, and the more true the realization of the fact that none but a great man could thus combine the classic treatment with the French technique and intense thoughtfulness, and the American's poetry and religious thought about the majesty of death and its meaning to man both here and hereafter.[79]

Dominating all, however, in both size and attention, was the *Republic*, a giantess swathed in gold amid a sea of white, "impressive and imposing in the highest degree," according to the guide to the fair. "Of colossal size...the characteristics of the figure are simplicity and grandeur. The pose is firm and majestic; the drapery chaste and severe; the expression is that of confident power and benign purpose."[80]

"There are differences of opinion about this work," conceded the fair's chroniclers, wondering "whether or not the gilding in the statue helps in this particular quality. The buildings are white, meant to be like marble....The gilded *Republic*, therefore, stands out in very sharp contrast with its surroundings." Pointing out in justification that the ancient Greeks had added color to their marble statues, too, the observers admitted: "Whatever be the reason, the brilliant gold of this immense solitary figure in the midst of the white columns and palaces seems hardly in place." The only concession they ventured was that the statue "looks better at night when, by reason of the yellow light on the building, everything is brought more nearly into the same key." The authors allowed French a final word in his own defense, but in the end seemed only reluctantly to endorse the artist's vision:

The sculptor himself says that he has treated the statue in a formal and almost archaic manner on account of the almost perfectly symmetrical arrangements of the architecture around it. It is his triumph that he has succeeded in doing this. In line and form, and in dignity too, this figure harmonizes well with the stately buildings about the Court of Honor. Taken

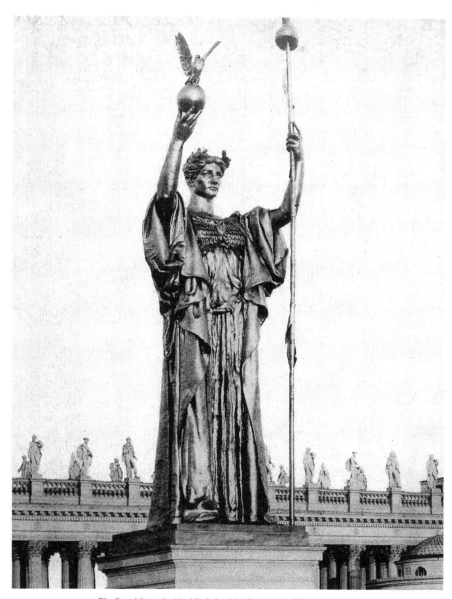

The Republic at the World's Columbian Exposition, Chicago, IL, 1893

by itself, the figure would not be so agreeable because it would seem a lit-
tle stiff and lacking in that grace which is to be expected in the sculptured
female form. On the whole, it must be said, that there is a grand and severe
dignity about the great "Republic" that is exceedingly impressive and well
emphasizes the grandeur of those halls into which she courteously invites
the nations of the world to enter.[81]

Even French's most ardent admirers, like Lorado Taft, admitted that
the centerpiece statue had not pleased everyone. "Some did not like it," Taft
allowed, adding, "but that was their misfortune." Insisting it was "more
than a big statue" but "a great one," Taft argued that the "archaic severity"
which put off some viewers "was not accidental." After all, French had been
specifically tasked with creating something that would "enter into an archi-
tectural scheme of classic spirit," yet endure, at least in memory, beyond the
life of the exposition. Meant to be seen from a distance, it had to be "a mon-
ument as well as a statue." The ability to "convey the impression of a soul
so great yet so far removed is a remarkable achievement," Taft avowed. He
compared the result favorably to the already beloved Statue of Liberty.[82]

So did the influential architecture journal, the *Builder*, which acknowl-
edged the *Republic*'s "strong family likeness to the statue of Liberty" and
echoed Taft's cautionary reminder that French's sculpture was "emphat-
ically an architectural figure," intentionally "treated in an almost archaic
manner."[83] For all the constraints the sculptor had faced, the *Builder* added,
the theme had been "treated in many respects in a very original" way.[84] But
ignoring a tenet of the classicism to which French aspired, the London weekly
The Graphic lamented the statue's "excess of symmetry, which is unpleasing
to the eye, and has been the basis for unfavorable criticism."[85] Chicago's
influential German-language newspaper, the *Illinois Staats-Zeitung*, proba-
bly spoke for many visitors by stressing not the statue's artistic merit but its
majestic presence. Lauding its "brilliant resplendency upon the surrounding
scene," the paper acknowledged *The Republic*, if nothing else, as "the most
conspicuous figure" at the 1893 World's Fair.[86] It had been inspiring enough,
at least to Horace Spencer Fiske, board chair of the Chicago Art Institute,
founder of the University of Chicago, and sentimental amateur poet, to elicit
an especially composed ode in tribute to the statue:

> Engirt with dreamful beauty thou didst stand,
> By day and night illumined, and thy feet
> The gathered nations thronged with homage sweet,—

The world's hope shining in thine outstretched hand...
Like thine own eagle that no respite needs.
But sunward mounts with ever clearer eye,
Thou dost persuade to higher and higher deeds.[87]

That the *Republic* ultimately failed to achieve iconic status French could reasonably attribute to the transitory nature of the fair itself. Its organizers had mandated that it come down as swiftly as it had risen, adornments included. And as the respected art critic Royal Cortissoz pointed out, French had produced the perfect signature piece for such an impermanent environment. "[T]he intrinsic beauty of the Republic remained different from the beauty of classic art," he maintained in an appraisal of French for the popular *Atlantic Monthly*. "It was a goddess of the West, not the East...contrived to maintain an atmosphere, a style, an indefinable touch of character and vitality," but not to claim a permanent place in the culture. As consolation, Cortissoz authoritatively declared, French's work for the fair had at least "widened immensely the sculptor's celebrity" and propelled him into "the very front rank."[88]

◆ ◆ ◆

French never intended that his largest and most critically disputed work survive beyond the event for which it was designed. Made after all of perishable materials, *The Republic* was meant to endure only as long as the exposition itself. Not surprisingly, however, its organizers proved less adept at dismantling the fair than they had been at constructing it. A few buildings were successfully taken down soon after the fair ended its run, but others lingered, deteriorated, and began crumbling. Some later burned down. Chicagoans, hardly strangers to conflagrations, no doubt shuddered when one massive fire engulfed and destroyed most of the remaining structures in 1894. Daniel Burnham's official biographer and French's good friend, Charles Moore, lauded the *Republic*'s "spirit of permanence."[89] But in 1896, the statue caught—or was set on—fire and, fueled by its dry wooden frame and highly flammable rope-and-burlap undergirding, quickly succumbed to the blaze. Not even the surrounding lagoon could douse it, for it had long since been drained of water. In a way, French felt relieved, convinced the fire would prevent the onetime emblem of the world's greatest exposition from further, embarrassing disintegration.[90] Earlier that year, to provide a record of his work, he had asked Will French, who was conveniently in Chicago and readily able to marshal resources, to supervise the casting of two additional

plaster copies from the working model, one of which went on display at the Art Institute, the other of which was shipped to French's New York studio.

The Republic would rise again. Twenty years later, a Chicago monument fund endowed by leftover money from the fair offered French fifty thousand dollars to create a permanent, smaller-size bronze replica for Jackson Park. In a sign of French's growing prominence, after expenses for the casting and architect's fees, he stood to net a robust twelve thousand dollars.[91] This time, Henry Bacon would be invited to design an ornate new pedestal. French could not resist. He turned back to the surviving twelve-foot-plaster and enlarged it to twice its size. This time it was cast in bronze. Less than half as tall as the statue at the fair, it was completely gilded, face and arms included. *Chicago Tribune* publisher Robert H. McCormick chaired the May 11, 1918, dedication ceremony, which was preceded by a military parade.[92] In 1993, to mark the centennial of the World's Columbian Exposition, artisans regilded her with 24,500 sheets of gold leaf.[93]

Dedicated in time for both the twenty-fifth anniversary of the World's Fair and the centennial of Illinois statehood, the reduced-size statue featured only one other significant change from the original. In place of the Phrygian cap that had once topped the pole the figure grasps, French substituted a plaque encircled by a laurel wreath and inscribed with the single word "Liberty." He left no explanation for this change from representational to literal. The city of Chicago designated the reproduction an official landmark in 2003.

Still gleaming, the statue remains in place today, though in recent years it has sat "marooned" in a traffic intersection near a golf course. No doubt few onlookers realize that this is the onetime site of the fair's Administration Building, opposite which once sat the Great Basin above which the first *Republic* once towered. As the *Chicago Tribune* has reported, plans for the new Barack Obama Presidential Center call for liberating the statue "from its traffic island."[94]

French sculpted yet another replica of the *Republic* for the Wisconsin State Capitol building at Madison, this variant showing only one of its arms upraised and, in place of the original's diadem, a helmet on which preposterously rests the official state animal: a badger. The statue once dubbed "Big Mary" now bears a nickname inspired by the Wisconsin state motto: "Miss Forward." One more bizarre replica has reigned as a local curiosity piece on both the East and West Coasts from as early as 1896. That year, even as the original *Republic* succumbed to fire in Chicago, the newly built Siegel-Cooper department store on Sixth Avenue and Nineteenth Street in

Manhattan ordered a bronze replica to rise within its lobby from a seventy-foot-wide fountain. French ordered the reduction cast by the Bonnard foundry at a cost of more than $3,800 after changing a few more details and employing marble for the face, arms, and toes. For years, shoppers used the phrase, "meet me at the fountain," to designate their meeting spots at the crowded emporium—perhaps unaware that their rendezvous point had been designed by none other than Daniel Chester French.

When the store went out of business in 1918, the sculptor reimbursed its creditors for the full cost of its casting and reclaimed the statue, which he put into permanent storage at his marble cutters' workshop in the Bronx, keeping it in hiding for the rest of his life. Only in 1950, years after his death, did his daughter, Margaret, sell it to its new, presumably final resting place: Forest Lawn Cemetery in Glendale, California—fountain included. There, it now stands near the graves of countless movie stars, arguably more potent symbols of American exceptionalism than even French could have imagined when his *Republic* bestrode the White City.[95]

French could not have known, either, that James Roosevelt, father of future president Franklin Delano Roosevelt, had once so treasured his service as one of the six New York–based members of the National Commission for the Chicago World's Fair that he had ordered large-format souvenir photographs of its central structures and statues, including *The Republic* and *The Columbus Quadriga*.[96] After his death, his widow, Sara Delano Roosevelt, purchased a "cottage" at a favorite family vacation spot, remote Campobello Island in New Brunswick, Canada, presenting it to her son Franklin and her new daughter-in-law Eleanor as a wedding present. Somehow the World's Fair photographs ended up inside. Years later, when FDR enlarged the house into a thirty-four-room retreat for his own growing brood, he made sure his father's pictures adorned its walls. They hang there to this day.

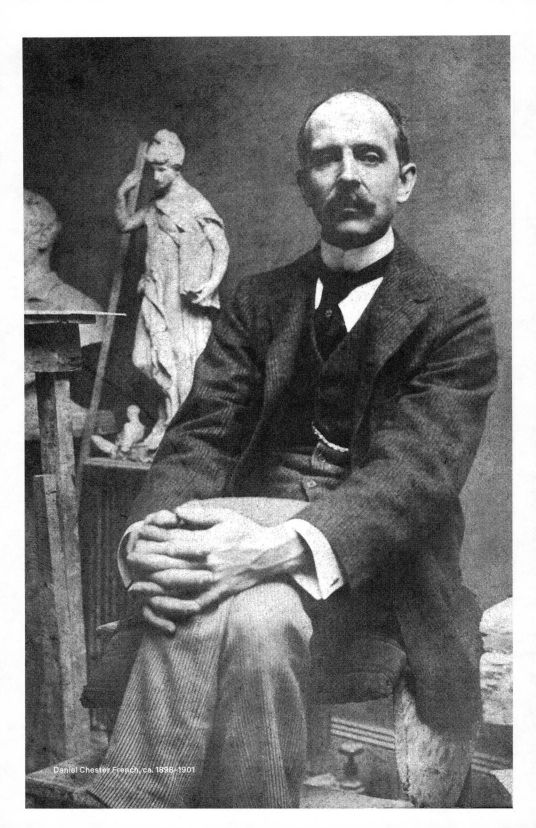
Daniel Chester French, ca. 1898–1901

MEMORIAL MAKER

Their eventful year in Chicago at an end, their visits to Washington and Concord over, Dan and Mary French returned to New York City in late spring 1893. Back in town, they enjoyed reunions with famous and influential friends like Richard Watson Gilder, editor of the *Century Magazine*; painters Kenyon Cox and Will Low; and one of their favorite acquaintances, artist Abbott Handerson Thayer, whose pate had become so bald and his mustache so thick that he now resembled French himself. Reentering the Manhattan social whirl, the Frenches frequented literary salons where they might meet William Dean Howells one evening and Mark Twain the next. Their circle now embraced prominent "writers and painters from all over the world," including society artist Benjamin C. Porter, even though, as Mamie French hinted, that well-married "painter of beautiful women...was led somewhat into the gayer walks of life."[1] She certainly had come a long way from the Georgetown convent.

Dan and Mamie went on to spend a second summer at Cornish. Yet after two years vacationing in their ancestral state, they came to the conclusion that New Hampshire was simply "too far from New York for us to adopt as our home." Cornish may have lacked another essential element they sought in a permanent refuge: while it offered proximity to fellow artists, the somewhat reclusive Dan French found the socializing to be distracting. For her part, Mamie enjoyed the society of Cornish celebrities like painter Maxfield Parrish and sculptor Herbert Adams, not to mention Saint-Gaudens, whose company she regarded as "a privilege." But she came to believe that Cornish lacked the cohesiveness she had once embraced at her husband's hometown

of Concord. Although a rural haven for creative spirits, Cornish was not quite a community, "not even what we might call a settlement," she insightfully observed. Most of the homes were "like small country estates, wide apart."[2] Even the postal carriers shunned these enclaves; mail was only available across the quaint covered bridge on the Vermont side of the river. The Frenches decided to set their sights farther south.

For the next two seasons, they rented a "derelict" house in the town of Enfield in central Massachusetts. The sculptor converted an adjacent tobacco barn into what turned out to be a leaky studio, where he settled in and worked away on new projects, occasionally alongside animal sculptor Edward Potter, himself a summer resident of the Connecticut Valley hamlet.[3] The most celebrated of its dwellers, it turned out, was the elderly Civil War general "Fighting Joe" Hooker, whom French (with help from Potter) was destined one day to sculpt. Ultimately, the stars did not align for Dan and Mamie at Enfield. At the end of their second and final summer there, French told his wife that he was determined to build a "really first-rate studio" somewhere "within striking distance of both New York and Boston," the two cities from which he believed most of his future commissions would come. Abandoning Enfield turned out to be a wise move for another reason; a few decades later, most of the central village was evacuated so it could be submerged beneath a new reservoir.

Back to work in New York City, French turned to a new project he had kept at bay for months: a large bronze bas-relief portrait honoring the recently deceased textile and shipping magnate Theophilus Wheeler Walker, a longtime benefactor of Bowdoin College in Brunswick, Maine. Although a Dartmouth alumnus, the unmarried millionaire had switched his allegiance to Bowdoin after a cousin became its president.[4] His nieces, who inherited his large estate, commissioned the sculpture to adorn the interior wall of a new college art museum to be named in Walker's honor. The domed, Renaissance-style building, designed by Charles McKim, would also feature murals by Kenyon Cox, Elihu Vedder, John La Farge, and French's friend Abbott Thayer. Although French had greeted the offer by protesting that he had no time to devote to it—he told the Walker sisters in 1892 that he could not "spare even a day" from his World's Fair obligations—he changed his mind and accepted the assignment once the Chicago exposition opened. Without the benefit of surviving records of his fee, we can assume that French took the job at least in part because he found it "gratifying" to be recommended by architect McKim, whose friendship had become important to him in Chicago.[5]

Once again, French faced the challenge of portraying a subject he had never seen in the flesh. For a model, the Walker sisters proposed that the sculptor consult a painting of their uncle by noted portraitist Joseph Alexander Ames. French replied that "since it is by Ames, I should suspect to find the data quite ample."[6] In fact, he all but copied the canvas, changing only the arrangement of his subject's arms, a subtle but skillful alteration that served to correct its surprisingly clumsy perspective.

French had completed his initial clay model at Concord in the summer of 1893. The following spring, the finished bronze was cast and installed inside the museum rotunda. It was dedicated on June 20, 1894, at a ceremony highlighted by an oration by Martin Brimmer, the founding director of Boston's Museum of Fine Arts.[7] By the time the Bowdoin piece was unveiled, it could accurately be said that French had all but cornered the market on sculpted portraits of generous college donors—for along with Thomas Gallaudet and John Harvard statues, the Theophilus Walker was his third such commission. The next time he produced a statue for a campus, he would substitute allegory for portraiture.

◆　◆　◆

Although he toyed with new ideas and alluring offers after returning to New York (some of these prospects had begun percolating back in Chicago), French did not install another major work for two more years—until 1896. Yet he grew busier than ever, and like most successful sculptors, often found himself working on several projects simultaneously.

It was the apex of the prosperous Gilded Age, and wealthy donors seemed to line up to commission public art that would "commemorate great events," "mark public gratitude to heroes,"[8] or memorialize family and friends in grand settings. During this period and ever after, French found himself perpetually juggling commissions, with each work often in different stages of planning or execution. In what can only be called an astute high-wire balancing act, French molded clay models of some statues while supervising plaster casts of others and polishing off final bronzes or marbles of still more. In between, he entered competitions, attended dedications, answered new solicitations, negotiated contracts, and wooed potential patrons. He began attracting so much newspaper attention that he hired a clipping service to gather and forward his reviews. French was able to fulfill so many commitments simultaneously because, as one art historian has pointed out, he was primarily a modeler, not a carver. Like most of the sculptors who worked in large scale, he created clay sketches in bursts of

creativity, but deployed both assistants and students to enlarge and adapt his models into plaster, and then foundries to cast them into bronze or marble cutters to carve them in stone, content to supervise them from a distance until he was ready to apply his almost magical finishing touches to bring the works fully to life.[9] "In no other art," Nathaniel Hawthorne had written in *The Marble Faun*, "does genius find such effective instruments, and so happily relieve itself of the drudgery of actual performance; doing wonderfully nice things by the hands of other people, when it may be suspected they could not always be done by the sculptor's own."[10]

In this way, while completing a number of new projects, French also began brainstorming with his collaborator, Edward Potter, on an equestrian statue of General Ulysses S. Grant for Philadelphia. At the same time, French accepted an offer to create a statue of the late Congressman Rufus Choate for the courthouse at Boston's Pemberton Square; commenced work on a memorial to an Irish-born local hero; and prepared to fulfill an order for three pairs of sculpted bronze doors for the city's Public Library.[11] Soon Boston also welcomed French's "noble effigy" to Bishop Phillips Brooks, while New York City's new "palace of justice" on Madison Square featured French's allegorical group, *Justice*.[12] The price of success was being exacted in toil but rewarded with fame and fortune.

Coping with multiple commissions meant that French's growing roster of patrons often had to bide their time awaiting the delivery of finished works. With few exceptions, they found him worth any such delay. To the occasional consternation of architect Charles McKim, for example, the bronze doors for the Boston Public Library took nine years to complete. The Grant equestrian progressed so slowly that its creation straddled the century mark. French found himself straddling in another sense as well, bridging sculptural styles as artistic fashion and his own creative impulses changed in the waning days of the 1890s. Reflecting on these evolving tastes, he elected again to combine realistic portraiture with symbolic allegory for his next project: a memorial to the Irish-born editor, novelist, poet, and political activist John Boyle O'Reilly. Whether he could harmonize such disparate styles as fluidly as he had for the Milmore memorial, French was determined to find out.

His new subject had been a member of the Republican Brotherhood—known as Fenians—who agitated, sometimes violently, for Irish independence in the old country. Running afoul of the British, O'Reilly had been captured in Ireland, tried for treason, and sentenced to death back in 1866. Because he was only twenty-two at the time, the authorities had shown

mercy, commuting his death sentence and exiling him to remote Western Australia to serve twenty years at hard labor. But O'Reilly escaped the penal colony in 1869, hid out along the rugged coast for weeks, and somehow managed to sneak aboard a ship bound for America. Ultimately, he made his way to Boston, where news of his arrival electrified the growing Hibernian community.

Once in residence there, O'Reilly quickly rose to prominence, writing for, and later running, the Catholic newspaper the *Pilot*. He also published half a dozen books of fiction and poetry, and resumed his campaign for a free Ireland. Within a year he had become a local hero. But O'Reilly died young in 1890 after accidentally ingesting an overdose of his ailing wife's sleeping potion. Overnight, a celebrity morphed into a legend. His passing unleashed an outpouring of grief at a mass meeting at Boston's Tremont Temple, followed quickly by a successful campaign to raise fifty thousand dollars to fund a statue in his honor. Without pausing to initiate a competition, O'Reilly's admirers invited French to design and execute "a suitable memorial to the genius and manhood of John Boyle O'Reilly."

That "such a monument should be erected in Boston is significant," *Frank Leslie's Illustrated Newspaper* applauded, "when it is considered that O'Reilly arrived there in tatters and penniless, a fugitive from a penal colony, whither he had been sent as an outlaw and Irish agitator of a very dangerous type."[13] That an established (and establishment) artist such as French had been engaged for the project contributed to growing expectations for the final result, especially after O'Reilly's widow viewed the initial model during a brief display at Boston's Studio Building and "expressed great admiration and delight in the sculptor's conception."[14]

For French, accustomed to offers from wealthy Anglo-Saxon patrons, the assignment from the John Boyle O'Reilly Memorial Committee presented an opportunity to broaden his audience appeal. With his architectural collaborator C. Howard Walker (who taught at MIT, the very school from which French had once flunked out), he responded to the challenge with an ingenious double-sided design combining both representational and symbolic sculpture. For one side of the memorial, French proposed a larger-than-life bronze bust of the thickly mustachioed O'Reilly set against a richly carved granite stele. For the opposite side, against a similar backdrop, he would install a trio of allegorical statues in tribute to O'Reilly's virtues. A draped, hooded, and enthroned central figure would represent Erin, the personification of Ireland, her head downcast in mourning, weaving a wreath of shamrock for the fallen hero. She would be surrounded by statues

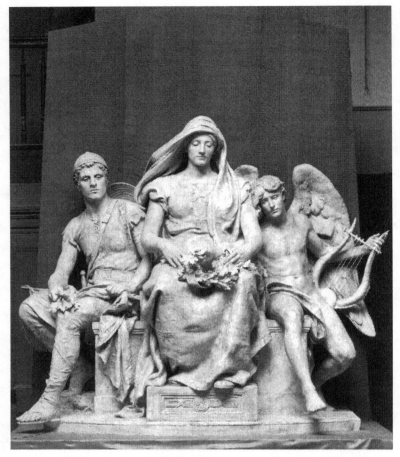

Model of *John Boyle O'Reilly Memorial* in French's New York studio, 1897

representing "Patriotism" (a Celtic warrior clutching a sword in one hand and an oak leaf—the symbol of strength—in the other); and the seminude, winged figure of "Poetry" (offering laurel—the ancient reward to poets).

The complex design would give French the chance to demonstrate his virtuosity, for he would show *Poetry* playing a delicately stringed harp, and *Erin* twisting her proffered branches into a hero's crown. In a single, harmonious composition the sculptor would showcase his ability to create faithful realistic likenesses as well as imaginative allegories. The sculptures would be mounted at least fifteen feet high and designed to be viewed from several vantage points.

Couching their response "in very flattering terms," the O'Reilly Memorial Committee unanimously accepted French's design proposal

in early September 1893 and gave the sculptor two years to complete the project. (Not surprisingly, he would take nearly three.) The committee also bowed to the sculptor's absolute authority to make changes (which he did, eventually clothing his once-nude *Patriotism* in armor and substituting a lyre for *Poetry*'s original harp).[15] The delays and revisions seemed minor considering that the committee believed it had obtained the services of an artist who held "a prominent place among great living sculptors."[16] On a visit to French's New York studio, Lorado Taft saw the "great work" on the sculptor's turntable and predicted it would "certainly add to Mr. French's reputation, for it is magnificent." Taft was particularly taken with the swerve of the figures...most delicately planned to produce undulation" of the masses. "Wonderful art," Taft called it, "that conceals art!"[17]

The memorial's unique setting posed both challenge and opportunity. It was earmarked for the marshland along the Back Bay Fens, then in the midst of reclamation, under the guidance of Frederick Law Olmsted, into a new jewel for Boston's Emerald Necklace park system. A local newspaper predicted that French's composition would find "a place suitable to its impressiveness as a memorial and its worth as a remarkable sculptural achievement."[18] On its triangular plat at the foot of Boylston Street, it would serve as both a tribute to a local favorite and an anchor for a rapidly improving neighborhood. Only a few years later, as fate would have it, the Boston Red Sox would select a nearby spot for the team's new baseball stadium, destined to become a beloved and enduring landmark in its own right, utterly transforming the original vision for the neighborhood, and quickly coming to dominate it. Perhaps French, who lived to see Fenway Park rise and overwhelm the area with crowds and noise, at least found comfort in the fact that standing opposite his *O'Reilly Memorial* was the new headquarters of the Massachusetts Historical Society, in whose former location he had once worked so diligently to research details of Puritan clothing for his John Harvard statue.

Although French produced large plaster models of the O'Reilly allegorical statues by 1895, he found himself hesitating when the time neared to ship the finished pieces to the foundry for casting in bronze. As his patrons waited and waited, French's own exacting standards conspired to delay the work. As faithfully as he had enlarged his clay into plaster, French believed he had failed to give it the zest that seemed to animate his original sketch— and John Boyle O'Reilly himself. For a time, the sculptor covered the large casts with a tarp and turned to other projects. Not for a full half-year did he usher his wife into his studio to confide: "Mary, I left this group here last

spring on purpose so that I shouldn't see it for six months and could come back to it with a fresh eye, and now what should you think...if I told you that I was going to pull it to pieces and make it over, more like the original sketch? We may not have much to eat for a while...but I know I can better it, and I really don't see what else I can do." Accustomed to her husband's penchant for drastic eleventh-hour revisions, she did not discourage him. The rest of that "winter was devoted to getting into it something that he felt he had missed in his previous year's work," she remembered. "Of course, all artists do that kind of thing," she added in his defense, "and having an artist for both a husband and cousin, I was quite used to the idea."[19]

For her part, daughter Margaret judged the resulting "surgical operation" as no less profound and fortuitous an act of sculptural editing than the last-minute adjustments her father once had made, on the eve of his own wedding, to the legs of his Gallaudet statue.[20] Margaret also came to believe that her father's bold decision to sacrifice six months' work and start his O'Reilly allegories afresh may have been triggered in part by the death of his stepmother, Pamela Prentiss French, at age sixty-seven, in late 1895. Returning home from the funeral, a few of her modest possessions in hand to put aside for his daughter, French seemed to regard the objects in his crowded studio with a newly critical eye, perhaps stimulated by this final, complete, and no doubt painful break from his past. Whatever the motivation, French took his time, slowly imposing his radical changes as his O'Reilly patrons waited in Boston. The revisions proved worth the delay. Lorado Taft believed the final conception combined "tenderness and reserve" to create a "total effect...of gentle dignity" devoid of theatricality but "enlivened" by the artist's uncanny ability to communicate both "exaltation" and "sorrow."[21]

Dedication day for the finished bronze O'Reilly Memorial was scheduled for June 20, 1896. As the time for the ceremony approached, local reporters as usual enjoyed a preview glimpse of the work, lauding the statues enthusiastically. Just as French had hoped, one critic rhapsodized that the result managed to unite "in a singular degree the warmth and poetic sympathy of a brilliantly imaginative genius with an instinctive classic power of creation."[22] As workmen labored in the late spring heat to build a wooden stage to accommodate dignitaries at the unveiling on the Fenway, Daniel Chester French himself—"who has for years known only through the conjurings of his fancy the appearance of his wrought-out conception"—arrived on-site to watch for himself as the heavy bronzes were gently hoisted into the air and set in place on their granite bases. If the sculptor

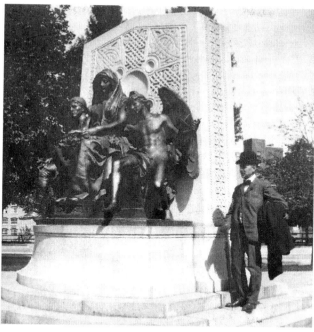

Daniel Chester French at the *John Boyle O'Reilly Memorial* (1896),
bronze, the Fenway, Boston, MA, 1905

"needed any assurance" of his success, remarked the *Boston Herald*, "it was supplied by the admiring comments of those who saw the bronze figures raised to place."[23]

Hailing what it called a "composite art work of portraiture and symbolism," the *Herald* pronounced the statuary "full of ideality and realism," and "fittingly" evocative of "a man of action and imagination." The *Herald* critic acknowledged the "truth and beauty of the modelling," the "grace and force of composition," as well as the "delicately finished surface, unity of effect and elaboration of detail being harmoniously blended." As for the portrait of O'Reilly, it boasted "unexpected detail and artistic fidelity in the contour of his countenance and the outlines of the fine head and chest." If these observations struck some readers as too technical, they were at least supplemented by the plain-spoken observations of a laborer on the scene who had helped truss up the bronze statues so they could be raised to their granite stage. He was quoted as saying: "I am hoping that we will soon be able to get the ropes off these beautiful necks."[24]

Just two afternoons later, with outgoing Vice President Adlai E. Stevenson I in attendance and Daniel Chester French looking on, the presentation

exercises drew a large throng to the park to witness a program of prayers, orations, and music. Toward the conclusion of the ceremonies, a male chorus sang out the words of "Forever," one of O'Reilly's beloved poems, aptly beginning with: "Those we love truly never, never die." As its final verse floated into the air, the Irish martyr's daughter tugged at a cord, releasing the veils, and revealing the "striking" memorial to the crowd.[25]

Then it was up to the art critics to comment on the final result. And while the granite base endured its share of rebuke—"the best we can say of the stone work is that it is unobjectionable and inoffensive," sniffed one— the Boston press universally commended the sculpture. "Mr. French has lavished his thought, his labor, and his love," raved the *Transcript*, adding: "there is no use in mincing words—it may as well be candidly called the loveliest group that American sculpture has produced. There is a quality of sweetness, intimate human sweetness, in these three gracious figures of Erin, Poetry, and Patriotism, which is captivating and touching beyond expression."[26] Echoed the *Herald*: "Here we have an addition of vast importance to the outdoor statuary of Boston—of almost epoch-making importance, it may be said, because it stands, we hope, for the beginning of an era of ideal and allegorical monumental work in the place of portrait statuary."[27]

Apparently the same could not yet be said of portrait statuary in Paris. Just a few weeks earlier, the very same newspaper had announced that French would soon become "the first American artist to whom permission has been granted to erect an outdoor statue in Europe—that of [George] Washington." For this project, however, the likeness would be unabashedly realistic. Nearly a hundred years after his death, the Father of his Country remained beyond allegory, a symbol in his own right.[28] But the project would have to wait. French's plate was full.

◆ ◆ ◆

One of the many projects to which French directed his attention while completing the *O'Reilly Memorial* was an irresistible commission for his adopted city.[29] French's first major sculpture for New York, it would be yet another public memorial, a growing specialty for the sculptor. Commissioned by the city's art-loving elite and designated to occupy a prime spot along Central Park on Fifth Avenue, the new project nonetheless became, after inexcusably long delays, something of an embarrassment, if not for French, then for New York itself.

Its subject was the revered dean of American architects, Richard Morris Hunt, who had died in July 1895 at age sixty-seven after a flourishing career

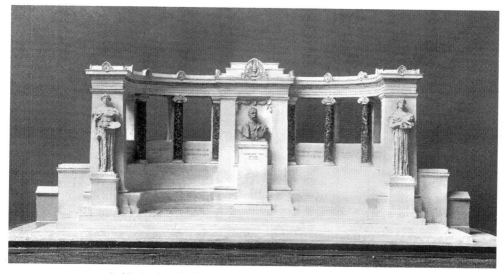

Architectural model of the *Richard Morris Hunt Memorial* for the perimeter
of Central Park, New York, NY, 1900

designing Beaux-Arts classics, from the stately residences in Newport to the majestic new Fifth Avenue facade of the Metropolitan Museum of Art.[30] Now his admirers at the Municipal Art Society proposed honoring Hunt near the museum with what they described as a "monumental seat": a granite bench to be situated along the Olmsted-designed park.[31] The patrons solicited the city's major art institutions for financial support (Met trustees alone quickly raised five thousand dollars), and named a committee to select a sculptor. Since the delegation included J. Q. A. Ward, it came as little surprise when the panel "unanimously" awarded the commission to French.

The sculptor was not at home when committee members paid an unannounced visit to his West Eleventh Street studio on March 31, 1896, to inform him of their decision. Not sure of what to do in his absence, the visitors left word of the commission on a sheet of French's own stationery, which they likely secured from a servant.[32] However it was proffered, the sculptor found the honor "gratifying," especially since his patrons "expected to spend from twelve to twenty thousand dollars" on the memorial and offered him full authority to choose an architect as his collaborator.[33] Surprisingly, French selected modernist designer Bruce Price. A proponent of the so-called Shingle Style, which he would soon help make famous, Price was capable of Beaux-Arts splendor as well, as he had demonstrated with the recently opened Château Frontenac hotel in Quebec. For

the *Hunt Memorial*, the two men settled on a formal arc-shaped entabla-
ture—a semicircular horizontal ledge backed by granite columns support-
ing a stone awning—a design conceived in homage to Hunt's classical design
ethos. French's well-received proposal called for yet another combination
of realism and symbolism in the manner of the O'Reilly project: a true-to-
life portrait bust of the architect adorning a central plinth, flanked at left
and right by a pair of allegorical statues representing "Architecture" and
"Painting and Sculpture."

French had become more adept than ever at generating press attention.
It seemed now that whenever he contracted for, cast, previewed, or unveiled
his works, journalists flocked to report the news. The announcement that
he had been awarded the Hunt commission set off another wave of news-
paper accolades. Beneath a flattering engraved portrait of the sculptor, the
New York Tribune commented that French was already "widely known by
his works," proceeding to list most of his major achievements to date.[34] The
American Architect, which similarly applauded the designation ("No one...
needs to be informed in regard to Mr. French's reputation"), added of the
proposed design: "The style of the composition is rather free Greek Ionic
and although the idea is not particularly new, the effect of the monument
promises to be excellent."[35]

Setting to work on the draped female figures—he was by now so
expert at sculpting goddesses that the task probably represented little chal-
lenge—French produced two small, exquisite maquettes by early 1897.
He ingeniously depicted *Painting and Sculpture* grasping a sculptor's
mallet in her right hand, and in her left, a palette (which cradles a small
replica of Dionysus from the Parthenon pediment). The companion piece,
Architecture, clutched a domed building meant to suggest the much-ad-
mired Administration Building that Hunt had designed for the White City in
Chicago. In his now-characteristic style, French left the drapery rough-hewn
while smoothing the figures' faces and arms.[36] As soon as they were cast, the
bronze models (or "bozzetti," the term used at the time) went on exhibit at
New York's Architectural League.[37] Things seemed to be moving apace.

Later that same year, French completed his mesmerizing bust of Richard
Morris Hunt, shown dressed stylishly in a coat and vest, his elaborate mus-
tache fully delineated, his gaze directed skyward as if contemplating one
of his blueprints coming to life at the nearby, ever-expanding Metropolitan
Museum. But the project never made it to the museum's doorstep as planned.
For reasons that have never been explained—the records of the decision do
not exist—the *Hunt Memorial*, originally slated to rise on the plaza, outside

either the Met's southern or northern wings (bordered at the time by Eighty-First and Eighty-Third Streets), ended up occupying a modest spot at Central Park more than ten blocks downtown, at Seventieth Street. There was some solace in the fact that the memorial was erected across the street from one of Hunt's other masterpieces, the Lenox Library. But as it turned out, the library fell to demolition in 1912, and *Hunt* would soon, and forever, be compelled to stare at the replacement building designed by rival architect Thomas Hastings: the Henry Clay Frick mansion, later to be converted into the art museum that bears Frick's name.

Its siting was not the only aspiration for the *Hunt Memorial* that failed to materialize as planned. Costs for the project ran over budget even as the memorial committee failed to achieve its original fund-raising goal. Public attention refocused on the brief but sensationally reported Spanish-American War, which raged overseas for much of 1898. The result at the home front was a mortifying delay in the casting of French's full-size allegorical figures. Meanwhile, construction of the granite enclosure and its three pedestals proceeded as if the entire project were actually on schedule. In fact, when the *Hunt Memorial* was finally dedicated on October 31, 1898, it remained incomplete, with the piers meant to hold *Architecture* and *Painting and Sculpture* standing mortifyingly vacant. Only the Hunt bust sat in its designated central location. Insistent on going forward with the dedication as if the memorial was finished, sponsors and other guests gathered that day at the Lenox Library. Then they strolled across Fifth Avenue, stood patiently in the Halloween chill for speeches and prayers, and watched Hunt's grandson lift an American flag and white silk banner to unveil the bust. Acting Mayor Randolph Guggenheimer officially accepted the incomplete work on behalf of the municipal government.[38]

Behind the scenes, however, the drama continued, and not even New York's wealthiest philanthropists seemed able—or willing—to summon the relative pittance still required to pay French and rescue the tribute to their favorite architect from the embarrassment of its abandonment. Not until 1900—two years later—did French have the full-size allegorical statues cast in bronze at the Henry-Bonnard company, each six feet, three inches in height. Even then, they went on display only at the National Academy of Design. One journalist who viewed the towering figures there remarked that they were "full of sentiment, showing refined imagination, a scholar's grasp of the requirements and an artist's appreciation of fitness." In sculpting them, French had confirmed his claim to "a foremost position for the excellence of his work."[39] But problems lingered. The Hunt Memorial Committee seemed

unwilling "to take the statues before they are paid for," yet lacked sufficient money to make the final payment.[40] For all its ambitions, the group had raised only $16,800 from local "art societies and art lovers"—including the Century Association and the Architectural League—and still needed another $4,500 "to pay Mr. French for his work."[41] One observer bravely predicted that the necessary money would be raised "if many who visit the exhibition and admire the statues of Mr. French contribute."[42] They did not.

The fund-raising campaign dragged on. In the view of the *American Architect*: "French, whose work has been to some extent a labor of love, ought to have his money."[43] Stressing "urgency," the journal implored its readers to rescue "the committee from an embarrassing position, and at the same time show the sculptor that he has not labored in vain."[44] With nowhere else to turn for cash, the patrons took to publicizing their financial woes in the newspapers, confessing in print that the organization was "seriously embarrassed for lack of funds." One paper reported overdramatically that French's statues "are said to be practically in pawn because the committee has not money sufficient to pay for them."[45] When even this alarm failed to spark contributions, the committee warned of the possibility that the statues "should never be erected" at all. At one point it even published the name and home address of its treasurer so "small or large contributions" could be mailed to him directly.[46]

Only after further delay did the emergency campaign limp over the finish line. By late April 1901, a few weeks after President William McKinley took the oath of office for his second White House term, funds at last became available to compensate the forbearing French. His statues were installed, albeit three years behind schedule.[47] This time there was no ceremony. Most of the new wave of reviews nonetheless proved positive, with a typical notice pronouncing one allegorical figure "noble" and the other "divine."[48] In a lengthy career assessment inspired by their belated installation, an Indiana newspaper placed French "in the front rank of American artists." The article featured Lorado Taft's recent assessment that the sculptor was also "one of the most genial and gentle of men." In Taft's judgment: "Everyone of us rejoices in Mr. French's prosperity. It means just that much more of good art in our country. We need more men like Mr. French—men of character and culture; men of ideas and sympathy with all that is beautiful and good. Long life and a full one to Daniel C. French."[49]

Earning praise and friendship was one thing, but as was his habit, French also made certain that variations of his latest work enjoyed wide and potentially profitable circulation, regardless of the setbacks that had prevented

the timely placement of the originals outside Central Park. He sent his plaster maquettes of both *Architecture* and *Painting and Sculpture* to be shown at the 1901 Pan American Exposition at Buffalo (where President McKinley was assassinated and succeeded by New Yorker Theodore Roosevelt). Five years later, in the midst of the Roosevelt era, French lent a bronze study based on the head of *Architecture* for display at his brother's Art Institute of Chicago. For reasons unrecorded, he retitled the head *Carlotta*. By any name, it did not elicit the praise the original had earned, one Philadelphia journalist dismissing it as "not wholly pleasing."[50] The rare dose of criticism may have inhibited French from authorizing further displays, but very late in his life, in 1927, he would finally place the foot-high bronze models of his *Hunt Memorial* figures on view at New York's Grand Central Art Galleries, a decision he soon came to regret. A thief made off with *Architecture*, and it was not found for years. Not until 1931—the year of French's death—was the maquette recovered, the mystery of its disappearance still, and ever after, unsolved.[51]

As for the original *Hunt Memorial*: fits, starts, and funding crises notwithstanding, it immediately took its place among New York's many off-the-beaten-path sculptural treasures. The structure remains in place to this day against the stone perimeter wall of Central Park. Recently restored to its original luster, its granite bench still beckons to weary pedestrians strolling along the cobblestoned sidewalk on the park side of one of New York's most glamorous streets. There, it shows absolutely no evidence of the difficulties that the art lovers and Hunt admirers of Gilded Age New York once encountered in installing it.

◆ ◆ ◆

As frustrating as the Hunt project became, none of French's public statues ever took longer to accomplish—from the point of inspiration to the day of dedication—than the brooding yet majestic equestrian of General Ulysses S. Grant that he created for Fairmount Park in Philadelphia. For once, however, the vexing delays had nothing to do with either the workload of the sculptor or the parsimony of his patrons.

Ex-president Grant, not only the most famous man in America but the most famous American in the world, had died of cancer on July 23, 1885, triggering an avalanche of interest in memorializing the Civil War hero. Admirers quickly proposed heroic bronzes for both Washington, DC, and St. Louis, while a new Grant Monument Association seized most of the attention—and donations—for the general's tomb in New York City. (Six

days after Grant's demise, Western Union alone pledged five thousand dol-
lars to that project.)[52] Meanwhile, statues honoring Grant's less successful
but more picturesque Confederate rival, General Robert E. Lee, rose with
alacrity in Virginia, Louisiana, and Arkansas, though Lee himself had made
clear before his own death that he opposed any commemorations that pro-
longed the hard feelings engendered by the Civil War.[53]

Just four days after Grant's passing, a Philadelphia-based art commission
did commit to raising ten thousand dollars to create "a suitable memorial
statue" in Fairmount Park. Fund-raising proceeded quickly and success-
fully, but the idea languished: the group did not reconvene for three more
years, by which time Grant statues had already appeared in Chicago (by
Louis Rebisso) and St. Louis (the work of Robert Bringhurst). Inexplicably,
the only action the Philadelphia commission took that day in 1888 was to
double its funding goal to twenty-five thousand dollars without launch-
ing a formal competition of its own. Instead the group attempted to woo
Augustus Saint-Gaudens, who turned down the offer and identified French
and Frederick William MacMonnies, among other sculptors, as poten-
tial candidates for the job. Perhaps learning of the recommendation from
Saint-Gaudens himself, French took the initiative and wrote to the com-
missioners to express his interest. Other artists did likewise. Inexplicably,
it took another four years for the commission to invite actual proposals. In
November 1892, French visited Philadelphia to make his case in person, no
doubt reporting that, if hired, he intended to collaborate once again with
Edward Clark Potter, the equine specialist with whom he had partnered so
successfully for the *Columbus Quadriga* at the World's Fair.[54]

Shortly before Christmas 1892, French officially secured the twenty-two-
thousand-dollar assignment. "I think I am more jubilant on Potter's account
than on my own," he rejoiced. "He is radiant....It will be a good chance for
us both and we intend to make the most of it." French joked that he had "suf-
ficiently impressed" the commissioners "with Potter's and my importance,"
adding with understandable surprise: "There was no competition or even
preliminary model."[55] But seven years had been wasted on preliminaries.

French and Potter worked out their initial design at the Enfield farm in
the summer of 1893, and by 1894 submitted it and secured a formal con-
tract from the commission. Its beleaguered chairman now felt confident
enough to predict that the memorial would "make Philadelphia famous in
the possession of another Art Treasure of national importance which every
patriot will desire to see." To guide him in his work, French had easy access
to an abundance of Grant photographs, and for the details of the general's

uniform, including the overcoat he wore "several inches longer than usual," he relied on advice from Grant's son, Frederick, who had accompanied his father on several military campaigns.[56] The portrait would be military without being militaristic. As the sculptor explained: "We chose for our motif, a moment when Grant was surveying a battle field from an eminence and he is supposed to be intent upon the observation of the forces before him. The horse is...obedient to the will of his rider. We endeavored in the figure of Grant to give something of the latent force of the man, manifesting itself through perfect passivity....If the statue impresses the beholder by its force as having character and stillness, it will have fulfilled its mission."[57]

Progressing rapidly now even as they worked simultaneously on other assignments, French and Potter completed their full-size plaster model at Enfield in the summer of 1895, and late that year shipped it to a Philadelphia foundry for casting. The bronze was not completed, however, until April 1897—this latest delay caused by problems in constructing the pedestal.[58] By this time the project's cost had soared to thirty-three thousand dollars.[59] Then, just as the base finally neared completion, and with a dedication date on the calendar, America went to war with Spain, and the commission put the planned 1898 unveiling on indefinite hold.

Not until April 27, 1899—on what would have been Grant's seventy-seventh birthday—was the statue at last unveiled, preceded by the arrival in Philadelphia harbor of the Spanish-American War cruiser USS *Raleigh*, fresh from combat in Manila Bay.[60] Counting from the date of the Fairmount Art Commission's first meeting, the project had consumed nearly thirteen years. Even so, the Philadelphia ceremony—and the equestrian statue—proved a triumph. President McKinley and his entire cabinet attended the dedication, along with "three generations of Gen. Ulysses S. Grant's family and a great crowd of people."[61] The general's widow, Julia Grant, arrived with Mrs. McKinley for the 2 p.m. event, preceded by a parade of sailors from the *Raleigh*, which had docked in the Schuylkill River within sight of the crowd.

Critics hailed French's almost antiheroic concept, lavishing praise on the restrained statue and commending not only its artistry but its originality. To *Frank Leslie's Weekly*, the "magnificent bronze" was "a remarkably fine piece of work in all respects."[62] Of all the equestrians inspired by the Civil War, added the *Philadelphia Times*, "the majority depict the horse in an impossible attitude and the hero with uplifted hand or sword. The statue of General Grant departs entirely from the conventional composition. There is no attempt at theatrical representation....Rider and steed are one in aspect of restrained strength." Lauding French as "one of the foremost of American

sculptors," the paper hailed the equestrian as "one of the handsomest in the world," adding insightfully:

> The statue of General Grant will not catch the popular eye so quickly, per-haps, as would a statue of dashing Phil Sheridan or impetuous [George A.] Custer, where there is more opportunity for dramatic action. To many the prancing steed, the gesticulating hand, the flourishing sword savor more of war and seem more in harmony with the beating drum, the shrill-voiced fife, the proudly stepping troops and all the glittering pageantry as it moves along the street. But this is not war itself—it is merely the paraphernalia of war. It was no trifling task to make a large, dignified and quietly impos-ing figure of the silent "man on horseback"; to produce a memorial that should possess an enduring art value and be truly expressive of the person-ality embodied, executed with directness and independent of the artifices in which escape is often sought from the difficulties of a simple design.[63]

Commenting for the *Century Magazine* a few months later, the painter-turned-art critic William Anderson Coffin further cemented the reputation of both the statue and its sculptor. "Mr. French," declared Coffin, "is endowed with a faculty of the greatest importance in the arts of sculpture and paint-ing—that of expressing, not only by fidelity of detail, but also by the compo-sition of a work as a whole, the character of the subject....He conceives his Grant as a great captain who showed the least emotion under the mightiest strain, the greatest exterior calm in the most acute and trying situations, and consistently develops a figure whose posture may not be inaptly likened to that of a sentinel in a shower of rain which causes the passers-by to hurry to shelter, but leaves him standing unmoved in the steady drenching."[64]

◆ ◆ ◆

As he juggled the O'Reilly, Hunt, and Grant projects—along with the com-missions for portrait statues of Phillips Brooks and Rufus Choate—Dan and Mary French had faced the unhappy prospect of another rootless summer. Determined to rectify the situation, they had begun back in 1894 scour-ing the Berkshire Hills of Massachusetts for purchase or rental opportuni-ties, though nothing they initially viewed tempted them. One day in August 1895, on a whim, they set off again by rail to Kent, Connecticut, where they hired a horse and buggy to transport them toward Great Barrington, Lenox, Pittsfield, and Williamstown—towns that dotted a region French recalled with fondness from his 1883 apprenticeship at Frederick Crowninshield's

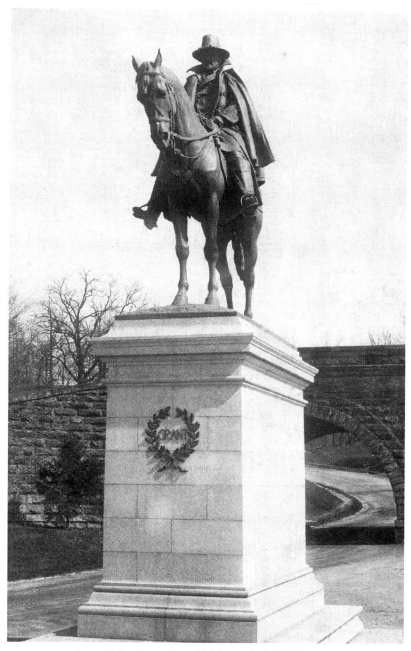

Ulysses S. Grant, bronze, 1892–99, Fairmount Park, Philadelphia, PA

Daniel Chester French and cousin Anne French outside the Warner
farmhouse at Chesterwood, Stockbridge, MA, 1898

Richmond, Massachusetts, art school. All along the route, they visited homes
advertised both for sale and rent. They still found none to their liking.

Winding their way through the picturesque Berkshires until they reached
Stockbridge, Mary would remember of their initial impression, "we loved it
from the first moment we looked upon it."[65] They stopped for the night at a
commodious old hostelry called the Red Lion Inn. The charming white-clap-
boarded onetime tavern, conveniently situated midway between the capitals
of New York and Massachusetts, had been lodging and feeding guests for
more than a century. The Frenches sat contentedly on its wide veranda, per-
haps enjoying tea or cocktails (as its guests still do), watching the coaches
rolling along the Albany-Boston road. Mary strolled down Main Street,
impressed by the elm trees, broad lawns, and gracious colonial-style homes
opposite the Red Lion, delighted by the profusion of shops near the hotel.
"I don't know what you're going to do," she soon informed her husband,
"But I am going to live here."[66] Of course, "downtown" Stockbridge seemed
too public a place for an artist's studio, so the next day the sculptor and his
wife headed into the nearby countryside to inspect one more available prop-
erty: the Marshall Warner farm. The onetime boys' school stood up the road

The French residence at Chesterwood,
Stockbridge, MA, 1922

in the sparsely populated Glendale section of Stockbridge.[67] As they rode the three miles west along dirt roads toward the hilltop site, Dan and Mary French must have grown increasingly aware of the "soul-satisfying" vistas emerging on all sides.[68]

Arriving at the Marshall Warner property, they encountered yet another run-down barn, but this one near an appealing green-shuttered white farmhouse encircled on three sides by a slender porch. The structures faced a dense swath of trees, framed by majestic mountains and serenaded by flocks of birds: eighty acres, as French described it, mostly "wood-land and the rest grass-land and pasture."[69] Flowers bloomed everywhere, although the air was thick not only with their fragrance but with mosquitoes and midges. The existing farmhouse was dilapidated, but the magnificent natural setting exhilarated the artist. No alluring body of water stood nearby, yet French judged the vista "the best 'dry view' he had ever seen."[70] English poet Matthew Arnold, on one of his visits to America, had reportedly concurred, calling it a "beautiful and soul-satisfying view."[71] Still, it was an undeveloped property at best, ramshackle at worst, and its transformation would require time, labor, and considerable investment.

Unwilling at first to commit, the Frenches inspected other locations nearby, but as if under a spell, headed back to the Warner place toward dusk. The view toward Monument Mountain and the surrounding peaks looked even grander silhouetted in twilight. According to their daughter, who no doubt heard the story many times from her parents' own lips, Mary finally turned to her husband and whispered: "Do you think it's ours?" To which Dan replied: "Yes, I think it belongs to us."[72] They acquired the 150-acre property for three thousand dollars, which French raised by securing a cash advance on his Grant statue.[73]

Dan and Mamie French would soon name their new acquisition in honor of the family's ancestral home in southeastern New Hampshire. From the turn of the century onward it would be "Chesterwood." Virtually from the moment he acquired the property, French found his thoughts straying back to his days on the Concord farm even as he envisioned the future on his new land. Citing the "possibilities in the place, he told his brother: "I find my mind reverting to it with more interest than to anything I expect to see in Europe, and I have already a real satisfaction in its possession....The best of it is said to have been very productive, but it has been allowed to run wild for ten years and is all run down....I am rather surprised to find how my interest in farming revives, now that I have land of my own. I am already planning to restore the worn-out land and have visions of cows and sheep and other expensive luxuries."[74]

For the next three-and-a-half decades, the Frenches faithfully took up residence at their Chesterwood estate each May and, save for vacations abroad, remained there annually through mid-November, spending precisely six months of every calendar year at their beloved retreat. During their first few summers in the Berkshires, the family lived in the existing century-old farmhouse—which the industrious artist repaired, modernized, and outfitted with locally acquired furnishings, many of them bargains, for which French shopped himself—even though the original house never boasted more than one bathroom.[75]

The sculptor turned his immediate attention to the construction of a new free-standing studio, for this was to be not only a country home but a workplace. To help him design this crucial building, he turned to his young colleague from the World's Columbian Exposition, Henry Bacon, who had since relocated to New York City and left the architectural offices of McKim, Mead & White to form a new partnership with architect James Brite. French and Bacon were nearly a generation apart in age, but shared an artistic

sensibility: a love of placidity. As historian Christopher Thomas has pointed out, the handsome young Bacon seemed "like a man out of his time,"[76] and this must have appealed to the older sculptor. "Whatever he did," French later marveled in tribute to Bacon, "was exquisitely done and possessed that calmness of aspect which belongs only to great works of art...his standard was perfection."[77] He might have been describing his own work.

With Bacon enlisted as his designer, French rejected the simplest, cheapest option: converting the existing barn into a studio in the manner of his Enfield rental. But he was unwilling to sacrifice access to the hilltop site it occupied. In a flight of expensive fancy, he had the barn moved intact to higher ground a few hundred yards away, and specified that the new studio be erected on its original foundation. French directed that the replacement be both handsome and functional. After all, as he had told a local newspaper upon his arrival in the Berkshires, his "definition of a sculptor" was "a man nine-tenths mechanic and one-tenth poet."[78] The new designs would have to meet the needs of both engineering and art.

Harry Bacon proceeded to plan an extraordinary studio pavilion for the sculptor. Construction on the stucco-clad structure began in the summer of 1897 while the Frenches were again touring Europe, a trip that began in Greece, where French devoted some two weeks to haunting the Acropolis, continued in Rome, where he was inducted into the three-hundred-year-old Accademia di San Luca, and ended in Paris, where French met another giant of contemporary sculpture, Auguste Rodin.

By the following summer, back in residence in Stockbridge, French was able to take up occupancy in his new studio, which he made sure included a colonnaded piazza from which, seated in wicker chairs, the sculptor and his visitors could enjoy unobstructed views of Monument Mountain.[79] Like Saint-Gaudens's Aspet, French's new warm-weather professional headquarters would be grand enough to reflect his stature as a major artist and country landowner, and functional enough to accommodate his commitment to further work. In the northern entranceway to the studio, French set up a sitting room to receive guests and patrons. He decorated it with family heirlooms and a hodgepodge of freshly acquired antiques in a cacophony of periods and styles. For a "cozy corner" recess, he brought the Pompeian-style daybed he had built for his Concord studio, convinced it could still provide comfort and solitude. In the sitting area, French installed a grandfather clock and a fireplace frieze commercially cast after a Donatello relief in the Church of San Martino in Lucca, Italy. A pair of Ionic columns (strung

The new Chesterwood studio, looking toward north entrance, 1914

with a red curtain designed to drop discreetly whenever nude models were posing inside) led the way into a large, square, thirty-by-twenty-nine-foot work area. His daughter called it "perhaps the finest studio in the country."[80]

This high-ceilinged workroom featured a strategically placed skylight to supply all-important soft, indirect illumination without shadows; and shelving and pedestals ample enough to display plaster and bronze maquettes in abundance (although French typically discarded his casts when the space became too crowded). A bookcase overflowed with easily accessible research volumes on such vital topics as military uniforms. Hanging intriguingly on one large hook was a leather saddle, ready whenever needed to accommodate a model posing indoors for an equestrian statue. A trap door in the floor allowed assistants to store old casts and fresh clay in the cellar. The whole effect was ingeniously utilitarian yet whimsically personalized, a combination colonial barn and European atelier, fully equipped to accommodate French's devotion to precision, salesmanship, and routine.

"A fine casting room was at the back of the studio," Margaret remembered, "with a carpenter's bench, a vise, a grindstone and cupboards for sculpture tools, carpenter tools, paints, shellac, varnishes and all the

Portrait of Daniel Chester French in a pongee smock, 1900

paraphernalia that a sculptor needs at hand. There was a sink and faucet for the water that has to be sprayed on a clay statue every day."[81] A portable wooden potter's wheel stood on casters, enabling French to roll his clay models from room to room so he could examine them from many angles and in different shades of light. Here, still and ever after working in a dress shirt and bow tie, he might occasionally don his pongee smock, roll up his shirtsleeves, and even dive into a vat of clay himself. Otherwise, this room would be the province of his casting crew, a beehive of frenzied and unavoidably messy activity by day, but always cleaned and restored to pristine condition, each tool back in its carefully outlined place on the wall, after work ended in the evening. When French returned to begin his next day's work at precisely nine o'clock the following morning, all would be in order and ready for his latest instructions.

By far the most innovative feature of the studio could be found in its main room: a revolving modeling platform atop a railroad flatcar. The car sat on a submerged indoor track leading outdoors through twenty-two-foot-high, floor-to-ceiling double doors along the studio's western wall. By utilizing it, French could roll his latest work outside so he could view even his largest models in the full light of day—just as the public would eventually view his finished statuary.

When the weather cooperated, French would have his assistants open the floorboards and jump down to the track level, from which they would push the car outside through the doorway, onto a terrace on the meadow. There he could inspect his sculptures outdoors from ideal perspective, by gazing up from the lower hillside, as if each statue were already on a pedestal. At the end of a day's contemplation, the process would be reversed, and the movable cart would be rolled back inside. Otherwise the studio would be illuminated by large windows along the northern and eastern walls, equipped with shades that could be drawn fully or partway to adjust interior lighting to the sculptor's specifications. French had come a long way from the freezing room he had rented in Florence a quarter century earlier.

On July 12, 1898, no doubt bursting with ideas and eager to make use of the new accommodations, French moved the sculpted horse that was to accommodate his new George Washington statue into the still-unfinished studio.[82] He moved himself into the space just four days later and soon hosted "a little tea to show it off."[83] By early August the windows were washed, the furnishings installed, and the sculptor ready to work there. Promptly establishing his routine, he began finding spare time to attend to the grounds as well. Each day he finished his work around 5 p.m. and,

Daniel Chester French, *Mary and Margaret French*, pastel, 1893
(Chapin Library, Williams College)

when there was time before dinner, headed to join Mamie to tend the gardens. Every day, while the light lasted, French's tightly organized schedule set aside time for him to apply his hands to the grounds. He planted apple groves, grapevines, flowers, and shrubs, adding fountains, cherubs, and jardinieres in unexpected places.

French devoted additional attention to Chesterwood's landscape, planting new trees, hedges, and the flower seeds he bought from mail-order

catalogs. Meanwhile, Henry Bacon began work on designing the family home close to the new studio, to be connected by a pathway. The limestone-covered stucco mansion that Bacon conceived was designed in the colonial style, but could almost be described as a villa, for its architecture also reflected elements of the Italian Revival. Like the artists' compounds that French had haunted back in Florence, it faced south to embrace the scenery and welcome fresh air into the house. No doubt, French collaborated closely with Bacon on the conception. In a show of eclectic adventurousness, the sculptor incorporated architectural elements from the original farmhouse and, just as he had done in Manhattan, personally supervised the interior detailing and decor. He designed the hearths, selected wallpaper and paint colors, and brought in antique furnishings, works of art (one of the first was a painting of a sailmaker by Abbott Thayer), and decorative embellishments that he began collecting locally or acquiring in New York City.[84] Only later would Mary French almost reluctantly add flourishes of her own. Their airy new house was ready for occupancy shortly after the beginning of the new century: the summer of 1901.

When he first purchased Chesterwood and began putting his personal stamp on the property, French was forty-six years old—acclaimed, wealthy, and in demand. His wife was a still youthful thirty-seven, their daughter Margaret, nine. And soon, like the great artists in whose shadow he had so long labored, French at last boasted an estate fit for a country gentleman, along with a modern studio spacious enough to store his old works and inspiring enough to stimulate new ones. Here he could—and would—increase his already voluminous output.

After a visit to "Mr. French's very beautiful estate" a few years later, the magazine *American Homes and Gardens* provided its thousands of readers full details about the sculptor's "enchanted space." The reporter hailed the design of both the studio and home, describing the "very well studied" house as ideally suited to "the distinguished artist whose loving care and fine appreciation of the beautiful has embowered the house and grounds." But the writer came away impressed chiefly by "the wonderful and marvelous view" that had once hypnotized Dan and Mary French, declaring that "mere words are inadequate to describe the loveliness and the grandeur of the outlook. 'It was what brought us here,' said Mr. French, and truly the whole vicinity contains no more superb attraction."[85]

For the rest of his life, French looked forward to his yearly escapes to the country and would grow increasingly reluctant to leave Chesterwood and

return to Manhattan each November. He went so far as to install a Franklin stove to keep the casting room, and its workers, warm on frosty autumn mornings. When asked many years later whether he now lived in the country full-time, it is little wonder that French replied: "I spend six months of the year up there. That is heaven; New York is—well, New York."[86]

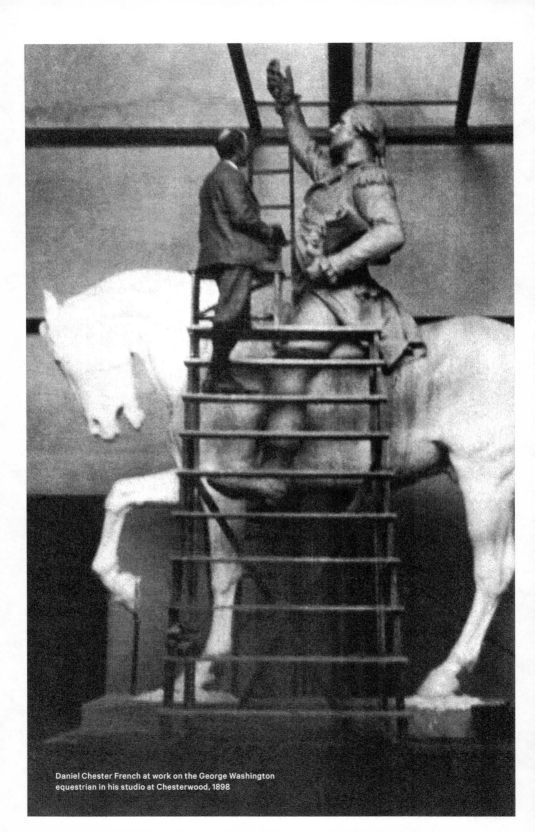

Daniel Chester French at work on the George Washington equestrian in his studio at Chesterwood, 1898

A NEW CENTURY

The first project French undertook at his new Chesterwood studio in 1897 also became his only completed assignment for foreign shores: the commission to create a heroic George Washington equestrian for the Place d'Iéna in the sixteenth arrondissement of Paris. The statue would sit opposite the city's Asian art museum, the Guimet, and within sight of the soaring new Eiffel Tower across the Seine. Its patrons conceived the epic sculpture as a gift to the French government to coincide with the 1900 Paris Exposition Universelle, the latest in world's fairs, each aiming to outdo the one before. In another sense, the statue would also serve to reciprocate for France's 1886 sculptural gift to America: Bartholdi's *Liberty Enlightening the World*, the Statue of Liberty in New York Harbor.

A committee of the Daughters of the American Revolution, precisely named the Association of American Women for the Presentation of a Statue of Washington to France, raised the funds for the project, in short order collecting forty thousand dollars to finance this tribute to the founding American who had never set foot in Europe. Yet Washington symbolized liberty and fraternity in France as strongly as he did in America.[1] Sculptor French and his collaborator Potter split a fee of thirty thousand dollars, but eventually spent most of it on expenses, including the thirty-foot-deep foundation that was unexpectedly required to stabilize the ground beneath the heavy equestrian.[2]

To facilitate work on the piece at Stockbridge, French hired the "son of a neighbor with a rangy, powerful build" to dress up and pose as Washington. The amateur model uncomplainingly endured the "sultry" August 1897 heat

to sit "for hours on end...high up on a platform, astride a barrel to give the desired spread." Ever the stickler for detail, French even sent the boy to a New York City costumer to have him properly fitted up in a brass-buttoned broadcloth uniform. On the days his young model failed to appear, French pressed his Chesterwood guests into service, including his cousin Anne, who at one point agreed to don army boots to pose "for George Washington's legs."[3]

The Stockbridge studio was still under construction outside when French's assistant, Augustus Lukeman, first began working inside to construct the framework for the figure. Even as laborers troweled stucco onto exterior walls, Lukeman busied himself mounting the Washington "skeleton" astride Potter's fully formed plaster horse. To reach the top of the work, French would now be obliged to scale a newly installed movable stepladder. Or he might work outdoors. One momentous day, French summoned his entire family from the farmhouse to watch as assistants wheeled the railcar that supported the huge plaster model into the sunshine for the first time. Though Margaret was only nine years old, she vividly remembered watching the assistants pushing the big platform along the newly installed tracks as her father skipped down the steps that led to the meadow just below the studio. From this slope, French availed himself of the same perspective a viewer might enjoy when gazing upward at a finished statue atop a typical pedestal outdoors. French cupped his hands "to shut out too much sun," squinted at his Washington, then beamed proudly—at first. Predictably, the exacting sculptor quickly concluded that "there was too much play of light on the front of the coat," and ordered the statue back inside so he could add "a few concaves and creases."[4] The trial run at least demonstrated that the new track system worked perfectly.

By the late spring of 1899, the two sculptors felt confident enough in their Washington to begin showing the work in progress to visitors. On May 11 seventeen members of the local Pittsfield-based DAR chapter conducted an outing to the Chesterwood studio, "where stood the colossal statue of George Washington on his steed, the model in plaster for the bronze statue to be presented during the Paris Exposition," as their official records noted. On what they described as "A Field Day," they "enjoyed pleasant talks with both artists: Mr. French who models the figure of Washington, & Mr. Potter who models the horse."[5] Of course, they also took in the spectacular view from the studio porch.

In August, French invited four hundred fellow "summer visitors at Stockbridge and Lenox" to Chesterwood, for their own "private view" of the statue, which they "much admired." The event caused a country-road

George Washington, bronze, 1896–1900, Place d'Iéna, Paris, France

traffic jam of seventy-five carriages.[6] As was his custom, the sculptor also made certain that the statue enjoyed ample advance publicity. On the Sunday after the annual celebration of Washington's Birthday, 1900, a large photograph of the plaster model graced the cover of a Boston newspaper under the plainspoken headline, "New Statue of Washington."[7] By that time, French had shipped the full-size plaster to New York to be cast in bronze by Henry-Bonnard. When he welcomed journalists to the Manhattan-based foundry in April for a three-day preview exhibition, a correspondent for the *New York Tribune* built momentum by describing the "beautiful" bronze as "thoroughly American in character."[8]

Meant to reimagine the moment Washington assumed command of the Continental Army at Cambridge, Massachusetts, on July 3, 1775, French's statue depicted the bare-headed general, magnificently upright in the saddle, gracefully reining his horse with his left hand, and with his right holding perpendicularly aloft "the sword that consecrates his country." It was an awkward pose at best, difficult to portray, yet according to an unidentified press clipping that French retained in his files, he and Potter had triumphed: "The conception and characterization are superb, the technique beyond reproach....The effect is of patriotism personified." The writer noted that while "Mr. French and Mr. Potter have collaborated on many important works...nowhere in that history which they have traversed so successfully is the imprint of their strong individualities so comprehensively revealed as in this last achievement."[9]

Concurring that the result was both "heroic and dramatic," painter and art critic William A. Coffin added a flattering endorsement of his own: "The spirit of the motive is admirably expressed in the action of the figure, and the head is noble and commanding in aspect." Coffin declared in the *Century Magazine* that sculptor French "is endowed with a faculty of the greatest importance....He decides that his Washington shall be heroic and striking and dramatic (but of course not theatrical), and he produces just this impression on the spectator."[10]

Standing twenty-two feet high and weighing more than five thousand pounds, the bronze was shipped to Paris to be set on a granite base designed by Charles McKim. French followed overseas himself. But when he appeared in the city to supervise the installation and witness the dedication, he found local organizers in a state of panic: the sculptor had arrived, but the sculpture had not. With less than a week to go before the scheduled unveiling, a panic-stricken French scoured the city for his lost statue, finally locating it "on a boat at a dock on the river." He spent an entire day beseeching customs officials to release it, then returned to the Place d'Iéna to see the *Washington* safely hoisted onto its eight-foot-high pedestal.[11] The fastidious sculptor was still not quite satisfied. Once he viewed the statue perched on its base, he concluded that he had made Washington's sword too thin, and had neglected to dramatically render the ruffles on the general's sleeves. Of course, it was too late to make major adjustments. French spent some time merely touching up the bronze. He consoled himself that night by attending the somewhat notorious Parisian cabaret music hall, the Folies Bergère.

Exactly as planned, on July 3, 1900, the eve of US Independence Day and the 125th anniversary of Washington's investiture as commander of the Continental Army, American and French officials gathered at the Place d'Iéna to dedicate the George Washington statue. More than a thousand spectators—including "practically every known member of the American colony" in Paris—looked on. Augustus Saint-Gaudens himself attended the ceremony, along with Frank Millet and other expatriate American artists. As the statue sat draped beneath the official flags of the two countries, John Philip Sousa's renowned marching band played both national anthems, "The Star-Spangled Banner" and "La Marseillaise." The American ambassador to France, Horace Porter, a onetime Civil War aide to General Grant, delivered the official presentation address. Porter reminded the audience that the "enduring bronze" represented an "exalted character" who had not only secured American liberty but had befriended Lafayette to forge the French-American alliance. Then, as Sousa's band struck up "Hands across

the Sea," the president-general of the Daughters of the American Revolution tugged at a cord and "unveiled the bronze statue" of Washington.[12] As was the custom at such ceremonies, French remained mum. Sousa concluded the patriotic event by performing his signature "Stars and Stripes Forever" as an encore.

Daniel Chester French, now lionized on both sides of the Atlantic, returned to his home country to find customers eager for reproductions of the *Washington*, perhaps numerous and generous enough to compensate him for merely breaking even on the Paris original. But the statue gained domestic popularity rather slowly. Some years later, in 1904, the city of Chicago almost furtively installed a full-size bronze replica in Washington Park, after paying forty-eight thousand dollars for the statue's fabrication. While the *Chicago Tribune*'s art critic reproached French for making General Washington look too warlike and insufficiently human, he regretted that "a great statue" had been installed "as quietly as though it had been a hitching post or a watering trough."[13] Not until 1917, as the United States joined France in the multinational war against Germany, did the sculptor finally order multiple bronze reductions for private sale to fireside patriots.[14]

With evident pride, French also collected and lovingly preserved his own little mementoes of the original: two souvenir postcards of the *Statue de Washington* published in Paris around 1906.[15] At the dawn of a new century, a Daniel Chester French sculpture had become a foreign tourist attraction.

French returned home from the 1900 unveiling in triumph, met by "a body of sculptors from New York" who had chartered a tug just to welcome him. That afternoon, Augustus Lukeman, Andrew O'Connor, and the others treated French to a celebratory lunch at the Arts Club.[16]

◆ ◆ ◆

French began his fourth decade as a professional sculptor balancing a bevy of prestigious new assignments. In one example, Congress commissioned him to portray Admiral George Dewey, the naval commander at the outset of the Spanish-American War who had won world fame by triumphing at the 1898 Battle of Manila Bay. As a government-funded gift for the 1,600 veterans of Dewey's victorious American Asiatic Squadron, French designed a bronze medal. The coin, struck by Tiffany & Co., featured a profile of the uniformed Dewey on one side, epaulets emerging in bold relief, and on the other, the portrait of a bare-chested American sailor seated on a gun clutching a rammer.[17] *Frank Leslie's* called it "a notable contribution to the medallic art of the country."[18]

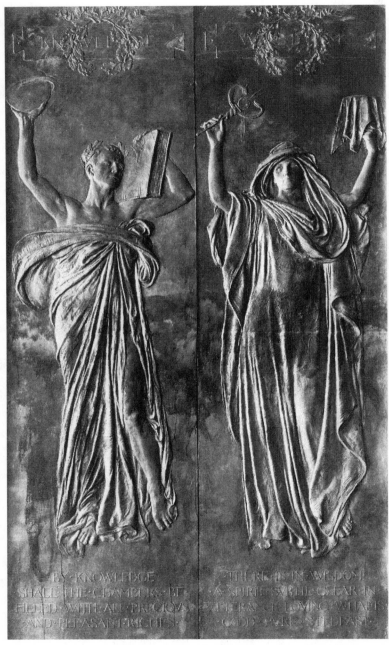

Models for the bronze doors of *Knowledge* and *Wisdom*, 1902,
for the Boston Public Library, Boston, MA (Chesterwood, Stockbridge, MA)

In a less martial mood, French went on to produce a *Peace* group for a temporary "Dewey Arch" for Madison Square in New York City, joining a roster of twenty-eight fellow sculptors, including J. Q. A. Ward, Karl Bitter, Charles Niehaus, and George E. Bissell. But lacking a firm commission for a permanent monument, its designers produced the seventy-five-foot-high arch in staff—the same plastery mix French had used for the *Republic* in Chicago. "It is a work of art too beautiful to be committed only to wood and plaster," lamented one observer.[19] But the project never attracted funding for a version in marble or granite, and after just a few months, the deteriorating arch was taken down.[20]

As a measure of French's high reputation, many of his new works were earmarked for state capitals. By 1902 he had produced six allegorical figures for the Cass Gilbert–designed Minnesota State Capitol in St. Paul; the allegorical *Justice* for the Appellate Courthouse in New York City; a statue of Minnesota governor (and fellow New Hampshire native) John S. Pillsbury for Minneapolis; and a standing bronze of Commodore George H. Perkins, a Civil War ironclad commander, for the rear of the New Hampshire State House at Concord. Simultaneously creating small clay models and then overseeing their conversion into full-size plasters, French kept his assistants busy on a virtual assembly line of enlargements and castings.

During this breathtakingly prolific period of his career, the sculptor managed to complete by 1904 the three pairs of bronze doors he had long promised Charles McKim for his Boston Public Library. The delicately carved allegorical portrayals, crafted in the light style he had used for the realistic Theophilus Walker tablet at Bowdoin, depicted *Knowledge and Wisdom*, *Truth and Romance*, and *Music and Poetry*—one of them featuring a bravura depiction of a male figure holding a large book on his shoulder. Although he had seen Lorenzo Ghiberti's incomparable sixteenth-century *Porta del Paradiso* (*Gates of Paradise*) at the Baptistery in Florence, French wisely chose not to mimic Ghiberti's approach, which featured six complex scenes on every door. Instead, French produced a single large image for each. He sculpted the doors in low relief—subtle images that barely emerged from the surface—demonstrating mastery of a demanding technique that Lorado Taft described as "one of the final tests of a sculptor's skill." As Taft noted: "In the importunate and most difficult problems of composition, foreshortening, and draping, reduced almost to the ethereal, Mr. French has shown his skill to be quite equal to his refined taste."[21]

◆ ◆ ◆

French soon after collaborated again with McKim on what turned out to be a more frustrating project: a memorial to the historian Francis Parkman for Jamaica Plain, a park alongside a pond on the Brookline side of Boston. Here the recently deceased Parkman had for years spent his summers. To clear the way for the memorial, the city razed Parkman's cottage and carriage house. The historian, whose popular studies of the American West were long praised (by critics like Edmund Wilson) for their "clarity" and "momentum"—even after their nationalistic bravado went out of fashion—proved one of the most influential American historians of the nineteenth century.[22] He may be the only one ever to have inspired memorial statuary.

French and McKim initially proposed a boxlike marble structure in the shape of a cemetery vault. Then, in homage to Parkman's books, especially *The Oregon Trail* and *The Conspiracy of Pontiac*, French came up with the idea of representing the historian by adding depictions of Native Americans. Emerging in bold relief from within cave-like niches on either shaft would be deeply carved figures costumed in the style of the Iroquois people, but representing no particular nation. French insisted that he was ambiguously portraying "one of the five nations about which Parkman wrote so much."[23] The design would come close to illustrating precisely what Parkman had written in his *Pontiac* book: "Some races of men seem molded in wax, soft and feeble...but the Indian is hewn out of rock."[24] Set above these allegorical figures would be a relief profile of Parkman himself, dug directly into the stone.

As enthusiastically as McKim and French advocated for this unusual design, both the Parkman Memorial Committee and the Boston Art Commission, which held veto power, resisted it. The chief spokesman for the Bostonians, a wealthy philanthropist named Loren F. Deland, best known locally as a onetime Harvard football coach, proved especially difficult to please, imposing roadblock after roadblock over the years. It was McKim who finally concluded, following what he archly called a "pow-wow" with French in Boston, that "the most classic background for the Indian, would be that with the least possible architecture, as close to nature as possible."[25] McKim then withdrew from the project entirely. At French's urgent invitation, Henry Bacon took over. It would be one of the first of their astonishing fifty collaborations.[26]

Bacon quickly embraced McKim's suggested refinements, shelving the original concept entirely and proposing in its stead one granite slab featuring

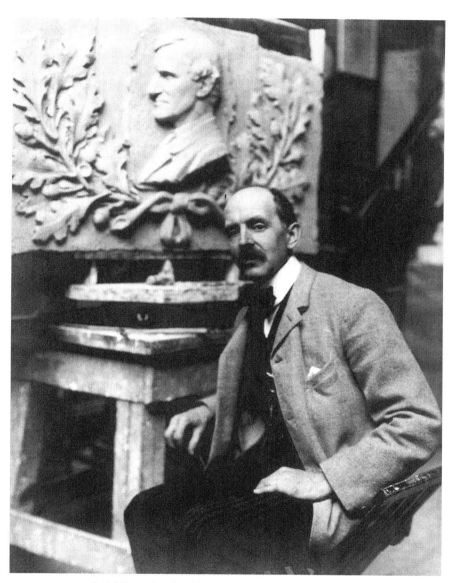

Daniel Chester French with his plaster relief of *Francis Parkman*, 1906

a sole Native American sachem. The profile of Parkman would now appear below, rather than above, the central figure, not in stone but on an affixed bronze plaque. As McKim had hoped, the emphases would be on sculpture and landscape, not design.[27]

French still had trouble making it cohere. After McKim criticized the figures in a revised plaster model as "stumpy" and "wilted,"[28] the sculptor engaged Augustus Saint-Gaudens as an adviser, asking him to Chesterwood to examine his latest maquettes. But his invitation betrayed a nagging lack of confidence, for it boasted only about his studio technology, not the work he was trying to create there. "[You really ought to see that railroad!" French beseeched Saint-Gaudens in October 1901 after deploying the studio hand-car to examine the plasters outdoors. "I had a fresh demonstration of its value the other day when I rolled the Parkman figures out (after working too long on them in the studio) and found them all wrong—too little and complex, all over."[29] French went back to work. He revised the Parkman profile, too, after the Boston commission unaccountably spurned the original (modeled accurately enough from a photograph). Not for years did French win the long-withheld blessing of both arbiter Loren Deland and the historian's daughter (and committee member), Grace Parkman Coffin.

Using French's belatedly approved final model, the Boston committee hired a local artisan named Francesco C. Recchia to carve the figure onto a specially quarried granite slab in his studio. French himself traveled to the Jamaica Plain to make final alterations after the stele was set in place in October 1906; by the following month he completed it. No dedication ceremony ever took place.

The *Parkman Memorial* would not become one of the sculptor's best-loved or best-known works, yet French remained committed to his belief that it represented the only way to memorialize a writer he regarded as "a curious mixture of Boston culture and Puritan simplicity, not to say ruggedness."[30] The sculptor convinced himself that it would "stand as long as the Pyramids."[31] In that prediction he has thus far proved correct, but by the 1970s, the memorial was attracting more vandals than visitors. At one point, thieves even made off with the bronze Parkman plaque. Though the tablet was eventually reimagined and reinstalled, even the official website of the Jamaica Plain Historical Society admits: "The Francis Parkman Memorial is hidden in plain sight."[32]

French never quite forgave his Boston patrons for shunning his original idea for a Parkman likeness carved within the granite itself. In the manner of the O'Reilly and Hunt memorials, it would have added a dose of explanatory

realism to an otherwise ambiguous allegory. But if he was irritated by the fre-
quent rejections he endured ("Like an eel," he insisted at one point, "I am
accustomed to being skinned alive"),[33] French surely found solace in the large
fee he earned for the project: twenty thousand dollars. As he wrote around
this time to his friend, painter Edwin Blashfield: "I don't wonder that the
price of sculpture seems high to people. I haven't got accustomed myself to
them and I blush when I name my prices....Times have changed."[34]

◆　◆　◆

Meanwhile, French's horse-and-rider partnerships with Edward Clark Potter
continued rewardingly. "It is probable that no American sculptor knows the
horse quite so well, structurally," Lorado Taft said of the equestrian special-
ist. "Most experienced of all in this particular field is Mr. French's old-time
pupil and all-time colleague."[35] Together, the sculptors now produced yet
another marvel: a statue of that Enfield celebrity, Massachusetts-born Civil
War general Joseph Hooker, commissioned by the commonwealth for the
southeast lawn of the State House in Boston.

Hooker was hardly an obvious subject for such an exalted tribute. He
had assumed command of the Army of the Potomac back in 1863, infamously
snatching defeat from the jaws of victory in Virginia that June by misman-
aging Union forces to a catastrophic rout at the Battle of Chancellorsville.
In the wake of that dispiriting loss, which cost the army seventeen thou-
sand casualties, Abraham Lincoln relieved and replaced Hooker. Just a few
days later, federal forces under George Meade prevailed at Gettysburg, leav-
ing military historians to ponder ever since whether Robert E. Lee would
still have suffered defeat there had Hooker remained in command of fed-
eral forces.

Transferred to the western theater, "Fighting Joe" redeemed himself
somewhat later that year at the Battle of Lookout Mountain in Chattanooga,
Tennessee. There he led a charge up the steep cliff, seizing the high ground
"above the clouds"—although General Ulysses S. Grant, learning that the
enemy had fled before Hooker's advance, later dismissed the "victory" as
"one of the romances of the war."[36] Adding insult to injury, Grant, in his
posthumously published best-selling memoir, acknowledged Hooker as
"brilliant," but skewered him as "a dangerous man...not subordinate to
his superiors," and "ambitious to the extent of not caring for the rights of
others."[37] His reputation shattered, Hooker retained fame mainly from the
belief that he had unwittingly given his name to the "women of the night"
who always seemed welcome at his encampments: "hookers."

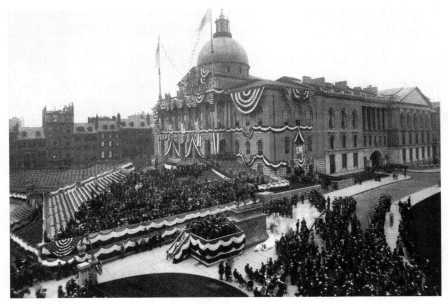

Dedication of the General Joseph Hooker equestrian, State House, Boston, MA, June 25, 1903

The handsome general managed to have the last laugh. By the time he died in 1891, he had outlived both critics and criticism, eventually earning the nostalgic gratitude of both his native state and his onetime soldiers. When the Massachusetts legislature unanimously approved the statue project, one of the officers who had fought under "Fighting Joe's" command justified the "unusual tribute" by asserting that the statue would not "honor Hooker alone, but Hooker as a representative soldier of Massachusetts."[38] A journalist who saw an early three-foot-high model of the statue declared that French had "vividly reproduced" the "fire in Hooker's eyes."[39]

By this stage of his own career, French much preferred assignments from individual clients, not committees, which he believed to be "the worst foe to monumental work that exists."[40] But he not only accepted the job from the Hooker Memorial Commission, he welcomed its members to Chesterwood to examine and approve the full-scale model. The party "drove down" to Stockbridge in August 1902 "in three four-horse wagons, thirty of them," French reported, as if the visitors were locusts.[41] The commission members evidently liked what they saw. French's statue depicted the spruce Hooker on the summit of Lookout Mountain sitting ramrod straight in the saddle, a suitable pose for a general notable for his panache and enormous self-regard. (Lincoln once lamented that Hooker seemed stubbornly "over-confident.")[42]

Time had evidently softened such harsh judgments. In sentimental tribute, survivors of Hooker's old brigade turned up for the "striking" statue dedication on June 25, 1903, proudly carrying "the old battle flags" to the ceremony.

A *New York Times* reporter who had previewed the finished bronze six months earlier caught its spirit perfectly: "The statue has a horse with all four hoofs on the ground, its head pulled in, its tail pendant. The General is equally quiet. He wears the soft chapeau, sits with straight knees very erect and holds his head a little back as if observing the movements of troops at a distance."[43] Still, the real Hooker had won what little military glory he retained by being aggressive, not contemplative in the manner of Ulysses S. Grant. What worked for the Grant statue failed to revive widespread admiration for "Fighting Joe," and did little to further the reputation of Daniel Chester French, either—another example of presidential history dominating American memory.

French and Potter nonetheless soon collaborated on another tribute to a Massachusetts-born Civil War general: their equestrian statue of General Charles Devens for the town of Worcester. Once again, French assumed responsibility for creating the human portrait, his collaborator, the horse. Although the assignment suggested that there was no end in sight to the vogue for public memorials to all manner of Civil War heroes, the Devens assignment seemed at first glance harder to justify than most. The comparatively obscure subject, who had notched no major victories in combat, was probably best-known for his astonishing luck, having survived battlefield wounds at three different Virginia engagements: Ball's Bluff, Seven Pines, and Fredericksburg. On one occasion, a bullet had bounced harmlessly off one of the brass buttons on his uniform. Yet in a way, Devens's service had bracketed the entire Civil War experience. Just after the attack on Fort Sumter in 1861, he had rallied the young men of Worcester to enlist for the defense of Washington; then, near the war's end in 1865, after Jefferson Davis and his government fled Richmond, Devens's troops had been the first to occupy the abandoned Confederate capital.

Years later, Devens served as US attorney general under President Rutherford B. Hayes, in the same administration that had employed French's father, a fact Dan likely knew. Perhaps that personal connection added to the sculptor's willingness to take on the assignment—that, and the usual steep fee of fifty thousand dollars, expenses included. The result, however, proved merely adequate, and seemed to echo a pattern French had established with previous equestrians. Art historian Michael Richman may have

been a bit too kind when he praised the Devens work as "reminiscent of the *Grant* without being imitative."[44]

By the time the Devens statue was dedicated in 1906, the team of French and Potter had clearly established an aesthetically pleasing and financially lucrative formula to portray Civil War "heroes." Civil War memory never had a better artistic advocate than Daniel Chester French. But the ever-inventive sculptor was growing weary of the genre. Six years would pass before French would produce another Civil War military equestrian.

◆ ◆ ◆

As the sculptor's roster of patrons and projects expanded in the early twentieth century, so did his stature—and, inevitably, his role in the institutional pantheon of American art. He joined the National Sculpture Society, founded in 1893, and became its first vice president. By happenstance, he was holding the chair (in president J. Q. A. Ward's absence) for its annual meeting in 1904 at the Fine Arts Building in New York when upstart member Gutzon Borglum rose to condemn the group's most recent annual exhibition as "a disgrace." Borglum demanded that the society's governing body be disbanded, monthly meetings established, and the administration professionalized. French, who hated conflict and treasured collegiality, ruled him out of order.[45] The episode hit the press, and French, who preferred that publicity focus on his work, not fracases at his clubs, must have been mortified.

Over time, French overcame both his shyness and aversion to discord and grew active at the Art Students League, the Art Commission of the City of New York, and the American Academy in Rome, an affiliation which he punctuated by taking Mary on a monthlong visit to Italy in 1900—making sure to show her the sites associated with his early days in Florence.[46] French also joined New York's Century Association, a haven for creative spirits, and worked to nominate fellow artists for membership. Such volunteer commitments not only demonstrated his genuine interest in promoting fine art in the United States, but opened doors to yet more clients and commissions, further widening French's already vast professional network.

When President Theodore Roosevelt was ready to name a temporary federal advisory board to counsel him on forming a permanent National Commission on the Arts, French was one of sixteen notables summoned to the White House to consult. He was no doubt the only one among them who could still remember Senator George Hoar's recommendation to create just such a panel back in 1886. The group assembled in the East Room, fully expecting Roosevelt to make a dramatic entrance. The president did not

disappoint. French remembered him bursting into the room "immaculate of dress, perfectly appointed in every way, brilliant as to complexion, and of course as to teeth, with a fresh buoyancy of manner that was almost theatric." Greeting his visitors one by one, the charismatic chief executive proved "cordial, responsive, glad to see everybody," making "each of them feel entirely at ease and at home, as if he were the particular person he had long wanted to know." Reaching the sculptor, the president exclaimed: "How do you do, Mr. French? A great pleasure to meet so distinguished a man."[47]

Then Roosevelt laid out his plan: he intended to bypass Congress and create by executive order a federal arts commission to oversee federal design and building in Georgetown and other parts of the District of Columbia. In his view, the nation's capital had too long weighed public art projects according to the whims of the House and Senate. Washington, DC, would be beautified in spite of opposition from Roosevelt's real and imagined Congressional "enemies." Whereupon Roosevelt led his visitors on an impromptu tour of the White House portrait collection and bade the group farewell—after gritting his teeth as he complained yet again about the endless opposition he faced from his countless foes.

Sometime later, French's wife and daughter found themselves attending a Washington reception at which the president made a surprise appearance. "Where's French?" Roosevelt demanded when he was presented to Mary. "French ought to have come. You ought to have brought him." Mary tried to explain that her husband never went out after a day's work; that the time he spent "climbing on stepladders and handling clay was frequently tiresome." Roosevelt would have none of it. "Well, he has a good defender, anyhow," he teased. Then, again baring those famous teeth, he added fiercely: "Does he know that you defend him like that? Does he *make* you do it? My wife wouldn't defend me. How does he do it? Does he beat you?"[48]

The Frenches must have laughed over the encounter, for neither one ever lost admiration for the progressive president despite the antipathy that reigned toward him within their social set. Never a talker, French seldom joined in when his conservative friends talked politics at dinnertime, a reticence that inhibited him from defending Roosevelt when the attacks intensified over brandy and cigars. Riding home along the cobblestone streets of Manhattan by carriage one evening after yet another party at which anti-Roosevelt scorn dominated the conversation, French sighed to his wife: "Really, it's almost embarrassing after dinner to sit at the table with a group of men, feeling as they all seem to do, bitter, vituperative. I can't feel as they do, and so I just sit still and don't say much of anything, and that kind of makes them mad, too."[49]

As promised, Roosevelt would soon establish his National Arts Commission, although his White House successor, William Howard Taft, later revoked the executive order and asked Congress for legislative authority to reconstitute the group as the US Commission of Fine Arts. (That group has supervised development in the Washington area ever since, especially around the National Mall and along Pennsylvania Avenue.) To serve as its first chairman, Taft would name Daniel Burnham, the demanding chief planner of the World's Columbian Exposition. Burnham's successor would be French himself.[50]

◆ ◆ ◆

The one organizational affiliation that gave French more pleasure, and influence, than any other was his decades-long involvement with the Metropolitan Museum of Art, even if many of its wealthy trustees, chief among them the banking titan J. Pierpont Morgan, counted themselves virulent Roosevelt foes chiefly in response to his trust-busting policies. Elected to the board in May 1903, French would remain a trustee for the rest of his days. Mary French called it "one of the greatest interests of his life—the association with a handful of distinguished men who have given of their best for the building up of one of the world's great museums."[51]

Those "distinguished men" included Morgan, a tycoon capable of causing or averting economic crises almost at will, and considered by many, Roosevelt notwithstanding, to be the most powerful individual in the nation; John L. Cadwalader, a prominent attorney and direct descendant of Revolutionary War patriots; newspaper publisher, former ambassador, and Republican stalwart "Whitey" Reid, whose wedding French had attended years earlier in Paris; philanthropist Darius O. Mills, once considered the wealthiest man in California; Rutherfurd Stuyvesant, who could trace his bloodline back to Peter Stuyvesant, the original Dutch colonial governor of New Amsterdam; and veteran white-shoe lawyer Joseph Hodges Choate, like French a summer resident of Stockbridge, who had delivered the oration at the opening of the Metropolitan's Central Park museum building back in 1880.[52] That his board colleagues were all considerably older, much more influential, and far more affluent than the newest of its trustees was surely not lost on French.

But "building up"—as Mamie had expressed it—was just what the thirty-four-year-old institution then needed, especially with regard to its still-meager collection of American sculpture. Funding for acquisitions was entirely dependent on well-heeled patrons like Morgan, meaning the

shut-mouthed French would have to continue keeping his political opinions to himself. On one occasion, he simply could not restrain himself. At an informal gathering of the trustees at Morgan's opulent private library, one guest praised the room's vivid tiger-skin rug. "Humph," Morgan growled, "people ask if Roosevelt gave me that rug." (The president was an avid big-game hunter.) To which French brought down the house with a typically terse three-word comment: "Well, did he?"[53]

Feeling tentative at first among such wealthy luminaries, French turned for encouragement to J. Q. A. Ward, his old mentor. At age seventy-five, Ward had stepped down from the Met board after more than thirty years as a founding trustee in a move orchestrated so French could take his seat as resident American sculpture specialist.[54] "I hope you will give me any points you can think of about the Metropolitan," French implored him early in his maiden term. "I need them. With your aid we ought to be able to make some impressions on the Trustees."[55] Indeed, he had already decided on a bold plan to broaden the institution's Eurocentric collections.[56] Elected chairman of the sculpture committee, French quickly began championing contemporary American art, working tirelessly to build the museum's holdings in American sculpture and, late in his life, contributing his own works to the collection. (Not only would he later authorize the new marble reproduction of his *Milmore Memorial* for the Met; at the very end of his career he would help install a plaque in memory of the museum's longtime curator of arms and armor, Bashford Dean. Declaring himself "unable to compete with my multi-millionaire associates" in terms of a cash donation for that project, French would offer instead "to contribute the tablet in bronze" by sculpting it himself.[57] He would go on to produce a tablet adorned with clever allegorical armor elements, among them a crest representing loyalty, a helmet for wisdom, and spurs to suggest diligence."[58] The memorial remains on view at the Met to this day.)

At the Metropolitan, the new trustee also advocated collecting works by the Parisian modernist Auguste Rodin, even though Rodin's impressionistic style and sensual themes clashed almost violently with those of traditionalists like French. He nevertheless touted one 1904 Rodin cast as "a great acquisition" for the museum,[59] and endorsed the purchase of additional Rodin bronzes, including *Adam* and *Le frère et la soeur*, some of which the Met specifically commissioned. When a rival institution, his brother's Art Institute of Chicago, scheduled an exhibition of sculpture by the avant-garde Belgian Constantin Meunier, who had shocked the art establishment by portraying ordinary working men, French not only endorsed the show but proposed

that it travel next to the Met. The opportunity "to exhibit the works of this original artist," he declared, was "one of the most important things that could happen at any art institution."[60] But it was for American sculpture that French became the museum's principal proponent, chief fund-raiser, resident expert, prime exhibition organizer, and relentless acquisitions manager.[61]

The museum's very first published *Bulletin* featured French's passionate recommendation that the trustees remedy years of neglect by committing to purchase American works. His essay noted trenchantly that the "expenditure of a sum of money equal to the cost of one original work of antiquity or of one moderately important picture would create a whole collection of small bronzes which would be of popular interest and would tend to stimulate this important department of art." Finding his voice at last in his new role, French made the case for his entire field. "Much sculpture of bronze has been produced in this country, of historic interest as well as of artistic value," he argued, "and in our judgment, this fact might well be recognized within reasonable limits."[62]

In 1906, funded by a huge bequest from the late railroad manufacturer Jacob S. Rogers, French began collecting for the museum in earnest. When in New York, he found time from his own busy professional schedule to visit galleries, studios, and showrooms in search of artworks. He besieged philanthropists like Jacob Schiff for additional contributions to fund new purchases. And he often engaged with artists directly to ask if potential acquisitions "would fairly represent"—as he once inquired of sculptor Frederic Remington—their best work.[63] Before bringing his acquisition proposals to the board, he often negotiated with artists to secure bargains, sheepishly admitting to the suffragist sculptor Janet Scudder early in his tenure that while he could offer only "an absurdly low price" for one of her works, he hoped "it may be worth something to you to have the statue in the Metropolitan."[64] Producing "desiderata"—wish lists—identifying more than two dozen deceased sculptors not yet represented in the collection, French pushed forward proposals to fill gaps in the museum's holdings.[65] In the absence of an adequate professional staff, French all but became the institution's de facto curator of sculpture.[66]

The list of acquisitions and artists that joined the Met collection under French's longtime committee chairmanship—works by William H. Rinehart, Frederick W. MacMonnies, William Rimmer, and Gutzon Borglum—transformed the museum. Even if French disapproved of Borglum's behavior at the National Sculpture Society years before, he wisely calculated that one of his sculptures belonged in the Met. In 1905, two years before his untimely

death from cancer, the museum also acquired its first work by French's long-time friend and irreplaceable adviser Augustus Saint-Gaudens.

Only a few years earlier, Saint-Gaudens had beseeched French, in his role on the National Sculpture Society's advisory committee to the New York City Parks Department, to urge municipal authorities to clear the trees blocking sight lines to the elder sculptor's new William T. Sherman statue at Grand Army Plaza on the northwest corner of Fifth Avenue and Fifty-Ninth Street. In the end, French did not need to intervene, for as the statue was being installed in 1903, workers became "enthusiastic" about surreptitiously cutting down branches, accelerating their pruning after being "plied with whiskey," Saint-Gaudens happily reported.[67] Only the closest of friends could share such confidences. French had admired, and sometimes competed with, Saint-Gaudens, and Saint-Gaudens had come to believe that French's works showed "intellectual comprehension, distinctive training, faithfulness to little things, and respect for the whole"—along with a more intangible quality: "the reticence of the New Englander."[68]

Their sculpture had been—and would forever be—compared, but French always dismissed any resemblance. "Our work is so different that it does not seem to me that any comparison is possible," he wrote to his painter friend, Abbott Handerson Thayer, adding with characteristic modesty: "I fear that posterity will not put me very near him, but I am sure posterity will find eternal pleasure in his work and I hope some discerning people will find something agreeable in mine."[69] To another friend he acknowledged Saint-Gaudens as the "master of my art," but allowed himself to add: "My only criticism of him...might be that he thought too much about *art* in working out his ideas." Critic Selwyn Brinton may have come closest to the truth by tactfully noting that in 1912, French stood "at the head of American sculpture"—that is, "since the death of Augustus St. Gaudens." As a newspaper of the day agreed, "He would be rash who would question the verdict."[70]

After "The Saint's" passing, French immediately went to work organizing a tribute exhibition, a landmark event at the Metropolitan in the days before rotating shows routinely filled its annual schedule. In fact, when the *Memorial Exhibition of the Works of Augustus Saint-Gaudens* opened for a three-month run from March through May 1908, it marked the first time the Met had mounted a temporary show in eight years. On the night of March 2, 1908, resplendent in evening attire, French stood on the official receiving line, alongside New York City mayor George McClellan (son of the Civil War general), to welcome two thousand guests to the opening gala. To the strains of a serenade provided by a twenty-two-piece orchestra, the

elite invitees viewed the 154 works on display.[71] That night, it must have seemed to many of the cognoscenti that Daniel Chester French had not only fully declared himself a member of New York society, but had succeeded Augustus Saint-Gaudens as the reigning dean of American sculptors. After the exhibition closed, French kept the Saint-Gaudens Memorial campaign alive, showering wealthy patrons with letters beseeching them to "help the fund a little" to support his dream of commissioning new bronze casts of the late sculptor's works for the Met's permanent collection.[72]

Later on in his transformative Met board service, French would champion the acquisition of works by an entirely new generation of sculptors, including his disciple Paul Manship, together with women artists like Gertrude Vanderbilt Whitney and French's onetime studio assistant and dear friend Evelyn Beatrice Longman. In 1918, French would help organize another milestone, *Exhibition of American Sculpture*, actually a long-term installation, hoping it would "open the eyes of the public to the fact that there is an American school" of "great importance."[73] The exhibition proved another triumph, with a little help from an astute promoter: French himself. Learning that the influential *New York Tribune* art critic Royal Cortissoz had previewed the exhibition, French hastened to contact him before he could file a review. "I have no wish, even if it were possible, to prejudice you in favor of the show," French wrote, although of course he meant the opposite, "but I would like to tell you how important I regard this new departure of the Museum. As you know, there has been no adequate exposition of American sculptures in the Museum heretofore....For a number of years I have been trying to secure space for giving an adequate representation of American work....My particular reason for writing you is to enlist your interest in the importance of the continuation of this movement....It even seems to me that the future of American sculpture and American sculptors will be very much affected one way or the other by this exhibition."[74]

French's appeal worked its magic. "I congratulate you with all my heart on this scheme," the critic replied two days before his favorable notice appeared in print. "It is splendid, and you may be sure that I shall henceforth steadily keep a watchful and sympathetic eye on it, losing no chance to recur to it as occasion offers." In a preview feature article, Cortissoz acknowledged recent efforts to build the Met's collection of works by American sculptors, and cheered the new show, pointing out that "not hitherto, save in the case of the Saint-Gaudens exhibition, has their craft received quite the recognition which has now been paid to it." Cortissoz assigned credit where it belonged: "The new tribute is due, we understand, very largely to

Official photograph of Daniel Chester French, ca.1901, Metropolitan Museum of Art, New York, NY

the ardor of Mr. Daniel Chester French, who in this exhibition realizes, in fact, a dream entertained for years. It is easy to understand the enthusiasm with which he conceived the idea and worked for it."[75] In his official review a week later, Cortissoz took special care to lead with the Met's decision to convert the exhibition space into permanent galleries for "the plastic art" at "precisely the [right] psychological moment." Loans would be returned and replaced by new acquisitions as they arrived. "It is not merely for our momentary pleasure, but for practical usefulness in the future," Cortissoz cheered, "that Mr. French and his colleagues have labored."[76]

Little wonder that art historian and museum curator Thayer Tolles has described this metamorphic period of Met history as "The Daniel Chester French Years."[77] During French's long and influential service as a trustee, the Metropolitan expanded its limited collecting ethos and introduced "blockbuster" exhibitions before the term entered the vocabulary. French helped build the institution not only into a world-class repository for masterpiece antiquities but into a showcase—and advocate—for contemporary American art. Such works never became the principal focus at the Metropolitan Museum, neither during the French years nor later. But within the so-called encyclopedia of world art meant at the Met to represent every culture, and every age, at the highest levels of creativity, American art finally took its rightful place.

Emboldened and empowered, French would later try widening his field of influence at the Met, no longer timidly, and not always successfully. Six days after the 1921 death of Abbott Handerson Thayer, French would propose a memorial exhibition of his pictures. French considered Thayer an artist who could "see nature with fresh eyes"—indeed, some historians credit Thayer with inventing camouflage—and believed him personally, though plagued by bipolar disorder, to be "as near to being an angel as it is given to mortals to be."[78] Thayer in turn considered French part of an "essential brotherhood" of like-minded artists committed to pure beauty.[79]

In an attempt to persuade Met director Edward Robinson, a specialist in antiquities, to commit immediately to such a show, French proved a bit heavy-handed, warning him: "I am sure some other museum will get ahead of us if we delay." When the director dallied, French went over his head, writing board president Robert de Forest just a few days later to remind him: "I consider it a very important matter and I hope it may materialize." French evidently got what he wanted, for just six days later he was asking Thayer's widow for permission to stage the show. The Thayer exhibition opened less than a year thereafter, on March 29, 1922.[80]

Not all of French's Met initiatives earned approval and approbation. After J. P. Morgan died, the trustees voted to erect a memorial to him inside the museum's great hall. But the tycoon's son, who had joined his father on the Met board, dismissed French's initial sketch as "clumsy and somewhat meaningless."[81] Other trustees tried to shield French from the embarrassment of such criticism, but Paul Manship ended up producing the Morgan memorial.[82] Even if disappointed by this rejection, French was not to be stalled from proposing new museum initiatives, though his approach became measured. When he suggested an exhibition devoted to the paintings of American impressionist painter J. Alden Weir, director Robinson put his foot down, insisting that such a project would "throw so much work in [at] the Museum that it will be impossible to do anything else until after that event."[83] This time French relented.

It is difficult to comprehend how French managed to make room for twenty-seven years of active board service at the Met while fulfilling a growing list of sculptural commissions of his own. But after years trapped in a chrysalis of self-restraint, French had fully emerged. By age fifty-three, when he became a Met trustee, he had become a leader in his profession, an art world diplomat, an entrepreneur managing his own studio assistants and students as well as his large catalog, a marketing innovator, and an increasingly respected spokesman for American sculpture. Not only had he grown into this leadership role, he now looked it. In his undated official museum photograph, he exudes the status he had earned: his jawline a bit thicker than in his youth, his once exuberant mop of hair reduced to fringes on the side of his domed head, and his Teddy Roosevelt–style mustache, still unflecked by gray, as luxuriant as ever. French stares into the camera clear-eyed, serious, resplendent in a fashionable suit of dark-gray pinstripe, a taut Edwardian-style collar encircling his neck, his coat lapels immaculately curled, and his outfit enhanced by a dark vest, black bow tie, shirt studs, and a white pocket square—evincing not only sartorial splendor, but vigor and aplomb.[84]

No longer could anyone take seriously French's unconvincing assertion that after the World's Columbian Exposition, "I just went on doing things, and gradually recognition came."[85] He had outgrown both his modesty and his insecurity, mastered the negotiating skills to deal with boards, patrons, and even those vexing committees from which he had long recoiled. He had secured financial success, won the hearts of the critics, and become the master of his own reputation, as well as the chief exponent for an entire generation of American sculptors. And at the time he joined the Met board, his career was barely half over.

◆ ◆ ◆

It is hard to determine with certainty which of French's avalanche of major projects came next. Assigning a precise chronology remains difficult, since the sculptor now routinely accepted commissions as they came along, launching the creative process for each with a small preliminary clay model, then assigning plaster-casting work to his staff as he turned his attention to conceiving the next assignment in line. In the subsequent stages of work, after completing and winning approval for a small model, he might next produce the full-size clay enlargement with his own hands, then turn the piece back over to the casting crew. Finished bronzes and marbles invariably received his final personal refinements before they were unveiled; in this way his hand touched the works at every stage of their production. Out of this extraordinarily efficient system, whether working in Stockbridge or Manhattan, came another decade's worth of remarkable work.

One of French's most intriguing new commissions came from St. Louis for yet another world's fair, the Louisiana Purchase Exposition of summer 1904. The nation's so-called "Mound City" planned the event to celebrate the centennial of Thomas Jefferson's nation-changing land acquisition in 1803. To illustrate "the sway of liberty from the Atlantic to the Pacific through the acquisition of the Louisiana Territory," organizers invited one hundred American sculptors to create "1,000 figures" to "adorn the buildings and grounds" at "an expense of $500,000.00."[86]

French was by this time far too established—and much too busy—to take on the kind of immersive role he had assumed at Chicago a decade earlier. He did lend a replica of a statue he had crafted of Andrew Carnegie's inspiring friend Colonel James Anderson, a former blacksmith who had opened Pittsburgh's library to young Carnegie and his other needy friends. The statue showed Anderson in his blacksmith's gear, hunched over a book. The *New York Times* called it "one of French's happiest figures, combining realism and idealism in a capital fashion."[87] Consenting to contribute only a single new statue for the St. Louis fair's "Cascade Gardens," French produced a naturalistic, daringly informal portrait of the man who had actually sold the territory to the United States: Napoleon Bonaparte, then First Consul of France. In the life-size seated portrait, French showed Napoleon without his tricornered hat or hand-in-vest attitude, instead depicting him slouched in his chair as if pondering the monumental land transfer to Thomas Jefferson's administration.

Napoleon for the 1904 St. Louis World's Fair
(Louisiana Purchase Exposition), 1902

Fashioned of staff, the same impermanent plaster-and-hemp material that French and others had employed at the World's Columbian Exposition and for the ill-fated Dewey Arch, the statue was not made to endure.[88] What became of French's *Napoleon* after the fair, however, remains a mystery—and a significant loss. According to some rumors, an attempt was made to preserve the brittle statue and display it on the former fairgrounds once its pavilions were demolished and the site reverted to parkland. Yet even if it did end up in such a setting, it failed to withstand the city's blistering summers, eventually disintegrating, or at least disappearing. The sculptor's original two-and-a-half-foot plaster model, however, did survive, and it remains in storage somewhere inside the city's vast Old Court House. The preliminary model is the only surviving vestige of one of French's most unusual creations of the early twentieth century and his only work for St. Louis.[89]

◆　◆　◆

Additional assignments continued to emanate from Massachusetts, a state he now all but saturated with sculpture that testified to new political and

social trends: growing American military power, conservation, the quest for equal justice, even women's rights. For the State House in 1907 came a seated bronze statue of fin de siècle Governor Roger Wolcott, flanked by marble reliefs of a Spanish-American War soldier and sailor; for the Wellesley College Chapel, a 1907 memorial honoring Alice Freeman Palmer, the school's onetime president and a leading advocate for women's education; and for Worcester again, a 1908 statue of his old family friend, the late anti-imperialist senator George F. Hoar. The increasingly prolific French left his mark in other cities as well: a 1906 bronze relief sculpture in memory of mining engineer August Meyer to welcome visitors to the Paseo, one of the urban parks Meyer had helped develop in Kansas City; 1908 statues of England's King Edward I and seventeenth-century British legal-rights advocate John Hampden to represent equal justice at the new Cleveland Court House, one of a suite of buildings in Daniel Burnham's famed Cleveland Group Plan; and with Edward Potter, one more "Quadriga," this one a 1907 gilded, horse-drawn, Roman-style chariot and rider, commissioned by architect Cass Gilbert to symbolize "The Progress of the State" at the base of the dome at the Gilbert-designed Minnesota State Capitol in St. Paul.

It was in New York, however, that French made his greatest mark in the first decade of the new century. In 1898 the city had expanded into a five-borough metropolis. In addition to Manhattan, "Greater New York" now embraced Brooklyn, Queens, Staten Island, and the Bronx. The Brooklyn Bridge had spanned the East River since 1883, but the five-borough consolidation inspired new engineering marvels to connect these once-distinct counties. The immigrant neighborhoods along both the Manhattan and Brooklyn shorelines were soon connected via the recently opened Williamsburg Bridge, the longest suspension span in the world. Now a new Manhattan Bridge was being planned for a site just a few blocks south, and French would eventually have a role in its design.

Well before he was invited to participate in the bridge project, works by French took their place in one of these outer-borough outposts: for the Brooklyn Institute of Arts and Sciences, the sculptor produced elaborately draped twelve-foot-high limestone statues of Greek goddesses representing virtues like "Lyric Poetry" and "Religion."[90] The project marked the sculptor's first major collaboration with the six Piccirilli Brothers—Ferruccio, Attilio, Furio, Masaniello, Orazio, and Getulio—expert second-generation carvers from the Bronx by way of Massa di Carrara in Tuscany, who emerged as French's monument makers of choice for the remainder of his career. And the assignment established a relationship between French and an institute

that soon morphed into the Brooklyn Museum and began aspiring to compete with the Metropolitan across the river.

French apparently saw no conflict in pledging allegiance to both. To adorn the Brooklyn's new McKim, Mead & White building's Beaux-Arts facade, French went on to design an elaborately carved pediment. Not even the Metropolitan Museum of Art featured such elaborate exterior decorations.

Photograph of Daniel Chester French, 1909

HIGH WATER MARK

hat would a grand new public building be without grand new public statuary? To the enormous benefit of Daniel Chester French and his audiences, the answer, in turn-of-the-twentieth-century New York, was: not grand enough.

One such majestic structure, the domed Charles McKim–designed Low Library, had begun rising on the new campus of Columbia University in 1895. It was named for Seth Low, the still reigning college president and one-time mayor of Brooklyn who had engineered the school's relocation from midtown Manhattan north to bucolic Morningside Heights. The splendid neoclassical library soon took its place as the center of college life. When the widow of a wealthy alumnus offered funding to adorn its front steps with a statue, McKim immediately recommended that the commission be given to his friend French, already serving on the school's Advisory Committee on Art.[1] The result was one of the sculptor's most famous works, destined to become every bit as iconic—and abused—as the statue he had created decades earlier for Harvard.

Unlike that effort, French would design the Columbia piece to be allegorical, not a work of portraiture dedicated to the school's founder. After all, Columbia had been chartered as King's College by England's George II, hardly a fitting subject for a twentieth-century American statue. (Back in 1776, incensed local colonists had responded to the first reading of the Declaration of Independence by pulling down an existing statue of the monarch's grandson George III at Bowling Green Park, and chopping it to pieces to forge forty-two thousand lead musket balls to fight the British.)[2] It was

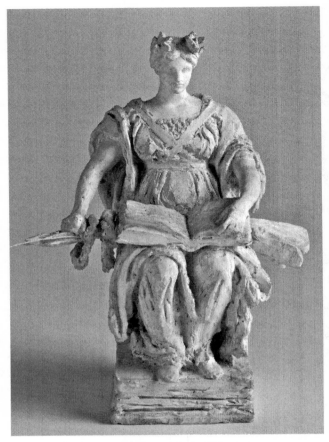

Model of *Alma Mater*, plaster, 1900
(Chesterwood, Stockbridge, MA)

probably French who came up with the idea of adapting Columbia's benign
college seal into a three-dimensional seated female figure representing *Alma
Mater*, Latin for "nourishing mother." In his preparatory sketch, French
modeled a robed woman holding an open book on her lap. The sculptor
thought the original design "beat the band," as he put it. A correspondent
for the *Brooklyn Eagle* agreed, predicting after a peek at the maquette that
it would someday take its place as "one of the finest pieces of sculpture to be
found in the city." The reporter found it "easy to imagine" that, when com-
pleted, the "strikingly dignified" statue would "express all that its environ-
ment stands for."[3]

Both the donor and President Low were "greatly delighted" by the
maquette, too. But they suggested revisions, and French obligingly went

back to work.[4] The hands-in-lap pose was discarded. Hearkening back to his statue of *The Republic*, French conceived a gilded figure "draped in the College gown" and wearing a wreathed headdress "copied from the old iron crown inherited from Kings College."[5] Her arms would now be outstretched, one hand clutching a scepter adorned with designs from the school's original shield, the other extended in a beckoning welcome to modern students. The outsize book remained, now balanced on the statue's lap, hands-free. On either side of her throne would stand lamps meant to light the way to higher learning, inscribed *Doctrina* and *Sapientia*—Latin for "learning" and "wisdom."

Once French completed the revised model, two committees, not one, visited his New York studio to view the work in progress. French, who dreaded dealing with such groups, might well have feared the worst. But out of the inspection came a contract for twenty thousand dollars to execute a twelve-foot-high version in bronze, gold leaf to be applied later. McKim would design the granite pedestal himself.[6] President Low optimistically hoped the finished statue would be in place facing West 116th Street, the thoroughfare that ran through the campus in its early days, by graduation day 1902.[7]

The project hit another snag, however, when McKim and Low invited Augustus Saint-Gaudens, then in the final decade of his life, to have his own look at photographs of French's revised model. The older sculptor responded with what he later admitted was "inane" criticism of the arrangement of the figure's arms, although he made sure to add in an otherwise apologetic letter to French: "I think I should prefer the knees wider apart, somewhat bigger in character and perhaps one of the feet out a little, but you are the best judge of what you wish to express."[8] Understandably feeling wounded, French tactfully told Saint-Gaudens that while he regarded his *Alma Mater* design as "vulnerable at every point," he also believed that "as it stands," it was "above my average," warning there was "danger in spoiling it if I make any radical change."[9] French vowed to continue working to improve the arms, but he was now beyond the point where a slight from even Saint-Gaudens could derail him. His patrons reiterated their confidence.

At Chesterwood, French turned for further inspiration to a frequent guest and sitter, stage actress Mary Lawton. Judging from her resemblance to a plaster head he crafted in 1902, it is clear that the beautiful Lawton served as the model for the final *Alma Mater*. French hired Henry Bacon to design the seat, which the architect pared down to a plain, Hellenistic-style bench in order to keep the focus on the sculpture. Hoping to avoid another "Big Mary"—the derisive sobriquet once given his statue of the

Republic—French worked carefully to balance the scale of the full composition. The final statue would have to be large enough to command attention in front of the library's columned exterior without attempting to overwhelm it. In his almost innocent conception, French aspired "to make a figure that should be gracious in the impression that it should make, with an attitude of welcome to youths who should choose Columbia as their College." But as he hastened to add: "An artist rarely describes his own work with any success."[10] The only language he spoke, French insisted, was "sculpture."[11]

French went on to supervise both the enlargement and the subsequent casting of *Alma Mater* at the John Williams bronze foundry on West Twenty-Sixth Street. Ever the perfectionist, however, he could not make the final statue ready in time for the 1902, or even the 1903, commencements. Instead it was unveiled on campus at convocation exercises in September 1904, an event marking the school's 150th anniversary. A few weeks later, the dispirited sculptor told his brother, Will French, to whom he had sent the plaster model for display in Chicago: "The bronze one was unveiled last month and has not made a ripple on the surface of New York. I have not seen a notice of any kind." French could only hope that "some art critic will discover it sometime."[12]

In fact, the statue got plenty of attention from the outset, even if the school sesquicentennial dominated news coverage. At the time, French was in residence in the Berkshires. Perhaps his clipping service simply failed to speed cuttings to Chesterwood. Dubbing the work "French's masterpiece of sculpture," *Frank Leslie's Illustrated Newspaper* ran a large snapshot of the unveiling just a few days after the event, showing the precise moment a row of gowned academics had parted a blue curtain to reveal the golden statue to thousands of spectators crowding the Low Library steps.[13] Acknowledging it as "an extraordinarily difficult piece of work" to create, the *New York Times* recognized that "in pose and gesture," the figure "invites the student of the university."[14] Adding its own seal of approval, the *Catholic Union* tried flattering the sculptor by pointing out—erroneously—that French had copied his statue from the "Mother of Christ" in Bonn, Germany, adding: "How closely is not the Catholic Church associated with all that is noble and tender in the mind and heart of man!"[15]

Not all the reactions were noble and tender. Within weeks of the dedication, the university was forced to provide twenty-four-hour protection for *Alma Mater*, guarding her with a "relay" of proctors by day and "an extra force of janitors" by night, for fear "that some overbold freshmen or sophomores, inspired by class rivalry, might venture to print their numerals on

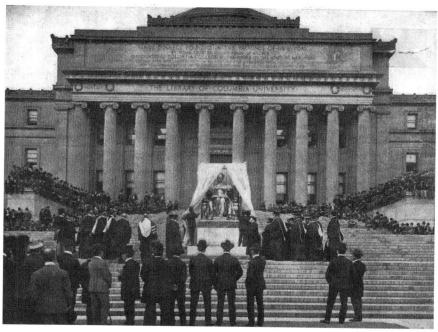

"Striking Statue of *Alma Mater* Unveiled at Columbia University,"
Frank Leslie's Illustrated Newspaper, October 8, 1904

the statue." Warning against "disfigurement," the *Times* branded the threat "a commentary on student morals."[16] Ensconced at Stockbridge at the time, French likely remained unaware of the shenanigans that otherwise would have reminded him of the abuse to which his *John Harvard* had long been subjected. He was no doubt happy to learn that the Columbia statue soon inspired a far tamer ritual. As a symbol of wisdom, but one that literally had to be discovered, French had secretly included a small owl within the voluminous folds of *Alma Mater*'s gown. A tradition soon flourished on the then all-male campus that whichever freshman found the owl first each year was destined to marry a girl from Barnard—Columbia's sister college—or as consolation, to become class valedictorian.[17]

Other students took the statue's gesture of welcome literally and expected the school to live up to it. When Seth Low was elected mayor of New York and was succeeded at Columbia by ex-diplomat Nicholas Murray Butler, some complained that the school began favoring "the aristocracy." Such favoritism seemed at odds with the statue's message. One pseudonymous critic, signing himself only "engineer," commented acidly: "We all think up here on the Heights that the sculptor turned *Alma Mater*'s hand the

wrong way."[18] By winter, "our girl on the front steps," as students now called her, also began attracting tourists to campus. Comparing it to New York's other new gilded statue, Saint-Gaudens's equestrian of General Sherman, one observer noted that "since the recent fall of snow they have been ever more conspicuous in their gold and white than while standing out in their all gold gorgeousness. Lovers of the beautiful are going from all parts of the city to see the effect of the snow with the shimmering gold."[19] No wonder French recommended the regilding of *Alma Mater* when the patina began to flake in the late 1920s.[20] By that time it had deteriorated markedly but had at least escaped—barely—the impact of a baseball when Columbia student athlete Lou Gehrig unleashed, all the way from South Field across the street, a titanic 1922 home run that landed on the library steps at the statue's base.[21]

Far more dramatic erosion was yet to come. In the late 1960s, the Columbia campus would erupt with student demonstrations fueled by opposition to the Vietnam War. During this convulsive period, activists routinely vandalized *Alma Mater* with hand-painted peace symbols and anti-government, anti-university slogans. The statue became a virtual billboard of the peace movement. Yippie leader Abbie Hoffman even mounted *Alma Mater* one memorable day to deliver a fiery speech. Then in 1970, a bomb exploded on the statue, damaging the right side of the figure and maiming her chair. No one was ever charged with the crime. School authorities left *Alma Mater* as she was, perhaps to caution students they would have to live with the consequences of destructiveness. Not until 1978 was the statue carted off, repaired, returned to its original bronze patina, sans gilding, and reinstalled on its original site, its deeper tone glowing handsomely.

As for French, his rewarding association with Columbia would continue for decades. On the school's art committee, he alternately championed and vetoed sculptural acquisitions for years to come.[22] Then in 1908, in partnership with the National Academy of Design, President Butler offered French an appointment as professor of sculpture. "To be connected with the University even in an humble capacity would be an honor," French replied appreciatively, "but that so high an office should be conferred upon me is quite over-powering." His only caveat was that the title remain honorary and that he not be expected to teach actual classes. He had refused an offer to teach sculpture at Harvard in 1893, and he would not accept a similar offer from Columbia now. "My ideas do not crystallize themselves in the form of speech," he apologized, "and lecturing is an impossibility to me."[23] Five years later, still determined to recognize him, the school further

acknowledged the sculptor "as the leading representative in his profession" by awarding him an honorary degree. French called it "the greatest honor that has come to me."[24]

Columbia capped its long relationship with French by inviting him in 1918 to design the gold medal for the new journalism prizes to be administered by the university: the Pulitzers. In collaboration with his former student Henry Augustus Lukeman, he created the enduring symbol of the coveted award: a medallion portraying the nation's first famous newspaperman, Benjamin Franklin, and on the flip side, a delicate allegorical image of a draped printer working at an old handpress.[25]

The sculptor's final interaction with the college would prove as anticlimactic as it was awkward. When in 1923 Columbia proposed erecting a heroic-size statue of its lion mascot opposite *Alma Mater*, French spoke for the art advisory board (and as the creator of the school icon) in opposing it. As the seventy-three-year-old French put it, "the grounds of the University should not become a gallery of sculpture" except for "statues of representative men or...bearing a close relation to Academic purposes."[26] Although a bronze lion did soon find its way to Baker Field, the school's football stadium, not until 2004, long after French's death, did a lion statue appear on the north side of the main campus after all.

◆　◆　◆

As the Low Library neared completion uptown in 1902, an opulent new US Custom House began rising about as far downtown as Manhattan reached: the historic shoreline site of Fort Amsterdam, the long-vanished earthwork redoubt built in the seventeenth century to protect the first Dutch settlement huddled on the island's southern tip. Legend held that on this very spot, the colonists had paid displaced local Native Americans all of twenty-four dollars in beads and trinkets to purchase the entire island—the first, and still the most unjust, real estate deal in New York City history. What could be more ironic than erecting a revenue-generating custom house on ground where such a dubious transaction had occurred?

In size and grandeur, the new Cass Gilbert–designed Beaux-Arts structure would erase all vestiges of the site's long and diverse history. Yet the building would be more than a demonstration of architectural splendor for its own sake. In the decade before the imposition of the permanent federal income tax in 1913, duties collected at major domestic ports supplied more than half the revenues raised by the US government. Of this annual $254 million, it was said that nearly $116 million "passed through the New-York

Model of *Asia*, plaster, 1903
(Chesterwood, Stockbridge, MA)

Model of *Africa*, plaster, 1903
(Chesterwood, Stockbridge, MA)

Model of *America*, plaster, 1903
(Chesterwood, Stockbridge, MA)

Model of *Europe,* plaster, 1903
(Chesterwood, Stockbridge, MA)

Custom House" alone, housed at the time in cramped space on Wall Street.[27] The operation now employed seven hundred people.[28] Needing more room for more collectors to corral more tariffs, the Treasury Department planned to respond in the grandest—and most intimidating—manner.

The federal government assigned most building projects to government architects, yet as with major works of high prestige, symbolic value, and economic importance, the US Custom House inspired the Treasury Department to initiate a design competition, this one attracting twenty architects. Gilbert had won the competition in January 1900.[29] His selection was not without controversy, as the department's supervising architect had once been Gilbert's business partner back in St. Paul.[30] The ensuing scandal, however, neither quelled Gilbert's ambitions for the project nor limited his power to achieve them. In a nod to the City Beautiful Movement—which encouraged architecture to unite with engineering and fine arts to create ideal public spaces—Gilbert made sure his contract specified that the "modeling and carving of sculptured figures" would be "done by sculptors of known skill and ability" whom he would have total authority to select. Gilbert budgeted a handsome $13,500 each for the "symbolical sculptural groups" he had in mind for the Bowling Green steps of the building: a quartet of statues representing "the four great continents" from which taxable imports flowed. The statues would face the spot where the equestrian statue of George III had once fallen to the Colonists. But who could produce such an important visual statement? Unable to choose between the two most obvious candidates, Gilbert reached a Solomonesque decision: he would assign one pair—two "continents" apiece—to Augustus Saint-Gaudens and Daniel Chester French.[31]

Notwithstanding the acrid memories of his early experiences with government commissions, French viewed the Custom House opportunity as "a tremendous proposition," especially after Saint-Gaudens, already battling the cancer that would soon kill him, reported ominously that his own "time" was "insufficient" to permit his participation.[32] Gilbert, who had worked amicably with French on the Minnesota State Capitol, promptly invited him to fashion all four statues: allegorical groups to symbolize Asia, America, Europe, and Africa. The sculptor went to work on them by 1903, at precisely the time he became a trustee of the Metropolitan Museum. He had only three years to complete the work, but as French told Gilbert, "these things interest me more than any things almost I ever had to do, and I am willing to make great sacrifices in order to be permitted to execute them."[33]

French lived up to that vow with one of his greatest bursts of creative intensity. In less than three months' time, he conceived and created clay, then

plaster, maquettes of all four groups. Executing them in animated baroque style, he ornamented each with an array of emblems that reflected extensive historical research, demonstrated artistic balance, and testified to what his daughter called "his love of symbolism and ancient meaning."[34] After glimpsing the preliminary sketches in May 1903, Gilbert pronounced them "*entirely satisfactory,*" telling the sculptor he was "highly pleased" with all four.[35]

Invited to examine the little maquettes arrayed "on a marble table" at French's Eleventh Street studio eight months later, a journalist from the *New York Tribune* admitted at first that "an untrained eye might pass them by as so many pieces of street bric-a brac." French urged him to look more closely. The reporter soon discovered that "each one is exceedingly precious in the eyes of the sculptor, for it holds captive in material form many a labored thought and fugitive inspiration." To provide readers with a rare on-the-spot glimpse into the sculptor's working style, the journalist looked on one winter morning as French kneaded away at a larger version of his *Europe*, "glancing now and then from the clay to the little plaster sketch, as a composer might from the keys of his instrument to some scribbled notes."[36]

French enlarged all four multidimensional "sketches" into quarter-size, then half-size models even as the search began for just the right Tennessee marble for the final carvings. According to the season, he worked at either his Manhattan studio or at Chesterwood, shipping the progressively bigger models by rail freight to and from whichever headquarters he was occupying at the time. He similarly transported his assistants back and forth between New York and Massachusetts to help him continue the refinement process without pause. While living in the country, French worked both indoors and out. A remarkable 1905 photograph shows the half-size plaster of *America* sitting outside the studio on the Chesterwood railroad track, its head seemingly gazing at the treetops. As always, the "disorder and confusion" of the workrooms, where "sections of lions, tigers, horses, Indians, Sphinxes and high-bred" ladies lay scattered among the "white footprints" of plaster dust dotting the floor, bothered French not a whit. Such chaos had famously made Saint-Gaudens "as nervous as a prima donna," according to Margaret, but French always "eyed the demolishment with a certain amused forbearance."[37] Making order out of the tumult was the job of Adolph Weinman, a goateed thirty-four-year-old German-born sculptor recruited to serve as principal assistant. Weinman went on to contribute so much to the "Continents" project that French, increasingly generous about sharing credit, would make sure the young sculptor's name was inscribed right below his own on each statue.[38]

Daniel Chester French (face obscured) with model of *America* and various friends
and relatives on the railroad track at Chesterwood, 1905

In the spring of 1906, after one of his inspection visits to the work-
shops in the Bronx, French assured Gilbert: "They are coming out splen-
didly in the marble. I am delighted with the manner in which [the] Piccirilli
Brothers are executing them. They consider it a great opportunity to show
what they can do and are doing their very best."[39] As usual, French also
did his utmost to promote the works in advance of their installation. As
"bulky" as they were, French shipped the plaster models that November
for exhibit at the Pennsylvania Academy of the Fine Arts; later he displayed
them at the Indianapolis Museum of Art. French estimated that together,
the four groups included fourteen or fifteen figures "of life-size," requiring
up to twenty-three cases "to pack them."[40] Mere photographs of the mod-
els proved enough to constitute "by far the most important feature" of the
1906 show at the New York Architectural League, intriguingly hinting "at
the superb technique" in the statuary.[41]

After overcoming a bout of "extreme anxiety" over whether the final
ten-foot-high marbles should be hoisted into place before Gilbert himself

arrived and gave them his final approval (they were apparently uninsured), the *Continents* were set on their four rectangular pedestals along the Custom House facade in March 1907.[42] *Asia* and *Africa* occupied the outer edges, and *Europe* and *America* flanked the building's central staircase. Only one of the groups—*America*—remained unfinished. French attacked that problem by working on-site to complete its features.

The sculptor always preferred to let his work speak for itself, yet he left a surprising record of the ideas he meant to convey in these enthroned female giantesses. Several notations can be found in explanatory letters he sent architect Gilbert, but French also expounded on the compositions for a newspaper correspondent, a first for him. These private and public reports provide rare and valuable insight into the mature French's creative impulses and extraordinary grasp of visual allegory.

In his *Europe* group, as the artist himself described it, a regal-looking goddess wraps one arm around a large globe while, behind her throne, a somber, hooded figure meant to suggest ancient history sits concealed amid the crowns "of her dead kings."[43] French confided to the journalist who visited his studio that he had "sought to symbolize imperialism....She holds her head high, as one long accustomed to command. Her left arm rests on a globe, signifying her control of the world's commerce." He had added an open book to concede Europe's "learning and intellectual achievement."[44]

By contrast, the spirited image of *America* was a Progressive Era portrait depicting raw power still in its youth and ready to discard impediments to progress—a window into French's own political beliefs. A Native American cowering behind the central figure's shoulder symbolizes the unlamented retreat of indigenous peoples, while a muscular white man coiled for action nearby suggestively grasps a wheel of progress. The husks of corn on *America*'s lap signify "the American idea of plenty, and her torch reiterates a familiar motif: that of American liberty enlightening the world."[45] French did want his New World figure to express more than prosperity. As he put it, it was also meant to celebrate "the triumph of mind over material things." In his revealing description, the group portrayed "a young civilization, grown powerful through the development of its natural resources, in contrast to the ancient culture of Europe, whose might has been increased by foreign conquests and colonization." French wished observers to recognize from the figures that the nation was both "progressive" and "aggressive,"[46] surely a conscious endorsement of Theodore Roosevelt's robust brand of nationalism.

French believed his remaining two groups would contrast with *Europe* and *America* the way "stagnant pools" compare to "rushing waters." For

The Continents, marble, 1903–07, at the
United States Custom House, New York, NY, ca. 1930

Asia, he portrayed "stolidity and self-contentment" in the form of a bejeweled Indian woman, her voluptuousness reminiscent of a Shiva figure, her throne supported by skulls to evoke reincarnation. A Buddha in her lap acknowledges religious reverence while hinting at an insularity that stultifies progress—an isolation from the Anglo-Saxon concept of civilization. A tiger coils at Asia's left, "representing her vast jungles," and on her right a group of emaciated men personify what French described as "the hordes of India, and the hopelessness of the life of so many of the inhabitants."[47] Finally, *Africa*, perhaps the most original of the four groups, even if it owed a debt to *Night*, the Michelangelo masterpiece he had studied decades earlier in Florence, appears in the form of a slumped, half-naked, dozing giantess, feet resting on rocks, head cradled in her hand. A nearby Sphinx alludes to the mystery of the region, while a lion suggests untapped might. The journalist who got the chance to write down French's insights remembered the sculptor calling Africa "the slumbering continent" while cautioning that "the Sphinx is arousing a figure of power, alert and alive, typifying the spirit of Western civilization which has begun to conquer Africa." When some observers criticized the sculpture for looking more European than

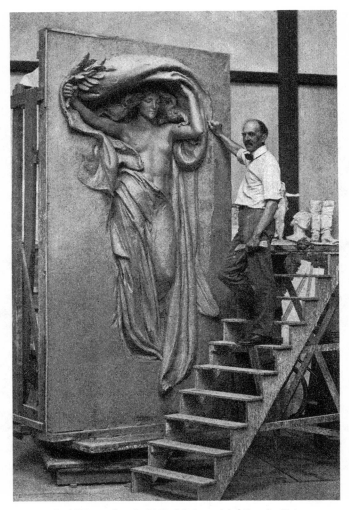

Daniel Chester French with the full-size model of *Mourning Victory*
in his studio at Chesterwood, 1907

African, French shrugged it off; after all, he pointed out, he had been trained in Europe, not Africa.[48]

The entire suite of masterpieces, by far French's greatest achievement in architectural sculpture, earned immediate praise from many contemporaries, hailed as enthusiastically for their "symbolism" as for their "sculptural qualities."[49] "At one step," Charles de Kay cheered in the *Century Magazine*, "Mr. French has moved forward to a new feeling, an original method in dealing with abstract ideas in sculpture....Surely congratulations are due to the genius and profound skill which have combined to produce such results. These works

differ radically from any previous work by Daniel Chester French, and mark a stride forward in his career. They are cast in a larger, more masculine mold than any hitherto, and show a richer vein of imagination."[50]

The journal *Monumental News* confirmed that the sculptor had earned accolades from fellow professionals as well. "Mr. French's commission was of the kind that is at once the joy and terror of every imaginative and creative artist," the magazine acknowledged. "In this case the pitfalls seem to have been avoided with great judgment."[51] Adding that the works had excited "Mr. French's fellow sculptors" and also "laymen," yet another publication called French's prodigious effort not only "his best work" but "among the most remarkable sculpture of modern times."[52] Offering his own "laurel crown of praise," Cass Gilbert wrote in tribute that "by his steady adherence to sincere, straight-forward technique" and "the ideal of pure *beauty*," French had "created a series of works almost unrivaled and certainly unsurpassed by any artist of his time."[53]

French's account books indicate that he earned much more than praise for the project. The sculptor took in $54,000 for the *Continents*, out of which he paid $14,500 to the Piccirilli Brothers for the marble-carving. It turned out to be one of the best-paying projects of his career—and one of the most enduring.[54] But while the original plaster maquettes still reside safely at Chesterwood and the marble statues survive intact at the old Custom House building (now serving as a combination federal courthouse, municipal archive, and Museum of the American Indian), the half-size plaster models met a sadder fate. French presented them to the John Herron Institute of Art at Indiana University in 1906, but the staff there mistakenly registered the sculptures as reproductions. They later lent what they believed to be worthless copies to an Indianapolis high school, which destroyed them in the late 1930s.[55]

French never knew about that disgraceful loss, but he may have come to regret that, along the way to producing his exquisite monumental works, he had once shared so many insights into the project. As late as 1915, admirers were still writing him to inquire about the symbols lurking within his Custom House compositions. When one correspondent wondered that year about the reason for the hooded figure crouched behind the Sphinx at the rear of the *Africa* group, French finally decided he was done explaining. "Sculpture is the language that the sculptor speaks in," he replied, "and often the introduction of a motif is one of feeling rather than of any literary expression....The fact that several writers seem to have felt that this figure represented mystery seems to prove that I expressed the feeling that I had in

mind."[56] Years later, the prolific art writer Adeline Pond Adams, author of *The Spirit of American Sculpture*, enthusiastically concurred: "In every one of the four, we see a master sculptor's intellect at work and play."[57]

◆ ◆ ◆

In 1906, the year before he completed the *Continents*, French undertook yet another of his Civil War–inspired memorials, this one begun more than fifty years after the conflict ended but inspired by an idea that had been percolating between both sculptor and patron for the entire half century preceding it.

He would accomplish some of the work in a new environment. The year before, French had decided to build a new, "extra" studio in the woods down the hillside at Chesterwood, separated from his principal property by a dirt road.[58] Later known as the "lower studio," it was designed to provide a high-ceilinged space for his larger statues, and also to give him a more secluded place to escape the tumult of studio assistants, workmen, and plaster sculptures now overwhelming his original Chesterwood workspace. The new studio was two stories high and illuminated by a large skylight facing north. Not one but three small tracks led to a back porch where French could examine several works at once outdoors. Because the building was perched on a cliff, French could head "down the hill" to study his statues at "the elevation they will be at on the buildings." French called the project "expensive, but worthwhile," and here he began working on his new Civil War project.[59]

Commissioned by an old Concord friend named James C. Melvin, the work was to honor three of Melvin's brothers—Asa, John, and Samuel—all of whom had joined Company K of the First Massachusetts Heavy Artillery and died in the war. (James, the youngest, had enlisted and survived unscathed.) John perished before ever seeing action, a victim of disease, at a Union military hospital near Arlington. The surviving Melvin boys fought in Grant's deadly 1864 Overland Campaign in Virginia. Asa fell during the federal assault against Petersburg. Samuel, captured after the Battle of Spotsylvania, died at the notorious Confederate prison camp at Andersonville, Georgia. French had often heard Jim Melvin vow to pay tribute to his late brothers if he ever amassed enough money to honor them properly.[60] Now a wealthy Boston businessman, he made good on his promise, commissioning French to create a tablet in their memory for Concord's Sleepy Hollow Cemetery. The sculptor made a nostalgic visit to the site in January 1907, declaring it a "beautiful place for the monument."[61] Emerson himself was interred nearby.

Collaborating with French once again, Henry Bacon designed the simple but graceful wall before which it would stand, just behind a bench inscribed with the names of the honored dead and grave-like slabs bearing relief images of rifles enmeshed by wreaths. For the vertical shaft at the center, French crafted a miraculous relief sculpture that evoked both sacrifice and glory. It showed the partially nude female figure of "Victory," her eyes shut as if meditating, emerging from under a "shroud-like" American flag, her long hair flowing in a dramatic art nouveau–style swirl, and her hand clutching a large sprig of celebratory laurel.[62] It was not at all to be a martial tribute. Increasingly, French desired to emphasize sacrifice, not glory, in his war memorials—a radical departure from Saint-Gaudens's acclaimed monument to the annihilated "colored troops" of the Civil War's 54th Massachusetts Regiment.[63]

French began working on his large clay model at Chesterwood in June 1907.[64] A surviving photograph shows him bareheaded, sleeves rolled up in concession to the summer heat but bow tie as always in place, posing before the railroad track outside the Chesterwood studio, dwarfed by the nine-foot-high work. The monument was unveiled at Sleepy Hollow Cemetery on June 16, 1909, the anniversary of the Petersburg charge. The ceremony was followed by a dinner honoring the surviving veterans of the Melvin brothers' regiment.[65]

"I have seldom put up anything," the sculptor reported to his brother after the marble was installed, "that I think of with as much satisfaction."[66] Though officially known as the *Melvin Memorial*, French began referring to his sculpture with a heartfelt title of his own: *Mourning Victory*—not meant to suggest the act of regretting triumph, as it is sometimes misinterpreted, but to describe a figure representing "triumph" who laments her dead.

In 1913, James Melvin showed his appreciation for the work by providing $1,700 to pay the Piccirilli brothers to carve a two-thirds-size marble reproduction (in reverse, as in French's original design) for presentation to the Metropolitan Museum of Art. Melvin died before the replica was completed, prompting French to remember: "One of the very keenest pleasures of my professional life has been his pride and pleasure in the work that I did for him and it has been and is a matter of the greatest gratification to me that it turned out to be one of my best things."[67] In an otherwise understated essay he called "Six Good Memorials," French would uninhibitedly rank his *Melvin* the best war memorial in the entire nation, every bit the equal of Saint-Gaudens's better-known tribute to Colonel Robert Gould Shaw and the 54th Massachusetts.[68]

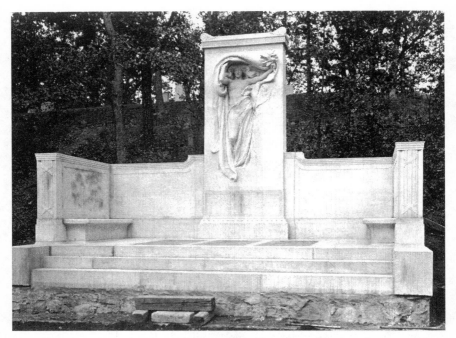

The Melvin Memorial during the final stages of installation
in Sleepy Hollow Cemetery, Concord, MA, 1909

In that assessment, French was not alone. Critics of the day hailed *Mourning Victory* as "impressive" and "splendid," and its reputation has only grown since.[69] In 2017, it inspired yet another acknowledgment at the Metropolitan, when artist Adrián Villar Rojas assimilated an interpretation of the piece into his rooftop installation of fused replicas from the museum collection, *The Theater of Disappearance.*

◆ ◆ ◆

"I have not been entirely idle since I saw you," French rather casually informed the art historian Selwyn Brinton in late 1910. In fact, he was engaged in his most important project to date. As he explained: "I have been very much engrossed these last two years by a statue of Lincoln, which I have just completed in clay, and which is destined for the City of Lincoln, Nebraska. It will be erected next spring. My artist friends and the public generally seem to think this is my high-water mark, and I think pretty well of it myself."[70]

In a way, it was almost inevitable that French at last confront the ultimate challenge in American sculpture: portraying the country's greatest and

most distinctive-looking hero—even if Abraham Lincoln was the "most difficult subject who ever taxed my skill as an artist," according to a painter who had attempted to capture his likeness from life during the Civil War.[71] Sculptors had tried, too, beginning as early as a few months before his May 1860 nomination for the presidency, when Leonard Wells Volk had taken a life mask of Lincoln in Chicago. Several others had sculpted him from the flesh, as well as after Lincoln's 1865 death.[72] Since then, Larkin Mead had created a full-length statue for Lincoln's tomb; Henry Kirke Brown, a standing bronze for New York's Union Square; Thomas Ball, the famous depiction of Lincoln as an emancipator lifting a kneeling slave from bondage; John Rogers, a seated figure for a school in New Hampshire; Adolph Weinman, an enthroned Lincoln for Lincoln's Hodgenville, Kentucky, birthplace; and Gutzon Borglum, *The Soul of Lincoln*, a 1908 marble head at the US Capitol, which he intended to carve in super-monumental size on Mount Rushmore, South Dakota.

The most acclaimed of all the Lincoln statues to date was Augustus Saint-Gaudens's majestic *Abraham Lincoln: The Man (Standing Lincoln)* dedicated in 1887 at Lincoln Park in Chicago and unveiled by the subject's grandson and namesake, Abraham Lincoln II.[73] Here was a daunting roster of predecessors and competitors whose outpouring of straightforward portraiture seemed at odds with French's recent immersion in allegory. "Certain it is," Adeline Adams conceded, "that Daniel French would much rather do torsos than trousers. What sculptor wouldn't? The paradox," she pointed out, was that his "Lincoln statues in their honest unromantic dress" became "masterpieces."[74]

In a way, French had been addressing the Lincoln theme for years, but indirectly. He had portrayed military men who served under Lincoln (generals Butler, Hooker, and Grant) as well as politicians who knew him (Amos Tuck, John Sherman, and James A. Garfield). He had created a beloved work for Gallaudet College, an institution chartered by Lincoln's administration, and portrayed Lewis Cass, the Democrat on whom a young Lincoln had directed uncharacteristic vitriol after the Mexican War. French had sculpted Emerson, who met the future president when he lectured in Lincoln's Springfield hometown in 1853, and again at the White House in 1862. French's own wife still remembered the long-ago April morning she had awakened to news of Lincoln's assassination, and their adored Uncle Benjamin had served as a Lincoln administration official. Now the ultimate sculptural opportunity at last came French's way—from a northwestern state capital renamed for Lincoln four years after his death. The

sculptor seized the chance, but proceeded with a caution he had not manifested since the John Harvard project. No living sculptor could claim to have seen Lincoln with his own eyes, but thousands of surviving Americans, as French well knew, and perhaps feared, could still remember glimpsing him. Millions more felt his presence keenly from photographs, paintings, and indeed, other statues.

The Nebraska Legislature had created an Abraham Lincoln Centennial Memorial Association on the thirty-eighth anniversary of his assassination: April 14, 1903. As its name suggested, its original goal was to erect a statue in time for the centennial of Lincoln's birth in February 1909.[75] The six-year timetable proved too optimistic. While the state quickly appropriated twenty thousand dollars for the project, raising twenty-five thousand in matching private donations proved more difficult.[76] Not until the fall of 1908 did the group's chairman, local attorney and art collector Frank M. Hall, first travel east to interview sculptors capable of work that would "make our hearts thrill with pride and love for our country."[77]

Details of the competition are lost to history. We know only that Gutzon Borglum submitted his name for consideration, reportedly withdrawing only after his younger brother, Solon, applied, too.[78] There were probably others. Assuring the governor that he would make sure the state hired "nothing short of the best,"[79] Hall offered French the assignment in June 1909, probably in response to his Custom House triumph, but surely because of his renowned statues of Civil War heroes as well. "I can hardly tell you how much pleasure the announcement has given me," French enthusiastically replied, "not only because of the importance of the commission... but because of the interest that attaches to the subject. It is a great opportunity and I pray that I may rise to the occasion."[80] By September, he told his patrons he was already "collecting materials, photographs, casts, lives of Lincoln, etc." In crafting the statue, he pledged to "spare no pains to make it worthy of the subject and of the location."[81]

Two months later, accompanied by Henry Bacon, who was to design the architectural setting, French traveled to Nebraska to scout locations on the sprawling state capitol grounds. Only there did he determine that he must make a standing statue. The site was so expansive that a seated figure would be swallowed up by the surroundings. The attention and acclaim the late Saint-Gaudens had earned for his own standing Lincoln did not seem to concern him. In fact, whether French was inspired, influenced, or unmoved by the Saint-Gaudens work has never been ascertained. The two statues are in some respects similar—both show a downcast Lincoln, one foot slightly

forward, about to deliver an oration—but they are also markedly differ-
ent. Saint-Gaudens's Lincoln confidently grasps his lapel and looms large
before a symbolic chair of state. French's Lincoln, by contrast, would clasp
his large, clumsy hands before him, seemingly searching for the confidence
that Saint-Gaudens's figure already exudes. No prop would intrude on his
solitude, no gesture relieve his anxiety. One eastern paper understood that
the assignment meant that a torch had been passed: "Mr. French thus suc-
ceeds with great credit to the honor of Saint Gaudens, as Elisha to the man-
tle of Elijah. Nebraska is likely to have a great masterpiece in this Lincoln
statue."[82]

To his "unalloyed pleasure," French's enthusiastic welcome in Nebraska
"transformed a journey on business into a pleasure trip." The local press cov-
ered every step of his visit under headlines like "Artist French in Lincoln."[83]
At a banquet thrown there in his honor, the sculptor managed to speak pub-
licly about his plans and methods "without disgracing us all."[84] Once home,
he reported to his hosts: "I am still alive in spite of your...attempts to kill
me with compliments and honors."[85] In a more serious vein, he adapted a
famous phrase from Lincoln to caution his patrons that he faced "a task that
is going to test my skill as it has never been tested before."[86]

Working with unusual deliberation—quite unlike the furious pace that
had marked his efforts on the *Continents*—French took months to fashion a
ten-inch-high preliminary clay model. In April 1910, he offered to show it to
Frank Hall, should Hall wish to visit New York, and then suddenly changed
his mind and told him not to come after all. French liked what he had mod-
eled well enough, but weighed down by the burden of so important a com-
mission, felt he should not trust his own first reaction. The sculptor was also
facing a significant personal milestone: he was about to reach age sixty, often
a rude awakening. Rather than continue working on the Lincoln, he decided
to treat Mamie, Margaret, and himself to a long European vacation. "It is
possible that I may see things over there that will revise my ideas," he told
Hall, "even to the extent of making another model." He wanted to "take all
the time that is necessary to bring about the very best result." Besides, "com-
ing back to it after an absence of three or four months, I shall be able to view
it more impartially and with a fresh eye and estimate its artistic value more
nearly....I am writing you on my sixtieth birthday, but 'I have just begun to
fight.'" Hall in turn assured his fellow Nebraskans that "French was going
to try to make this work the crowning effort of his life."[87]

The French family spent four months in Europe, visiting the great muse-
ums and cathedrals in London, Oxford, Paris, Bruges, Ghent, Antwerp,

and Amsterdam. Their stops included dinner at London's Simpson's on the Strand and tours of Westminster Abbey, the Tate Museum, Shakespeare's cottage in Stratford-on-Avon, the Louvre, such tourist "musts" as the Eiffel Tower, Stonehenge, Versailles, and the sprawling Rijksmuseum.[88] In Paris, French almost certainly took his wife and daughter to see his *George Washington* equestrian at the Place d'Iéna.

In mid-July, French found a way to combine pleasure with Metropolitan Museum business. He rendezvoused with then-assistant director Edward Robinson*at Auguste Rodin's summer studio at Meudon, southwest of Paris, to inspect Rodin's new sculpture, *Musset and His Muse*. The piece had been offered to the Metropolitan, but after viewing photographs, French and his fellow committee members feared the work might be a bit too erotic for public display in New York. The meeting at Meudon went off splendidly. Awed by Rodin's "glass-topped studio," French described his sixty-nine-year-old counterpart as "entirely simple and unassuming and kindly in his manner and apparently so pleased with praise of his work as if he never had any." French found Rodin a "much more attractive man than I expected" and declared, "I am glad to have got rid of my preconceptions of him."[89] Margaret and Mary met him, too. The four had lunch in Paris, and Rodin gave Mary "photographs of himself and his studio."[90] A great divide had been bridged. French ended up recommending a number of Rodin pieces for acquisition, including *The Thinker*, and within two years the Met opened its first Rodin gallery.[91]

Although he felt guilty for "wasting so much time" overseas, French did not head home until September. Reinvigorated, he focused on the Nebraska project with new determination. As he molded his Lincoln with head down-cast, hands clasped before him, did he remember the similarly posed figure in the William Morris Hunt painting he had seen in that artist's studio nearly half a century earlier?[92] It is hard to imagine that he did not. Whatever the inspiration, once French "keyed" up the statue "tremendously," as he put it, he allowed himself to predict "a success." Hailing him as "a sculptor of international reputation," the Nebraska press echoed, "he is determined to give this state if possible one of the country's great masterpieces."[93]

French wanted "to represent Lincoln bearing the burdens and perplexi-ties and problems of the Great War," and this tension he placed into the stat-ue's brooding face.[94] For a few weeks more, it was a familiar mechanical problem that continued to vex him: the positioning of the statue's legs. "The

* Robinson would be elevated to full director three months later, on October 31, 1910.

more I study Lincoln," French admitted, "the bigger he seems"; he called it his "Lincoln problem."[95] It took him nine months more to produce something he was willing to submit to his patrons for approval. Finally declaring, "I have struck it rather rich this time," he took his latest three-foot-tall plaster model—together with Bacon's plan for a granite background wall inscribed with the words of the Gettysburg Address—to Nebraska in January 1911.

Just before the model was uncrated to go on exhibition at a local school there, a visitor to Frank Hall's home announced she could hardly wait to inspect it; her mother, she explained, had seen Abraham Lincoln "several times" in person giving speeches. "She said he had a curious way of standing before he began to speak, with his hands clasped as if he was collecting his thoughts." The next day, the woman was astonished to find the new statue posed in precisely that attitude—"as if he was thinking deeply." French could not account for his own insightfulness, except that "he had kind of felt as if he must have stood like that, those few moments before his [Gettysburg] address."[96]

The submission earned unanimous approval in Nebraska, along with a formal contract for $22,000, plus a separate $8,400 fee for Bacon as architect.[97] French was so eager to commence work on the enlargement that he headed up to Chesterwood in April, well ahead of the season, to "prepare for the Summer campaign in the studio."[98] There he instructed his assistants to set up not only the armature and clay for the Lincoln, but the skeleton for an equestrian portrait he would have to create that summer, too: a statue of yet another Civil War military hero, General William Draper. The Lincoln would be modeled in the smaller studio in the woods.

Determined to reveal "the crushing weight of a war still to be won,"[99] French now began to study Lincoln's rugged face in earnest. He bought a reproduction of Leonard Volk's Lincoln life mask. The future president himself had described the realistic bust that Volk later adapted from that mold as "the animal himself!"—an unusual endorsement from a man who otherwise declared himself "a very indifferent judge" of his own portraits.[100] The commercially available mask had already inspired generations of sculptors. (A subsequent attempt at taking a cast of Lincoln's face, made in 1865 by sculptor Clark Mills, accurately portrayed the exhausted Lincoln as he looked near the end of the deadliest war in American history, but made him appear so haggard that most viewers, even Saint-Gaudens, mistook it for a death mask.)[101] French made his own cast of the Volk, and while it was still soft, inserted metal rods into the skull to serve as guideposts to help him

accurately calculate the distance between Lincoln's features in subsequent enlargements.

French also obtained a copy of the new volume of Lincoln photographs assembled by pioneer collector Frederick Hill Meserve. The book was the first comprehensive attempt to present, in chronological order, all the camera portraits for which Lincoln ever sat. The progression of images vividly revealed the awful toll the presidency took on an increasingly careworn Lincoln. Meserve may have made separate enlargements for French as well. "I cannot begin to thank you enough for the invaluable assistance you have given me by sending me these fine photographs of Lincoln," the sculptor wrote Meserve. "They will furnish just the data I need and I should be able to make a faithful portrait of the great man from such material."[102] Another recent book of Lincoln photos, by Francis Trevelyan Miller, provided yet more "very valuable material."[103] Volk's mask supplied the dimensions of Lincoln's clean-shaven, still youthful face as it looked before he became president; the wartime images published by Meserve and Miller provided visual insight into the Lincoln who achieved his apogee at Gettysburg—the bearded statesman French intended to portray.

While financial problems continued to plague the project back in Nebraska, French plowed ahead as if under a spell. He even proposed offering concessions on his fee, a rarity for him, if the committee would grant him the right to produce replicas later. Thinking ahead, he explained: "I could not make another as good as this, and it would be but little pleasure to make one inferior to it."[104] The combination of work and anxiety was beginning to exact a toll on the artist, much as the presidency had once aged his subject. French began suffering from painful sciatica that kept him from sleeping. He grew so busy he took to pecking out personal letters on a typewriter instead of handwriting them—a concession to modernity for which older gentlemen, like French, still felt they must apologize. Somehow the Lincoln got done. In late August 1911, Frank Hall finally made the trip from Nebraska to Chesterwood, where at last he saw and enthusiastically approved the final model. This prompted French to report to his brother, "Everybody seems to think it is my high-water mark"—the same confident phrase he had used in his note to Selwyn Brinton the year before.[105]

The final hurdle fell when the Nebraska sponsors raised sufficient funds to construct Bacon's tall background slab as proposed, with the words of the Gettysburg Address inscribed. Bacon would trim the shaft with classical fasces to signify the authority Lincoln derived from his majestic words.[106] But it was French who provided the authorized text, submitting a sketch

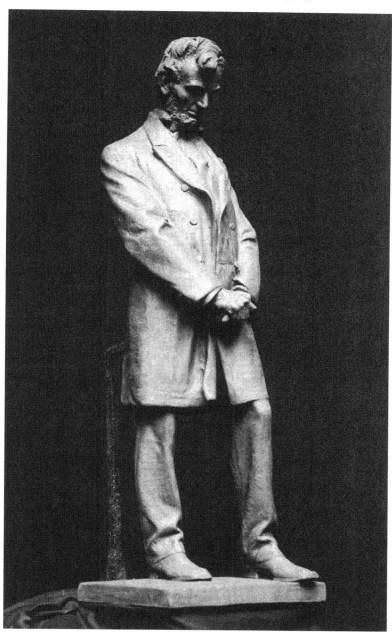

Full-size plaster model of *Abraham Lincoln,* ca. 1912,
for the Nebraska State Capitol, Lincoln, NE

outlining Bacon's precise arrangement of its 272 words.[107] "I feel that the success of the monument depends upon it," French had argued for the granite backdrop. "If people should make up their minds that the monument looked meagre or incomplete when first shown, it would never recover its prestige....Let a joke or two be cracked about a statue at the start and it will queer it for all time."[108] He had never gotten over "Big Mary."

In mid-October 1911, French pronounced his Lincoln complete. "It has been almost finished for a month or more," he confided on the 14th, "but I have kept it by me in order that I might key it up a little by further study. I have now to confess that I can do no more to improve it—that it is as well as I can do....It has been an absorbing subject and one that called for the best that is in an artist."[109] At Chesterwood, Mamie invited "a host of Lenox and Stockbridge people" to a "picturesque" tea "in its honor," where "women in bright clothes" strolled "down across the field to see 'Lincoln's Shrine,'" as they called it."[110] Margaret remembered that "the floor of the little studio was well washed with the tears" of villagers awed by "the poignant figure."[111] Nothing he had ever done, French told his Nebraska patrons a few days later, "has evoked so much praise." People "say it is my high-water mark," he announced one more time. On this occasion he added, "and I tend to agree with them."[112]

At the end of the usual extended summer, French transported the full-size plaster to his brand-new Manhattan studio on Eighth Street at Sixth Avenue. The larger space stood just across MacDougal Alley, a gated mews only three blocks from the workplace he had occupied alongside his Eleventh Street townhouse since moving to New York with Mary more than twenty years earlier. He had purchased the new studio because he had simply outgrown the old one—it could no longer accommodate the large pieces he was making—and, besides, he saw the nearby Eighth Street building as a good investment. "I rather shrink from going into a thing which will increase my responsibility," he worried to a friend, "but the difficulty of getting a studio in New York is very serious."[113] Within months, he was profitably leasing space to six painter-tenants and projecting more than $3,600 in annual rentals. He called it "pursuing the almighty dollar by way of the studio."[114]

Before sending his Lincoln statue to the John Williams foundry for casting in bronze, French hosted a New York studio showing in early January 1912, attended by more than two hundred guests. Offering "warm congratulations," one critic on hand predicted "a distinguished ornament to the city that bears the name of the Great Martyr-President."[115] French hoped he might "be forgiven for being a little conceited for the reception given

the statue."[116] The sculptor seemed "particularly pleased to have the artists express themselves so enthusiastically about it." As he told a friend that same week: "I think I have never made anything that has created so much of a ripple on the surface of New York."[117] Not even news of the death of his old mentor Thomas Ball at age ninety-two could deflate him.

It took six more months for the Lincoln bronze to emerge from the casting process and respond to French's finishing touches. The 1,500-pound statue arrived at the Nebraska capital on June 13, 1912; two months later, workers hoisted it into position. On September 2, some twenty thousand spectators braved "spiteful and fitful rain" to witness the dedication. The crowd, which included three hundred aged Civil War veterans, filled chairs, pressed against the speakers' platform, overflowed onto the lawn, clung to tree branches, and stayed their ground even when ordered to move by bayonet-toting guards.[118]

There would be no Lincoln descendants at this dedication. Claiming he was "not in sufficiently good health," the president's sole surviving son, Robert, now past seventy, had turned down an invitation to attend. Mary French, too, stayed home. Margaret, age twenty-three, accepted.[119] The program lasted two hours. A band played patriotic airs, a church choir sang "Hallelujah," elected officials delivered remarks invariably lengthier than the Gettysburg Address, and in a voice "clear, musical and powerful," a local woman recited that brief masterpiece. Then the principal speaker, three-time presidential candidate William Jennings Bryan, an Illinois-born Nebraskan, intoned the dedicatory speech. French seemed pleased to meet "The Silver Tongued Orator of the West," a Democrat in politics whose open admiration for Lincoln ordinarily made Republicans like French apoplectic.[120] "I wonder," Bryan intoned at one point in his address, "if there are any here who ever saw Lincoln?" As the *Nebraska State Journal* reported: "Instantly a hundred hands were waving wildly, scores of eager voices shouted 'Yes, yes I did,' and some rose from their seats in their excitement. 'It must be compensation for what you suffered in that war to have had the chance to look upon his sad face,' remarked the speaker, visibly impressed."[121]

With these final words, Frank Hall rose to speak proudly of the "noble monument" he had assigned to French three years earlier: "The dignified pose, the bowed head, the great, sad but loving and kindly face, the clasped hands, all speak out plainer than words of the solitude and loneliness of the man in his struggle with human problems for the adoration of mankind." As French and his daughter listened from the platform, Hall concluded: "And now, Mr. French, I want on this occasion, and in this public manner...to

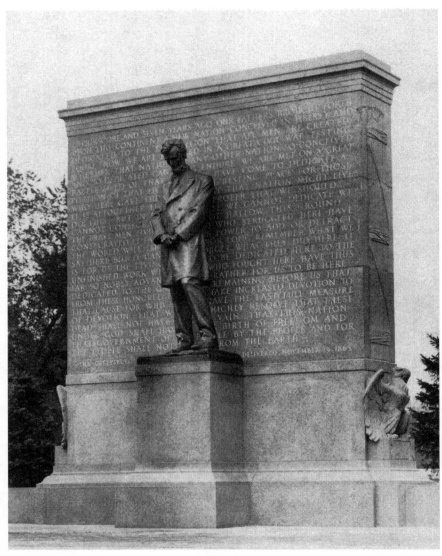

Abraham Lincoln, bronze, 1909–12, Nebraska State Capitol, Lincoln, NE

express to you our very great appreciation for your efforts on producing one of a half dozen great statues of the world." French stood, bowed briefly, and resumed his seat without speaking. Finally, to the strains of "Marching through Georgia," two elderly Civil War veterans tugged at the ropes that veiled the statue, revealing it to the world.[122]

That night, Daniel Chester French, accompanied by Margaret, attended a reception in his honor attended by 250 dignitaries at the lantern-lit, rose-strewn Hall mansion. The sculptor departed on a wave of adulation, stopping with Margaret en route home to see a natural wonder once visited by Lincoln: Niagara Falls.

◆ ◆ ◆

French never earned the sustained praise he had anticipated for his Nebraska *Lincoln*, but for good reason: he would later better it. After a flurry of press accolades, attention waned, and some blamed French's naturalistic conception. The *Architectural Record* tried explaining that while the statue was "graceful in its awkwardness...the somber, uncouth figure" seemed "so different from the popular conception of a monument to a nation's hero, that many have hesitated in their desire to express approbation."[123] By 1914, French was reduced to sending Frank Hall a recently published photo of the bronze "as a reminder of my existence, and of the apparent popularity of our statue."[124]

A few years later, Robert Lincoln brought the subject of Lincoln statuary back into the limelight by denouncing a proposal to install a replica of a far more ungainly Lincoln statue, by George Grey Barnard, at Parliament Square in London.[125] A committee had proposed the statue as a gift marking the centennial of American-British amity that had followed the war of 1812. Ex-presidents Roosevelt and Taft applauded the design, but Lincoln, America's minister to the Court of St. James's from 1893 to 1899, spared no invective in labeling the Barnard sculpture "monstrous," "grotesque," and "defamatory."[126] Joining the battle, *The Independent–Harper's Weekly*, a New York newspaper, conducted a public opinion survey to determine whose statue might be substituted in London. Alas, French and his Nebraska work finished a disappointing fourth—behind Saint-Gaudens's *Standing Lincoln*, George E. Bissell's 1893 *Lincoln* statue for the Old Calton Burial Ground in Edinburgh, Scotland, and Gutzon Borglum's 1911 seated Lincoln outside the county courthouse at Newark, New Jersey. Bowing to the popular will, patrons installed a reproduction cast of the Saint-Gaudens's *Lincoln* in Parliament Square.[127] "I cannot help being sorry for Barnard," French

admitted, perhaps reflecting his own disappointment, "even though I do not like his representation of our great President."[128]

In 1919, agreeing that French's statue "has been slow in winning world wide recognition," Abraham Lincoln's onetime law student, Henry Rankin, now eighty-three and too infirm to visit Nebraska, saw a photograph of French's work and pronounced it "good, nay excellent." In a fine hand that eerily resembled Lincoln's own penmanship, Rankin wrote the sculptor: "Yours is the Lincoln I have often seen in the peculiar self-centered or meditative mood...when being introduced to an audience before he spoke," admitting, however, "the heavy lock of hair in the center of forehead I do not like."[129] Not long afterward, one of Lincoln's most popular contemporary biographers, Godfrey Rathbone Benson, known as Lord Charnwood, whose 1916 book French was then consulting for his next Lincoln project, hailed the bronze as "the most satisfactory statue he has seen." As the *Nebraska State Journal* exulted: "The man with the pen and the man with the chisel, working on two sides of the Atlantic, but each unconscious of helping the other, had found the same Lincoln."[130]

The Nebraska statue lived on in other forms. Although French had never pursued an official agreement to relinquish part of his fee in exchange for reproduction rights, once the Hall commission ran out of funds to pay him his final installment, he commenced offering recasts "without asking permission." To make the replicas, he used duplicate plaster models he had created before sending his original to the foundry.[131] Per custom, one full-size plaster was shipped to Will French's Art Institute of Chicago and another displayed at a 1915 world's fair in San Francisco.[132] Reduced-size bronze statuettes first appeared on the market at $600, with French, concerned the price was "much too low," hiking it to $1,500 before settling on $1,000.[133]

Apparently their growing ubiquity irritated his Nebraska patrons. French felt compelled, after all, not only to apologize for being "a little careless," but to surrender the final payment they still owed him in exchange for permission to make additional casts. He continued to argue, however, that neither reductions nor reproductions cheapened the reputation of the original, but "the reverse."[134] Eventually, replica statuettes of French's *Lincoln* became one of the most admired of his works—desirable enough for Gertrude Vanderbilt Whitney to acquire one for the new museum of American art to be named after her in New York.[135]

The full-size Nebraska plasters proved less durable. The Art Institute copy perished along with the other casts destroyed in the liquidation madness of the 1930s. Fortunately, the model that had been first displayed in San

Francisco and then sent to the Cincinnati Museum of Art would be reacquired by French's daughter in 1964. She then had it cast in bronze and installed two years later on the grounds of Chesterwood, where it remains on view today not far from the old barn the sculptor had once moved to a hillside to make way for his studio. A three-foot-high plaster model once owned by Henry Bacon returned to Chesterwood in 1974.

As for the original bronze, while the modest old Nebraska state capitol building eventually came down, to be replaced by a skyscraper version in 1932—now the second-tallest state house in the nation—the bronze continues to hold its own before even that monolith. French would soon wade even deeper into the Abraham Lincoln waters, this time with truly epochal results. Perhaps his subsequent Lincoln triumph helps explain the Nebraska statue's limited fame. As one Lincoln scholar later put it: "Quite often, a sculptor's masterpiece overshadows his other works."[136]

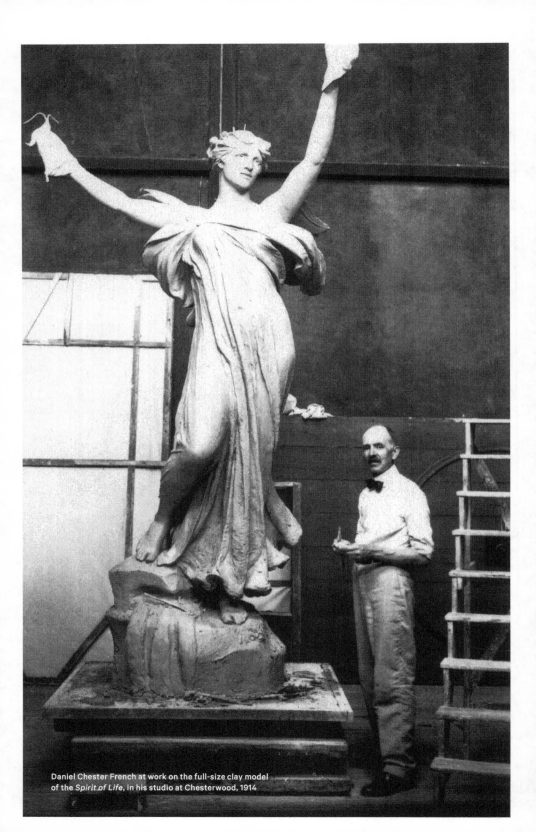

Daniel Chester French at work on the full-size clay model of the *Spirit of Life*, in his studio at Chesterwood, 1914

THE GENIUS
OF CREATION

ollowing the triumphant but exhausting Nebraska ceremonies, French hoped to salvage what was left of the family's customary extended summer at Chesterwood. Returning to the Berkshire hills by late September, he resumed work on unfinished projects. He still had one more Civil War equestrian to finish and faced looming deadlines for additional statues he had agreed to produce for New York, Washington, Boston, and Detroit.

With the approach of autumn, the rest of the country turned its attention to the roiling 1912 race for president, which bore an uncanny resemblance to the campaign that had put French's most recent sculptural subject, Abraham Lincoln, into the White House more than fifty years earlier. Back in 1860, the Democratic Party had split into northern and southern factions, nominating separate candidates, dividing the anti-Republican vote, and assuring Lincoln's election. This time it was the Republicans who splintered. After a bitter primary campaign—the first in the nation's history—President Taft eked out a convention majority to secure his party's renomination. Yet former president Theodore Roosevelt, who had come out of retirement to challenge his handpicked White House successor, refused to accept the verdict and sought a third term. He organized a new political party and emerged as the Progressive—or "Bull Moose"—nominee for the job. Democrats united behind the Southern-born New Jersey governor, Woodrow Wilson.[1]

That fall, as photographs of French's new Lincoln statue proliferated, all three presidential candidates strove to attach themselves to Lincoln' coattails. They not only pledged to follow his example, but implied that Lincoln would have blessed their respective candidacies. Roosevelt reminded voters

Daniel Chester French reading in the studio garden at Chesterwood, Stockbridge, MA.
The fountain was designed by Henry Bacon in 1911.

that, for inspiration, he always wore a ring bearing a lock of Lincoln's hair, a gift for his 1905 inaugural from Secretary of State John Hay, who had once served Lincoln as a private secretary. During the campaign, Roosevelt, who had viewed Lincoln's New York funeral as a boy, even endured an attack by a gun-wielding would-be assassin, which he miraculously survived. What could Taft do in response but travel to Manchester, Vermont, to receive the tacit endorsement of Lincoln's sole surviving son, an establishment Republican who loathed Roosevelt? Robert Lincoln may not have been able to summon the strength to attend the unveiling of French's statue in Nebraska, but he proved hale enough just a few weeks later to provide what he doubtless considered the ultimate political blessing: inviting Taft for a round of golf at his country club.[2] After struggling to extricate himself from his limousine, the obese president gave a twenty-minute speech at a local hotel, no doubt repeating what he said during an earlier campaign swing through New England: "My former friend Roosevelt likes to appropriate Abraham Lincoln. But I ask you good people...if you think Lincoln would have treated an opponent, much less a friend, the way he treated me?"[3] Both Robert Lincoln and William Howard Taft would loom large in the project Daniel Chester French would next take on: the Lincoln Memorial.

Wilson, for his part, insisted that his own progressive agenda most accurately reflected Lincoln's legacy (omitting the inconvenient truth of his, and his party's, deep-seated opposition to equal rights for African Americans). Ever since the Civil War, Democratic presidential aspirants, dependent on unified support from the old Confederacy, had steered clear of Lincoln (with one exception: the chronically unsuccessful Bryan). But during the 1912 campaign, Wilson broke the rules and made a pilgrimage to Springfield, Illinois, to visit Lincoln's tomb and orate glowingly about the Republican with whom he now claimed close identification.[4]

French, despite his long-standing respect for Roosevelt, probably cast his November ballot for Taft, who had named him to the federal fine arts commission conceived earlier by Roosevelt. "I have never voted for any but the Republican candidate," he told one of his patrons.[5] Mary, who liked the former president a great deal, might have favored Roosevelt. But she could not vote. Women's suffrage, a bitterly contested issue in America, boiled to the surface again during the 1912 Republican presidential primaries. It was not resolved by election day.

Like the rift among Republicans, the women's rights struggle marked another sea change in the life French had once known. He had begun his career in the age of gaslight, telegraphy, all-male election contests, and the horse and buggy. Now his homes and studios were illuminated by electric bulbs and reachable by telephone. Automobiles had begun to appear on the streets of New York and even Stockbridge. Women were about to win the vote, and and a woman sculptor, Evelyn Beatrice Longman, worked with French as a studio assistant. The world into which French had been born, and achieved early success, had vanished; the new one was virtually unrecognizable to him, as it was for most men of his background and accomplishment. It remained to be seen whether he could sustain his professional standing within its rapidly changing art scene.

The era of Civil War memorials seemed to be fading, too, but not without a few final spasms of patriotic nostalgia. Once, such statues had been meant in the North not only to celebrate heroes, but to assert America's survival as a single, unified nation. Over the decades since the war, however, regional hubris and white dominance had overtaken national unity as surely as Lee had overtaken Hooker at Chancellorsville. In the hearts of unreconstructable white Southerners, the rebellion had not been waged to preserve slavery, but to resist Northern aggression. In this distorted vision of Lost Cause memory, the Confederacy never really lost at all; it had merely been overwhelmed. It might even rise again. And in a way, it did, at least in the

form of statues celebrating General Robert E. Lee, Jefferson Davis, and a host of other Confederate leaders. These memorials rose in defiance of the sentiments of African Americans freed by the war; indeed, many such statues were erected to punctuate their continued subjugation.[6] Sculptors who took on such commissions seldom won assignments from Northern patrons to honor Union heroes—and vice versa.[7] For the most part, artists had to choose their loyalties and stick with them. French remained faithfully in the Northern camp. He was a Yankee through and through, by birth and political orientation alike. As the lines between the sections blurred in the age of Woodrow Wilson and World War I, French remained available to respond to the final gasps of Union memory with the heroic portraiture for which veterans and their descendants still yearned. He never completed a memorial to a Confederate leader.

Just three weeks after the dedication of his Lincoln statue in Nebraska, the last surviving Massachusetts veterans gathered in Milford to witness the unveiling of the equestrian statue on which French and Edward Potter had begun working years earlier to honor favorite son William Draper. A general who had served from Fredericksburg to Vicksburg, Draper had survived a near-fatal wound at the Battle of the Wilderness and returned home to start a thriving business and run (successfully) for Congress. At his death, Draper had been worth $6 million.[8] Following the customary dedication day military parade and speeches, the late hero's daughter tugged at a rope—repeatedly, until it yielded—to reveal the bronze statue as a band played "Hail to the Chief" and artillery erupted with an eleven-gun salute.[9] French, who had attended so many of these ceremonies, this time stayed home in Stockbridge.

His thoughts turned to the past. In 1915, this man of few words wrote a nostalgic tribute to Ralph Waldo Emerson for the *Art World* that drifted understandably into a paean to "the golden age of classic Concord...a thing of the past."[10] Three years later, he agreed to the publication of his tribute to Augustus Saint-Gaudens ("he gave the best that was in him") for the American Academy of Arts & Sciences.[11] Professionally, French kept his eye on the future. "My prices are very much higher," he warned one prospective client. So was demand for his work.[12]

◆ ◆ ◆

As French approached age sixty-five in 1915, death seemed to be encircling him, and not just in the personages of the late Civil War heroes he was so often asked to memorialize. Saint-Gaudens had been gone since 1907. French's old teachers, J. Q. A. Ward and Thomas Ball, had died in 1910 and

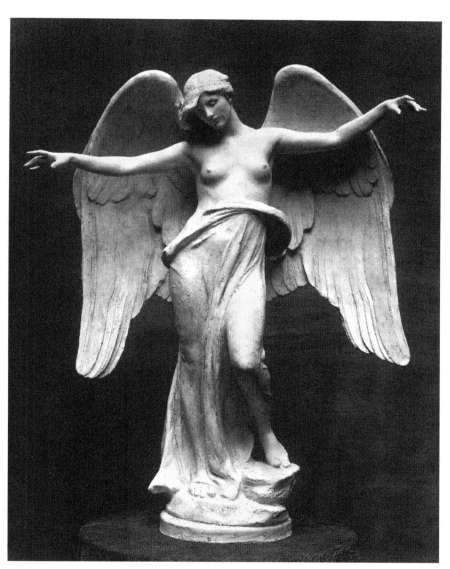

Model of *Spirit of the Waters*, plaster, 1914 (Chesterwood, Stockbridge, MA)

1911, respectively. Then on June 1, 1914, French suffered a blow as devastating as the loss of his father nearly three decades earlier. His beloved older brother, Will, still sporting his neatly rounded Ulysses Grant–style beard and mustache, died in Chicago after a brief fight against cancer. He was seventy.[13]

Will had led, and popularized, the city's Art Institute for thirty-four years, transforming it into much "more than a cold storage space for pictures," and making certain throughout his tenure that its growing collection always made room for Dan's latest works.[14] A museum director, educator, writer, artist, and public speaker—his specialty was drawing pictures as he lectured—William M. R. French had for decades toured the country with the same "delightful" talk: *The Wisdom of the Crayon.* "It was with sensations approaching to wonder," one attendee had written in 1904, "that the audience saw a skeleton rapidly drawn upon a large sheet of paper, and then clothed with muscles, flesh, and the ordinary garments of civilization, acquiring color and expression" even as French spoke "as rapidly as he drew."[15] A "master hand" in "everything he did and said," Will was for his younger brother an adviser, sounding board, and intimate confidant.[16] His loss could only be described with the word that a journalist used to describe the impact of William French's passing on his adopted city: "incalculable."[17]

French may well have further felt the fragility of life when one of the six "painter tenants" renting space at his Eighth Street studio accidentally "set his room on fire" just a few months later. The New York City Fire Department responded with aplomb and doused the blaze before it could spread and cause injury. If he was traumatized by this close call, French consoled himself by filing for "remuneration from the insurance company," adding: "Such are the joys of possession."[18] It was the work, as always, that diverted him from these losses.

Another all-consuming project had come French's way in 1913. That year a civic committee, charged with rehabilitating the run-down upstate New York town of Saratoga Springs, invited him to create a memorial there to one of the restoration group's founders: banker and summer resident Spencer Trask, who had died in a railroad accident in 1909.[19] The project would be financed by Trask's onetime business partner, the progressive millionaire George Foster Peabody, and overseen by Trask's widow, Katrina, a successful author and playwright who wrote under the name Kate Nichols Trask.

Appreciating the "compliment" of the Trask offer, French and Henry Bacon headed off to the long-famous resort village and inspected the park where the proposed memorial would stand. The sculptor and architect

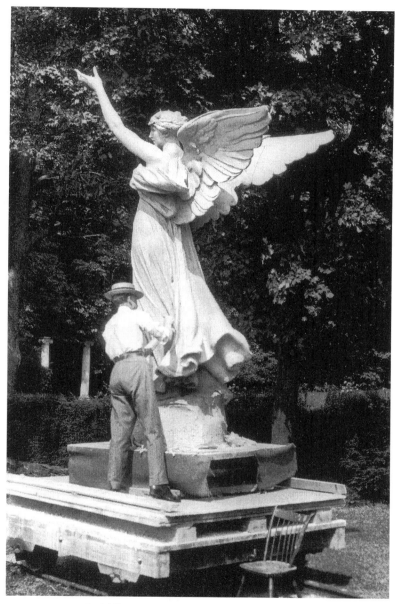

Daniel Chester French at work on the full-size model of the
Spirit of Life on the railroad track at Chesterwood, 1914

suggested a fountain, and agreeing, Trask's widow made it clear she wanted as its centerpiece a winged angel. The sculptor obliged with one of his beautiful female seraphs, arms outstretched *Alma Mater* style and head downcast as if in mourning. Mrs. Trask objected to it as too grim, however, and French rethought the composition. The revised design emphasized what he described as "buoyancy and life." He called the central figure "the spirit of the waters."[20] As his increasingly friendly letters to Mrs. Trask made clear, French was willing to do anything his patron wanted except produce the final sculpture in marble, which he doubted could long survive the kind of saturation the Trask fountain promised to produce.[21]

Before he could make more progress on the work, President Wilson asked French to join landscape architect Frederick Law Olmsted on an unusual mission to Panama. The new American-built canal across the isthmus was nearing completion, and the United States planned to create a model village called Balboa on the Pacific side. The president felt the new town could be enhanced by the kind of green space and public art in which French and Olmsted specialized. French arrived on the blisteringly hot construction site to find George Washington Goethals, the engineer serving as the first governor-general of the Canal Zone, willing to entertain suggestions only on plans he had not already formulated. After enduring the long, unpleasant voyage, steamy Panama conditions, and icy welcome, French was glad to get home and resume work on the Trask memorial.[22]

To pose for the full-size *Spirit of the Waters*, French hired America's first supermodel: the notorious Audrey Munson, whose face adorned the Liberty Dime, and the rest of whom could be seen, unclad, in "America's most celebrated painting and statuary," according to an advertisement for one of her silent films.[23] French had the finished work cast in bronze by the Gorham Company.[24] The nine-foot-high golden-hued allegorical bronze, dedicated in 1915 with French in attendance, depicted the winged angel holding a branch of pine (Mr. Trask's "symbol") in one hand, and in the other, a small basin "to suggest the return of the waters to Saratoga," a city known for its healing springs.[25] The composition was no longer grim.

Pleased with the result, French went on to reproduce statuettes and heads over the years, telling his daughter he thought it "the best thing of the kind I ever made."[26] Art writer Adeline Adams agreed, calling the work "the most exquisite vision in all his long line of draped symbolic female figures."[27] French's contract had called for twenty-five thousand dollars for the Trask project, out of which French netted eight thousand after expenses—enough to consider himself "*well* paid."[28] Even so, he endured the usual postpartum

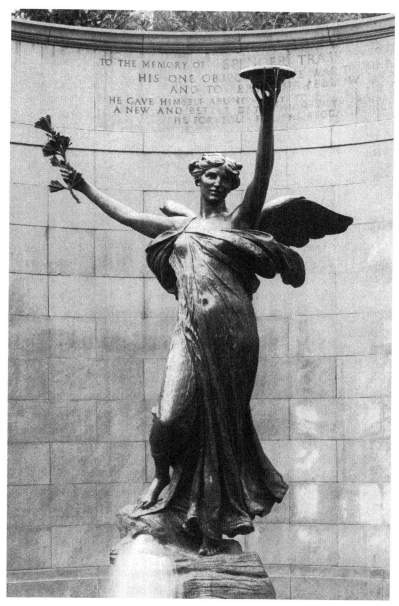

Spencer Trask Memorial (Spirit of Life), bronze, 1913–15,
Saratoga Springs, NY

blues that each new statue dedication seemed to trigger. As he confided to Katrina Trask after finishing yet another piece: "I am in the depressed frame of mind that usually follows the completion of one."[29]

Emotional letdown notwithstanding, *The Spirit of Life*, as the Trask fountain came to be called, garnered French another round of positive press attention, including a lavish photo spread in the journal *Art & Progress*.[30] It earned something more for the widow Trask: a new husband. Six years after the memorial was dedicated, she married her partner in the enterprise, George Foster Peabody. But Katrina Trask Peabody, long beset by family tragedy, died less than a year later.[31] Before her passing, she grew even closer to French. They exchanged visits and maintained a vigorous correspondence. It was Katrina who brought French into Yaddo, the artists' community that she and her second husband opened on the grounds of her estate. Becoming an enthusiastic supporter who reveled in its "peace and calm," French went on to serve on its board.[32]

◆ ◆ ◆

Two years after accepting the Trask commission French at last received the formal, irresistible offer from the architects of the new Manhattan Bridge, John Merven Carrère and Thomas Hastings. The designers asked French to create large statues representing "Manhattan" and "Brooklyn" for the pylons slated to stand at the Brooklyn approach to this newest East River span. (The Manhattan side was simply too crowded to accommodate either, much less both, statues.) The architects offered French the freedom to employ whatever themes and symbols suited his fancy, but the opportunity left the usually inventive sculptor uncharacteristically at a loss for inspiration, even though by now he had lived in the city for decades. Writing to the director of the Brooklyn Museum, he implored: "Will you not tell me what you regard as the special attributes of the two cities, what they stand for, and what they are famous for or anything that can be used in the statues representing them. I have not found it so difficult to endow New York with intelligible attributes as Brooklyn. If you come to my rescue I shall be very much indebted to you."[33] By March 1915, no doubt with the subsequent guidance of the museum's director—his ideas perhaps offering some of the inspiration Will had once provided—French had finished and inscribed small clay maquettes for each.

In his original concept, French designed a rather imperious female figure of *Manhattan*, holding a steamship in her lap and leaning on a skyscraper. The idea was to convey not only the borough's power, but its confident, even

supercilious, attitude. Perhaps in response to suggestions from architects Carrère and Hastings, the sculptor replaced these emblems with a globe and ship's prow to symbolize international commerce, along with a peacock, a subtler emblem of pride. The expression of hauteur remained intact. The graceful *Brooklyn* group featured more modest but entirely suitable symbols on either side of the central female figure: a church steeple and a little boy reading a book, perfect representations of spiritual and educational priorities in the so-called "borough of churches and homes." The figure of *Brooklyn* holds a tablet inscribed with the borough's motto, "Unity Makes Strength," carved in Dutch (the language spoken by the region's first nonindigenous settlers). In this case "unity" stood not for the preservation of the United States, the underlying subject of French's many Civil War memorials, but the 1898 union of the five boroughs to form Greater New York.

To fashion the portraiture for the figures, French turned to live models. He hired an attractive family friend, singer Rosalie Miller, whose heavy-lidded eyes and severely parted black hair made her resemble the Ingres portrait of the Princess de Broglie, to pose at Chesterwood for *Brooklyn*. A surviving, elaborately staged photograph shows a bald, bespectacled French from behind, clad in a white summer shirt, perched on a platform and pretending to press his fingers to the all-but-completed full-size clay. Both the smaller plaster working model and his glamorous sitter are visible on either side of him.

For the face of *Manhattan*, French chose a different model. The sculptor invited architect Cass Gilbert's debutante daughter to pose for the statue's face, a choice that backfired when a number of newspapers publicly identified the sitter as Julia Gilbert.[34] The father sent off a stinging letter to his friend, outraged by the "distressing" and "objectionable publicity." Huffing that his family's "personal affairs are always kept out of the newspapers," Gilbert expressed his desire "to shelter our dear daughter from all that sort of thing," demanding that "insofar as the statue may have any resemblance to Julia it should be changed."[35] Of course it was too late, and the friendship suffered.

More importantly, at least as far as he was concerned, French hoped that the final statues could be carved in durable marble, and by the Piccirilli brothers. But just as he had eschewed marble for the widow Trask, his new patrons rejected marble now. French got his way in only one regard: his favorite carvers secured the contract, but to do the work in granite, notwithstanding French's warning that it was "the most unsympathetic material of sculptures that I know."[36] Ironically, the choice of stone ended up causing a

Model of *Manhattan*, 1915 Model of *Brooklyn*, 1915

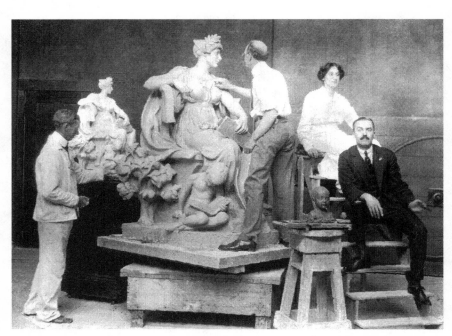

Daniel Chester French working on *Brooklyn* in his studio at Chesterwood, ca. 1915.
Model Rosalie Miller sits at right in this staged photograph.

Model for *Memory*, plaster, in the studio at Chesterwood, 1917

delay in completing the statues, but not for the reason French feared. Rather, a strike by the Granite Workers' Union forced a temporary shutdown at the Piccirilli operation. The finished works, each of which stood twelve feet high and weighed twenty tons, were not set in place in Brooklyn until the fall of 1916. In total, French received sixteen thousand dollars for the statues, from which he paid all expenses.[37] No one knew it at the time—perhaps French included—but they would be the very last architectural sculptures he would ever undertake.[38] *Brooklyn* and *Manhattan* capped a specialized career that had lasted, on and off, for some forty years, ever since his late father had helped his struggling son win his very first commissions from the Treasury Department.

Sadly, "Miss Manhattan" and "Miss Brooklyn" would occupy their pylons for less than a half century. Traffic exhaust and salt air could not harm them, but the elderly, still all-powerful city planner Robert Moses could. In 1963, he decreed that the statues be removed and discarded to make way for construction of a second deck and a wider traffic approach to the Manhattan Bridge. Fortuitously, preservationists rallied to rescue the statues, reinstalling them outside the Brooklyn Museum to flank its street-level entrance doors, where they have welcomed visitors ever since.[39]

In an ironic double twist, fifty years later still, in 2016, two inventive Brooklyn artists used computer technology to create centennial replicas of French's originals and place them near where they had once loomed. In a demonstration of nostalgic but quirky respect for the vanishing ethos of civic art, they designed and fabricated uncannily accurate acrylic resin copies of the two granite statues. The artists, Josh Young and Brian Tolle, even secured funding for the project from New York City's economic development agency. They added rotating pedestals to keep them in perpetual slow motion and illuminated them from within using high-tech LED lighting. The rotating pedestals enabled the statues to face Manhattan part of the time, and Brooklyn at others—contortions that French's hefty originals could never have accomplished. Art no longer merely decorates; it has to entertain. It is difficult to imagine what French might have thought of this combination homage and spoof. A spokesperson for the city's Department of Transportation at least expressed confidence that the moving statues would not distract drivers.[40]

◆ ◆ ◆

Around the time he labored on *Brooklyn* and *Manhattan*, simultaneously, as had become his habit, French turned back to a long-gestating pet project: a

purely idealized female figure on which he had begun working some twenty-five years earlier. The heroic-size nude, reclining on a rock, stares into a hand-held mirror. The pose is relaxed yet almost contorted, clearly meant to evoke admiration not only for the lovely subject, but for the sculptor who could accomplish such a nimble composition. French called the serene work *Memory*, and took pains to explain its meaning. "As the slight motive represented in the statue is not perfectly evident to everyone," he told the art editor of the *New York Sun*, "I will say that *Memory* is supposed to be reflecting in the mirror which she holds, not her own face, but what is behind her."[41] In a way, the statue was not only an academic exercise—the latest example of French's growing mastery of the female form—it was French's own reflection on the vanishing years, an admission that perhaps the past now held more attraction for him than the future.

To be sure, it was not a commercial project. "I made it for the pleasure of doing it," French insisted.[42] He kept no record of its costs in his otherwise meticulous account books.[43] *Memory* might also be seen as artistic absolution for a previous misfire, for *Memory* was, in a sense, the female equivalent of *Endymion*, the reclining male figure that French had created under Thomas Ball's supervision four decades earlier in Florence. There, Michelangelo's marble statue of *Night* in the San Lorenzo Sacristy had clearly made more of an impression than young Dan had been willing to admit at the time. Haunted by *Endymion*'s failure but clearly inspired by Michelangelo, *Memory* offered both a tribute and an expiation. Initially, French dared not hope for a buyer for the new statue. Like *Endymion*, it was undertaken without a patron or contract in hand, a rarity for an artist who sculpted to earn his living. The only deadline for its completion was imposed by the preoccupied sculptor himself, and he let the project languish for decades. French accomplished an initial version in 1886, worked on it in Paris the following year, labored on it from time to time in New York, and may have taken a copy with him to Europe when he fled the pressures of the Nebraska commission in 1910. He made his final minor revisions at Chesterwood in the summer of 1917.[44] To model for later versions of the piece, he probably employed Rosalie Miller, who had sat for the *Brooklyn* statue. "Somebody else said my *Memory* looked like you," he later teased her, adding: "I should like to think so."[45]

More than a year later, French finally sent the full-size plaster model to the Piccirillis for carving in expensive Carrara marble, absorbing the cost himself. Then, again showing his usual commercial acumen, he placed the final statue at New York's prestigious Knoedler & Co. Gallery, which

occupied a Carrère and Hastings building at Fifth Avenue and Forty-Sixth Street. Here, for eleven days in February 1919, in an emporium otherwise resembling "a bazaar," *Memory* sat in isolated splendor inside a hushed room covered wall-to-wall with tapestries.[46] The asking price may have brought a hushed silence, too: fifty thousand dollars to individuals, and twenty-five thousand for museums.[47]

The exhibit caused an immediate sensation in the art community. Painter Edwin Blashfield quickly wrote to French to applaud: "Beautiful thigh, beautiful torse [sic], beautiful details of all sorts." Sculptor Frederick W. Ruckstull told French: "That is what I call Great Art. Universal yet personal, nude but not naked. True, Good, and Beautiful." And painter Maria Oakey Dewing—whose artist-husband Thomas rented a studio from French on Eighth Street—effused that *Memory* seemed to her "less removed, more human and lovable" than even the *Venus de Milo*, "but not less perfect, not less noble."[48] Not every tenant's wife would associate the word "lovable" with her spouse's landlord.

French seemed slightly conflicted when the Metropolitan Museum expressed interest in the statue at the very start of the eleven-day showing at Knoedler's. "I want you to know how much it pleases and gratifies me to know that you think it is worthy of a place at the Museum," he wrote to its president, Robert de Forest. "Naturally I would rather it go there than anywhere else in the world. I understand, however, that the fact that I am a Trustee precludes the possibility of the purchase of the statue...and I recognize that it is a somewhat remote possibility that anyone will feel like donating the statue to the Museum."[49]

Perhaps that declaration constituted a broad hint. If so, it worked wonders. Just a few weeks later, the Metropolitan Museum's vice president, the railroad tycoon and philanthropist Henry Walters, used his own funds to purchase *Memory* for thirty thousand dollars (five thousand over the museum price) and "presented her" to the Met as a gift. The donation triggered a wave of favorable newspaper publicity that kept French's clipping service busy.[50] Knoedler earned six thousand dollars as a commission, and French took home the hefty balance of twenty-four thousand. French described the gallery's response to the sale as one of "excitement and satisfaction," but no doubt these words summarized his own exhilaration as well.[51] "I have worked on it off and on for ten or eleven years," he told his brother's successor at Chicago's Art Institute, "and consider it rather the chief effort of my life."[52] Commenting a few weeks after the acquisition, art writer Royal Cortissoz agreed, calling *Memory* "the best kind of museum

Admiral Samuel Francis Dupont Memorial, marble, 1917–21, Washington, DC

piece...an example of sterling workmanship" that constituted "Mr. French's masterpiece."[53]

To traditionalist critics like Cortissoz, *Memory* represented something more than a major addition to the Met collection. It was also a convincing response—perhaps, though Cortissoz never said so, a last gasp—for academic sculpture steeped in beauty; a bold retort to what he called the "regrettable superficiality" of "the cult of Rodin," which stressed "surface effect without conveying an impression of structural validity." The critic even applauded French for taking so much time to complete it, calling it "a lesson to an impatient generation." *Memory*, cheered Cortissoz in his widely read *New York Tribune* Sunday art column, "is the very negation of all those easy plausibilities," possessing "a beauty resting upon organic construction" so flawless it seemed to be "built up from within," not "modeled from the outside." It was "indispensable," the critic scolded, that fellow American sculptors "should know the rules of the game; that they should be accomplished men of their hands...that their work should have not only form but substance; that it should be rich in ideas, in truly significant emotion, and here in this 'Memory' is at once an admonition and an encouragement." Its acquisition, Cortissoz concluded, was "of value not only to Mr.

French alone or to the museum as an institution, but to the American school of sculpture as well."[54]

What was remarkable about French at this time—as he adroitly juggled patrons and commissions (soon to include the Lincoln Memorial), along with critics and fellow artists, professional obligations, and volunteer commitments—is that he never adopted Cortissoz's absolute disdain for modern art. Even as French was bringing his own traditional style to its climactic apex, even as he emerged as the dean of the so-called "American school of sculpture," he remained open to other approaches as well—including Rodin's. It was no accident that a Rodin sculpture entered the Metropolitan collection during this period, even if he had by this time earned broad, if grudging, acceptance. True, French's acquisitions committee never embraced sculptors experimenting with folk style, or more progressive representations representations of the female form, like the work of Polish-American Elie Nadelman or French-born Gaston Lachaise. The Met's slowly broadening taste was guided by French himself, now powerful and generous enough to bless other artists' work (within his parameters of taste) while advancing his own. Even if such largesse often benefitted him, it benefitted the museum, and its visitors, more.

◆　◆　◆

Notwithstanding the accolades for *Memory*, French was in some ways beginning to look back, not ahead. The flippant, adventurous, insecure youth of Concord, Florence, and Washington had matured into a self-assured establishment figure, his sly sense of humor often concealed behind a taciturn Puritan mask. In an era of avant-garde art, French surely worried that his kind of work might soon go out of fashion. And like many men of his years, however well-established, he also seemed to yearn for the freedoms he had savored in his footloose youth. The casual flirtations he had once enjoyed with women, repressed after his marriage, now began recurring as if in a second childhood, at least in verbal comments and letters.

In summertime, with his Chesterwood workplace constantly crowded with workmen and visitors, French retreated more often than ever to the smaller studio in the secluded woods across the road from his house, and there posed favorite models like Rosalie Miller, who often sat unclothed. There is no evidence that there was more to these encounters than the professional relationships artists routinely maintained with their professional models. But a resurgence of sensual banter may have been hormonal, on

Margaret French as *Diana*, the goddess of the hunt,
in the studio garden at Chesterwood, 1913

Mamie's part as well as his, perhaps coinciding with her menopause and a declining appetite for intimacy.

One day, for example, French told Adelaide Parsons that he had really employed no model at all to pose for *Memory*, prompting the intrigued visitor to inquire: "What do you think of when you're doing a beautiful figure like this?" French looked into her eyes and replied, "I was thinking of you."[55] We also know that when his accountant's wife visited Chesterwood in June 1919, French not only gave her a long look at the plaster version he still kept at the main studio, he also wrote provocatively to her afterward to analyze the statue. The letter seems not only revealing, but downright seductive. *Memory*, he began, "shows too little of 'human joys and sufferings,' and I fear my inclination is to ignore too much of the gloom and emphasize the beauty and joy of life—leaving out the snake, which, alas! was devised with Paradise. I haven't been able entirely to eliminate it from my every-day life, but why not at least forget it in the life that I live with my clay and marble folk? I like to think that perhaps for a minute or two, through my marble lady, you too were led into the serpentless paradise of my dreams."[56]

Whether such thinly veiled overtures ever progressed past flirtation is unknown. Clearly his close relationships with younger women meant nothing to Mrs. French. Rather than express jealousy, Mary treated the procession of women, even her husband's unclothed models, casually. To her, the uninhibited naked beauties came and went "all in the day's work." Mary proudly remembered one of these models once presenting her husband a manuscript of her memoirs, hinting that they revealed sexual harassment by many an artist. As she handed the exposé to French, the model-turned-author commented: "There, read them and be thankful that you were *good*."[57]

◆ ◆ ◆

The sculptor's mastery of the female form was evident again in the new suite of allegorical goddesses that he created for the *Samuel Francis Dupont Memorial* in the nation's capital—yet another entry in his expansive Civil War oeuvre, but this time with a difference: it would be symbolic, not realistic, and certainly not a man on horseback.

For one thing, Du Pont had been a navy man. A wartime admiral, one of the oldest and highest-ranked in federal service at the outset of the rebellion, Du Pont's long career had ended badly. Leading an ironclad fleet in an 1863 attempt to recapture Charleston harbor from the Confederacy, he lost a number of ships and failed to seize the city's garrisons, including Fort Sumter, the spot where the war had begun. Du Pont then resigned and faced

a humiliating Congressional inquiry.[58] He died a few months after the war ended. Ultimately, the admiral was vindicated, and while his name never ascended to the pantheon of leading Union naval heroes alongside David G. Farragut, Du Pont's fabulously wealthy family (heirs to the Delaware-based gunpowder fortune) had more than enough funds to do battle for his historic reputation.

By 1884, his descendants had successfully placed a Launt Thompson portrait of Du Pont, albeit a "crude" and "pedestrian" one, at a traffic round-about renamed in the admiral's honor at the intersection of Connecticut and Massachusetts Avenues not far from the White House.[59] By 1917, the district decided that "Dupont Circle,"[60] and the man for whom it was rechristened, deserved a worthier centerpiece. His heirs banished the existing statue to a nearby park and commissioned French and Henry Bacon to create a marble fountain to replace it. The team responded with a three-sided masterpiece featuring tropes for the sailor's elements—large allegorical representations of sea, wind, and sky—so placed as to be visible from all approaches to the circle. Calling the result "lovely," a Du Pont descendant wrote to the sculptor, "You can't imagine how glad I am to have this wonderful piece of work finished, and safely enthroned in all its beauty in the circle. It all seemed too good to be true, that we could get you to do it for us."[61]

Dedicated in May 1921, French, Bacon, and the Piccirilli brothers shared a sixty-thousand-dollar fee for the *Dupont Memorial*. Ever alert to publicity opportunities, and believing no publication too small to merit his attention, French wrote directly to one art critic suggesting she "might like to write some notice of it for the Cemetery Review or some other periodical."[62] He was no doubt pleased when another critic, noting of the Du Ponts that "their taste had increased with their wealth," praised the "beautiful" new memorial and observed: "To see it is to fall under the spell of its intrinsic esthetic merit."[63] The fountain still stands in Dupont Circle, though it has been ravaged over the years by both soot and vandalism.

Yet another female goddess, this one armored and partially clad with one breast bared, grasping a sword in one hand and a shield inscribed with the Michigan coat of arms in the other, soon dominated a fountain that French and Bacon created and installed that same year in Detroit's Grand Circus Park. This was an allegorical tribute to the former governor, US senator, and secretary of war Russell A. Alger. A Civil War hero in his own right, Alger had reputedly seen action at an astonishing sixty-six battles and skirmishes, including Gettysburg, before returning home unharmed and, later, entering politics. French was done with equestrians—or so he hoped. His

only concession to realism in the Detroit fountain was a relief profile of Alger on the base.[64]

Prestigious and lucrative commissions kept arriving: for allegorical statues of *Commerce* (holding a globe) and *Jurisprudence* (cradling tablets of law) installed on the new federal building in Cleveland even before the sculptor commenced his final architectural project for New York's Manhattan Bridge; a memorial to retail magnate Marshall Field in Chicago;[65] and two statues for the state of Georgia, a realistic seated bronze statue of railroad tycoon Samuel Spencer for Terminal Station in Atlanta, funded by thirty thousand of his employees after he was killed in a train collision; and a full-figure bronze of the eighteenth-century founder of the colony of Georgia, British general James Oglethorpe, for Chippewa Park in Savannah.[66] In 1913, French had also commenced a poignant sculptural tribute to Henry Wadsworth Longfellow for Longfellow Park in Cambridge, Massachusetts, the poet's hometown. Traditional Longfellow statues had already risen in Portland, Maine (by Franklin Simmons), and Washington, DC (the work of Thomas Ball and William Couper). Years earlier, French had proposed a Longfellow memorial for Minnehaha Falls, Minnesota, without success. Now his inspired concept called for a bronze bust of Longfellow situated before a granite slab carved with relief portraits of characters from his poems, among them Miles Standish, the Village Blacksmith, Hiawatha, and Evangeline (for which Margaret posed).

That same year, French also produced the most unique, and ill-fated, piece he ever made for a college campus: a life-size bronze memorial at Princeton University to honor an undergraduate named William Earl Dodge Jr., who had died tragically at age twenty-five. French's almost jarringly modern statue—like none he had ever sculpted before—depicted Dodge in a football uniform, an academic robe draped across his shoulder, and a stack of books cradled under his arm. Over the years, the Dodge statue became known on campus as *The Student Athlete*. But the affectionate nickname did little to guarantee respect; in fact, the statue suffered more vandalism than *John Harvard* and *Alma Mater* combined. Seniors first pulled it down "during a spree" following the 1929 commencement, and the following fall "intoxicated students" dragged it off its pedestal "during a riot that grew out of a football rally." The second desecration convinced university officials to place the statue in permanent storage, later returning it to Chesterwood. Princeton made amends by commissioning French to create statues of Benjamin Franklin and Professor Joseph Henry, the Civil War–era secretary of the Smithsonian, to flank the entrance to the school's Palmer

Hall.[67] Only later did *The Student Athlete* return to campus; today it is back on display in the lobby of Princeton's Jadwin Gymnasium.

◆ ◆ ◆

By now, it seemed as if no world's fair could open without a representative work by America's preeminent sculptor. In 1914, French produced an elaborate winged angel called *The Genius of Creation* for the latest such fair, the Panama-Pacific International Exposition at San Francisco. Busy as he remained, he traveled all the way to the West Coast to see the installed work. It was an aptly titled submission. A genius of creation seemed now to spark all of French's undertakings.

The following year came offers for two works for the Boston area: a bronze likeness of abolitionist leader Wendell Phillips, shown speaking from a lectern, a symbolic shattered chain in his hand; and, in a return to the Revolutionary War theme at Concord, site of his iconic *Minute Man*, a relief bronze portraying Major John Buttrick, one of the commanders of the colonial militiamen who had squared off against the British at the famous bridge on April 19, 1775. French produced the rigid but earnest portrait of the musket-toting major in collaboration with Edmond Thomas Quinn, who later did a sculpture of French's preferred marble carver, Attilio Piccirilli.

Not long after the installation of the Buttrick memorial, French began work on a bronze relief of Lafayette for Prospect Park in Brooklyn, designed by landscape architects Frederick Law Olmsted and Calvert Vaux. (Decades earlier, French had lost the competition to create a statue of the young marquis for Lafayette Park across from the White House.) Calling the Brooklyn work "one of the handsomest monuments French has to his credit," one critic described it in language that increasingly described all of French's work: "It has simplicity, dignity and beauty." As he grew older, and perhaps crustier, French did not always appreciate compliments that described his work as predictably serene. "Of course I have a predilection for quiet things and apparently people so far recognize this," French wrote, adding: "I am somewhat tired of the word 'placid' in connection with notices of my productions."[68] The critic was adamant. French's *Lafayette*, he insisted, "encourages us to hope that the day has gone by when inferior and sometimes grotesque statuary can be forced upon our public squares and buildings and parks."[69]

The Brooklyn piece, loosely adapted from *Lafayette at Yorktown*, a 1783 painting by Jean-Baptiste Le Paon, featured an intriguing but anonymous portrait of a black man, the first time French had portrayed an African

American since his teamster for the World's Columbian Exposition. Dressed in the uniform of the Continental Army, he holds the marquis's horse, his head turning away as the steed nuzzles him. It was a clearly sympathetic figure, less noble than Lafayette but fully a man in his own right. Although the work came under criticism in the twenty-first century for failing to identify the servant—he was eventually revealed to be the enslaved James Armistead, who later gained his freedom and took Lafayette's name—French's respect for this secondary subject should not be overlooked. Historical accuracy demands that works created decades, even a century, ago be scrutinized by today's critics in the context of the culture and mores of their time. In fact, a glance at the canvas that inspired the sculpture shows that French made vast and humane improvements to the caricature in the painting, which showed Armistad in a red costume that made him look like a jester.[70]

French would enjoy one final word on the subject by later producing a dramatic, free-standing, full-length Lafayette in bronze for the college named in the marquis's honor at Easton, Pennsylvania. Once again, Bacon designed the pedestal for his friend's latest campus statue, for which French recommended "very little inscription...simply LAFAYETTE," although he admitted, "this is a matter for a College President, not a sculptor!"[71] French had become such an adept diplomat that his patrons more often than not embraced his ideas.

◆ ◆ ◆

By 1915 French had undertaken dozens of works in partnership with Henry Bacon. Their collaboration remained productive, respectful, and mutually rewarding. But it was not unique. French had long shown collegiality to any number of younger artists, most recently working with Edmond Thomas Quinn on the John Buttrick relief for Concord. French could always be depended on for encouragement, advice, and opportunities—and frequently shared credit as well. He had been public about his reliance on Potter for the horses supporting his Civil War generals. He had insisted on acknowledgment for Adolph Weinman at the Custom House, and had granted Augustus Lukeman billing for the Pulitzer medallion. After supervising his studio assistant, Andrew O'Connor, in depicting Civil War general Henry Lawton for Indianapolis, a project he had accepted with great fanfare, French insisted that the younger sculptor "did most of the work." Typically, he conceded only that "I supervised him carefully at the start and for a number of months." It became "his work and I do not claim any great amount of credit."[72] As architect Cass Gilbert said of French: "His counsel and advice is

sought by every one who practises [*sic*] the art of sculpture, or hopes to do so. How in the world he finds time to do his own work and help everybody else is the mystery of the age. And such work!"[73]

French also mentored Paul Manship, who would later win fame for his *Prometheus* at New York's Rockefeller Center.[74] Manship first visited French at Chesterwood en route to study at the American Academy in Rome, "a slim, boyish" young man who seemed transfixed by the studio and grounds. He kept in touch with French for years, asked the senior sculptor for advice when he won a commission to produce a Lincoln statue of his own for Fort Wayne, Indiana, and benefited enormously when French convinced the Met to acquire one of Manship's works.[75]

Sculptor Evelyn Beatrice Longman became a particular favorite. The daughter of an Ohio farmer, she had been inspired to become an art student at age nineteen after seeing the statues on display at the 1893 Chicago World's Fair—presumably, French's included.[76] Small, dark, and possessed of a "have mercy" expression, she had first arrived at French's studio in 1900, bearing a letter of introduction from Will French, while seeking work at a time when the sculptor had a surfeit of assistants. Still, heeding his older brother's introduction and not looking forward to doing the lettering required for his Boston Library bronze doors, French had, "first thing he knew...found he had another assistant."[77] Longman recalled working on a bust one day at the "little studio" at Chesterwood when French walked in and barked, "Make the concaves bigger—Write it large on the wall." That day, Longman recalled appreciatively, "I think I saw real sculpture for the first time—and my work changed from that moment, technically. The next time he came in to see the bust he made me happy by the remark, 'Well, it is necessary to tell you a thing only once!'"[78] It did not hurt, as French confided to his brother, that Evelyn was "a very attractive woman."[79] In 1918, the sculptor made time to craft a bust portrait of his onetime student. A museum curator who accepted it for his collection enthused that the donation "arouses an enthusiasm in us."[80] No doubt, Evelyn aroused enthusiasm in French.

Did their relationship go further? Probably not, but addressing her as "*La mia cara Scultrice*"—Italian for "my dear sculptress"—he once teasingly warned Longman after a long separation that "if I do not observe the proprieties when I do see you, well! it won't be entirely my fault."[81] Rejoicing in her later success, French could not help expressing his astonishment that so many big commissions had come to such "a little *might* [*sic*] of a girl!"[82] However flirtatious he might be in private, French could neither abandon his conventional public facade nor compromise his notion of artistic

probity. When the Met considered acquiring Stirling Calder's *Scratching Her Heel*, French wrote the younger artist: "I cannot help wishing you would call it something besides 'A Girl Scratching Her Heel', which does not seem a very lady-like employment for a young woman in public."[83]

French's generous impulses extended not only forward but back. He never forgot his own mentors—including his very first professional teacher, J. Q. A. Ward, who had remained a revered adviser even after French succeeded him as the American sculptor in residence on the Metropolitan Museum board. Ward had died at age eighty with one notable project unfinished and unsituated: an equestrian statue of Civil War general Philip Henry Sheridan originally intended for Washington, DC. Expectations for the statue had run high, for "Little Phil" had become a figure of myth after galloping his horse, Rienzi, twenty miles from Winchester to Cedar Creek, Virginia, on October 19, 1864, rousing battle-weary Union troops and turning the tide of battle. "On he rode," marveled an eyewitness, "his famous war horse covered with foam and dirt, cheered at every stop by men in whom new courage was kindled."[84]

Sheridan's Ride quickly inspired paintings and poetry, but the very idea of freezing his action-packed gallop into unavoidably static statuary proved daunting even for Ward, who had already produced a number of admired war-hero equestrians.[85] For years, he argued instead for a noble statue of the mature Sheridan (who gained additional, if dubious, post–Civil War fame as an Indian fighter). Ward, who had known Sheridan personally, insisted he spoke for the hero's own wishes. But the group that had hired Ward, the Society of the Army of the Cumberland, together with the general's widow—Sheridan died young, in 1888—held out for a dramatic image celebrating "the ride."[86] Since a federal appropriation was involved, a Congressional committee intervened, cancelled the Ward contract, and awarded it instead to Gutzon Borglum. Things became so acrimonious that Ward filed a lawsuit. The matter remained unresolved at Ward's death.[87]

Into this treacherous breach stepped French, no doubt irritated that his old nemesis Borglum had received rave reviews for the vivid, naturalistic Sheridan's Ride statue he later produced for the nation's capital. French quietly made sure that the Met rejected the acquisition of Borglum's head of Lincoln, arguing it was so large it would "kill everything in sight."[88] And French defiantly elected to resuscitate Ward's Sheridan project. To attract funders, French placed Ward's small model on display at his own New York studio so it could be "inspected under the best possible conditions."[89] Then he tried to interest the Art Institute of Chicago in commissioning a full-size

Daniel Chester French in his studio at Chesterwood, seated in front
of the clay relief for the *Longfellow Memorial*, 1913

bronze, but without success. After a year and a half of frustration, French learned that New York governor Martin H. Glynn had unexpectedly proposed a Sheridan statue for Albany, a city the general claimed as his birthplace.[90] By chance, French met Governor Glynn on June 26, 1915, at the dedication of the *Trask Memorial* at Saratoga, where the sculptor pressed the case for the Ward proposal, no doubt pointing out that the state could save considerable money by adapting an already designed statue—at "one-half or a third of what such an equestrian statue usually costs."[91] For a time, Mrs. Sheridan continued to resist, unable yet to reconcile herself to Ward's staid portrayal. Then French convinced a group of fellow sculptors to sign a letter recommending the statue for "the birth city of the great general."[92]

Only after the state offered a formal contract for an enlargement of the Ward model did Mrs. Sheridan finally yield. In 1914, French proudly told Ward's widow that the new sponsors had seen and were "immensely pleased" with the model, "and intend to do everything possible to bring about its reproduction in bronze and its erection in Albany in front of the State Capitol! That would be a splendid thing indeed for Mr. Ward's memory."[93] French went on to personally supervise the required enlargement, engaged Henry Bacon to design the pedestal, and negotiated the agreement with New York State.[94] He visited the site several times, raised the remaining funds, modified Ward's original design, and secured a foundry to fabricate the statue in bronze. He expended as much time and energy on the project as he did for his own work.

French attended the ceremonies but shunned the credit (and a "dreary and forbidding banquet"[95]) when the statue was dedicated at Albany in 1916 before fifty thousand people—among them Mrs. Sheridan and several dozen surviving veterans of "Little Phil's" Civil War commands. French remained determined to assign the laurels entirely to his old mentor.[96] "I think of what a splendid position this work of Mr. Ward's occupies, far finer than the position it would have held in Washington," he wrote to Ward's widow, unable to conceal his sense of triumph, at least privately. "I am glad to have been associated so closely with it and to have saved this splendid work of Mr. Ward's from oblivion."[97] French had even made sure that the struggling widow received a bit more than the five thousand dollars promised her for the rights.[98] He took no compensation for his own contributions to the project. For French, it was purely, as a newspaper of the day reported, "a labor of love."[99] It was also a final salute to an influential mentor. "What he taught me," wrote French in tribute to Ward,

"has influenced my whole life to a marked degree, and his close friend-
ship until his death I regard as one of my most valuable privileges."[100]

But admiration had its limitations. When Ward's indomitable widow
pressed him to acquire for the Met her entire collection of her husband's
sculpture, French agreed—to purchase four.[101]

◆　◆　◆

Daniel Chester French's creative output during the period from 1912 to 1916
seems all the more dazzling in view of the attention he continued to lavish on
Chesterwood, but as always, the sculptor relished physical engagement and
big, challenging projects, especially if they also engaged him. In conscious
imitation of his teacher Thomas Ball's lavish studio compound in Florence,
French gradually transformed a once-overgrown Berkshire landscape into an
Italianate villa, replete with blossoming trees and flowers, handsome pergo-
las, and gated archways leading from the house to the studio.[102]

Emulating as well his father's lifelong commitment to agriculture,
French maintained his property as a modest working farm and took man-
agement of the estate seriously. Although he left gardening duties to his wife
and serious maintenance to caretakers, he personally ordered flower seeds,
sprayed plants, clipped hedges, set fire to tent caterpillars, and purchased
farm animals.[103] At one point he kept horses, cows, and chickens.[104] Like
Judge French before him, he grew asparagus and strawberries and planted
an abundance of fruit trees. He also kept a detailed journal of his farming
activities, which revealed that he found it easier to talk about frosts, har-
vests, and repairs than about his sculptural work. In one three-week period
during the summer of 1912, for example, he meticulously recorded abrupt
shifts in the weather, the first blooms on his yellow irises, and the com-
mencement of work on a new tennis court, but he devoted only a few words
to mentioning, "I finished the Wisconsin statue 2 weeks ago."[105] He dutifully
measured the output of milk from his cows, and paid a worker three dollars
a day to gather hay. He bought a modest car for Margaret (which he let her
drive home, without training, from Williamstown), later purchased a mare,
and eventually bought a $2,910 Studebaker as a thirty-fourth anniversary
present for Mary.

At Chesterwood, French took long walks in the woods, clutching a
nature guide to help him identify trees and plants, often in the company
of lifelong friend Will Brewster, if he was in residence as a guest. Where
a remote spot of ground looked too barren, French designed or commis-
sioned a sculpture or fountain; to their delight, guests strolling the grounds

Studio garden at Chesterwood showing Herbert Adams's *La Jeunesse*, ca. 1912

often came across such works "unexpectedly."[106] One outdoor room contained a sleeping cherub modeled by French's old associate Edward Potter, with whom he had parted amicably after (or during) their Draper project.[107]

"Our particular spot on earth looks prettier than ever this year," he once wrote to his brother. "It is a luxury to live." To an invited guest, French wrote years later: "It is as beautiful as fairy-land here now. The hemlocks are decorating themselves with their light-green tassels and the laurel is beginning to blossom and the peonies are a glory in the garden. I go about in an ecstasy of delight over the loveliness of things."[108] But paradise came at a price—in both money and toil. "I never thought I'd find myself a country squire," he mused.[109] Asked once how much land he owned, French once replied, "About two hundred acres, but *it* owns *me*."[110]

Upon arriving each spring, he ordered new trees, plants, and flowers, reveled in the first "signs of life" among the nascent pussy willows and returning robins, battled bees that once nested in the eaves of his studio, and mourned when he arrived too late in the season to catch the last glimpses of the glorious apple blossoms. Each autumn, before he departed for New York City,

he invariably purchased and planted voluminous orders of flower bulbs: two hundred narcissus and two hundred tulips in 1913 alone. One of his entries for June 1915 opens a window onto the frenzy of activity at the estate, and the endless variety of personal and professional issues vying for his attention:

> I have had electric lights put in the studio this past week. Had first peas yesterday—when, also, the Trask fountain was unveiled at Saratoga. The big apple tree east of the "Vista" was wrecked in a storm ten days ago. We are doing what we can to preserve what is left of it. Margaret and Rosalie Miller have been trying at sculpture lately. Margaret excels. Have made some strides for the Washington Lincoln & am at work on "Brooklyn." It has been very cold for June.[111]

Even in this paradise, the professional work never suffered, the daily routine seldom varied. Each summer day, except Sunday, French would spend the afternoon in his studio until six, then spend up to ten minutes washing "those strong, beautiful hands," remembered his daughter, "that must be immaculate like the rest of him and never show a trace of plaster."[112] He would nap—falling into a deep sleep each evening for ten minutes ("never less, and never more," testified Margaret)—then change clothes and report "fresh and cheerful as a bird" for dinner with his family and whatever guests occupied the house, most often his oldest friend, Will Brewster.[113] He and Mamie transformed their summer estate into a mecca for informal gatherings and formal entertainment alike. They hosted an annual al fresco ball, for which French strung lanterns, and installed tented walkways leading to the studio in case the weather failed to cooperate. The Frenches even hosted a Chesterwood coming-out party for Margaret. As she grew older, Margaret herself often transformed her father's studio into "a scene of revelry" for parties, with the latest "work-in-progress shoved into a corner, under a sheet."[114]

Dan and Mary French also frequented summer events in town. The sculptor eventually joined the boards of two Stockbridge treasures: the Austen Riggs Center, a respected psychiatric retreat; and the Berkshire Playhouse, where he later saw a play starring the Broadway luminary Eva Le Gallienne. The Frenches spent time at Edith Wharton's magnificent estate in nearby Lenox and reciprocated by inviting the novelist and her frequent guest, novelist Henry James, to Chesterwood. Will Brewster's stays sometimes extended for months, highlighted by loud demonstrations of his uncanny birdcalls, which one evening lured a large male hoot owl to

swoop over the Chesterwood porch in search of the mate it thought awaited him. Modern dance pioneers Ted Shawn and his wife Ruth St. Denis came from nearby Jacob's Pillow, and Isadora Duncan, who visited to consult with French about classical attire, "danced in our garden," Mamie recalled, "young, slim, ethereal, like a Botticelli Muse."[115]

In social settings, French still seldom spoke unless spoken to, responded in short sentences of one or two words, and rarely offered advice or criticism. But his rectitude did little to shield him from public view. He was a genuine art-world celebrity, so famous that his other interests now made news almost as often as his sculpture. "There is nothing like being an artist," he noted, "be it in paint or music or only mud."[116] In fact, he could claim a link to all three disciplines. In addition to sculpting in "mud" more busily than ever, he had resumed work in pastels, creating, among other things, lovely portraits of Mary and Margaret. His phonograph record collection had grown to include aria recordings by Enrico Caruso and Lily Pons, along with orchestral works by Rachmaninoff, Tchaikovsky, Schubert, and Chopin.[117]

So he was delighted when his friend Robert Underwood Johnson, coeditor of the *Century Magazine*, asked him to prepare for publication some thoughts about his passion for music. French obliged with an erudite essay that the punctilious editor subjected to several revisions. Responding to the initial submission, Johnson, a ruthless stickler for style, detail, and elegant prose, told French it was merely "OK as it stands, but I wish when the proof comes out that you could give it a little more of your gayety not epistolary touch....It will be all the better for being a little less serious."[118] The final article was indeed as lighthearted as Johnson would have wished, and evidently attracted so much interest that French republished it as a standalone pamphlet for distribution to friends. In one passage, an indictment of live concerts, he wrote: "Music suggests beauty. The source of music should not be seen." If people had to listen to concert orchestras in public, French suggested dimming the lights and placing a piece of decoration on the stage to redirect attention from the actual orchestra and conductor—though not a piece of sculpture, "which, however fine, might be distracting." The noise of applause he called a "barbarism."[119] (He probably would have been horrified when two Harvard freshmen launched a pop-rap duo in 2003 calling themselves "Chester French.")

Journalists seemed now to track his every quote and move. Once, by arriving at Phillips Exeter Academy in his onetime New Hampshire hometown, merely to mend the shattered nose on a bust displayed in the school

chapel, French drew the attention of the leading newspapers, including the *New York Times*. He had reportedly arrived at "his alma mater" garbed in his "studio rig," which led the resident Irish janitor to mistake French for the plumber summoned to fix the burst pipes. According to reports, French was scolded in a broad brogue: "Indade, it is hoigh toime. The wather is jist runnin' arl over the buildin'!" The incident may or may not have occurred as published, but it did not seem to bother those who printed the story that French had never attended, much less graduated from, Phillips Exeter Academy.[120] Daniel Chester French could now inspire celebrity sightings.

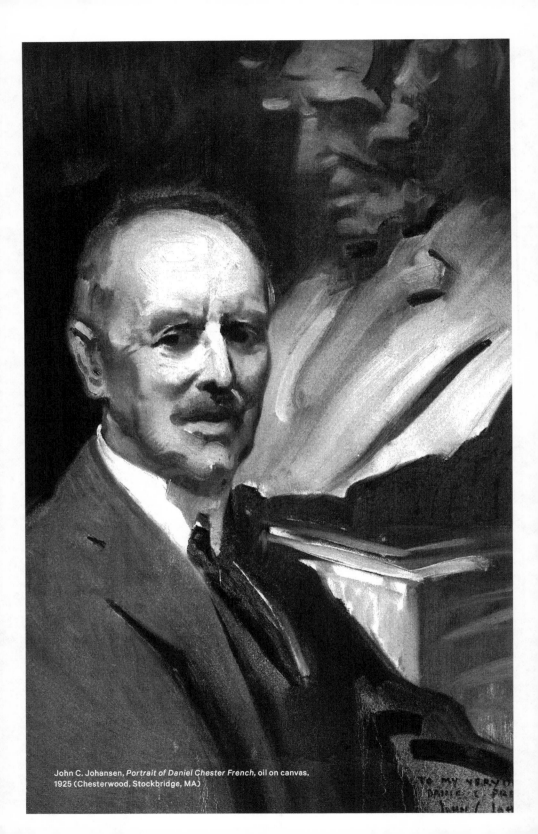

John C. Johansen, *Portrait of Daniel Chester French*, oil on canvas,
1925 (Chesterwood, Stockbridge, MA)

LINCOLN ENTHRONED

After nearly three score years of procrastination, the long-delayed proposal to build a Lincoln Memorial in Washington, DC, had suddenly, almost miraculously, sprung back to life in 1911. Two years earlier, the centennial of Abraham Lincoln's birth had inspired events, projects, and publications, but had ended with one of its chief goals unrealized: creating, at long last, a national shrine to Lincoln in the city where he had served as president and given his life. Not until February 9, 1911, did Congress at last establish a federal Lincoln Memorial Commission—after the three most recent legislative efforts to launch it had failed like all the others. Congress mandated the new commission to revive a project whose creation was deemed central to American identity yet whose long postponement more accurately symbolized lingering American disharmony.

Actually, plans for a memorial had percolated in fractious Washington ever since Lincoln's death back in April 1865. Just two years later, in 1867, an earlier Congressional commission had chosen Clark Mills, the sculptor who took the final life mask of Lincoln, to create a twelve-foot-high seated statue celebrating the martyred president as an emancipator. According to the initial plan, the Mills statue, surrounded by two layers of bronze figures depicting Union politicians and generals, would occupy a grand multistory pedestal in the shape of a tiered wedding cake. But private fund-raising stalled in the 1870s. By then, the white-supremacist Democrats who had regained political power in the South and, increasingly, in Washington, proved resistant to the idea of devoting public money to celebrate the Emancipation Proclamation—or its author. The federal government was

Daniel Chester French (at head of table) with the
National Commission of Fine Arts committee, 1912

unable to secure public funding and finally abandoned the grandiose Mills project.

It was not that Washington truly lacked for Lincoln statues. By the 1870s, the District boasted several. The earliest was the life-size marble hoisted atop a forty-foot-high pedestal in front of City Hall in 1868. It was the less-than-inspiring work of Irish-born sculptor and gravestone cutter Lot Flannery, whose main claim to fame was allegedly witnessing Lincoln's murder at Ford's Theatre. Flannery had melodramatically resolved to place his statue "so high that no assassin's hand could ever again strike him down." The unfortunate result was that no one on the ground could ever clearly see it.[1] Ironically, at its unveiling Daniel Chester French's uncle, Benjamin Brown French, delivered the dedicatory address.

Two years later, Vinnie Ream's standing Lincoln took its place inside the US Capitol Rotunda, despite fierce opposition from the late president's widow. Then in 1876, Thomas Ball's *Emancipation Group*, funded entirely by African Americans, arrived at nearby Lincoln Park, where it was dedicated by Frederick Douglass and unveiled by President Grant.[2] The long-delayed plan to memorialize Lincoln in monumental proportions, however, remained unfulfilled. Over the first ten years of the new century,

fresh proposals arose and in turn evaporated, even under the McKinley, Roosevelt, and Taft administrations, when Republicans again held both the White House and Congress.[3] The new memorial commission belatedly established in 1911 was expected finally to remedy what amounted to a national disgrace.

For a while longer, however, Lincoln's admirers could not even agree on where the long-awaited Lincoln Memorial should be situated. A turn-of-the-century blue-ribbon Senate parks commission, whose members included French's friends Daniel Burnham, Augustus Saint-Gaudens, and Charles F. McKim, had urged as early as 1902 that the District improve the undeveloped area from the Washington Monument westward to the Potomac.[4] Their recommendation was that the new Lincoln Memorial, if it was ever funded, would be built alongside the river. The commission envisioned a National Mall between the two monuments, with the obelisk honoring the nation's founder at one end and the new shrine to the nation's savior at the other. Skeptics doubted whether the marshland at the distant edge of what was then called Potomac Park could support a massive new structure, much less attract visitors.

With indecision reigning, alternative sites vied for designation. One proposal called for building the memorial near the new Daniel Burnham–designed Union Station. It was rejected, despite Burnham's flagrant lobbying, when opponents warned that passengers might rush past it indifferently en route to their trains. Another notion was to situate a memorial on the grounds surrounding the Capitol Building, an idea that was ruled out because a Ulysses S. Grant equestrian statue had already been commissioned for the base of Capitol Hill.[5] Advocates floated at least five other ill-conceived possibilities: a colonnade or monumental arch on a new boulevard leading from the Capitol to the Washington Monument, or memorials at the US Soldiers' Home in the northern reaches of the district, where Lincoln had kept a summer cottage; at the crowded neighborhood near Fort Stevens, where the Civil War president had come under enemy fire during an 1864 Confederate raid on Washington; at the Old Naval Observatory grounds on E Street; or in Meridian Hill Park, due north of the White House in Columbia Heights.[6]

Meanwhile, pressure mounted to build the memorial entirely outside Washington, near "the center of the Republic," one advocate suggested, "where more of the common people of the Nation would see and enjoy it."[7] One such proposal called for a site somewhere along what French called "the great road from Washington to Gettysburg." For a time, the sculptor seemed

surprisingly sympathetic to this scheme, if nothing else a clear signal of his early hope to produce the Lincoln statue for the memorial no matter where it was sited.[8] Mere mention of the "great road" idea spurred land speculation all along the suggested route. A similar scheme, backed by rapidly growing automobile interests, called for building a "Lincoln Memorial Highway" from Washington to the onetime Confederate capital of Richmond, Virginia. Still others thought it would be sufficient merely to consecrate the newest bridge scheduled to span the Potomac by naming it after Lincoln.[9]

At one point in the debate the former Speaker of the House, the sepulchral but still-influential Joseph G. Cannon, came up with a bizarre alternative of his own: planting the memorial on the Virginia side of the river at Arlington National Cemetery.[10] Once Robert E. Lee's property, the grounds had been seized by Union authorities early in the Civil War—on the pretext of nonpayment of taxes. The idea of siting a tribute to Lincoln on onetime Confederate territory struck many as perverse. For his part, Cannon hoped his provocative suggestion would at least kill the National Mall plan. An unadulterated Roosevelt hater, even though he counted himself a Lincoln Republican, he reflexively opposed any idea that embraced visionary park expansion of the kind Roosevelt championed, especially if it meant locating a shrine to a man Cannon worshipped at a location he considered unworthy. "I'll never let a memorial to Abraham Lincoln," he swore, "be erected in that God damned swamp."[11] Cannon's successor as Speaker, Democrat Champ Clark, mischievously endorsed the "Lincoln boulevard" scheme, though White House guards physically barred him from President Taft's office when he tried to present the plan at a commission meeting.[12]

Only after another year of contentious debate—and not until the Memorial Commission reminded naysayers that West Potomac Park was the site preferred by Lincoln's onetime aide and biographer, John Hay, "whose rank in statesmanship and whose taste in matters of art combine to give value to his opinion"—did the Mall alternative prevail.[13] As Hay had said of Lincoln in testimony opposing any downtown site: "He was of the immortals. You must not approach too close to the immortals. His monument should stand alone, remote from the common habitations of man, apart from the business and turmoil of the city; isolated, distinguished and serene."[14] Architect Henry Bacon, who hoped for the assignment to design the memorial, concurred: "The power of impression by an object of reverence and honor is greatest when it is secluded and isolated." Only "without distraction," Bacon argued, could "the beholder" be properly inspired—a "principle of seclusion" he traced with admiration back to the Greeks.[15]

Ultimately French, the master of serenity, endorsed Potomac Park too; he spent the 1912–13 holiday season lobbying on its behalf.[16] As he later put it, "So much depends upon the site of a monument that I have come to think that a poor monument or statue, well placed, is better in effect than a good monument badly placed."[17] Finally, on February 3, 1913, with outgoing President Taft presiding as chairman, and over the no doubt cranky dissent of member Joe Cannon, the Lincoln Memorial Commission met at the White House and officially designated West Potomac Park as the location for the shrine.

The decision on whom to name as chief designer proved far less contentious than the debate over where to place it. An array of architects pressed forward with proposals, résumés, and references.[18] Inexplicably rejecting an outright competition, the Memorial Commission had in August 1911 summoned Bacon, "recommended by the National Commission of Fine Arts"—on which French served—"as an expert advisor."[19] Ostensibly Bacon was to do nothing more than confer about design options.[20] Just two days after this initial meeting, however, the Lincoln Memorial Commission formally invited him, and later, almost as an afterthought, but one other rival, to submit ideas for a structure worthy of accommodating a new Lincoln statue. He was so little known that the *Washington Post* referred to him as "Robert Bacon" in reporting that his appointment "arouses protests."[21]

Charles McKim, once the obvious choice, had died two years earlier, after scribbling some preliminary sketches. There now seemed few alternatives for the plum job. Though young and relatively unknown, Bacon was at least a McKim disciple, his onetime junior partner. The only other architect invited to submit a proposal was the equally inexperienced John Russell Pope. Pope was then serving with French on the National Commission of Fine Arts, a role that portended a serious conflict of interest since that group held veto power over all construction projects on the district's public lands, the Lincoln Memorial included. Pope submitted several design schemes anyway, including one for a colonnade of pillars seemingly inspired by Berlin's Brandenburg Gate. The Lincoln Memorial Commission rejected them.[22]

Usefully, Bacon was a native of "The Land of Lincoln," and his admirers came to include fellow Illinoisan Joseph Cannon, still a powerhouse, if slightly diminished by the twin impacts of old age and legislative reform. Late in 1910, a bipartisan Congressional revolt against Cannon's vise-like grip on the lower house had stripped "Uncle Joe" of much of his power; two years later, in a shocking upset, he had even lost reelection to the House. In his convenient absence, Congress earmarked an initial

three-hundred-thousand-dollar federal appropriation toward a final cost of two million to fund the memorial. (To no one's surprise, the cost would rise, and the indestructible Cannon would win back his seat in 1914 at age seventy-eight.)[23] Cannon was still out of office, and William Howard Taft had but five weeks left in his presidency, when Taft signed the Congressional resolution in late January 1913 formally appointing Henry Bacon the official architect of the Lincoln Memorial, and, significantly, granting him the sole power to recommend a sculptor to create the statue for its interior.[24] Congratulating his friend "with enthusiasm," French called his appointment not only "a feather in your cap," but, doubtless with one eye on the impending sculptural assignment, "a victory all around."[25]

Even as Bacon began weighing design concepts—at one time he briefly toyed with the idea of a circular building—he turned quickly to the matter of the sculptural commission. Although no written record of his deliberations survives, it seems hard to imagine that he did not begin immediately discussing statue ideas with his frequent collaborator, especially since it was French who had engineered his first interview with the Memorial Commission. At the time, moreover, the two were working together on their Trask and Dupont fountains and preparing simultaneously for the unveiling of the Nebraska statue.[26] Indeed, their two joint Lincoln commissions very nearly overlapped.

Other sculptors did apply for the assignment. Vinnie Ream Hoxie, whose marble Lincoln already occupied the Capitol Rotunda, predictably suggested an enlargement of her own work for the new memorial.[27] Danish-born Chicagoan Johannes Gelert received a nomination from his own agent. Chicago congressman Adolph J. Sabath suggested a constituent named Frank Vlaciha. And French's longtime competitor Gutzon Borglum hinted that "a seated figure of Lincoln, built in the scale of my large head, would be about as impressive a treatment as you could give him."[28] Borglum all but disqualified himself when he remarked, "In heaven's name and Abraham Lincoln's name, don't ask the American people even to associate a Greek temple with the first great American"[29]—precisely the architectural concept Bacon was considering.

It was obvious to nearly everyone in the art world that Bacon would inevitably attempt to return the many favors French had bestowed on him over the years. But French faced a seemingly insurmountable conflict of his own: not only did he serve on the National Commission of Fine Arts, he had become its chairman in 1912. And the commission would be required by law to approve whatever sculptural model Bacon ultimately submitted. How could Daniel Chester French both design and judge his own statue?

There seemed only one reasonable solution: pursue the memorial assignment and, when it became necessary, quit the most prestigious art body in the country. Meanwhile, French began working on his statues for the new Manhattan Bridge. He was a busy man indeed, although his proven ability to balance concurrent projects was about to face its severest test.

Meanwhile, as required, Bacon submitted his final architectural renderings for the memorial to the Public Works branch of the War Department, which approved them on July 15, 1913. The design called for a mammoth Greek-style rectangular temple inspired by the Parthenon, ringed by 36 Doric columns, one for each state in the reunited country at the time of Lincoln's murder. (Bacon later claimed he had hit on the number purely by chance.) The interior chamber would feature "a colossal marble statue of the man himself," along with decorative frescoes at the ceiling line, and, on each side wall, the etched words—Bacon called them "monuments"—of Lincoln's two greatest oratorical masterpieces, the Second Inaugural and the Gettysburg Address.[30] The shrine would be devoted to Lincoln alone; proposals to use parts of it for the Supreme Court or as "a training school for the Negro race" were dismissed.[31]

Once the blueprint won approval, bids were invited from construction firms, with specifications calling for a superstructure of elegant (and expensive) Colorado-Yule marble.[32] Seventeen contractors responded, but ten withdrew when they learned the foundation would have to descend at least sixty-five feet into the spongy soil just to reach solid rock.[33] A final contract with the winning bidder was signed in January 1914, and at high noon on February 12, Lincoln's Birthday, builders placed the first shovels in the frozen earth at the northeast corner of the site. There was little fanfare. Only a handful of spectators gathered in the cold, with just four Boy Scouts serving as the security contingent.[34]

What occurred next sent a far more ominous chill over the expected French-Bacon collaboration. Shortly after the ground breaking, a rumor floated through the capital that some commissioners had concluded it might be faster and cheaper to discourage a new statue for the memorial after all, and instead to install an enlarged duplicate of Augustus Saint-Gaudens's already famous *Standing Lincoln*. That the idea attracted genuine interest, at least for a time, is reflected in some of the earliest preliminary drawings of the memorial prepared by Bacon. At least two of them included what looks to be the Saint-Gaudens statue.[35]

Alerted to this unexpected opportunity, Saint-Gaudens's redoubtable widow soon paid Bacon a visit to apply pressure, reminding him that

"various people in Washington had expressed the view that her husband's Chicago *Lincoln* should be used in the Memorial." Would the architect be prepared, she asked him, "to waive any responsibility in regard to the selection of the statue?"[36] Bacon stiffened his courage and replied: "certainly not." By then, French no doubt had made his own displeasure known to his architect friend. Forced to choose between sculptors, Bacon bluntly told Augusta Saint-Gaudens he "should certainly oppose" any movement advocating for "the Chicago Lincoln" in his new building. For good measure, the usually shy architect suggested that if Saint-Gaudens himself could know of the proposal "he would turn in his grave!"[37] French agreed, forcefully condemning as "repugnant" the notion of "a replica in the Lincoln Memorial."[38] While certainly self-serving, French sincerely believed that the long-awaited Memorial must inspire an original work of art. The nation's capital deserved an original Lincoln, a unique memorial to be revered by the American public, and not a replica—especially one made by a competitor. By joining Bacon in the campaign to extinguish the Saint-Gaudens brushfire, French laid the groundwork for his own emergence as sculptor of choice.

Still, there remained the unresolved matter of French's ongoing leadership of the Commission of Fine Arts. "You understand," he coyly told Franklin W. Hooper, director of the Brooklyn Museum, "I would undertake the statue with the greatest enthusiasm if there were not this stumbling block in the way."[39] Worried that an unwise choice would doom the entire project, the usually reticent Bacon confided to the influential Hooper: "It would be fatal to its success were there to be associated with me a sculptor, however talented, whose idiosyncrasies would prevent collaboration between us." Presumably this included dead sculptors like Saint-Gaudens. To be sure, French had "idiosyncrasies" of his own, Bacon admitted, but their partnerships had proven "most congenial."[40] Hooper eventually came out for French, insisting that as a gifted artist "capable of understanding the genius of Abraham Lincoln," he was "the one man competent to produce a satisfactory figure."[41] Returning from his presidential mission to Panama, French thanked Hooper for his endorsement.[42] In his absence, the Saint-Gaudens boomlet had faded.

Well aware that he was about to be offered the crowning assignment of his career, yet ever the gentleman, French almost guiltily wrote the fine arts commission to insist: "I would rather relinquish my claim to this wonderful opportunity than to feel that I had been the cause of injury to a body that I feel to be a powerful good in the community."[43] Nonetheless, in early January 1915, at Henry Bacon's recommendation, the Lincoln

Memorial Commission formally offered the statue project to Daniel Chester French.[44] The cost was not to exceed fifty thousand dollars.[45] This time their long-standing roles would be reversed: in a way, French would now be working for Bacon, not the other way around. They had flourished as a team, but whether they could triumph again with Bacon as lead partner remained an open question.

Finally, French came face to face with the choice he had long dreaded. The decision proved more painful than problematic. As French told ex-President Taft, he could not "conceive of a greater honor" than to have been selected to do the Lincoln statue. He regarded his unanimous selection as "a command admitting of but one response on my part...grateful acceptance."[46] It took three months more, however, until April 1915, before French finally resigned from the National Commission of Fine Arts. In tribute to his service as chairman, President Wilson wrote to assure the sculptor that his service as chairman had "resulted in a marked improvement in the beauty and character of monuments and public buildings erected and planned for Washington since 1910."[47] A fellow commission member, architect Thomas Hastings, who had hired French for his Manhattan Bridge, put it more affectionately: "My Dearly Beloved, Gee we miss you on the Art Commission."[48] A year later, in 1916, French would show his gratitude to the Democrat now in the White House by abandoning the party loyalties of a lifetime to support him for a second term. "I am for President Wilson," he told Katrina Trask just before that Election Day, "and I have never voted for any but the Republican candidate before."[49]

There had never been much doubt that French would find a way to accept the momentous Lincoln assignment. He would need now to rise to the challenge. To portray a hero most Americans felt they knew intimately, he would have to combine the monumentality of his *Republic*, the luminosity of his Emerson, the humility of *Mourning Victory*, and the nationalistic fervor of the *America* he had created for the New York Custom House. Abraham Lincoln had been portrayed before, and often, but never on such a large stage, before so many eyes, and under such intense expectations. The artist, the subject, and the hour had met.

◆ ◆ ◆

He got off to a fast start. In May 1915, barely a month after resigning from the arts commission, French casually reported to Henry Bacon from Chesterwood: "It should interest you to know I am making sketch models for the statue of Lincoln. At present I am feeling very much encouraged,

but I am suspicious of my first enthusiasms." Sounding again like the team's senior partner, he added almost peremptorily: "When I get anything that is worthwhile I shall, of course, expect you to come up and see what I have to offer."[50]

Perhaps in wary response to the recent plot to install Saint-Gaudens's standing Lincoln at the memorial, French briefly flirted with the notion of replicating or adapting his own Nebraska statue, but he quickly dismissed the idea, concluding that if such a standing statue were "of adequate size, the head would be too far above the eye."[51] Instead, with Bacon's concurrence, he decided to produce a completely new, seated figure, rugged hands resting on the arms of a throne-size chair, face downcast and staring ahead, as if deep in a reverie, past the crowds of admirers likely to gather before him. The first artist to study Lincoln from life described that indefinable expression well: "It was a puzzled, melancholy sort of shadow that had settled on his rugged features, and his eyes had an inexpressible sadness in them, with a far-away look, as if they were searching for something they had seen, long, long years ago."[52]

But French would have to be careful—yet again to avoid duplicating the posture or portraiture of a previous Saint-Gaudens sculpture (a challenge he had also faced in Nebraska). Earlier in the century, Saint-Gaudens had also created his own seated Lincoln. The bronze had held the place of pride at the Metropolitan Museum's memorial exhibition of Saint-Gaudens's works in 1908—a show French had curated. Although Saint-Gaudens's *Abraham Lincoln: Head of State* would not be installed at Chicago's Grant Park until 1926, French and many contemporaries knew every contour of the piece long before: the tilt of the head, the arrangement of the clothes, the grip of the hands. It would be difficult for French to avoid yet another series of comparisons.

The statue would be either marble or bronze, probably the latter. The portraiture would echo the Nebraska Lincoln, including the dangling forelock to which Lincoln's old acquaintance Henry Rankin had objected.[53] French was unwilling to abandon this interpretation. Although he would work for months more to refine his preliminary concept, the final statue would remain much as he first fashioned it in clay in 1915: an enthroned hero gazing hypnotically at the national capital from a grand temple dedicated to the Union he had saved.

Although familiar with the Lincoln story from his Nebraska research, French now began scouring new books for further insights into his subject's appearance, habits, and character. His quest became so widely known that

publishers began sending him new books and manuscripts for his opinion.[54] Among these correspondents was the elderly onetime Lincoln acquaintance Henry Rankin. Along with praise for the Nebraska statue, Rankin sent the sculptor an inscribed copy of his volume *Personal Recollections of Abraham Lincoln*. Hailing it as "a most valuable contribution to our understanding of the great American," French told Rankin he anticipated "the greatest profit and pleasure in reading it."[55]

By this time, French had amassed what amounted to a small Lincoln library. His collection included recent biographies by Lord Charnwood (*Abraham Lincoln*, 1916), Ida Tarbell (*Life of Abraham Lincoln*, 1900), and Wayne Whipple (*The Story-Life of Lincoln*, 1915), along with C. S. Beardslee's 1914 *Abraham Lincoln's Cardinal Traits: A Study in Ethics*, and a "short life" edited by Lincoln's late private secretary, John G. Nicolay, in 1902. French had retained the volumes he had consulted for his Nebraska project. To these he now added Alonzo Rothschild's 1906 *Lincoln Master of Men* and Mary Wright Davis's 1919 *The Book of Lincoln*. Aside from Tarbell's books, for which the muckraking reporter had interviewed people who had known Lincoln personally, French's taste tended toward the romanticized. He acquired John Drinkwater's fictionalized *Abraham Lincoln: A Play* (1918) and Mary Raymond Shipman Andrews's 1916 *The Perfect Tribute*, which popularized the myth that Lincoln had scrawled the Gettysburg Address on the back of an envelope on board a train. Drinkwater's play enjoyed success on Broadway and French, a theater aficionado, may well have seen it; Andrews's slim volume became the best-selling Lincoln book yet published.[56]

French had also read the multivolume 1889 work known as *Herndon's Lincoln*—what might be called a warts-and-all biographical equivalent of the rough-hewn George Grey Barnard statue—co-authored by the future president's onetime law partner, William H. Herndon.[57] Now French opened up a correspondence with Herndon's collaborator, Jesse W. Weik, then at work on a new book of his own he would call *The Real Lincoln*. French told Weik he planned to write as well to Horace White, the eighty-year-old veteran editor who had covered the Lincoln-Douglas debates back in 1858 as a young reporter for the *Chicago Tribune*.[58] His quest for firsthand insights proved insatiable.

French grew especially interested in what Lincoln dressed like. In a crucial decision, he firmly rejected the Barnard interpretation that imagined Lincoln clad in a shabby, even slovenly, manner. From his deep reading, French concluded that Lincoln "might have preferred to be collarless

Leonard Wells Volk, *Commercial Life Mask of Abraham Lincoln*, 1860;
repurposed by Daniel Chester French, 1911 (Chesterwood, Stockbridge, MA)

Leonard Volk's cast of Lincoln's hands, ca. 1917 cast after 1860 original

French's casts of his own hands, 1916 (Chesterwood, Stockbridge, MA)

or coatless, but that his appreciation of the fitness of things would have led him to dress like the men about him." As French saw the matter: "It really is easier to dress conventionally than peculiarly, and I cannot imagine Lincoln bothering to dress with any affectation even of carelessness. His photos while he was president show that his clothes were made of fine material and by a good tailor. There was absolutely nothing careless about them except the way that they were worn."[59] To serve as a model for Lincoln's long frock coat, French chose a garment that he "acquired a great many years ago in Concord, Massachusetts," which dated to the 1850s. "It is somewhat old-fashioned, therefore, for Lincoln as President, but it has much more of an air than any coat that you can get from a costumer made in imitation of old styles."[60]

French already possessed several other useful references: the illustrated book on Lincoln photography by Francis Trevelyan Miller, the limited-edition portfolio of pictures issued by Frederick Hill Meserve, the Leonard Volk Lincoln life mask, and the plaster model of his own *Lincoln* for Nebraska. Hearing that the Rice Photograph Company possessed "an unretouched negative" of the exquisite Lincoln photographs taken in 1860 by Alexander Hesler, French ordered six prints, impressed by "the great beauty in the head."[61] Although they showed Lincoln beardless, the sculptor would consult them as models too.

French must have found particularly useful the later presidential portraits that included Lincoln's huge boots. "I can understand why that foot should be so enormous," Lincoln had joked to journalist Noah Brooks after seeing one such photo. "It's a big foot anyway."[62] French would replicate the boots with uncanny accuracy. As for the tilt of the head, some of Bacon's surviving sketches suggest that French at one point considered dropping Lincoln's chin almost to his chest, a pose that would have made him seem forlorn rather than resolute, exhausted rather than burdened.[63] Wisely, French chose to elevate the gaze as if to fix it on the Washington Monument across the Mall.

If French were now to produce an enthroned statue of Lincoln, he would also require accurate models of the large hands that would rest so prominently—not on the knee, as in Saint-Gaudens's more awkward interpretation, but on the chair of state: gnarled mitts equally capable of wielding an ax to split rails and cradling a pen to sign the Emancipation Proclamation. Again French turned to the best available source: plaster casts that Leonard Volk had made at Lincoln's Springfield home the day after his first nomination as president. Lincoln's right hand had grown swollen by the day

Volk arrived, the result of shaking hundreds of hands at a victory celebra-
tion the previous evening. Volk had suggested that Lincoln grasp a prop
that might mask the puffiness within his clenched fist. Lincoln agreeably
headed to his woodshed and sawed off the end of a broom handle, return-
ing to his dining room to clutch it while the plaster was applied.[64] "Hands,"
French maintained, "are almost as expressive as the face to me." They were
"a great part of the interpretation of character." Determined that Lincoln's
hands convey "strength and power and tension," French found himself "giv-
ing as much attention to them in my sculpture as to the head."[65] Few noticed
at the time that, ingeniously, French had reversed Lincoln's hands for the
memorial statue. Perhaps unwilling, for symbolic reasons, to portray the left
hand open and the all-important right hand clenched—the hand Lincoln
had used to greet people and write the words inscribed on the memorial
walls—French adopted the mirror images of Leonard Wells Volk's original
casts from life. True, Volk had shown Lincoln's hands more accurately, but
French's sculptural editing reflected the interpretive magic that separated
artists from craftsmen.*

◆ ◆ ◆

Within the year, by March 1916, French proudly declared that his three-
foot "small model for the statue is practically completed."[66] The fol-
lowing month, William Howard Taft and his fellow Lincoln Memorial
commissioner, George Peabody Wetmore, along with several members of the
Commission of Fine Arts, made their way to French's New York studio to
inspect it. Their verdict was swift, unanimous, and enthusiastic. The model
won their approval that same month and French received twenty percent of
his fee: ten thousand dollars.[67]

For French, the next step was to execute a seven-foot-high enlargement,
about half the planned size of the final statue. First, he set about refining the
original design. To get those hands precisely as he wanted them, he made
plaster casts of his own left and right hands in the exact positions he pro-
posed sculpting Lincoln's. French also rearranged the statue's legs, making
them appear strong yet relaxed. He draped a flag over the back of the chair
(Lincoln had been known for wearing shawls), and, in conscious mimicry

* Many observers have instead noticed a feature of the statue's hands that may be no more
than a coincidence. Apparently, they spell out, in the sign language of the deaf with which
French may have become familiar when he labored on his Gallaudet statue many years ear-
lier, the initials *A.L.* No evidence exists, however, to support the legend that the sculptor
arranged the gestures intentionally.

of the symbolic adornment Bacon had created for the slab behind the Nebraska *Lincoln*, bundled fasces on the armrests to represent civil power, unity, and law.[68] American eagles would decorate the four corners of the base (an adornment he later discarded).

As French made steady progress on the working model, slowly bringing Lincoln's careworn, wise, yet slightly bemused expression into focus, he sought approval from one of the few living men who could claim to have once seen Lincoln on a regular basis. This was the president's son, Robert T. Lincoln, now nearly seventy-four years old and retired from business and government. Even though Robert had failed to appear at the dedication of his Nebraska statue a few years earlier, French wanted his input—and blessing—now. "I am naturally very desirous that you should see my design and give me the benefit of your criticism and advice," French wrote him in April 1916. "Are you going to be in New York during the next few weeks? If so I should be very much indebted to you if you could call at my studio at 12 West 8th Street to see this model."[69]

Robert agreed to make the effort during his next scheduled visit to the city sometime in May. Yet French, unwilling to break his vacation pattern even for Abraham Lincoln's son, cautioned him that he would be closing down his Manhattan operation as usual by midmonth for his annual move to the Berkshires.[70] The rendezvous proved impossible to arrange, and French headed to Stockbridge with the new model in tow, unwilling to share photographs of the work in progress for fear they would be "inadequate" to communicate the full impact of the statue.[71] Nor could French persuade Robert to travel to Chesterwood that summer from his own country estate, Hildene, seventy-seven miles north in Manchester, Vermont. With or without Robert's review, a confident French proceeded to the next phase of his work, arranging to have a life-size copy made in plasticene. Impatient to accelerate the process, he contracted the work out to an artisan named Alexander Mascetti, but found it hard to make arrangements by telephone, perhaps because the Italian-born Mascetti spoke heavily accented English. "I could barely understand you at all," French complained, rather insensitively.[72] The order was placed in the old-fashioned way: scripted in writing and sent by US mail.

From Chesterwood, French wrote Katrina Trask that he had spent his entire 1916 summer "trying to make a statue of Lincoln worthy to occupy a place in the really beautiful memorial building that Henry Bacon has designed." The work was "finally approaching completion," he reported that October, "and I am virtually a prisoner here until it is done....I must

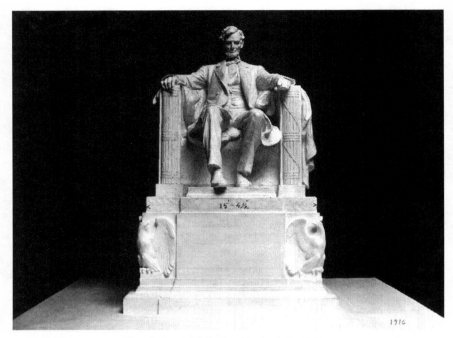

Three-foot model of *Abraham Lincoln*, plaster, 1916
(Chesterwood, Stockbridge, MA)

give to it the utmost of which I am capable in the effort to make it just a little better—a little better than I know how!"[73] After Mrs. Trask viewed and praised the model, French gratefully responded: "I am glad you find in the Lincoln all that you say you do. I am all too aware how great is the responsibility of making a statue of the Nation's best loved man to be put in such a place and I feel at times so inadequate, but I try not to think of these momentous things, but only of doing the best that is in me."[74]

The pressure was exacting the usual toll on his nerves. Sawing the model into eight pieces and "trying him with different lengths of body" sent French into a panic. "I find I can't decide which is best, by myself," he confessed to his onetime studio assistant, Evelyn Beatrice Longman. "Dear Beatrice," he wrote. "Listen to me! I need you and I want you, not because (this time) you are a charming lady, but because you are a sculptor." If this provocative invitation were not enough to encourage his former assistant to visit and appraise her old mentor's work, French enclosed "ten dollars for expenses."[75]

With or without Longman's further advice, French finished his seven-foot clay model by the end of October. And Robert Lincoln finally did examine one of French's preparatory plasters, probably the ten-foot

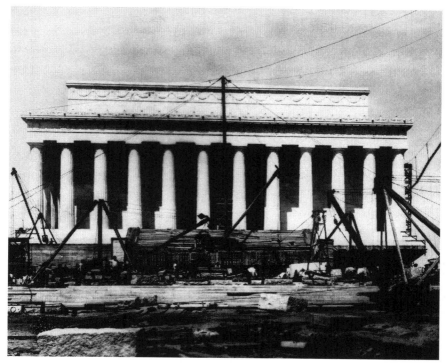

Lincoln Memorial under construction, ca. 1920

enlargement that the sculptor subsequently shipped to Washington in pieces and set up inside the half-completed memorial building in February 1917. There, sometime in the middle of winter, the two old men patiently contemplated the work as it stood in the still-roofless structure. Robert later told Henry Bacon he had "suggested a slight change in the position of the feet, which, as I remember, was assented to by Mr. French," hastening to add that "it had little to do with the general fitness of the work." In the judgment of the late president's son, the statue "surpasses anything that has ever been erected of the kind."[76]

French was not so sure. Practically from the outset, he and Bacon had fretted that even a twelve-foot-high statue on a raised pedestal might look dwarfed inside the vast atrium. As a final test, French commissioned a photographer to make a "full-size" solar print of his latest model and then set up the simulation for inspecting on-site on February 26, with Margaret, Henry Bacon, and Evelyn Longman in attendance.[77] As usual, French's instincts proved uncanny. After hanging the photograph inside the memorial, sculptor and architect concluded, with professed surprise, that the statue would

indeed look puny if made to the original specifications. It is conceivable that the two men overdramatized their astonishment knowing that a recalculation of dimensions would require additional supplies of costly material, surely sending budget-conscious Congressional appropriators into a tizzy. French proceeded to revise his original calculations anyway. Then he and Bacon rushed back to the construction site armed with new photographic blowups of eighteen and twenty feet. Afterward, French calmly informed the Memorial Commission that the statue "will have to be very much larger," and asked permission to make it nineteen feet high.[78] Bacon chimed in to concur that the "unusually large scale of the interior" indeed proved "that a larger statue is necessary."[79]

The cost overrun would prove enormous. Months would pass before the Lincoln Memorial Commission agreed merely to consider this major alteration. To spur its members toward a positive response, French made a full-size plaster of the statue's head in the proposed larger format—five feet high—shipped it to Washington in the fall of 1917, and had it hoisted into the precise spot Lincoln's marble head would occupy in the atrium.[80] While it dangled inside the memorial, French used the opportunity to study the effects of light on the face. The test displeased him, but lighting was a problem he would not deal with until much later. As dogged as he was in quest of perfection, even French could juggle only a few make-or-break challenges at once. The commission finally consented: the statue would indeed rise nineteen feet.

Earlier, French had insisted on another major change. The original plans for the statue had called for either marble or bronze. French, at first, had advocated for bronze, attempting some "experiments" in mid-1915 to find an alloy "more agreeable in color than what is known as standard."[81] Soon thereafter, he decided that the statue must be made of marble after all (which Bacon had favored from the start) to cohere with the warm, buff-colored stone Bacon had ordered for the interior. Now he proposed engaging his favorite carvers, the Piccirilli Brothers, to create the final piece in blocks. Marble it would be. French took it upon himself to "break it" to the commission that, owing to the increase in size and conversion to the costlier medium, "the statue is going to cost about $25,000 more than was expected."[82] In May 1917, French told Bacon that the Piccirilli Brothers' new forty-six-thousand-dollar estimate to carve the statue would require six thousand cubic feet of Georgia white marble weighing some 240 tons.[83] In late autumn 1918 he at last sent both his five-foot head and seven-foot model statue to the carvers. Even to Henry Bacon, then mourning the recent

death of a son, French remained self-absorbed enough to comment: "I shall have to leave the country if the statue is not a success."[84]

French might have had an easier time convincing the commissioners to approve these cost overruns had he not forbidden them to circulate photographs of his model for publicity purposes. "As a general rule," he lectured the Memorial Commission in early 1918, "it has always seemed to me a mistake to publish photographic or other representations of a statue or monument before the monument is in place. It is, in fact, not quite just to the sculpture for the reason that the photograph is but an imperfect representation of the work and none of our statues are so good that we can afford to risk losing any of the elements of properly impressing the public."[85] In truth, French had long relied on photographs for publicity, but always insisted on controlling their creation and distribution. Learning that the Library of Congress had put such pictures on exhibit anyway, he demanded that officials remove them and not "exploit the statue or reproductions of it until the statue should be in place."[86]

"The casting in marble has just begun," French alerted the commission's executive secretary, Charles S. Ridley, in December 1918—just three weeks after news reached the country of the World War I armistice. It might even be "finished in the spring," he optimistically predicted, "but I doubt it will be in place in less than a year from now. I have lived with Lincoln so long that I feel as if he was a personal friend."[87] French made sure to visit the Piccirillis' Bronx headquarters often to "work personally on the marble,"[88] reporting on May 14, 1919, that he was "just putting the finishing touches on the head of the statue."[89] A few months later, he began spending additional time in the Bronx working on the hands.[90] The sprawling home and workspace, occupying an entire city block in a still-bucolic section of the borough, was a hive of activity in the manner of a busy Italian marble-cutting *bottega*, or workshop. Observers marveled that whenever one of the six Piccirilli brothers dropped his tools for a rest, another would effortlessly pick up where his sibling left off, and continue carving in precisely the same style. The frenzy of work stopped only at midday, when the laborers broke for lunches of "steaming spaghetti or appetizing ravioli" prepared and served by the Piccirillis themselves.[91] The senior partner, Attilio—known as "Uncle Peach"—had emerged as something of a celebrity in his own right. His friends included Congressman (and future mayor) Fiorello La Guardia and opera star Enrico Caruso, whose early recordings could often be heard playing on a wind-up Victrola while the brothers went about their business.[92]

Much as he disliked undertaking site visits, increasingly so as he grew older, French did take the train to Washington, more often than he wanted, to inspect the memorial building as construction progressed, often staying overnight at the Willard Hotel near the White House (where Lincoln himself had resided as president-elect).[93] On such visits, he usually met Bacon and commission officials at the memorial, where together they studied the progressively larger models, toured the building, and observed the play of light.[94]

In June 1919, as French settled in for the season at his beloved Chesterwood, Colonel Ridley "dropped a bomb into the camp," as French put it, by declaring "that eight of the nineteen blocks of marble for the Lincoln pedestal appear to be defective." Henry Bacon urged the sculptor to come at once and join him in the capital to have an emergency look for themselves. Yet even at this time of crisis, French declined to leave Stockbridge once his summer sojourn had begun. "I don't want to go to Washington," he bluntly told Bacon. "I really do not see that I should be of any particular use." Besides, he pointed out, the stones "that Col. Ridley considers defective" could be built "into the middle of the pedestal, mostly out of sight."[95] French remained ensconced at Chesterwood and a catastrophe was averted when steel support beams were delicately inserted under the base and the damaged slabs successfully replaced.[96]

The Piccirilli brothers completed their enormous carving project in the fall of 1919. Then they prepared for the statue's "shipment to Washington" in pieces—twenty-eight massive blocks in all, twenty-one of them fully carved and seven that would serve as interior fillers, none of which they had yet attempted to fit together, even as a test.[97] A few weeks later, all the marble blocks arrived safely at the site, and the Piccirillis' workmen began assembling them, massive piece by massive piece. No larger statue had ever been built in America. Had French's Lincoln been able to rise from his chair, he would have stood some thirty-feet tall. "To put him together correctly without breaking any of his component parts," observed a journalist at the scene, "is the last and the most delicate task." Once in place, the writer predicted, "The rubber-neck wagon will put a new stop on its itinerary, and the encyclopedic gentleman with the megaphone will have to add a piece to his spiel." The memorial would "be open to the public ere another crop of June brides has perspired in the shadow of the capital." In that prediction, the writer proved too optimistic.[98]

On November 19, 1919, the fifty-sixth anniversary of the Gettysburg Address, French declared the installation nearly accomplished. He had

anticipated a dedication before winter, but alluded mysteriously to "an accident that delayed the erection of the statue so that the dedication had to be postponed indefinitely."[99] Cracks had begun to appear on the floor as the huge building slowly settled into its boggy site. For now, French would resist the temptation to plan another visit to inspect the statue. As he confessed to Katrina Trask: "I am afraid to see it!"[100]

The sculptor celebrated Christmas that year in what had become the "established custom" for the French family: hosting a large dinner at his New York studio, where Rosalie Miller entertained "most enchantingly."[101] The "pretty" Evelyn Longman was there with her new fiancé. The master of the house no doubt capped the revelry by reading one of the rhymes he had taken to composing each holiday. His daughter remembered one of them: "There's a hirsute form of decoration / That has always graced the upper lip of Jack. / It is gone and what a revelation! / O, goodness gracious, Jacky, put it back."[102]

Presumably an abundance of eggnog made such ditties seem hilarious.

◆　◆　◆

Once the Lincoln statue was installed, French did a somersault regarding photographic reproductions, complaining now that the commission was generating too little publicity. Urging that "we should guard against the Press feeling slighted," French advised that it was high time to "start a little propaganda in regard to the Lincoln statue," perhaps giving newspapers "an early chance at its reproduction. This statue will attract attention," he predicted, "and I should be very sorry to have it started wrong. A word to the wise is sufficient."[103]

Nonetheless, when a midwestern magazine began the new year of 1920 by asking French to supply photographs of the model, French inexplicably insisted that the publisher assume responsibility for his "time & money"— up to $25—demanding that arrangements also be made for royalties.[104] He described himself as "a good deal disturbed" when he later spied a rogue illustration of the statue "tucked into the back" of another magazine that February.[105] Yet he wrote personally to Royal Cortissoz of the *New York Tribune* to suggest a "Sunday picture page of a group of Lincoln Memorial pictures."[106] Cortissoz quickly obliged. Even so, French now maddeningly described himself as "sorry not to have the statue introduced to the world with more of a flourish."

One iconic photograph of the installation, showing the statue rising from the bottom up, just as *The Republic* had risen in the lagoon at Chicago thirty years earlier, ranks among the most extraordinary process shots ever

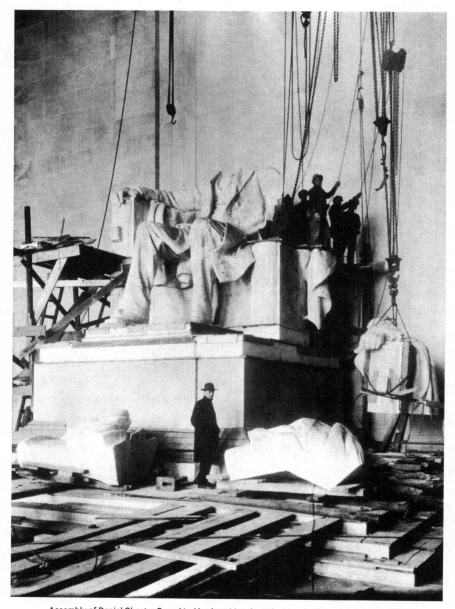

Assembly of Daniel Chester French's *Abraham Lincoln* at the Lincoln Memorial, January 1920

captured—with the headless behemoth dwarfing a worker posing before it and the block of marble containing Lincoln's left arm dangling in midair.

Another snapshot depicted French standing before his masterpiece, for he had returned to the site to apply finishing touches. "I am very relieved to see that it was not too large for its surroundings," French told a friend the day after Lincoln's Birthday, 1920. "I got into rather a panic about this for it didn't seem that a statue that large could fit into any place without being too colossal."[107]

Among the tributes that poured in for French's seventieth birthday that April was a "Sonnet" by an anonymous poet, ending: "And here, with skill no passing years can quench / Long may we have our Daniel Chester French."[108] Age notwithstanding, French could now be seen scuttling on a scaffold high above the floor, sanding the statue's seamlines until they faded from view, polishing the face and hands to perfection. Not until the end of May 1920 did he feel emboldened to declare: "The Lincoln statue, with its pedestal, is an accomplished fact...it is now as nearly perfect technically as I can make it."[109] But with the formal dedication still on hold, French was consoled to learn that the statue was "to be kept covered during the summer, and in fact until the time of the unveiling."[110]

Despite French's efforts to control images, photographs of the statue now appeared so often, in so many newspapers, that many observers, especially those distant from Washington, must have believed the memorial was already open to the public.[111] Robert Lincoln may have been one. He told Henry Bacon that he was already "very appreciative of what you and Mr. French have done in giving the Memorial to the world."[112] He hoped his health would permit him to attend the dedication, whenever it occurred. Another premature congratulatory letter came from England. The Lincoln biographer Lord Charnwood, too, had seen an early, perhaps unauthorized newspaper photograph of the statue in place. Even a small picture convinced Charnwood that the face was "beautiful...solemn, and strong and sweet, and in the right, not the wrong way. I am familiar enough with photographs and other representations of him to feel confident that it gives the real man." Charnwood thanked French "for giving the world what is and is likely to remain *the* statue of Lincoln—a work into which you must have put much of your heart's blood."[113]

"I cannot convey to you how much your praise means to me," French replied. "I have been on my knees to you from the time when I first read your life of Lincoln, the most vivid, the most understanding and the most just portrayal of him that has ever been written." French seemed especially

gratified that Lord Charnwood had liked the way he had arranged a par-
ticular feature. "I am glad you liked the hands," French told him. And then,
echoing what he had told Evelyn Longman three years earlier, he added:
"It has always seemed to me that the hands in portraiture were only sec-
ondary to the face in expression and I depend quite as much upon them
in showing character in force." Then French allowed himself a revelatory
moment—albeit in defense of his incurable modesty—by adding: "The mis-
take oftenest made by the sculptor is in thinking too much of the dress and
too little of the man." [114]

Seeing the statue inside the memorial building, Royal Cortissoz could
barely contain his own enthusiasm. Noting that French had, with a statue of
"ghostly grandeur...risen to the high, monumental plane of his opportunity,"
the critic prophesied that "the multitudes for whom it is thus interpreted
will be not only impressed but touched. They will recognize the man whose
genius as a leader yet left them one of themselves." [115]

◆ ◆ ◆

Once the seated Lincoln was safely in place, and after six years of almost con-
stant work, Mary insisted that her husband needed a rest and arranged for
an extended Italian vacation. "Don't faint," French told a friend, "but Mary
and I have decided to go to Sicily in the fall to be gone all winter—Margaret
too!" [116] Something more than a getaway was in the works. Margaret had
become engaged, to Pennsylvania-born William Penn Cresson, an architect
and diplomat sixteen years her senior. Mary thought to pack her old wedding
dress for the trip, anticipating that Margaret might have use for it overseas.

The family departed from New York on the SS *Patria* on November 23,
1920. [117] After steaming past Gibraltar and entering the Mediterranean on a
"perfect day," they disembarked at Palermo on December 5, and in the days
to come went on to Rome to visit the attractions in the Eternal City before
returning to Sicily. Throughout the trip, the ever-precise Yankee sculptor
kept a meticulous diary devoted mostly to noting weather conditions and
recording expenses. Only in passing did he occasionally report that "Penn"
Cresson turned up from time to time to join the family.

French chose a small hotel at Taormina, a quiet, ancient resort town out-
side Messina on the island's east coast, where, to the sculptor's delight, room
and board cost only "a dollar-and-a-half a day" and laundry but fifty cents
weekly. No doubt Sicily's ancient archeological sites attracted French, but so
did its provincial and inexpensive lodgings and food. [118] A far bigger expense
was soon to come. Here in January 1921, Margaret walked down the aisle at

Wedding of Margaret French and William Penn Cresson,
Taormina, Italy, January 28, 1921

what her mother called "a medieval wedding, upon the edge of a volcano."[119] The ceremony took place in Taormina's twelfth-century Monastery of Santa Caterina. The entire village turned out for the reception, but among Dan and Mamie French's many American friends, only Robert Underwood Johnson, the former editor of the *Century Magazine*, was able to attend on such short notice; at the time he was serving as US ambassador to Italy. Perhaps the town's most famous resident was D. H. Lawrence, whose rather scandalous book *Women in Love* would appear in print just a few months later.[120] There is no evidence that either of them ever knew about the other's existence in the village, much less that Lawrence attended Margaret's nuptials.

The father of the bride greeted this latest family milestone as undemonstratively as ever. "Try as he would," Margaret recalled with palpable regret, "he could not scale that wall of discipline, and he found himself, against his

will, holding back in every little evidence of expressed affection." Not even
Margaret's recent emergence as a talented sculptor in her own right had
aroused anything more than the kind of restrained admiration that Judge
French had once given to his son. Only a few days before the wedding did
the father of the bride permit himself to write Margaret a letter addressed
to "My dear little girl." It was the only way French could express his faith
that he "trusted her own good judgment" and believed she had made a wise
choice in Penn Cresson.[121]

"I haven't done a stroke of work since I have been here," French con-
fessed to a friend from Sicily around the same time, "and I am not sure that
I can ever get down to it again. I would not have believed that I could so
easily have been converted to a life of idleness."[122] As much as he had man-
aged to relax during this long absence from home, the vacation did not
make French feel any younger, particularly when he headed south across the
Mediterranean in February 1921 for an exhilarating side trip to Egypt. One
day, on a ride into the desert to inspect an ancient temple, French's "canter-
ing" donkey stumbled, tossing its rider "over his head" and "nearly breaking
my neck."[123] When a traveling companion offered consolation by assuring
him, "you don't look a day over sixty," French replied indignantly: "What's
the use of telling me I look sixty? That doesn't help any. If you told me I
looked twenty-five, that would be really worth while!"[124]

Not until April 1921, five months after departing Sicily, did the Frenches
sail back to America.

◆ ◆ ◆

By then the Lincoln Memorial was still awaiting formal dedication while
also fighting what seemed to be a losing battle against its marshy surround-
ings. The outside steps had begun to sink, and Henry Bacon had launched a
program to buttress the entire structure and repair the widening cracks that
had begun to scar it. At least the building's interior details had come alive.
As French observed after visiting the site for the first time in months, some
elements had worked out magnificently, others less so.

Most important of all, the statue still looked perfectly poised on its pedes-
tal—neither too small to fill the cavernous atrium nor too large to overwhelm
it. It looked imposing yet inviting from the plaza below, and magnificent close
up inside. The pink Tennessee marble floor and pale-gray limestone walls pro-
vided perfect backgrounds for the white marble sculpture (even if it needed
cleaning, which French ordered). That was the good news. Of some concern,
Bacon had decided in French's absence to remove the bronze front doors

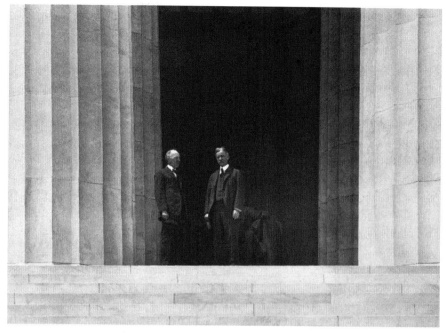

Daniel Chester French and Henry Bacon at the Lincoln Memorial,
several days before the dedication, 1922

originally designed to block out indirect sunlight by day and shut down the
memorial at dusk. A choice had been made—truly a brilliant one—to keep
the shrine open later, with the statue perpetually visible from outside. Access
would be virtually unlimited, but strong, direct light, magnified by the reflect-
ing pool to the east, now flooded the statue at certain hours. Making matters
worse, Bacon had replaced the glass skylight, originally conceived to pro-
vide the sole illumination on the statue from above, with a translucent mar-
ble membrane coated with beeswax. The resulting diffusion of overhead light
made distortions on the statue more palpable. To French's horror, the expres-
sion on his *Lincoln* now looked "flat and white and agitated," the knees loom-
ing out of all proportion.[125] French proposed opening up more light from the
ceiling, and also tried staining some of the marble to deflect the glare. But it
would be years before the situation was fully rectified.

Jules Guérin's newly installed interior canvas murals proved equally
hard to appreciate but impossible to revise. The Missouri-born artist—not
to be confused with a notorious anti-Semitic French journalist of the same
name—had created two rather pallid allegories meant to signify *Peace* and
Reunion. Uninspired and stylistically incompatible with the realistic statue,

the best that could be said of them is that they escaped visitor attention from the start and faded over the years.[126] Most observers were more impressed by the friezes surrounding the exterior attic wall, the work of the English-born Washington-based carver Ernest C. Bairstow.

The words of Lincoln's two greatest speeches had been beautifully incised on the interior walls and bordered by double wreaths and eagles. French had assigned the work to the sculptor who had earned a place on his studio staff years earlier carving the words on his Boston Library doors: Evelyn Longman.[127] French had previously promised Henry Rankin that he would consider adding two more Lincoln masterpieces: his 1861 farewell address to Springfield and his 1864 condolence letter to Lydia Bixby, a Boston widow believed at the time to have lost five soldier sons in defense of the Union. French followed up on his pledge, but was rebuffed, and wisely so.[128] The memorial was effective in large measure because it remained uncluttered. Besides, as it transpired, Lincoln's authorship of the so-called "Bixby Letter" later came into question. What was more, Mrs. Bixby was found to have lost but two sons in the war, not five, and one of the survivors proved to be a deserter.[129] French later advocated carving "Piccirilli Brothers" on the plinth of the statue.[130] Even at his most triumphant hour, he remained generous about sharing credit. The modest carvers refused the honor.

The final element to be imposed on the interior, just before its long-awaited dedication, was an epigraph to be placed between the pilasters behind and slightly above the statue. French seems to have initially offered the cherished assignment to his old friend Robert Underwood Johnson. "I should be delighted to have you for my poet laureate," French wrote him as early as fall 1918. There was "plenty of time for you to get your fine thoughts in metric order and be prepared to startle the world with your masterly composition."[131] But for reasons unknown, Johnson never proceeded. With no time to lose, French and Bacon chose a four-line inscription that another influential acquaintance, Royal Cortissoz, had proposed back in 1919, calling the opportunity "the ambition of my life":[132]

> In this temple
> As in the hearts of the people
> For whom he saved the Union
> The memory of Abraham Lincoln is enshrined forever.[133]

Not everyone involved with the project shared Bacon's fondness for this sentiment. Charles Moore, French's correspondent from his Chicago

World's Fair days and the architect who succeeded French as chairman of
the National Commission of Fine Arts, could barely conceal his contempt.
Moore agreed with an appraisal that a friend sent him, mocking the inscrip-
tion as "poor, cheap, sentimental, erroneous, disfiguring"[134]—and, indeed, in
emphasizing Lincoln's triumph in preserving the Union, it was at the very
least insensitive to his achievements on behalf of black freedom. But plan-
ners had intentionally been de-emphasizing that aspect of Lincoln's reputa-
tion for more than two decades.[135] With so many of French's acquaintances
now serving on the arts commission—among them J. Alden Weir, Herbert
Adams, and, of course, Henry Bacon—Moore kept his criticism to himself.
President Warren G. Harding, set to officially accept the memorial on behalf
of the United States just a few weeks later, did presume to suggest a slight
revision—he had, after all, once been a newspaper editor—which Cortissoz,
deeply offended, refused to entertain.[136]

◆ ◆ ◆

The tin lizzies started arriving early at West Potomac Park on the blisteringly
hot Memorial Day 1922, angling into every last parking spot. Passengers
alit, opened parasols to shield themselves from the blazing sun, and hur-
ried toward the memorial in quest of the best vantage point for dedication
day. As the War Department's newsreel photographers aimed at the scene,
the crowd ringing the memorial thickened, and ultimately overflowed.[137] By
most counts, fifty thousand people had gathered by the time the ceremo-
nies got underway; others counted more than twice that many spectators.
The statue seemed to gleam from inside the shrine; as his final request in an
endeavor that had consumed seven full years, French had insisted that the
marble figure be scrubbed clean before dedication day.

All eyes focused on the top step as President Warren G. Harding, Vice
President Calvin Coolidge, Chief Justice William Howard Taft, former
speaker Joseph Cannon, Robert Lincoln, poet Edwin Markham, Henry
Bacon, and Daniel Chester French all made their way to the seats reserved
for them between the marble pillars. At the last minute, perhaps after wait-
ing for free accommodations that were never offered, the Frenches had
booked "a moderate priced room" at the Powhatan Hotel.[138] He was not
about to let even this milestone moment overcome his lifelong Yankee par-
simony.

French had recommended that the ceremonies include the recitation of
the Gettysburg Address and Second Inaugural. Organizers rejected the idea.
But they did embrace the sculptor's proposal that Rev. Wallace Radcliffe,

pastor of Washington's New York Avenue Presbyterian Church, where Lincoln himself had once worshipped, be invited to deliver the invocation and benediction.[139]

No project French had ever worked on, no dedication he had ever attended, attracted so large an audience or such voluminous, nationwide press coverage. Despite the understandable criticism expressed in the African American press—and whether French was ever aware of the controversy over segregated seating or the editorial attacks it provoked, we do not know—the reviews proved rapturous. The dedication was front-page news in the white mainstream press, and the praise lavished on French proved unanimous and unrestrained. "The colossal figure of the beloved," William Howard Taft declared at the dedication, the work of "one of our greatest sculptors, fills the Memorial hall with an overwhelming sense of Lincoln's presence." The chief justice's praise set the tone for the exuberant press notices soon to follow.[140]

To one ecstatic critic, the statue was "awe inspiring," to another, "chastely magnificent," and to a third, "beautifully severe."[141] The *Washington Evening Star* characterized French's achievement as "colossal in size and yet distinctively personal." In the judgment of the *New York Times*, it was "magnificent and compelling in its purity of line and simplicity."[142] The *Washington Herald* pronounced it the "most impressive work of sculpture yet produced in the United States" while *Monumental News* declared it "the most impressive indoor memorial in the country."[143] The critic of the *Brooklyn Eagle* may have come closest to comprehending the statue's uncanny magic when he acknowledged: "In the gaunt face of Lincoln the sculptor has caught that suggestion of wistful power, a little saddened by ridicule. Patience, wisdom, kindness—these are all to be seen in the stone face, and beneath these seems to lurk a sorrowful smile."[144]

The *Architectural Record*, a journal that had covered French's career for decades, was no less rhapsodic in its judgment of his latest work: "The lover of good sculpture will revel in the fine pose of the majestic figure. He will study the masterly handling of its planes and lines. Most of all he will enthuse over the marvelous technique of the surface modeling and those remarkable hands. The lover of Lincoln will feel a thrill at the depth of feeling which emanates from this great statue, from the face so full of contentment yet bearing the deep furrows wrought by a tremendous struggle. The casual observer will of course be impressed by its huge bulk, for this statue is a veritable colossus. Mr. French has given the world such a vast and varied number of estimable works of art that it would require a masterpiece indeed

(left to right) Warren G. Harding, Robert Lincoln, and Joseph Cannon
at the dedication of the Lincoln Memorial, May 30, 1922

to add anything to his fame...however, he has added to his fame a transcendent work of art worthy [of] its creator, worthy [of] the unsurpassed locality where it stands, and...more nearly representative of America's present conception of Abraham Lincoln than any other statue hitherto created."[145]

Henry Rankin, Lincoln's onetime law student, could not summon the strength to attend the opening ceremonies. Eighty-five years old and "helpless from paralysis," he had to content himself with examining photographs of the statue in the press. Rankin had once suggested that French sculpt the clean-shaven Lincoln he had known back in Illinois, rather than the bewhiskered statesman of the Civil War—a suggestion the artist had politely deflected. Now Rankin called French's effort "to represent the great president" to be "a matter of the greatest gratification to me."[146] French's fellow sculptors were equally effusive. "Congratulations on another great achievement," wired one. "Am told Lincoln is most impressive[.] Love Lorado Taft."[147]

Soon, French began receiving up to fifty letters a day in fan mail—about the same number of letters that John Hay, the onetime White House aide who recommended West Potomac Park as the site for the Lincoln Memorial, had once helped to sort and answer in his days serving the Civil War president.[148] If this newfound celebrity were not enough to go to his head, the

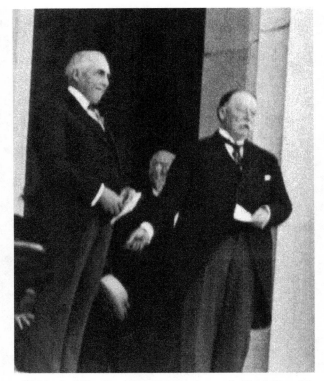

Chief Justice William Howard Taft (right) turning over the Lincoln Memorial
and President Warren G. Harding (left) receiving it on behalf of
the American people, May 30, 1922

"moving-picture men" who had filmed the dedication headed to New York the following winter and turned French's New York workplace into "a 'movy' studio," recording the sculptor pretending to "work on the first sketch" and subsequent models of the Lincoln statue. These early documentarians had "proposed a picture history of the making of the Memorial," and French was thrilled to cooperate—even if he was not sure that the result would be "very interesting."[149] He may have been right. If a final film was ever produced, or even processed, it has vanished.

Five months after the dedication, an admirer asked if French might try articulating in words what he had attempted to express in marble. As usual, words failed him. "A statue naturally has to speak for itself, and it seems useless to explain to everyone what it means." For help, he turned to the late family friend he had sculpted so many years before. "I think it was Emerson who said 'a poet is entitled to credit for anything that anyone can find in his work,' and I have no doubt that people will read into my statue of Lincoln a

great deal I did not consciously think. Whether it will be for good or ill, who can say?"[150]

Asked to describe his Lincoln's expression and attitude, French was terse but revealing: "Work over, victory his."[151] Addressing the Lincoln Memorial Commissioners who had engaged him, French was only slightly more voluble. "What I wanted to convey was the mental and physical strength of the great war President and his confidence in his ability to carry the thing through to a successful finish." He hoped the message "gets over."[152]

◆ ◆ ◆

It did. "I have been breaking the Sabbath down here today working on my income tax returns," French reported to Margaret in February 1923, some nine months after the dedication of the Lincoln Memorial. "Incidentally, I have discovered that the last year was a pretty good one financially for me."[153] A man notorious for understatement had uttered the understatement of a lifetime.

How modest his self-appraisal, both to his daughter and the Internal Revenue Service, we do not precisely know. Even a careful examination of French's meticulous account books makes it difficult to discern how much money the sculptor netted from the biggest project of his career. According to a statement entered into the Congressional Record many years later, the sculpture cost the government a total of eighty-eight thousand dollars, but how much of that fee French cleared for himself remains difficult to ascertain.[154] Ever prudent, French ended his otherwise merry 1923 letter to Margaret by making sure she knew that, "somehow expenses seem to keep pace with one's income and I haven't much to add to the accumulations of a lifetime."[155]

There would be, however, the additional acclaim and profit that came French's way from miniaturized replicas. Beginning in 1923, and for more than ninety years thereafter, the Lincoln Memorial appeared on postage stamps issued in the United States and more than two dozen foreign countries, from Mongolia to Turks and Caicos.[156] As early as 1924, the sculptor secured a copyright for a reduction of the statue. He called it *Lincoln of the Memorial.* For the last nine years of his long life, French would keep up a robust trade in these authorized copies. Several American museums—including the Art Institute of Chicago, where the sculptor's brother had once served as founding director—now boast copies of the thirty-three-inch-high bronze. Less than a year after the dedication of the original, French also authorized a New York photographer to make an official portrait of

the statue, and thereafter earned a 5 percent commission from the sale of prints.[157] Already wealthy, French undoubtedly became far wealthier from the rewards his crowning effort deservedly brought him.

◆　◆　◆

Robert Lincoln had not only inspected and praised French's working model, he had also attended the cornerstone-laying ceremony for the Lincoln Memorial on his father's birthday, February 12, 1915, contributing an inscribed Abraham Lincoln biography for its copper time capsule. [158] And for the first time since Robert and his wife, Mary, had witnessed the unveiling of the Saint-Gaudens statue thirty-five years earlier, they had agreed to attend the 1922 dedication at President Harding's invitation, but only on the condition that "no notice whatever be taken of us."[159] Nonetheless, Robert's arrival drew a large ovation from the crowd. And once the ceremony ended, the assembled dignitaries made their way to his seat and lined up to shake the old man's hand, eager to touch the last living connection to the hero vivified in French's statue.

It was the last public appearance Robert Lincoln ever made. But for years to come, whenever he visited Washington, he would ask his chauffeur to drive to the memorial, then pause there to stare at Daniel Chester French's sculpted portrait and exclaim, "Isn't it beautiful?"[160] On his final visit, a witness watched him gaze at the statue with "deep reverence, as if he were at worship." Then Robert "waved a last adieu to the cold stone face and departed."[161] He died in 1926 at the age of eighty-three.

To the shock of friends and colleagues, the much younger Henry Bacon predeceased Robert Lincoln. Two years earlier, while working with French on yet another, if unavoidably anticlimactic, assignment, a memorial to railroad tycoon Jesse Parker Williams and his wife, Cora, for an Atlanta cemetery, Bacon died soon after undergoing cancer surgery. He was only fifty-seven years old. Their final collaboration, a draped figure emerging from a granite arch, proved to be the first and only statue the team ever worked on to honor a Confederate veteran.

French was devastated, describing Bacon's loss as "a calamity the extent of which I have not yet faced." Bacon had seemed so certain that his recently diagnosed illness was minor. Now the architect's longtime colleague could barely summon words to express his grief and shock. "For twenty years," French told his daughter, "we have worked together and there has hardly been a time when were not actively engaged in some problem." He closed his partnership with the gifted architect by serving as one of his pallbearers.[162]

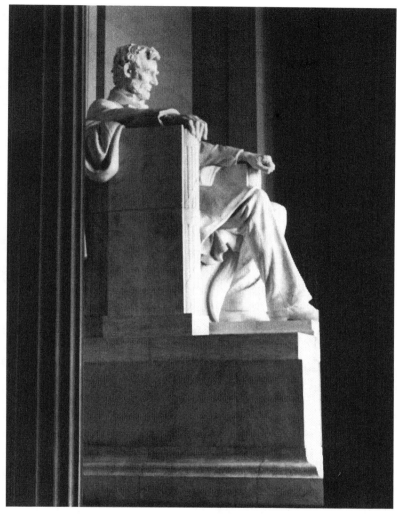

Abraham Lincoln at the Lincoln Memorial, marble, 1911–22, Washington, DC

"Before this reaches you," he wrote Evelyn Longman, "you will learn through the papers of the tragedy that has come into our lives....I seem to have nothing to say about it that is adequate."[163] Only to Bacon's surviving business associate, Charles A. Coolidge, could French put the "sad news" of his loss into words. "It seems as if he was created to make the Lincoln Memorial," he wrote of Bacon. The "great work" would "stand as a memorial to him as well as to Lincoln."[164] And also to Daniel Chester French.

Daniel Chester French at work on the clay model of
Ambrose Swasey in his studio at Chesterwood, 1922

THE MONUMENTAL MAN OF STOCKBRIDGE

T he lighting was so bad," Mary French protested after the Lincoln Memorial dedication, "that for those first few years it was a constant grief to the sculptor and his artist friends." The marble ceiling "gave a beautiful soft glow to the interior of the great room," she conceded, "but, alas! in conjunction with the hard light coming from the blue sky in front, was fatal....It made the face lined and haggard, and the knees unduly prominent." French was "so discouraged" that, for a time, his wife confided, "he felt that it could never look as it was intended to look." Had Henry Bacon lived, Mary believed, the flaw "could have been corrected, but, with the architect of the building gone, it became a serious challenge."[1]

In search of a solution, French was compelled to turn to the same man who had ordered the audience segregated at the dedication: Clarence C. Sherrill, who ironically claimed the same title, superintendent of buildings, that French's uncle Benjamin Brown French had held in the Lincoln administration. When French's initial appeals fell on deaf ears, he turned to modern technology for evidence. He had photographs made of the large model still at Chesterwood—lit perfectly by his overhead studio skylight. Then he ordered corresponding photos of the statue in Washington as it looked in the worst possible light streaming in from the visitor entrance. According to Mary, the first image looked "as if a beautiful woman were photographed in evening clothes, with all the accessories of studio lights, etc.; the second, the same woman as if a flashlight had been suddenly turned upon her face."[2] Still very much the publicity wizard, French released the comparative shots to the public.

Composite photograph showing effects of lighting the
head of Lincoln for the Memorial, 1922

It was clear, as French had been arguing since 1920, that "some powerful electric lights might be installed in the ceiling which might at least improve the effect."[3] In 1927, he asked Ulysses S. Grant III, the new director of public buildings and grounds, to allow Tiffany & Co. to try designing new glass panels overhead—to no avail.[4] Colonel Grant, the lookalike grandson of the Civil War hero, seemed too preoccupied with crackdowns on lovers "petting" in Washington's public parks. It took years more for French to enlist scientists at General Electric to prepare a report on alternatives. Finally he turned to the Sunlike Illuminating Company, headquartered a few blocks from his New York home, to design "not merely a bulb, but a specially made reflector with a prismatic arrangement of cobalt oxide mirrors inside" to light the statue artificially.[5] At last Grant came around. For funding, French appealed directly to Congress. The combination of potent names—Lincoln, GE, and Grant—proved enough to stimulate an "open sesame" on Capitol Hill.[6] Floodlights were finally installed on the ceiling, removing the last barrier to the perfection French had long sought for the Lincoln Memorial. He described himself as a "happier man" after visiting Washington in the spring of 1929 and finding the illumination "more satisfactory than I could have believed possible."[7] For his part, a nervous Colonel Grant now worried that

the architectural community would be "somewhat critical of the break that we have made in Bacon's marble ceiling."[8]

◆ ◆ ◆

However flawed, the Lincoln Memorial dedication had proven the crowning moment of Daniel Chester French's long and extraordinary career. But instead of merely basking in the unmitigated public and critical triumph, the sculptor continued to welcome lucrative and prestigious offers for new commissions. For a time, he worked on a succession of new clay models, maintained his studios in both New York and Stockbridge, and continued to keep both workplaces crowded with assistants, pupils, and specialists attending to various stages of his new projects. French now ranked, indisputably, as the most famous sculptor in America. Yet, cautious by nature, he harbored the sense that while he had reached the apex, the descent loomed. He greeted the inevitable with a maximum of humor—and a minimum of self-delusion. At age seventy-two, his principal jobs became staving off debility and keeping his name before the public. In these he succeeded brilliantly—as long as he could.

The three bust portraits he reproduced for the newly created New York University Hall of Fame for Great Americans—of Edgar Allan Poe, Phillips Brooks, and his frequent subject and onetime neighbor Ralph Waldo Emerson—earned the kind of praise he was accustomed to receiving for his historical pieces.[9] A publicity photograph taken at the time showed a bespectacled French, predictably wearing a suit, white shirt, and bow tie, his head nearly devoid of hair now except for a few snowy wisps, working away at a bust of New Hampshire–born telescope inventor Ambrose Swasey—with models of the recent Lincoln Memorial and Edgar Allan Poe works intentionally prominent in the background. In a more daring vein, French labored on perhaps his most sensual work—he originally called it *Immortal Love*— inspired when he glimpsed a magazine illustration of the gushing geyser, Old Faithful.[10] Indeed, the result revealed an undiminished erotic spirit: a beautifully carved marble of a rapturous woman in the embrace of a winged angel. Reconsidering his first burst of creativity, the sculptor retitled the piece after an obscure verse from Genesis: "The sons of God saw the daughters of man that they were fair"—as if a chaste and cumbersome new name could mask the erotic effect of this astonishing work.

Like many sculptors, French also turned his attention and energy to an epochal modern theme: World War I, the catastrophic global conflict

that had claimed forty-one million lives in Europe, among them 117,000 American military casualties, before the 1918 armistice stilled the guns. The war, Mary French remembered, "came to us like a bomb here in our little garden." Her own father had once befriended the pioneering battlefield nurse Clara Barton, so it was natural that both Mary and Margaret volunteer at New York military hospitals treating the wounded.[11] French himself did his part through generous financial donations and with sculpture created to benefit wartime charities. He later joined a number of prominent war-weary artists to produce a work called *Disarmament*, for another of those temporary arches built of wood and artificial stone, or "staff," for Madison Square Park.

Conceived to commemorate New Yorkers who died in World War I, the 1918 memorial, known alternately as *The Victory Arch* or *The Altar of Liberty*, was, for a time, French proudly reported, "in active use daily as a speech-making and rallying point for all the countries of the globe."[12] Like earlier arches erected on the site, however, including the Dewey Arch to which French had contributed back in 1899, it crumbled away without inspiring a permanent replacement.

A notable World War I commission of his own came in 1921, when veterans of the First Division of the American Expeditionary Force—known as the "Big Red One"—raised one hundred thousand dollars and hired French to create a monument in Washington, DC, to honor its fallen heroes. Overcoming their recent rift, French's frequent architectural collaborator, Cass Gilbert, designed a thirty-five-foot-high granite column as a pedestal. The project's chief sponsor, General Charles P. Summerall, had led the division in France, enduring some 1,500 casualties in just two days of brutal fighting in the Argonne Forest. Now he asked that the memorial to his martyrs reflect the "spirituality" needed to "typify the spirit of triumphant sacrifice and of service of the Division's dead."[13]

The ground rules proved difficult to fulfill, at least as far as Summerall was concerned. French designed one of his typically graceful goddesses: a helmeted, winged figure of Victory, one arm extended as if in a blessing, the other holding the divisional colors above her head. But the general disliked the proposal, wings included. "While the figure is beautiful, and would no doubt compel admiration in a gallery," he noted undiplomatically after seeing a photograph of French's small plaster model, "I feel that it is too voluptuous and not sufficiently spiritual." Indeed, the figure boasted not only bare breasts and an exposed leg, but a bit of a tummy. "Let me repeat," Summerall remonstrated, "that our purpose is to preserve this spirit of triumph, of

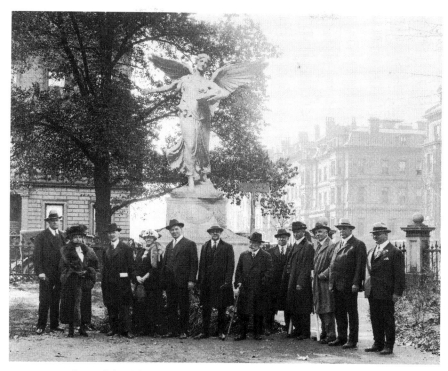

George Robert White Memorial, solar print of statue and pedestal in place in the
Boston Public Garden, with Daniel Chester French, Mary Adams French,
and members of the committee, October 9, 1923

spiritual exaltation, of sacrifice glorified by renunciation of pride, and of reward."[14]

French took the comments as an affront. Despite a lifetime spent successfully wooing clients, he referred the general's complaints to Cass Gilbert unanswered. At this stage of his career, he expected that his creative choices would be honored without question. Moreover, angels had been his specialty ever since the *Milmore Memorial*. The recent death of his lifelong friend Will Brewster had doubtless made French more sensitive than ever to criticism of this aspect of his art. Worst of all, as French told Gilbert, Summerall did not seem to understand that a statue sitting atop a towering column needed to be dramatically sculpted—even "voluptuous"—to be effective from the ground below. Gilbert went on to defend French, and even the intractable General Summerall retreated. The statue, more or less as French conceived it, was unveiled on October 4, 1924, in President's Park south of the White House, outside the rococo headquarters of the State, War,

and Navy Departments—now the Eisenhower Executive Office Building—where it still stands.[15]

Just three days earlier, French had attended the Boston dedication of yet another of his winged-goddess memorials, this one to George Robert White, a philanthropist who had left five million dollars to the city to fund "civic improvement." French gave a rare interview to explain what he intended his statue to signify, conceding that finding a way to represent "the spirit of giving" was "a difficult matter." He wanted his statue, he said, to "interpret the text 'Cast thy bread upon the waters for thou shalt find it after many days.'" French seemed more comfortable reminiscing that "the late Henry Bacon" had visited Boston with him to choose a site for the fountain in the Public Garden.[16] He wished his old colleague to have his share of credit for the result.

In the years following the armistice, World War I memorials became the rage, and French produced several more, much as he had done to honor the Civil War dead during the decades following reunion. There would be one such statuary group for Exeter, a design for a Red Cross medal, and *Death and Youth* for the chapel of St. Paul's School at Concord, New Hampshire. Then in 1925, French sculpted for the town of Milton, Massachusetts, a memorial featuring an exhausted seminude youth holding aloft a torch. French meant the statue to represent the climactic words of the already beloved poetic tribute to the war dead by Canadian military doctor John McCrae: "We shall not sleep, though poppies grow / In Flanders fields."

"For the life of him," Margaret French Cresson remembered of *In Flanders Fields* and her father's other sublime tributes to the dead, "Dan could not do a war memorial that bespoke only victory. To him war was the supreme tragedy and every way he approached it brought out, not the terror nor the horror nor even the glory and triumph, but always the pain and sense of loss." As Margaret put it, "he tried not to show the futility of it, the utter senselessness; he wanted always to do something that would show the dignity of death and be a comfort and a consolation to those who stayed."[17]

◆　◆　◆

Old age mellowed him—for the most part. In an appreciative mood, French accepted renomination as president of the New York City Art Commission, jokingly calling the honor "a fresh proof of hope over experience."[18] That very same day, he generously responded to a request for the maxims he lived by, scribbling: "Look for beauty, not ugliness, Look for goodness, not evil, Look for cheer, not trouble."[19] The sentiment echoed an epigram he kept in

Milton War Memorial (In Flanders Fields), bronze, 1923–25, Milton, MA

his desk drawer: "I expect to pass through this world but once. Any good thing therefore, that I can do, or any kindness I can show, to any fellow human being, let me do it NOW. Let me not defer, or neglect it, for I shall not pass this way again." His favorite Bible passage, he revealed, was from Ecclesiastes: "Whatsoever thy hand findeth to do, do it with all thy might."[20]

More often than not, however, French reflexively deflected both interview requests and lecture invitations. When *Liberty* magazine asked him to contribute his thoughts on "what is beauty in sculpture?"—at fifty cents a word, no less—French insisted that he had "nothing valuable to say."[21] To the Memorial Craftsmen of America, who invited him to lecture on "sculpture and its relation to memorial art," French replied: "Speaking in public is a thing that I decided long ago was outside of my domain and I universally decline to attempt it."[22]

When one reporter attempted merely to get him to submit a few lines for a survey of famous men on the subject "How My Wife Has Helped Me," French tartly replied: "It would take a book to tell you how much my wife has helped me, and I feel that it is entirely out of the question to give you

a brief reply. I trust you may have better luck with sculptors who are not as much indebted to their wives as I am."[23] The amusing and affectionate response may have given Mary French an idea. Not long thereafter, she commenced writing a book of her own for Boston publisher Houghton Mifflin. The charming result, *Memories of a Sculptor's Wife*, price five dollars, appeared in 1928 and quickly went into a second printing. A typical review called the book "chatty and pleasing...filled with a wealth of anecdotes concerning her gifted husband."[24]

Afterward, the publisher tried to persuade French to follow up with a memoir of his own, but he demurred. "If I am articulate at all," he insisted, just as he had for most of his life, "it is in my images." [25] A few months later, however, an enterprising interviewer broke through and successfully inquired if French did not "look back contentedly upon a lot of work well done." The sculptor replied with his usual combination of introspection and self-deprecation: "Well, there are always regrets. I wish my things were better, particularly some of them. I am sorry that I did not get to study in Paris with that brilliant crowd that came from there when I was young. As things were, I did not learn my trade until I was thirty-five, and I could have learned it better and more quickly with proper instruction abroad." The interviewer concluded: "A sincere artist is always humble before his job."[26]

Humility proved difficult to sustain. Tributes came regularly now, including the *Légion d'honneur* from France and a medal conferred at a joint meeting of the American Academy of Arts and Letters and National Institute of Arts and Letters—making French the only sculptor honored since Saint-Gaudens.[27] From New England arrived a raft of invitations to accept more honorary degrees. But each of these proposed encomia required French to attend commencement ceremonies in person, and he felt too weak to promise Tufts, Williams, or Dartmouth that he could summon the strength to be on hand. He had no choice but to decline them all.

◆　◆　◆

For a time, French kept himself busy with fresh projects, but with mixed results. In 1925, he agreed to create a gold-leafed heroic-size bronze statue of a book-toting schoolboy, dressed in a hooded sweater, designed to represent *The Spirit of American Youth*. It was to be the central figure for *The Power of Perseverance*, a memorial to electrical industry titan George Westinghouse at Schenley Park in Pittsburgh. Westinghouse, inventor of the railway air brake, a device that secured his fortune, had lived most of his life in the Steel City. But he had summered until his 1914 death in Lenox,

Massachusetts, adjacent to Stockbridge, where the sculptor and his future subject became acquainted. It was said that fifty-five thousand employees of the Westinghouse companies contributed two hundred thousand dollars to finance the memorial to their well-liked founder.[28] French positioned his symbolic, enterprising young man to face a central tablet adorned with a bronze relief portrait showing Westinghouse as an engineer, bent over his work. The plaque was situated so it would appear that the youth standing opposite was taking inspiration from the tycoon.

The design was not French's idea. Originally, he proposed a statue of Westinghouse himself, placed inside an architectural niche. The memorial committee, proudly holding themselves "entirely responsible for diverting the sculptor...away from the classic interpretation," encouraged French instead to strive for "a 'modern' masterpiece."[29] A mellowing French obligingly revised his design to conform to the narrow specifications. The stylistic shift required French to abandon idealism for realism—in the words of one observer, to turn "from emotion to description"—a milieu in which he was less comfortable.[30] That he did so reluctantly was evident in the awkward result, which several critics panned. "The more I look at it," the project architect nonetheless steadfastly assured French, "the more I am convinced that it is one of your masterpieces."[31] At the time, not everyone agreed. French contented himself with exhibiting his original Westinghouse bust at the annual Stockbridge Art Show.[32]

Tributes, however, flowed without dissent. His seventy-fifth birthday—and the concurrent golden anniversary of the unveiling of the *Minute Man*—found him at a Metropolitan Museum board meeting, where his fellow trustees surprised "our own dear 'Dan French'" with a special resolution honoring his "fifty years of unbroken accomplishment." Optimistically, if unrealistically, predicting "even greater triumphs," the trustees declared: "You stand foremost among the living sculptors of America, honored alike at home and abroad....Yet it is not for your attainments as an artist or for your fidelity as a trustee that we hold you most in esteem on this your anniversary. It is for your own approachable and lovable self. Your statues appropriately stand on pedestals—some of them on very high pedestals, but you have no such aloofness to us."[33]

Meanwhile, another new project brought together two genuine "weavers of legends": Daniel Chester French and Washington Irving, one of America's first famous writers.[34] The town of Irvington-on-Hudson raised thirty thousand dollars to finance a memorial to the area's favorite son, who had died at his Sunnyside estate in adjacent Tarrytown in 1859. French was

only nine years old when Irving died, but had clearly read his books as a youth or since. Revisiting the format he had introduced for his Longfellow memorial, he proposed a central bust of the author set against a granite wall adorned with bronze relief portraits of Irving's most famous fictional characters. French believed the most dramatic sculptural tension would be achieved by arranging a full-size figure of Rip Van Winkle to face Boabdil, the last king of Granada from Irving's *Tales from the Alhambra.*

Typically, the sculptor undertook a prodigious amount of research for the Irving project. Believing that most modern viewers would expect Rip Van Winkle to resemble the late actor Joseph Jefferson, who had portrayed him countless times on stage and in silent films, French wrote Jefferson's son to request photographs of the thespian in costume.[35] He secured a "not very inspiring" Irving bust by Ball Hughes, which at least provided "a typographical survey of Irving's face," and he studied engraved portraits by J. Stuart Newton and Jacques Reich.[36] French refreshed his memory by securing Irving books from publisher G. P. Putnam's, including a new biography, and asked illustrator George S. Hellman to share engravings from his collection of "Irvingiana."[37]

For the figure of Boabdil, French asked the Metropolitan Museum librarian to recommend published guides to Moorish costumes, and then consulted further with the museum's Arms and Armor Department. At one point, its founding curator, Bashford Dean, lent French the closest thing he had to an authentic helmet.[38] Dean was confident that critics would "not be intemperate in discovering a Hungarian-Turkish headpiece of 1600 on the head of Washington Irving's Moor."[39] When even these sources proved insufficient, French sought further advice from the director of New York's Hispanic Society, where French had recently exhibited, and which boasted one of the world's great collections of Spanish art.[40]

"The bust is already well under way," French told illustrator George Hellman in late June 1925. Not for two more years, however, and only after several site visits by the sculptor, was the completed memorial unveiled on an Irvington street corner. Hundreds of spectators gathered on a late June Monday for the "great historic occasion," listening patiently to long speeches, enduring several performances by the Gloria Trumpeteers, and applauding as "Master Washington Irving, great-great-grandnephew of the first Washington Irving, drew aside the flag that veiled the handsome memorial."[41] Calling it "an enduring tribute to Irvington's namesake and greatest citizen," a local journalist enthused: "The characteristical modesty of Washington Irving is delicately preserved for us by the distinguished sculptor,

Daniel Chester French in front of the model for
the *Washington Irving Memorial*, 1927

Daniel Chester French, in subordinating the bust of Irving to the ever-ex-
panding figures of his imagination, King Boabdil and Rip Van Winkle. This
conception is not only as the modest Irving would desire it, but in addition,
it is psychologically accurate, since in our literary appreciation we proceed
from the characters to the artist and not from the artist to the characters."[42]

The critic was on to something crucial here. French had long been
described as a traditionalist. But in the *Washington Irving* memorial he
again ruptured the boundaries of sculptural convention, creating imagery in
multiple dimensions, in this case both realistic and fictional. It was almost as
if, in the new age of motion pictures, French sensed that audiences expected
something more immersive than mere statuary. Whether by instinct or
design, he had provided it.

French did not attend the ceremony, but that same year, 1927, he took
on yet another assignment: what turned out to be not only his last statue
for a college campus but his final winged figure, in this case holding aloft
a donation box like some spectral fund-raiser. The statue of *Beneficence*

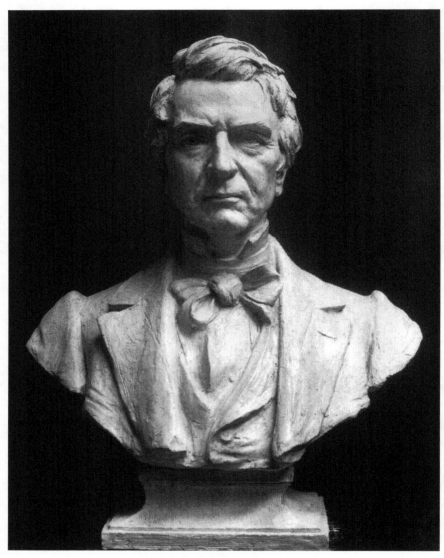

Model of *Portrait of William Seward*, 1930

was meant to honor the leading philanthropists of Muncie, Indiana, at the college endowed by and named for these five generous brothers: Ball State University. French would never see the memorial on-site; it would not be unveiled until 1937, six years after the sculptor's death. By then, students had come to believe that if the angel's wings flapped during the romantic encounters they enjoyed in their shadow, their love would last forever.[43]

◆ ◆ ◆

"I have been amusing myself by making a large bust of Secretary Seward which is to be the chief feature of a monument to be erected to his memory at Florida, N.Y.," French wrote Evelyn Longman in July 1930. "It is finished and if you could see it I have faith to believe that you would think the old man is not falling off!"[44] French had been the obvious choice for the commission—his first work undertaken in the seventh decade of his professional life—for Seward had once been the indispensable counselor to the sculptor's most celebrated subject, Abraham Lincoln. The only question was whether French could summon the strength to complete it.

William Henry Seward, born in the tiny village of Florida, about fifty miles northwest of Manhattan, had moved to upstate Auburn, entered Whig politics early, and became the "boy governor" of New York at age thirty-eight. Later serving as an antislavery US senator, he seemed well on his way to the 1860 Republican presidential nomination when his party's national convention unexpectedly turned instead to the lesser known Lincoln. After the election, Seward found consolation by accepting Lincoln's appointment as his secretary of state. At first a doubter of the rustic Illinoisan, Seward quickly grew into a devoted loyalist whose fate was forever linked to the sixteenth president when assassins attacked both men on the same night of April 14, 1865. Unlike Lincoln, Seward survived, recovering from hideous knife wounds to serve another four years under Andrew Johnson and gaining further fame for shepherding the American purchase of Alaska—mocked at first as "Seward's Folly."[45]

Seward's birthplace home had been demolished five decades earlier, so Florida's town leaders decided to erect the memorial at a nearby public school named in his honor. Discussions between French and Seward's descendants had begun as early as 1923, culminating in a contract offered on the basis of an approved plaster model.[46] Sponsors asked French to adapt it into a larger-than-life bronze that would be mounted on a six-foot granite pedestal.[47] Richard H. Dana Jr., son of one of French's old friends, became supervising architect. The generous deal, which called for a fifteen-thousand-dollar fee,

reflected French's rarified status as the creator of the Lincoln Memorial.[48] But he would not be left entirely to his own devices. The late diplomat's grandson, W. H. Seward, an Auburn lawyer, became deeply involved in the new project, and returning to form, French courted him assiduously.

The sculptor searched for appropriate portraits to guide his portrayal, at first hoping a plaster cast could be made of Seward's head from the statuary group *The Council of War* by John Rogers, whose work French had admired in his early days. The bronze version had been on loan to the Metropolitan Museum, along with six other Rogers groups, since 1900.[49] But Rogers's widow, chagrined that the museum refused to buy all seven for five hundred dollars apiece, had ordered them returned to her in 1929. More to the point, as someone may have reminded French before the statues departed, *Council of War* portrayed Secretary of War Stanton, not Secretary of State Seward.[50] Fortunately, other models were available. Seward had occasionally posed before cameras during the Civil War, though French regarded the first Mathew Brady photographs he consulted as "indifferent." In desperation, the sculptor turned to the secretary's descendants for additional portraits. W. H. Seward responded by sending a plaster copy of a marble bas-relief on display at the family's Auburn home.[51]

Evidently this combination of visual references proved sufficient. In July 1930, French invited Seward and his wife to Chesterwood to examine, and hopefully approve, the plaster model. "The field seems to be cleared," French alerted Dana afterward, "and we can proceed with the work."[52] Although the sculptor was far too frail to undertake the journey to the dedication, Seward attended the ceremony that September, declaring his "very great satisfaction" with French's work, and writing the sculptor afterward to express his "gratification that there is in existence for posterity such a wonderful likeness of Secretary Seward, made by your hands." The memorial "received most favorable comments from everyone" at its unveiling,[53] but as was his recent custom, French assigned principal credit for the success to architect "Dick" Dana.[54]

◆　◆　◆

As he worked on all these commissions, simultaneously as usual, French began laboring in his spare time, once again "just for fun,"[55] on a new reclining female nude reminiscent of his idealized statue of *Memory*. This time it was a life-size figure of *Andromeda*, the beautiful Aethiopian princess of Greek mythology. According to the story, to punish her mother for boasting about Andromeda's physical perfection, the god Poseidon ordered the girl

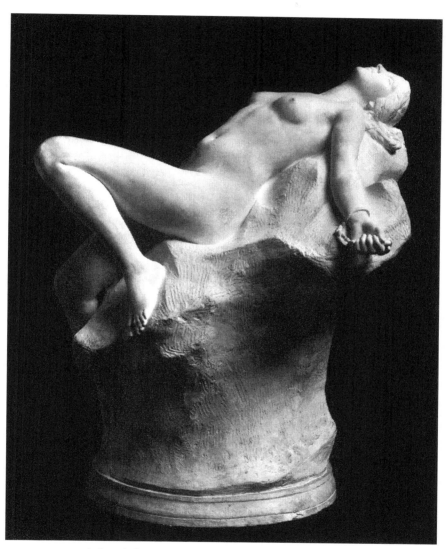

Andromeda, final plaster model, 1930 (Chesterwood, Stockbridge, MA)

chained to a rock to be ravaged by a sea monster. Only at the last moment did Perseus swoop down to rescue her. For centuries, the nail-biting myth had inspired artists, among them Vasari, Rubens, and Titian. French's sudden interest put him in very good company.

For a live model, French employed Ethel Cummings, a twenty-one-year-old caretaker's daughter who had begun posing for French at Chesterwood when she was only seventeen. For *Andromeda*, she sat three days a week, from 8:45 a.m. to 12:30 p.m., earning seventy-five cents per hour, which French always paid her in cash at the end of each session. He told her that she had "perfect ears," but to pose for *Andromeda* required her to pose nude on a "mock-up of a rock," holding chains in her hand. She remembered that French worked in silence, wearing a smock to cover his gray suit, and always a bow tie. He was, she remembered, a "nice-looking man." During breaks, the sculptor's "valet" brought her snacks of milk and saltine crackers. When the sculptor needed a break of his own, he might invite Ethel for a brief stroll in the garden. At the end of the sittings, French's liveried chauffeur, Joseph Wyman, always drove her home to the estate where her father worked.[56]

With Ethel as his model, French progressed from a rough clay sketch to a "somewhat larger" version a few weeks after the stock market crash of October 1929.[57] As his investments plummeted, the ethereal figure must have proven a happy distraction. In French's hands, *Andromeda* at first bore a resemblance to *Memory*, but in the newer effort, he splayed the alluring nude more provocatively, arms bound, one leg raised, staring upward in hope that her rescuer will arrive. In another sense, *Andromeda* looked like she might be sunbathing on a nude beach—a thoroughly modern woman reenacting an ancient beauty-and-the-beast drama.

For the longest time, French seemed as unsure about his concept as he once had been about his portrayal of John Harvard as a pilgrim. At one point he even asked Evelyn Longman, though long absent, to hasten to Stockbridge "to sit in judgment on my to be world famous statue of Andromeda." French added whimsically: "It seems rather absurd for an old thing like me to be making such an ambitious image, and if there were a chance of my ever being any younger, I would wait."[58] Perhaps the invitation was no more than an excuse to regain the company of Evelyn, a sculptor whom he admired and a woman who invigorated him, even though she was now married and recovering from a recent illness. At the time French claimed he was keeping the statue "covered up" in the studio, allowing only a very few friends to glimpse it. As usual, the sculptor's confidence level

proved tidal, surging as often as it ebbed. One day he might discourage visitors, fretting that he was caught "in the usual state of uncertainty about whether it is good for anything or not."[59] Only a few weeks later, he could sarcastically, almost bombastically, summon neighbors to view "the celebrated statue of Andromeda by the equally distinguished sculptor, Daniel Chester French."[60] At his core, he remained unpredictable. The gift of a stereo card of his early statuette *Matchmaking* made him "feel as if the ancient days were returning," but annoyed him, too, because it served as a reminder that he had made but fifty dollars for the project and "thousands of dollars for the men who exploited it."[61]

For his landmark eightieth birthday in April 1930, the press descended on French for interviews. The "distinguished sculptor" increased the attention by endeavoring to withhold comments. "The less said about art at this time the better," he remarked with customary terseness to the *New York Times* two days before the milestone. "American Art is undergoing a sharp period of transition and one cannot place a fair value on it nor safely prophesy its future."[62] The *Times* published a full profile anyway. "Daniel Chester French, dean of American sculptors," the paper reported, "is still active in the art life of the United States on this, his eightieth birthday. Every morning he goes to his studio on Eighth Street, where he works on, surrounded by mementoes of his long and busy life," including the primitive modeling tool that May Alcott had given him almost seventy years earlier. Asked to name his favorite from among his many works, French told the reporter: "I think the portrait of Mr. Emerson." The *Times* expounded: "How hard he worked over it...trying to put into the eyes that something which made people say of the philosopher that he looked as if he had seen God."[63]

As alert as ever to marketing and promotion, French skillfully used his big birthday to focus principal attention on the future, not the past—specifically on his newest labor of love. The rest of the country might be facing the harsh reality of the economic depression, but French rosily viewed *Andromeda* not only as evidence of his evolution as an artist but as a positive expression of the advances women had made since the beginnings of recorded history. To one reporter, French provided a frank and somewhat plaintive version of feminist evolution clearly meant to justify his daring new work.

"I still believe that the beauty of woman is beauty at its best and highest," he declared. His newest statue not only reflected that ideal, but testified to women's advanced state of liberation. "The modern woman," he contended, had "reached a perfection which woman hasn't achieved since

(left to right) William Penn Cresson, Margaret French Cresson, Mary Adams French,
Daniel Chester French in the studio garden at Chesterwood. Photograph taken on the
occasion of all four family members being named to "Who's Who," 1929

the days of Greece. The reason is very simple. She is the first free woman of many centuries. She has intellectual freedom, and she has physical freedom. Her figure has improved marvelously since she got out of stays. In fact, it is almost unbelievable, the difference between the modern woman and woman [sic] of my youth. The generation of women which hasn't worn stays is the most nearly perfect that the world has seen in many centuries. Even when she passes her first youth she still has a good figure."[64]

French celebrated his actual birthday on April 20, 1930, by strolling from his and Mamie's new Manhattan apartment building at 36 Gramercy Park East—they had recently sold off their beloved Greenwich Village town house—to a nearby park, where he sat resting for a time alone in the sun gazing at the budding magnolia trees. He returned home to find the congratulatory cables, telegrams, letters, and flowers that his family had been accumulating to show him.

The following month, French felt secure enough about *Andromeda* to hire the young Japanese-born sculptor Gozo Kawamura to start an enlargement in plasticene—a malleable mix of plaster, wax, and oil—five times the size of the latest maquette. Kawamura, French told a friend, "does pointing better than anybody I ever employed."[65] Still, French cautioned him not to produce "a finely finished enlargement, but only something that will give the general lines" so he could further refine the resulting figure with his own hands at his own studio.[66] Secrecy remained important. "I shall not show your sketch to anyone except my assistant," Kawamura pledged.[67] Once the piece was enlarged, French had it shipped by rail to Chesterwood and resumed work on it there in late May.

By November 1930, yet another summer season at an end, both French and *Andromeda* returned to the city, where the sculptor continued to make slow but steady progress on the statue at his new studio at 17 East Ninth Street. Feeling himself a bit too frail to remain a landlord, he had recently sold his Eighth Street building to Gertrude Vanderbilt Whitney. It would soon become "a museum of some sort," French reported, as indeed it would, with French's Nebraska Lincoln statuette prominently displayed at the Whitney.[68] The sculptor's new workspace, just a block north, was only a quarter as big, but "rather more to my mind than the former one," he convinced himself.[69] In fact, he had no more commissions for big statues, and thus no further need for a cavernous studio to house them.

The decision to sell also reflected the New Englander's lifelong reverence for frugality. That is why his next outlay of cash must be judged as remarkable. After a few more months of labor on the full-size *Andromeda* plaster—insisting that he was still "in a tolerable state of preservation" and capable of future work—French spent $4,300 of his own money to have the statue "translated into marble" by the Piccirilli brothers.[70] Following months of carving, the Piccirillis shipped the resulting marble by rail to Stockbridge in August 1930. Although the statue weighed more than seven hundred pounds crated, Getulio Piccirilli expressed confidence that his most famous client would have no trouble working with it once it was set up at Chesterwood. "I think," Getulio encouraged French, "it will be quite easy for the monumental man of Stockbridge to handle the marble figure."[71]

For "the rest of his summer," French continued painstakingly refining *Andromeda* at Chesterwood, bombarding his friends with tongue-in-cheek boasts about it one moment, doubting his ability to complete it the next, and growing increasingly unsure about what to "do with it when it is finished."[72]

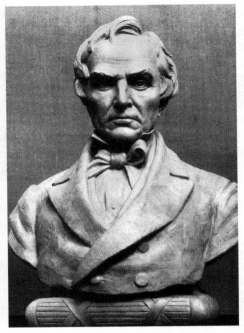

Model of *Daniel Webster*, 1931

Portrait of *Daniel Webster*, 1931–32,
completed by Margaret French Cresson

For certain, he viewed the statue as his last, and hopefully, best argument for preserving the tradition of the ideal in art. Recent trends suggested idealism was falling out of fashion. In January 1931, a few months after again closing Chesterwood for the season, French visited an exhibition of Henri Matisse sculptures at a New York gallery, where the nearly eighty-one-year-old sculptor found himself face-to-face with an artistic revolution he neither liked nor comprehended. For public consumption, he was circumspect, telling a journalist: "The standard of taste rises in America, but rises slowly. There are few people who are capable of producing worth-while things."[73] Privately, he held nothing back. "I think that altogether it is the greatest insult to intelligence that I have ever met," he railed about the Matisse show in a letter to Evelyn Longman. "I had seen isolated specimens of his enormities, but not such a mess as this. How long is this thing going to last?—longer than I shall, I fear."[74]

Indeed, his strength was fading. Although French somehow summoned the power to join the April 1931 meeting of Metropolitan Museum trustees, he now missed more board sessions than he attended, and seriously considered resigning. He did accept the museum's invitation to create a plaque

honoring the late arms and armor curator Bashford Dean, but needed Margaret's help to complete it.

French still clung to what his Stockbridge neighbor, theater critic Walter Pritchard Eaton, called his "true Yankee brevity." When Pritchard created a marble mask of tragedy for his new fountain, he proudly told French, "Until I carved this I didn't know I was a sculptor." To which French replied: "Do you now?" As Pritchard put it, no doubt meaning it as a compliment: "He could be almost as laconic as the late Mr. Coolidge...dry and shafted like an arrow."[75] Indeed, when an art teacher wrote to ask French to provide for her 350 students, then studying the Lincoln Memorial, an autographed picture of its sculptor, he showed another flash of dry humor by cautioning: "I remember the disappointment of a man who had seen the colossal statue I made for the World's Fair in Chicago when he was introduced to me and said he had expected to see a much larger man."[76]

By that time, French was unable to write his own letters; he retained only "imperfect control" of his penmanship. "It can't be that I am getting old," he tried joking to Evelyn Longman as he neared another birthday.[77] His workload was now greatly reduced. As he playfully bragged to his one-time model, Rosalie Miller, that summer: "I am still able to work three or four hours a day and thereby am creating the greatest statue ever." The truth was, he was soon reduced to working but one or two.[78] And, if he could no longer write without trembling, it was doubtful he could do much sculpting. Still, he never abandoned hope that he could complete *Andromeda* and someday sell it.

He had little else on his schedule. He did pay what he called "an income tax of colossal proportions in the summer of 1931"—having profited handsomely from the sale of his Eighth Street studio building—but to his business manager he admitted: "It looks as if income taxes would not trouble me next year, I regret to say."[79] Whether he was alluding to his reduced income or his mortality we are left to wonder.

◆ ◆ ◆

Art historians consider *Andromeda* to be French's last completed work, but in the late spring of 1931, he took on a portrait of one of the few riveting American faces he had somehow overlooked. Daniel Webster, the fierce, dome-browed freedom advocate, had, along with Henry Clay and John C. Calhoun, dominated the pre–Civil War Senate during its so-called golden years. That French had taken so long to portray Webster was a surprise, especially since they shared not only a given name, but a common heritage:

like the sculptor, "Black Dan" had been born in New Hampshire and then settled in Massachusetts. Perhaps it was only that no patron had ever before hired French to portray him. Now, unaware that the sculptor was ailing, a committee approached him with a plan to erect a Webster statue in time for the 1932 sesquicentennial of his birth. It would occupy the New Republic Bridge on the Daniel Webster Highway in Franklin, New Hampshire, close to the Senate lion's Salisbury birthplace.[80]

Surviving maquettes of a full-figured Webster indicate that the sculptor at first hoped to create a standing statue.[81] New Hampshire's reigning US senator, George H. Moses, seconded the motion that French undertake the work, but suggested that to conserve time, money, and energy he create not a full statue but a bas-relief. For a time, French was adamant that Webster deserved a statue, and that the sculptor deserved what might be his final chance to create one. In fact, he told patrons in July 1931 that "the more I have considered the subject, the more I am convinced that if it is possible to afford it, there should be a statue rather than a bust or relief. I feel so strongly about this, and I have developed so keen a desire to deal with the problem, that I feel disposed to make almost any concessions in my price to meet the appropriation available for the monument."[82] Eventually accepting his own limitations, French ultimately agreed to settle for a bust. He offered either to advise his patrons on the project or to undertake it himself as long as they understood that "my health will not permit me to visit Franklin personally."[83] Moses agreed, settling on the bust portrait and asking French to remain directly involved in its creation.

More than half a century earlier, young Dan French had taken up professional residence at the Florence studio of Thomas Ball—where he had first encountered, and admired, the old sculptor's recently completed statue of Webster. Returning home from Italy to sculpt Ralph Waldo Emerson, he had heard from his subject's own lips that among all the famous men he had met, Webster ranked in his view highest. Now, in a sense coming full circle, French would at last get his own chance at those distinctive features. As it transpired, however, the Webster commission came a bit too late. Daniel Chester French never completed the portrait he was born to create. Margaret French Cresson was by then a competent enough sculptor to complete it herself.

◆　◆　◆

Merely by reaching age eighty-one, though now in rapidly declining health, French made news yet again—as an American treasure celebrated just for surviving another year. Enduring one more round of birthday interviews in

New York about "the passing parade in the arts," he again cantankerously underestimated his long-proven ability to communicate in words.

"To paraphrase a truism," he insisted that day, "if an artist is a good speaker, he isn't an artist." Asked nonetheless to comment on the proposed new designs for the massive midtown development to be known as Rockefeller Center, French admitted that he had not felt strong enough to head uptown to view the controversial models for himself. But he hastened to add that, in his opinion, too many architects were subjected to criticism before the "cellar was dug" on their buildings. Then, halting himself in midthought, he told the reporter that he seemed to be violating his own cautionary restraints by "proffering opinions on art" after all. Who had a better background to do so, the interviewer countered in an obvious attempt to encourage French to keep talking, than the creator of the statue at the Lincoln Memorial? "But," French had the last grumpy word, "backgrounds aren't in the fashion now, are they?"[84] That choleric expression would prove to be the last public comment he ever made.

That May, after practically willing himself back to Stockbridge, French took to his bed more frequently than ever, repeatedly felled by unspecified illnesses. In September he suffered a heart attack, but stubbornly refusing to be hospitalized, remained at home to convalesce. The Webster bust was left unfinished. When doctors proposed hiring a round-the-clock nurse to tend him, French responded to the suggestion by pouting "like a child." The doctor tried appealing to his well-known eye for beauty by assuring his patient that the woman he had in mind was "pleasant and attractive." French replied: "The sad part of it is...that I feel so down I don't care whether she is pretty or not."[85]

"Mr. French may live to a hundred, and I hope he does," commented his country neighbor, the appropriately named Frank P. Stockbridge, in a story published in the local press a few days later. "But when the end comes, he will be found still working, like the artist in his own beautiful piece which stands in the Metropolitan Museum, called 'Death and the Sculptor.'"[86] In truth, French's working days at the studio had come to an end.

Only a few months earlier, Margaret and husband Penn Cresson had stepped into the Chesterwood studio late one afternoon to ask if the old man might like to join them for a stroll on the grounds. French had been working hard and clearly needed a break. But he would not be budged from the studio. After a few more entreaties, French finally turned to his daughter and son-in-law and said: "Do you know what I'd really like to do? I'd like to live to be two thousand years old and just 'sculp' all the time."[87]

"He was worn and thin," Margaret now sadly observed, "like old silver. He felt miserable a good deal of the time and his voice seemed to be failing."[88] In an attempt to cheer him up, a trio of friends visited Chesterwood in mid-September 1931, including his old Lincoln Memorial colleague Charles Moore, now serving in the post French had once held as chairman of the National Commission of Fine Arts. Joining him were the married sculptors Laura Gardin Fraser and James Earle Fraser. James had first met French as a precocious teenage contributor to the sculptural displays at the 1893 Chicago World's Fair; Laura had just won the coveted commission to sculpt a profile of George Washington for the new silver quarter.

Sadly, French was too weak or too self-conscious about his emaciated appearance to greet his guests, but sent word from his bedroom that he hoped they would walk over to his studio and have a look at *Andromeda*. They did as they were asked. "Nothing," James Fraser marveled after viewing the statue, "could be more wholly perfect than the modeling of that arm, fresh from Mr. French's chisel. One could see how a master's hand had caressed and enveloped every plane in its right relation to the whole."[89] But the master's hand could accomplish no further labor.

On October 6, 1931, the ailing old sculptor summoned the strength to leave his bed while a nurse changed the sheets. He used the opportunity to glance out the window to take in the splendid view that had first enthralled him four decades earlier: his long-inspiring Chesterwood realm, so rich in memories of creative accomplishment and family happiness. The next morning, with Mamie at his side, Daniel Chester French died—as customary with him, without further word—in his sleep.

Repeatedly recalling his great Milmore work, headline after headline announced French's passing with the same apt words: "Death Stays the Sculptor's Hand."[90] President Herbert Hoover sent Mary a condolence message meant not just for the widow but for the entire nation: "He was recognized not only in this country but throughout the world, as an artist of pre-eminent skill and power. He wrought in marble imperishable incidents and personages of American history. His statue of Abraham Lincoln in the Lincoln Memorial in the national capital will be a national shrine forever."[91] One editorial approvingly commented, "President Hoover does not indulge of hyperbole when he writes of Mr. French."[92] Another obituary writer punctuated his tribute with a prediction: "He was the classic spirit among us, and the essence of classicism is immortality."[93]

The funeral took place on Sunday, October 11, in the flower-bedecked Chesterwood studio, with *Andromeda* and his other sculptures serving as a

backdrop, and several of his plaster models arranged "beside [his] coffin." Most conspicuous of all was his beckoning angel *The Genius of Creation*, its hands outstretched toward the bier as if in a blessing. Nearby stood the large model for the enthroned Lincoln, with French's many medals and awards arrayed at its base. To another side rested French's "unfinished bust in clay of Daniel Webster, with the working tools just as he had left them the last day he was in the studio."[94]

From across the country, friends and relatives had descended on Stockbridge to join Mary, Margaret, and Penn for the service, including Will French's widow and an assortment of cousins. The Metropolitan Museum sent two representatives. Onetime partners, patrons, and fellow artists on hand for the ceremony included Cass Gilbert, James Earle Fraser, Stirling Calder, Edwin Blashfield, Augustus Lukeman, Herbert and Adeline Adams, George Foster Peabody, and "Uncle Peach," the marble-cutter Attilio Piccirilli. Stockbridge neighbors vied for the few remaining chairs, with most forced to stand.

During the memorial service, Frank Stockbridge read a poem he had composed to honor his friend:

> Where the great craftsmen stand
> Close to the Throne—
> Ageless the Sculptor's hand,
> Flawless the stone—
> There shall these hands work on
> For work's pure joy alone,
> Find in Celestial stone
> Beauty unknown.[95]

French's onetime model, Rosalie Miller, whose musical studies the sculptor had helped to fund, then sang two hymns, ending with Schubert's *Rest in Peace*.[96] After the service, French's ashes returned to Concord for interment at Sleepy Hollow Cemetery, where Emerson's remains rested, and the *Melvin Memorial* still stood. The gravestone was simple. Beneath a laurel wreath designed by Margaret, just four words were inscribed: "A Heritage of Beauty."

True to character and his admiration for French, art critic Royal Cortissoz provided a sympathetic final word, delivering a eulogy to French at the American Academy of Arts and Letters a few weeks later. Hailing his old friend as "a singularly penetrating interpreter of the types it fell to him

Funeral of Daniel Chester French, in the studio at Chesterwood, Stockbridge, MA, October 11, 1931

to commemorate," Cortissoz conceded that in a modern age "saturated" with statues by modernists such as Maillol, Daniel Chester French "made no appeal" to trends or fads. Cortissoz instead argued for French's timeless importance. "He was all for simplicity and a grave, measured handling of a problem." He "drove absolutely at poise and dignity." Sculpture "was not 'easy' for him, for he made it an affair of depth and emotion. He was "a sculptor, pure and simple."[97]

Perhaps no one more accurately defined French's career than the uncredited *New York Times* writer who praised him a few days after his death as a "distinctively American 'apostle of beauty'" and a "Patriot Sculptor." As the writer astutely observed: "There was in all that he did a certain restraint, a self-control and conscientious fidelity characteristic alike of Greek and Puritan." Above all, "It was his representation of America's best that insured him a tremendous popularity and has given him a place of honor in the history of American sculpture."[98]

"Greatest of all" those sculptures, as another print eulogist reminded readers, remained "the heroic statue of Lincoln in the Lincoln Memorial at Washington. Surely there is divine inspiration in that marvelous face of marble, with eyes that seem to see far more than other men can see of God and man and national destiny."

True, conceded the writer, "We are likely to think only of Lincoln as we stand in that presence. Such is the genius of perfect art. But when we go again to the Lincoln Memorial let us see if we do not feel that the spirit of the sculptor also is there."[99]

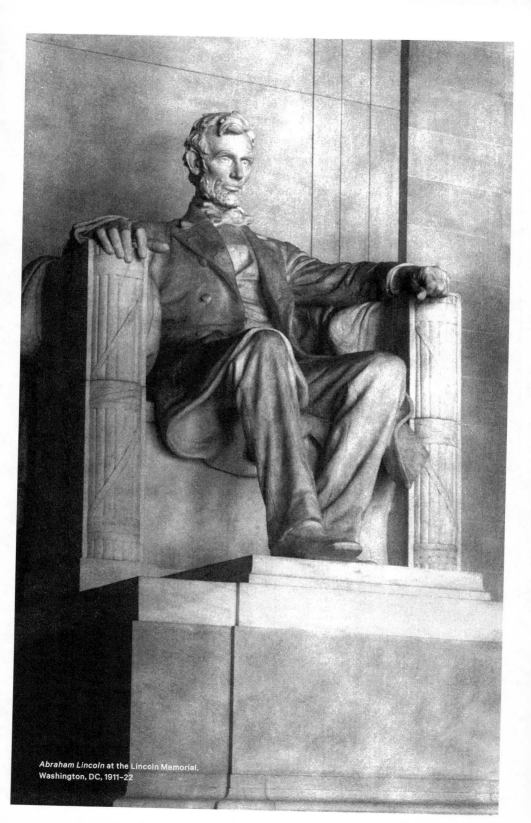

Abraham Lincoln at the Lincoln Memorial,
Washington, DC, 1911–22

"THE HALLOWED SPOT"

The metamorphosis of the Lincoln Memorial into something greater than a memorial to Lincoln began seventeen years after its dedication to an audience forcibly divided between whites and blacks.[1]

In the spring of 1939, the great African American contralto Marian Anderson was blocked from performing at Constitution Hall, the Washington headquarters of the lily-white Daughters of the American Revolution. In protest, First Lady Eleanor Roosevelt resigned from the organization and urged that the concert be relocated to an even larger stage: the steps of the Lincoln Memorial.[2] There, Anderson's hour-long Easter Sunday program attracted an integrated crowd of seventy-five thousand, "the largest assemblage Washington has seen since Charles A. Lindbergh came back from Paris."[3] A national radio broadcast brought to every part of the country Anderson's magnificent renditions of such pieces as "My Country, 'Tis of Thee" and "Nobody Knows the Trouble I've Seen."

Welcoming the throng to what he called "this great auditorium under the sky," Secretary of the Interior Harold Ickes declared to loud applause: "Genius, like Justice, is blind. For Genius with the tip of her wing has touched this woman, who, if it had not been for...the great heart of Lincoln, would not be able to stand among us today a free individual in a free land."[4] The meaning of the Lincoln Memorial would never again be the same; it had been transfigured at last, in the course of a single hour, from a monument to sectional reunion into a touchstone for racial reconciliation. As the African American educator Mary McLeod Bethune put it: "Through the Marian Anderson protest concert we made our triumphant entry into

Dr. Martin Luther King Jr., interviewed at the Lincoln Memorial
during the March on Washington, August 28, 1963

the democratic spirit of American Life."[5] The Lincoln Memorial became a source of that spirit on the very same afternoon.

The prestige of the memorial soon expanded further through the power of popular culture. The film *Mr. Smith Goes to Washington*, released just six months after the Anderson concert, featured a particularly evocative scene set within its interior atrium. In search of inspiration, the uncertain freshman "Senator Jefferson Smith," in the person of Lincolnesque actor James Stewart, visits the memorial on his first day in Washington. There he studies the wall text of Lincoln's Second Inaugural with wide-eyed awe, and listens "dewy-eyed" as a little boy reads aloud from the Gettysburg Address to his visually impaired grandfather. An elderly black man then enters the memorial atrium and doffs his hat, his own eyes filling with tears, just as the words "new birth of freedom" escape haltingly from the child's lips. The scene

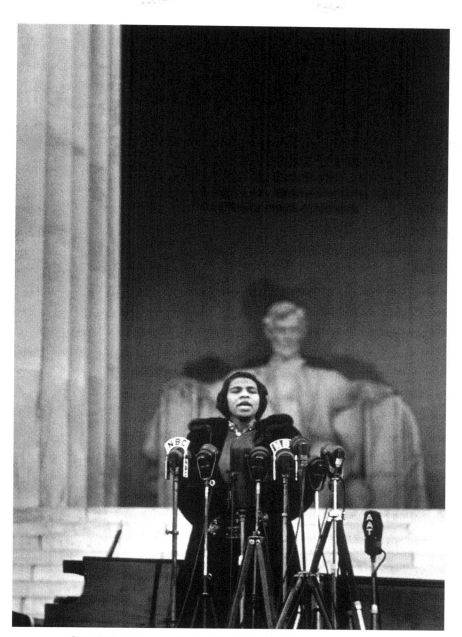

Singer Marian Anderson performing in front of the Lincoln Memorial, April 9, 1939, after she was denied the use of a DAR hall because of her race

fades out with a giant close-up of the statue's face to the swelling strains of the "Battle Hymn of the Republic," "The Star-Spangled Banner," and the folk song "Red River Valley." Millions of movie fans flocked to see the film. It earned an eight-million-dollar profit in its original release, and has aired countless times since on television.[6]

That it exposed many Americans to the memorial for the first time was no accident. Its patriotic Italian-born immigrant director, Frank Capra, fully intended that his movie consecrate the Lincoln Memorial as the dominant visual representation of American virtue. After a site inspection he had concluded that "the most majestic shrine we have in America," the "colossal marble figure of our greatest man—rumpled, homely—his eyes daily filling the hearts of thousands of Americans" offered the perfect symbol of resistance to the growing fascist threat from Europe. "The more uncertain are the people of the world," Capra believed, "the more their hard-won freedoms are scattered and lost in the winds of chance, the more they need a ringing statement of America's democratic ideals. The soul of our film would be anchored in Lincoln."[7]

Twenty-four years later, after an era filled with real-life struggles, came the most pivotal moment in the Lincoln Memorial's entire history, and one of the most important moments in all of American life. On August 28, 1963, Dr. Martin Luther King Jr. stood at what he called a "hallowed spot": the same top step from which Robert Russa Moton had been censored and then banished some forty years earlier; the same terrace from which Marian Anderson had sung in 1939. Here, Dr. King delivered his momentous "I Have a Dream" speech to a crowd of two hundred thousand and a television audience of millions more. The Lincoln statue loomed behind him as Dr. King spoke from what he called its "symbolic shadow." The oration provided not only the thrilling culmination of the history-altering March on Washington, but the crowning moment of Dr. King's cruelly interrupted life, and a high-water mark for the modern civil rights movement.

More recent, signal occasions on the memorial steps—including the emotionally tortured Richard Nixon's secret, but widely reported, midnight visit just days before his 1972 resignation, along with President-elect Barack Obama's triumphant preinaugural appearance there in 2009, and his 2013 speech to commemorate the fiftieth anniversary of Dr. King's—have cemented the memorial's status as both a national mecca and a national symbol. The Lincoln Memorial has evolved into the sacred place at which pilgrims, visionaries, prophets, and penitents gather to reaffirm their connection to the American dream, and on memorable occasions, to expand

Dr. Martin Luther King Jr., giving his "I Have a Dream" speech at the
Lincoln Memorial, August 28, 1963

it. It has become an altar of freedom and equality despite the more benign
intentions of those who built it and the malevolent restrictions imposed by
those who dedicated it.

In 1976, the US Senate authorized the Interior Department "to inscribe
on the walls...at an appropriate place in a manner and style consistent with
the existing inscriptions of the names of the 48 states, the names of Alaska
and Hawaii."[8] After an outpouring of protest by architects and historians, the
plan to alter Bacon's original conception for the attic parapet was dropped.
It is hard to improve upon perfection. Not that the memorial will remain
unchanged. It is currently undergoing an $18.5 million renovation funded
by the generous Washington philanthropist David M. Rubenstein, which
will add classrooms and exhibition space, and open up the cavernous stalac-
tite-covered basement undercroft, which features graffiti left by the original
workers who built the memorial.[9] Meanwhile, Northeast Washington, DC,
has welcomed a new mural honoring the African American laborers who
once quarried the Georgia marble used to construct French's statue.[10]

Ninety-five years after its flawed dedication, the *New York Times*
published a report on "America's Most Popular Statues," ranking them

according to data amassed from the National Park Service, the website TripAdvisor, and Travelport, a travel research firm based in Great Britain. The Lincoln Memorial, which by the end of July 2017 had drawn 4.74 million visitors, not including protestors and marchers at the National Mall, placed number one.[11]

◆ ◆ ◆

Mary French outlived her husband by less than eight years. The sculptor's widow and biographer died in January 1939 in a Great Barrington, Massachusetts, hospital after fracturing her shoulder and hip in a holiday-time fall at a friend's house. She was seventy-eight.[12]

Their daughter, Margaret "Peggy" French Cresson, went on to write a charming book of her own about her father: *Journey into Fame*. Undeterred by rejections from commercial publishers, she persevered with her manuscript until it was accepted by Harvard University Press, which issued the book in 1947. She also produced a series of articles and reminiscences about her father, most of which remain unpublished.[13]

Margaret also enjoyed a significant career as a sculptor in her own right, specializing in marble bust portraits. Encouraged by her father, she had studied under the Iowa-born feminist artist Abastenia St. Leger-Eberle and the Greek-born teacher George Demetrios. During her lifetime her work was featured at several exhibitions, and one of her busts was acquired by the Corcoran Gallery of Art in Washington—the same institution that once declined to purchase Daniel Chester French's *Endymion*.[14] Margaret's husband, William Penn Cresson, died in 1932, just a year after her father's passing. The couple had no children.

Margaret spent much of her final years championing, and endeavoring to locate and preserve, her father's work. In one example of her relentless pursuit of his scattered early sculptures, she sought the return of the plaster casts French had once sent to the Art Institute of Chicago, his brother's museum. When its then-reigning director wrote to report regretfully that the works were "no longer in existence," Margaret responded with understandable anger. Writing to "protest" the "calamity" of their loss, she replied: "In other words, they were destroyed, and I can see why you do not care to use the word." The director sheepishly conceded that the works had been "eliminated from the collection" for no better reason than to open up "space for showing originals."[15]

Margaret also lived in, and saved, the family's Chesterwood property, succeeding in locating and bringing back to the estate many of the scattered

Civil rights March on Washington, DC. Leaders of the march posing in front of the statue of Abraham Lincoln, Lincoln Memorial, August 28, 1963. These include (front row, from left to right) Whitney M. Young Jr., Cleveland Robinson, A. Philip Randolph, Martin Luther King Jr., and Roy Wilkins. Standing behind them are future congressman John Lewis (third from left) and Floyd McKissick (second from right).

Daniel Chester French sculptural models that had been crafted there. She also preserved her father's papers and, in 1968, transferred the estate and its contents, while maintaining life interest in the residence, to the National Trust for Historic Preservation. It was at her father's spectacular home, while addressing the Chesterwood Advisory Council, that Margaret French Cresson collapsed and died of an apparent heart attack on October 2, 1973. She was eighty-four. Today, thanks in large measure to her foresight and beneficence, Chesterwood endures as a major cultural attraction and education center in the Berkshires.

Geographical List of Public Works

This list includes the major public works by Daniel Chester French that are permanently displayed and publicly accessible. The following works have been included: sculpture in parks, public gardens, and town squares; sculpture that is part of a building's architecture or featured on the exterior of a building; and important funerary works in cemeteries and memorial parks.

* Some works, including many funerary monuments, may not be accessible twenty-four hours a day. Check specific locations for opening times.

CALIFORNIA

GLENDALE
*The Republic, marble and bronze, Forest Lawn Memorial Park, Court of Freedom
1895

SAN FRANCISCO
Thomas Starr King, bronze, Golden Gate Park, Intersection of John F. Kennedy and Music Concourse Drives
1888–92

GEORGIA

ATLANTA
Samuel Spencer, bronze, Norfolk Southern Corporation Plaza, 1200 Peachtree Street NE
1909–10

ATLANTA
*Jesse Parker Williams Memorial (Spirit Of Achievement), marble, Westview Cemetery
1915–20

SAVANNAH
Governor James Edward Oglethorpe, bronze, Chippewa Square
1907–10

ILLINOIS

CHICAGO
The Bulls: Indian Corn and Wheat [with Edward Clark Potter], two bronze groups, Garfield Park original 1893; cast from plaster working models ca. 1914

CHICAGO
General George Washington [with Edward Clark Potter], bronze equestrian [replica of original in Paris], Washington Park, Fifty-First Street and Dr. Martin Luther King Jr. Drive
1903–04

CHICAGO
*Marshall Field Memorial (Memory), bronze, Graceland Cemetery and Arboretum
1908–12

CHICAGO
The Republic, gilded bronze, Jackson Park
1915–18

INDIANA

MUNCIE
Ball Brothers Memorial (Beneficence), bronze fountain, Ball State University, 2000 West University Avenue
1929–31; dedicated 1937

IOWA

COUNCIL BLUFFS
Ruth Anne Dodge Memorial (Dream Angel), bronze fountain, Lafayette Avenue and North Second Street, at the edge of Fairview Cemetery
1916–20

AS

LAWRENCE
Dean James Woods Green, bronze group,
University of Kansas, Lippincott Hall, Jayhawk
Boulevard
1922–24

MASSACHUSETTS

BOSTON
*Science Controlling the Forces of Electricity and
Steam*, marble group from the old Boston Post
Office building, moved to current location in 1930,
Dorchester, Franklin Park, flanking the Giraffe
Entrance to Franklin Park Zoo
1880–85

BOSTON
Labor Sustaining Art and the Family, marble group
from the old Boston Post Office building, moved to
current location in 1930, Dorchester, Franklin Park,
flanking the Giraffe Entrance to Franklin Park Zoo
1882–85

BOSTON
*Milmore Memorial (The Angel of Death Staying
the Hand of the Sculptor)*, bronze relief, Jamaica
Plain, Forest Hills Cemetery
1889–93

BOSTON
Clark Memorial (Kneeling Angels), marble reliefs,
Jamaica Plain, Forest Hills Cemetery
1894

BOSTON
*John Boyle O'Reilly Memorial (Erin and Her Sons,
Patriotism and Poetry)*, bronze group and bust,
the Fenway, at Boylston Street
1892–97

BOSTON
George Robert White Memorial (Angel of Peace),
bronze, Jamaica Plain, Forest Hills Cemetery
1898

BOSTON
General Joseph Hooker [with Edward Clark Potter],
bronze equestrian, State House Grounds
1898–1903

BOSTON
*Music and Poetry, Knowledge and Wisdom, Truth
and Romance* (left to right), bronze reliefs, Boston
Public Library, Entrance Doors, Copley Square,
1894–1904

BOSTON
Francis Parkman Memorial, granite inset relief
and bronze plaque, Jamaica Plain, Olmsted Park,
Parkman Drive
1897–1907

BOSTON
Wendell Phillips, bronze, Boston Public Garden,
near Boylston and Charles Streets
1913–15

BOSTON
*George Robert White Memorial (The Spirit of
Giving)*, bronze fountain, Boston Public Garden,
near Beacon and Arlington Streets
1922–24

CAMBRIDGE
John Harvard, bronze, Harvard University, in front
of University Hall, Harvard Yard
1883–84

CAMBRIDGE
Henry Wadsworth Longfellow Memorial,
bronze bust and marble relief, Longfellow Park,
Mt. Auburn Street
1912–14

CONCORD
The Minute Man, bronze, North Bridge,
on the west bank
1871–75

CONCORD
Melvin Memorial (Mourning Victory), marble relief,
Sleepy Hollow Cemetery
1906–9

MILFORD
General William Draper, bronze equestrian,
General Draper Park, Main Street
1910–12

MILTON
Milton War Memorial (In Flanders Fields), bronze,
Town Green
1923–25

WORCESTER
General Charles Devens [with Edward Clark
Potter], bronze equestrian, Main and Highland
Streets, in front of the old Worcester County
Courthouse
1902–6

WORCESTER
Senator George Frisbie Hoar, bronze, City Hall,
near the corner
1907–8

MICHIGAN

DETROIT
Russell Alger Memorial, bronze fountain and
portrait medallion, Grand Circus Park
1913–21

MINNESOTA

MINNEAPOLIS
Governor John S. Pillsbury, bronze, University of Minnesota, Pillsbury Drive SE
1900

SAINT PAUL
Wisdom, Courage, Bounty, Truth, Integrity, Prudence (left to right), marble on entablature, State Capitol
1896–1901

SAINT PAUL
The Progress of the State [with Edward Clark Potter], gilded sheet copper quadriga and three figures in front of the dome, State Capitol
1905–7

MISSOURI

KANSAS CITY
August Robert Meyer Memorial, bronze portrait relief, Paseo Boulevard and Tenth Street
1907–9

ST. LOUIS
Peace and Vigilance, marble group, US Custom House and Post Office, original inside, reproduction on facade
1878–82

ST. LOUIS
Sculpture, marble, Saint Louis Art Museum, at entrance
1913–15

NEBRASKA

LINCOLN
Abraham Lincoln [standing], bronze, State Capitol, west entrance
1909–12

NEW HAMPSHIRE

CONCORD
Commodore George Hamilton Perkins Memorial, bronze, on the State House Grounds, behind the New Hampshire Historical Society
1899–1902

CONCORD
Modern and Ancient History Flanking the Seal of The New Hampshire Historical Society, granite relief, New Hampshire Historical Society, above main entrance doorway
1909–11

EXETER
Exeter War Memorial, bronze group, Gale Park, Front and Linden Streets
1920–22

FRANKLIN
Daniel Webster Memorial [completed by Margaret French Cresson], bronze bust, in front of the Congregational Christian Church, South Main Street
1931–32

NEW JERSEY

ALLAMUCHY
Rutherfurd B. Stuyvesant Memorial (Angel of Peace), marble, Tranquility Cemetery
1912–14

NEW YORK

ALBANY
General Philip H. Sheridan [after John Quincy Adams Ward], bronze equestrian, Capitol Park
1916

FLORIDA
William Henry Seward Memorial, bronze bust, Main Street
1923–30

IRVINGTON
Washington Irving Memorial, bronze bust and reliefs, Broadway (Route 9) and Sunnyside Lane
1924–27

THE BRONX
Kinsley Memorial, marble high relief, Woodlawn Cemetery
1908–12

THE BRONX
Edgar Allan Poe, bronze bust, City University of New York, Bronx Community College, Hall of Fame for Great Americans
1922

THE BRONX
Ralph Waldo Emerson, bronze bust, City University of New York, Bronx Community College, Hall of Fame for Great Americans
1923

THE BRONX
Phillips Brooks, bronze reworking of marble bust, City University of New York, Bronx Community College, Hall of Fame for Great Americans
1924

THE BRONX
Nathaniel Hawthorne, bronze bust, City University of New York, Bronx Community College, Hall of Fame for Great Americans
1928–29

BROOKLYN
Greek Epic Poetry, marble, Brooklyn Museum of Art, attic story, first from right center, Brooklyn
1907–9

BROOKLYN
Greek Lyric Poetry, marble, Brooklyn Museum of
Art, attic story, second from right center, Brooklyn
1907–9

BROOKLYN
Greek Religion, marble, Brooklyn Museum of Art,
attic story, third from center right
1907–9

BROOKLYN
*Manhattan and Brooklyn (Manhattan Bridge
Groups)*, two granite groups, Brooklyn Museum of
Art, near entrance
1913–16

BROOKLYN
Marquis de Lafayette Memorial, bronze high
relief, Prospect Park, at Ninth Street Entrance and
Prospect Park West
1914–16

BROOKLYN
Alfred Tredway White Memorial, bronze relief,
Brooklyn Botanic Garden
1921–23

MANHATTAN
*University Club Seals (Seals of Harvard University,
Yale University, Princeton University, Columbia
University, Brown University, Williams College,
Amherst College, and Hamilton College, and
Military and Naval Academies)*, University Club
facade, 1 West Fifty-Fourth Street
1898

MANHATTAN
Justice, marble group, Appellate Court House,
Madison Square and East Twenty-Fifth Street,
above the pediment
1899–1900

MANHATTAN
Richard Morris Hunt Memorial, bronze sculpture,
Central Park side of Fifth Avenue, between
Seventieth and Seventy-First Streets
1896–1901

MANHATTAN
Alma Mater, gilded bronze, Columbia University,
Low Library, front steps
1900–1903

MANHATTAN
*Continents (left to right, Asia, America, Europe,
Africa)*, marble groups, Alexander Hamilton US
Custom House, now National Museum of the
American Indian–New York, Bowling Green
1903–7

SARATOGA SPRINGS
Spencer Trask Memorial (The Spirit of Life), bronze
fountain, Congress Park, east end
1913–15

OHIO

CLEVELAND
Jurisprudence and Commerce, two marble groups,
Old Federal Building, 201 Superior Avenue, on far
left and far right of entrance
1905–8?

CLEVELAND
Edward I, marble, Cuyahoga County Court House,
1200 Ontario Avenue, south facade, attic story,
third statue from left
1910

CLEVELAND
John Hampden, marble, Cuyahoga County Court
House, 1200 Ontario Avenue, south facade, fourth
statue from left
1910

PENNSYLVANIA

EASTON
Marquis de Lafayette, bronze, Lafayette College,
Colton Chapel, south entrance
1921

PHILADELPHIA
Law, Prosperity, and Power, marble group for US
Post Office and Federal Building in Philadelphia,
moved to current location in 1937, Fairmount Park,
South George's Hill Drive, north of Mann Music
Center
1878–82

PHILADELPHIA
General George Meade, bronze, Smith Memorial
Arch (Civil War Memorial), North Concourse and
Lansdowne Drive, West Fairmount Park, atop the
right column
1898

PHILADELPHIA
Ulysses S. Grant [with Edward Clark Potter], bronze
equestrian, Fairmount Park, along Kelly Drive at
Fountain Green Drive
1892–99

PITTSBURGH
Colonel James Anderson Memorial, bronze bust
and figure, Carnegie Free Library of Allegheny,
Federal and Ohio Streets, Allegheny Square
1899–1904

PITTSBURGH
*George Westinghouse Memorial and Spirit of
American Youth,* gilded bronze portrait relief, figural
reliefs, and figure, Schenley Park, by the entrance to
Steve Faloon Trail
1926–30

RHODE ISLAND

PEACE DALE
Hazard Memorial (Life, Time, and the Weaver),
bronze relief, South Kingston Public Library
Grounds
1918–20

WISCONSIN

MADISON
Wisconsin, gilded bronze, State Capitol, dome finial
1912–14

MILWAUKEE
T. A. Chapman Memorial bronze, Forest
Home Cemetery
1896–97

WASHINGTON, DC

Thomas Gallaudet Memorial, bronze,
Gallaudet University, Kendall Green
1885–89

*Francis Davis Millet And Major Archibald Butt
Memorial*, marble fountain reliefs, the Ellipse,
Executive Avenue and Ellipse Drive, at Northwest
Junction
1912–13

*Admiral Samuel Francis Dupont Memorial
(Sea, Wind, and Sky)*, marble fountain reliefs,
Dupont Circle
1917–21

Abraham Lincoln, marble, Lincoln Memorial, Lincoln
Memorial Circle NW
1911–22

First Division Memorial (Victory), bronze,
President's Park South
1921–24

FRANCE

PARIS
General George Washington [with Edward Clark
Potter], bronze equestrian, Place d'Iéna
1896–1900

STRASBOURG
*The Marseillaise Memorial (Claude Rouget de Lisle
Memorial)*, bronze relief, Town Hall, inner courtyard
1919–20

Notes

EPIGRAPHS

Arnold Rampersad, ed., *The Collected Works of Langston Hughes*, 1931 (repr. New York: Alfred A. Knopf, 1994), 103. Margaret French Cresson, *Journey into Fame: The Life of Daniel Chester French* (Cambridge, MA: Harvard University Press, 1947), 291.

PROLOGUE
IN THIS TEMPLE

1 *Washington Times*, May 28, 1922. Women had won the right to vote two years earlier with ratification of the Nineteenth Amendment to the Constitution.
2 *Chicago Broad Ax*, June 17, 1922.
3 *Baltimore African-American*, June 2, 1922.
4 *New York Age*, June 10, June 17, 1922.
5 *Washington Tribune*, June 3, 1922.
6 Although the title has been challenged by some late-twentieth-century and early-twenty-first-century historians, it was in common use in the 1920s. The African American weekly, *New York Age*, called Lincoln the "Great Emancipator" on June 17, 1922.
7 *Washington Tribune*, June 3, 1917; *Baltimore Afro-American,* June 2, 1922. The *Chicago Defender* (June 10, 1922) identified the insulted official as Whitfield McKinley (also reported as "McKinlay"), former collector of the Port of Georgetown.
8 *Chicago Defender,* June 10, 1922. For an evocative summary of the event, see Christopher A. Thomas, *The Lincoln Memorial & American Life* (Princeton: Princeton University Press, 2002), 156.
9 *New York Age*, June 10, June 17, 1922.
10 *Washington Post*, May 31, 1922.
11 *New York Age*, June 17, 1922.
12 *Chicago Defender*, June 10, 1922.
13 *Crisis*, 24 (July 1922): 122.

14 Philip S. Foner and Yuval Taylor, eds., *Frederick Douglass: Speeches and Writings* (Chicago: Lawrence Hill Books, 1999), 618. Douglass spoke at the dedication of Thomas Ball's *Emancipation Group.*
15 *Louisville Courier-Journal*, May 28, 1922.
16 Harold Holzer, ed., *The Lincoln Anthology: Great Writers on His Life and Legacy from 1860 to Now* (New York: Library of America, 2009), 432–34. For the original, see "Address [at the Lincoln Memorial] as originally written," Box 11, folder 13, Moton Family Papers, Library of Congress. Also see William H. Taft to Robert R. Moton, May 23, 1922, Taft Papers, Library of Congress.
17 Holzer, *The Lincoln Anthology*, 430, 433–34; a paraphrased highlight was featured on the front page of the *Baltimore American,* June 2, 1922.
18 Albert Boime, *Unveiling of the National Icons: A Plea for Patriotic Iconoclasm in a Nationalist Era* (Cambridge: Cambridge University Press, 1998), 295.
19 Ibid.
20 *Chicago Defender,* June 10, 1922.
21 Thomas, *The Lincoln Memorial & American Life*, 123.
22 "Political religion" from Lincoln's speech to the Young Men's Lyceum, Springfield, Illinois, January 27, 1838; "almost chosen people" from Lincoln's speech to the New Jersey State Senate, Trenton, February 21, 1861, Basler, *Collected Works of Lincoln*, 1:112, 4:236.
23 For an appraisal of Lincoln's evolving, and in many ways declining, reputation, see Barry Schwartz, *Abraham Lincoln and the Forge of National Memory* (Chicago: University of Chicago Press, 2000), esp. chap. 7. A harsher judgment can be found in Lerone Bennett Jr., *Forced into Glory: Abraham Lincoln's White Dream* (Chicago: Johnson Publishing, 1999).
24 For the Mauldin cartoon, see Harold Holzer and Gabor Boritt, "Lincoln

in 'Modern Art,'" in Boritt, ed., *The Lincoln Enigma: The Changing Faces of an American Icon* (New York: Oxford University Press, 2001), portfolio section following p. 152.

25 Cresson, *Journey into Fame*, 299.

26 First Inaugural Address, March 4, 1861, in Basler, ed., *Collected Works of Lincoln*, 4:271.

CHAPTER ONE
THE MAKING OF A SCULPTOR

1 D. C. F. to William M. R. French, April 3, 1878, Daniel Chester French Papers, LOC; Michael Tingley Richman, "The Early Career of Daniel Chester French, 1869–1891," PhD dissertation, University of Delaware, 1974, typescript copy in the collection of Chesterwood, Stockbridge, MA, 149n2.

2 Though this and two similar commissions for architectural sculpture—in Philadelphia and Boston—were to decorate post offices, the jobs came from the Treasury Department, where the elder French served as assistant secretary.

3 Henry Flagg French to D. C. F., October 8, 1878, French Family Papers, LOC. The St. Louis project paid good wages by 1878 standards, but still constituted a laborer's remuneration, not an artist's. A similar commission to create architectural decorations for yet another post office in Philadelphia seemed equally unappealing.

4 D. C. F. to William M. R. French, May 15, 1878, French Family Papers, LOC.

5 D. C. F. to William M. R. French, October 3, 1881, French Family Papers, LOC.

6 Henry Flagg French to Benjamin Brown French, April 21, 1850, French Family Papers, LOC. The French family tree was already incredibly complicated. Eleven years his senior, brother Benjamin was also Henry's brother-in-law—since his wife, Elizabeth, was Anne French's older sister.

7 Ibid.

8 Margaret French Cresson, *Journey into Fame: The Life of Daniel Chester French* (Cambridge, MA: Harvard University Press, 1947), opp. 32.

9 Daniel Chester French "Final Interview" with DeWitt McClellan Lockman (1927), original typescript in the New-York Historical Society, 4. The original manuscript transcription of this extended interview is also housed at the N-YHS, but because it is nearly illegible, the author has chosen to cite the typed version throughout this book (hereinafter cited as Lockman, D. C. F. Interview). Spelling errors have been corrected. Lockman (1870–1957) was a well-known portrait painter who produced a number of interviews with artists and architects associated with the National Academy of Design. Why he compiled this interview, accompanied by a list of known French works, remains unknown. Two years after preparing it, Lockman became a trustee of the Historical Society, and remained a member of its board until the year of his death.

10 President and Mary Lincoln prevented their son from enlisting until 1865 when Robert, by then a student at Harvard's law school, joined General Ulysses S. Grant's staff as a captain, serving without exposure to danger for the final few months of the Civil War.

11 Quoted in the *Concord Journal*, October 15, 1932, 2.

12 Mrs. Daniel Chester [Mary] French, *Memories of a Sculptor's Wife* (Boston: Houghton, Mifflin Co., 1928), 46.

13 Lockman, D. C. F. Interview, 6. Here French paraphrased the popular nineteenth-century humorist Artemus Ward.

14 Ibid.

15 Cresson, *Journey into Fame*, 3–6.

16 D. C. F. introduction to William Brewster, *October Farm: From the Concord Journals and Diaries of William Brewster* (Cambridge: Harvard University Press, 1937), vii. French wrote the introduction in the last year of his life, 1931, six years before it appeared in this book.

17 Young French and Brewster were no doubt inspired by Thomas Nuttall, *A Manual of the Ornithology of the United States and Canada* (Cambridge: Hilliard & Brown, 1832).

18 Brewster, *October Farm*, ix.

19 D. C. F., "William Brewster," typescript in the French Family Papers, LOC; for

information about the John Brewster bust, see Richman, "The Early Career of Daniel Chester French" 75.

20 Mrs. Daniel Chester [Mary] French, *Memories of a Sculptor's Wife*, 1, 4–5.

21 Daniel Chester French Journal, original at the Chapin Library, Williams College, Williamstown, MA. French made no mention of the closing days of the Civil War either—even of Robert E. Lee's surrender to Ulysses S. Grant on April 9. During this fraught period he instead focused on sightings of cedarbirds, snow buntings, blue jays, and meadowlarks.

22 French, *Memories of a Sculptor's Wife*, 10–11.

23 The descriptive handwritten card, authored and signed by "B. B. French, Comm. of P. B.," is now in the Chesterwood collection.

24 This is a distillation of two separate quotes: the first, from D. C. F. to Katrina Trask, October 22, 1916, typescript copy in French Family Papers, LOC; the second from D. C. F. to Nicholas Murray Butler, January 8, 1908, Rare Books and Manuscript Library, Columbia University.

25 Lockman, D. C. F. Interview, 8. French took pains to add that the board later vindicated his father.

26 Donald B. Cole and John J. McDonough, *Benjamin Brown French, Witness to the Young Republic: A Yankee's Journal, 1828–1870* (Hanover, NH: University of New England Press, 1989), 595–96.

27 Daniel Chester French, "The Humor of Henry Flagg French, Read to the Gathering of the Clan at the One-Hundredth Anniversary of my Father's Birthday," August 14, 1912," typescript in the French Family Papers, LOC.

28 Henry Flagg French to Gail Hamilton, September 14, 1867, Chesterwood Archives.

29 D. C. F. to William Brewster, September 29, 1867, French Family Papers, LOC.

30 For a litany of celebrated Concord residents, see Gilbert Hasbrouck, dedicatory lecture at the Hall of American Artists, New York University (Hall of Fame), on the unveiling of a bust of Daniel Chester French, May 26, 1934 (privately published by NYU, copy in the French Family Papers, LOC), 2.

31 Henry David Thoreau to Richard Frederick Fuller, April 2, 1843, in F. B. Sanborn, ed., *Familiar Letters of Henry David Thoreau* (Boston: Houghton Mifflin, 1894), 79.

32 "Grotesque" assessment by Helen Emerson, reprinted in Richman, "Early Career of Daniel Chester French," 98; Cresson, *Journey into Fame*, 41.

33 French, *Memories of a Sculptor's Wife*, 27–28; Cresson, *Journey into Fame*, 43.

34 D. C. F. to Warren Whiteman, December 6, 1922, French Family Papers, LOC.

35 Richman, "Early Career of Daniel Chester French."

36 Walter Tittle, "A Sculptor of the Spirit: How Daniel Chester French Puts Character into Marble," [London] *World Today* (December 1928), 55. William French did ultimately become a force in the art world, as founding director of the Art Institute of Chicago and a mesmerizing lecturer who drew pictures as he spoke.

37 Quoted in undated clipping, "Stockbridge Sculptor Talks of Emerson as He Ends Thirtieth Season," *Berkshire Eagle*, clipping in the Stockbridge, MA public library. See also D. C. F. "Prelude" to Caroline Ticknor, ed., *May Alcott: A Memoir* (Boston: Little, Brown & Co., 1928), xx. French recalled that Alcott was known for creating "the best copies of Turner that were ever made." Lockman, D. C. F. Interview, 9.

38 Tittle, "A Sculptor of the Spirit," 55.

39 The "May Alcott tool" now resides in the Chesterwood collection.

40 Cresson, *Journey into Fame*, 47.

41 French, *Memories of a Sculptor's Wife*, 28.

42 The plaster reliefs of Sallie and Harriette French are in Chesterwood's collection.

43 The description of Ward is based on Charles Niehaus's bust of the sculptor, reproduced in Wayne Craven, *Sculpture in America*, 1968 (rev. ed. Newark: American Art Journal & University of Delaware Press, 1984), 465. Ward's *Indian Hunter* was the first statue in Central Park by an American.

44 D. C. F. to Henry Flagg French, March 26, 1870, French Family Papers, LOC.

45 G. W. Sheldon, "An American Sculptor," *Harper's New Monthly Magazine* 57 (June 1878): 62.

46 Lockman, D. C. F. Interview, 10; D. C. F. to Sarah French (Bartlett), April 11, 1870, French Family Papers, LOC.

47 Sheldon, "An American Sculptor," 63.

48 D. C. F. to Henry Flagg French, March 30, 1870, French Family Papers, LOC.

49 D. C. F. to Henry Flagg French, March 26, 1870; Richman, "Early Career of Daniel Chester French," 55–60.

50 Course description recalled in Truman R. Bartlett, *The Art Life of William Rimmer* (Boston: James R. Osgood, 1881), 60.

51 Jeffrey Weidman, *William Rimmer: Critical Catalogue Raisonné*, 7 vols. Reprinted from Dissertation Abstracts International, Vol. 412 (1982). Years later, French helped organize a Rimmer Committee at the Metropolitan Museum of Art dedicated to casting Rimmer bronzes for the museum collection. French himself donated *Fighting Lions*. See Thayer Tolles, ed., *American Sculpture in the Metropolitan Museum of Art*, Vol. 1 (New York: Metropolitan Museum of Art, 1999), 58.

52 Nathan Cabot Hale, "William Rimmer: A Yankee Michelangelo," *Art World*, 10 (Summer 1986): 1.

53 Craven, *Sculpture in America*, 351; Truman Bartlett, *The Art Life of William Rimmer*, 1882 (repr. New York: Da Capo Press, 1970), 46.

54 D. C. F. to William M. R. French, August 22, 1879, French Family Papers, LOC.

55 Tittle, "A Sculptor of the Spirit," 55. A plaster cast of *Mary Fay* is in the Chesterwood collection.

56 "Special pupil" quoted in Richman, "Early Career of Daniel Chester French," 7; McClellan Lockman interviews, 9.

57 D. C. F. sketchbooks in Chesterwood collection.

58 The original of the untitled drawing survives in the collection of the Concord Museum, Concord, Massachusetts.

59 D. C. F. to Elbert Baldwin, February 4, 1916, French Papers, LOC.

60 The basic references are Kimberly Orcutt, *John Rogers: American Stories* (New York: New-York Historical Society, 2010), and David H. Wallace, *John Rogers: The People's Sculptor* (Middletown, CT.: Wesleyan University Press, 1967), esp. 120, 225.

61 Ten months before his death, Lincoln had thanked Rogers for sending him his Civil War–themed group, *Wounded Scout—A Friend in the Swamp*, showing an African American helping an injured Union soldier. Lincoln praised it as "very pretty and suggestive, and, I should think, excellent as a piece of art." See Lincoln to Rogers, June 13, 1864, in Roy P. Basler, ed., *The Collected Works of Abraham Lincoln*, 8 vols. (New Brunswick, NJ: Rutgers University Press, 1953–55), 7:389. In 1868, Rogers featured the late president in a best-selling statuary group titled *The Council of War*, and in 1892 Rogers produced an expressive larger-than-life plaster statue of a seated Lincoln, which he later donated to a library in New Hampshire, the state of French's birth. See Wallace, *John Rogers*, 218–20, 270.

62 D. C. F. to William Sumner Appleton, December 2, 1922, French Family Papers, LOC.

63 A surviving plaster is in the collection of the Concord Museum.

64 French Diary for 1873, French Family Papers, LOC; Tolles, *American Sculpture*, 327–28.

65 A plaster intaglio—undoubtedly the mold for positive plaster versions that may never have been produced—survives in the collection of the Concord Library. See also Oliver Wendell Holmes Jr., *Elsie Venner: A Romance of Destiny* (Boston: Ticknor & Fields, 1861). Holmes described it as a "medicated" novel.

66 Donald B. Cole and John J. McDonough, eds., *Benjamin Brown French, Witness to the Young Republic: A Yankee's Journal, 1828–1870* (Hanover, NH: University Press of New England, 1989), 610.

67 Ibid., 596, 611.

68 Tittle, "A Sculptor of the Spirit," 56.

CHAPTER TWO
THE *MINUTE MAN*

1 *Boston Post*, April 20, 1875. See also, *Proceedings of the Centennial Celebration of Concord Fight, April 19, 1865* (Concord, MA: Tolman & White Printers, 1876), 11–12.

2 Quoted in Margaret French Cresson, *Journey into Fame: The Life of Daniel Chester French* (Cambridge, MA: Harvard University Press, 1947), 67.

3 Quoted in Michael Tingley Richman, "The Early Career of Daniel Chester French, 1869–1891," PhD dissertation, University of Delaware (1974), manuscript copy in the collection of Chesterwood, Stockbridge, MA, 10.

4 Other members of the original commission were George Heywood, George M. Brooks, John B. Moore, and Addison G. Fay, who died and was replaced by Henry F. Smith. Emerson was a later addition, as were Frederic Hudson, George A. King, Andrew J. Harlow, and William W. Wilde. See *Proceedings of the Centennial Celebration*, 12–13.

5 Henry Flagg French letter to unknown recipient, possibly a draft, August 10, 1871, French Family Papers, LOC.

6 October 1871 sketchbook, original in the Chesterwood collection.

7 Cresson, *Journey into Fame*, 65.

8 Quoted in Richman, "Early Career of Daniel Chester French," 10; "pretty bad" in Lockman, D. C. F. Interview, 11.

9 D. C. F. sketchbook in Chesterwood collection.

10 Cresson, *Journey into Fame*, 69.

11 The powder horn and the Jacob Brown coat are in the collection of the Concord Museum. The author is grateful to David F. Wood, curator, Concord Museum, Concord, MA.

12 D. C. F. diary entry, 1873, Box 37, French Family Papers, LOC.

13 D. C. F. to John Keyes, November 3, 1873, copy in the archives of the Concord Free Library, Concord, MA.

14 Shipping bill of sale for "D. C. French's statue of 'The minute man'" from Paul A. Garey, importer and dealer in antique and modern statuary, September 11, 1874, copy in the Chesterwood Curatorial Files.

15 D. C. F. diary entry, 1873, Box 37, French Family Papers, LOC.

16 John Quincy Adams Ward to D. C. F., March 27, 1874, Concord Free Library (transcript), copy at Chesterwood.

17 Margaret French Cresson, having enjoyed the benefit of years of conversation with her father, penned an adoring biography, published decades later, which overflowed with unsourced quotes. *Journey into Fame*, 78.

18 Cresson, *Journey into Fame*, 78.

19 G. W. Sheldon, "An American Sculptor," *Harper's New Monthly Magazine* 57 (June 1878): 63. For a photograph on French working on the Martin Milmore memorial *(Death and the Sculptor)* around 1890, with the figure of *Fame* (later draped) still nude, see Richman, *Daniel Chester French: An American Sculptor* (New York: Metropolitan Museum of Art, 1976), 71.

20 *Berkshire Evening News*, April 20, 1929.

21 D. C. F. diary, April 18, 1874, French Family Papers, LOC.

22 Although recollections of this near-fatal mishap differ, the most straightforward account may be found in "A Concord Sculptor," *Boston Herald*, December 28, 1928.

23 Diary entries quoted in Richman, "Early Career of Daniel Chester French," 112.

24 D. C. F. to Henry Flagg French, March 18, 1875, French Family Papers, LOC.

25 D. C. F. to Edith D. Kingsbury, n.d. but in 1917 "Minute Man" file, French Family Papers, LOC.

26 For source of bronze, see *Boston Post*, April 20, 1875. Article in the Springfield [MA] *Republican*, reprinted in the *Morning Oregonian*, April 8, 1875. Among the items in the time capsule buried under the pedestal were accounts of the 1775 battle, a town report from 1874, a map of the village in 1875, and "coins, stamps, newspapers of the Day. Invitations to the Celebration, &c." See *Proceedings of the Centennial*, 16.

27 Craven, *Sculpture in America*, 253.

28 For text of the 1874 statute, approved by President Grant on April 22, 1874, see *Proceedings of the Centennial*, 14. Fr

29 D. C. F. to William Brewster, December 7, 1875, French Family Papers, LOC.

30 *Morning Oregonian*, April 8, 1875.

31 *Proceedings of the Centennial*, 16–17.

32 Henry Flagg French to D. C. F., March 9, 1875, French Family Papers, LOC.

33 *Springfield Republican* quoted in *Burlington Weekly Free Press*, March 26, 1875.

34 D. C. F. to E. R. Hoar, R. W. Emerson, and George Heywood, "Committee of Invitation," March 6, 1875, Town of Concord collection, copy at Chesterwood.

35 Formal invitation (featuring an engraving of the statue by H. Brett & Co., Boston) to "Henry F. French, Esq. & Lady," from Committee of Invitation (E. R. Hoar, R. W. Emerson, George Haywood), copy in the Chesterwood Archives, Chapin Library, Williams College; D. C. F. to "My dear Bartlett," February 20, 1881, D. C. F. Papers, LOC.

36 Grant stayed at the home of another leading Concord resident, his former attorney general Ebenezer Rockwood Hoar, who served as chairman of the committee of arrangements for the *Minute Man* dedication.

37 Ulysses S. Grant to Joseph A. Harmond [Harwood], April 27, 1875, quoting Grant's December 29, 1874, reply to the original invitation. John Y. Simon, ed., *The Papers of Ulysses S. Grant*, 32 vols. (Carbondale, IL: Southern Illinois University Press, 1962–2012), 26:104n.

38 *Grant Papers*, 26: 102–4.

39 *Proceedings of the Centennial*, 63.

40 Henry Flagg French to D. C. F., April 21, 1875, French Family Papers, LOC.

41 *Proceedings of the Centennial*, 65–72.

42 Henry Flagg French to D.C.F., April 21, 1875, French Family Papers, LOC.

43 *Proceedings of the Centennial*, 74

44 French, *Memories of a Sculptor's Wife*, 60.

45 Henry Flagg French to D. C. F., April 21, 1875, French Family Papers, LOC.

46 *Boston Post*, April 20, 1875.

47 Peter McLaughlin, "Will the Real Minuteman Please Stand Up?" *Berkshire Magazine* 12 (Spring 1994): 52; excerpt from Curtis's speech in *Proceedings of the Centennial*, 110.

48 "19th April 1775–1885: An Oration...by George William Curtis," *Harper's Weekly Supplement*, May 1, 1875, 369–71.

49 "Barnum" quote from *Bloomington* [IL] *Pantagraph*, April 22, 1875; *Philadelphia Times*, April 20, 1875; *New York Times* [assemblage], April 20, 1875.

50 Invitation to "citizens of Concord," copy in the Chesterwood collection; "continued until sunrise" from *Proceedings of the Centennial*, 160; Henry Flagg French to D. C. F., April 21, 1875, French Family Papers, LOC.

51 *Girard* [KS] *Press*, April 22, 1875; *Belvedere Standard*, May 4, 1875.

52 Earl Marble, "Art in Boston-IV," *The Aldine: The Art Journal of America*, 8 (May 1876): 161, quoted in Richman, "Early Career of Daniel Chester French," 117; Phillips quoted in "Boston Statues," *Boston Advertiser*, November 7, 1879.

53 *Proceedings of the Centennial*, 17.

54 D. C. F. to Harriette French Hollis, November 10, 1875, French Family Papers, LOC.

55 D. C. F. to William Brewster, December 7, 1875, French Family Papers, LOC.

56 D. C. F. to Henry Flagg French, November 8, 1875, French Family Papers, LOC.

57 D. C. F. to Henry Flagg French, November 21, 1875, French Family Papers, LOC.

58 D. C. F. to William M. R. French, November 26, 1875; Henry Flagg French to D. C. F., November 4, November 21, 1875, French Family Papers, LOC.

59 Henry Flagg French to D. C. F., December 21, 1875, French Family Papers, LOC. The family papers also include a copy of the circular.

60 D. C. F. to Henry Flagg French, December 5, 1875, French Family Papers, LOC

61 Original account book in *Minute Man* file, Chesterwood Archives, Chapin Library.

62 D. C. F. to Eugene F. Aucaigne, general manager, Kathodian Bronze Works, January 4, January 11, 1917, French Family Papers, LOC.

63 The Gorham Company Bronze Division to D. C. F., June 27, 1924, copy at Chesterwood. Original list of prices for statuette reproductions in the Chesterwood Archives, Chapin Library.

64 Inventory in Richman, "Early Career of Daniel Chester French," 283.

65 Henry Flagg French to D. C. F., March 5, 1876, French Family Papers, LOC.

66 D. C. F. to Harry F. Reubens, Secretary of the Minneapolis Society of Fine Arts, February 6, 1917; and to Mrs. O. H. Shepley, March 22, 1917, French Family Papers, LOC.

67 Advertising ephemera in the Chesterwood collection.

68 Report by William A. Babcock, *Christian Science Monitor*, March 31, 1975.

CHAPTER THREE
AT HOME ABROAD

1 Thayer Tolles, *Augustus Saint-Gaudens in the Metropolitan Museum of Art* (New York: Yale University Press, 2009), 6–9.

2 Henry Flagg French to D. C. F., October 16, 1874, French Family Papers, LOC.

3 Margaret French Cresson, *Journey into Fame: The Life of Daniel Chester French* (Cambridge, MA: Harvard University Press, 1947), 85.

4 Sven Beckert, *Empire of Cotton: A Global History* (New York: Alfred A. Knopf, 2014), 260.

5 Liverpool Autumn Exhibition of Modern Pictures (Liverpool: Free Public Library and Museum, Liverpool, 1874), http://sculpture.gla.ac.uk/view/event. php?id=misb4_1278332881.

6 Cresson, *Journey into Fame*, 86.

7 Lockman, D. C. F. Interview, 12.

8 D. C. F. to Henry Flagg French, November 7, 1874, French Family Papers, LOC.

9 Walter Tittle, "A Sculptor of the Spirit: How Daniel Chester French Puts Character into Marble," [London] *World To-Day* (December 1928): 60.

10 Abigail May Alcott Nieriker, *Studying Art Abroad* (Boston: Roberts Bros., 1879). For more on Paris, see also, Kathleen Adler, "'We'll Always Have Paris': Paris as Training Ground and Proving Ground," in Kathleen Adler, Erica E. Hirshler, H. Barbara Weinberg, and Rodolphe Rapetti, *Americans in Paris, 1860–1900* (New York: National Gallery London and the Metropolitan Museum of Art, 2006), chap. 1.

11 David McCullough, *The Greater Journey: Americans in Paris* (New York: Simon & Schuster, 2011), 342–47. Monet's movement-defining work, now in the collection of the Musée Marmottan Monet, Paris, was entitled *Impressionism: Sunrise*. Louisine Elder, daughter of an American merchant, acquired most of her collection after marrying sugar baron H. O. Havemeyer. The Havemeyer Collection is now in the Metropolitan Museum of Art in New York. See Alice Cooney Frelinghuysen, Gary Tinterow, Susan Alyson Stein, Gretchen Wold, and Julia Meech, *Splendid Legacy: The Havemeyer Collection* (New York: Metropolitan Museum of Art, 1993).

12 Frelinghuysen et al., *Splendid Legacy*, 6; Mrs. Daniel Chester [Mary] French, *Memories of a Sculptor's Wife* (Boston: Houghton Mifflin, 1928), 67.

13 Cresson, *Journey into Fame*, 87; French, *Memories of a Sculptor's Wife*, 67.

14 John Ruskin, *Mornings in Florence: Being Simple Studies of Christian Art, for English Travellers*, 2nd ed. (Sunnyside, Orpington, Kent: George Allen, 1881), esp. 45. French eventually owned a multivolume set of Ruskin's works, which he kept at Chesterwood.

15 D. C. F., Italian diary for November 26, 1874, French Family Papers, LOC; hereinafter cited as "Italian Diary."

16 Italian Diary, November 25, 1874.

17 K[arl] Baedeker, *Italy. Handbook for Travellers* (Coblenz: Karl Baedeker, 1870), 286.

18 Italian Diary, October 26, 1875.

19 Italian Diary, November 25, 1874.

20 D. C. F. to Henry Flagg French, October 26, 1875, French Family Papers, LOC.

21 D. C. F. to William French, November 26, 1875.

22 Thomas Ball, *My Threescore Years and Ten. An Autobiography* (Boston: Roberts Bros., 1891), 295.

23 D. C. F. to Henry Flagg French, December 13, 1874, French Family Papers, LOC.

24 D. C. F. to Henry Flag French, November 28, 1874, typescript in the French Family Papers, LOC.

25 Lockman, D. C. F. Interviews, 13.

26 D. C. F. to Thomas Ball, December 1, 1876, French Family Papers, LOC.

27 D. C. F. to Henry Flagg French, November 28, 1874, French Family Papers, LOC.

28 Italian Diary, November 28, 1874.

29 D. C. F. to Henry Flagg French, December 5, 1875, French Family Papers, LOC.

30 D. C. F. typescript dated February 15, 1875 [?], French Family Papers, LOC.

31 D. C. F. to Henry Flagg French, January 24, 1875, French Family Papers, LOC.

32 Thomas Ball to D. C. F., January 24, 1875, French Family Papers, LOC.

33 D. C. F. to Henry Flagg French, January 24, 1875, French Family Papers, LOC.

34 "Ball's Studio at Florence. President Lincoln and Governor Andrew...by an American Artist at Florence. (From a Letter to the Chicago Tribune)," undated clipping, ca. 1874–75, in the French Family Papers, LOC. Although imperfectly clipped, its date missing, it seems clear from its byline, "An American Artist at Florence," along with later references to such a contribution in the family correspondence, that it was written by French. The piece goes on to say that Ball's studio was a mecca for many visiting sculptors.

35 At its 1877 dedication, Boston's mayor would come close to predicting the robust market for future Lincoln sculpture by declaring: "His fame will suffer nothing from the corrosion of time, but increase with the advancing years." See Donald Charles Durman, He Belongs to the Ages: The Statues of Abraham Lincoln (Ann Arbor, MI: Edwards Bros., 1951), 46, 50.

36 Lockman, D. C. F. Interviews, 13.

37 Ibid., 14.

38 D. C. F. to Henry Flagg French, January 24, 1875, French Family Papers, LOC.

39 Thomas Ball to Henry Flagg French, April 4, 1875, French Family Papers, LOC.

40 Italian Diary, December 14, 1874.

41 D. C. F. to Henry Flagg French, April 25, 1875, French Family Papers, LOC.

42 Italian Diary, December 14, 1874; D. C. F. to William French, November 26, 1875, French Family Papers, LOC.

43 D. C. F. to William Brewster, December 7, 1875.

44 French, Memories of a Sculptor's Wife, 72.

45 The "cupid" cast is now in the Chesterwood Collection.

46 D. C. F. to Henry Flagg French, November 26, 1875, French Family Papers, LOC; see also Michael Tingley Richman, "The Early Career of Daniel Chester French, 1869–1891," PhD dissertation, University of Delaware (1974), manuscript copy in the collection of Chesterwood, Stockbridge, MA, 122–25. May Queen was produced for patron Joel Goldthwait; Daybreak is in the Chesterwood Collection.

47 Lockman, D. C. F. Interviews, 13.

48 The original is now in the Museum of Fine Arts, Boston; a cast is in the Concord Museum, Concord.

49 Richman, "Early Career of Daniel Chester French," 19.

50 Glenn V. Sherwood, Labor of Love: The Life and Art of Vinnie Ream (Hygiene, CO: Sun Shine Press, 1997), 65.

51 Oddly, Ball's statue would originally—and until French created his own version in the same city—be called by many the "Lincoln Memorial."

52 Thomas Ball to Henry Flagg French, April 4, 1875, French Family Papers, LOC.

53 Quoted in French, Memories of a Sculptor's Wife, 73.

54 Entry dated February 28, 1875, in French, Memories of a Sculptor's Wife, 77.

55 D. C. F. to Sarah Flagg (Sallie) French, May 5, 1875, French Family Papers, LOC.

56 D. C. F. to Sarah Flagg French, May 5, 1875. Garibaldi was probably attired in his signature garb because he was scheduled in a few hours to appear on his balcony and address his admirers.

57 D. C. F. to Thomas Ball, September 26, 1875, French Family Papers, LOC.

58 Henry Flagg French to D. C. F., August 13, 1875, French Family Papers, LOC. William M. R. French continued to be a prolific writer and lecturer, taking on the road one particular talk, "The Wit and Wisdom of the Crayon," for more than twenty years. During the acclaimed lecture, French would talk as he painted. See, for example, "He Speaks Well of Art in Des Moines," Des Moines Register, February 4, 1904.

59 "Art Gossip...A Visit to Pompeii," Chicago Tribune, May 30, 1875, clipping in the French Family Papers, LOC. Dan could not help adding of the Pompeiian houses he examined: "The paintings on the walls are in a wonderfully good state of preservation, but most of them are very bad in drawing."

60 D. C. F. to Sarah "Sallie" Flagg French, May 5, 1875.

61 Henry Flagg French to D. C. F., April 21, 1875, French Family Papers, LOC. The letter would have crossed the Atlantic

and reached Dan just around the time he returned to Florence.

62 Henry Flagg French to D. C. F., May 14, June 7, June 26, 1875, French Family Papers, LOC.

63 Henry Flagg French to D. C. F., August 13, 1875, French Family Papers, LOC.

64 Richman, "Early Career of Daniel Chester French," 135; D. C. F. to Henry Flagg French, March 5, March 19, 1876, French Family Papers, LOC. Whatever his disdain for *Sleeping Faun*, Dan's *Endymion* owes an undisguisable artistic debt to Hosmer's effort.

65 Henry Flagg French to D. C. F., December 21, 1875, French Family Papers, LOC.

66 D. C. F. to William Brewster, January 27, 1876, French Family Papers, LOC.

67 D. C. F. to Henry Flagg French, March 19, 1876, French Family Papers, LOC.

68 D. C. F. to Henry Flagg French, June 11, 1876, French Family Papers, LOC.

69 D. C. F. to Henry Flagg French, July 15, 1876, French Family Papers, LOC.

70 D. C. F. to William Brewster, June 9, 1876, French Family Papers, LOC.

71 D. C. F. to Mrs. Thomas Ball, November 22, 1877, French Family Papers, LOC.

72 D. C. F. to William M. R. French, November 19, 1876, French Family Papers, LOC.

73 Preston Powers to D. C. F., December 8, 1878, quoted in Richman, "Early Career of Daniel Chester French," 136–37.

74 D. C. F. to Ellen Ball, November 4, 1878, French Family Papers, LOC.

75 Lorado Taft, *The History of American Sculpture* (New York: Macmillan, 1903), 316.

76 Cresson, *Journey into Fame*, 101.

77 D. C. F. to Henry Flagg French, July 15, 1876, French Family Papers, LOC.

78 Cresson, *Journey into Fame*, 102.

79 D. C. F. to Thomas Ball, September 26, 1875, French Family Papers, LOC.

CHAPTER FOUR
THE RAGE OF CONCORD

1 Margaret French Cresson, *Journey into Fame: The Life of Daniel Chester French* (Cambridge, MA: Harvard University Press, 1947), 103–4.

2 Ibid., 106.

3 D. C. F. to Mrs. Thomas Ball, September 14, 1876, French Family Papers, LOC.

4 The best book on the subject is Thomas J. Craughwell, *Stealing Lincoln's Body* (Cambridge, MA: Belknap Press, 2007). Larkin Goldsmith Mead's heroic bronze, *The Emancipator*, adorning the portico of the Lincoln Tomb in Springfield, had been dedicated on October 15, 1874. See Donald Charles Durman, *He Belongs to the Ages: The Statues of Abraham Lincoln* (Ann Arbor, MI: Edwards Bros., 1951), 141–43.

5 D. C. F. to William M. R. French, November 19, 1876, French Family Papers, LOC.

6 Ibid.

7 Both quotes from D. C. F. to Ellen Ball, February 11, 1877, French Family Papers, LOC.

8 D. C. F. to Ellen Ball, December 17, 1876, French Family Papers, LOC.

9 Thomas Ball to D. C. F., April 26, 1877, Houghton Library, Harvard University.

10 D. C. F. to Ellen Ball, April 7, 1878, typescript in the Chesterwood collection.

11 D. C. F. to William M. R. French, April 3, 1878, French Family Papers, LOC.

12 D. C. F. to Ellen Ball, January 1, 1878, typescript in the Chesterwood collection.

13 Quoted in James M. McPherson, *Battle Cry of Freedom: The Civil War Era* (New York: Oxford University Press, 1988), 551–52.

14 Harold Holzer, *The Civil War in 50 Objects* (New York: Viking, 2013), 271–76.

15 D. C. F. to Ellen Ball, December 17, 1876, French Family Papers, LOC.

16 Dan also boarded the Custom House steamer with a party of thirty friends and relatives for a tour of Boston Harbor in August. See D. C. F. to Ellen Ball, August 4, 1878, French Family Papers, LOC.

17 D. C. F. to Ellen Ball, December 17, 1876, French Family Papers, LOC.

18 D. C. F. to Ellen Ball, January 1, 1878, typescript in the Chesterwood collection.

19 D. C. F. to Ellen Ball, December 5, 1877, typescript in the Chesterwood collection.

20 D. C. F. to Ellen Ball, January 1, 1878, typescript in the Chesterwood collection.

21 Mrs. Daniel Chester [Mary] French, *Memories of a Sculptor's Wife* (Boston: Houghton Mifflin, 1928), 116, 120–121.

22 Cresson, *Journey into Fame*, 114.

23 Couper (1853–1942) studied in Florence for more than twenty years, and eventually shared a New York studio building with his father-in-law. Couper retired in 1913, when he was sixty.

24 D. C. F. to Harriette French Hollis, February 5, 1876, French Family Papers, LOC.

25 D. C. F. to Lizzie Ball, March 16, 1877, French Family Papers, LOC.

26 Both quotes from D. C. F. to Ellen Ball, April 7, 1877, typescript in the Chesterwood Collection.

27 D. C. F. drawing of Mamie French in Chesterwood Collection.

28 D. C. F. to Ellen Ball, March 1, January 1, 1878, typescripts in the Chesterwood Collection.

29 D. C. F. to Ellen Ball, December 5, 1877, January 1, 1878, typescripts in the Chesterwood collection.

30 D. C. F. to Thomas Ball, July 18, 1878, French Family Papers, LOC.

31 D. C. F. to Ellen Ball, March 16, 1879, French Family Papers, LOC.

32 D. C. F. to William M. R. French, August 25, 1878, French Family Papers, LOC

33 D. C. F. to William M. R. French, March 2, 1879, French Family Papers, LOC.

34 The onetime studio still stands on its original spot, now enlarged and converted into a family home and bearing no historical marker to testify to its original occupant, Daniel Chester French.

35 D. C. F. to Ellen Ball, July 13, 1879, French Family Papers, LOC.

36 D. C. F. to Ellen Ball, November 4, 1878, French Family Papers, LOC.

37 French, *Memories of a Sculptor's Wife*, 87.

38 Daniel Chester French, "A Sculptor's Reminiscence of Emerson," *The Art World* 3 (October 1916): 44

39 *Chicago Tribune*, November 29, 1871.

40 *Cedar Falls* [IA] *Gazette*, February 22, 1867.

41 *St. Paul* [MN] *Pioneer*, February 1, 1867.

42 *Chicago Times*, December 3, 1871. This and the following physical descriptions were gathered in Hubert H. Hoieltje, "Ralph Waldo Emerson in Minnesota," *Minnesota History* (January 1930): 150–51.

43 Earl Schenck Meirs, *Lincoln Day by Day: A Chronology*, 3 vols. (Washington, DC: Lincoln Sesquicentennial Commission, 1960), 2:91, 3:93; Edward Waldo Emerson and Waldo Emerson Forbes, eds., *Journals of Ralph Waldo Emerson, with Annotations*, 10 vols. (Boston: Houghton Mifflin, 1909), 9:375–76.

44 A few days later, Lincoln borrowed Emerson's *Representative Men* from the Library of Congress. See Meirs, *Lincoln Day by Day*, 3:93.

45 French, "A Sculptor's Reminiscence of Emerson," 44.

46 D. C. F. to Ellen Ball, August 4, 1878, typescript in the Chesterwood collection.

47 Pamela Prentiss French to D. C. F., January 3, 1879, French Family Papers, LOC.

48 D. C. F. to Ellen Ball, March 16, 1879, French Family Papers, LOC.

49 Henry Flagg French to D. C. F., April 27, 1879, French Family Papers, LOC.

50 French shared this story in 1901, and it was picked up by many newspapers. See, for example, *North Platte* [NE] *Semi-Weekly Tribune*, September 17, 1901.

51 French, "A Sculptor's Reminiscence of Emerson," 44.

52 Ibid., 44, 47; "droll expression" from "Emerson as a Model."

53 Archives of the Metropolitan Museum of Art.

54 D. C. F. to George Palmer, February 8, 1915, French Family Papers, LOC; French, "A Sculptor's Reminiscence of Emerson," 44, 47.

55 D. C. F. to William M. R. French, June 29, 1879, French Family Papers, LOC.

56 Ellen Emerson to D. C. F., July 26, 1879, French Family Papers, LOC.

57 D. C. F. to Ellen Ball, August 12, 1879, typescript in the Chesterwood collection.

58 Samuel G. W. Benjamin, "Society of American Artists VIII," *American Art Review* 2 (June 1881): 77.

59 "Tattler," "Notes From the Capital: Daniel Chester French," *Nation* 104 (March 8, 1917): 274.

60 Quoted in Michael Tingley Richman, "The Early Career of Daniel Chester French, 1869–1891," PhD dissertation, University of Delaware (1974), manuscript copy in the collection of Chesterwood, Stockbridge, MA, 164.

61 *New York Times*, November 29, 1879.

62 Samuel G. W. Benjamin, "Society of American Artists," *American Art Review* 2 (June 1881): 77.

63 Richman, "Early Career of Daniel Chester French," 162.

64 Replica in the Concord Museum.

65 D. C. F. to Charles F. McKim, March 8, 1892, French Family Papers, LOC.

66 French's fellow trustees initiated the effort to acquire a cast, but acknowledged to French that "as Chairman of our Committee on Sculpture it might be embarrassing for you to deal with such a matter." French solved the problem by donating the piece as a gift. See Thayer Tolles, ed., *American Sculpture in the Metropolitan Museum of Art*, Vol. 1 (New York: Metropolitan Museum of Art, 1999), 329.

67 D. C. F. to Newton Mackintosh, May 3, 1912, French Family Papers, LOC.

68 William Justin Mann, "Little Walks About Boston," *Boston Post*, April 21, 1920.

69 French, "A Sculptor's Reminiscences of Emerson," 47.

70 "Busts of Notables Formally Unveiled, N.Y. Hall of Fame," *Bloomington* [IL] *Daily Pantagraph*, May 23, 1923.

71 The Concord Free Public Library also has a replica of D. C. F.'s Emerson sculpture.

72 Quoted in Walter Tittle, "A Sculptor of the Spirit: How Daniel Chester French Puts Character into Marble," [London] *World To-Day* (December 1928): 56.

73 Lorado Taft, *The History of American Sculpture* (New York: Macmillan, 1903), 317; Tolles, *American Sculpture in the Metropolitan*, 326.

74 D. C. F. to Ellen Ball, February 11, 1877, typescript in Chesterwood collection.

75 Ibid.

CHAPTER FIVE
LABOR SUSTAINING ART

1 Ellen Tuck (1837–1893) was the wife of Francis O. French (1838–1915), son of Benjamin Brown French. See French family tree on flyleaf of Donald B. Cole and John J. McDonough, eds., *Witness to the Young Republic: A Yankee's Journal, 1928–1870* (Hanover, NH: University Press of New England, 1989).

2 Mrs. Daniel Chester [Mary] French, *Memories of a Sculptor's Wife* (Boston: Houghton Mifflin, 1928), 150.

3 Henry Flagg French to D. C. F., October 26, 1881, French Family Papers, LOC.

4 Henry Flagg French to D. C. F., November 30, 1879, French Family Papers, LOC.

5 Henry Flagg French to D. C. F., July 4, 1880, French Family Papers, LOC.

6 Margaret French Cresson, *Journey into Fame: The Life of Daniel Chester French* (Cambridge, MA: Harvard University Press, 1947), 126.

7 D. C. F. to William M. R. French, September 27, December 16, 1881, March 11, 1882, French Family Papers, LOC.

8 French, *Memories of a Sculptor's Wife*, 118.

9 D. C. F. to William M. R. French, August 21, 1883, French Family Papers, LOC.

10 Michael Tingley Richman, "The Early Career of Daniel Chester French, 1869–1891," PhD dissertation, University of Delaware (1974) typescript copy in the collection of Chesterwood, Stockbridge, MA, 202.

11 D. C. F. to William M. R. French, April 17, 1885, French Family Papers, LOC.

12 *Memorial of John Harvard. The Gift to Harvard University of Samuel James Bridge. Ceremonies at the Unveiling of the Statue, October 15, 1884, with an Address by George Edward Ellis* (Cambridge, MA: John Wilson & Son, 1884), 3.

13 D. C. F. to Richard Dana, July 12, 1883, quoted in Michael Richman, *Daniel Chester French: An American Sculptor* (New York: Metropolitan Museum of Art, 1976), 56.

14 Quoted from a tablet displayed outside the Johnston Gate to Harvard Yard.

15 Quoted from a second tablet at the Johnston Gate.

16 Henry C. Shelley, *John Harvard and His Times* (London: Smith, Elder & Co., 1907), 277.

17 The fierce contest for the Garrison commission included Anne Whitney, a friend of French's against whom he regretted competing. Originally, Augustus Saint-Gaudens may have considered seeking the commission, but had begun

shunning competitions. See Richman, "The Early Career of Daniel Chester French," 205–7.

18 Richman, "The Early Career of Daniel Chester French," 209–11; Henry Flagg French to D. C. F., November 23, 1884, French Family Papers, LOC.

19 Homer Saint-Gaudens, ed., *The Reminiscences of Augustus Saint-Gaudens*, 2 vols. (New York: The Century Co., 1913), 1:174.

20 Thayer Tolles, *Augustus Saint-Gaudens in the Metropolitan Museum of Art* (New York: The Metropolitan Museum of Art, 2009), 21.

21 D. C. F. to Charles Knowles Bolton, December 8, 1921, French Family Papers, LOC. The "god-like" quote is from the sole description of John Harvard, which Dan undoubtedly found in the first known history of the college, the pamphlet *New England's First Fruits* (London: Henry Overton, 1643), copy in the Massachusetts Historical Society.

22 The description of Hoar's good looks is in—of all places—the [Necedah, WI] *Yellow River Lumberman,* July 3, 1884.

23 D. C. F. to William M. R. French, December 2, 1883, French Family Papers, LOC; emphasis added.

24 Bust of Helen Van Voast described in Richman, "The Early Career of Daniel Chester French," 176. The sculptor's Channing Street location (which the sculptor identified as the "same building as last year") reported in D. C. F. to William M. R. French, December 7, 1884, French Family Papers, LOC.

25 Henry Flagg French to D. C. F., February 23, 1884, French Family Papers, LOC.

26 Michel Richman, "The Man Who Made John Harvard," *Harvard Magazine* 80 (September–October 1977): 46.

27 D. C. F. to William M. R. French, March 21, 1884, French Family Papers, LOC.

28 D. C. F. to John Quincy Adams Ward, April 6, 1884, J. Q. A. Ward Papers, New-York Historical Society.

29 Ibid.; Joseph B. Felt, *The Customs of New England* (Boston: T. R. Marvin, 1853), copy—perhaps the very one that French once borrowed—in the Massachusetts Historical Society.

30 *New Orleans Times-Picayune,* July 2, 1884.

31 D. C. F. to John Q. A. Ward, April 6, 1884, Ward Papers, New-York Historical Society.

32 D. C. F. to William M. R. French, April 20, 1884, French Family Papers, LOC.

33 Ibid.

34 *Rochester Democrat and Chronicle,* April 16, 1884.

35 Henry Flagg French to D. C. F., June 1, 1884; D. C. F. to William M. R. French, December 2, 1883, French Family Papers, LOC.

36 Richman, *Daniel Chester French,* 58.

37 "The Unveiling of the Harvard Statue," *Harvard Crimson,* October 16, 1884.

38 *Memorial of John Harvard,* 3–5.

39 Ibid., 14–15.

40 Ibid., 15, 16.

41 Ibid., 17, 18; "The Unveiling of the Harvard Statue," *Harvard Crimson,* October 16, 1884.

42 *New York Times,* October 12, 1884.

43 Reprinted in the *New York Times,* October 18, 1884.

44 *New Orleans Time-Picayune,* July 2, October 3, 1884; *Washington Evening Star,* November 29, 1884; *Frank Leslie's Weekly,* October 11, 1884.

45 Emily Dickinson to Daniel Chester French, undated (ca. October 1884), French Family Papers, LOC. For the published verse see Thomas H. Johnson, ed., *The Poems of Emily Dickinson,* 3 vols. (Cambridge, MA: Harvard University Press, 1955), 3:1111–12.

46 D. C. F. to Charles W. Eliot, August 1, 1893, French Family Papers, LOC.

47 Lilian C. Whiting, "Life in Boston... Daniel C. French an American Sculptor of Rare Genius," *The* [Chicago] *Inter Ocean,* May 30, 1896. The newspaper, successor to the partisan *Chicago Republican,* had been founded by former Civil War assistant secretary of War Charles A. Dana; Whiting (1849–1942) was a pioneering woman art writer, essayist, poet, and journalist.

48 D. C. F. to A. Lawrence Lowell, June 5, 1920, French Family Papers, LOC.

49 *Harvard Crimson,* March 22, 1924.

50 Richman, "The Man Who Made John Harvard," 46.

51 *Saint Paul Globe,* November 22, 1884.

52 *Detroit Free Press,* November 22, 1884

53 Reprinted in the *Wilmington Morning News,* November 24, 1884.

54 Noting both aspects of its iconic allure, the commercial venture Cambridge Historical Tours promoted the *John Harvard* as recently as 2016 as "the 'Statue of Three Lies.'" For one thing, the company's website trumpeted, as if revealing the fact for the first time, it was not a statue of John Harvard at all since "No one knows what he looks like!" The second and third "lies" could be found inscribed on the pedestal, which identifies the subject as "John Harvard, Founder, 1638," even though Rev. Harvard was not the actual founder of the college, which in fact had opened its doors two years earlier, in 1636. To all this, the tour company added a falsehood of its own, describing Daniel Chester French as "a Harvard graduate." Nonetheless, a visit to the statue was urgently recommended. "For current students," Cambridge Historical Tours reported, "it is good luck to rub John Harvard's toe, making one foot shinier than the other. Although, we wouldn't recommend it. Take a tour with [us] to find out why." Actually, the explanation was already known to both students and campus maintenance staff.

55 Daniel E. Herz-Roiphe, "The Truth About John Harvard," *Harvard Crimson,* December 18, 2006.

56 Corydon Ireland, "Biography of a Bronze," *Harvard Crimson,* October 2, 2013.

57 Hellary Y. Zhang, "Student Voices Bring John Harvard Statue to Life," *Harvard Crimson,* April 22, 2015. In 2007, a snow-capped image of the statue even made a cameo appearance in a film about Harvard alumnus Mark Zuckerberg, *The Social Network.*

58 D. C. F. to R. F. Hole, December 26, December 3, 1914, French Family Papers, LOC.

59 Frank Purdy (Gorham Co.) to D. C. F., October 1, 1915, French Family Papers, LOC.

60 D. C. F. to Frank Purdy, October 4, 1915, French Family Papers, LOC.

61 Henry Flagg French to D. C. F., March 14, 1885; D. C. F. to William M. R. French, October 3, 1885, French Family Papers, LOC. If it was any consolation, the other aspirants for the Lafayette commission included Larkin Mead and Auguste Bartholdi, sculptor of the Statue of Liberty. The bronze is still on view in Washington's Lafayette Park.

62 D. C. F. to William M. R. French, October 8, 1884, French Family Papers, LOC.

63 D. C. F. to William M. R. French, April 27, 1885, French Family Papers, LOC.

64 William Kloss and Diane K. Skvarla, *United States Senate Catalogue of Fine Art* (Washington: US Government Printing Office, 2002), 428–430.

65 Silvio A. Bedini, *Declaration of Independence Desk: Relic of Revolution* (Washington, DC: Smithsonian Institution Press, 1981), 80–81, 83–84, 103–5.

66 "Notes on the Life of Henry Flagg French after 1860," manuscript and typescript in the French Family Papers, LOC.

67 Cresson, *Journey into Fame,* 140.

68 Ibid., 141.

69 Both quotes about the judge are from Daniel Chester French, "The Humor of Henry Flagg French. Read to the Gathering of the Clan at the one-hundredth anniversary of my Father's Birthday August 14, 1923," typescript in the French Family Papers, LOC.

70 D. C. F. to William M. R. French, December 18, 1885.

71 *National Portrait Gallery Smithsonian Institution: Permanent Collection Illustrated Checklist* (Washington, DC: Smithsonian Institution Press, 1987), 255.

72 D. C. F. to John Quincy Adams Ward, May 21, 1886, J. Q. A. Ward Papers, New-York Historical Society.

73 Ibid.

74 William Henry Harrison, a Whig, triumphed in the 1840 contest. Not until 1860, when Lincoln became the first Republican elected President, did a Democrat lose an election for the White House.

75 From Lincoln's speech on the presidential race, US House of Representatives, July 27, 1848, in Roy P. Basler, ed., *The Collected Works of Abraham Lincoln,* 8 vols. (New Brunswick, N.J.: Rutgers University Press, 1953–1955), 1:509.

76 D. C. F. to William M. R. French, March 3, 1886, French Family Papers.

77 Disputed accounts of French's Paris activities 1886–1887, as provided by William M. Coffin (Glaize) and Margaret French Cresson (Mercié), are discussed in Richman, "The Early Career of Daniel Chester French," 257 and 262n8,9.

78 D. C. F. to Charles Moore (later the head of the federal Commission of Fine Arts), July 23, 1887, reprinted in Richman, "The Early Career of Daniel Chester French," 258.

79 D. C. F. to Charles Moore, September 7, October 3, 1887, in Richman, "The Early Career of Daniel Chester French," 258–59.

80 D. C. F. to Charles Moore, September 7, 1887, in Richman, "Early Career of Daniel Chester French," 258.

81 *Congressional Record,* February 18, 1889, 2005.

82 Unidentified clipping, 260,

83 D. C. F. to Pamela French, January 27, 1889, French Family Papers, LOC; payment recorded by the secretary of state of Michigan, in Richman, "Early Career of Daniel Chester French," 260, 263n19.

CHAPTER SIX
THE HAND OF THE SCULPTOR

1 The standard reference is Maxine Tull Boatner, *Voice of the Deaf: A Biography of Edward Miner Gallaudet* (Washington, DC: Public Affairs Press, 1959).

2 D. C. F. to William M. R. French, December 18, 1885, French Family Papers, LOC.

3 May 3, 1887 Resolution of the National Association of the Deaf, quoted in "The Gallaudet Memorial Statue," *American Annals of the Deaf,* 32 (July 1887): 201–2, quoted in Michael Richman, *Daniel Chester French: An American Sculptor* (New York: Metropolitan Museum of Art, 1976), 63.

4 For the genesis of the project, see Richman, *Daniel Chester French,* 63.

5 D. C. F. to Charles Moore, July 2, 1887, Charles Moore Papers, LOC. Ballin (1861–1932) was also an actor and writer, author of *The Deaf Mute Howls,* published in 1930 by Gallaudet University Press.

6 D. C. F. to Augustus Saint-Gaudens, July 8, 1887, French Family Papers, LOC.

7 Undated clipping in Box 39 of the French Family Papers, LOC.

8 Richman, *Daniel Chester French,* 67–68n6.

9 D. C. F. to Charles Moore, October 3, 1887, quoted in Richman, *Daniel Chester French,* 64.

10 D. C. F. to William M. R. French, June 20, 1888, French Family Papers, LOC.

11 Mrs. Daniel Chester [Mary] French, *Memories of a Sculptor's Wife* (Boston: Houghton, Mifflin & Co., 1926), 36, 138.

12 French, *Memories of a Sculptor's Wife,* 146–47.

13 Margaret French Cresson, *Journey into Fame: The Life of Daniel Chester French* (Cambridge, MA: Harvard University Press, 1947), 137.

14 French, *Memories of a Sculptor's Wife,* chap. 6, "Concord in 1878," esp. 79–87.

15 Cresson, *Journey into Fame,* 137.

16 William A. Coffin, "The Sculptor French," *Century Magazine* 59 (April 1900): 873.

17 Henry Flagg French to D. C. F., October 4, 1883, French Family Papers, LOC.

18 French not only kept his bust of Mamie French out of public sight, but, after displaying it at home for more than forty years, eventually let himself be persuaded by Mamie to destroy it. Perhaps the portrait represented something so intimate between them that they simply could not bear to share it with others. Or possibly the somewhat vain model never really liked it—believing, for all her exposure to the simple life in Concord, that, and as much as Dan had tried to imbue the portrait with lifelike tinting, it still did not do her full justice.

19 French, *Memories of a Sculptor's Wife,* 118.

20 Cresson, *Journey into Fame,* 153.

21 Ibid., 152.

22 Ibid., 154, 159.

23 Ibid., 155–56.

24 French, *Memories of a Sculptor's Wife,* 154.

25 Ibid.

26 Ibid.

27 Ibid., 171.

28 Michael Tingley Richman, "The Early Career of Daniel Chester French,

1869–1891," PhD dissertation, University of Delaware (1974), typescript copy in the collection of Chesterwood, Stockbridge, MA, 177–78, 212–13.

29 Historian Cynthia Mills has speculated that the couple moved to cosmopolitan New York in part to assure acceptance, but strong evidence suggests that French had long yearned to work from New York. See Cynthia Miles, *Beyond Grief: Sculpture and Wonder in the Gilded Age Cemetery* (Washington, DC: Smithsonian Institution Press, 2015), 101.

30 Ibid., 155.

31 Cresson, *Journey into Fame*, 162–64.

32 Ibid., 162.

33 French to Charles Moore, October 3, 1887, in Richman, *Daniel Chester French*, 66.

34 *New York Times*, June 19, 1889.

35 Robard, "Daniel Chester French, Sculptor," *Godey's Magazine* 131 (October 1895): 365–66.

36 Henry James to D. C. F., March 20, 1889, French Family Papers, LOC. The two had met in London in 1886.

37 French to Lorado Taft, September 5, 1925, French Family Papers, LOC.

38 Odell Shepard, ed., *The Journals of Bronson Alcott* (Boston: Little, Brown & Co., 1938), 514, 525–26.

39 Richman, "The Early Career of Daniel Chester French," 182–83, 286–87. As newly established American art museums began acquiring original works for their collections in the late nineteenth century, some institutions disposed of the plaster casts and models that had dominated their galleries when they first opened. (The Art Institute, like the Museum of Fine Arts, Boston, and the Metropolitan Museum of Art in New York, opened its doors in 1870.) Twenty-six years after William M. R. French died, the Art Institute apparently saw nothing wrong with dumping its considerable collection of his brother's plaster casts.

40 D. C. F. to Edward Clark, n.d., quoted in William Kloss and Diane K. Skvarla, *Untied States Senate Catalogue of Fine Art* (Washington, DC: US Government Printing Office, 2002), 6.

41 D. C. F. to Edward Clark, July 27, 1886, quoted in Richman, "Early Career of Daniel Chester French," 270.

42 For a comparison, it seems fairly clear that French's bust owed a debt to the Gilbert-Jane Stuart painting; see *National Portrait Gallery Permanent Collection Illustrated Checklist* (Washington, DC: Smithsonian Institution Press, 1987), 23 (NPG.71.4).

43 Ibid., 8–9.

44 H. W. S. Cleveland to William Folwell, n.d., quoted in "Minneapolis Park History," http://minneapolisparkhistory. com. The surviving photo is in the Chapin Library, Williams College, Williamstown, MA.

45 Oscar T. Shuck, *Representative and Leading Men of the Pacific: Being Original Sketches of the Lives and Characters of the Principal Men, Living and Dead, of the Pacific States and Territories...*(San Francisco: Bacon & Co., 1870), 165–66.

46 "Among the Sculptors," *Monumental News* 1 (September 1889): 171.

47 In dedicating Springfield, Illinois's new Oak Ridge Cemetery, Abraham Lincoln's neighbor James C. Conkling emphasized "the surroundings of nature combined with art as exhibited in the cemeteries of Père Lachaise and Mt. Auburn and Greenwood and Laurel Hill and other celebrated burial places of the dead." Quoted in Garry Wills, *Lincoln at Gettysburg: The Words that Remade America* (New York: Simon & Schuster, 1992), 68. See also *Forest Hills Cemetery: Its Establishment, Progress, Scenery, Monuments, Etc.* (Roxbury, MA: John Backup, 1855), esp. 11–13.

48 Wayne Craven, *Sculpture in America*, 1968 (rev. ed. Newark: University of Delaware Press, 1984), 236; Kloss and Skvarda, *United States Senate Catalogue of Fine Art*, 348.

49 Taft, *History of American Sculpture*, 203.

50 D. C. F. to Adeline Adams, February 7, 1931, French Family Papers, LOC. A year after receiving this letter, Adams produced a biography, *Daniel Chester French: Sculptor* (Boston: Houghton Mifflin, 1932).

51 D. C. F. to William M. R. French, February 27, 1889, French Family Papers, LOC.

52 Mills, *Beyond Grief*, 110.

53 D. C. F. to Mrs. G. R. Streeter, March 6, 1914, French Family Papers, LOC.

54 See Joy M. Giguerre, "'The Americanized Sphinx': Civil War Commemoration, Jacob Bigelow, and The Sphinx at Mount Auburn Cemetery," Journal of the Civil War Era 3 (March 2013): 62–84.

55 D. C. F. to William Brewster, October 5, 1890, quoted in Richman, Daniel Chester French, 72.

56 Some of the wings survive in a Lucite cube at the Stockbridge Library Museum and Archives, Stockbridge, MA.

57 French, Memories of a Sculptor's Wife, 174–75.

58 D. C. F. to William M. R. French, January 5, 1892, French Family Papers, LOC.

59 William A. Coffin, "The Sculptor French," Century Magazine 59 (April 1900): 878.

60 Comments, and a translation of the undated French newspaper clipping, in Richman, Daniel Chester French, 73–74. The bronze was subsequently shown at a Paris exhibition organized by the Société Nationale des Beaux-Arts on the Champs de Mars.

61 Lorado Taft, The History of American Sculpture (New York: Macmillan, 1903), 321.

62 D. C. F. to William M. R. French, February 3, 1893, French Family Papers, LOC.

63 D. C. F. to William Brewster, May 24, 1892, French Family Papers, LOC.

64 Boston Evening Transcript, August 1, 1893, reprinted in Richman, Daniel Chester French, 75.

65 Undated manuscript by James Stark [?], in the French Family Papers, LOC; Jenkin Lloyd James, All Souls Pulpit No. 1: Death as a Friend (Chicago: Unity Publishing, ca. 1894), copy in the French Family Papers, LOC, inscribed "To D. C. French—with the thanks of the author"; George W. Chadwick to D. C. F., February 2, 1919, French Family Papers, LOC. Original music at www.youtube.com/watch?v=LKah395zdBM.

66 Richman, Daniel Chester French, 79n22. This plaster was also used as the model for the marble carved for the Metropolitan Museum of Art.

67 D. C. F. to Oscar Longfellow Milmore, August 5, 1914, French Family Papers, LOC.

68 Coffin, "The Sculptor French," 878.

69 Chicago Tribune, September 17, 1893.

70 Henry Charles Payne, "Death and the Sculptor—Mr. French's Masterpiece," The [Chicago] Inter Ocean, November 2, 1902.

71 "French's 'Death and the Young Sculptor,'" The Art World (November 1917): 93.

72 Royal Cortissoz, "New Figures in Literature and Art. 1. Daniel Chester French," Atlantic Monthly 75 (February 1895): 228–29.

73 See Margaret Lathrop Law, ed., Pepita Milmore: An Appreciation (New York: privately printed, 1951). Mrs. Henry Longfellow Milmore (1882–1951) was a largely unrecognized, amateur, and occasionally published poet.

74 Thayer Tolles, ed., American Sculpture in the Metropolitan Museum of Art, Vol. 1: A Catalogue of Works by Artists Born before 1865 (New York: Metropolitan Museum of Art, 1999), 331–33. The Metropolitan Museum trustees who contributed to the acquisition of Death and the Sculptor in 1926 were: Robert W. de Forest, Edward D. Adams, George F. Baker, George Blumenthal, Charles W. Gould, Edward S. Harkness, Arthur Curtiss James, W. Everit Macy, J. P. Morgan, Jr., William Church Osborn, George D. Pratt, Henry Walters, and Payne Whitney. Gratitude goes to Linda Seckelson of the Met for providing the list.

75 D. C. F. to Robert W. de Forest, October 10, 1917, French Family Papers, LOC.

76 "French's 'Death and the Young Sculptor,'" 93.

77 Tolles, American Sculpture in the Metropolitan, 332.

78 See diary of Philemon T. Sherman, Sunday, February 15, 1891 ("Plaster cast by St. Gaudens & French in evening"), University of Notre Dame Archives, copy in the files of the Metropolitan Museum of Art. The mask was presented to the New-York Historical Society by Philemon Sherman in 1932, and supplemented twelve years later by a testimonial from Sherman's granddaughter, along with the 1891 letter from the general's lawyer. See Mrs. E. Sherman Fitch statement, November 11, 1943; Charles C. Beaman to

Philemon Tecumseh Sherman, February 16, 1891, in the Sherman Papers, New-York Historical Society. See also John F. Marszalek, *Sherman: A Soldier's Passion for Order* (New York: Free Press, 1993), 492,584n28.

CHAPTER SEVEN
THE WHITE CITY

1 The original is now in the Chesterwood Collection.

2 Mrs. Daniel Chester [Mary] French, *Memories of a Sculptor's Wife* (Boston: Houghton, Mifflin Co., 1928), 174–75.

3 For a superb brief overview, see Thayer Tolles, "American Sculpture at the World's Columbian Exposition, Chicago, 1893," Metropolitan Museum's online Heilbrunn Timeline of Art History, www.metmuseum.org/toah/hd/cwfs/hd_cwfs.htm.

4 Homer Saint-Gaudens, ed., *The Reminiscences of Augustus Saint-Gaudens*, 2 vols. (New York: The Century Co., 1913), 2:73; Daniel Burnham to Augustus Saint-Gaudens, June 22, 1891, Saint-Gaudens Papers, microfilm copy in the Library of Congress.

5 Michael Richman, "Daniel Chester French's *Republic*: 1893, 1918, and 1993," *Sculpture Review* 43 (Spring 1994): 12.

6 Charles Moore, *Daniel H. Burnham: Architect of Cities*, 2 vols. (Boston: Houghton Mifflin, 1921), 1, 46n.

7 Walter Tittle, "A Sculptor of the Spirit: How Daniel Chester French Puts Character into Marble," [London] *World To-Day* (December 1928): 59.

8 D. C. F. to William M. R. French, September 29, 1891, French Family Papers, LOC.

9 Michael Tingley Richman, "The Early Career of Daniel Chester French, 1869–1891," PhD dissertation, University of Delaware (1974), manuscript copy in the collection of Chesterwood, Stockbridge, MA, 295.

10 *New York Times*, March 9, 1893.

11 Charles Moore, *The Life and Times of Charles McKim* (Boston: Houghton Mifflin Co., 1929), 119.

12 Lorado Taft, quoted in "Daniel Chester French's Career," *Indianapolis News*, April 27, 1901.

13 Moses P. Handy, ed., *The Official Directory of the World's Columbian Exposition May 1st to October 30th, 1893. A Reference Book of Exhibitors and Exhibits...*(Chicago: W. B. Gonkey Co., 1893), 882, 885–86.

14 Saint-Gaudens, ed., *Reminiscences of Augustus Saint-Gaudens*, 1:277.

15 D. C. F. to William M. R. French, January 5, 1892, French Family Papers, LOC.

16 Daniel Burnham to D. C. F., December 28, 1891, January 2, 1892, French Family Papers, LOC.

17 Daniel Burnham to Daniel Chester French, January 2, 1892, French Family Papers, LOC.

18 D. C. F. to William M. R. French, January 5, 1892, French Family Papers, LOC.

19 D. C. F. to William M. R. French, November 29, 1891, French Family Papers, LOC.

20 D. C. F. to Pamela Prentiss French, February 6, 1892, French Family Papers, LOC.

21 D. C. F. to Pamela Prentiss French, February 21, 1892, French Family Papers, LOC, typescript at Chesterwood.

22 Ibid.

23 Ibid.

24 *San Francisco Chronicle*, January 8, 1893.

25 The standard reference about this urban planner, who went on to design New York's Flatiron Building and Washington's Union Station, is Carl Smith, *The Plan of Chicago: Daniel Burnham and the Remaking of the American City* (Chicago: University of Chicago Press, 2006).

26 Louis Sullivan, *The Autobiography of an Idea* (New York: Press of the American Institute of Architects, 1924), 325.

27 Ibid., 318, 319, 321, 322, 324; "Architecture at the World's Columbian Exposition," *Century Magazine* 44 (May 1892): 88.

28 See Erik Larson, *The Devil in the White City* (New York: Random House, 2003), 220. Larsen's is the most famous book about the World's Columbian Exposition, but unaccountably, he mentions Daniel Chester French only twice.

29 Jean Zimmerman, *Love, Fiercely: A Gilded Age Romance* (Boston: Houghton Mifflin, 2012), 63.

30 Sargent's *Mr. and Mrs. I. N. Phelps Stokes* entered the collection of the Metropolitan Museum of Art in 1938 as a bequest from Mrs. Stokes—French's model, Edith Minturn.

31 Original photograph, labeled "Posing for The 'Republic' by D. C. French," caption in the handwriting of Margaret French Cresson, in the Chesterwood collection housed at the Chapin Library, Williams College, Williamstown, MA.

32 Gary Ossewaarde, "Jackson Park's *The Republic*," Web report for Jackson Park and Hyde Park KCC, www.hydeparkorg/parks/jpac/prepublic.htm#story.

33 D. C. F. to Pamela Prentiss French, February 21, 1892.

34 D. C. F. to William Brewster, May 24, 1892, French Family Papers, LOC.

35 D. C. F. to Pamela Prentiss French, June 5, 1892, French Family Papers, LOC.

36 Lukeman would take over the project from Borglum in 1925. See "Famous Sculptor to Finish Work," *Bakersfield Californian*, October 15, 1925.

37 Ibid. and French, *Memories of a Sculptor's Wife*, 176.

38 French, *Memories of a Sculptor's Wife*, 176.

39 Margaret French Cresson, *Journey into Fame: The Life of Daniel Chester French* (Cambridge, MA: Harvard University Press, 1947), 172.

40 French, *Memories of a Sculptor's Wife*, 177.

41 Richman, "Daniel Chester French's Republic," 13.

42 D. C. F. to Pamela Prentiss French, April 24, 1893, French Family Papers, LOC.

43 D. C. F. to Pamela Prentiss French, August 11, 1892, French Family Papers, LOC.

44 D. C. F. to Pamela Prentiss French, December 21, 1892, French Family Papers, LOC; Lorado Taft, *The History of American Sculpture* (New York: Macmillan, 1903), 322; V. Robard, "Daniel Chester French: Sculptor," *Godey's Magazine* 131 (October 1895): 368.

45 White and Igleheart, *World's Columbian Exposition*, 387–88.

46 *Builder* 44 (September 30, 1893), 240.

47 Author unknown, *Some Artists at the Fair* (New York: Scribner's, 1893), 23.

48 D. C. F. to Pamela Prentiss French, August 11, 1892, French Family Papers, LOC.

49 *Some Artists at the Fair*, 23.

50 For pictures of the final result, see C. D. Arnold and H. D. Higinbotham, *Official Views of the World's Columbian Exposition* (Chicago: Chicago Photo-Gravure Co., 1893), plate 13; French, *Memories of a Sculptor's Wife*, 176–77.

51 French, *Memories of a Sculptor's Wife*, 179–80.

52 Benjamin C. Truman, *History of the World's Fair, Being a Complete and Authentic Description of the Columbian Exposition from its Inception* (Chicago: E. C. Morse & Co., 1893), 91.

53 D. C. F. to William M. R. French, October 17, 1892, and to Daniel Burnham, October 18, 1892, French Family Papers, LOC.

54 D. C. F. to William M. R. French, November 18, 1892.

55 Charles F. McKim to D. C. F., March 6, 1893, French Family Papers, LOC.

56 D. C. F. to Pamela Prentiss French, March 26, 1893, French Family Papers, LOC.

57 D. C. F. to Harriette French Hollis, April 21, 1893, French Family Papers, LOC.

58 Language of the federal legislation authorizing the fair in Chicago, quoted in Trumbull White and William Igleheart, *The World's Columbian Exposition, Chicago*, 1893 (Boston: John K. Hastings, 1893), 43. The book identified White as a "World's Fair Correspondent," and Igleheart as the "World's Fair Editor of the 'Chicago Record.'"

59 White and Igleheart, *World's Columbian Exposition*, 41.

60 William Walton, *World's Columbian Exposition MDCCCXLIII: Art and Architecture* (Philadelphia: George Barrie, n.d.), 13.

61 Mrs. Potter Palmer, et al., *Rand, McNally & Co.'s Handbook of the World's Columbian Exposition with Special Descriptive Articles…* (Chicago: Rand, McNally & Co., 1893), 19–22, 26. Palmer was president of the fair's Board of Lady Managers.

62 Truman, *History of the World's Fair*, 155.

63 Ibid., 155, 157.

64 Ibid., 160.

65 *Rand, McNally Handbook*, 15–17.

66 Handy, *Official Directory*, 193–96, 205.

67 Ibid., 117, 183–87; Davis & Palmer, *World's Columbian Exposition*, 578–79, 599.

68 Handy, *Official Directory*, 198–99; Davis and Palmer, *World's Columbian Exposition*, 599.

69 Davis & Palmer, *World's Columbian Exposition*, 575–77, 598; French, *Memories of a Sculptor's Wife*, 177–78.

70 Florence Adele Sloane, *Maverick in Mauve: The Diary of a Romantic Age* (New York: Doubleday, 1983), 72–73; Clarence Day, *The Best of Clarence Day* (New York: Alfred A. Knopf, 1948), 152–53.

71 *Rand, McNally Handbook*, 27.

72 Ibid., 150, 155–59; Handy, *Official Directory*, 203.

73 Carolyn Kinder Carr and George Gurney, eds., *Revisiting the White City: American Art at the 1893 World's Fair* (Washington: National Portrait Gallery, 1993), 78.

74 *Rand, McNally Handbook*, 155–58, map p. 159. By another account, however, "two of the greatest sculptors of this country, Mr. St. Gaudens and Mr. [Frederick William] MacMonnies, are not represented at all." See White and Igleheart, *World's Columbian Exposition*, 368. Description of Manet work, p. 376. Perhaps both accounts were correct; it is conceivable that Saint-Gaudens installed his Logan bust after the first guidebooks were set in type. Yet another report suggested that a copy of Saint-Gaudens' famous New York statue, *Diana*, adorned one of the fair building's rooftops.

75 Some scholars insist that Augustus Saint-Gaudens remained unrepresented at the World's Columbian Exposition in Chicago.

76 William A. Coffin, "The Columbian Exposition, I. Fine Arts: French and American Sculpture," *The Nation* 57 (August 3, 1893), 80. The Saint-Gaudens bronze may well have been the model for the John A. Logan memorial statue he

unveiled in Chicago, with the backing of fair manager Daniel Burnham, in 1897.

77 Official photograph published in Arnold & Higinbotham, *Official Views of the World's Columbian Exposition*, plate 61. The jury awarded fourteen medals to American sculptors exhibiting at the fair, including John Rogers and Charles Niehaus. As a jury member, French undoubtedly recused his works from the competition. See *New York Times*, August 22, 1893.

78 Lorado Taft, *The History of American Sculpture* (New York: Macmillan, 1903), 320.

79 White and Igleheart, *World's Columbian Exposition*, 371.

80 Handy, *Official Directory*, 203.

81 White and Igleheart, *World's Columbian Exposition*, 387. Mariana Griswold Van Rensselaer, known as America's first female architecture writer, was also the subject of a low relief portrait by Saint-Gaudens, now in the Metropolitan Museum of Art.

82 Taft, *History of American Sculpture*, 322.

83 "Sculpture at the Chicago Exhibition," *Builder* 65 (September 30, 1893): 240.

84 Ibid.

85 *The* [London] *Graphic*, January 14, 1893.

86 Translated and reprinted in the *Chicago Inter-Ocean*, July 8, 1893.

87 Horace Spencer Fiske, "The Statue of the Republic (In the Court of Honor, Chicago)," *Brush and Pencil* 5 (January 1900): 163.

88 Royal Cortissoz, "New Figures in Literature and Art. 1. Daniel Chester French," *Atlantic Monthly* 75 (February 1895): 228.

89 Moore, *Daniel H. Burnham*, 1:55.

90 D. C. F. to William M. R. French, September 27, 1896, French Family Papers, LOC.

91 Daniel Chester French account book for 1915, p. 139, original in the Chapin Library, Williams College, Williamstown, MA; copy in the Chesterwood collection.

92 "Programme" for the "Dedication of the Statue of the Republic in Jackson Park," souvenir in the French Family Papers, LOC.

93 Richman, "Daniel Chester French's The Republic," 14.

94 Blair Kamin, "Golden Lady Statue in Jackson Park Would Be 'Liberated' by Obama Center," *Chicago Tribune*, January 22, 2018.

95 Zimmerman, *Love, Fiercely*, 67–68.

96 Roosevelt cohosted a dinner for World's Fair officials at Delmonico's Restaurant on December 21, 1891. See *New York and the World's Fair: The Dinner Given in the Interest of the World's Columbian Exposition by the New York Members of the National Commission...*(Chicago: World's Columbian Exposition, Department of Publicity and Promotion, 1892), 5. It is conceivable that the pictures originally hung in Sara Delano Roosevelt's own smaller cottage on the island, which fell into disrepair and was demolished in the 1950s. No records of the furnishings survive.

CHAPTER EIGHT
MEMORIAL MAKER

1 Mrs. Daniel Chester [Mary] French, *Memories of a Sculptor's Wife* (Boston: Houghton, Mifflin Co., 1928), 154–55.

2 Ibid., 181–84.

3 Margaret French Cresson, *Journey into Fame: The Life of Daniel Chester French* (Cambridge: Harvard University Press, 1947), 176–77.

4 Laura Fecych Sprague, "Theophilus Walker and Gore Place," in *The Legacy of James Bowdoin III* (Brunswick, ME: Bowdoin College Museum of Art, 1994), 217. For details of the Walker sister's beneficence, see Lillian B. Miller, "The Legacy: The Walker Gift, 1894," ibid., 187–215.

5 D. C. F. to Harriet Walker, December 5, 1892, quoted in Michael Richman, *Daniel Chester French: An American Sculptor* (New York: Metropolitan Museum of Art, 1976), 82n2.

6 Richman, *Daniel Chester French*, 81.

7 Patricia McGraw Anderson, *The Architecture of Bowdoin College* (Brunswick, ME: Bowdoin College Museum of Art, 1988), 48. For more on Brimmer—who, with Luigi di Cesnola (at the Met) and Dan's brother Will (in Chicago), formed the triumvirate of founding directors of great American art museums organized in the same year, 1870—see Walter Muir Whitehill, *Museum of Fine Arts, Boston: Centennial History*, 2 vols. (Cambridge, MA: Harvard University Press, 1970) 1:11–12.

8 This is a paraphrase of the rationale that civic leaders issued in Boston to promote plans to build a monument to Robert Gould Shaw, the martyred commander of the 54th Massachusetts Regiment of US Colored Troops. Quoted in Lincoln Kirstein, "The Memorial to Robert Gould Shaw and His Soldiers by Augustus Saint Gaudens," in *Lay This Laurel: An Album on the Saint-Gaudens Memorial on Boston Common Honoring Black and White Men Together Who Served the Union Cause with Robert Gould Shaw and Died with Him July 18, 1864* (New York: Eakins Press, 1973), Section IV (the book is unpaginated).

9 Richman, *Daniel Chester French*, 22.

10 Nathaniel Hawthorne, *The Marble Faun: Or, the Romance of Monte Beni*, 1860 (repr. New York: Signet Classic Books, 1961), 88–89.

11 For the Choate statue, see *Boston Herald*, March 25, 1898.

12 For Phillips Brooks, *Boston Herald*, December 24, December 25, 1899; for *Justice* atop New York City's new appellate courthouse, see *Boston Herald*, March 12, 1899.

13 Both quotes from *Frank Leslie's Illustrated Newspaper*, July 30, 1896.

14 *Boston Herald*, September 8, 1893.

15 Richman, *Daniel Chester French*, 24–25.

16 Both quotes from the *Boston Herald*, September 8, 1893.

17 Lorado Taft, "Daniel Chester French, Sculptor," *Brush and Pencil* 5 (January 1900): 156, 158.

18 *Boston Herald*, September 8, 1893.

19 French, *Memories of a Sculptor's Wife*, 188–89.

20 Cresson, *Journey into Fame*, 179.

21 Taft, *History of American Sculpture*, 325.

22 Lilian Whiting, "Life in Boston...Daniel C. French: An American Sculptor of Rare Genius," [Chicago] *Inter-Ocean*, May 30, 1896.

23 Ibid.

24 *Boston Herald*, June 18, 1896.

25 *Boston Transcript*, June 20, 1896.

26 *Boston Transcript*, June 22, 1896.

27 *Boston Sunday Herald*, June 21, 1896.

28 *Boston Sunday Herald*, May 3, 1896.

29 That French was working on all these initiatives simultaneously was reported in the *New York Tribune*, April 4, 1896.

30 Morrison H. Heckscher, "The Metropolitan Museum of Art: An Architectural History," *The Metropolitan Museum of Art Bulletin* 53 (summer 1995): 30–38.

31 William R. Ware to Henry G. Marquand, March 30, 1896, archives of the Metropolitan Museum of Art.

32 "Dear French" original in the French Family Papers, LOC, copy in the Chesterwood collection.

33 D. C. F. to William M. R. French, April 1, 1896, French Family Papers, LOC.

34 *New York Tribune*, April 4, 1896.

35 Both observations quoted in Richman, *Daniel Chester French*, 84.

36 Millard F. Rogers, Jr., *Sketches and Bozzetti by American Sculptors 1800–1950* (Cincinnati: Cincinnati Art Museum, 1987), 71.

37 *The Architectural League of New York Illustrated Catalogue of the Twelfth Annual Exhibition 1897* (New York: Galleries of the American Fine Arts Society, 1897), 122. The author is grateful to curator Thayer Tolles for sharing a copy of the original catalog in the collection of the Metropolitan Museum of Art. The copies now in the Metropolitan Museum collection were owned by the Hunt family.

38 *New York Times*, November 1, 1898. For the acting mayor, see "Death of Mr. Guggenheimer," *New York Times*, December 30, 1907. Democrat Guggenheimer, elected as President of the New York City Council, took over in the temporary absence of newly elected Mayor Robert A. Van Wyck from 1898 to 1900.

39 Quoted in David B. Dearinger, ed., *Rave Reviews: American Art and Its Critics* (New York: National Academy of Design, 2000), catalog listing No. 57.

40 *New York Times*, January 11, 1901; *American Architect* 71 (January 12, 1901): 9.

41 *New York Times*, January 4, 1901.

42 *The Art World*, January 1, 1901, quoted in Dearinger, *Rave Reviews*, catalog listing No. 57.

43 *American Architect* 71 (January 12, 1901): 9.

44 *American Architect* 72 (February 9, 1901).

45 *Asheville* (NC) *Citizen-Times*, January 5, 1901.

46 *New York Times*, February 22, 1901.

47 *Vermont Phoenix*, April 26, 1901. The best account of the Hunt project can be found in Richman, *Daniel Chester French*, 83–89.

48 *Vermont Phoenix*, April 26, 1901.

49 *Indianapolis News*, April 27, 1901.

50 *Philadelphia Inquirer*, January 20, 1901.

51 See *Carved and Modeled: American Sculpture 1810–1940*, Hirschl & Adler catalog published in 1982, when the gallery placed the bronze on view at an exhibition "organized for the benefit of Chesterwood." For the 1927 theft, see French's account books for that year, noting its sale price ($200), and the entry: "Stolen."

52 David M. Kahn, "General Grant National Memorial: Historical Resource Study," manuscript, January 1980, 29; www.nps.gov/gegr/learn/education/upload/Kahn-Historic-Resource-Study-1980.pdf.

53 The growing roster of Lee statues eventually came to include equestrians (like the famous statue in Richmond), as well as standing statues, among them a tribute for Statuary Hall in the US Capitol and a statue in New Orleans removed by that city in 2017. Among the oddest is Edward Valentine's "recumbent" statue of Lee inside the Lee Chapel at Washington & Lee University in Lexington, Virginia, purporting to show Lee sleeping on a battlefield, but often mistaken for a mummy-like grave marker. For an example of the media frenzy that greeted the removal of the arms-folded New Orleans Lee, see, for example, Campbell Robertson, "From Lofty Perch, New Orleans Monument to Confederacy Comes Down," *New York Times*, May 19, 2017.

54 Michael Richman, "Ulysses S. Grant," in *Fairmount Park Association, Philadelphia's Treasures in Bronze and Stone* (New York: Walker, 1976), 188, 352n4. Richman conducted extraordinary archival research into the

Minute Book of the Fairmount Park Art Association.

55 D. C. F. to William M. R. French, December 14, 1892, French Family Papers, LOC.

56 Ibid., 194; *Philadelphia Times*, April 16, 1899.

57 Richman, "Ulysses S. Grant," 192.

58 Ibid., 190.

59 *Frank Leslie's Illustrated Newspaper*, June 18, 1896.

60 *The North American*, April 28, 1899.

61 *Boston Herald*, April 29, 1899.

62 *Frank Leslie's Weekly*, May 11, 1899.

63 Ibid.

64 William A. Coffin, "The Sculptor French," *Century Magazine* 59 (April 1900): 876.

65 French, *Memories of a Sculptor's Wife*, 200.

66 D. C. F. to William M. R. French, October 6, 1895, French Family Papers, LOC.

67 French told his brother, "Glendale is one of the villages within the township of Stockbridge, of which there are several." See D. C. F. to William M. R. French, August 16, 1896, French Family Papers, LOC. Decades later, another famous artist did establish a studio on Stockbridge's Main Street: Norman Rockwell.

68 Cresson, *Journey into Fame*, 182.

69 D. C. F. to William M. R. French, August 16, 1896, French Family Papers, LOC, copy at Chesterwood.

70 Margaret French Cresson, "Daniel French's Heaven—Reminiscences of Chesterwood," *Historic Preservation* 25 (April–June 1973): 18.

71 Quoted in French, *Memories of a Sculptor's Wife*, 201.

72 French, *Memories of a Sculptor's Wife*, 200; Cresson, *Journey into Fame*, 183–84.

73 Michael Richman, "Ulysses S. Grant," in Fairmount Park Association, *Philadelphia's Treasures in Bronze and Stone* (New York: Walker Publishing, 1976), 191.

74 D. C. F. to William M. R. French, August 16, 1896.

75 Paul Ivory, "Daniel Chester French and Chesterwood," postscript to Richman, *Daniel Chester French*, 201.

76 Christopher Alexander Thomas, "The Lincoln Memorial and Its Architect, Henry Bacon (1866–1924)," PhD dissertation, Yale University, 1990, 208.

77 *American Magazine of Art* 15 (April 1924): 190.

78 "Old Berkshire Honored Again—Daniel French, the World Renowned Sculptor, Chooses to Make His Summer Home in the Village of Glendale," [Pittsfield, MA] *Sunday Morning Call*, March 20, 1898.

79 Michael Gotkin, "Republic in the Round," *The World of Interiors* (September 2016): 100.

80 Cresson, *Journey into Fame*, 185.

81 Margaret French Cresson, "The Strength of the Hills," typescript in the Chesterwood Archives, 4.

82 D. C. F., *Garden Journal*, July 12, 1898.

83 Cresson, *Journey into Fame*, 185.

84 Linda Wesselman Jackson, "Chesterwood: Home of Daniel Chester French," *American Art Review* 16 (May–June 2004): 16.

85 Barr Ferree, "Homes of American Artists—'Chesterwood,' the Country Home of Daniel Chester French, Glendale, MA, *American Homes and Gardens* 6 (January 1909): 5–7, 10.

86 *New York Herald-Tribune*, April 20, 1930.

CHAPTER NINE
A NEW CENTURY

1 *Boston Herald*, July 4, 1900.

2 Margaret French Cresson, *Journey into Fame: The Life of Daniel Chester French* (Cambridge: Harvard University Press, 1947), 196.

3 Ibid., 185.

4 Ibid., 186–87.

5 Minutes Book, Peace Party Chapter of the National Society, Daughters of the American Revolution, Pittsfield, Berkshire County, Massachusetts, 1897–1899, 62–63. Copy in the Chesterwood Collection.

6 Undated, unsourced clipping in the French Papers, Chapin Library, Williams College; Garden Notebook, August 10, 1899, I:49.

7 *Boston Herald*, February 25, 1900.

8 *New York Tribune*, April 13, 1900.

9 The undated, unsourced clipping is in the French Papers, Chapin Library, Williams College, Williamstown, MA.

10 William A. Coffin, "The Sculptor French," *Century Magazine* 59 (April 1900): 875.

11 Cresson, *Journey into Fame*, 196.

12 *Boston Herald*, July 4, 1900.

13 "In the Field of Art," *Chicago Tribune*, June 5, 1904. The statue stands today on the corner of Martin Luther King Drive and Fifty-First Street.

14 D. C. F. account book, 1917–1918, Chesterwood Collection.

15 Postcards in the French Family Papers, LOC, copies in the Chesterwood Archives.

16 "Sculptor French Back from Paris," *Boston Herald*, January 27, 1901.

17 *Concord Evening Monitor*, October 2, 1899.

18 *Frank Leslie's Weekly*, September 23, 1899.

19 *Boston Herald*, August 27, 1899.

20 Reportedly some of the sculptures, perhaps including French's, were rescued and sent to Charleston for exhibition. But these, too, were ultimately destroyed.

21 Lorado Taft, *The History of American Sculpture* (New York: Macmillan, 1903), 330.

22 Edmund Wilson, *O Canada: An American's Notes on Canadian Culture* (New York: Farrar, Strauss and Giroux, 1955), 54.

23 D. C. F. to William M. R. French, June 10, 1908, French Family Papers, LOC.

24 Francis Parkman, *The Conspiracy of Pontiac and the Indian War after the Conquest of Canada* (1851), quoted in Richard Heath, "Parkman Memorial," Jamaica Plains Historical Society, 4, www.jphs.org/people/2005/4/14parkman-memorial-html.

25 Charles F. McKim to D. C. F., February 13, 1901, McKim Papers, Library of Congress.

26 Some scholars have called the Parkman project the first French-Bacon collaboration; others have cited the Joseph Hooker Memorial.

27 The early plaster "reverse" reliefs now stand on the piazza of the Chesterwood studio.

28 Charles F. McKim to D. C. F., August 9, 1901, quoted in Michael Richman, *Daniel Chester French: An American Sculptor* (New York: Metropolitan Museum of Art, 1976), 98.

29 D. C. F. to Augustus Saint-Gaudens, October 4, 1901, Saint-Gaudens Papers, Dartmouth College.

30 D. C. F. to William M. R. French, June 10, 1908, French Family Papers, LOC.

31 D. C. F. to H. L. Brown (contractor for the Parkman project), November 28, 1906, French Family Papers, LOC.

32 See www.jphs.org/people/2005/4/14/parkman-memorial.html.

33 D. C. F. to Loren F. Deland, June 7, 1906, French Family Papers, LOC.

34 D. C. F. to Edwin Blashfield, undated [ca. 1900], Blashfield Papers, New-York Historical Society.

35 Taft, *History of American Sculpture*, 474.

36 John Russell Young, *Around the World with General Grant: A Narrative of the Visit of General U. S. Grant, Ex-President of the United States, to Various Countries in Europe, Asia, and Africa, in 1877, 1878, 1879...*, 2 vols. (New York: American News Co., 1879), 2:306.

37 Ulysses S. Grant, *Personal Memoirs of U. S. Grant*, 2 vols. (New York: Charles L. Webster, 1885), 2:539.

38 Brevet Captain Isaac P. Gragg, "The Statue of Gen. Hooker," *Boston Herald*, January 27, 1901.

39 "'Joe' Hooker in Bronze. The Statue Which Is About to Be Erected Here. Messrs. French and Potter Produce a Splendid Equestrian Piece for the State House Grounds," *Boston Herald*, April 7, 1897.

40 D. C. F. to Katrina Trask, August 30, 1914, French Family Papers, LOC.

41 D. C. F. to William M. R. French, August 22, 1902, copy in the Chesterwood Collection.

42 Lincoln to Hooker, January 26, 1863, in Roy P. Basler, ed., *The Collected Works of Abraham Lincoln*, 8 vols. (New Brunswick, NJ: Rutgers University Press, 1953–1955), 6:79. Hooker reportedly carried this withering letter with him for the rest of his life, insisting: "I love the man who wrote it." See Harold Holzer, ed., *Lincoln on War* (New York: Algonquin Books, 2011), 183.

43 *New York Times,* January 30, 1903.

44 *Boston Globe,* September 19, 2000; Michael Richman, "Ulysses S. Grant," in Fairmount Park Association, *Philadelphia Treasures in Bronze and Stone* (New York: Walker Publishing, 1976), 193.

45 *New York Tribune,* January 13, 1904.

46 Trip Diary, May 15–June 15, 1900. French also took his family to Switzerland and Greece.

47 The encounter was actually recalled by the sculptor's wife, but she surely heard it directly from her husband. See Mrs. Daniel Chester [Mary] French, *Memories of a Sculptor's Wife* (Boston: Houghton Mifflin, 1928), 195.

48 French, *Memories of a Sculptor's Wife,* 197.

49 French, *Memories of a Sculptor's Wife,* 197–98.

50 See Sue A. Kohler, *The Commission of Fine Arts: A Brief History,* 1910–1995 (Washington, DC: US Commission of Fine Arts, n.d.).

51 French, *Memories of a Sculptor's Wife,* 192.

52 "Address of Joseph Choate: At the Opening of the Museum Building, March 30, 1880," *Metropolitan Museum of Art Bulletin* 12 (1917): 126. The roster of board members comes from the *Annual Report of the Trustees of the Metropolitan Museum of Art* 34 (1904): 5–7.

53 French, *Memories of a Sculptor's Wife,* 199.

54 The Metropolitan's founding board had included several artists—including Frederic Edwin Church, John Frederick Kensett, and Eastman Johnson—but by the early twentieth century their ranks had dissipated. For a well-researched but highly critical analysis of the museum board's early recruitment efforts within both the art and business worlds, see Michael Gross, *Rogue's Gallery: The Secret History of the Moguls and the Money that Made the Metropolitan Museum* (New York: Broadway Books, 2009), esp. 28–29.

55 D. C. F. to J. Q. A. Ward, April 22, 1904, J. Q. A. Ward Papers, New-York Historical Society.

56 According to the museum's catalog of American sculpture, French "was almost single-handedly responsible for the acquisition by the Museum of its substantial core collection of American bronzes in the early twentieth century." See Thayer Tolles, "Daniel Chester French (1850–1931)," in Tolles, ed., *American Sculpture in the Metropolitan Museum of Art* (New York: Metropolitan Museum of Art, 1999), 327. The Bashford Dean plaque can be seen in Gallery 503 at the entrance to the Arms and Armor galleries.

57 D. C. F. to Robert W. de Forest, June 26, 1929, French Family Papers, LOC.

58 Donald J. LaRocca, "The Bashford Dean Memorial Tablet by Daniel Chester French," *Metropolitan Museum Journal* 31 (1967): 156. See also D. C. F. to Mrs. Bashford Dean, August 8, 1929, Metropolitan Museum Archives. The author is grateful to Don LaRocca for his guidance in exploring this story.

59 D. C. F. to J. Q. A. Ward, Ward Papers, New-York Historical Society.

60 D. C. F. to William M. R. French, November 6, 1913, French Family Papers, LOC.

61 Calvin Tomkins, *Merchants & Masterpieces: The Story of the Metropolitan Museum of Art,* 1970 (rev. ed. New York: Henry Holt, 1989), 299. Tomkins is correct in asserting that "From 1906 to 1933, purchases of American sculpture had been left entirely in the hands of Daniel Chester French," but not that his "sympathies were limited to the work of his friends and pupils."

62 D. C. F., "Modern American Bronzes," a report to the Board of the Met, *Metropolitan Museum of Art Bulletin* 1 (September 1, 1906).

63 Tolles, *American Sculpture in the Metropolitan,* xix.

64 D. C. F. to Janet Scudder, June 7, 1906, French Family Papers, LOC.

65 Tolles, *American Sculpture in the Metropolitan,* xvii.

66 Thayer Tolles, "Daniel Chester French and the Metropolitan Museum of Art," *Fine Art Connoisseur* (May–June 2016): 57–58.

67 Saint-Gaudens to D. C. F., March 19, 1902, May 21, 1903, in Homer

Saint-Gaudens, ed., *The Reminiscences of Augustus Saint-Gaudens*, 2 vols. (New York: The Century Co., 1913), 2:294–96.

68 Ibid., 210; Joyce K. Schiller, "Winged Victory, a Battle Lost: Augustus Saint-Gaudens's Installation for the Sherman Monument Installation," in Thayer Tolles, ed., *Perspectives on American Sculpture Before 1925* (New York: Metropolitan Museum of Art), 2004.

69 D. C. F. to Abbott Handerson Thayer, March 27, 1916, French Family Papers, LOC.

70 *Brooklyn Daily Eagle*, May 8, 1912.

71 Thayer Tolles, *Augustus Saint-Gaudens in the Metropolitan Museum of Art* (reprint from *The Metropolitan Museum of Art Bulletin*, spring 2009): 50.

72 Tolles, *American Sculpture in the Metropolitan*, xix–xx.

73 Ibid., xx–xxi.

74 D. C. F. to Royal Cortissoz, March 10, 1918, French Family Papers, annotated typescript in the Chesterwood collection.

75 Royal Cortissoz, "American Artists at the Metropolitan Museum," *New York Tribune*, March 10, 1918.

76 Royal Cortissoz, "The Past and Present in American Painting," *New York Tribune*, May 17, 1918. Despite the headline, Cortissoz devoted the first twenty-six lines of his review to "the exhibition of American sculpture at the Metropolitan Museum."

77 Tolles, *American Sculpture in the Metropolitan*, xvi.

78 D. C. F. typescript memorial tribute to Abbott Handerson Thayer (1921), in the French Family Papers, LOC; transcript in the Chesterwood collection.

79 Abbott Handerson Thayer to D. C. F., February 21, 1916, French Family Papers, LOC.

80 D. C. F. to Edward Robinson, June 4, 1921; to Robert W. de Forest, June 9, 1921, and to Mrs. Abbott H. Thayer, June 15, 1921, French Family Papers, LOC.

81 J. P. Morgan Jr. to Edward Dean Adams, September 12, 1913, quoted in Thayer Tolles, "Daniel Chester French, Paul Manship, and the *John Pierpont Morgan Memorial* for the Metropolitan Museum," *Metropolitan Museum Journal* 42 (2006): 178.

82 Ibid., 171–93.

83 D. C. F. quoting Edward Robinson in a letter to Emil Carlson, January 14, 1920, French Family Papers, LOC.

84 Photograph in the Metropolitan Museum Archives, printed in Tolles, *American Sculpture in the Metropolitan*, xvii, fig. 5.

85 Quoted Walter Tittle, "A Sculptor of the Spirit: How Daniel Chester French Puts Character into Marble," [London] *World To-Day* (December 1928): 59.

86 M. J. Lowenstein, *Official Guide to the Louisiana Purchase Exposition, at the City of St. Louis, State of Missouri, April 30 to December 1, 1904*...(St. Louis: Official Guide Company of St. Louis, 1904), 27; illustration of French's Napoleon statue on p. 22.

87 *New York Times*, May 8, 1904.

88 Once again, however, fair organizers made sure the official art gallery was constructed of stronger stuff, and in replication of Chicago, it was later converted into the headquarters of the St. Louis Art Museum.

89 The only known source for this history is Robert A. Mosher, "The Mysterious Lost First Consul: 'Napoleon' by Daniel Chester French," posted online in "The Napoleon Series" under the category "Napoleon Himself." See www.napoleon-series.org/research/napoleonic/c_saintlouis1904.html.

90 The Brooklyn—which aspired at the time to be larger than the Metropolitan—later acquired other Daniel Chester French works, including one of his earliest pieces, the Rogers Group–inspired *Joe's Farewell*.

CHAPTER TEN
HIGH WATER MARK

1 Financing was provided by the Goelet family in memory of Robert Goelet (class of 1860), a wealthy philanthropist who died young. See Rudolf Tumbo Jr., "Daniel Chester French. An American Artist," typescript (1906) retained by Daniel Chester French under the heading (in his daughter's hand): "The Alma Mater, Columbia College," copy in the Chesterwood Collection. For French's service on Columbia's art advisory

committee, see D. C. F. acceptance letter to President Seth Low, January 10, 1898, Columbia University Rare Book & Manuscript Library.

2 Arthur S. Marks, "The Statue of King George III in New York and the Iconology of Regicide," *American Art Journal* 13 (summer 1981): 62. The school was originally founded as King's College.

3 *Brooklyn Eagle*, May 5, 1901.

4 Charles F. McKim to Seth Low, January 10, 1901, Columbia University Archives; D. C. F. to William M. R. French, July 31, 1900, French Family Papers, LOC.

5 D. C. F. to Frances C. Heddell, June 14, 1914, French Family Papers, LOC.

6 Seth Low to D. C. F. March 5, 1901; D. C. F. to Low, March 10, 1901, Columbia University Rare Book & Manuscript Library. See also Michael Richman, *Daniel Chester French: An American Sculptor* (New York: Metropolitan Museum of Art, 1976), 91.

7 D. C. F. to Seth Low, March 26, 1901, Columbia University Rare Book & Manuscript Library.

8 Augustus Saint-Gaudens to D. C. F., September 29, 1901, French Family Papers, LOC.

9 D. C. F. to Augustus Saint-Gaudens, October 4, 1901, French Family Papers, LOC.

10 D. C. F. to Frances C. Heddell, June 16, 1914, French Family Papers, LOC.

11 D. C. F. to F. H. M. Murray, February 17, 1915, French Family Papers, LOC.

12 D. C. F. to William M. R. French, October 11, 1903, French Family Papers, LOC.

13 *Frank Leslie's Illustrated Newspaper*, October 8, 1903; curtain color and crowd estimate from the *New York Times*, September 24, 1903.

14 *New York Times*, September 24, 1903.

15 Reported in the *Elmira Star-Gazette*, November 19, 1904.

16 *New York Times*, October 4, 1903. By "class rivalry" the paper was alluding to competition between the freshman and sophomore classes, not the kind of social warfare the phrase later came to represent.

17 For a photograph of a pipe-smoking student searching for the owl on the steps of Low Library, see *New York Herald Tribune*, February 22, 1950.

18 "Rich and Poor at Columbia," letter from "Engineer" to the *New York Times*, June 14, 1904.

19 "Brilliant Objects in Winter," *Rochester Democrat and Chronicle*, January 2, 1904.

20 See D. C. F. to Albert W. Putnam, April 20, 1928, and to Henry Morris (director of works, Columbia University), August 30, 1928, Columbia University Archives.

21 Ray Robinson, "Lou Gehrig: Columbia Legend and American Hero," *Columbia Magazine* (Fall 2001), www.columbia. edu/cu/alumni/Magazine/Fall2001/ Gehrig.html.

22 See, for example, his letter dismissing a proposed donation of sculpted lions— the university mascot—as "beneath notice" (D. C. F. to Nicholas Murray Butler, April 5, 1905) and his enthusiasm for the acquisition of portrait sculptures of Nicholas Schermerhorn (D. C. F. to Butler, May 4, 1904), Frederick C. Havemeyer (D. C. F. to Butler, May 20, 1904), and a George Washington bust by Houdon (D. C. F. to Butler, January 6, 1908), all in the Columbia University Rare Book & Manuscript Library.

23 Nicholas Murray Butler to D. C. F., January 6, 1908; D. C. F. to Butler, January 8, 1908, Columbia University Rare Book & Manuscript Library.

24 Nicholas Murray Butler to George L. Rives, January 22, 1913 (noting that it had been "some time since the University has conferred an honorary degree upon a representative of the Fine Arts"— the last, apparently, had been Charles F. McKim); D. C. F. to Butler, March 5, 1913, Columbia University Rare Book & Manuscript Library.

25 Among the many pieces of correspondence between French and Columbia University officials over the years regarding the Pulitzer medal commission, see D. C. F. to Nicholas Murray Butler (calling the project "eminently worthy of consideration"), July 16, 1918, Columbia University Rare Book & Manuscript Library. French had insisted that Lukeman be co-commissioned to design the Pulitzer medallion.

26 D. C. F., Edwin H. Blashfield, and William Rutherford Mead to Nicholas Murray Butler, November 28, 1923, Columbia University Rare Book & Manuscript Library.

27 Import-tax statistics published in the *New York Tribune*, January 17, 1904.

28 Mollie Martin and James Keller, "US Customs Service," in Kenneth T. Jackson, ed., *The Encyclopedia of New York City*, 2nd ed. (New Haven, CT: Yale University Press, 2010), 1355–56.

29 For the announcement of the competition see "N.Y. Custom House," *American Architect and Building News* 64 (May 13, 1899): 49; for a detailed history see Kathryn T. Greenthal and Michael Richman, "Daniel Chester French's Continents," *American Art Journal* 8 (November 1976): 47–58.

30 The ensuing scandal inspired Congress, in 1913, to enact legislation to ban such contests in the future.

31 Contract proposal dated September 23, 1901, pp. 62–63, Cass Gilbert Papers, New-York Historical Society. I am grateful to the early scholarly inquiries of historian Michael Richman, whose published source notes led me to examine the Gilbert collection to consult original documents. See also Gilbert to D. C. F., February 12, 1903, Cass Gilbert Papers, New-York Historical Society. Originally, Gilbert left it to the discretion of the sculptor whether to produce "single figures, or have in [the] composition a child, a globe, an eagle, or some other accessory as the sculptor might find in working up the subject" (Gilbert to D. C. F., February 12, 1903).

32 D. C. F. to Cass Gilbert, February 21, 1903, Cass Gilbert Papers, New-York Historical Society.

33 D. C. F. to Cass Gilbert, June 29, 1903, Cass Gilbert Papers, New-York Historical Society.

34 Margaret French Cresson, *Journey into Fame: The Life of Daniel Chester French* (Cambridge, MA: Harvard University Press, 1947), 211–12.

35 D. C. F. to Cass Gilbert, February 24, 1903; Gilbert to D. C. F., May 13, 1903, Cass Gilbert Papers, New-York Historical Society.

36 "To Adorn New Custom House at Bowling Green. The Great Groups of Statuary Now Under Way. Will Symbolize the Entire World—Sculptors at Work," *New York Tribune Illustrated Supplement*, January 17, 1904.

37 Cresson, *Journey into Fame*, 213.

38 Richman, *Daniel Chester French*, 109.

39 D. C. F. to Cass Gilbert, June 9, 1906, Cass Gilbert Papers, LOC.

40 French to John E. Trask (Pennsylvania Academy of Fine Arts), November 12, 1906, French Family Papers, LOC.

41 "Daniel Chester French's Four Symbolic Groups for the New York Custom House," ca. 1906, undated clipping in the Chesterwood collection.

42 See D. C. F. to Cass Gilbert, October 22, October 24, 1906, French Family Papers, LOC.

43 D. C. F. to Cass Gilbert, August 31, 1916, Cass Gilbert Papers, New-York Historical Society.

44 *New York Tribune Illustrated Supplement*, January 17, 1904.

45 D. C. F. to Cass Gilbert, August 31, 1916, Cass Gilbert Papers, New-York Historical Society.

46 *New York Tribune Illustrated Supplement*, January 17, 1904.

47 Ibid.; D. C. F. to Francis E. Browning, February 26, 1926, French Family Papers, LOC.

48 *New York Tribune Illustrated Supplement*, January 17, 1904. Later called upon to explain why the figure seemed to some to radiate European, rather than African, facial features, French replied: "Of course I could retreat into the safe ground that I am depicting an Egyptian and so even defend the long hair," but admitted, "it is a fact that I have, in the figure, spoken the language of European art instead of sticking closely to the African type." See D. C. F. to F. H. M. Murray, February 24, 1915, French Family Papers, LOC.

49 Lewis I. Sharp, *New York City Public Sculpture by 19th-Century American Artists* (New York: Metropolitan Museum of Art, 1974), 39.

50 Charles de Kay, "French's Groups of the Continents: The Four Marble Groups by Daniel Chester French, Designed for the Main Front of the New Custom-House

in New York," *Century Magazine* 71 (January 1906): 428, 431.

51 *The Monumental News*, 3 (March 1906): 203, quoted in Greenthal and Richman, "Daniel Chester French's Continents," 58.

52 *Burr McIntosh Monthly* 2 (November 1906), quoted in Kathryn T. Greenthal, "Daniel Chester French's Sculpture Groups for Public Buildings," dissertation typescript in Chesterwood Collection, 28n3.

53 Cass Gilbert to Howard Childs, corresponding secretary of the Salmagundi Club—a letter to be read at a dinner there honoring French—November 18, 1914, copy in the Chesterwood Archives.

54 D. C. F. account book, Chesterwood collection. The back of one of the pages in the entry for the *Continents* shows a hasty but endearing little sketch of one of the groups. French had not lost his touch as a draftsman.

55 Greenthal, "Daniel Chester French's Sculpture Groups for Public Buildings," 29n58.

56 D. C. F. to F. H. M. Murray, February 17, 1915, French Family Papers, LOC.

57 Adeline Adams, *Daniel Chester French: Sculptor* (Boston: Houghton Mifflin, 1932), 51–53.

58 Mrs. Daniel Chester [Mary] French, *Memories of a Sculptor's Wife* (Boston: Houghton Mifflin, 1928), 222.

59 D. C. F. to William M. R. French, May 28, August 27, 1905, French Family Papers, LOC.

60 Cresson, *Journey into Fame*, 212–13.

61 D. C. F. to James C. Melvin, January 4, 1907, French Family Papers, LOC.

62 Wayne Craven, *Sculpture in America*, 1968 (rev. ed. Newark, DE: University of Delaware Press, 1984), 402. Craven posited that French's relationship with the Melvin family inspired him to invest the composition "with considerable personal feeling" (ibid.).

63 Saint-Gaudens famous relief sculpture showed the soldiers marching toward their deaths at Battery Wagner in Charleston, S.C., their captain, Robert Gould Shaw, riding among them. See *The Monument to Robert Gould Shaw: Its Inception, Completion and Unveiling*

1865–1897 (Boston: Houghton Mifflin, 1897).

64 He employed as his newest assistant the German-born Carl Augustus Heber, whom French would later use, along with others, to sculpt the pediment for the Brooklyn Museum.

65 Alfred Seelye Roe, ed., *The Melvin Memorial, Sleepy Hollow Cemetery, Concord, Massachusetts: A Brother's Tribute. Exercises at Dedication* (Cambridge, MA: Riverside Press, 1909), 1, 22.

66 D. C. F. to William M. R. French, October 22, 1908, French Family Papers, LOC.

67 D. C. F. to William Brewster, January 20, 1915, reprinted in Richman, *Daniel Chester French*, 117.

68 Henry Bacon, "Six Good Memorials," *American Magazine of Art* 10 (May 1919): 260–61.

69 Quoted in "Feminine Mystique: Woman as Allegory in the Sculpture of Daniel Chester French," *Magazine Antiques*, 183 (September-October 2016): 121. For the original reviews, see *New York Herald*, December 12, 1908, and Charles Henry Meltzer, "Sculptures Rival Paintings at the Academy Display," *New York American*, December 12, 1908.

70 Selwyn Brinton, "An American Sculptor: Daniel Chester French," *International Studio* 66 (May 1912): 214.

71 Edward Dalton Marchant, who painted Lincoln from life and photographs in 1863, quoted in Rufus Rockwell Wilson, *Lincoln in Portraiture* (New York: Press of the Pioneers, 1935), 191; see also "Lincoln's Growth as Portraits Tell It," *New York Times Magazine*, February 7, 1932.

72 Other early works included a bust from life (and photographs) by Sarah Fisher Ames, wife of Joseph Ames, on whose portrait of Theophilus Walker French had based his relief sculpture for Bowdoin; and the precocious youngster Vinnie Ream, who won a commission from the US Senate (to the horror of Lincoln's widow) to create a marble statue for the US Capitol Rotunda.

73 The authoritative checklist of heroic Lincoln statuary (through 1943) is still to be found in Donald Charles Durman,

He Belongs to the Ages: The Statues of Abraham Lincoln (Ann Arbor, MI: Edwards Bros., 1951), ix–xii.

74 Adeline Adams, *Daniel Chester French Sculptor* (Boston: Houghton Mifflin, 1932), 69.

75 Samples of the association letterhead, filed with the office of the Nebraska Secretary of State, declared: "Object: To provide the funds and erect a memorial to Abraham Lincoln on the State House Grounds in Lincoln, Nebraska, during the centennial year of his birth, 1909." Archives of the Nebraska Secretary of State, copies in the Nebraska State Historical Society, Lincoln, hereinafter referred to as NSHS.

76 *Norfolk* [NE] *Weekly News*, March 27, 1908; *Nebraska State Journal,* January 27, 1909.

77 F. M. Hall to Governor George L. Sheldon, July 16, 1908, NSHS.

78 Gutzon Borglum to Governor George Sheldon, July 23, 1908, NSHS; report on the Borglum brothers in *Nebraska State Journal,* June 25, 1909.

79 F. M. Hall to Governor George Sheldon, August 8, 1908, NSHS.

80 D. C. F. to Frank M. Hall, June 28, 1909, NSHS. Reporting that the reply "teems with enthusiasm," the *Nebraska State Journal* reprinted the entire letter on July 2, 1909.

81 Lincoln to Nebraska Secretary of State Addison Wait, September 10, 1909, NSHS.

82 *Springfield* [MA] *Republican*, reprinted in the *Nebraska State Journal,* July 4, 1909.

83 *Nebraska State Journal,* November 9, 1909.

84 Ibid.; D. C. F. to Anna [Mrs. Frank M.] Hall, November [?] 1909, typescript in NSHS.

85 Ibid.

86 D. C. F. to Anna Hall, November 11, 1909, NSHS. Lincoln had memorably said he had "a task before me greater than that which rested upon Washington." See Roy P. Basler, ed., *The Collected Works of Abraham Lincoln,* 8 vols. (New Brunswick, NJ: Rutgers University Press, 1952–1955), 4:190.

87 D. C. F. to Frank M. Hall, March 11, April 20, 1910, NSHS; "Sculptor Asks

for Time," *Nebraska State Journal,* April 24, 1910.

88 Margaret French travel diary, May 19 September 10, 1910, copy in the Chesterwood Archives.

89 D. C. F. to William M. R. French, August 13, 1910, French Family Papers, LOC.

90 French, *Memories of a Sculptor's Wife,* 203. The original photographs, inscribed to French, Mary, and Margaret and signed by Rodin and the Duchesse de Choiseul, are in the Chesterwood Archives at the Chapin Library, Williams College.

91 For more on the visit, see Clare Vincent, "Rodin at the Metropolitan Museum of Art: A History of the Collection," *Metropolitan Museum of Art Bulletin* 38 (spring 1981): 3, 30.

92 When French began his statue, the painting was still in private hands; the Museum of Fine Arts did not acquire it until 1919. But French probably remembered seeing it as a student. For provenance information, see www.mfa.org/collections/object/abraham-lincoln-31741.

93 French to F. M. Hall, October 8, 1910, NSHS; *Nebraska State Journal,* October 16, 1910.

94 D. C. F. to Robert Treat Paine, April 12, 1929, French Family Papers, LOC.

95 *Nebraska State Journal,* October 16, 1910; D. C. F. to William M. R. French, January 30, 1910, French Family Papers, LOC.

96 French, *Memories of a Sculptor's Wife,* 223–24.

97 D. C. F. to Newton Mackintosh, January 3, 1911, French Family Papers, LOC; Richman, *Daniel Chester French,* 123.

98 D. C. F. to Newton Mackintosh, January 3, 1911, French Family Papers, LOC.

99 Quoted in Durman, *He Belongs to the Ages,* 128.

100 Leonard Wells Volk, "The Lincoln Life-mask and How It Was Made," *Century Magazine* 23 (December 1881): 228; Lincoln to Thomas Doney, July 30, 1860, in Basler, *Collected Works of Abraham Lincoln,* 4:89.

101 John Hay, "Life in the White House in the time of Lincoln," *Century Magazine* 41 (November 1890): 37.

102 D. C. F. to Frederick Hill Meserve, March 30, 1911, quoted in Richman, *Daniel*

Chester French, 18. It would seem that French consulted both the book and some individual prints Meserve sent later at the sculptor's request; these French sent later to one of his protégés, Paul Manship, for his use in sculpting a Lincoln statue of his own (see D. C. F. to Manship, January 25, 1929, French Family Papers, LOC). Meserve's limited-edition book was undoubtedly useful as well; it featured individually printed photographs, tipped in by hand by Meserve himself, giving the appearance of separately published images collected as if for a photo album. The Chesterwood collection includes the copy French owned. See Meserve, *The Photographs of Abraham Lincoln* (New York: privately printed, 1911). An account of Meserve's efforts can be found in Carl Sandburg, "Frederick Hill Meserve," in Meserve and Sandburg, *The Photographs of Abraham Lincoln* (popular edition; New York: Harcourt Brace & Co., 1944), 23.

103 D. C. F. to J. N. Marble, April 30, 1913, French Family Papers, LOC. Miller's book was *Portrait Life of Abraham Lincoln, the Greatest American, told from Original Photographs taken with His Authority During the Great Crisis through which He Led His Country...* (Chicago: W. B. Conkey Co., 1910).

104 D. C. F. to William M. R. French, July 9, 1911, French Family Papers, LOC.

105 D. C. F. to William M. R. French, July 9, September 17, 1911, French Family Papers, LOC. French may well have known that the phrase "high water mark" had special meaning to Civil War students; it referred to the climactic moment at the Battle of Gettysburg, July 3, 1863, when Union defenders repulsed Pickett's charge.

106 Christopher Alexander Thomas, "The Lincoln Memorial and Its Architect, Henry Bacon (1866–1924)," PhD dissertation, Yale University, 1990, 219.

107 D. C. F. to Frank M. Hall, August 15, 1911, NSHS, and November 11, 1911, French Family Papers, LOC. French seemed astonished when Bacon learned that Lincoln had written several drafts of his most famous speech. For the most accessible line-by-line guide to the five variants, plus the texts transcribed by stenographers on the spot, see Philip B. Kunhardt Jr., *A New Birth of Freedom: Lincoln at Gettysburg* (Boston: Little, Brown & Co., 1983), 242–53.

108 D. C. F. to Frank M. Hall, October 10, 1911, French Family Papers, LOC.

109 D. C. F. to Frank M. Hall, October 14, 1911, French Family Papers, LOC.

110 French, *Memories of a Sculptor's Wife*, 222.

111 Margaret French Cresson, "The Strength of the Hills," copy of manuscript in the Chesterwood Archives.

112 D. C. F. to Frank M. Hall, September 23, 1911, French Family Papers, LOC.

113 D. C. F. to Newton Mackintosh, January 17, 1912, French Family Papers, LOC.

114 "Studio 12 W. 8th St.," notations in his account books, pp. 151–52, copies at Chesterwood; D. C. F. to Newton Mackintosh, February 26, 1911, French Family Papers, LOC.

115 "New Statue of Lincoln," *Brooklyn Eagle*, January 4, 1912.

116 D. C. F. to Anna Hall, January 12, 1912, NSHS.

117 D. C. F. to William M. R. French, January 12, 1912, and to Newton Mackintosh, January 12, 1912, French Family Papers, LOC.

118 Except when noted, all quoted and paraphrased descriptions are from "Unveil Lincoln Statue at Capitol Grounds: Monument to Great American Dedicated with Impressive Ceremonies with Bryan as Principal Speaker," *Nebraska State Journal*, September 3, 1912.

119 Robert had attended the Saint-Gaudens dedication twenty-five years earlier, and his own son, the late president's grandson, Abraham Lincoln II (who died in 1890), had unveiled it. See Robert Lincoln to Addison Wait, July 8, 1912. Former secretary of war Lincoln at least commented of French's new work: "It has been a great pleasure to me to know that this memorial to my father is to be placed in your City named after him."

120 Merrill Peterson, *Lincoln in American Memory* (New York: Oxford University Press, 1994), 158. As Peterson noted, the pro-Republican *New York Times* said of Bryan's professed admiration for Lincoln:

"Every word of that noble man ought to be a rebuke" to such presumption.

121 *Nebraska State Journal*, September 3, 1912.

122 Ibid.

123 *Architectural Record* 33 (March 1913): 277–78.

124 D. C. F. to Frank M. Hall, August 14, 1914, French Family Papers, LOC.

125 For the artist's defense, see George Grey Barnard, "The Sculptor's View of Lincoln," in *Barnard's Lincoln: The Gift of Mr. and Mrs. Charles P. Taft to the City of Cincinnati* (Cincinnati: Stewart & Kidd, 1917), 21–30.

126 Robert T. Lincoln to William Howard Taft, March 22, 1917, quoted in Jason Emerson, *Giant in the Shadows: The Life of Robert T. Lincoln* (Carbondale: Southern Illinois University Press, 2012), 383.

127 The vote was: Saint-Gaudens, 9,820; J. Patrick [Bissell], 3,356; Borglum, 2,841; French, 1,467; Ball, 1,356; and Barnard, 1,207. For the survey, see "Which Is Your Lincoln," *The Independent-Harper's Weekly*, November 3, 1917, 207–8; results published on December 29, 1917; for an analysis, see Roy P. Basler, *The Lincoln Legend: A Study in Changing Conceptions* (New York: Octagon Books, 1969), 292–94. Bissell's 1893 statue for Edinburgh, Scotland, had been inexplicably misidentified by the *Independent* as the work of one "J. Patrick," and after the public voted accordingly—based on illustrations published in the paper on November 3—the misattribution was occasionally repeated. See, for example, "An Edinburgh Memorial," credited to "J. Patrick," undated clipping in the Lincoln Museum Collection, "Lincoln Statues" file, Allen County, Indiana Library. The *Independent* did not correct its glaring error for nearly a year; see "The Edinburgh Lincoln," *Independent*, August 31, 1918, 269.

128 D. C. F. to Charles Moore, December 7, 1917, French Family Papers, LOC.

129 Henry Rankin to D. C. F., [July] 18, 1919, reported in the *Lincoln* [Nebraska] *Evening Journal*, September 4, 1919. French responded with "sincere thanks" on July 27.

130 *Nebraska State Journal*, October 13, 1921.

131 D. C. F. to Addison Wait, Nebraska Secretary of State, November 13, 1912, NSHS.

132 For the loan to Chicago, see the *North Platte Semi-Weekly Tribune*, January 3, 1913.

133 On pricing for the bronze statuettes, see D. C. F. to J. Scott Hartley, secretary of the Nebraska commission, November 8, 1912, and to Bernard Hoffmann, November 12, 1912, NSHS; D. C. F. to Sherwood Godfrey, March 14, 1913, French Family Papers, LOC.

134 D. C. F. to Frank M. Hall, November 3, 1912.

135 Ricardo Bertelli, president of the Whitney Museum, to D. C. F., October 2, 1931, French Family Papers, LOC.

136 Louis A. Warren, "The Bronze Lincoln by French," *Lincoln Lore* 1030 (January 3, 1949).

CHAPTER ELEVEN
THE GENIUS OF CREATION

1 The best book on this unusual campaign is Geoffrey Cowan, *Let the People Rule: Theodore Roosevelt and the Birth of the Presidential Primary* (New York: W. W. Norton, 2016).

2 For a photograph, see Mark E. Neely Jr. and Harold Holzer, *The Lincoln Family Album: Photographs from the Personal Collection of a Historic American Family* (New York: Doubleday, 1990), 134–35. See also *Manchester Journal*, October 10, 1912, clipping in the collection of Robert Todd Lincoln's Hildene, the Lincoln family home in Manchester, VT.

3 From a speech in Massachusetts, reported in the *Chicago Tribune*, April 30, 1912.

4 Merrill Peterson, *Lincoln in American Memory* (New York: Oxford University Press, 1994), 160, 164. For a later politician's analysis of Lincoln's appeal to both political parties, see Mario M. Cuomo, *Why Lincoln Matters: Today More Than Ever* (New York: Harcourt, 2004), esp. "Lincoln as Political Scripture," 13–23, written with Harold Holzer as historical consultant.

5 D. C. F. to Katrina Trask, October 22, 1916, French Family Papers, LOC.

6 The racially threatening message implicit in Confederate statuary was widely reported in August 2017 after a neo-Nazi and Ku Klux Klan rally in Charlottesville, Virginia, ostensibly organized to oppose the removal of a statue of Robert E. Lee. One of the best books on the subject is Gaines M. Foster, *Ghosts of the Confederacy: Defeat, the Lost Cause, and the Emergence of the New South* (New York: Oxford University Press, 1987), esp. 273–75.

7 An exception was the second-generation sculptor Henry Shrady (1871–1922), who produced the Ulysses S. Grant Memorial in Washington and began the now-disputed Lee equestrian in Charlottesville, completed by Leo Lentelli after Shrady's death.

8 "Will Share $6,000,000," *New York Times*, February 18, 1910.

9 Gerry Gawalt, "General Draper Statue 50 Years Old," *Milford Daily News*, September 12, 1967; clippings, photographs, and original dedication program at www.hope1842.com/gendraper.html.

10 Daniel Chester French, "A Sculptor's Reminiscences of Emerson," *The Art World* 1 (October 1916): 44 (the piece was written on July 3, 1915).

11 Daniel Chester French, "Augustus Saint Gaudens (1948–1907). Fellow of Class III, Section 4, 1896." *Proceedings of the American Academy of Arts & Sciences* 53 (September 1, 1918): 859.

12 D. C. F. to Rev. Thomas Clayton, December 5, 1912, French Family Papers, LOC.

13 *New York Times*, June 2, 1914.

14 *Chicago Tribune*, June 4, 1914.

15 *Pittsburgh Daily Post*, December 4, 1904. For a similar appraisal, written thirty years before, see *Poughkeepsie Eagle News*, February 6, 1884.

16 *Wichita Beacon*, December 9, 1910.

17 *Springfield* [MA] *Republican,* July 9, 1914.

18 D. C. F. to Newton Mackintosh, December 10, 1912.

19 Martha Lyon Landscape Architecture, *Spirit of Life/Spencer Trask Memorial/Design Report* (Northampton, MA, 2013), 1.

20 D. C. F. to Katrina Trask, January 24, 1914, French Family Papers, LOC. A bronze statuette of the discarded model, titled *Spirit of the Waters*, is now in the collection of the Harvard University Art Museums.

21 French later produced a bronze version with interior pipes, clearly intended as a fountain. It is in the Chesterwood collection, along with several plaster models.

22 Margaret French Cresson, *Journey into Fame: The Life of Daniel Chester French* (Cambridge, MA: Harvard University Press, 1947), 227–28.

23 Advertising card for 1916 Munson movie, *Purity* (showing her unclothed), reproduced in Mike Hare, "Audrey Munson, the model for The Spirit of Life," *All Over Albany*, March 25, 2015, http://alloveralbany.com/archive/2015/03/25/audrey-munson-the-model-behind-the-spirit-of-life.com. Audrey Munson's landlord-lover later killed his wife, and the model's career ended in scandal. Committed to a psychiatric hospital, she lived there until her death in 1996 at the age of 104.

24 See David B. Dearinger, *Daniel Chester French: The Female Form Revealed* (Boston: Boston Athenaeum, 2016), 49–52.

25 D. C. F. to George Foster Peabody (who commissioned the Trask Memorial), February 28, 1913, D. C. F. to Katrina (Mrs. Spencer) Trask, January 24, 1914, French Family Papers, LOC.

26 D. C. F. to Margaret French (Cresson), February 13, 1922, French Family Papers, LOC.

27 Adeline Adams, *Daniel Chester French* (Boston: Houghton Mifflin, 1932), 64–65.

28 D. C. F. account books, copies in the Chesterwood collection, and reported in Michael Richman, *Daniel Chester French: American Sculptor* (New York: Metropolitan Museum of Art, 1976), 137.

29 D. C. F. to Katrina Trask, May 11, 1914, French Family Papers, LOC.

30 "The Spencer Trask Memorial/Saratoga Springs, New York/Daniel Chester French, Sculptor," *Art & Progress*, 7 (November 1, 1915), n.p.

31 Katrina Trask Peabody had lost all four of her children in infancy or childhood.

32 D. C. F. to Katrina Trask, September 28, 1913, French Family Papers, LOC. See also, "Minutes of the Annual Meeting of the Corporation of Yaddo," May 9, 1931, copy in the French Family Papers, LOC.

33 D. C. F. to Franklin Hooper, June 24, 1918, French Family Papers, LOC.

34 Richman, *Daniel Chester French*, 146.

35 Cass Gilbert to D. C. F., May 14, 1915.

36 D. C. F. to Thomas Hastings, August 10, 1915.

37 D. C. F. account books, copies at Chesterwood. The *New York Times* for May 2, 1915, published a preview look at "The Granite Statue, Representing Manhattan," photographed by A. B. Bogart.

38 Technically speaking, French's "Lincoln" for the Lincoln Memorial would be an architectural sculpture, too, but it earned so much fame it must fairly be viewed as an independent creation.

39 "Putting the Ladies in Place," *Museum News* (September 1964), n.p. The publication is the official journal of the American Association of Museums (now the American Alliance of Museums), which had been founded by Dan's brother William M. R. French. See also Jerry and Eleanor Koffler, *Freeing the Angel from the Stone: A Guide to Piccirilli Sculpture in New York City* (New York: John D. Calandra Italian American Institute, 1966), 66.

40 James Barron, "Allegories of 2 Boroughs Prepare for a Homecoming," *New York Times*, December 21, 2016.

41 D. C. F. to Henry McBride, February 11, 1919, French Family Papers, LOC.

42 *New York American*, March 2, 1919.

43 Michael Richman, "Memory," in Jeanne Wasserman, ed., *Metamorphoses in Nineteenth-Century Sculpture* (Boston: Harvard University Press, 1975), 247–48.

44 Thayer Tolles, ed., *American Sculpture in the Metropolitan Museum of Art* (New York: Metropolitan Museum of Art, 1999), 337.

45 D. C. F. to Rosalie Miller, March 2, 1919, French Family Papers, LOC; reprinted in Richman, "Memory," 247.

46 Tolles, *American Sculpture in the Metropolitan*, 337; Rene Gimpel, *Diary of an Art Dealer* (1966), quoted in Christopher Gray, "Streetscapes: The Philippine Center, 556 Fifth Avenue; Behind the Stucco, the Work of Carrère & Hastings," *New York Times*, April 30, 2000.

47 D. C. F. to Robert W. de Forest, February 15, 1919, French Family Papers, LOC.

48 F. W. Ruckstull to D. C. F., February 17, 1919; Edwin Blashfield to D. C. F., ca. February 18, 1919, French Family Papers, LOC; Maria Oakey Dewing, "French's Statue—'Memory,'" *American Magazine of Art* 10 (April 1919): 195.

49 French to de Forest, February 15, 1919.

50 See, for example, *New York World, Baltimore Evening Sun*, both February 22, 1919. To search for and forward newspaper coverage, French retained Henry Romeike Inc., which billed itself as the "most complete newspaper cutting bureau in the world." The motto was stamped on all the clippings the service sent to French in 1919. There is no surviving record to explain why Walters did not get the full institutional discount.

51 D. C. F. to Margaret French Cresson, February 21, 1919, French Family Papers, LOC. Walters also founded the Baltimore art museum named in his honor, later donating the collection to the city.

52 D. C. F. to Charles L. Hutchinson, February 5, 1919, French Family Papers, LOC.

53 *New York Tribune*, March 2, 1919.

54 Ibid.

55 Cresson, *Journey into Fame*, 220.

56 D. C. F. to Marguerite Bush, June 29, 1919, French Family Papers, LOC.

57 Mrs. Daniel Chester [Mary] French, *Memories of a Sculptor's Wife* (Boston: Houghton Mifflin, 1928), 212.

58 Craig L. Symonds, *Lincoln and His Admirals* (New York: Oxford University Press, 2008), 215–18.

59 Report of the Office of Public Buildings, quoted in Richman, *Daniel Chester French*, 155.

60 The name is spelled different ways by different sources: The admiral called himself "Du Pont," other family members used "du Pont," but the memorial and circle are known as "Dupont."

61 Sarah Du Pont Ford to D. C. F., May 25, 1921, French Family Papers, LOC.

62 D. C. F. to Irene Stanley Martin, August 15, 1921, French Family Papers, LOC.

63 George Perry Harris, "The Lincoln Memorial and Notes on Other Recent Art Developments at the National Capital," *American Review of Reviews* 63 (February 1921): 178.

64 Richman, *Daniel Chester French*, 164–70.

65 The Marshall Field model went on display at the Architectural League of New York in 1912. See *International Studio* 46 (April 1912): xvii.

66 The Oglethorpe monument, which barely survived a crane accident during its 1910 installation, inspired a three-day dedication event marked by history lectures, "rough riding," and cavalry demonstrations. See "Savannah, GA's Oglethorpe Monument," http://gosouthsavannah.com/historic-district-and-city/monuments/oglethorpe-monument.html. The Spencer statue was later relocated to the David R. Goode building.

67 See Alexander Leitch, *A Princeton Companion* (Princeton: Princeton University Press, 1978), 97, 351 (for the French statues situated at Princeton's Palmer Hall); D. C. F. to Charles W. Gould, November 30, 1930, French Family Papers, LOC.

68 D. C. F. to Abbott Thayer, March 27, 1916, French Family Papers, LOC.

69 "The Lafayette Memorial by Daniel Chester French," *The Art World*, 2 (July 1, 1917).

70 Summer Brennan, "The Invisible Black Man on a Prospect Park Statue," *New York Magazine*, February 29, 2016, http://nymag.com/daily/intelligencer/2016/02/invisible-black-man-on-lafayettes-statue.html.

71 D. C. F. to John W. McCracken, June 29, 1921, French Family Papers, LOC.

72 *Indianapolis News*, March 29, 1901; D. C. F. to Homer Saint-Gaudens, December 21, 1906, French Family Papers, LOC. French also helped O'Connor produce—and assigned him much of the credit for creating—Old and New Testament biblical scenes for the bronze doors of the new St. Bartholomew's Church in Midtown Manhattan.

73 Cass Gilbert to Howard Childs, November 18, 1914, copy in the Chesterwood Archives.

74 Edwin Murtha, *Paul Manship* (New York: Macmillan, 1957), 11, 150.

75 French, *Memories of a Sculptor's Wife*, 247–48; for the museum acquisition of *Centaur and Dryad*, see D. C. F. to Paul Manship, April 13, April 22, and December 1, 1913, French Family Papers, LOC.

76 "Evelyn Longman Batchelder," *Connecticut Women's Hall of Fame*, http://cwhf.org/inductees/arts-humanities/evelyn-longman-batchelder#.WXNKqITyuUl. Though Ohio born, Longman spent her early adult years in New York City, but lived in Connecticut after her 1920 marriage.

77 Cresson, *Journey into Fame*, 210.

78 Evelyn Beatrice Longman, from notes prepared for Margaret French Cresson, ca. 1945, Chesterwood Archives.

79 D. C. F. to William M. R. French, December 30, 1900, French Family Papers, LOC.

80 Quoted in Michael Richman, "The French-Longman Collection," in Marilyn and Walter Rabetz, *Evelyn Beatrice Longman Batchelder Collection* [exhibition catalog] (Windsor, CT: Richmond Art Center of the Loomis Chafee School, 1993), 13.

81 D. C. F. to Evelyn Beatrice Longman, October 24, 1912, French Family Papers, LOC.

82 D. C. F. to Longman, October 24, 1912.

83 D. C. F. to Alexander Stirling Calder, October 2, 1922, French Family Papers, LOC; reprinted in Donna J. Hassler, "Alexander Stirling Calder (1870–1945)," in Tolles, *American Sculpture in the Metropolitan*, 530.

84 Quoted in Harold Holzer and Mark E. Neely, Jr., *Mine Eyes Have Seen the Glory: The Civil War in Art* (New York: Orion Books, 1990), 159.

85 See, for example, Thomas Buchanan Read's painting at the Union League Club of Philadelphia, and, for his poem, "Sheridan's Ride," Harvey S. Ford, "Thomas Buchanan Read and the Civil War: The Story of 'Sheridan's Ride,'" *Ohio State Archaeological and Historical*

Quarterly 56 (September 1947): 215–18, 223–26. Herman Melville produced his own "Sheridan's Ride" poem for his *Battle-Pieces*; see Hennig Cohen, *The Battle-Pieces of Herman Melville* (New York: Thomas Yoseloff, 1963), 110, 223, 251–52.

86 The best narrative history of the commission is Valerie A. Balint, "'A Labor of Love and Patriotism': The Artistic and Historic Legacy of Albany's General Philip H. Sheridan Memorial," *The Hudson Valley Review* 27 (Spring 2011): 117–47.

87 Lewis I. Sharp, *John Quincy Adams Ward: Dean of American Sculptors* (Newark: University of Delaware Press, 1985), 86–87.

88 D. C. F. to Edward Robinson, October 6, 1918, French Family Papers, LOC. French was here quoting Herbert Adams and, in all fairness, offered to visit Borglum's studio when he was in town "and report to you my [own] impressions." Borglum enlarged the monumental head for Mount Rushmore, completed in 1937.

89 D. C. F. to Mrs. J. Q. A. [Rachel] Ward, January 13, January 15, January 31, 1913, French Family Papers, LOC.

90 In his memoirs, Sheridan claimed Albany as his place of birth, but some scholars have speculated that he was born in Ireland or Ohio. See *Personal Memoirs of P. H. Sheridan, General United States Army*, 2 vols. (New York: Charles L. Webster, 1888), 1:1–2.

91 D. C. F. to Franklin M. Danaher, May 16, 1914; D. C. F. to William P. Rudd, October 20, 1916, French Family Papers, LOC.

92 Balint, "'A Labor of Love and Patriotism,'" 126–27.

93 D. C. F. to Rachel Ward, March 13, 1914, French Family Papers, LOC. Mrs. Ward was the sculptor's third wife.

94 "Proposal for the Execution and Erection of an Equestrian Statue of General Phillip [*sic*] H. Sheridan in the City of Albany," December 17, 1914, manuscript and typescript versions in the French Family Papers, LOC.

95 D. C. F. to Henry Bacon, October 2, 1916, French Family Papers, LOC.

96 *Albany Times Union*, October 7, 1916; *Knickerbocker Press*, October 8, 1916.

97 D. C. F. to Rachel Ward, November 15, 1916, French Family Papers, LOC.

98 Balint, "'A Labor of Love and Patriotism,'" 143.

99 *Knickerbocker Press Illustrated Magazine*, October 8, 1916.

100 D. C. F. to Rachel Ward, June 22, 1914, French Family Papers, LOC.

101 Tolles, *American Sculpture in the Metropolitan*, Vol. 1, 144–46, 150.

102 For this idea, the author acknowledges art historian Karen Zukowski, and her lecture, "City and Country: Daniel Chester French and Studio Life," delivered at the National Arts Club on September 24, 2017, as the third annual Daniel Chester French lecture in New York, cosponsored by Chesterwood.

103 For a typical seed order, see D. C. F. to H. S. Horsfone, October 1, 1912, French Family Papers, LOC; Cresson, *Journey into Fame*, 203.

104 Margaret French Cresson, "The Strength of the Hills" (unpublished, unpaginated typescript), [11–12], Chesterwood Archives.

105 This was a reference to the statue that would be installed at the Wisconsin State Capitol in Madison in 1914. D. C. F., Farm Journals for 1912, [145–46]. Margaret French Cresson later titled the transcribed material, *Two Note Books of Daniel Chester French: 1897–1921, 1923–1931—Chronicles of Chesterwood*.

106 Ibid., [8].

107 Barr Ferrer, "'Chesterwood': The Country Home of Daniel Chester French, N. A., Glendale, Massachusetts," *American Homes and Gardens* 6 (January 1909): 8. In 1919, French engineered the Met's acquisition of a bronze version of Potter's *Sleeping Faun*, a cement version of which he kept on the grounds of Chesterwood. See Tolles, *American Sculpture in the Metropolitan*, Vol. 1, 359.

108 D. C. F. to William M. R. French, June 19, 1904; Newton Mackintosh, June 13, 1911, French Family Papers, LOC.

109 D. C. F. to Walter Hancock, 1925, quoted from an oral history interview of Walter

Hancock by Paul W. Ivory, October 12, 1972, copy in the Chesterwood Archives.

110 Margaret French Cresson, spiral notebook, 13, Chesterwood Archives.

111 D. C. F., Garden Notebooks, entry for June 27, 1915, [159–60].

112 Cresson, *Journey into Fame*, 205.

113 Ibid.

114 Undated typescript by Warren Prichard Eaton in the French Family Papers, LOC.

115 French, *Memories of a Sculptor's Wife*, 247–49.

116 D. C. F. to Mrs. Albert Miller, November 30, 1913, French Family Papers, LOC.

117 "Lists of Records/Phonographs Owned by D. C. F.," Chesterwood Archives.

118 Robert Underwood Johnson to D. C. F., January 16, 1912, French Family Papers, LOC, copy in the Chapin Library, Williams College. For the article, see "On Certain Obstacles to the Highest Enjoyment of Music from a Sculptor, With Practical Suggestions," *Century Magazine* 83, new series, vol. 61 (November 1911–April 1912): 956–57.

119 Daniel Chester French, *On Certain Obstacles to the Highest Enjoyment of Music* (Stockbridge, MA: Chesterwood, the Studio of Daniel Chester French, n.d.), 2–4.

120 *New York Times*, February 16, 1902; *Detroit Free Press*, April 6, 1902.

CHAPTER TWELVE
LINCOLN ENTHRONED

1 "Lot Flannery, 86, Sculptor, is Dead," *Washington Evening Star*, December 19, 1922. The Flannery statue continued to hold pride of place when the building was converted into a courthouse. Taken down in 1920 to make room for a sidewalk expansion, it was not reinstalled until 1935, thirteen years after the sculptor's death. See David Charles Durman, *He Belongs to the Ages: The Statues of Abraham Lincoln* (Ann Arbor, MI: Edwards Bros., 1951), 30.

2 For an account of the Ball project, see Harold Holzer, "Picturing Freedom: The Emancipation Proclamation in Art, Iconography, and Memory," in Harold Holzer, Edna Greene Medford, and Frank J. Williams, *The Emancipation*

Proclamation: Three Views (Baton Rouge, LA: Louisiana State University Press, 2006), 132; for Douglass's 1876 oration at the Thomas Ball statue unveiling, see Philip S. Foner and Yuval Taylor, *Frederick Douglass: Selected Speeches and Writings* (Chicago: Lawrence Hill Books, 1999), 616–24.

3 Edward F. Concklin, *The Lincoln Memorial[,] Washington* (Washington: US Government Printing Office, 1927), 16–18. This book, written by the special assistant to the Director of Public Buildings and Public Parks of the National Capital and published by the government, constitutes the official history of the project.

4 The commission was the brainchild of US Senator James McMillan of Michigan, chairman of the Senate Committee on the District of Columbia. Augustus Saint-Gaudens was asked to join the prestigious panel, too, but was too ill at the time to accept.

5 Concklin, *The Lincoln Memorial*, 32–33, 38–39.

6 *Lincoln Memorial Commission Report* (Washington: US Government Printing Office, Senate Document No. 965), 19–21; William F. Downey to William Howard Taft (Naval Observatory), August 7, 1911, Lincoln Memorial Commission records, Correspondence Files, 1911–1922, Box 1, National Archives and Records Administration (NARA); *Washington Star* (Soldiers' Home), August 20, 1911; A. S. Perham (secretary) and Lewis C. White (treasurer, Fort Stevens Lincoln Memorial Association) to the US Lincoln Memorial Commission, July 12, 1911 (NARA); *Washington Times*, July 8, 1911. The influential African American leader William H. Davis offered no opinion on specific sites, but urged that any monument emphasize Lincoln's role in emancipation—a theme intentionally de-emphasized in order to gain Congressional approval for the project.

7 O. P. Ergenbright to Lincoln Memorial Commission, August 3, 1911, Lincoln Memorial Commission Records, NARA.

8 See D. C. F. to Robert Underwood Johnson, March 31, 1911, French Family Papers, LOC. The site, French

told Johnson, was the "pet idea" of James T. McClarey, retired Republican Congressman from New York.

9 Anxious for a resolution, some called merely for forgoing the memorial plan altogether and merely consecrating the new bridge slated to span the Potomac between Washington and Arlington. Such a plan "would not in itself," the commission replied, "impress one as a memorial" (Concklin, *The Lincoln Memorial*, 39). Later, the bridge was so named anyway.

10 Meridian Hill, once owned by Admiral David Porter, father of the Civil War naval hero who bore the same name, had been the site of the Union Army's Camp Cameron during the Civil War. Ironically, it now features a statue of Lincoln's White House predecessor, James Buchanan, whose indecisiveness hastened Southern secession in 1860–1861, and who is now consistently ranked among the worst US presidents in history. For the Arlington proposal, see *Congressional Record* 43 (January 21, 1909): 1202; and Charles Moore, Daniel Burnham: *Architect Planner of Cities*, 2 vols. (Boston: Houghton Mifflin, 1921), 1: 135–36.

11 Cannon quoted in Philip C. Jessup, *Elihu Root*, 2 vols. (New York: Dodd, Mead, 1938), 1:279–80. As Root remembered it, Cannon was furious that the commission had done an end run around Congress, securing preliminary financing from a Contingency Fund rather than properly seeking support from the House. Root was a trustee of the Metropolitan Museum and a supporter of building the National Mall.

12 *Washington Star*, August 9, 1911.

13 Concklin, *The Lincoln Memorial*, 37. Hay went on to serve as US secretary of state under Presidents William McKinley and Theodore Roosevelt, and was a friend [and portrait subject] of Augustus Saint-Gaudens. For his (and John Nicolay's) Lincoln biography, see John G. Nicolay and John Hay, *Abraham Lincoln: A Biography*, 10 vols. (New York: The Century Co., 1890).

14 *Washington Times*, May 28, 1922.

15 Bacon quoted in "A Memorial to Lincoln Worthy Alike of the Nation and the Man," *New York Tribune*, January 7, 1912.

16 See, for example, D. C. F. to Addison Wait, and J. Randolph Anderson, both December 25, 1912; to Charles L. Hutchinson, January 17, 1913, French Family Papers, LOC.

17 D. C. F. to Josephus Daniels, December 30, 1925, French Family Papers, LOC.

18 See, for example, Henry Van Brunt (president, American Institute of Architects), to Lincoln Memorial Commission, August 1, 1911, Records of the Lincoln Memorial Commission, NARA.

19 Amended minutes of the meeting of July 31, 1911, Records of the Lincoln Memorial Commission, NARA.

20 Concklin, *The Lincoln Memorial*, 20.

21 *Washington Post*, August 11, 1911.

22 Perhaps the commissioners noted that Pope had the misfortune to bear the name of one of the most unsuccessful of Lincoln's Civil War generals, John Pope, who had led Union troops at the disastrous Second Battle of Bull Run in 1862. The architect Pope, no relation to the general, would later be consoled with commissions to design the Jefferson Memorial, National Archives building, and the west building of the National Gallery of Art.

23 During Cannon's final years of service, the project cost would rise, without much objection from "Uncle Joe," by more than 25 percent to $2.6 million.

24 Concklin, *The Lincoln Memorial*, 21.

25 D. C. F. to Henry Bacon, December 7, 1912, French Family Papers, LOC.

26 Michael Richman, *Daniel Chester French: An American Sculptor* (New York: Metropolitan Museum of Art, 1976), 172.

27 Glenn V. Sherwood, *Labor of Love: The Life and Art of Vinnie Ream* (Hygiene, CO: SunShine Press, 1997), 313.

28 Robert T. Walker (re: Gelert) to Lincoln Memorial Commission, July 26, 1911; Adolph J. Sabath to William Howard Taft (Vlaciha), April 10, 1911; Gutzon Borglum to Senator George Peabody Wetmore, August 9, 1911, Records of the Office of Public Buildings and Public Parks of the National Capital, Records of the Lincoln Memorial Commission,

Correspondence and Other Records of the Secretary and the Special Resident Commissioner, 1911–1922, Box 1, February 9–August 22, 1911, National Archives and Records Administration (NARA), Washington.

29 Quoted in F. Lauriston Bullard, *Lincoln in Marble and Bronze* (New Brunswick, NJ: Rutgers University Press, 1952), 335–36.

30 Henry Bacon, "The Architecture of the Lincoln Memorial," in Concklin, *The Lincoln Memorial*, 41.

31 William H. Davis to the Lincoln Memorial Commission, March 23, 1911; Orson C. Warner to William Howard Taft, February 12, 1911, Records of the Lincoln Memorial Commission, Box 1, Entry 362, NARA. Davis was "official stenographer" of the National Negro Business League.

32 The choice of expensive marble triggered an outcry from Congressional Democrats, especially southerners. See *Washington History* 5 (fall/winter 1993–1994): 51–55.

33 Concklin, *The Lincoln Memorial*, 22, 41.

34 Ibid., 22–23. By April 1915, coincidentally the fiftieth anniversary of Lincoln's assassination, the foundation would be completed.

35 "Studies of Statue & Pedestal for Lincoln Memorial Washington D. C. By Henry Bacon," published Skinner Books and Manuscripts Catalogue, Sale No. 1645, November 11, 1995, 14. These initial drawings show the standing Lincoln on a plinth, possibly outside the structure.

36 Memorandum of Record by Henry Bacon, April 24, 1914, in Christopher Alexander Thomas, "The Lincoln Memorial and Its Architect, Henry Bacon (1866–1924)," PhD dissertation, Yale University History Department (December 1990), 618. Thomas later expanded his doctoral thesis into an excellent contribution, cited elsewhere in this book.

37 Ibid. It is not clear whether Bacon shared this memo with the commission; even if he kept it to himself, he certainly made his opposition clear.

38 D. C. F. to Franklin W. Hooper, May 23, 1913, French Family Papers, LOC.

39 D. C. F. to Franklin W. Hooper, March 1, 1913, French Family Papers, LOC.

40 Henry Bacon to Franklin W. Hooper, May 23, 1913, quoted in Thomas, "The Lincoln Memorial and Its Architect," 619.

41 Franklin W. Hooper to William Howard Taft, April 3, 1914, reprinted in Richman, *Daniel Chester French*, 175.

42 D. C. F. to Franklin W. Hooper, March 1, 1913, French Family Papers, LOC.

43 D. C. F. to William W. Harts, December 21, 1914, French Family Papers, LOC.

44 William Howard Taft to D. C. F., January 2, 1915, French Family Papers, LOC.

45 French account books, copies in the Chesterwood Archives. Perhaps jealous that the architect had fewer expenses to bear, French later teased Bacon, maybe only half-jokingly, "I hear you have made half a million out of the Lincoln Memorial!!! So glad I know you." The jest provoked an unusually sharp reply: "Of all the works I have ever engaged in, this Memorial has been the most unprofitable financially." D. C. F. to Henry Bacon, August 12, 1919, French Family Papers, LOC; Bacon to French, August 15, 1919, in Richman, *Daniel Chester French*, 182. Bacon actually netted $155,371 for his twelve years of work; see Concklin, *The Lincoln Memorial*, 68. French's profit remains harder to gauge. See his notarized certification for $59,320 in expenses to Lincoln Memorial Commission, August 9, 1920, French Family Papers, LOC. French eventually took in an additional $29,000.

46 D. C. F. to William Howard Taft, January 15, 1915, French Family Papers, LOC.

47 Woodrow Wilson to D. C. F., April 24, 1915, quoted in Valerie A. Balint, "'A Labor of Love and Patriotism': The Artistic and Historic Legacy of Albany's General Philip H. Sheridan Memorial," *Hudson Valley Review* 27 (spring 2011): 134.

48 Thomas Hastings to D. C. F., December 1, 1916, French Family Papers, LOC.

49 D. C. F. to Katrina Trask, October 22, 1916, French Family Papers, LOC.

50 D. C. F. to Henry Bacon, May 29, 1915, original in Bacon Collection, Wesleyan University; copy in the Chesterwood Archives.

51 Quoted in Margaret French Cresson, *Journey into Fame: The Life of Daniel*

Chester French (Cambridge, MA: Harvard University Press, 1947), 272.

52 Thomas Hicks in Allen Thorndike Rice, ed., *Reminiscences of Abraham Lincoln by Distinguished Men of His Time* (New York: North American Publishing, 1886), 607.

53 Indeed, the image was based on photographs for which Lincoln had posed on February 9, 1864, with his hair inexplicably parted on the opposite side than he normally wore it. Robert Lincoln nonetheless liked these photographs best, and images made that day at Mathew Brady's Washington gallery were later adapted for the five-dollar bill and the copper penny. See Charles Hamilton and Lloyd Ostendorf, *Lincoln in Photographs: An Album of Every Known Pose*, 1963 (rev. ed. Dayton, OH: Morningside Press, 1975), 176.

54 See, for example, Lyman Stowe (Doubleday, Page & Co.) to D. C. F., December 27, 1922; D. C. F. to Lyman Stowe, January 20, 1922, regarding a book by Woodrow Wilson's brother-in-law, a Dr. Axson. French cautioned it might be "too scholarly."

55 D. C. F. to Henry B. Rankin, July 27, 1919, French Family Papers, LOC. Rankin also sent French his sixteen-page pamphlet, *Lincoln's Cooper Union Speech*, and only this work, reprinted from a newspaper article, survived to be counted in the Chesterwood inventory conducted after the sculptor's death. We know from this thank-you letter that Rankin sent French a copy of his *Recollections* with a "gracious inscription." For both of Rankin's publications, see Jay Monaghan, ed., *Lincoln Bibliography 1839–1939*, Collections of the Illinois State Historical Library, 32; Bibliographical Series, 5, 2 vols. (Springfield, IL: Illinois State Historical Library, 1945), 2:61, 78. See Henry B. Rankin, *Personal Recollections of Abraham Lincoln* (New York: G. P. Putnam's Sons, 1916). The Rankin memoirs were later routinely questioned regarding authenticity. Historian Dan E. Fehrenbacher commented that by 1996 the "majority of scholars consider them unreliable." See Don E. Fehrenbacher, *Recollected Words of Lincoln* (Stanford,

CA: Stanford University Press, 1996), 374.

56 "I am so fond of it," French said of the theater. See D. C. F. to Newton Mackintosh, February 5, 1917, French Family Papers, LOC.

57 This point was well articulated by Jason Emerson, *Giant in the Shadows: The Life of Robert T. Lincoln* (Carbondale, IL: Southern Illinois University Press, 2012), 383.

58 D. C. F. to Jesse W. Weik, December 23, 1914, French Family Papers, LOC.

59 D. C. F. to [Godfrey Rathbone Benson] Lord Charnwood, July 4, 1920, French Family Papers, LOC.

60 D. C. F. to Mrs. H. K. Bush-Brown, December 20, 1920, French Family Papers, LOC.

61 D. C. F. to Rice Studio, June 30, July 10, 1916, French Family Papers, LOC. For the photographs, made at the Illinois State Capitol on June 3, 1860, see Hamilton and Ostendorf, *Lincoln in Photographs*, 376–77.

62 Hamilton and Ostendorf, *Lincoln in Photographs*, 147.

63 For Bacon's various sketches of French's statue, see Skinner Galleries Catalogue, 15–16.

64 Leonard W. Volk, "The Lincoln Life-Mask and How It Was Made," *Century Magazine* 23 (December 1881): 227–28. For an illustration of Volk's final statue, dedicated at the Springfield state house in 1876, see Harold Holzer and Lloyd Ostendorf, "Sculptures of Abraham Lincoln from Life," *Magazine Antiques* 113 (February 1978): 383.

65 D. C. F. to Katrina Trask, January 28, 1917, French Family Papers, LOC; D. C. F. quoted in Cresson, *Journey into Fame*, 273.

66 D. C. F. to Arno Cammerer, March 22, 1916, French Family Papers, LOC.

67 Richman, *Daniel Chester French*, 178.

68 *Memorial Symbolism, Epitaphs and Design Types* (Boston: American Monument Association, 1947).

69 D. C. F. to Robert T. Lincoln, April 26, 1916, French Family Papers, LOC.

70 D. C. F. to Robert T. Lincoln, May 1, 1916, French Family Papers, LOC.

71 D. C. F. to Robert T. Lincoln, May 12, 1916, French Family Papers, LOC.

72 D. C. F. to Alexander Mascetti, June 1, 1916, French Family Papers, LOC.

73 D. C. F. to Katrina Trask, October 22, 1916, French Family Papers, LOC.

74 Draft of a letter from D. C. F. to Katrina Trask, late 1916, French Family Papers, LOC. This model, dated October 31, 1916, is now on exhibit in the barn gallery at Chesterwood.

75 D. C. F. to Evelyn Beatrice Longman, June 22, 1916, French Family Papers, LOC.

76 Robert T. Lincoln to Henry Bacon, April 23, 1918, Henry Bacon Papers, Olin Library, Wesleyan University. Robert later said, "It is a little curious that of all of the statues that have been made of my father, I was asked by the artist in only two instances to look at their work before it was too late to have any suggestions of mine adopted. These were Mr. Saint-Gaudens and Mr. French, in regard to the statue he is now making for the Lincoln Memorial. In both of these cases I was able to make suggestions which they professed themselves glad to have." Robert T. Lincoln to Clinton Conkling, November 24, 1917, reprinted in *Emerson, Giant in the Shadows*, 280. Robert's opinion was expressed to F. Wellington Ruckstull on November 1, 1917, quoted in *Emerson, Giant in the Shadows*, 407, 546n16.

77 D. C. F. to A. B. Bogart, October 16, 1916, French Family Papers, LOC.

78 D. C. F. to William M. Harts, June 1, 1917, French Family Papers, LOC.

79 Henry Bacon to William H. Harts, September 17, 1917, quoted in Richman, *Daniel Chester French*, 180.

80 Years later, Margaret French Cresson rescued the long-abandoned head from New York's Roman Bronze Works, had it rebronzed, and donated it to the New-York Historical Society in 1954.

81 D. C. F. to William W. Harts, June 28, 1915, French Family Papers, LOC.

82 D. C. F. to Henry Bacon, May 2, 1917, French Family Papers, LOC.

83 Ibid.

84 D. C. F. to Henry Bacon, November 27, 1918, French Family Papers, LOC.

85 D. C. F. to Charles S. Ridley, February 13, 1918, French Family Papers, LOC. As French had told Katrina Trask,

"Photographs sometimes look better than the work and more often not so well and in any case rarely represent the work as it really is." (D. C. F. to Trask, April 30, 1914, French Family Papers, LOC).

86 D. C. F. to Herbert Putnam, March 11, 1918, French Family Papers, LOC.

87 D. C. F. to Katrina Trask, December 1, 1918, French Family Papers, LOC.

88 D. C. F. to Charles S. Ridley, May 24, 1920, French Family Papers, LOC.

89 D. C. F. to Charles S. Ridley, May 14, 1919, French Family Papers, LOC.

90 D. C. F. to Piccirilli Brothers, June 4, 1919, French Family Papers, LOC.

91 W. M. Berger, "Making a Great Statue: How French's Lincoln Was Put into Marble," *Scribner's* 66 (October 1919): 430–431.

92 Nicholas Falco, "The Piccirilli Studio," *Bronx County Historical Society Journal* 9 (January 1972): 19–21.

93 Lincoln stayed at the original Willard's, since replaced by a far grander hotel. See Harold Holzer, *Lincoln President-Elect* (New York: Simon & Schuster, 2009), 396.

94 See, for example, D. C. F. to Charles S. Ridley, February 2, 1920, French Family Papers.

95 D. C. F. to Henry Bacon, June 13, 1919, to Charles S. Ridley, June 21, 1919, French Family Papers, LOC.

96 Jannelle Warren-Findley, "Chronological History of the Construction of the Lincoln Memorial," Report to the National Park Service, September 15, 1985, 11.

97 D. C. F. to Charles S. Ridley, November 19, 1919, French Family Papers, LOC.

98 Frederic J. Haskin, "The Lincoln Memorial," *Decatur* [IL] *Herald*, December 1, 1919.

99 D. C. F. to W. A. Livingston (Detroit Publishing Co.), October 18, 1919, French Family Papers, LOC.

100 D. C. F. to Katrina Trask, December 27, 1919, French Family Papers, LOC.

101 Ibid.

102 First Drafts of Christmas nonsense rhymes, by Dan. C. French, manuscript by Margaret French Cresson in the French Family Papers, LOC.

103 D. C. F. to Charles S. Moore, December 12, 1919, French Family Papers, LOC.

104 D. C. F. to W. A. Livingstone, January 15, 1919 [1920], French Family Papers, LOC.

105 D. C. F. to Charles S. Moore, February 20, 1920, French Family Papers, LOC.

106 D. C. F. to Royal Cortissoz, January 7, 1920, French Family Papers, LOC.

107 D. C. F. to Newton Mackintosh, February 13, 1920, French Family Papers, LOC.

108 "Sonnet to Daniel C. French, Esq. upon his 70th Birthday," signed in an indistinguishable hand, typescript in the French Family Papers, LOC.

109 D. C. F. to Newton Mackintosh, February 13, 1920, French Family Papers, LOC.

110 D. C. F. to F. M. Hall, March 5, 1920, French Family Papers, LOC.

111 For a sampling of coverage, see *Statues of Abraham Lincoln: Daniel Chester French, Lincoln Memorial, Folder 1— Excerpts from Newspapers and Other Sources from the Files of the Lincoln Financial Foundation Collection* (London: Forgotten Books, 2015). The book presents highlights from the legendary clipping files of the old Lincoln National Life Foundation, now housed at the Allen County, Indiana, Public Library.

112 Henry Bacon to D. C. F., October 27, 1920, French Family Papers, LOC.

113 Lord Charnwood to D. C. F., June 9, 1920, typescript copy in the French Family Papers, LOC.

114 Ibid; D. C. F. to Lord Charnwood, July 4, 1920, French Family Papers, LOC.

115 Royal Cortissoz, "French's Lincoln for the Memorial at Washington," *New York Herald Tribune*, February 29, 1920.

116 D. C. F. to Robert Rush, June 15, 1920, French Family Papers, LOC.

117 D. C. F. Trip Diary for 1920–1921, copy in Chesterwood Archives.

118 Mrs. Daniel Chester [Mary] French, *Memories of a Sculptor's Wife* (Boston: Houghton Mifflin, 1928), 268.

119 Ibid., 273.

120 Bill Goldstein, *The World Broke in Two: Virginia Woolf, T. S. Eliot, D. H. Lawrence, E. M. Forster and the Year that Changed Literature* (New York: Henry Holt, 2017), 81.

121 Cresson, *Journey into Fame*, 247, 254. Dan remained supportive of Penn for the rest of his life, engaging him on occasion to manage the sale of his sculptural reproductions and loaning the couple a thousand dollars when they were "cramped for ready cash." See D. C. F. to Margaret French Cresson, February 22, 1924, French Family Papers, LOC.

122 D. C. F. to Newton Mackintosh, January 26, 1921, French Family Papers, LOC.

123 D. C. F. to Margaret French Cresson, February 23, 1921, French Family Papers, LOC.

124 Cresson, *Journey into Fame*, 261–62.

125 Margaret French Cresson, "Making the Lincoln Statue," unpublished typescript in the Chesterwood Archives, [78].

126 For a more positive appraisal, see Jesse Lynch Williams, "The Guérin Decorations for the Lincoln Memorial: How They Were Done," *Scribner's* 66 (October 1919): 416–23.

127 While the etched words of the two speeches would similarly blanch over time, the US Lincoln Bicentennial Commission would in 2009 fund a re-inking project. The legislation would be cosponsored by US Senator Dick Durbin (D-Illinois) and Congressman Ray LaHood (R-Peoria), cochairs (along with the author) of the US Abraham Lincoln Bicentennial Commission. The bill also called for the re-inking of the words carved on the step from which Martin Luther King Jr. delivered his "I Have a Dream Speech" in 1963.

128 D. C. F. to Henry Bacon, August 12, 1919 (discussing the two existing versions of Lincoln's Farewell Address, one taken down by a Springfield stenographer, the other rewritten by Lincoln aboard his inaugural train), French Family Papers, LOC.

129 Lincoln had been misinformed about the Bixby family's sacrifice by the adjutant general's office. His letter was printed in the *Boston Transcript* on November 25, 1864. For the full text, along with a discussion of the controversy over authorship—some have claimed that John Hay actually drafted the letter— see Roy P. Basler, *The Collected Works of Abraham Lincoln,* 8 vols., (New Brunswick, NJ: Rutgers University Press, 1953–55), 8:117; also Michael Burlingame, "New Light on the Bixby Letter," *Journal of the Abraham Lincoln Association* 16 (winter 1995): 59–71.

130 D. C. F. to Getulio Piccirilli, June 30, 1926, French Family Papers, LOC.

131 D. C. F. to Robert Underwood Johnson, October 30, 1918, French Family Papers, LOC.

132 Paul W. Ivory, "The Lincoln Memorial, a Factual Basis for the Exhibition, 'The Lincoln Memorial: Bacon, French, and Guérin'" (1972), typescript in the Chesterwood Archives, 16.

133 Royal Cortissoz to Henry Bacon, April 6, 1919, quoted in Thomas, "The Lincoln Memorial and Its Architect," 624.

134 William DeLancey Howe to Charles Moore, January 17, 1935, Lincoln Memorial Commission Project Files, Box 66, Envelope 2, National Archives and Records Administration.

135 Gabor Boritt, *The Gettysburg Gospel: The Lincoln Speech That Nobody Knows* (New York: Simon & Schuster, 2006), 163–203; Thomas J. Brown, *The Public Art of Civil War Commemoration: A Brief History with Documents* (Boston: Bedford/St. Martin's, 2004), 158–59

136 Thomas, "The Lincoln Memorial and Its Architect," 624–25.

137 Silent newsreels made that day include a time-lapse film record of the arrivals, with the area becoming increasingly congested as more spectators arrived by automobile. For the seven-minute montage of film, see http://mallhistory.org/items/show/542.

138 D. C. F. to the Powhatan Hotel, May 13, 1920, French Family Papers, LOC.

139 D. C. F. to William Howard Taft, January 26, 1921, February 2, 1922, French Family Papers, LOC.

140 Quoted in William Howard Taft, "The Lincoln Memorial," *National Geographic* 63 (June 1923): 601.

141 *Louisville Courier-Journal*, May 28, 1922; *Washington Times*, May 31, 1922; *Brooklyn Daily Eagle*, May 28, 1922.

142 *Washington Evening Star*, May 31, 1922; *New York Times*, May 31, 1922.

143 *Washington Herald*, May 28, 1922; *Monumental News* 62 (August 1922): 201.

144 *Brooklyn Daily Eagle*, May 31, 1922.

145 Frank Owen Payne, "Daniel Chester French's New Lincoln," *Architectural Record* 47 (1920): 377, 371.

146 Henry B. Rankin to D. C. F., March 19, 1926 [?], French Family Papers, LOC.

147 Lorado Taft to D. C. F., March 29, 1922 (telegram), French Family Papers, LOC.

148 For Hay's labors sorting and answering Lincoln's mail, see Harold Holzer, ed., *Dear Mr. Lincoln: Letters to the President* (New York: Addison-Wesley, 1990), 9–12, 21.

149 D. C. F. to Margaret French Cresson, February 4, 1923, French Family Papers, LOC.

150 D. C. F. to Mrs. W. of Osborn, October 12, 1922, fragment in the French Family Papers, LOC.

151 *New York Evening Post*, March 10, 1920.

152 D. C. F. to Charles S. Moore, May 13, 1922.

153 D. C. F. to Margaret French Cresson, February 4, 1923, French Family Papers, LOC.

154 *Congressional Record*, Proceedings of the 89th Congress, First Session, Vol. 3, No. 29, February 15, 1965, p. 2601.

155 D. C. F. to Margaret French Cresson, February 4, 1923.

156 Rob Kaplan, "A Brief History of Lincoln on Stamps," *The Wide Awake* (Bulletin of the Lincoln Group of New York), February 2018, 5.

157 Brown-Robertson Co. (Print Publishers) to D. C. F., June 20, 1922, French Family Papers, LOC.

158 *Washington Post*, February 13, 1915. To John W. Dwight, the House Republican Whip from New York who had helped marshal the votes needed to approve the memorial, Robert donated an astonishingly valuable relic: the manuscript of the speech Lincoln delivered from the second-floor window of the White House after his 1864 reelection. See Emerson, *Giant in the Shadows*, 406.

159 Ibid., 407.

160 David C. Mearns, ed., *The Lincoln Papers: The Story of the Collection with Selections to July 4, 1861*, 2 vols. (New York: Doubleday, 1948), 1:109.

161 Joseph C. Haertzell, "Appreciation of Robert Todd Lincoln," quoted in Emerson, *Giant in the Shadows*, 408.

162 D. C. F. to Margaret French Cresson, February 22, 1924, French Family Papers, LOC.

163 D. C. F. to Evelyn Beatrice Longman, February 16, 1924; Michael Richman, "The French-Longman Connection," in Marilyn andWalter Rabetz, eds., *Evelyn Beatrice Longman Batchelder* (exhibition catalog, Windsor, CT: Loomis Chaffee School, 1993), 13.

164 D. C. F. to Charles A. Coolidge, February 19, 1924, French Family Papers, LOC.

CHAPTER THIRTEEN
THE MONUMENTAL MAN OF STOCKBRIDGE

1 Mrs. Daniel Chester [Mary] French, *Memories of a Sculptor's Wife* (Boston: Houghton-Mifflin, 1928), 261–62.

2 Ibid., 263.

3 D. C. F. to Charles S. Ridley, August 23, 1920, French Family Papers, LOC.

4 D. C. F. to Ulysses S. Grant III, April 2, 1927, French Family Papers, LOC.

5 Sunlike Illuminating Company to Ulysses S. Grant III, March 27, 1929, French Family Papers, LOC.

6 French, *Memories of a Sculptor's Wife*, 262.

7 D. C. F. to Rep. Allen T. Treadway, September 7, 1929, French Family Papers, LOC.

8 Ulysses S. Grant III to D. C. F., February 22, 1929, French Family Papers, LOC.

9 To these Hall of Fame busts, French added one of Nathaniel Hawthorne in 1929.

10 French, *Memories of a Sculptor's Wife*, opp. 128.

11 Ibid., 226–27.

12 D. C. F. to Sherry Fry, October 31, 1918, French Family Papers, LOC.

13 Charles B. Summerall to D. C. F., June 28, 1921, French Family Papers, LOC.

14 Charles P. Summerall to D. C. F., September 18, 1922, French Family Papers, LOC.

15 See *Washington Star*, October 4, 1924; Michael Richman, *Daniel Chester French: An American Sculptor* (New York: Metropolitan Museum of Art, 1976), 191.

16 *Boston Herald*, October 2, 1924.

17 Margaret French Cresson, *Journey into Fame: The Life of Daniel Chester French* (Cambridge: Harvard Universality Press, 1947), 221.

18 D. C. F. to Harry Rutgers Marshall (assistant secretary), January 24, 1923, French Family Papers, LOC.

19 D. C. F. to Henry Corlerre, January 24, 1923, French Family Papers, LOC.

20 Clippings preserved in the Chapin Library, Williams College.

21 Sheppard Butler to D. C. F. (telegram), May 9, 1929, and Butler to French (quoting French's declination), May 29, 1929, French Family Papers, LOC.

22 D. C. F. to T. E. Cassidy, May 11, 1922, French Family Papers, LOC.

23 Betty Brainerd, "We Women," *Houston Post*, May 23, 1924.

24 *Oshkosh Daily Northwestern*, May 27, 1929. Even the scholarly *New England Quarterly* weighed in, hailing *Memories of a Sculptor's Wife* as "sprightly" and "delightful." See Edward W. Forbes, "*Memories of a Sculptor's Wife*. By Mrs. Daniel Chester French," *New England Quarterly* 2 (April 1929): 325.

25 Cresson, *Journey into Fame*, 299. Houghton Mifflin turned to sculptor Herbert Adams's wife Adeline to write an illustrated biography of the tight-lipped French.

26 Walter Tittle, "A Sculptor of the Spirit: How Daniel Chester French Puts Character into Marble, [London]*World Today*, December 1928, 60.

27 "Medal for Sculpture to Daniel C. French," undated clipping (ca. 1918) in the French Family Papers, LOC. According to the article, the award was conferred in New York on January 26 of that year. Saint-Gaudens had been honored posthumously seven years earlier.

28 Quentin R. Scribe, Jr., *George Westinghouse: Gentle Genius* (New York: Algora Publishing, 2007), 3–4.

29 Henry F. Hornbostel, "The Westinghouse Memorial: Schenley Park, Pittsburgh, Pa.," *Monument and Cemetery Review* 16 (November 1930): 61.

30 "Problems Conquered," undated, unsourced clipping in the French Family Papers, LOC.

31 H[enry]. Hornbostel to D. C. F., May 15, 1928, French Family Papers, LOC.

32 Undated press clipping from the French Family Papers—showing French, in shirtsleeves, "Putting the

Finishing Touches to the Bust of George Westinghouse for the Art Exhibition at Stockbridge, Mass., Opening This Week." The photograph shows the model for the Lincoln Memorial statue in the background.

33 "The Trustees of the Metropolitan Museum of Art to Daniel Chester French, April XX, MCMXXV," typescript in the French Family Papers; *To Daniel Chester French On the Occasion of His Seventy-Fifth Birthday April 20, 1925*, printed copy signed by fourteen trustees, both in French Family Papers, LOC.

34 The *New York Times* called Irving a "weaver of legends" on the occasion of the statue's arrival, January 31, 1926.

35 D. C. F. to Frank Jefferson, June 23, 1925, French Family Papers, LOC.

36 D. C. F. to George S. Hellman, June 27, 1925. French misspelled the British-American sculptor's name as "Highes."

37 D. C. F. to George Haven Putnam, April 23, 1925; George S. Hellman to D. C. F., June 25, 1925; Hellman to D. C. F., July 7, 1925, French Family Papers, LOC.

38 D. C. F. to William Clifford, July 14, 1925, and Clifford to French, July 18, 1925 (with list); Stephen O. Granscay to D. C. F. July 10, 1925; Bashford Dean to D. C. F., January 23, 1926, French Family Papers, LOC. Chesterwood owns the drawings of helmets, on museum stationery, that Granscay sent to French.

39 Bashford Dean to D. C. F., October 19, 1925, French Family Papers, LOC.

40 D. C. F. to George B. Brunnell, July 2, 1925, French Family Papers, LOC.

41 *Irvington Gazette*, July 1, 1927.

42 "The Irvington Fireside: A Notable Event," *Irvington Gazette*, July 1, 1927.

43 "The Legacy of 'Beneficence," http://cms.bsu.edu/Academics/Libraries/CollectionsAndDept/Archives/Collections/UniversityArchives/Exhibits/Beneficence/Legacy.aspx.

44 D. C. F. to Evelyn Beatrice Longman, July 6, 1930, French Family Papers, LOC.

45 The best biography is Walter Stahr, *Seward* (New York: Simon & Schuster, 2011).

46 See Frederick W. Seward Jr. to D. C. F., September 22, 1923; W. H. Seward to D. C. F., August 2, 1924, French Family Papers, LOC. Frederick's 1923 letter was written on the sixty-first anniversary of the day Lincoln had issued the Preliminary Emancipation Proclamation.

47 US Department of the Interior, National Park Service, National Register of Historic Places Continuation Sheet, *William Henry Seward Memorial, Village of Florida, Orange County, New York*, Section 7, 3–4, copy in the Chesterwood Archives.

48 Agreement between Daniel C. French and the William H. Seward Memorial Fund, signed, undated copy (ca. January 1930) in the French Family Papers, LOC.

49 D. C. F. to Joseph Breck [acting director of the museum], April 21, 1930, French Family Papers, LOC.

50 Correspondence between Mrs. John [Katherine] Rogers and Metropolitan Museum registrar Henry F. Davidson, 1928–1930, John Rogers File, Metropolitan Museum Archives, R633.

51 D. C. F. to W. H. Seward, April 26, 1930, May 3, 1930; Seward to D. C. F., May 7, 1930, French Family Papers, LOC.

52 D. C. F. to Richard H. Dana, Jr., W. H. Seward to D. C. F., both July 10, 1930, French Family Papers, LOC.

53 W. H. Seward to D. C. F., September 27, 1930, French Family Papers, LOC.

54 W. H. Seward to D. C. F., October 1, 1930, D. C. F. to Seward, October 3, 1930, French Family Papers, LOC.

55 D. C. F. to Henry Hollis [French's nephew], November 27, 1929, French Family Papers, LOC.

56 Notre's interview with Miss Ethel Cummings, Church St., Stockbridge, MA, October 21, 1976, memorandum to the oral history files, January 2, 1979, by Paul Ivory and Susan Frisch, Chesterwood Archives.

57 D. C. F. to Newton Mackintosh, November 29, 1929, French Family Papers, LOC.

58 D. C. F. to Evelyn Longman, July 6, 1930, French Family Papers, LOC.

59 D. C. F. to Evelyn Beatrice Longman, September 30, 1930, French Family Papers, LOC.

60 D. C. F. to Mr. and Mrs. H. Horton Batchelder, October 24, 1930, French Family Papers, LOC.

61 D. C. F. to "Mrs. Appleton," January 22, 1929, French Family Papers, LOC.

62 "D. C. French 80 on Sunday," *New York Times*, April 18, 1930.

63 "D. C. French at 80 a Busy Sculptor: Man American Pioneer Artist, He Brings to the Life of Today Traditions of New England Culture—Emerson His Favorite Subject," *New York Times*, April 26, 1930.

64 "At 80 Starts His Masterpiece," *New York Sun*, April 21, 1930.

65 D. C. F. to Horton Batchelder, July 8, 1925, copy in Chesterwood Archives.

66 D. C. F. to Gozo Kawamura, May 30, 1930; Kawamura reply to D. C. F., May 31, 1930, French Family Papers, LOC.

67 Gozo Kawamura to D. C. F., June 15, 1930, French Family Papers, LOC.

68 D. C. F. to Frederick W. Ruckstull, May 20, 1931, French Family Papers, LOC.

69 D. C. F. to Charles W. Gould, November 30, 1930, French Family Papers, LOC.

70 D. C. F. to Nathan D. Potter, January 12, 1931; to Frederick W. Ruckstull, May 20, 1931; D. C. F. account book for *Andromeda*, copy in the Chesterwood Archives; Richman, *Daniel Chester French*, 195–96.

71 Getulio Piccirilli to D. C. F., July 16, 1931, French Family Papers, LOC.

72 D. C. F. to James E. Fraser, August 17, 1931, to Frederick W. Ruckstull, May 31, 1931, French Family Papers, LOC.

73 "'America Needs Art Spokesmen,' French Asserts. Sculptor, 81 Tomorrow, Declares Forward Trend of Public Taste is Hampered. Sees Slow Improvement," *New York Herald*, April 19, 1931.

74 D. C. F. to Evelyn Longman, February 1, 1931, French Family Papers, LOC.

75 Walter Pritchard Eaton, 1946 typescript in French Family Papers, LOC, published as foreword to Cresson, *Journey into Fame*, vii–viii.

76 D. C. F. letter to "Miss Hall's Art Appreciation classes," incomplete 1931 clipping, source unknown, in French Family Papers, LOC.

77 D. C. F. to Evelyn Beatrice Longman, February 1, 1931, French Family Papers, LOC.

78 D. C. F. to Rosalie Miller, August 12, 1931, French Family Papers, LOC.

79 D. C. F. to George S. Keyes, June 22, 1931.

80 Claude M. Fuess to D. C. F., May 6, 1931, French Family Papers, LOC.

81 The full-figure maquette of Webster is stored in the village library at Stockbridge. A long-unknown bronze version was offered at auction in New York in 2017. A plaster and bronze model is in the Chesterwood Collection. See D. C. F. to Claude M. Fuess, June 15, 1931, in which he reported to the Phillips Academy (Andover) teacher, who had first approached him about the project, "I have even gone so far as to make some sketches which enhance my interest in the subject. Transcript in the Chesterwood Archives. For the auction version, see Doyle Galleries Catalogue, *American Paintings, Furniture, & Decorative Arts*, October 4, 2017, Lot No. 50.

82 D. C. F. to George M. Moses, July 11, 1931, French Family Papers, LOC.

83 Senator George H. Moses to D. C. F., June 30, 1931; French to Moses, July 2, 1931, French Family Papers, LOC.

84 *New York Herald*, April 19, 1931.

85 Cresson, *Journey into Fame*, 294.

86 *Lockhart Post-Register*, September 17, 1931.

87 Cresson, *Journey into Fame*, 295.

88 Ibid.

89 Adeline Adams, *Daniel Chester French: Sculptor* (Boston: Houghton Mifflin, 1932), 89.

90 See, for example, *Wilmington News-Journal*, October 10, 1931, and the *Art Digest*, October 15, 1931 ("Death Stays the Hand of Daniel Chester French, Sculptor").

91 "Hoover Praises Daniel French," *New York Telegram*, October 8, 1931, one of several obituaries and related clippings in the French Family Papers, LOC.

92 *Brooklyn Eagle*, October 8, 1931.

93 *St. Louis Post-Dispatch*, October 10, 1931.

94 *New York Times*, October 12, 1931.

95 Frank Parker Stockbridge, "In Memoriam Daniel Chester French 1850–1931," typescript in the French Family Papers, LOC.

96 Ibid., and list of funeral attendees, typescript with handwritten emendations, dated October 11, 1931, French Family Papers, LOC.

97 Royal Cortissoz, *American Academy of Arts and Letters: Proceedings of its Literary Exercises, November 10, 1932*,

60–65. Cortissoz's eulogy was read at the ceremony by sculptor Herbert Adams, French's immediate successor as chairman of the National Commission of Fine Arts, whose wife Adeline had just published a biography of French.

98 "A Patriot Sculptor," *New York Times*, October 11, 1931, clipping in the French Family Papers, LOC.

99 Rolfe Cobleigh, "What the Sculptor Expressed," *The Congregationalist*, October 22, 1931.

EPILOGUE
"THE HALLOWED SPOT"

1 For an account of Lincoln Memorial memory, see Thomas Mallon, "Set in Stone: Abraham Lincoln and The Politics of Memory," *New Yorker*, October 13, 2008, www.newyorker.com/ magazine/2008/10/13/set_in_stone.

2 For Eleanor's role in the affair, see Blanche Wiesen Cook, *Eleanor Roosevelt: The War Years and After*, vol. 3 of a trilogy (New York: Viking, 2016), 34–35.

3 *New York Herald-Tribune*, April 10, 1939.

4 Quoted in Raymond Arsenault, *The Sound of Freedom: Marian Anderson, the Lincoln Memorial, and the Concert that Awakened America* (New York: Bloomsbury Press, 2009), 159.

5 Quoted in Scott A. Sandage, "A Marble House Divided: The Lincoln Memorial, the Civil Rights Movement, and the Politics of Memory, 1939–1963," *Journal of American History* 80 (June 1993): 136.

6 Production costs and grosses for *Mr. Smith Goes to Washington* (1939) on IMDb; "dewy eyed freshman Senator from Montana" was so described by the film's director in Frank Capra, *The Name above the Title* (New York: Macmillan, 1971), 255.

7 Capra, *The Name above the Title*, 259–60.

8 "Alert Architect Helps Preserve Memorial Design," *New York Times*, November 28, 1976.

9 *New York Times, Washington Post*, February 16, 2016.

10 Armando Trull, "Northeast D.C. Gets a New Mural Honoring the Workers Who Built the Lincoln Memorial Statue," WAMU Radio, August 22, 2017, http:// wamu.org/story/17/08/22/northeast-d-c-gets-new-mural-honoring-workers-built-lincoln-memorial-statue.

11 *New York Times* Travel Section, September 10, 2017.

12 "Widow of Daniel Chester French Dies in Barrington," January 10, 1939, unidentified clipping in the French Family Papers, LOC.

13 For an exception, see Margaret French Cresson, "My Father and the Impetuous Rough Rider," *Berkshire Eagle*, October 27, 1958.

14 "Margaret Cresson, Sculptor, 84, Dead," *New York Times*, October 3, 1973.

15 Daniel Catton Rich to Margaret French Cresson, March 24, 1955, April 22, 1955, August 15, 1955, and Cresson to Rich, April 18, 1955, French Family Papers, LOC.

Credits

FRONT MATTER

p. 02 © 1976 Bernie Cleff, Collection of the Smithsonian American Art Museum; Chesterwood Archives, Chapin Library

p. 05 "Lincoln Monument: Washington" from *The Collected Works of Langston Hughes* by Langston Hughes, edited by Arnold Rampersad with David Roessel, Associate Editor, copyright © 1994 by the Estate of Langston Hughes. Used by permission of Alfred A. Knopf, an imprint of the Knopf Doubleday Publishing Group, a division of Penguin Random House LLC. All rights reserved.

PROLOGUE
IN THIS TEMPLE

p. 16 Photograph by Underwood & Underwood Studios, New York; Chesterwood Archives, Chapin Library

p. 18 US Army Signal Corps photographer, National Park Service, National Archives (111-SC-74847), Washington, DC

p. 21 Photograph by National Park Service, National Archives (74855), Washington, DC

p. 24 National Archives (111-SC-74827), Washington, DC

CHAPTER ONE
THE MAKING OF A SCULPTOR

p. 28 Photograph by J. W. Black, Boston; Chesterwood Archives, Chapin Library

p. 30 Chesterwood Archives, Chapin Library

p. 31 Chesterwood Archives, Chapin Library

p. 37 Chesterwood Archives, Chapin Library

p. 43 Library of Congress, Daniel Chester French Family Papers, Library of Congress, LCMS-21576-6 (218844), Washington, DC

p. 47 Chesterwood Archives, Chapin Library

p. 50 Photograph by Charles Darling, Medford, MA; Chesterwood Archives, Chapin Library

CHAPTER TWO
THE *MINUTE MAN*

p. 52 Photograph by H. G. Smith, Studio Building, Boston; Chesterwood Archives, Chapin Library

p. 56 Photograph by Miller & Rowell, Boston; Chesterwood Archives, Chapin Library

p. 58 Photograph by Simon Wing; Chesterwood Archives, Chapin Library

p. 60 (top) Chesterwood, Stockbridge, MA; (bottom) Chesterwood, Stockbridge, MA

p. 62 French Family Papers, Library of Congress, Washington, DC

p. 64 Chesterwood Archives, Chapin Library

p. 285 Photograph by A. B. Bogart; Chesterwood Archives, Chapin Library

p. 285 Chesterwood Archives, Chapin Library

CHAPTER ELEVEN
THE GENIUS OF CREATION

p. 292 Chesterwood Archives, Chapin Library

p. 294 photograph by A. B. Bogart; Chesterwood Archives, Chapin Library

p. 297 Chesterwood Archives, Chapin Library

p. 299 Chesterwood Archives, Chapin Library

p. 301 Photograph by H. B. Settle, Saratoga Springs. H. B. Settle Collection, Historical Society of Saratoga Springs, NY

p. 304 (upper right) Photograph by A. B. Bogart; Chesterwood Archives, Chapin Library (upper left) Photograph by A. B. Bogart; Chesterwood Archives, Chapin Library (bottom) Chesterwood Archives, Chapin Library

p. 305 Photograph by A. B. Bogart; Chesterwood Archives, Chapin Library

p. 309 Photograph by Commercial Photo Co., Washington, DC; Chesterwood Archives, Chapin Library

p. 311 Chesterwood Archives, Chapin Library

p. 319 Photograph by Peter S. Juley & Son; Chesterwood Archives, Chapin Library

p. 322 Chesterwood Archives, Chapin Library

CHAPTER TWELVE
LINCOLN ENTHRONED

p. 326 John C. Johansen, *Portrait of Daniel Chester French*, 1925, oil on canvas; Chesterwood, NT 69.38.784. Photograph by Nicholas Whitman

p. 328 Photograph by Harris & Ewing; Chesterwood Archives, Chapin Library

p. 338 (top) Chesterwood, Stockbridge, MA (middle) National Portrait Gallery, Smithsonian Institution, Washington, DC (bottom) Photograph by Paul Rocheleau; Chesterwood, Stockbridge, MA

p. 342 Photograph by A. B. Bogart; Chesterwood Archives, Chapin Library

p. 343 Photograph by National Park Service, Washington, DC

p. 348 National Archives, Office of Public Building and Public Parks of the National Capital (42-M-J-1), Washington, DC

p. 351 Chesterwood, Stockbridge, MA

p. 353 US Army Signal Corps photographer, National Archives (111-SC-74889), Washington, DC

p. 357 Lincoln Financial Foundation Collection, courtesy of the Indiana State Museum and Allen County Public Library

p. 358 National Photo Company Collection, Library of Congress, Washington, DC

p. 361 © 1976 Bernie Cleff, Collection of the Smithsonian American Art Museum; Chesterwood Archives, Chapin Library

CHAPTER THIRTEEN
THE MONUMENTAL MAN OF STOCKBRIDGE

p. 362 Chesterwood Archives, Chapin Library

p. 364 Photograph by De Witt Ward; Chesterwood Archives, Chapin Library

p. 367 Photograph by Conlin, Boston, MA; Chesterwood Archives, Chapin Library

p. 369 Chesterwood Archives, Chapin Library

p. 373 Chesterwood Archives, Chapin Library

p. 374 Photograph by De Witt Ward; Chesterwood Archives, Chapin Library

p. 377 Photograph by De Witt Ward, Peter A. Juley & Sons, printer; Chesterwood Archives, Chapin Library

p. 380 © *The Boston Post*, Boston, MA, 1929; Chesterwood Archives, Chapin Library

p. 382 (left) Chesterwood Archives, Chapin Library (right) Photograph by De Witt Ward; Chesterwood Archives, Chapin Library

p. 388 Photograph by Margaret French Cresson; Chesterwood Archives, Chapin Library

EPILOGUE
THE HALLOWED SPOT"

p. 390 Chesterwood Archives, Chapin Library

p. 392 United States Information Agency photographer, National Archives (NWDNS-306-SSM-4B-102-26), Washington, DC

p. 393 Photograph by Thomas D. MacAvoy, the LIFE Picture Collection

p. 395 © Bob Adelman [LC-DIG-ppmsca-34869], Library of Congress, Prints & Photographs Division, Washington, DC

p. 397 National Archives (306-SSM-4D-102-15), Washington, DC

Index